Photography

Photography

Sixth Edition

Phil Davis University of Michigan

Wm. C. Brown Publishers

Book Team

Editor Meredith M. Morgan Production Editor Gloria G. Schiesl Designer David C. Lansdon Art Editor Donna Slade Photo Editor Mary Roussel Permissions Editor Mavis M. Oeth Visuals Processor Andé Meyer

WCB Wm. C. Brown Publishers

President G. Franklin Lewis Vice President, Publisher George Wm. Bergquist Vice President, Publisher Thomas E. Doran Vice President, Operations and Production Beverly Kolz National Sales Manager Virginia S. Moffat Advertising Manager Ann M. Knepper Marketing Manager Kathleen Nietzke Production Editorial Manager Colleen A. Yonda Production Editorial Manager Julie A. Kennedy Publishing Services Manager Karen J. Slaght Manager of Visuals and Design Faye M. Schilling

Cover and title page photograph © Craig Blouin, f/Stop Pictures

Copyright © 1972, 1975, 1979, 1982, 1986, 1990 by Wm. C. Brown Publishers. All rights reserved

Library of Congress Catalog Card Number: 89-50286

ISBN 0-697-05859-X

No part of this publication may be reproduced, stored in a retrieval system, or transmitted, in any form or by any means, electronic, mechanical, photocopying, recording, or otherwise, without the prior written permission of the publisher.

Printed in the United States of America by Wm. C. Brown Publishers, 2460 Kerper Boulevard, Dubuque, IA 52001

10 9 8 7 6 5 4 3 2

Contents

1

A Survey of the History of Photography 1

The Discovery and Evolution of Photography 2 Discovery of Image Formation by Light 2 / The Chemical Investigations 3 / The Daguerreotype Period 4 / The Calotype Period 6 / The Collodion Period 8 / Applied Photography-A Commercial Enterprise 9 / The Gelatin Period 16 / Advancement of Color Techniques 18 / Editorial Photography 20 The Art of Photography 28 Photography and Painting 29 / Photography Becomes an Art in Its Own Right 32 / The Post-War Era 40 / Photography Today 43 / The Future

of Photography 49 Summary 50

2

Qualities of a Good Photograph 51

Consumer vs. Producer 52 Using Criticism Constructively 54 Limits to Personal Expression 56 Human Vision vs. Camera Vision 57 Composition 60 One Photographer's Search 68 Finding Your Own Way 75 Summary 76

3

Introduction to the Photographic Process 77

Light-Sensitive Materials 78 Image Formation 79 Using a Pinhole 79 / Using a Lens 81 / Film and Paper 82 Summary 84

4

Camera Types and Accessories 85

Simple Cameras 86 Rangefinder Cameras 86 Reflex Cameras 86 Shutter Types 91 View and Field Cameras 93 Accessories 94 Flash Units 95 Before You Buy 97 Summary 98

5

The Camera's Controls and Features 99

Checking the Batteries 100 The Camera's Controls: Focus 101 Aperture Calibration 102 Depth of Field 104 Shutter Calibration 106 The Built-In Meter: Film Speeds 107 Preparing to Photograph 110 Caring for Your Camera 112 Summary 114

6

Using Your Camera Effectively 115

Know Your Purpose 116 Visualization and Perception 116 Technique 118 Controlling the Camera Image: Framing 118 Preview 120 Calculating Exposure 124 Semiautomatic Exposure Control 125 Programmed Exposure Control 126 Unusual Subject Conditions 127 Summary 132

?

Light and Lens Characteristics 133

Light Behavior 135 Lens Aberrations 136 Lens Characteristics 138 Image Perspective 141 Depth of Field 142 Summary 146

8

Film and Filters 147

Image Characteristics 148 Film Speed 149 Reciprocity Effects 150 Color Sensitivity 150 Filters 152 How Filters Work: Color Fundamentals 152 / Filtering and Focusing for Infrared 154 / Filter Factors 155 / Polarizing Filters 157 / Neutral Density Filters 159 Summary 159

9

Working with Light 161

Available Light 167 Selected Light 168 Using Flash 169 Flashbulbs 169 / Electronic Flash 170 / Simple Uses of Flash 171 Artificial Lighting 172 The Attributes of Light 174 / Basic Lighting 175 / Tent Lighting 180 Summary 185

10

Processing Rollfilm 187

Rollfilm Processing Equipment and Facilities 188 The Developing Tank 188 / Thermometer 188 / Timer 188 / Utensils and Containers 188 / Film Washing and Drying Equipment 189 / Cleanup 189 Process Introduction 189 Water for Photographic Use 189 / Preparing and Storing Developers 189 / Metol Poisoning 190 **Development Controls** 194 Time 194 / Temperature 194 / Agitation 194 / The Stop Bath 195 / The Fixing Bath 196 / Reticulation 197 / The Hypo-Clearing Bath and Wetting Baths 197 / Film Drying and Negative Storage 199 Summary 200

11

Printing Equipment and Materials 201

The Darkroom 202 Safelights 202 The Enlarger 202 Enlarging Lenses 203 Accessory Equipment 205 Easel 205 / Grain Focuser 205 Printing Frame 206 / Dodging and Burning Tools 206 / Processing Trays 206 / Miscellaneous Items 207 Mounting and Matting Equipment 208 Introduction to Printing Materials 209 Developer 209 / The Stop Bath 209 / The Print Fixing Bath 209 Printing Papers 210 Paper Characteristics 210 / Stabilization Processing 214 Summary 215

12

Black-and-White Printing 217

Proofing Your Negatives 218 Making Prints by Projection 222 Making Test Strips 224 The Test Print 226 / Dodging and Burning-in 228 Post-Development Controls 229 Reducing 229 / Bleaching 232 Archival Processing of Prints 234 Summary 237

13

Print Finishing 239

Print Spotting 240 Mounting and Matting Prints 243 Summary 250

14

Introduction to Color Photography 251

Color Balance 252 Color Filtration 254 Color Compensating Filters 255 / Special-Purpose Filters 255 How Color Films Work 256 Color Negative Films 257 / Color Positive (Reversal) Films 257 / Special Film Types 257 / Reciprocity Effects 259 / Film Latitude 260 Processing Color Films 261 Summary 262

15

Color Printing 263

Color Printing Equipment 264 Tone and Color Fidelity 265 Negative Color Processes 266 Kodak Ektacolor Paper 266 Positive Color Processes 267 Kodak Ektachrome Papers 267 / Ilford Cibachrome All 267 / The Kodak Dye Transfer Process 269 Color Negative Printing 271 Color Negative Filtration 272 / Color Analyzer 272 / Color Matrix 273 / Calculating Filter Pack Adjustments 277 / Exposure Calculation 280 Color Positive Printing 281 Tricolor Printing 285 Color Print Permanence 285 Summary 286

16

Close-up Photography and Copying 289

Close-up Photography with a Small Camera 293 Using Supplementary Close-up Lenses 293 / Extension Tubes and Bellows Units 294 / Macro-Zoom Lenses 294 / Special Macro Lenses 295 Close-up Photography with the View Camera 295 View Camera Lenses for Close-up Work 297 / Lighting for Close-up Photography 297 / Metering for Close-ups 299 Copying 300 Summary 303

17

Using the View Camera 305

Sheet Films 306 Processing Sheet Film 308 / Processing Chemicals 309 Using View and Field Cameras 309 The Shifts and Swings 313 What the Shifts Do 315 / What the Swings Do 316 / View Camera Lenses 319 / Shutters 319 Summary 320

18

Exposure/Development Systems 323

The Exposure/Development Relationship 324 Testing Film 324 Analyzing the Test Results 326 Interpreting the Film Characteristic Curves 327 / Curve Gradient 330 / The Paper Exposure Scale (ES) 332 / Locating the Film's Speed Point 333 / Charting the Working Data 334 Light Meter Types and Characteristics 336 Wide-Field Averaging Luminance Meters 338 / Spotmeters 338 / Incident Meters 340 An Incident Metering System 341 The Zone System 343 The Concept of Zones 344 / Zone System Calibration 346 / Translating CI to N-Numbers 347 Summary 348

Appendixes 351

- 1. Some Available Film Types and Their Characteristics 352
- 2. Some Available Paper Types and Their Characteristics 355
- 3. Chemical Formulas 358
- 4. Close-up Exposure Correction 360
- 5. Filtration for Color Photography 361
- 6. Filtration for Black-and-White Photography 362
- 7. Compensation for Reciprocity Effects 363
- Equivalent Lens Focal Lengths for Various Camera Sizes and Lens Angular Coverage Chart 364
- 9. Film Development Charts 365

Glossary 367 Bibliography 385 Index 386

Preface

Photography has undergone another of its periodic technical revolutions since the fifth edition of this book was published in 1986. The angular cast-metal camera bodies of just a few years ago are being replaced by sculptural, ergonomicallydesigned forms of tough, light-weight plastic. Lenses are sharper and more versatile, and shutters now provide speeds that were unthinkable just a few years ago. But the big news is "intelligence"; built-in miniature computers can now monitor and control most camera functions for totally automatic operation.

In fact, photography has never been easier. Multitudes of people who would never dream of calling themselves photographers are now happily producing billions of excellent-quality snapshots every year, thanks to "point-and-shoot" cameras that insulate their owners from the tedious details of film handling, focus, and exposure. These and other technical innovations have given new meaning to George Eastman's famous slogan, "you press the button, we do the rest," and have permanently altered our notion of what photography is and what photographs mean.

For example, we have generally thought of photographs as reliable documents of real places or things; but computers can now manipulate the photographic image so convincingly that its legendary "truth" is no longer certain. In fact, computers can now create persuasively realistic fantasy images for which no "subjects"—other than numerical data—exist. These manipulated and contrived "photographs" have become so common in advertising illustration, television, and cinema that we no longer question them.

Is conventional photography still relevant in this computer age? I think it is, although its role is obviously changing. The conventional photographic image is no longer novel, and even manipulated and distorted forms that were exciting just a few years ago are now commonplace. But if the photograph-as-object has been cheapened by overproduction and technical innovation, the act of photography remains engrossing and worthwhile. There is still excitement in the viewfinder or ground-glass image, and watching a print image slowly materializing in the developer is always a magical experience.

Technology advances endlessly, tools and materials become obsolete and are replaced, but we humans change more slowly. We are still image-makers by instinct, and photography continues to serve that instinct well.

This book is intended to provide you with the information you need to use photography effectively. Although this sixth edition retains much of the flavor of previous versions, it has been extensively revised and reorganized. Large portions of the text have also been rewritten to update the technical references and to rephrase and clarify many of the instructional sequences.

In response to many requests and suggestions, I have expanded the material that appeared in the fifth edition under the chapter heading "What Is a Good Photograph?" It is now titled "Qualities of a Good Photograph" and has been relocated as the new Chapter 2 to relate more closely to the summary of the history that remains as Chapter 1. I have also heeded reviewers' suggestions in repositioning the discussion of artificial lighting. It appeared previously as Chapter 19 but is now merged with the consideration of basic lighting principles, as Chapter 9. Readers who are familiar with the previous edition will also notice that several other chapters have been combined to reduce the total from 22 to 18.

This edition contains a great many new photographic illustrations, many of them in color, and the color is now more uniformly distributed throughout the text. Photographs continue to play an important role in the process instruction sequences and I have extensively revised the accompanying text in an attempt to eliminate redundancies and clarify the descriptions. The popular marginal notes and chapter summaries have been retained and revised to facilitate skimming of the text material, and the book's new layout and typography are intended to enhance readability.

I'm indebted to the many corporations, including the Eastman Kodak Company, Ilford Inc., Nikon Inc., Minolta Corporation, the Polaroid Corporation, Agfa-Gevaert Inc., Fuji Photo film U.S.A., Inc., Photo Color Systems Division/3M, the Ries Camera Company, and others, whose representatives supplied me with technical data and product information for this edition. I also thank Ron Wisner of the Wisner Classic Camera Company for his loan of equipment for some of the illustrations, and David Jay, editor of Darkroom and Creative Camera Techniques magazine, for his continuing encouragement and support. Finally, Bill Wylie deserves special acknowledgment; the results of his efforts and cooperation are apparent in Chapter 2.

Reviewers

Harold Baldwin Middle Tennessee State University

David L. DeVries California State University-Fullerton

James Hawley Pan American University

Gregory T. Moore Kent State University

William G. Muller Jr. Hudson Valley Community College

Gary Pearson Ricks College

Michael Peven University of Arkansas

Michael Sherer University of Nebraska 1

A Survey of the History of Photography

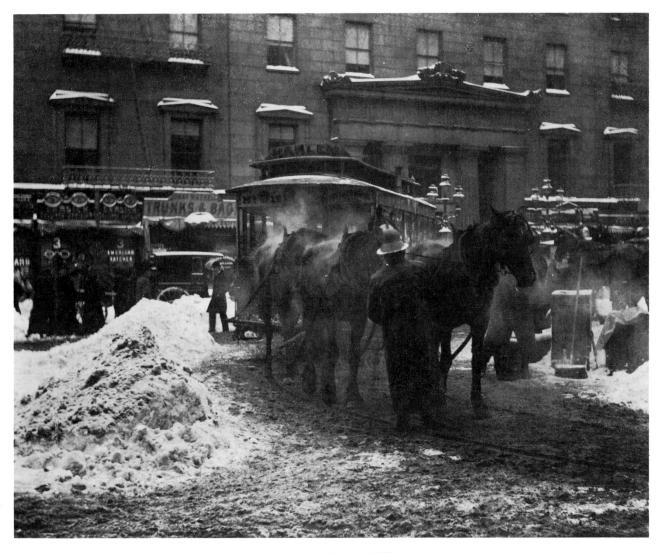

 The Terminal, ca. 1892

 Alfred Stieglitz (1864–1946). Chloride print

 8.8 cm × 11.3 cm.

 (The Alfred Stieglitz Collection, © The Art Institute of Chicago, All rights reserved)

1

Photography is involved in almost everything we experience

No one knows when the first camera was constructed

della Porta refined the camera obscura

and was accused of sorcery

Can you imagine what the world would be like if photographs and photographic processes were suddenly taken from us. Although we take television for granted and accept motion pictures, photographic magazines, and newspaper illustrations as a matter of course, these are only the more obvious signs of the influence of photography on our lives. It is involved, directly or indirectly, in almost everything we experience.

It wasn't always like this. Newspaper and magazine reproduction of photographs was still a novelty at the beginning of this century. Color photography was in its infancy in 1910. Sound-on-film recording was introduced to the motion picture industry in the 1920s. And television, which seems to have made the whole world picture-conscious, was still new to most people in 1950.

Considering the fascination that image-making has always held for people, it sometimes seems surprising that it took so long for photography to be invented. But it wasn't just invented; it evolved and that evolution was a long and painful process.

The Discovery and Evolution of Photography

Discovery of Image Formation by Light

No one knows when the first camera was constructed, but it was long before there was any real use for it. It was probably inspired by the observation of some naturally formed image. Aristotle mentioned the images of a solar eclipse formed on the ground by sunlight passing through little gaps in tree foliage, and his comments indicate that he had some grasp of the principles involved.

In view of Aristotle's obvious recognition of the principles, the first camera could have been constructed by some unknown Greek. More likely, though, it came more than a thousand years later. Roger Bacon discussed the camera obscura knowledgeably about 1267 and is presumed to have learned about it from the writings of tenth-century Arab scholars.

In its earliest form, the camera obscura was what the name implies—a dark chamber or room. Leonardo da Vinci described one in some detail about 1490, pointing out that the image was viewed through the back of a screen of paper, which "must be very thin." He also specified that the hole "should be made in a piece of very thin sheet iron."

In 1558 the camera obscura was described fully by Giovanni Battista della Porta. In the first edition of his *Magiae Naturalis*, he specified that a conical hole be installed in the shutter of a darkened room and that the image be shown on a white screen. He said that the image would appear upside down and reversed from left to right, and that the image size would be proportional to the distance from the hole to the viewing screen—all of which are equally valid observations for the cameras we use today. Porta recommended that the camera obscura image be used as a guide for drawing and then went on to invent a method for producing an erect image using lenses and curved mirrors. With this apparatus, he astounded viewers with the images of elaborate theatrical productions staged outside and supposedly was even accused of sorcery for his trouble.

The application of lenses to the camera obscura after 1550 was a significant step. The image could then be made both sharper and more brilliant because a lens can admit much more light than a simple hole and can also focus the light rays to finer points. Cameras began to be refined in design and construction as more and more people became interested in them. By about 1575, the first movable cameras appeared. They were, at first, wooden huts or tents that completely enclosed the viewer and viewing screen. Later, more elaborate models, such as sedan chairs, were constructed.

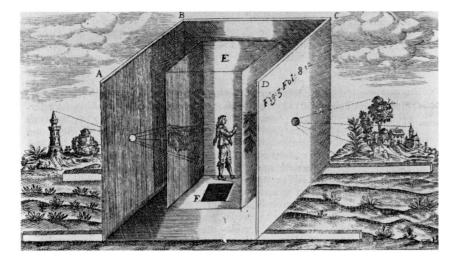

From that point on, the evolution was rapid. Smaller models were designed, which permitted the operator to view or trace the image from outside the main enclosure. Finally, completely portable cameras appeared. A *reflex* camera, one in which the image is reflected up onto a top-mounted viewing screen by an inclined mirror behind the lens, was built in 1676; a *ball-andsocket* mount (like some modern *tripod heads*) appeared in 1680; and a *telephoto* lens was installed in a camera obscura in 1685. The camera was ready, but for what?

The Chemical Investigations

Photographic chemistry started late and proceeded slowly. In 1614 Angelo Sala noted that silver nitrate turned black when exposed to the sun, but he apparently saw nothing significant in the change and did not ascribe it to the action of light.

The first discovery of importance was made in 1725 by Johann Heinrich Schulze, a professor of anatomy at the University of Altdorf. He had mixed powdered chalk into a solution of nitric acid in an attempt to make a phosphorescent material (the "luminous stone" of the alchemist, Balduin) and was amazed to discover that the mixture turned dark violet in sunlight. He traced the discoloration to a contaminant in the acid, silver, and eventually proved that silver compounds were visibly changed by the action of light rather than heat or exposure to air, as had been previously suggested. Schulze made numerous stencil prints on the sensitive contents of his bottles, but apparently he never applied the solutions to paper or made any attempt to record natural images.

In 1777 Carl Wilhelm Scheele, the Swedish chemist, investigated the properties of silver chloride and made some interesting discoveries. Like Schulze, he established that the blackening effect on his silver salt was due to light, not heat. He also proved that the black material was metallic silver and he noted that ammonia, which was known to dissolve silver chloride, did not affect the blackened silver. If Scheele had realized the importance of this last discovery, he could very well have become the inventor of photography because by this time the essential processes were known. Silver chloride could be reduced to black metallic silver by exposure to light; ammonia could preserve the image by dissolving the silver chloride without harming the image tones; and, of course, the camera was still waiting in the wings. But Scheele's investigations were only noted in passing. The world was not yet ready for photography. The fantastic possibility of producing images by the action of light had simply not occurred to anyone as a serious thought.

Figure 1.1

Camera obscura. From an early print. (Courtesy of the International Museum of Photography at George Eastman House)

Camera evolution was rapid

but chemical investigations proceeded slowly

Schulze made stencil prints

Scheele overlooked the significance of his discoveries

Joseph Niépce experimented with silver chloride

but had more success with asphalt coatings

Niépce produced the world's first camera image in 1826

Daguerre wrote to Niépce in 1826

The partners corresponded in code

This essential idea finally came to Thomas Wedgwood, the youngest son of the famous potter, Josiah. In addition to being an outstanding craftsman and artist, Josiah was a brilliant and respected member of the English scientific community. Thomas was familiar with the camera obscura because his father had used it as an aid in drawing scenes for use on his pottery. The Wedgwood family also owned the notebooks of William Lewis, who in 1763 had described Schulze's and his own experiments with the silver compounds. These circumstances and natural curiosity prompted young Thomas to begin experiments of his own, probably about 1795. Thomas Wedgwood narrowly missed becoming the inventor of photography for two reasons. He gave up attempts to make pictures with the camera obscura (his exposures were not sufficient), and he was unable to fix the silver images he did produce by direct printing.

In France, meanwhile, Joseph Nicéphore Niépce and his son Isidore were busy experimenting with lithography at the family estate near Chalon. When Isidore, who had been copying drawings onto the stones for his father, joined the army, and Nicéphore began to explore light-sensitive varnishes, hoping to find a coating for the stones that would record the drawings by exposure to light. He must have made some progress because in 1816 he set out to take pictures from nature using a camera and paper sensitized with silver chloride.

Niépce had limited success almost immediately, but he was displeased because the image tones were reversed from nature (they were negative) and he could not make the image permanent. He realized that the tonal reversal was an inherent part of the silver process and tried to produce a positive print by reprinting one of his negatives, but his attempts were unsuccessful. He also found that nitric acid helped to preserve the image for a while, but it only postponed disaster and could not prevent it. He began to experiment with other materials.

Finally, in 1822 he produced a copy of an engraving by exposing through the original onto a glass plate coated with bitumen of Judea, a type of asphalt. Light hardens this material, so when Niépce washed his exposed plate with the usual solvents, only the unexposed portions were floated away, leaving the image in permanent lines. He called his process heliography (sun-writing). He made a number of similar heliographs in the next few years and continued his efforts to record a camera image. At last, in 1826, he succeeded. The world's first permanent camera image shows the view from Niépce's second floor window and is little more than an impression. It is a bitumen image on pewter, showing only masses of light and dark tones. The exposure supposedly took about eight hours.

The Daguerreotype Period

In January 1826 Niépce received a letter from a Parisian painter, Louis Jacques Mandé Daguerre, who mentioned that he also was working with light images and inquired about Niépce's progress. Niépce was initially cautious, but after visiting Daguerre while on a trip through Paris, his suspicions were somewhat allayed. After occasional correspondence, he finally suggested to Daguerre in 1829 that they form a partnership to do "mutual work in the improvement of my heliographic process." Daguerre accepted and visited Niépce to work out the details. They became friends and corresponded frequently, but they never met again.

Until the time of their partnership, Daguerre had not produced a useful light image, although he had implied that his work was rather well advanced. The agreement with Niépce seemed to spur him on. He became a tireless experimenter and mentioned his growing interest in silver iodide in a letter

dated May 21, 1831. 'I think after many new tests that we ought to concentrate our researches on 20,'' he wrote, 'this substance is highly light-sensitive when it is in contact with 18.'' They were writing in code: ''20'' meant iodine, ''18'' meant silver plate.

Niépce could not contribute much in this direction. His early experiments with silver compounds had left him prejudiced against them. Finally, impoverished and discouraged, he died. Daguerre was saddened, but resumed his work with lsidore Niépce as his partner. He was now completely committed to working with the silver compounds.

In 1835 Daguerre discovered (quite by accident, if the story is true) that treatment with mercury vapor would produce a visible image on an iodized silver plate that had been briefly exposed to light. He also managed to stabilize the image with a strong solution of salt.

In 1838 he contacted a group of leading French scientists, among them François Arago, and solicited their help. Arago was immediately impressed with the invention and made a brief announcement of it at the Academie des Sciences in January 1839.

Daguerre had supported himself quite handsomely during most of the period of his research with the proceeds from his Diorama, a kind of light show that combined enormous paintings on translucent screens with some real objects, controlled light effects, and music to create illusions of famous scenes or ceremonies. It was a disaster for him, then, when the Paris Diorama was totally destroyed by fire in March 1839.

Arago immediately sprang to his aid and succeeded in convincing the government that French national honor was at stake. A bill was passed granting life pensions to Daguerre and Niépce, and the details of the process were announced to a frenzied public in August 1839. Although the French government had announced that the process was now public property, this was not entirely true. Daguerre had secretly patented it in England just a few days before the formal French announcement.

News of the daguerreotype process spread like wildfire. Enthusiastic experimenters, French and foreign, were soon happily engrossed in the new technique, but there was dismay in England. A respected member of the Royal Society of London, William Henry Fox Talbot, saw the new process as a threat to his own investigations. In an attempt to establish priority, Talbot had written Arago on January 29, 1839, claiming that he had been the first to find a method for taking pictures with the camera obscura and for fixing them. He overstated his case. He had not accomplished much more than Niépce had in his experiments with silver chloride, and his method of fixation was far from satisfactory.

Having heard that silver nitrate was light-sensitive, Talbot made his first attempts with silver-nitrate-coated paper. He quickly found it unsatisfactory and turned to silver chloride, at first coating paper with the prepared salt, then producing it in the paper by successive washes of sodium chloride (common salt) and silver nitrate. He soon found that too much salt reduced the sensitivity of the paper and turned, as Daguerre had done, to the use of a strong salt solution for fixing the image. Before long, Talbot ran across the accounts of the experiments of Wedgwood and Davy and investigated them fairly thoroughly, apparently without discovering much of real value. He had not yet heard of the work of either Niépce or Daguerre.

Although his early experiments were confined to making prints of objects laid directly on the paper surface, Talbot had succeeded by the summer of 1835 in taking pictures with a tiny camera obscura fitted with a microscope lens (his wife called his little cameras "mousetraps"). The pictures were only about an inch square, but he had found larger ones impossible to make due to the length of the exposure time required.

When Niépce died, Daguerre resumed his work with Isidore Niépce

Arago announced Daguerre's discovery in 1839

The daguerreotype was given to the world except England

William Henry Fox Talbot was dismayed

Talbot had begun his experimentations in 1834

He took pictures with "mousetraps"

Talbot made little progress during the next three years. His attention was diverted to other things. His interest and concern were apparent, though, when he received word of Arago's announcement of Daguerre's fantastic discovery.

The Calotype Period

The news that had stunned Talbot also greatly intrigued Sir John Frederick William Herschel, son of the famous German-born English astronomer and a prominent mathematician, astronomer, and chemist in his own right. Within a week, Herschel was at work in his laboratory near London investigating the various known processes and keeping careful notes of his procedures.

It is an indication of Herschel's intelligence and acuity as an investigator that in less than two weeks he successfully tested several silver salts for sensitivity, took several successful pictures, printed a negative to make a positive paper image, and fixed the images with a chemical he had described twenty years previously, which he called "hyposulphite of soda."

At the height of this investigation, less than two weeks after hearing about Arago's momentous announcement, Talbot visited Herschel at his laboratory, bringing with him samples of his work. Herschel showed Talbot his results and described them in full detail, including his use of *hypo* for fixing. Talbot, on the other hand, revealed nothing. He referred airily to his own method of fixing the image, without explaining how it was done, and convinced Herschel that he should not mention the use of hypo until Talbot had announced his process. Herschel agreed, later writing admiringly that Talbot's method of fixing ''must be a very chemical jewel,'' and gave Talbot permission to announce the use of hypo with his own process.

In Talbot's letter of disclosure to a member of the French Academy, he outlined his own methods of fixing, then described Herschel's hypo as being "worth all the others combined." Daguerre immediately applied it to his own process.

Niépce, Daguerre, and Talbot can each be called the "inventor of photography" with certain justification, but so can a fourth man who is less well known, Hippolyte Bayard. Bayard lived in Paris and was a minor employee of the Ministry of Finance. His experiments with light-sensitive materials probably began about 1837 and, initially, seem to have paralleled Talbot's. His first images were negatives on silver-chloride-treated paper. On learning of Daguerre's discovery, he set out to produce direct positive images. Within a few months he succeeded with a process that involved blackening a conventional silver chloride paper in light, then coating it with a solution of potassium iodide, and exposing it in the camera. The exposing light bleached this paper, producing a direct positive image, which he then fixed in hypo.

Bayard was apparently a very quiet, retiring man of modest means. Many of his pictures are still-life arrangements or details of his house and garden. In some of these views he appears seated in a doorway or in his garden surrounded by flowerpots and garden tools. Although he did make a few tentative attempts to gain recognition and support, he was not very successful. Perhaps, too, he was unlucky in his choice of consultants. He showed some prints to Arago in May 1839 and asked for his help, but Arago was interested in Daguerre's career at that point and arranged for a token grant of six hundred francs to help Bayard finance his experiments, counseling him to remain quietly in the background until Daguerre's work seemed anticlimactic and insignificant, and he was virtually ignored by the public and the government alike.

Herschel made the calotype process practical—in two weeks

Talbot learned of hypo from Herschel

Hippolyte Bayard also invented photography, but his attempts to gain recognition were not very successful

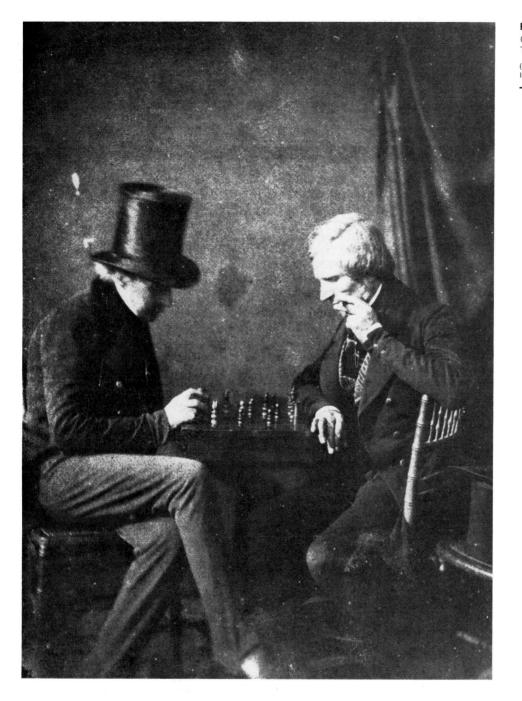

Figure 1.2

Chess Players. William Henry Fox Talbot. Original calotype. (Gift of Blum-Kovler Foundation, © The Art Institute of Chicago, All rights reserved)

Understandably bitter at this callous treatment, Bayard expressed his hurt by photographing himself as a half-naked corpse and explained, in a long and piteous caption that this was the dead body of the unhappy Bayard who, unrecognized and unrewarded, had thrown himself into the water and drowned.

Although he was never really given the credit he deserved during his lifetime, he did eventually receive a little prize of three thousand francs. He is now remembered as a significant figure, a victim of circumstances who might have been as well known as Daguerre if things had worked in his favor. Bayard photographed himself as a corpse

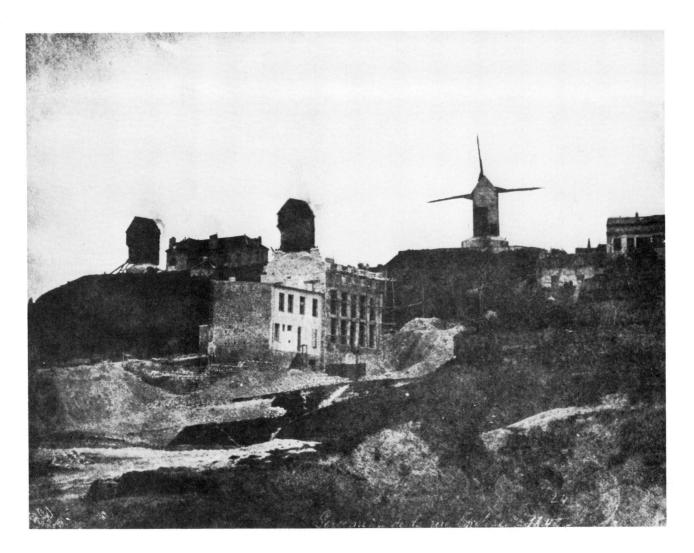

Figure 1.3 Moulins de Montmarte 1842. Hippolyte Bayard. (Courtesy of the International Museum of Photography at George Eastman House)

Talbot patented his processes

and controlled photography in England until 1855

Isidore Niépce's cousin invented the albumin process

Photography, a name generally credited to Herschel, languished in England. The daguerreotype process was patented, and Talbot immediately began to secure his own processes by patents so restrictive that even amateur experiments were inhibited. Talbot improved his original paper-negative process by subjecting the exposed paper to development in gallic acid and silver nitrate solution, thus shortening the necessary exposure time considerably. He called the new process *calotype* (also later referred to as *talbotype*) and included in its patent the use of hypo for fixing—blatantly appropriating Herschel's discovery.

Talbot must receive credit for inventing the photographic process as we now know it, but he must also be remembered as a stumbling block in its evolution. As new procedures were announced, Talbot promptly laid claims to them on the grounds that they were only modifications of the basic principles of his patented processes. Although these tactics created a great deal of antagonism and various suits were threatened, Talbot was generally successful in controlling photography in England until 1855.

The Collodion Period

The two decades following the invention of photography were years of rapid technical evolution and experimentation. The daguerreotype process was sufficiently refined to permit studio portraiture by about 1841. Talbot's calotype process was improved by Louis-Désiré Blanquart-Evrard; Gustave LeGray

went a step further by sensitizing waxed paper to produce negatives of greater sharpness and translucency; and Claude Niépce de St.-Victor's glass plates, sensitized with an albumin emulsion, gave photographers still another alternative. All of these processes were in use in 1851 when Frederick Scott Archer announced the details of his collodion process and gave it freely for all to use.

The process was not free for long. Talbot, displaying his typical lack of scruple, claimed that it was covered by his patents and announced that he would prosecute anyone who used it without his license. A number of challenges were made to this outrageous claim. Finally in December 1854 the courts found Talbot's claims illegal and his tyranny ended.

Applied Photography—A Commercial Enterprise

By the 1850s photography was well established as a commercial enterprise. As early as November 1839 Noel Lerebours, a French optician and entrepreneur, had dispatched several crews of painters and photographers to various exotic places, such as Greece, England, America, and Egypt. The views that they collected while "daguerreotyping away like lions," as one group reported, were copied by skilled engravers, and Lerebours published them as *Excursions Daguerriennes.*

In England, Talbot had sold "sun pictures" of landscapes and other scenes and eventually set up a "glass house" at Reading where his several employees printed editions of photographs and sold calotype materials to Talbot's license-holders. In 1844 the "Reading Establishment" began turning out the calotype illustrations for Talbot's famous *Pencil of Nature*, the first book ever published with photographic illustrations. Several years later, Blanquart-Evrard opened a similar, but larger, printing establishment in France, where, using his improved process, his employees were able to produce several hundred prints per day. He also produced several booklets and albums illustrated with actual paper prints.

The paper processes were never popular in America, although various experimenters had worked with them unsuccessfully before the announcement of the daguerreotype. One of these men, Samuel F. B. Morse, had visited Daguerre in Paris (he was demonstrating his telegraph to Daguerre in the hour that the Diorama burned) and was enchanted by the images that Daguerre had shown him. After returning to America, Morse had a camera built and soon joined forces with John W. Draper in attempting to master the process. Morse and the other pioneers soon became enthusiastic teachers and many of their students, among them Mathew Brady and Albert Southworth, ultimately became famous portrait photographers.

The American daguerreotypist was not confined to the studio by any means. The Langenheim brothers of Philadelphia produced a panoramic view of Niagara Falls in 1845 by mounting five separate pictures edge to edge. An even more spectacular panorama of the city of Cincinnati, eight feet long, was assembled by Fontayne and Porter in 1848. A daguerreotypist named Platt Babbitt specialized in photographing tourist groups in front of Niagara Falls; and, in St. Louis, J. H. Fitzgibbon photographed riverboats, frontier scenes, and Indians, as well as maintaining a conventional portrait studio. A number of adventurous men, such as Britt, Vance, McIntyre, and Carvalho, daguerreotyped the Far West, including the Rocky Mountains, the California gold fields, and San Francisco, several years before the better-known expeditions of Carleton Watkins, Timothy O'Sullivan, and William H. Jackson.

For somewhat similar work being done at about the same time, European photographers favored the various paper processes or albumin-coated glass plates. The calotype and the waxed-paper process were popular there until about 1855, and proof of their refinement is seen in the works of Charles Nègre,

Talbot claimed Archer's collodion process and lost

"We are daguerreotyping away like lions!"

Talbot and Blanquart-Evrard: publishers

Morse and Draper became enthusiastic teachers

American daguerreotypists made spectacular pictures

European photographers favored the paper processes

Figure 1.4

Group at Niagara Falls. Platt D. Babbitt. (Courtesy of the International Museum of Photography at George Eastman House)

Fenton used it to document the Crimean War

The ambrotype and carte-de-visite doomed the daguerreotype

Tintypes were also very popular

Stereo views were produced in great numbers

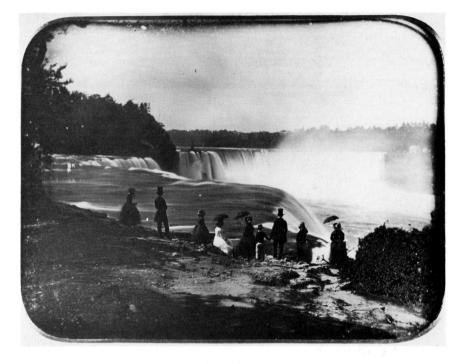

Henri Le Secq, John Shaw Smith, Roger Fenton, and others. Their landscapes, architectural views, and archeological records of Egypt, in particular, are frequently larger than one would expect and startlingly beautiful.

The collodion process offered photographers a negative material of greater sensitivity and better quality than paper, but the process was a demanding one. A glass plate had to be cleaned, then flooded with iodized collodion to form a uniform, blemish-free coating. It then had to be immersed in a bath of silver nitrate and rushed into the camera for exposure while still wet. Development in pyrogallic acid or a solution of ferrous sulfate had to follow immediately before the plate dried. For obvious reasons, it became known as the wet-plate process.

Roger Fenton was one of the first to use this process for reportage, by covering the Crimean War in 1855. In spite of almost insurmountable difficulties, Fenton managed to produce a series of photographs that, although curiously unwarlike, do record the terrain and the camp life impressively.

J. A. Cutting's invention of the ambrotype (collodion on glass) and André Adolphe-Eugène Disdéri's popularization of the photographic carte-de-visite (albumin emulsion on paper), both in 1854, doomed the daguerreotype and disrupted the studio portrait business. Although the ambrotype was markedly inferior to the daguerreotype in clarity and brilliance, it was cheap and relatively easy to make. The carte-de-visite images, usually made eight-to-a-plate and then cut into individual pictures, were even cheaper. They became a worldwide sensation and were sold, traded, and collected by the hundreds of thousands.

The tintype (collodion on metal), also called *ferrotype* and *melainotype*, was patented by Hamilton Smith in 1855. It, too, became a quick, cheap, and easy way to produce portraits and views, and although the image quality was poor, tintypes became popular. These cheap, mass-produced images were viewed with hostility and alarm by many "high-class" portrait photographers, but they had little choice; they could follow the trend or lose business. Most of them began producing the new, cheap images.

Stereoscopic views were also exceedingly popular. Although the principle of the stereoscope had been known for a long time, it was not adapted for photographic use until Charles Wheatstone suggested it in 1841. His early

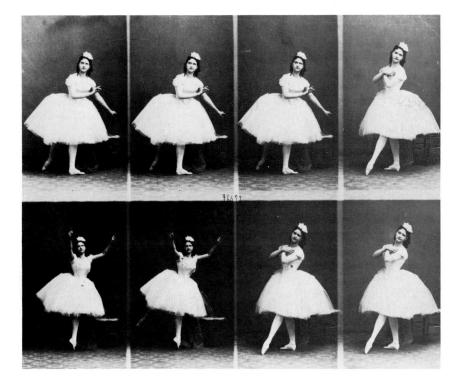

Figure 1.5 Carte-de-visite, uncut sheet. Adolphe-Eugène Disdéri. (Courtesy of the International Museum of Photography at George Eastman House)

Figure 1.6

Portrait of Lincoln, carte-de-visite (obverse and reverse). Mathew Brady (1823–1896). (Courtesy of William A. Lewis)

PUBLISHED BY E. ANTHONY, 501 Broadway, NEW YORK. FROM PHOTOGRAPHIC NEGATIVE, BY M. B. BRADY.

in coli

stereo viewer was effective but required careful adjustment and was rather clumsy to use. In 1849 Sir David Brewster replaced the mirrors in Wheatstone's design with lenses, an improvement that allowed the paired images to be mounted side by side on a single card. Before long stereoscope views, both prints and transparencies, were being produced and sold in great numbers. By 1860 every well-furnished American parlor featured an ornate album of carte-de-visite and tintype pictures, and a stereo viewer complete with dozens of slides. Francis Frith photographed Egypt

The Bisson brothers made Alpine photographs

O'Sullivan and Jackson photographed the American West

Portrait photographers were doing a brisk business as the Civil War threatened. Mathew Brady, internationally famous as "Brady of Broadway," saw the impending conflict as a momentous historical event. Brady's sense of history was already well demonstrated. For years he had made it a practice to photograph famous people and had published *The Gallery of Illustrious Americans* in 1850. Now he felt impelled to document the war.

President Lincoln gave Brady his consent, but no financial backing. This was enough. Brady was a moderately wealthy man and he was willing to spend his own money for such a significant purpose. He assembled a staff of several men, outfitted them with the materials and equipment needed to make wetplate photographs, and went to war. The pictures they made, under the most awkward and dangerous conditions imaginable, form a remarkable document of that desperate struggle.

Brady emerged from the enterprise practically destitute. There was little market for his war pictures and their historical value was overlooked. His plates were stored in warehouses and eventually auctioned off. Ironically, one lot of them was bought by the government for storage charges. Heavily in debt, Brady was forced to sell his portrait studio. Except for a belated government grant of \$25,000, he went unrewarded for his labors and died penniless in 1896.

The mid-nineteenth-century market for pictures of famous buildings, picturesque landscapes, and exotic foreign scenes kept many photographers employed. They were a hardy lot. The wet-plate process was difficult and awkward and was complicated considerably by the demand for larger and larger images. Francis Frith, one of the most enterprising travel photographers, journeyed more than 800 miles up the Nile River in Egypt in 1856. He carried several cameras, the largest of which accepted $16'' \times 20''$ plates. Flowing an even coat of collodion over such a plate is difficult under the best conditions, but Frith and others like him managed to do it in desert heat and mountain cold, despite blowing dust, biting insects, and dripping rain. The fact that their pictures turned out at all is amazing. In fact, many of them are of excellent quality even by modern standards.

In 1860 the Bisson brothers, Louis and Auguste, photographed Mt. Blanc. Climbing to more than 15,000 feet with cameras as large as $12^{\prime\prime} \times 17^{\prime\prime}$, they battled below-zero cold, which threatened to freeze the collodion on their plates, and made a number of spectacular views of the windswept peaks and glaciers.

After the Civil War, exploration of the West began again in earnest and photographers were in the vanguard. In 1867 Timothy O'Sullivan, who had been one of Brady's photographers during the war, joined an expedition exploring the 40th parallel and was soon photographing the deserts and mining areas of Nevada. Three years later he traveled to Panama with the Darien Expedition and in 1871 joined the Wheeler Expedition. O'Sullivan's photographs are technically fine and frequently display considerable artistic sensitivity.

William H. Jackson's work is probably better known than O'Sullivan's if only because Jackson's photographs of Yellowstone helped persuade Congress to establish that region as the first national park. As a child, Jackson was encouraged to draw and paint, and was introduced to photography by his father. He served with the Vermont infantry during the Civil War, then after being jilted by his fiancée—headed West with an ex-army buddy. They traveled with a wagon train to Montana where Jackson struck out on his own. After two years of wandering from job to job, he arrived in Omaha where he was hired by a local photographer.

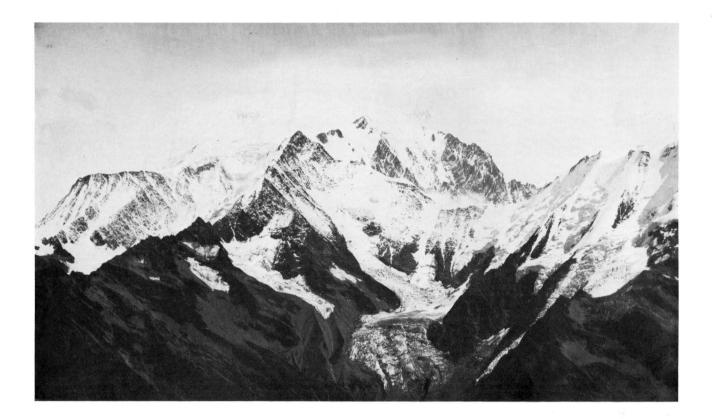

Before long he owned his own studio, but his wanderlust was still strong. Outfitting a horse-drawn wagon as a portable darkroom, he began to roam the country around Omaha photographing the prairies and the Indians who inhabited them. Soon he was attracted by the dramatic expansion of the railroads, and after redesigning his equipment to fit on packmules, he began to travel in earnest.

In 1869 he met Dr. F. V. Hayden, who was conducting a U.S. Geological Survey of the Territories. Jackson was persuaded to join him, and during the nine years that he worked on the survey, he produced thousands of magnificent negatives of both scientific and scenic value. An extract from his diary gives us some inkling of the difficulties of working in the mountains with the wet-plate process:

Aug. 2, (1878) Upper Wind River Lake. Returned to upper lake. Wilson, Eccles, his man Payot and Richardson going with me. Fine morning and got good 11 by 14 exposure first trial. There were two or three small defects but impossible to take it over and get as good a lighting. Time 9 m. with Portable Symmetrical, single lens, at F. 32. Made 5 by 8 of same subject. Came up too thin, but intensifying made it as much too dense. Took camera up high for a general view. Exposed 2 m., F. 16, Portable Symmetrical, with some overexposure. In packing up to return, I forgot to remove the two 11 by 14 plates that I had put in the bath holder to bring the solution up to its proper depth. Hoggie, the pack mule carrying the outfit, traveled so roughly that when I opened up the bath holder later I found the plates smashed to pieces and one side of the bath holder punched full of holes. It is going to bother me now to replace it. Was two or three hours making general repairs. I don't think I ever had so inconvenient an outfit.

Figure 1.7

Savoie 46—Mont Blanc, vu de Mont Joli, 1861. Auguste Bisson. Albumin print from collodion negative.

(Photography gallery restricted gift, The Art Institute of Chicago, All rights reserved)

Jackson joined the Hayden expedition

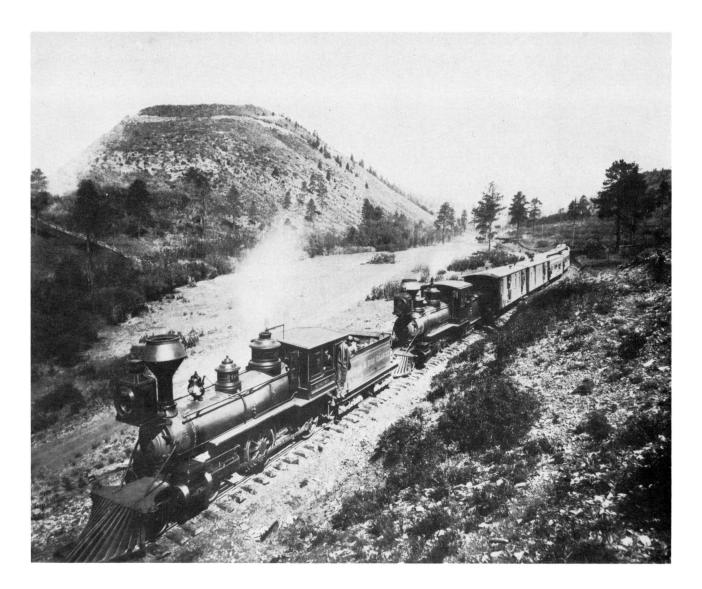

Figure 1.8

The Rocky Mountains, Scenes along the Line of the Denver and Rio Grande Railway. William H. Jackson (1843–1942).

(Courtesy of William A. Lewis)

Later Jackson specialized in photographing the railroads

Edward Muggeridge thought his name was really Eadweard Muybridge

In 1879 Jackson moved to Denver, set up a studio, and returned to his earlier interest, photographing the railroads. For twenty years he traveled through every state in the Union and from Montreal to Mexico City, often in "Jackson Special" cars supplied by the railroads, making photographs of all sizes from $20'' \times 24''$ to the popular stereo views. In 1898 he established the Detroit Publishing Company, specializing in views and postcards printed in color, derived from his vast store of negatives. When he "retired" in 1924, he took up painting again and did a series of pictures for the National Park Service. Still vigorous in his nineties, Jackson continued to tour, paint, and photograph the West each summer until his death in 1942.

Another western photographer was English-born Eadweard Muybridge (who thought that this strange spelling was the correct Anglo-Saxon version of his real name, Edward Muggeridge). Muybridge was well known in the 1860s as a fine landscapist and industrial photographer, but his fame now stems from his research in motion photography.

Almost from the beginning, photographers were intrigued by the possibility of taking "instantaneous photographs." In 1851 Talbot used an electric spark to record the image of a page from the *Times*, which he had fastened to a rapidly revolving wheel. By 1860 several other photographers had managed to take outdoor views that showed walking figures caught in midstride.

A Horse's Motion Scientifically Considered, engravings after photographs. Eadweard Muybridge (1830–1904).

(From a copy of *Scientific American Supplement*, no. 158, January 11, 1879, in the collection of the University of Michigan Library)

ness corresponding to that of cotion warp-sizes and silkolders. The bioiness of such plate melters, or of sausage grinders who load their sausages up with a large percentage of carries and calls meat. Examiner—What practical inference, sir, would you deduce from the existence of business and practice such as

you have described? It is country where adulteration constitions and the second second second second for known as Rivish "goods" are in the way to become notorions as British "bods". Examines of limiting such Resamines—Can you suggest any means of limiting such A HORSE'S MOTION SCIENTIFICALLY CONSIDERED not time since the SCREATIFE AMARCAN briefly and so pluce the fact that Mr. Muxindge, of San Francisco, had plazes in the deal an automatic electrop piozgraphic apparators, by one strike of which he had suggested in recording the action of two themsald in motion. Mr. Mynybriefle canculary is resulted by the harkword with he hadrogeneous the strength of the strength of the harkword with the harkword strength of the harkword with the harkword with

part. In taking the negatives of these photographs, Mr. May being emphased a series of ranners, operated by electricity and as photon is to fix with theories accuracy the series and the photon is the series of the series of the series to be an strike. The exposure for each negative was about its of two thematolik part of a second. The vertical lines can be due y hackground are very right index spart, the heavy host ground line supports the level of the track, the beings more ground line supports the level of the track. The being more part of the second line second lines are the second lines of the second lines are spart of the level of the second lines are spart of the second lines ar

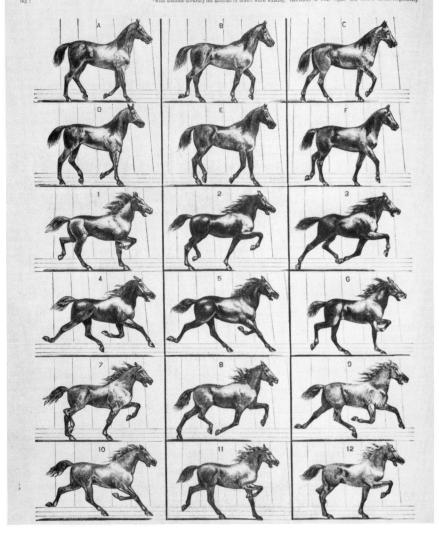

Muybridge was the first to attack the problem seriously though, when he was commissioned by Leland Stanford—one-time governor of California—to photograph a running horse. Stanford financed this experiment, so the story goes, to settle a bet he had made with a friend. Stanford claimed that all four of a trotter's feet leave the ground at some point in his stride; his friend insisted that at least one foot is always on the ground. Although his first attempts were failures, Muybridge finally managed to prove that Stanford was right.

In 1874 Muybridge was tried and acquitted for murdering his wife's lover. He left the country for a time, returning to resume his work in motion photography with Stanford in 1877. By 1880 he had refined his procedures considerably and was able to project a crude motion picture sequence with a device he called the *zoopraxiscope*. In 1883 he was invited to continue his experiments at the University of Pennsylvania, an invitation that may have been influenced by painter Thomas Eakins. In 1887 a set of his motion sequence photographs, analyzing both animal and human activities, was published under the title *Animal Locomotion*.

He photographed Leland Stanford's horses

and showed motion pictures with his zoopraxiscope

Figure 1.9

There was early interest in nonsilver processes

Poitevin's research led to the carbon and collotype processes

The woodburytype was an ingenious and elegant process

Although his work was denounced by a number of influential painters and photographers as "inartistic" and "untrue," Muybridge clearly influenced men like Etienne Jules Marey and Thomas Eakins, both of whom devised cameras for making multiple exposures of moving figures. Their work, in turn, clearly foreshadows the futurist paintings of Duchamps, Balla, and others.

The Gelatin Period

While most of the prints made for commercial purposes after 1850 were done on albuminized paper, the albumin process was not entirely satisfactory. The color was not altogether pleasing, and as was true of other silver papers, the image was likely to fade or discolor, especially if the photographer was less than meticulous in his processing. For these and other reasons, considerable attention was devoted to the perfection of nonsilver photographic materials.

This was not a new thought. In 1839 Mungo Ponton had discovered that a solution of potassium dichromate spread on paper would be insolubly stained by exposure to light, and he used this principle to produce simple images. Edmond Becquerel pointed out shortly thereafter that the reaction was largely due to the effect of the dichromate on the starch size in the paper. This soon attracted the attention of the ubiquitous Talbot, who in 1852 patented *photoglyphic drawing*, based on the tanning effect of dichromates on a number of organic colloids, including glue, gelatin, starch, and various gums.

The honor of applying this technique to the production of photographic prints belongs to Alphonse Louis Poitevin, a French chemist and engineer. His research led to the eventual discovery of several methods of printing, including carbon and collotype processes. In the carbon process, a layer of gelatin containing powdered carbon and dichromate is spread on paper, dried, and exposed under a negative. The image, composed of hardened gelatin and carbon, remains on the paper after the unexposed (still soluble) portions of the gelatin area are washed away in hot water. This first form of the technique produced a black-and-white image without gradation, but later modifications resulted in a complete range of tones, making it one of the best nonsilver processes.

The collotype process also uses a dichromated gelatin layer, often on glass, but without the carbon pigment. Exposure tans the gelatin, making it less absorptive to water and therefore capable of holding a coating of greasy ink. When properly dampened and inked, the collotype plate can be used for printing, similar to a lithograph stone. The exposed portions hold ink and print dark, while the unexposed portions hold water and repel the ink and thus print light in tone. When competently done, the process is capable of producing a complete range of tones and is still considered to be one of the finest methods of printing known, although it has practically disappeared as a commercial process.

Another interesting and ingenious process, which was used for production runs of a few thousand printed impressions, is the *woodburytype*. Making use of the fact that the image on an exposed dichromated gelatin film is in low relief, Walter B. Woodbury, an English photographer, devised a method that pressed the relief image onto a lead plate to form an intaglio image. The depressions thus formed were filled with liquid pigmented gelatin, which was then impressed on paper. The image was formed by the varying thicknesses of the pigment. The woodburytype process is without a doubt the most faithful method of mechanical reproduction of images ever devised. In many cases, woodburytype prints are indistinguishable from actual carbon prints; there is no artificial grain or texture, and the original tonal scale and sharpness of detail are preserved. Although albumin paper continued to be used into the 1900s, the gelatincoated papers, introduced before 1880, gave amateur and professional photographers a more versatile and stable print material. The "art" photographers, however, were not so easily pleased. The Naturalists, especially, sought a quality of surface and tone that the silver emulsions could not provide and began to look for alternatives. Two processes that suited them were photogravure and the platinotype.

Photogravure, which became popular in the 1890s, was derived from another early patent of Talbot's. In this process, a positive transparency is printed on gelatin-coated paper that is sensitized with dichromate. The paper is then soaked briefly and rolled onto a grained copper plate. Warm water rinses dissolve the unexposed gelatin, leaving the image in low relief on the copper surface. When dry, the copper is etched in ferric chloride to produce an intaglio image, which can be inked and printed like an aquatint etching. Although this procedure is a handcraft process, it was modified by Karel Klíč, a Czech, for use on rotary printing presses in 1895.

Herschel's early investigations led to various photographic processes based on the light-sensitive properties of iron salts. These included numerous variations on the blueprint or cyanotype, the chrysotype, kallitype, and most importantly the platinotype, which was first made practical and patented by William Willis in 1873. The platinotype image is composed of platinum metal and is considered to be one of the most permanent photographic prints. It is typically neutral gray to brownish in tone (although bluish grays are occasionally seen) with excellent, delicate highlight and midtone gradation. Platinum paper was manufactured and sold in Europe from about 1879 until World War I. It is still available occasionally today in America.

For almost thirty years after its introduction by Archer, the collodion process reigned supreme despite its obvious shortcomings. It was not sensitive enough, it had to be used wet, and the large glass plates were fragile and bulky to handle. In the mid-1870s gelatin began to be used, first as a coating for printing papers and then for camera materials.

The first of these required elaborate handling. The emulsion was coated on a paper base for exposure in the camera, then developed and stripped off the paper to another support material, such as glass, for printing. Glass plates were also coated directly for camera use, but the public's growing desire for smaller, lighter cameras spurred experimenters in their search for glass substitutes.

The first commercial production of flexible film is credited to John Carbutt in 1888, but the Reverend Hannibal Goodwin had independently invented a similar film and applied for patent rights the previous year. Goodwin did not have enough money to produce his film and his patent application was so vague that it had to be revised several times.

By the time Goodwin's patent was finally granted in 1898, the Eastman Company had also devised a flexible film, patented it, and begun production. At Goodwin's death in 1900, his patent was taken over by Edward and Henry Anthony, who filed suit against Eastman for infringement. The litigation continued for twelve years, during which time the firms of Anthony and Scovill merged to form Ansco. In 1914 the courts found in favor of Ansco, and Eastman settled the claim for \$5 million.

By this time the Eastman Kodak Company had captured the amateur market with a simple, portable camera that could be purchased, loaded with one hundred exposures of rollfilm, for \$25. Eastman selected the name *Kodak* for it quite arbitrarily. He wanted a name that was easy to remember, one that was not liable to be mispronounced in any language, and one that could be registered in the patent office without confusion. Additionally, he supposedly admired the firmness of the letter *K*.

Platinotype: one of the most permanent print processes

The flexible film controversy

George Eastman selected the name "Kodak" arbitrarily

"You press the button; we do the rest"

Color! The Lumiere brothers' Autochrome film

Early researchers in color photography

The Rev. Levi Hill announced a special color process

but was plagued by "invisible goblins"

In practically no time, the name Kodak and the slogan that accompanied it, "You press the button; we do the rest," were household words. The slogan was no idle boast. When the one hundred pictures were taken, the owner simply mailed the entire camera back to the company. For \$10 the film was removed and processed, prints were made, and the camera was reloaded and returned with the finished pictures, ready for the next one hundred shots.

With the formation of large manufacturing corporations like the Eastman Kodak Company, technical research in photography spurted ahead. The heyday of the amateur kitchen-chemist was definitely over.

The techniques of photography by 1910 were similar to those used today. Cameras of all shapes and sizes were available; films were sensitive enough to make action pictures possible; lenses of large relative aperture and good correction existed; and color photographs, long a theoretical possibility, became a practical reality in 1907 with the commercial production of *Autochrome* film by the Lumière brothers, Auguste and Louis.

Advancement of Color Techniques

From the earliest days of photography, fixing the colors was an intriguing problem. Color theory was still in a primitive state in 1839 and, of course, the simple silver compounds that formed the sensitive surfaces of the daguer-reotype and calotype were almost totally blind to half of the visible spectrum.

It was generally believed that color was an intrinsic quality of a material's surface and that the different hues were due to differences in the molecular structure. Because of this, the early researchers spent a great deal of time compounding various mixtures of the silver salts known to be light-sensitive, coating them on paper and other materials, and observing their reaction to colored light. They were encouraged occasionally by the formation of colored compounds that seemed to relate to the light color that formed them. In a few cases, daguerreotypes were reported to have recorded traces of color, frequently reddish tints.

Robert Hunt, one of the more reliable and perceptive chemists of the time, reported one instance, in 1843, when he photographed (on calotype paper) a scene containing "a clear blue sky, stucco-fronted houses and a green field." After a 15-minute exposure in the camera he obtained

a very beautiful picture . . . which held between the eye and the light, exhibited a curious order of colours. The sky was of a crimson hue, the houses of a slaty blue, and the green fields of a brick red tint.

In 1851 the Reverend Levi Hill, of Westkill, New York, announced that he had perfected a special daguerreotype process with which he claimed to have made

a view containing a red house, green grass and foliage, the wood-color of the trees, several cows of different shades of red and brindle, colored garments on a clothes-line, blue sky, and the faint blue of the atmosphere, intervening between the camera and the distant mountains, very delicately spread over the picture, as if by the hand of a fairy artist.

The excitement that this announcement generated was sufficient to bring ordinary daguerreotype to a virtual standstill and, according to a contemporary photographer Marcus A. Root, "injured the heliographic artists to the amount of many thousands of dollars." Hill seems to have convinced many of his contemporaries that the process was genuine. However, as time went by and he failed to release details of the procedure, explaining that he was having difficulty with the color yellow and referring to the "invisible goblins" that were plaguing him, their suspicions grew. Root, who had at first believed Hill's claim, ultimately discounted it as a trick and suspected that the few examples that Hill had actually shown were "probably common daguerreotypes, carefully colored by hand." One that he examined revealed "dry colored powder . . . distinctly visible on the face and hair," and he concluded, "As his endeavor succeeded but partially, if at all, and as there appears to have been deception in the matter, I shall meddle with it no further."

The idea that color is a characteristic of light rather than surface and the concept of *color separation* of white light were demonstrated in 1861 by Maxwell and Sutton. Sutton had photographed a colored ribbon through red, green, and violet filters (he also prepared a yellow separation that was not used) and made positive transparencies of the negatives. Using the same filters and three separate projectors, Maxwell projected the colored images in register on a screen to produce what Sutton described as "a sort of photograph of the striped ribbon . . . in natural colours."

Theoretically this shouldn't have worked because the collodion plates used were not at all sensitive to red, but Ralph Evans recreated the experiment a hundred years later and proved that the red image had actually been produced by fluorescence of the particular dye used in the red stripes.

In 1869 Louis Ducos du Hauron described a method of producing color images by making a negative and viewing the subsequent positive through a screen covered with tiny dots or lines of red, yellow, and blue. This was an ingenious idea and the one that was eventually used in the very successful Lumière process; however, du Hauron mistakenly recommended the *sub-tractive* (pigment) primaries instead of the correct *additive* (light) primaries, red, green, and blue. He did, however, present a workable plan for making color prints or transparencies by using colored carbon tissues.

In 1873 Dr. Hermann Vogel made the initial discovery of dye-sensitizing, which extends the sensitivity of silver emulsions into the green, yellow, and red regions of the spectrum. This discovery was soon improved by Becquerel, Waterhouse, Eder, and others. The first panchromatic gelatin plates, sensitive to all the visible colors, were marketed in 1906 by Wratten and Wainwright.

Panchromatic sensitivity finally made color photography possible. The Lumière brothers' Autochrome film, marketed in 1907, employed a screen of minute dyed starch grains coated with a panchromatic emulsion. The film, exposed through the screen, was developed to form a black-and-white negative which was, in turn, bleached out. Reexposure and development produced a positive transparency that, when viewed through the screen, appeared as a full-color image of the original scene. Several other films subsequently appeared. They were based on a similar principle but used screens of ruled lines rather than the dyed starch grains. One such material, Dufaycolor, was available in both roll and sheet sizes until the 1940s.

The screen processes, good as they were, had their faults. They were relatively insensitive—Autochrome required fifty times more exposure than comparable black-and-white film—and the image could not be enlarged to any great degree without revealing the screen texture. The Polaroid Corporation has revived and improved this old color screen principle very successfully in its "instant" color-slide film, 35mm Polachrome.

One solution to these problems was sought in the one-shot camera design. Three films were exposed simultaneously, each through its appropriate filter, by an ingenious arrangement of semitransparent mirrors. When developed, the negatives could be printed by any of several methods, such as *carbro* or *wash-off relief* (later called *dye-transfer*), to produce a full-color print. Although these cameras could take color photographs of fine quality under ideal conditions, they were clumsy and slow. Maxwell and Sutton produced 'a sort of photograph . . . in natural colors''

which shouldn't have worked at all

Louis Ducos du Hauron confused the color primaries

Autochrome was the first of the screen processes

Kodachrome was introduced in 1935, and

Ektachrome appeared in 1942

Gasparcolor employed the principle of dyedestruction

The "instant" color cameras

Color now dominates the market

Lewis Hine saw photography's potential for effecting social change

So had some earlier workers

As early as 1912, Siegrist and Fischer had devised a process for producing color by chemically forming dyes in the emulsion during development. This method is employed by most modern color films, but it was not reliable enough to be useful until about 1936. The early difficulties were largely due to the tendency of the dyes to migrate or bleed in the emulsion layers. Kodachrome film, introduced in 1935, avoided this difficulty by omitting the color couplers from the emulsions and introducing them during processing.

With the appearance of Ektachrome film in 1942, positive reversal color film became both practical and convenient. Kodacolor, released for general use in 1941, and Ektacolor, in 1947, were designed to produce color negatives. With their introduction color became a relatively simple process and successive improvements by various manufacturers have brought color printing within reach of everyone.

A quite different approach to color was described by Christiansen in 1918 and by Gaspar in the early 1930s. Gasparcolor and the modern refinement of it, *Cibachrome* (see Chapter 15), employed the principle of dye-destruction. In this process the image dyes are incorporated in the emulsion during manufacture and are bleached selectively as the silver image is removed during processing. This process results in images of relatively great stability and exceptional sharpness.

An incredibly complex and ingenious color film and camera system was announced in 1972 by the Polaroid Corporation. The camera, called the SX-70, features automatic exposure control and produces "instant" color prints that process themselves after ejection from the camera. The film, originally containing no fewer than sixteen layers of emulsion material, incorporates its own darkroom in the form of an opaque chemical layer that protects the developing image from light. At the end of the developing action, the image stabilizes and the opacifier gradually disappears, leaving the image sealed under a plastic cover, clearly visible against a white ground. SX-70 cameras and films have proved to be extremely popular.

Color materials continue to evolve at a rapid pace. The relative impermanence of color images has become the subject of intense research, and the color stability of both film and print materials has been improved substantially in recent years. At the same time, there have been impressive gains in the sensitivity and color quality of both negative and positive color films.

There's no doubt that color now dominates the popular market. Color print processing is now even simpler and faster than the conventional blackand-white procedure.

Editorial Photography

By 1900 halftone reproductions of photographs were appearing frequently in magazines, books, and newspapers, and the photograph was beginning to be appreciated as an effective means of communication and persuasion. Lewis Hine, a trained sociologist, saw its potential for effecting social change and, teaching himself to use a camera, began to document the callous treatment of immigrants at Ellis Island and their painful entry into the melting pot of New York City's tenement district.

Hine was not the first photographer to work in this vein. Mayhew and Beard had collaborated on a major social study, *London Labour and the London Poor,* in the early 1850s; Adolphe Smith and John Thomson had published a similar report, in words and pictures, called *Street Life in London* in

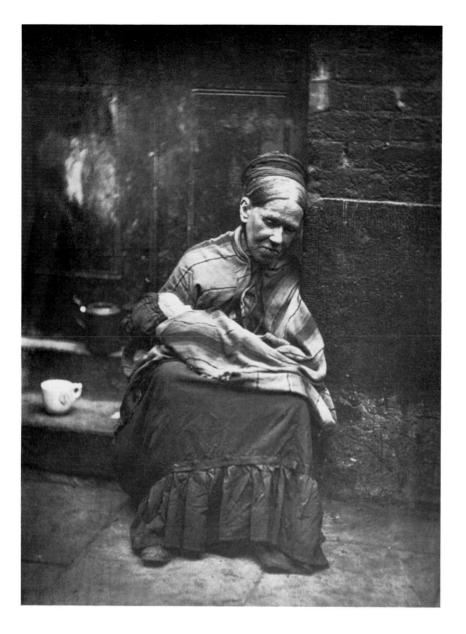

1877; and Jacob Riis had produced a series of books aimed at social reform, the first of which, *How the Other Half Lives*, was a scathing indictment of New York's slum lords and the festering conditions in their tenements in the 1880s.

Street Life in London was an important book for two reasons. It was a notable early attempt to use the camera editorially, and it was illustrated with woodburytypes, which gave Thomson's photographs authenticity and power. Beard's daguerreotypes for London Labour and the London Poor were copied and published as wood engravings, and Riis's photographs were similarly translated into print by a hand-engraver. In both cases the pictures suffer from a kind of aesthetic distance. They lack credibility and take on a stylistic prettiness that contradicts their intended message.

Street Life in London was an important book

Figure 1.10 The Crawlers, from Street Life in London, woodburytype. John Thomson (1837–1921). (Courtesy of the University of Michigan Museum of Art)

Figure 1.11

Old House in Cherry Street, The Cradle of the Tenement. Jacob A. Riis (1849–1914). (Jacob A. Riis Collection, Museum of the City of New York)

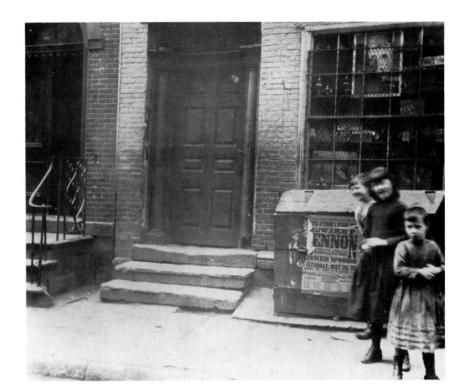

Figure 1.12

Before about 1900, Riis's book *How the Other Half Lives* was illustrated with engravings like this one. The artists apparently felt free to "improve" the compositions, as has been done here. (University of Michigan Museum of Art)

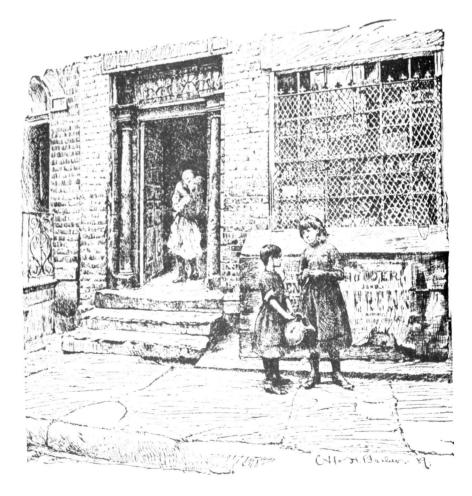

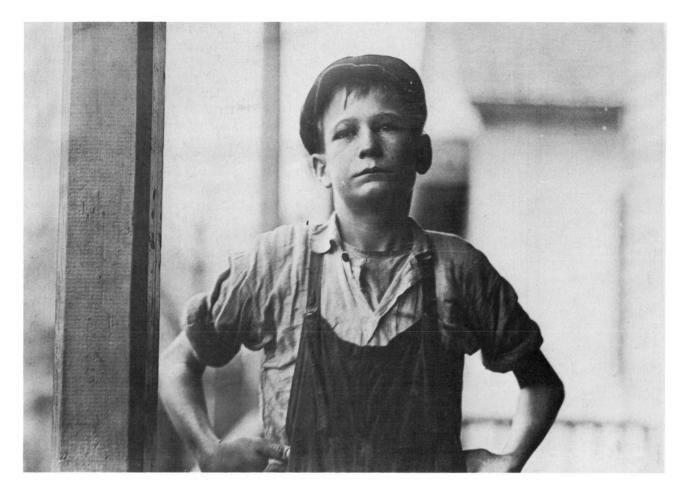

Hine's photographs undoubtedly benefited from being published as convincing halftones, but they are also well-seen, well-crafted images that invite attention. Thomson's pictures, superb as they are, have a theatrical quality, occasionally flawed by clumsy retouching. Riis photographed with obvious passion and sincerity, but the camera and the subject conditions were frequently too much for him to handle. His pictures are harsh in gradation, frequently out of focus or blurred, and rather haphazardly composed. It's probably remarkable that he managed to get any pictures at all considering the awkwardness of the circumstances. On at least two occasions the flame from his flash powder set fire to the buildings he was photographing, and once he managed to ignite his own clothing. Regardless of his technical ineptitude, Riis's pictures accomplished their purpose. They awakened public sympathy and started a program of reforms that brought about real improvements. Hine's first work with the immigrants, then, continued the campaign that Riis had begun some twenty years before.

In 1908 Hine began a series of pictures of Pittsburgh miners. He also worked for the Child Labor Committee to expose the exploitation of children in various industries. These are some of his most powerful pictures and they helped to bring about new laws and reforms designed to protect children. During World War I, Hine served as a photographer with the Red Cross in Europe. Later he returned to devote himself to a series called "Men at Work," in which he documented the construction of the Empire State Building, climbing among the girders with the construction workers to capture both the spirit and the details of the project.

Figure 1.13 Young Millworker. Lewis Hine (1874–1940).

(Collection of the author)

Riis photographed with obvious passion but had some problems

Hine's later work

Arnold Genthe documented the San Francisco earthquake

Dr. Erich Salomon: the father of modern photojournalism

The picture magazines appear

Advertising photography improved rapidly

In April 1906 San Francisco was virtually destroyed by a violent earthquake and the devastation was carefully recorded by Arnold Genthe, a resident portrait photographer. Genthe was well known for his idealized portrait studies and romantic landscapes, but his most significant early work was his extended document of San Francisco's Chinatown. The first tremors of the earthquake destroyed Genthe's studio, but he coolly borrowed a little box camera and proceeded to document the disaster as it occurred, displaying the courage and instincts of a true news photographer. This was probably the high point of his career. In later years he reverted to his pictorial style and his work, although competently done, was undistinguished.

After World War I, news photography was no longer a novelty. The unique power of the photograph to communicate ideas was just beginning to be appreciated.

Dr. Erich Salomon, sometimes called the father of modern photojournalism, was one of the first to concentrate in this field. Like many of the earlier workers, he began taking pictures rather late in life (at about age forty-two) more out of necessity than real interest. Employed by a German publishing house, he found that working with hired photographers was a timeconsuming and expensive business, so be bought a camera and set out to learn to use it.

The camera that made him famous was the Zeiss Ikon (Dresden) Ermanox, which was introduced in 1927. It took 4.5 cm \times 6 cm glass plates in individual holders and featured an amazingly fast f/1.8 Ernostar lens of 85 mm focal length. (Salomon's own camera was equipped with an f/2.0 lens, according to his son.)

Salomon experimented briefly with artificial lighting but soon gave it up in favor of the more natural and pleasing effect of available light. Using the little Ermanox on a tripod because of the long exposures required (usually from about 1/5 second to one full second), he specialized in photographing political notables, usually unposed, at their meetings and conferences. He had an uncanny knack for catching his subjects unaware in the midst of some characteristic or expressive gesture, somehow managing—in spite of the relatively long exposure times—to avoid excessive blurring of the image.

He was a master of persuasion and subterfuge when it was required to get the picture, often concealing his camera in a flower vase, in a briefcase, in a stack of books, or in his own clothing. It is ironic that he died in a German prison camp—a victim of a political system that he had watched, documented, and opposed. Characteristically, he managed to conceal his precious negatives from his captors. Just before he was arrested, he arranged for some of them to be left with the librarian of the Dutch parliament and was able to bury the rest, safely wrapped and sealed, in a friend's garden.

The 1930s were significant years in the history of photography. Fortune magazine was launched in late 1929 and did well in spite of the great stock market crash and the subsequent Depression. Life magazine began publication in 1936, starting a whole new trend in journalism based on the concept of the picture story. Life's Alfred Eisenstadt (who had worked beside Salomon in covering the Geneva League of Nations conferences) and Margaret Bourke-White were original staff photographers whose names soon became familiar to everyone. It was not long before other publishers got on the bandwagon. Look appeared in 1937, followed closely by a number of others, such as *Pic* and *Click*. Pictorial supplements were also added to Sunday newspapers and suddenly the nation was picture-conscious.

Advertisers were relatively slow to employ photographic illustration. Although articles and stories in magazines like *Vanity Fair* were illustrated almost entirely with photographs before 1900, their ad illustrations were rarely photographic before about 1910, and advertising photography, as we think of it

now, was not practiced until the 1920s. It quickly reached a high degree of quality and sophistication in the work of Steichen, Beaton, Outerbridge, Hiller, and later Horst, Rawlings, Blumenfeld, Matter, Penn, and a great many others.

The earliest advertising photographs were often simply pictures, frequently of unrelated subject matter, that presumably attracted attention because of their novelty. It was not long, however, before photographs of the products themselves appeared, then the now-familiar pictures of models frequently pretty girls and babies. Before World War I, though, exotic typography, art nouveau decoration, and outrageous verbal messages had been the major elements of successful advertising.

The stock market crash of 1929, and the Great Depression following it, left millions of Americans impoverished. Various government agencies were established to provide employment and stimulate economic recovery. One of these, now known as the Farm Security Administration, included a photographic unit headed by Roy Stryker. Stryker was not a photographer himself, but he was appreciative of good pictures. He was also sensible enough to hire good people and let them work more or less in their own styles. The project began in 1935 with Arthur Rothstein, Dorothea Lange, Walker Evans, Russell Lee, Ben Shahn, John Vachon, and Marion Post Wolcott among the dozen or so photographers employed. By the time America entered World War II, when the project was ended, they had amassed more than 250,000 negatives. These pictures, now filed in the Library of Congress Archives, are a stunning document of the suffering of the American poor during those dreadful times. The FSA project was successful in eliciting sympathy and support for the homeless and destitute victims of the Depression and proved again, as the work of Thomson, Riis, and Hine had done, the persuasive force of the photographic image.

Among the many photographers working in the photojournalistic style of the 1920s and 1930s, three names stand out: André Kertész, Brassaï (Gyula Halâsz), and Henri Cartier-Bresson.

Figure 1.14 Sharecropper Mother Teaching Children, Transylvania, La., 1939. Russell Lee (1903–). (Library of Congress)

Roy Stryker and the FSA photographic unit

compiled a stunning document of the American poor

Brassai is an unusually versatile and talented artist

Cartier-Bresson called his Leica "the extension of my eye"

Kertész (1894–1985), born in Budapest, traveled to Paris in 1925 to make his way as a photographer. He had virtually no previous training and only an amateur's experience, but his determination was strong. Before long he was selling some of his pictures to friends and managing to get a few assignments from local magazines. He was one of the first to buy and use the newly introduced Leica, and he immediately fell in love with it. By the mid-1930s he was successful and famous.

In 1936 he came to the United States to work for a commercial studio, a move that turned out to be a near-disaster. Unable to return to France because of the war in Europe, he found himself overwhelmed by the pressures of commercial photography and his natural sensitivity was stifled. He settled into semiobscurity for more than twenty years, supporting himself with competently done, but uninspired, work until illness forced him into temporary retirement in 1960. It gave him time to reflect, and in 1962 he gave up commercial work to return to his own expression. Once again the wry humor and economy of design that had characterized his work in Paris appeared in his pictures, and he has now been rediscovered as one of the most innovative of the pioneers of journalistic photography.

Brassaï (a name derived from his native Transylvanian town, Brasso) was a young painter fresh out of art school when he arrived in Paris in 1923 and immediately fitted himself into the community of artists. He soon met Kertész, who helped stimulate his interest in photography by lending him a camera. He immediately began a series of pictures that eventually became a book, *Paris by Night.* An unusually versatile and talented artist, Brassaï worked as a painter, sculptor, photographer, cinematographer, author, and stage designer and did them all well. This same restless capability is evident in his photographs. They are impressively varied in style, from the Atget-like views of streets and parks and the candid vignettes of cabaret life, reminiscent of Lautrec's lithographs, to penetrating portraits and abstract compositions based on graffiti. Brassaï's work wears well, and although well known, it deserves more attention than it has been given.

Henri Cartier-Bresson dabbled in painting as a child before taking up photography. His first photographs were taken with a little wooden camera without a shutter, in a style inspired by Atget's pictures. He discovered the Leica in the early 1930s and said of it, ''It became the extension of my eye. . . .'' An adequate allowance made it possible for him to travel extensively and he began working in the style that was to make him famous. He was, he said, ''determined to 'trap' life. . . to seize the whole essence . . . of some situation that was in the process of unrolling itself before my eyes.''

In 1947 Cartier-Bresson and four other free-lance photographers formed Magnum Photos, a cooperative organization that distributed their work. Since then, Cartier-Bresson's photographs have appeared frequently in publications around the world, including more than twenty books—the most famous, *The Decisive Moment*, was published in 1952 and is now a rare and expensive collector's item. Although he is an avowed "photo-reporter," committed to the concept of the published picture story, Cartier-Bresson's work shows a greater sensitivity than is typical in photojournalism. His compositions are always based on the full frame dimensions of the 35mm format and are typically taut and graceful. He has a masterful sense of organization and pattern and his pictures frequently feature dramatic effects of light and shade; however, the identifying characteristic of his work is suggested by *The Decisive Moment*— his ability to "preserve life in the act of living."

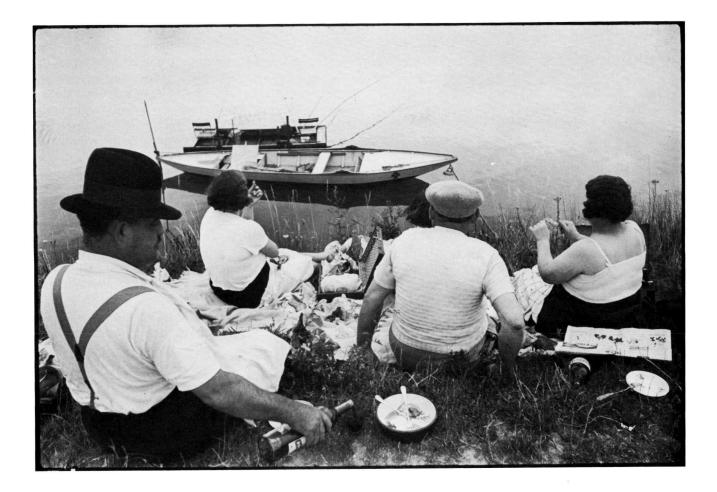

World War II brought tremendous advances in technology. Photography played a vital part in every phase of the war effort and was extensively employed for aerial reconnaissance. Its greatest value may have derived from the work of the news photographers who, moving into combat with the frontline troops, brought the grim reality of war home to the people with unprecedented immediacy. The work of these photographers—Robert Capa, Eugene Smith, Carl Mydans, Margaret Bourke-White, Gordon Parks, and many others—raised photojournalism to a new level of effectiveness as a medium of communication.

Until about 1960 the photojournalists were major interpreters of the world's news. At the same time the photo-illustrators played a major part in molding public taste and controlling buying habits. It was a serious blow to both groups when that lusty young medium, television, began to usurp their functions. *Look* magazine died rather quietly in 1971, a victim of increased costs and reduced advertising income—the same factors that had previously eliminated *Colliers, Saturday Evening Post,* and others. *Life* struggled gamely on, but the handwriting was on the wall. In spite of a brave editorial policy of "more picture emphasis," waning public interest in the magazine picture story and loss of advertising revenue finally took their toll. The magazine published its last regular issue (in its original form) in December 1972.

Figure 1.15

Sunday on the Banks of the Marne, 1938, from *The Decisive Moment*. Henri Cartier-Bresson (1908–).

(© Magnum Photos, Inc.)

World War II brought advances in technology

Figure 1.16

Two Teenagers with Record, Armagh, No. Ireland, 1987. David Alan Jay. An active contemporary photographer who is still concerned with capturing "life in the act of living," Jay is fascinated by the way people cope with stress in areas of conflict. This is one of an extended series of photographs that he has made over a period of several years.

(Courtesy of the photographer)

Television is an effective influence

The nineteenth century saw rapid advances in science

and the arts were in a similar state of flux

As the flow of advertising money began to shift from magazine space to television, a similar but less traumatic readjustment was forced on the illustrators. While some of the well-established photographers were relatively unaffected, a great many saw their profits dwindle. By 1970 it was clear that photographic journalism and illustration would never be the same again. Television has the public firmly in its grip and has become a frighteningly effective influence on our lives.

The Art of Photography

In the early years of the nineteenth century, rapid changes were beginning to take place in science and industry. In the entire history of chemistry, for example, only about thirty elements had been identified before 1800 and by 1839 twenty-five new ones had been discovered. Fundamental electrical theory was being formulated by Ohm, Faraday, Ampere, Henry, and others. The steam engine, which had supplied power for the beginning of the industrial revolution, was being refined and installed in ships and railroad engines. Iron was being rolled into sheets and bars for structural uses. The inventors were busy, too. The telegraph, the Colt revolver, Portland cement, McCormick's reaper, the electric pile battery, the electromagnet, and vulcanized rubber, to name a few, were all invented between 1800 and 1839.

The arts in France, especially painting, were in a similar state of flux. The neoclassic influence still lingered, with lngres at its head. Delacroix, as the leading Romanticist, was enthusiastically painting harem scenes and trading insults with lngres at every opportunity, and the open air painters of Barbizon were setting their easels in the fields and forests to paint directly from nature.

Photography and Painting

The formal announcement of the daguerreotype process on August 19, 1839, and the sudden concentration of public attention on the photographic image was shocking to at least some of the artists of the day. When Delaroche saw his first daguerreotype he exclaimed, "From this day painting is dead!" but later he described photography as "an easy means of collecting studies" and decided that Daguerre had "rendered an immense service to the arts."

This ambivalence was typical. Ruskin, initially charmed by the daguerreotype, later became one of photography's sternest critics, and lngres, who professed to despise photography (possibly because Delacroix was enthusiastic about it), is said to have worked rather frequently from photographs made for him by Nadar.

This uproar and confusion affected both painting and photography for many years. Many early photographers patterned their photographic compositions after the prevailing painting styles. Painters, acutely conscious of the unique visual character of the photograph, were undoubtedly influenced by photography's incredible rendering of detail, its characteristic interpretation of light and shade, its informal compositions, and its curious blurring of out-of-focus scenes and moving objects.

Although photography was probably a factor in the brief revival of interest in meticulously detailed painting such as that of the pre-Raphaelites, it was an even more obvious influence toward Impressionism and the freely composed snapshot vision of Daumier, Lautrec, and especially Degas. In this sense, painting profited tremendously from photography. On the other hand, the early photographers were hindered in their search for a genuinely photographic aesthetic style by the generally hostile art establishment. Figure 1.17 Two Ways of Life. Oscar G. Rejlander (1813–1875).

(Courtesy of the Royal Photographic Society, London, and the International Museum of Photography at George Eastman House)

Delaroche: "From this day painting is dead!"

Painting and photography influenced each other

Hill and Adamson worked in calotype

Rejlander's Two Ways of Life *was controversial*

H. P. Robinson's influence was enormous

Robinson and Emerson disliked each other's work

Emerson advocated a return to nature

It's hardly surprising, under the circumstances, that many of the early photographers were painters. Some of them, Delacroix, Corot, and Daubigny, for example, experimented a little with photography, but remained essentially painters. Others, like Oscar Rejlander and Henry Peach Robinson, turned away from painting and concentrated on photography.

Some of the most notable work produced by an early painter-photographer was done by David Octavius Hill in partnership with Robert Adamson. The pair began their work in 1843 by making calotype portraits, which Hill intended to use as reference material for a huge painting depicting a conference of some four hundred Scottish churchmen. They soon began to photograph other people and scenes as well. Hill became so preoccupied that his painting was not completed for more than twenty years. Although they worked together for only about four years (Adamson became terminally ill in 1847), Hill and Adamson produced more than 2500 calotypes, many of which were portraits of enduring charm. Hill continued to work sporadically after Adamson's death, but neither his later photographs nor his painting can be compared to the work done during his brief collaboration with Adamson.

Oscar Rejlander is best known for his large composite photographic composition, *Two Ways of Life*, done in 1857. Assembled from more than thirty separate photographs, this picture was a heroic allegory in the romantic style. Although it was a considerable success, it was highly controversial. The Photographic Society of Scotland refused to exhibit the photograph until it was agreed that the "offensive" half, depicting Dissipation, would be covered with drapery, leaving "respectable" Industry in view.

Rejlander made other composites, but eventually turned to "straight" photography and portraiture. Some of his work was remarkably inventive and advanced for his day and he deserves to be better known.

Robinson, like Rejlander, achieved immediate recognition for his montages. He was an extraordinarily prolific and extremely skillful photographer. He also was convinced that photography could be called an art, as long as it was governed by the same rules that had traditionally applied to painting. In promoting this view, he wrote almost a dozen books and numerous articles establishing himself as the spokesman for pictorial photography. His influence was enormous. So, apparently, was his ability to rationalize. Caught between the popular belief that "truth was beauty" and the obvious fact that the camera recorded much truth that was not beautiful, Robinson solved the dilemma by declaring, in effect, that beauty was truth, and contended that combination printing (photomontage) permitted the photographer "greater facilities for representing the truth of nature."

Robinson's views continued to dominate photography well into the 1880s until he was challenged by Peter Henry Emerson, an avid amateur photographer, naturalist, and physician. Emerson and Robinson disliked each other's work intensely and Emerson, in particular, made no effort to be polite about it. Of combination printing he said, "this process is really what many of us practised in the nursery, that is, cutting . . . and pasting . . . though such 'work' may produce sensational effects in photographic galleries, it is but the art of the opera bouffe." Emerson advocated a return to nature and referred his readers to the work of the Barbizon painters. A naturalistic photograph, he declared, must be

- 1. true in natural sentiment
- 2. true in appearance to the point of illusion
- 3. decorative

To achieve these qualities he thought it necessary to use a slightly undercorrected lens, of relatively long focal length, at moderate aperture. Naturalistic focus was achieved when the background of the picture was thrown

Figure 1.18

Dawn and Sunset.

Henry Peach Robinson (1830–1901). Photogravure. (Miss Lucia Woods restricted gift, $\ensuremath{\mathbb{C}}$ The Art Institute of Chicago, All rights reserved)

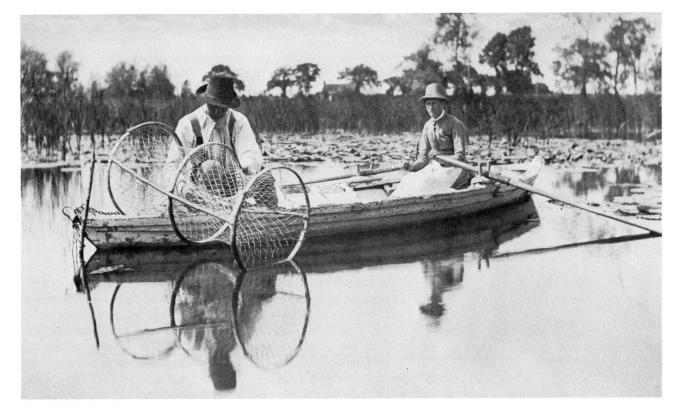

out of focus to an extent that did not produce "destruction of the structure." The principal object of the picture was either "sharp or just out of sharp."

Emerson's tremendous ego shows in his references to other photographers. Even in mentioning the three he most admired—Rejlander, Adam-Salomon, and Julia Margaret Cameron—he was careful to point out their limitations: Rejlander he thought of as a "trained painter (of) very second rate artistic ability"; Adam-Salomon, a sculptor "without first-rate ability"; and Cameron, "not an artist" and an "amateur." Figure 1.19

Setting the Bow Net, platinum print. Peter Henry Emerson (1856–1936).

(Courtesy of the University of Michigan Museum of Art)

and described Julia Margaret Cameron as ''not an artist''

Julia Margaret Cameron was an amateur, certainly, but we now recognize her as an artist of significance. She was forty-eight years old when she began photographing in 1863, and within a year she had taught herself the rudiments of the craft. Using a rapid-rectilinear lens of 30" focal length, she was a ruthless person to sit for, sometimes subjecting her subjects to extraordinarily long exposure times (in dim light) if she felt the visual effect was pleasing. Her portraits were her best work. Through them she introduced a new directness and sensitivity to photography that was ahead of her time. On the other hand, she was fond of illustrating biblical and literary themes, and it's tempting to agree with Emerson's opinion of these as "puerile and amateurish."

If the Impressionist painters were influenced by photography's treatment of atmosphere, soft-focus, movement blur, and halation (as it seems certain they must have been), some of the Naturalist photographers were, in turn, affected by Impressionism. One of them, George Davison, carried Emerson's naturalistic focus principles much farther than Emerson approved and, by promoting the virtues of soft-focus work, challenged Emerson's position as spokesman for art photographers.

Photography Becomes an Art in Its Own Right

In 1892 a little group of rebel pictorialists broke away from the Royal Photographic Society and formed The Linked Ring Brotherhood. This group, which included most of the Naturalists, led now by Davison, was devoted to advancing the art of photography and included such notables as J. Craig Annan, Horsley Hinton, and Frederick Evans. Interestingly, H. P. Robinson was also a member, but Emerson, after his *Death of Naturalistic Photography* tirade, had returned to the venerable and conservative Royal. The Linked Ring lasted until 1910.

In 1887, while judging a photography contest, Emerson awarded the first prize to a young American, Alfred Stieglitz. He told Stieglitz that his picture, *A Good Joke*, was the only "truly spontaneous picture" in the exhibition. Similarly, in 1903 he gave first prize to a young American college student, Frank Fraprie. Fraprie eventually became a driving force in the Pictorialist movement in America, as editor of several photographic publications, including *The American Annual of Photography*, while Stieglitz was soon to assemble a little group of dedicated photographers who would call themselves the Photo-Secessionists.

Alfred Stieglitz was born in New Jersey in 1864. He spent his student years in Europe and was introduced to photography in 1883 during his first year as an engineering student at the Berlin Polytechnic. He became obsessed with photography almost at once and experimented constantly while studying chemistry under Vogel. He spent nine years in Europe studying and traveling on a modest income from his family, apparently leading a life that any young man would envy and taking pictures incessantly. By 1890 he was internationally famous as an exhibitor of photographs.

He returned to New York in 1890 and was fascinated by the city. An abortive attempt at business occupied him briefly, but he was soon out of it, devoting himself to photographing and promoting interest in photography by publishing *Camera Notes*, a quarterly for the Camera Club of New York. The group of sympathizers that soon surrounded him could have been called the

A group of rebel pictorialists formed The Linked Ring

Emerson awarded prizes to Stieglitz and Fraprie

By 1890 Stieglitz was famous as an exhibitor

"who's who'' of American photography: Clarence White, Gertrude Käsebier, Alvin Langdon Coburn, Edward Steichen, Frank Eugene, Joseph Keiley, and others. In 1902 they formed their own informal group which Stieglitz, on impulse, named the Photo-Secession.

In 1903 Stieglitz published the first quarterly issue of *Camera Work*, a lavishly printed magazine devoted to the promotion of photography as an art form. The magazine and the Photo-Secessionists flourished for some time and their gallery, three rooms at 291 Fifth Avenue next to Steichen's room, became a meeting place for artists of all kinds.

The arts were united by Stieglitz as by no other individual. Although he was a photographer himself—and an extremely sensitive one—his passion transcended photography. He encouraged all artists who met his high standards of perception and dedication without caring what medium they chose to work in.

Together, Stieglitz and Steichen began to import European work that seemed vital and significant to them. As a result many of the artists who are recognized as outstanding today were discovered and shown in America for the first time at 291—among them, Cezanne, Picasso, Braque, Matisse, Picabia, Toulouse-Lautrec, and Brancusi. Stieglitz was equally supportive of promising American talent. The work of John Marin, Marsden Hartley, Arthur Dove, Max Weber, and Georgia O'Keeffe (whom Stieglitz later married) was shown frequently.

For the first three years, photographs dominated the walls of 291, but Stieglitz was discovering that the Photo-Secessionists were less vital than the young painters. During 1909 only three of the eleven shows presented were photographic. In the following years through May 1917, only three photographers were shown at 291: Steichen in 1910, Stieglitz himself in 1913, and Paul Strand in 1916. The other forty-seven exhibitions included paintings, drawings, children's art, sculpture, ceramics, lithographs, and caricatures.

Figure 1.20

Turner Family, Woburn, Mass. Gertrude Käsebier (1852–1934).

(Courtesy of the International Museum of Photography at George Eastman House)

"291" became a meeting place for artists of all kinds

Stieglitz and Steichen imported European work

Stieglitz's efforts culminated in the Albright show

Stieglitz's strength and vision brought the arts together

Atget was an important but lonely photographer

Lartigue began photographing at the age of seven

Stieglitz's efforts to promote photography as a fine art culminated in a monumental exhibition of photographs in the Albright Museum of Art in Buffalo, New York, in 1910. In spite of the opposition of Frank Fraprie, who denounced the Photo-Secessionists as a "reactionary force of the most dangerous type," the exhibition (designed and hung by Max Weber) was a great success and a very significant step toward the acceptance of photography by the art establishment.

For fifteen years Stieglitz's strength and vision had brought the arts together, and photography and painting had coexisted in an atmosphere of mutual respect; however, it was painting that profited most immediately. The majority of photographers after World War I, as if in reaction to Stieglitz's influence, reverted to the fuzzy Victorian silliness of the 1890s. Photography did not become a vital art again, with a few notable exceptions, for more than thirty years.

In every period there seem to be a few photographers whose work is difficult to classify, and Eugène Atget is one of them. Born in France in 1856, he was raised by an uncle and went to sea as a cabin boy. Later he became an actor and toured the country playing minor roles until he was about forty-two. He began to photograph in 1898 and was self-taught. Using an old view camera and a simple set of lenses, he spent most of the rest of his life recording the city of Paris and its environs. Although he made a meager living by selling his views (many of them to local artists), he apparently knew very little about the work of other photographers and was, himself, similarly unknown during his lifetime. Much of his work was saved from discard after his death by the efforts of Berenice Abbott—also a fine photographer—who obtained a large number of his plates and published a book of his images. Atget was a lonely figure, but an important one in the history of photography. His work was a personal, direct, intense, and unusually honest product of the photographic process.

At about the same time, another unknown photographer was beginning to exercise his unique vision. The absolute opposite of Atget in almost every respect, Jacques Henri Lartigue was seven years old when he took his first picture, a snapshot of his family. Lartigue's family was wealthy and they appear in his photographs as a very lively, fun-loving group of people. He recorded them in all sorts of activities, but specialized in sports and action shots swimming, jumping, attempting to fly, touring, and racing wheeled bobsleds. His other major interest was photographing fashionable women, usually strolling along the avenue, resplendent in silk and lace and feathers. These pictures have an immediacy and intimacy suggesting that the ladies considered the boy with the camera harmless, if not actually invisible. They could hardly have suspected that their images would hang in the Museum of Modern Art fifty years later, nor that they would become well-known visual symbols of the secure and affluent society of "La Belle Epoque."

The new freedom of thought and vision, which inspired painters to break away from the representation of subject matter, also affected a few photographers. Again, it appears that the two media fed on each other: the Futurists' attempts to express speed and motion obviously derived from the photographs of Muybridge, Marey, and Eakins, while the Futurists and Cubists, in turn, inspired Alvin Langdon Coburn to experiment with mirror-multiplied photographic images that he called *Vortographs*.

Coburn was not the first man to experiment with distortions of the photographic image; Ducos du Hauron, at least, had preceded him by almost thirty years. Coburn was, however, the first photographer to work with distortion in a deliberate attempt to create a new visual direction for photography. Although his Vortographs were clearly limited, his exploration of new viewpoints and perspectives was ahead of his time.

The appearance of the Dada movement in art, just before World War I, was a direct attack on traditional values of all sorts. Dada, proclaiming itself the anti-art of the irrational and absurd, produced such unsettling objects as a urinal displayed as *R. Mutt's Fountain*, a flat-iron studded with carpet tacks, and Marcel Duchamps' saucy distortion of a color reproduction of the *Mona Lisa*—to which he added a penciled beard and a moustache and the title *L.H.O.O.Q.*, which spoken rapidly in French sounds like the phrase "Elle a chaud au cul" (she has hot pants).

Figure 1.21 *Un Coin de la Rue Reynie.* Eugène Atget (1856–1927). (Courtesy of the University of Michigan Museum of Art)

Coburn experimented with Vortographs Dada: the anti-art of the irrational and absurd

Figure 1.22

Dr. Goebbels Heilsenf, photomontage. John Heartfield.

(Courtesy of the International Museum of Photography at George Eastman House)

Neue Erfolge der Naziheilkunde: SENF statt KÄSE

"Weg mit dem weißen Käse! Brauner Senf ist das einzige Heilmittel."

Heartfield used photomontage to attack the Nazi menace

Moholy-Nagy considered photography an extension of vision

The Dadaists and Surrealists were not interested in photography as such, but they frequently made use of photographic images in their collages. George Grosz, John Heartfield, and Hannah Höch were particularly adept at this art form. Heartfield, especially, used photomontage effectively to attack the rising Nazi menace in Germany. Dada eventually evolved into Surrealism and Constructivism, which, in turn, influenced some of the members of the Bauhaus in Germany in the early 1920s.

When the Nazis closed the Bauhaus in 1933, one of its members, László Moholy-Nagy, started the New Bauhaus (which later became the Institute of Design) in Chicago. Moholy-Nagy was convinced that photography was indispensable, not only as a scientific tool or means of expression but also fundamentally as an extension of vision. Like Christian Schad and Man Ray, Moholy-Nagy had reinvented the technique of shadow-printing, which Talbot had called "photogenic drawing." Schad's prints were called *Schadographs*, Man Ray called his *Rayograms*, and Moholy-Nagy named his *photograms* the term we generally use today.

Moholy-Nagy did not neglect straight photography, but he was an experimenter and investigator by nature. Like Coburn he explored the visual effects of optical distortion and unusual viewpoint; but he went beyond Coburn by applying these techniques to graphic design and by pointing out the beauty to be found in photomicrographs and other types of scientific photographs. Moholy-Nagy, like all the other Bauhaus artists, was committed to order, structure, and, to a degree, formula. He was also a brilliant innovator whose teachings had a great deal to do with photography's acceptance as a visual language.

Meanwhile, photography was also evolving as an expressive medium. The final double issue of *Camera Work* in 1917 was devoted to the work of a young protégé of Stieglitz, Paul Strand. While on a field trip to the 291 gallery with his teacher, Lewis Hine, Strand had been introduced to Stieglitz and they formed an immediate friendship. Strand quickly worked his way through the soft-focus Pictorialist style and concentrated on straight photographs of New York and its street people, which Stieglitz described as being "brutally direct . . . devoid of trickery . . . devoid of any attempt to mystify. . . . These photographs are the direct expression of today."

Strand worked as an X-ray technician and as a member of a medical movie crew during World War I. In the mid-1920s, after having supported himself for several years as a cinematographer, he returned to still photography and nature—first in Colorado, then in Maine and along the Atlantic coast. Later, in Mexico, Strand collected the images that ultimately composed his gravure *Mexican Portfolio*. Alternating still and motion picture photography for several years, Strand did a number of documentary films and had a major exhibition

Figure 1.23

Shadows, 1916. Paul Strand (1890-1976). Platinum print 33.7 cm \times 23.4 cm.

(The Alfred Stieglitz Collection, © The Art Institute of Chicago, All rights reserved)

Strand's photographs: "brutally direct . . . "

Stieglitz called his "Songs of the Sky" equivalents

An American Place was a mecca for artists

Weston sought personal expression in Mexico

His Daybooks are an inspiring record of his creative struggles

in the Museum of Modern Art. Then in 1948 he moved to France. He devoted the rest of his life to traveling and photographing, producing several books in collaboration with various authors. He died in 1976.

After the dissolution of the Photo-Secession group and the closing of 291 in 1917, Alfred Stieglitz withdrew to a more private existence for a while, but his crusade went on. He continued to encourage O'Keeffe and Marin especially, almost as symbols of an attitude in art that had to be protected and preserved. In 1921 he prefaced a retrospective exhibition of his own work with a statement that ended, "I was born in Hoboken. I am an American. Photography is my passion. The search for Truth my obsession."

Later, in response to a comment that the power of his photographs resulted from his influence over the sitters, Stieglitz produced a series of cloud photographs "to show," he wrote, "that my photographs were not due to subject matter—not to special trees, or faces, or interiors . . . clouds were there for everyone—no tax as yet on them—free." These pictures, according to Stieglitz, inspired the composer Ernest Bloch to exclaim, "Music! music! Man, why that is music!" In an exhibition the next year, he showed another series of small cloud pictures entitled "Songs of the Sky." These two groups of photographs, which are very abstract and evocative, he called *equivalents*, meaning that they were intended to be seen not just as pictures of clouds but as incitements to perception, analogous to other experiences.

Although Stieglitz was not universally loved, by any means, no one can contest that he was one of the most influential men in the history of art. Both painting and photography owe him a considerable debt. His final gallery, An American Place, opened in 1929 and continued to be a mecca for artists of all persuasions until his death in 1946.

On the West Coast, out of Stieglitz's immediate influence, the photography scene was less tempestuous. The Pictorialist influence was strong, and in 1906, when Edward Weston opened his first studio in California, he was completely committed to making soft-focus romantic portraits. He married and had four sons, but the marriage was not a happy one. He became increasingly dissatisfied with having to cater to the tastes of his clients, too, and in 1922 he traveled to New York where he met Stieglitz, O'Keeffe, Strand, and Sheeler. The meetings encouraged and stimulated him, and anxious to concentrate on a personal expression in photography, he traveled to Mexico with his oldest son, Chandler, and Tina Modotti, an artist's model. He lived there for almost two years, producing portraits, nudes, and cloud studies while working in quite close contact with Mexico's leading artists.

He returned to California in 1926 and in 1929 settled in Carmel, where he spent most of the remainder of his life. He worked with minimal equipment, an old $8^{\prime\prime} \times 10^{\prime\prime}$ view camera and a primitive darkroom, but there is no hint of this in his photographs. They are still exceptional for their glorification of natural forms in light, their sharpness of detail, and their delicacy of texture.

Weston kept a diary during most of his productive life and it has been published in two edited volumes, *The Daybooks of Edward Weston*. It is a revealing and inspiring record of the life and creative struggles of one of the major artists of this century. He was the first photographer to receive a Guggenheim Foundation Fellowship and was given a major retrospective exhibition in 1946 at the Museum of Modern Art in New York. He died in Carmel in 1958.

In 1932 a little group of West Coast photographers banded together informally in reaction to Pictorialism. Calling themselves Group f-64, they worked to achieve sharpness and brilliance in their prints by careful selection of subject, camera position, light conditions, and focus. The title suggested their use of small lens apertures for greatest depth of field and good definition. Weston was a charter member of the group, as were Imogen Cunningham and Ansel Adams.

Cances. Peter Payette. Payette is a dedicated and enthusiastic printer in various nonsilver processes. This intriguing print is an example of his considerable skill in handling 3-color gum—one of the most difficult processes to master.

22/28

Untitled. Todd Walker. Walker's stature as an artist and his mastery of printing processes—both historic and contemporary—is evident in the variety and elegance of his works. This exquisite little collotype print is a technical *tour de force*.

Told Walker 1957

Chapter House, Valle Crucis, Wales. Dick Arentz. 12" \times 20" palladium print. Arentz carries large-format quality to the practical limit with these stunning platinum and palladium images, contact printed (on handsensitized paper) from original negatives that he makes with an ancient 12" \times 20" banquet camera.

(Courtesy of the photographer)

Plate 4

Landscape for Edith. Evon Streetman. Cibachrome and Acrylic, $56'' \times 60''$. Many contemporary artists are using photographs or photographic elements in multimedia works to produce striking images, as illustrated by this fanciful example. (Courtesy of the photographer)

Plate 5 Untitled. Rice flour drawing from the India Portfolio. Martha Strawn. Many of Strawn's photographs of India are fleeting glimpses that manage to reveal elements of beauty in otherwise squalid surroundings. This familiar image, in typically somber tones, is an impressive example impressive example.

(Courtesy of the photographer)

Plate 6

Edith, 1986. Emmet Gowin. An intense, visually-rich statement by an established artist.

Plate 7 Digitized Agave. Todd Walker. Walker is a tireless investigator whose images, in a variety of printing techniques, have been uniformly intriguing, tasteful, and beautifully

crafted. He has now begun to explore the exciting potential of computer-enhanced imagery, as this recent work demonstrates. (Courtesy of the photographer)

Plate 8 Refugee Camp, Sidon, Lebanon. Bill Pierce. The wretched condition of these refugees' lives is in violent contrast with the superficial beauty of this remarkable photograph.

Untitled, 1987. Linda Bellon-Fisher. Many photographers favor very large prints for exhibition but Bellon-Fisher has countered that trend with this delicately hand-colored image that is barely $5'' \times 7''$ in size.

(Courtesy of the photographer)

Plate 10

Untitled Still Life. Sam Wang. Although both the hardware and software required to produce very high-quality digitized images are still very expensive, it's possible to produce interesting images of small size without a major investment. Wang's experiment in digitized color separation demonstrates what can be done with modest equipment, and is an exciting suggestion of things to come.

Plate 11 Pueblo Alto, Chaco Canyon, NM. Lorran Meares. By laboriously "painting" the night landscape with portable colored lights Meares transforms the natural environment into a weirdly beautiful stage set that challenges the imagination. He creates these fantastic images to be viewed in three dimensions. This is one of the stereo pair.

Adams had begun photographing only a few years earlier and was initially influenced by the prevailing Pictorialist style. He was a trained musician, and photography was only an absorbing hobby until he happened to see some of Paul Strand's photographs in 1930. He was tremendously impressed and immediately decided to make photography his career. Within a very short time, he was receiving international recognition, and in 1936 his work was shown in Stieglitz's gallery, An American Place. Adams spent much of his professional life photographing nature, concentrating on the Southwest and especially Yosemite. His photographs display a rare mixture of visual sensitivity and technical excellence, and are notable for their dramatic effects of light, rich textures, and brilliant tonality.

He was extremely productive and published several books of photographs. His first textbook, *Making a Photograph*, was published in 1935. He also worked commercially and was a consultant to the Polaroid Corporation for many years. As the acknowledged leader of the West Coast landscape photographers, Adams influenced generations of students through his frequent workshops. His fame as a teacher is due largely to his Zone System, a procedure for predicting and controlling the translation of subject tones into print values. Adams's place in the history of photography is secure; probably no other photographer has been more highly respected, more widely known, or more materially successful. Adams died in 1984.

Edward Steichen, whose name had been intimately associated with photography since before 1900, became the director of photography for the Museum of Modern Art in New York in 1947. He brought to the post a variety of experience as painter; Pictorialist; Secessionist; aerial reconnaissance photographer during World War I; portrait, advertising, and fashion photographer;

Figure 1.24 Roses and Sunshine. Edward Weston (1886–1958). (From the Platinum Print, vol. 1, no. 5 August 1914)

Adams was a trained musician before turning to photography

Steichen assembled "The Family of Man" exhibition

Figure 1.25

Self Portrait, 1902. Edward Steichen (1879– 1973). Gum single printing period of 1902, $10\%'' \times 7\%''$.

(The Alfred Stieglitz Collection, © The Art Institute of Chicago, All rights reserved)

and director of photography for the Navy in World War II. During his directorship at the Museum of Modern Art, Steichen expanded and diversified the collection of photographs and put on more than forty photographic exhibitions, culminating in 1955 in a massive display of more than five hundred prints by photographers from all over the world. He called it "The Family of Man." Assembled from more than two million prints submitted, the exhibition was a notable success. In 1964 the museum established the "Edward Steichen Photography Center" in his honor and conferred on him the title of Director Emeritus, which he held until his death at the age of 94 in 1973. Steichen's career in art and photography is almost without parallel. No other individual has combined so many talents, devoted so much energy, and achieved such success in so many branches of the medium.

In spite of its enthusiastic acceptance by viewers around the world, the "Family of Man," seen in retrospect, was impressive more for the statistics of its presentation than for its artistic significance. It told its story and was persuasive, but it used photography conservatively. Its real power lay in the sheer size and number of prints and the magnificence of its installation. It probably had to be done if only to complete the era of the picture story in a grand manner, but it was primarily a tour-de-force of photojournalism and had little to do with the "modern art" of photography in the 1950s. New, more personal and creative expressions were soon to appear.

The Post-War Era

The end of World War II brought sweeping social changes. With the post-war prosperity and the flood of consumer goods came the sobering realization that the world's last frontiers had been explored and that—for the first time in history—man had the physical capacity to exterminate himself with one

It was a tour-de-force of photojournalism

The war's end brought sweeping social changes

grand gesture. To many young people of the 1950s and 1960s, these factors combined into a ghastly paradox. They saw ahead of them lives full of comfort and plenty, but devoid of purpose, empty of human value, and threatened by atomic disaster, runaway population growth, and resource depletion. Their initial unease, heightened by the Korean War, became anguished rebellion with our involvement in Vietnam. Some of them looked at this new, crazy world with suddenly sharpened perception, and while many were caught up in waves of semiorganized protest and demonstration, a few expressed themselves through their art, including photography.

Robert Frank's book, *The Americans*, gave us a first shocked look at ourselves in 1959. Frank's work was a new, raw descendant of the social commentary approach to imagery, traceable through the Farm Security Administration documentary of the Depression to Hine, Riis, and Thomson. It had a new roughness of style that seemed to deny, or at least ignore, the older traditions of compositional elegance and the concept of the fine print. *The Americans* leads more or less directly to the work of Lee Friedlander, Garry Winogrand, Danny Lyon, and others, who have come to be known as the Social Landscape photographers.

Modern photography of the fifties still had some link with the past, however. The creative spark that Stieglitz passed on to Weston, Strand, and Adams persisted after World War II to inspire Harry Callahan, Minor White, and many others.

Callahan, under whose later direction the Chicago Institute of Design's photography program became nationally known, first displayed an interest in pattern and design. Since the late 1940s he has worked in a variety of styles including experimental multiple exposure abstractions, nudes, street photographs, and formalistic patterns. All are characterized by an obvious interest in organization and structure, but for him they represent an intensification of the essential qualities of his subjects. Callahan has been an important force in photography as both artist and teacher for more than thirty years, but in a quiet way. He has seldom written or lectured on photography, but his numerous exhibitions attest to his continuing productivity and his appreciation by an ever-widening audience.

Figure 1.26 Elevator Girl. Robert Frank. (Courtesy of Robert Frank, from *The Americans*)

Frank's book, The Americans, was new and startling

Callahan has been an important force in photography

Figure 1.27

Scotia Coffee Shop at 11:45 A.M., Any Weekday. Ellen Land-Weber. Land-Weber has been documenting Scotia—one of the last company towns in the country—for several years. This formal, objective record of a local coffee shop, both strange and familiar, suggests a great deal about the town and the people who inhabit it.

(Courtesy of the photographer)

White's sequences are some of his best work

Minor White became interested in photography as a boy, but put it aside during his college years in favor of writing. At the age of thirty, in 1938, he took up photography again and, resisting the prevailing Pictorialist influences, studied the work of Stieglitz, Adams, Weston, and Abbott. He quickly became a masterful technician, and in 1938–1939 he completed documentary projects on the ironfront buildings and the waterfront areas of Portland, Oregon.

He returned to writing during his army service and developed an interest in religion and philosophy, which preoccupied him increasingly for the rest of his life. After World War II, he became interested in the concept of "reading" photographs, and after meeting Stieglitz, Strand, Callahan, Adams, and Weston in 1946, he began working with Stieglitz's idea of the *equivalent* and images in series.

In the following years, he taught at the California School of Fine Arts, the Rochester Institute of Technology, and, finally, at the Massachusetts Institute of Technology. Meanwhile, he was a very active exhibitor, writer, critic, lecturer, and workshop instructor. Additionally, he found the time to join the staff of George Eastman House and to edit *Aperture* magazine. His interest in religious experience, philosophy, and psychology eventually embraced various Far Eastern religions and astrology, and these principles became inseparable from his artistic expressions in photography and poetry.

White's *sequences*, photographs in series, frequently with accompanying poems, are some of his best work. He had a masterful command of technique, and his prints are rich and luminous. His images are always evocative, usually ambiguous, and frequently involve forms that are poetically suggestive of religious and erotic ideas. White was not without his critics, however. He inspired either admiration or scorn without much middle ground, but on the whole he was a genuinely constructive and powerful force.

The stylistic shift in the late 1950s, represented by Frank, Winogrand, and others, had some of the characteristics of the Dada movement in the teens and 1920s. By finally disposing of the restrictive and ritualistic aesthetic formula of the Pictorialists, the young rebels of the 1950s opened the door to experimentation and gave photographers a new freedom of expression.

Figure 1.28 Boys Flying. Nancy Rexroth. (Courtesy of the photographer)

By 1960 photography had begun to find widespread acceptance in high schools, colleges, and universities. This acceptance spread rapidly. In 1963 a group of teachers founded the Society for Photographic Education (SPE) to establish formal lines of communication between teachers of photography, to encourage the growth of photography in the schools, and to cooperate with other organizations, such as the Professional Photographers of America (PP of A), who were also interested in education. The SPE now has about 1,500 active members widely distributed throughout the United States as well as a few members in foreign countries.

Photography Today

Photography's acceptance by the academic community after World War II had an unprecedented effect. Interest in photography as a respectable art form increased dramatically, and photographs began to appear in galleries, art museums, and private collections.

Steichen's 1955 *Family of Man* exhibition had successfully aligned photography with "art" in the public eye, but had presented it as an essentially narrative medium, used (as Carl Sandburg wrote in the catalog prologue) to create "A camera testament, a drama . . . of humanity, an epic . . ." John Szarkowski, Steichen's successor as Director of Photography at MOMA, saw the medium differently. Shortly after assuming his position in 1962, Szarkowski mounted an exhibition called *The Photographer's Eye*, whose announced purpose was to investigate "what photographs look like, and why they look that way." Photography finds acceptance in the schools

Steichen saw photography as a narrative medium

Figure 1.29

The Haitian Women, from the book, Merci Gonaives. Danny Lyon. It takes hard work and quick reflexes to capture expressive images in situations of this sort. Much of Lyon's work has this "frozen frame" intensity.

(Courtesy of the photographer)

Szarkowski was concerned with the nature of photography itself

New Topographics: 'anthropological rather than critical'

Steichen had used photography to present a grand theme—a pictorial epic; Szarkowski was concerned with the nature of photography itself. His influence was immediate and lasting. Although the decade of the sixties was a period of active exploration, a new, analytical attitude toward the nature, significance, purpose, and use of the medium began to emerge.

One aspect of this attitude was a renewed interest in the snapshot—that is, the unplanned, genuinely naive, artless, pictorial document. During this period, Szarkowski actively supported photographers who elected to work in this tradition, by including several of them in MOMA exhibitions and praising their work in critical reviews. Gary Winogrand was one of this favored group. Although far from naive and seldom artless, his photographs do have a spontaneous roughness that, at first glance, makes them appear unplanned and haphazardly organized. Like Szarkowski, Winogrand professed to be uninterested in the meaning or significance of photographs, especially his own, as evidenced by his famous statement, "I photograph to see how (things look) photographed."

The New Topographics exhibition that appeared at the International Museum of Photography at George Eastman House in 1975 exemplified one of the more intellectual directions that photography was taking as it emerged from the chaos of the 1960s. In his catalog introduction, the curator William Jenkins identified the New Topographics photographers' common viewpoint as "anthropological rather than critical, scientific rather than artistic," and stated that the "central purpose (of the exhibition). . . is simply to postulate, at least for the time being, what it means to make a documentary photograph."

If neutral, styleless, anonymous documentation was the intent of the New Topographics photographers (as is suggested by Baltz's statement that "The ideal photographic document would appear to be without author or art"), they were not entirely successful. Many of the images were more carefully composed and more elegantly printed than was necessary to simply display objective fact about the subject matter. Paradoxically, this somewhat selfconsciously stated intent to conceal the photographer's influence on the image serves, in retrospect, to emphasize it.

Although photographers have worked in a great variety of overlapping and interrelated styles since the 1960s, it's possible, for the sake of discussion, to identify a few important trends. The ''dispassionate witness'' approach of the New Topographers continues, although it is now frequently tempered somewhat by an apparent interest in formal organization or content. A significant number of photographers—many of them women—work with highly personal themes, picturing themselves, their families, and their immediate friends, or expressing attitudes of personal importance (fig. 1.30).

Figure 1.30

Julia Sleeping. Joanne Leonard. Although Leonard has worked in a variety of styles, she is perhaps best known for her sensitive treatment of her home and neighborhood environment. This beautiful photograph is of her daughter—a favorite subject. (Courtesy of the photographer)

A few important trends

Figure 1.31 Ibex Dunes #1. California 1984. William Garnett. Garnett is well known for his beautiful aerial photographic abstractions. This elegant image typifies both his unusual sensitivity to the visual effects of light on form and his technical mastery of the medium.

(Courtesy of the photographer)

Figure 1.32

South Miami Beach, 1984. Gay Block. "Street photography," in black and white and in color, is a popular form of expression. Deliberately unstructured and unrefined, these works are glimpses of a reality that is seldom profound but often revealing.

Relatively few photographers are still actively engaged in a search for beauty (fig. 1.31); while others are critical observers of social structures, mores, and customs (fig. 1.32). Some, not content to merely observe society, use their cameras in an attempt to effect social change (fig. 1.33).

Color is increasing in importance. In some cases it's used naturalistically to enliven an image that would be relatively less interesting in black and white (plate 13). In many other instances the color itself is the significant element of the photograph.

A great many photographers manipulate the process or their materials in some way to produce images that range from the surreal (fig. 1.34) to mixed media forms that retain almost no trace of photographic imagery. Others work more conceptually with "made-to-be-photographed" constructions (plate 14 and fig. 1.35) or disrupt perception with carefully contrived modifications of the subject space. A great deal of this more experimental work seems to be centered on the West Coast, especially in California.

Figure 1.33

Molder, 29 years, Industrial Accident, 1975. Ken Light. Ken Light's work reflects his social concerns and expresses his compassion for the plight of the underprivileged. He photographs simply, without artifice, and his images are notable for their tasteful restraint and honesty.

Figure 1.34 Untitled, 1987. Jerry Uelsmann. Uelsmann's beautifully-crafted composite images are surreal, fascinating, and frequently unsettling.

(Courtesy of the photographer)

Figure 1.35

Homage to the Whale, 1980. Voy Fangor and Carolyn Patkowski. This work was commissioned for use as an illustration in a book on whales. Fangor made the "drawing" by rolling out more than 100 rolls of paper towels on a slope near Summit, NY. The whale was actually almost circular—420 feet deep by 615 feet long—but appears correctly proportioned in perspective. For use in the book, Patkowski photographed the work from a vantage point about 1,000 yards away. The paper whale lasted about a month and created a local sensation.

(Courtesy of the artists)

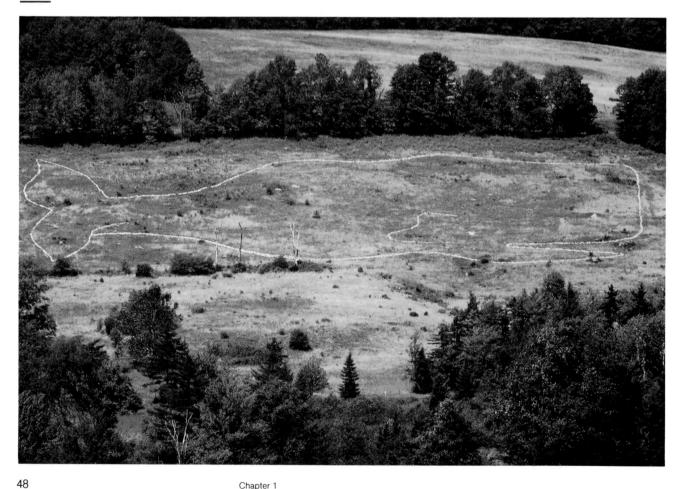

Figure 1.36

An "Unretouched" Photograph of John W., Thus a "Truthful" Image of the Digitized Image. Sam Wang. Wang combines his love of photography with a passionate interest in computers in producing playful experimental images of this sort. This rapidly evolving technology is attracting the attention of many photographers and promises to be increasingly influential.

(Courtesy of the photographer)

Figure 1.37

Environmental Portrait #5. James Ransweiler. Video graphics is an exciting area of exploration for many young photographers because of its potential for combination, manipulation, and distortion of images.

(Courtesy of the photographer)

The Future of Photography

After several decades of rapid growth, art photography programs in the nation's schools and colleges suffered a substantial setback during the recession of the early 1980s. If there is another crisis to face in the future, it may be one of direction and philosophy. Photography's relatively short history has been marked by rapid evolution, both technical and aesthetic. Now, after relatively few years, the definition of photography has been expanded far beyond the simple camera image, and the search for new expressive image forms continues unabated.

In addition, recent dramatic advances in computer-generated imagery and digital imaging techniques promise to influence profoundly the ways we make and use pictures in the future. How will they affect photography as we now know it? What skills will photographers need and what tools and materials will we use by the end of this century? We'll have to wait and see, but one thing is fairly certain: we seem to have an innate need to picture our world, and photography, in some form, will certainly continue to serve that need.

Summary

The camera obscura was invented long before there was any real use for it. At first it was a curiosity, then an aid for drawing. Niépce is credited with producing the first camera image in 1826. He later formed a partnership with Daguerre to work toward an improved process. At the same time others, such as Talbot and Bayard, worked independently toward the same goal.

After the announcement of the daguerreotype process in 1839, the evolution of photography was rapid. Archer's invention of the collodion wet-plate process in 1851 established the basic procedures that are used today. Numerous methods were devised for producing photographic images in pigments and inks. Eventually this experimentation led to the introduction of such processes as carbon, collotype, woodburytype, and photogravure. Flexible film was introduced commercially in 1888, and in a few years George Eastman began to sell Kodak cameras with the slogan "You press the button; we do the rest." The introduction of Autochrome film in 1907 marked the successful end of a long search for a practical color material, a search that began almost as soon as photography was invented.

The popularity of photography has grown as rapidly as its technical advancements. Photojournalism had its roots in the documentation of the Civil War by Mathew Brady, the explorations of the West by Timothy O'Sullivan and William H. Jackson, and the studies of the immigrants and child laborers by Lewis Hine. By 1900 halftone illustrations were beginning to appear in books and magazines. This enabled the development of the picture story magazines and the fields of photo-illustration and advertising photography.

Almost from the beginning, art and photography had a tremendous influence on each other. At first photographers followed the current painting styles, which were undoubtedly influenced by photography's unique visual characteristics. Photographers such as Alfred Stieglitz and Edward Steichen encouraged many young photographers and promoted photography as an acceptable art form. Exhibitions of photographs in major museums, especially the Museum of Modern Art, have given the medium new status.

Technological advances today suggest that the way we make and use photographs may change significantly. We can only wait and see; but regardless of the form it takes, photography will undoubtedly continue to help us picture our world.

Qualities of a Good Photograph

Untitled

From the series *In Front of the Sky* by Rob Kangas. Kangas has a keen eye for those bizarre and absurd situations that most of us overlook. This hooded object is pictured clearly enough but its identity and significance are uncertain. The harsh, manipulated color adds to the unreality, and the questions *what* and *why* are left for the viewer to answer.

Figure 2.1

Untitled. Nick Merrick. Professional photographers are often asked to make beautiful images of ordinary things or places. Merrick's solution to this typical problem is a minimal composition of light and line that forms an elegant "portrait" of a chair.

(Courtesy of Hedrich-Blessing)

A photograph is good if it serves its intended purpose

The artist and the public have different criteria

What is a good photograph? That depends upon whom you ask and what criteria are being used to make the judgment. In the opinion of the gallery owner, a good photograph is one that can be sold easily and at a good price. The scientist considers a good photograph to be one that displays the desired visual information clearly and succinctly. Advertising art directors and their clients call a photograph good if it will glamorize the product and make it appealing to the purchaser. Your photography teacher may call your photographs good if they display some sign of visual awareness, technical ingenuity, or personal expression. To your mother, any photograph of you is good, especially it it shows you smiling. A good photograph for you is any photograph you like, whether anyone else likes it or not.

Consumer vs. Producer

The definitions above relate to the judgment of the consumer of photographs; as a producer of photographs, your criteria of what is "good" should be quite different. Logically, an artist can consider his or her work good if producing it is an engrossing and gratifying experience and if the finished work measures up to or exceeds expectations. The process of *making* and satisfaction with the result reflect the artist's taste. The success or failure of the work in the marketplace reflects the taste of the consuming public.

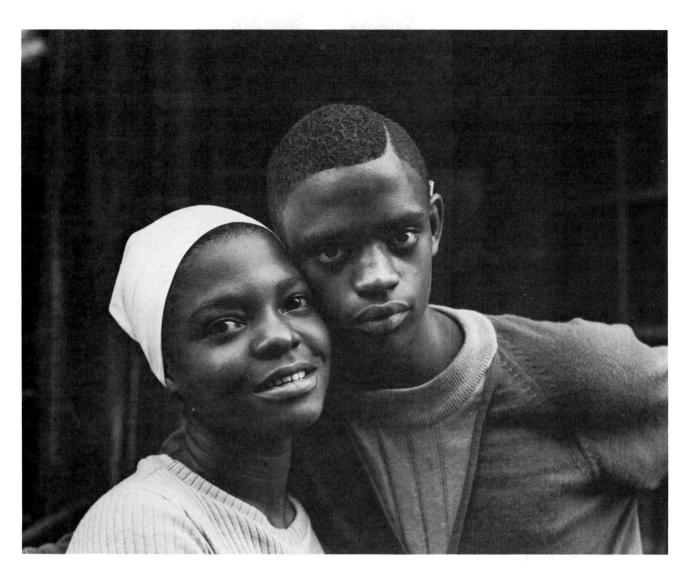

Consider this difference carefully. Although a great deal of fine art of the past was commissioned by wealthy patrons, much of the work that we consider to be significant or seminal in the history of art reflects the desire of the artist for *self*-expression. It seems unlikely that Picasso's *Guernica*, for example, could have resulted from a commercial assignment. Julia Margaret Cameron's magnificent portraits of the great men of her time resulted from her feeling that photographing them was the "embodiment of a prayer." By comparison, her contrived allegorical illustrations of literary and biblical themes are unremarkable and, in some cases, insipid and silly. More recently, the commercial work of Avedon, Arbus, Davidson, and Michals—although skillful and ingeniously effective for its purpose—is much less interesting and inspiring than their personal work. It seems clear that the "best" work done by any artist is done for self-satisfaction, in personal "dialogue" with the chosen materials and without concern for the opinions or criticisms of others (fig. 2.2).

But don't consider this a license to "do your own thing" regardless of consequences. Only relatively mature and sophisticated individuals who have mastered their craft are equipped to produce work of much lasting significance. Furthermore, as human beings, we can't operate in total isolation; communication, sharing of ideas, and approval are all important to us.

The work of inexperienced, unskilled artists, however gratifying it may be for them, will probably seem naive and crude to a sophisticated public, and this rejection can be a painful experience. Far too many young artists react

Figure 2.2

Portrait, from *East 100th Street.* Bruce Davidson. Of the two years he spent photographing East Harlem, Davidson said, "I entered a life-style, and like the people who live on the block, I love and hate it and I keep going back."

(© Bruce Davidson/Magnum Photos)

Personally inspired work is likely to be most successful

Figure 2.3

Redstone Missile/Indian Creek Petroglyphs. John Pfahl. Although Pfahl maintains that his photographs are "politically neutral," they suggest a perceptive social awareness as well as a refined sense of visual organization.

(Courtesy of the photographer)

Catering to public taste will lead to mediocrity

Consider reactions to your work carefully . . .

to this rejection by subduing their own instincts and catering mindlessly to what they perceive to be "public taste." This can only lead to mediocrity. Without the intuitive guidance of well-established personal standards, their work must necessarily mimic that of others, and become derivative and "trendy." It's far better to work harder to develop your own taste and improve your skills until your work merits attention. Then you'll get the approval you deserve.

Using Criticism Constructively

Although you shouldn't accept other people's pronouncements of what is "good" and "bad" without question, you should consider their reaction to your work carefully and as objectively as you can. By showing your work, you

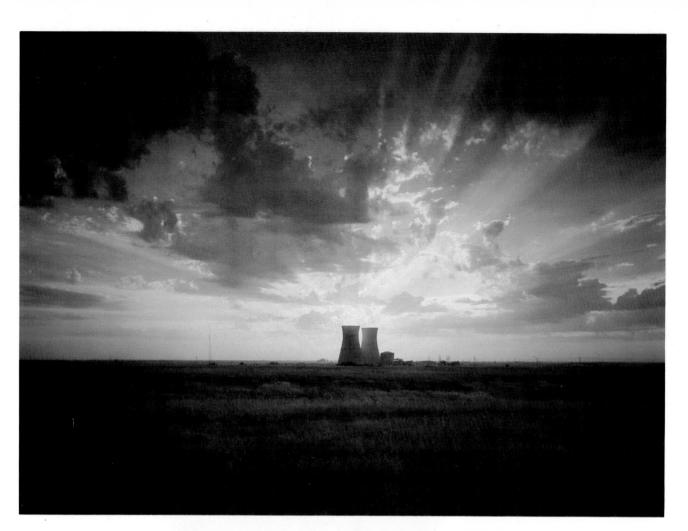

Plate 12

Rancho Seco Nuclear Plant. Sacramento County, CA. 1983. John Pfahl. Although Pfahl's handsome documentary photograph of reactor cooling towers can be interpreted as either pronuclear or antinuclear, his stated intent is to make "politically neutral" images.

(Courtesy of Robert Freidus Gallery)

Plate 13

Untitled, 1983. Jim Bemis. The search for interesting abstractions occupies many photographers. Here Bemis has chosen to emphasize the color relationships in this handsome detail of a rusty automobile fender—a subject that would be drab in black and white.

Plate 14 Formal Frolic, Fla. Andy Ross. Ross combines riotous color with personal symbols in this highly structured still life. (Courtesy of the photographer)

Plate 15

Deceptions #22. Thomas Porett. Porett is a pioneer in the area of digitized imagery. This image is one a series that he has created, using a computer to manipulate and reorganize digitized image fragments, and an ink-jet printer to produce the "hard copy."

(Courtesy of the photographer)

Plate 16

Video Generated Photographic Paintings; Group Four, Number Six. Tim Bies. Video manipulation can produce a wealth of effects that are difficult or impossible to achieve by conventional photographic means. Here is an experimental example from a series of "Video Generated Photographic Paintings."

Plate 17

Urban Canyon, Omaha, NE. Lorran Meares. This garishly-illuminated cityscape fantasy is typical of Meares' recent stereo imagery (this is one of the stereo pair). When viewed in three dimensions, as intended, elements of these images seem to float free in space and the visual effect is stunning.

are both asking for approval and risking disapproval. If you get negative criticism rather than approval, it's obvious that your critic's taste differs from yours or that the fine qualities you see in the photograph are not apparent to others. If approval is important to you (and if you're human, it certainly is), you must find out what the problem is and try to correct it.

A simple difference in taste is not particularly serious. Your critic can express lack of interest in your work, but concede that it's well-conceived and well-executed for what it is. The more serious problem is a difference in *perception* of the work. Consider this carefully. If you're a beginner in photography you may still be so charmed by the mere mechanics of image formation that *any* picture is a triumph. On an intermediate level, you may feel that you've entered the ranks of the Friedlanders and Winogrands with a series of "street photographers can fall into the trap of "wishful seeing" and fail to recognize in their work flaws that are distractingly evident to another person. Just as a man singing in the shower can be charmed by the resonance of his own voice, we tend to see in our own photographs just those qualities we *want* to see; and just as the singer's efforts may sound, to a person outside, like the bellowing of a wounded moose, so may the flaws in our work be distressingly obvious to others.

Take criticism—whether favorable or unfavorable—*seriously*, but not *personally*. Good criticism can indicate to you the success or failure of your efforts to share your ideas and emotions. Accept it objectively; interpret it as being directed at *your work*—not at *you*, the person. Criticism—even uninformed criticism—can help you grow; learn to deal with it objectively.

Figure 2.4

Fontenelle Fatality, Bellevue, NE. Lorran Meares. This grisly image of a dead deer illustrates photography's power to evoke emotional response and influence opinion. Meares' "fine art" treatment of the subject gives his comment an ironic twist that makes it doubly effective.

(Courtesy of the photographer)

. . . and avoid "wishful seeing" if you can

Criticism can help you grow if you view it objectively

Francis Bacon, Artist, April 11, 1979, Paris, France. Photograph by Richard Avedon. Avedon is an acknowledged leader in the field of fashion photography, and has been for years. More recently he has become equally respected for penetrating portraits, such as this one, that combine technical mastery of the medium with interpretive ingenuity and dramatic economy of means. (Copyright © 1979, Richard Avedon. All rights reserved.)

Photography is governed by physical and chemical laws

Creativity is limited

Limits to Personal Expression

Photography is a complex mechanical medium governed largely by physical and chemical principles that are reliable, predictable, and inflexible. Because of this, it's fairly easy to become technically competent; all that's required is comprehension of the principles, respect for the materials, and careful workmanship. But this same technical rigidity makes photography a difficult medium for personal expression. Unlike the other visual arts, which permit the gradual building up of a work and the constant subjection to review and modification at the artist's whim, photography allows almost no opportunity for review or change during the actual process of image formation. The image can be modified, to be sure, by subsequent manipulation, but it is initially a record of what the lens "saw" at the instant of film exposure.

In this sort of medium, the hand of the artist is well concealed. There are no telltale brushstrokes, no personal idiosyncrasies of line, perspective, or color, and very few possibilities for useful "accidents," such as the natural blending of fluid color in a wash drawing or the spontaneous crazing of a ceramic glaze. Accidents in most photographic processes are disastrous rather than decorative. "Creativity" in photography is, therefore, limited to the selection and organization of subject matter before the shutter is snapped, and adjustment or manipulation of the image after it's formed.

In "straight" photography, one can choose the camera position, lens focal length, depth of field, exposure interval, film type, filters or other lens attachments, light condition, and development. These decisions contribute to a certain quality of image that will reflect to some extent the taste and sensitivity of the photographer. The work will be further personalized by the choice of print materials and the presentation form of the finished image. The degree to which a personal style is recognizable depends partly upon the degree to which the photographer's own judgment is involved in making these selections and decisions. It also depends upon the photographer's commitment and the lengths to which he or she will go to achieve "perfection".

Don't be fooled by the apparent simplicity of this medium. Technically, it's easy to master; artistically, you'll find it a formidable challenge!

Human Vision vs. Camera Vision

One of your first challenges as a beginning photographer will be learning to see things as the camera will record them. You'll have to become accustomed to a few fundamental differences between human vision and camera vision. In the first place, your eyes really see sharply only a very small area of the subject at any given moment. Your visual impression of things you look at is assembled mentally from a series of fragments that you perceive in very brief, scanning glances. Added to this is a general visual orientation of the entire subject area obtained by your very wide-angle but unfocused peripheral vision. You use the peripheral vision to establish the relative position of objects in space, then glance at the areas that seem to need more complete analysis with your precise central vision.

This is generally a very brief, totally unconscious act. Your eyes leap from point to point without being willed to do so, and your brain pieces the visual bits together. At the same time your brain computer is operating to make the impression intelligible. It automatically emphasizes things that it knows will interest you and suppresses things that you have programmed it, by experience, to classify as insignificant.

In addition to the purely visual impressions you receive, your computer circuits may supply you with some information from your other senses. All of these bits add up to a general impression of the total experience. If you're paying attention, you'll experience some sort of reaction, usually a mild one, of interest or boredom, pleasure or displeasure; and if this happens while you're looking for photographic subject matter, you'll probably take a picture of the object or scene that prompted it. It's very probable that a photograph taken so casually and for so trivial a reason will turn out to be a rather trivial picture.

The reason should be obvious; the camera simply doesn't record what your brain recorded. Your snapshot photograph really does little more than confirm that you were present at the subject area when the picture was taken. It emphasizes none of the points that interested you, suppresses none of the areas that bored you, illustrates a very small area of the total subject space described by your peripheral vision, and then displays the whole disorganized interpretation in smaller-than-life scale, confined within artificially described boundaries, in two dimensions, and perhaps in black and white. Obviously there can be no hint of the extravisual perceptions that you experienced and that contributed to your total impression.

Is it any wonder that your friends fall asleep when you show your vacation slides? *You* can enjoy them because they help you relive your trip. They serve for your memory the same function that the prompter serves for an actor who has forgotten his lines. But no amount of prompting can help an actor who has not learned his part, and no amount of visual reminding can be of much use or much pleasure to a person who has not had the experience to remember.

If you want to communicate your own impressions to others (and what photographer doesn't?), you must supply them with complete, coherent pictures. In very simple terms of straight photography, this means that your print must display clearly, sharply, and without confusion of background details, all those areas of the subject that your eye examined with pertinent interest.

Qualities of a Good Photograph

Technique is easy; artistry is a challenge

Your visual impressions are assembled fragments . . .

. . . supplemented by other sensory information

The camera is not selective . . .

. . . no wonder your slides put your friends to sleep

You must supply complete, coherent pictures

Untitled, San Francisco, CA 1988. Gordon Hammer. Hammer makes deliberate use of motion, image grain, and emphatic effects of light and dark to create these evocative images that suggest perceptions "at the edge of consciousness."

(Courtesy of the photographer)

Figure 2.7

Broken Doll Still Life. Henry Talbot. Talbot is an Australian teacher and photographer whose commercial assignments have taken him around the world. This handsome image—both whimsical and grotesque—has been widely exhibited.

Figure 2.8 Goodland, Kansas. William Garnett. Most of Garnett's remarkable low-level aerial photographs exhibit his interest in abstract design and his remarkable ability to recognize and capture these striking compositions in the few critical seconds when everything is "right."

Children's Playground after Storm, Hamtramck, MI, 1987, from the *Unknown Landmarks* series. Carlos Diaz. Diaz surveys the urban landscape with an ironic eye but frequently finds beauty there also.

(Courtesy of the photographer)

A photograph is a picture—it's also a pattern

In addition, your print must conceal or subdue those areas of the subject that your brain classified as irrelevant or uninteresting. Every visible feature of the print will affect viewers in some way, and if you supply them with the wrong elements, or present them with visual confusion, they will not get your message.

Composition

Another very important factor is the composition or visual arrangement of the image forms (fig. 2.10). Consider it this way: the photographic print is a picture of something that conveys real information about the subject. With luck and skill on your part, it may suggest your feeling about the subject while making the picture. In addition to this symbolic aspect, the print is physically a piece of paper coated with gelatin, containing irregular areas of black, white, and gray. Even if they represented nothing at all, these areas of tone create a pattern that nearly everyone can appreciate—to some small degree, at least—for its own sake. In fact, whether consciously aware of it or not, virtually every viewer will be at least subtly influenced by the abstract design of the image tones and textures.

First Baptist Church, Richmond, Texas. Dan Biferie. Biferie has emphasized the natural contrast of this scene to create a striking compositional structure.

(Courtesy of the photographer)

Edward Weston once described composition as "the strongest way of seeing," and that's not a bad definition. Certainly a well-composed picture is more attractive and more effective for its purpose than one that appears unorganized and chaotic. But how do you distinguish between "good" and "bad" composition; how can you organize the elements of a picture for best effect; and how can you avoid pictorial chaos? These are good questions—obvious questions—but, unfortunately, they don't have good, obvious answers. Furthermore, if you give it some thought for a moment, I think you'll agree they *shouldn't* have answers.

What is "good" composition? There's no firm answer

Untitled, 1984. Robert Kangas. In this unusual photograph, Kangas violates all the usual "rules" of composition by tucking his subject elements away in the extreme corners of the frame. The empty space becomes an active and interesting part of the compositional structure.

(Courtesy of the photographer)

Sensationalism is as bad as mindless conformity

H. P. Robinson preferred the pyramid to the square . . .

If there were firm and inviolable rules for composition, there would be very little chance for personal expression, and picture-taking would become a simple matter of following instructions. Anyone could produce good pictures, one after another, and those closest to the defined "ideal" would be "best." Of course this would also mean that pictures not adhering to the rules would be automatically branded as "bad," even though they might be powerful images, dramatically presented. Anything new or different would be disqualified, and art museums would soon become dismal wastelands, full of endlessly repetitive, thoroughly tiresome pictures.

That's one hypothetical extreme; now let's consider the other one. If no inviolable rules exist and if a formula approach to picture-making leads to tiresome imagery, does this mean that the traditional rules and conventions should be deliberately flouted, and that anything new and different must necessarily be better than something that's been seen or done before? Of course not! Either extreme is silly. Sensationalism for its own sake is just as shallow and unproductive as mindless obedience to the rules. The compulsion to be different is just as hampering to creativity as is the compulsion to conform.

Henry Peach Robinson, in his famous book *Pictorial Effect in Photog-raphy*, published in 1869, insisted over and over again on the importance of abiding by the "recognized and certain laws" of composition—but without ever stating unequivocally just what those laws are. He advocated the triangle, the diagonal line, and the circle as guides to be followed in con-

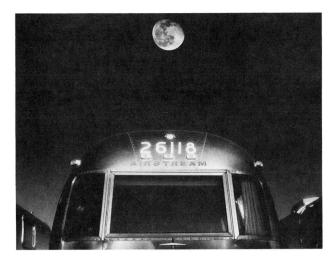

This striking photograph by Bill Longo is a simple blend of two images: a 400mm shot of the moon on Tri-X film; and a 28mm shot of the motor home, in sunlight, on infrared film.

(Courtesy of the photographer)

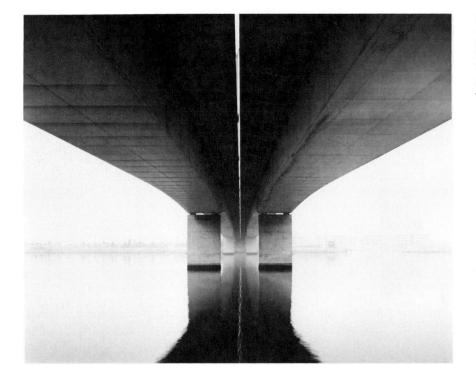

Figure 2.13

Queen's Drive Bridge, Long Beach, CA. Neil Chapman. Chapman's keen eye and impeccable technique are demonstrated in this dramatic formal composition. (Courtesy of the photographer)

structing the "most pleasing and agreeable" compositions. "A square," he said, "is much less picturesque than a pyramidal form," and warned that "an important object will never be found exactly in the centre (of a composition)." But Robinson was wise enough to realize that an art governed entirely by rules is no art at all. "Laws become hurtful when carried to excess," he declared, "rules are not intended as a set of fetters to cripple those who use them, and it is not intended that the student should absolutely abide by them."

Later authors were less cautious and occasionally inclined to justify their statements with pseudoscientific explanations. Arthur Hammond, an influential magazine editor and author of *Pictorial Composition in Photography*, published in 1932, counseled his readers that right angles in a composition are "not good" because they "tax the eye muscles." He advocated scribing

. . . and Hammond warned that right angles tax the eye

Snow Geese with Reflection of the Sun over Buena Vista Lake, California, 1953. William Garnett. Garnett's exquisite aerial abstractions of earth and water patterns have been widely published for more than thirty years. This relatively early work has an almost oriental elegance and simplicity.

(Courtesy of the photographer)

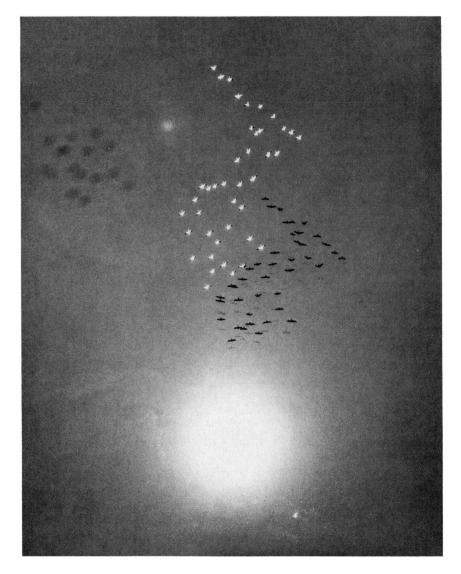

the camera groundglass into three equal vertical and horizontal areas so that "the principal object of interest" could be placed at one of the four "strong positions" formed by the intersections of the dividing lines—a principle still sometimes invoked as the "rule of thirds." Finally, Hammond stated flatly, "the laws of principality and unity, harmony and balance, must always be observed."

Things have changed considerably since Hammond's time (and certainly since Robinson's). We no longer believe that a triangular relationship of lines or points in a picture will result, necessarily, in compositional excellence. (Nothing is simpler than locating triangles or squares or circles or mythological beasts in a picture—or in the stars—if you're inclined to find them there.) We're now aware that the eye can't be depended on to "enter" a composition at a designated spot, travel a prescribed route through the picture, and leave (presumably satisfied) at a selected exit point.

We now feel much less sure that including an S curve, or observing the rule of thirds, will guarantee a great picture. But, more importantly, we don't think of photography as being restricted to expressing "the sublime, the

Now we know that composition is a matter of taste

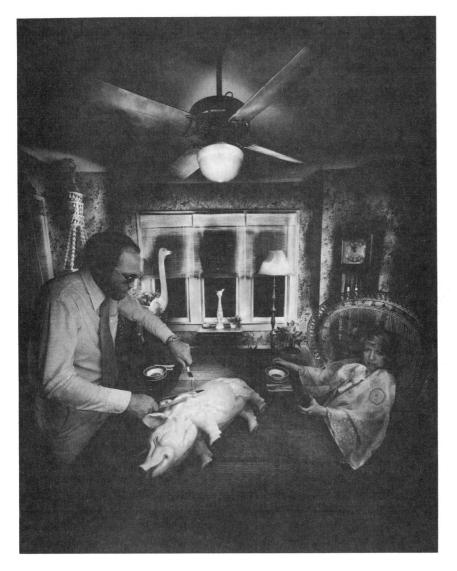

beautiful, and the picturesque'' any more. We realize that "good" composition is a matter of taste and we're aware that taste is not a universal verity. Different cultures see things differently, as do different age groups and different individuals. There *are* no rules of taste that we can agree on universally, or depend on to remain unchanged.

If the rules of composition have acquired a bad name over the years (and they have), it may be because they've been interpreted, all too often, by extremists. Furthermore, there's faulty logic at work; while it's absolutely true that a picture we admire *may* contain an S curve and a pyramidal form of some sort, feature an obvious balance of opposing diagonals, and observe the rule of thirds, it's equally *possible* that a picture may contain all these ''desirable'' features and be obviously and offensively dull.

The thesis that, ''since all good pictures contain S curves (for example), all pictures that contain S curves must be good,'' is just as ridiculous as concluding that because all dogs have four legs, all four-legged things must be dogs!

Figure 2.15

Thanksgiving with the Findells. Lorran Meares. Meares is becoming well-known for these bizarre tableaux vivant, which he illuminates by painting selected areas of the set with a spotlight, and photographs with a stereo camera. This two-dimensional reproduction is unsettling, but it can only suggest the nightmarish quality of the original stereo image.

Figure 2.16 Untitled. Laura Plansker. A decorative, highly manipulated work involving many personal symbols.

Figure 2.17 Der Held, 198

Der Held, 1983. Aus der Serie, *Mann.* Monika Wegler. Although we see relatively few examples of European photography, it appears to be thriving in great variety. Here is an extraordinary print image, skillfully blended from two negatives by a German photographer.

(Courtesy of the photographer)

The traditional rules should probably be divided into two categories: (1) rules that define desirable compositional effects—such as unity, variety, harmony, balance, and so on; and (2) rules that specify methods for *achieving* compositional effects—such as preferred shapes, ideal proportions, permissible placement, and so forth. There's not much reason to quarrel with the first category. We can generally agree that it should be apparent what a picture is about (unity, clarity, harmony); that there should be more than just the bare bones of the idea present (variety); and that the picture should appear more or less comfortable in its format boundaries or frame (balance). These generalities are by no means binding, but they often apply. When you've identified and defined them to suit your own informed taste, you can use them as guides in studying a composition to see "if it works"—and if not, why not.

The rules for achieving these effects, on the other hand, are at least controversial, and perhaps even dangerous. The idea that one physical arrangement of lines or forms or tones is "better" than some other one is unprovable, We can generally agree on rules that define effects . . .

. . . but rules for achieving effects are controversial

Untitled. Ted Tuescher. The search for drama and beauty in the natural landscape is alive and well on the west coast. This is an unusually fine example by a talented young photographer.

(Courtesy of the photographer)

misleading, and restrictive. If the terms *creativity* and *personal expression* have any significance at all, there is no place in art for arbitrary regulations of this sort.

Of course you should be aware of the various visual elements—line, form, texture, tone, color, and so on—and the way in which they can relate to each other—size, direction, juxtaposition, perspective, and so on—because they'll be represented in your compositions whether you like it or not. Merely recognizing the existence of these relationships is a good beginning, but they'll become very important to you if you pursue photography seriously. You'll learn to compose intuitively and effectively, sooner or later, if you study your pictures (and other people's) objectively to see what they *really* look like. Then, if you can decide what you like when you see it, you'll be off to a good start.

One Photographer's Search

Any photographer who works seriously at making fine photographs will eventually develop a style that is both personal and fairly satisfying. Notice the word *fairly* here because it's unlikely that any image you ever make will satisfy you completely. The real joy is in the search for complete expression and the realization that your skill and vision are improving as you work.

Because growth is such a personal thing there's no formula for producing it. You must decide for yourself what kinds of photographs you want to make and what standards you want to set for yourself.

Learn to see, then decide what you like

It's unlikely that any image you make will satisfy you completely

To provide an example of this process, I asked Bill Wylie, a young graduate student photographer, to document his experiences during a summer of intensive photographing. He initially declared an interest in working on an extended portrait of his wife, and on a series of natural landscapes (fig. 2.18). We agreed that this decision was tentative and that he could change his mind at any point if some new interest evolved. We also agreed that there was no imminent deadline; the project would be considered finished when he was happy with it.

During the eight months of the project's duration, we met occasionally to review his work and discuss his progress. I was especially interested in monitoring his attitude toward his work to see how his concepts evolved and what factors influenced his decisions.

This project summary is intended only to illustrate some of the problems that one photographer faced and the decisions he made in solving them. It is not intended to suggest that landscapes are the "best" photographic subject matter, nor that palladium prints are "better" than silver. These were Bill's choices, and they are valid for him. Your choices, if thoughtfully and honestly made, are equally valid for you, because "art" is a personal matter. But there are decisions to be made, and I hope that Bill's experience will help you define your own goals, whatever they may be.

Here are some freely transcribed excerpts from his "project log" and from our discussions:

On why he chose 'straight' photography rather than some manipulated form:

I chose the straight approach because I find the reality of the physical world to be more beautiful and imaginative than anything I could think up. I'm interested in understanding our relationship to Nature; and the unmanipulated image enhances an awareness of the world that we exist in.

On his choice of black-and-white rather than color:

I feel that black and white is more beautiful and more capable of subtlety than color. Although it (B&W) is an abstraction it maintains its associations with the physical world. The images are rich and more permanent than color.

On the choice of landscape:

I photograph natural landscapes because I feel it is important that we reestablish a connection with Nature. The pictures are meant to evoke a sense of reverence toward Nature; and by excluding man-made and social subjects, I'm focusing on what exists in spite of—rather than because of—Man.

On his choice of location:

I decided to photograph Nichols Arboretum for this project because this 120-acre park includes diverse environments such as stands of white pine, spacious meadows, and densely vegetated woods. I like the fact that a mancontrolled environment can remain so beautiful and peaceful. Depending on one's location, the weather, the season, and time of day, it can evoke a variety of feelings.

On his decision to abandon the plan to photograph his wife:

As I worked I realized that by including Kay in the photographs as a 'figure in landscape' I was forcing situations, and the pictures felt contrived. I was trying to do 'something different' rather than paying attention to what exists. My main interest was in the landscape. Your choices are valid for you

Figure 2.19 Bill Wylie initially declared an interest in working on an extended portrait of his wife, Kay, but we agreed that this decision was tentative and could be changed.

(From The Arboretum project by Bill Wylie)

Figure 2.20 "As I worked I realized that by including a "figure in landscape' I was trying to do 'something different' rather than paying attention to what exists."

On his choice of equipment and materials:

After experimenting with Widelux, view cameras, and 35mm formats, I chose medium format because it is portable and uses rollfilm which allows me to take many images. I like the balance and stability of the square format. I tried filters but they detracted from the sense of reality that I sought. I used a slightly wide angle lens to subtly increase the sense of space in the pictures. I chose T-Max 400 film for its speed and fine grain, and Portriga-Rapid paper because its creamy warmth works well with landscapes and portraits, and because it tones well.

On interpreting the subject matter:

I recognize the quality of light as an important influence on perception and wait for conditions that will emphasize the significant visual details, and enhance the mood that I associate with the subject. I maintain sharp focus throughout the picture to contribute to a sense of acute, highly sensual awareness.

On his decision to produce a fine book of the photographs, rather than the gallery display of exhibition prints as originally planned:

I had seen some beautiful hand-made books and realized the potential of that format for my project. I felt that the book format would allow me to fix the image sequence permanently, make a cohesive visual unit and provide the viewer with a more personal and intensive experience—all things that became clear to me as I worked.

On his reason for abandoning silver prints in favor of palladium (figs. 2.23 and 2.24):

I abandoned silver prints because it became obvious to me that they couldn't provide the image quality I wanted. Palladium's delicate print quality added an atmospheric effect to the images. With palladium I could choose the paper I wanted and print right into the paper, which was especially important for a book. I chose palladium instead of platinum because of its warmer tone and lower cost.

Figure 2.21

"After experimenting with Widelux, view cameras, and 35mm formats, I chose medium format. . . ."

Figure 2.22 "I used a slightly wide-angle lens, T-Max 400 film, and Portriga-Rapid paper because its creamy warmth works well with landscapes. I wait for light conditions that will emphasize visual details, and maintain sharp focus to contribute to a sense of acute, highly sensual awareness."

"I abandoned silver prints because it became obvious that they couldn't provide the image quality I wanted. Palladium's delicate print quality added an atmospheric effect to the images."

(From The Arboretum project by Bill Wylie)

Figure 2.24

"With palladium I could choose the paper I wanted and print right into the paper. I chose palladium instead of platinum because of its warmer tone and lower cost."

Qualities of a Good Photograph

"I wanted to create a beautiful object that would be aesthetically appealing in every respect. I'm pleased with the result."

(From The Arboretum project by Bill Wylie)

On his reason for expanding the project concept to include custom-printed marble-paper liners for the book cover, and a tray case to contain the book (fig. 2.25):

I think that every aspect of the work adds to the overall experience. I wanted to create a beautiful object that would be aesthetically appealing in every respect.

On his appraisal of the success of the project:

In retrospect the only thing I would do differently is use a large format camera. That would eliminate the necessity of making larger duplicate negatives and insure better print quality. The most frustrating aspects of this project were solving a staining problem in the palladium prints, and working out the fine details—such as sequencing the photographs and integrating the text and materials. I'm pleased with the result. I think the book is intimate and beautiful and that it successfully evokes an experience of reverence toward nature.

Although Bill embarked on this project voluntarily and chose his own subject matter and method of working, he was not totally free. The fact that a definite goal (completion of the project) had been set and agreed upon was an artificial, external pressure that undoubtedly influenced his performance. This is normal enough in a school situation but quite different from "real life," where (at least ideally) artistic motivation should come from within. In response to the questions, "Do you feel that you were handicapped in any way during this project, and if you were to do this project again under *absolutely ideal* circumstances, what would you do differently?" his response was:

The only handicaps were those I placed on myself. I put pressure on myself to 'produce' something, even when I was unsure what I wanted to do. Under ideal circumstances I would allow myself the freedom to fail—to not produce anything.

Recognizing the importance of the "freedom to fail" is a significant insight—especially when the alternative is "production" simply for its own sake. Unfortunately, especially in the school environment, production is frequently valued more highly than inspiration, and problem solving is often confused with expression.

Finding Your Own Way

Stay alert to photographic possibilities but don't burden yourself with mindless pressure to produce. Sooner or later, if you're a perceptive person with an active interest in life and your environment, you'll feel the urge to express that interest in some tangible form. As a photographer you'll probably respond to those moments of inspiration by making photographs. If you're unusually skillful and your response is especially insightful, you may even make a "great" photograph occasionally; but I suggest that the photographs themselves, *as objects*, are relatively unimportant. The perceptions, the search for understanding, those occasional flashes of insight and inspiration, and the elation that accompanies a satisfactory expression are what art—and perhaps life—are all about.

Figure 2.26

Untitled, from the Cobo Construction series. Carlos Diaz. Diaz finds much of his subject matter in the city of Detroit and its environs. Although many of his photographs comment on urban decay, he is also inspired by the city's rebirth, as illustrated by this handsome study of new construction forms and patterns.

⁽Courtesy of the photographer)

Don't burden yourself with mindless pressure to produce

Bouillabaisse Recipe—Studio Set. David Cornwell. Cornwell's studio complex includes complete kitchen facilities where his staff prepares the food items for elaborate still life photographs of this sort.

(Courtesy of the photographer)

Summary

A photograph is good if it suits its intended purpose. Work that satisfies the artist reflects his or her personal tastes; its success in the marketplace reflects the taste of the consuming public.

Self-motivation usually inspires an artist's best work, but none of us works in total isolation, immune to the opinions of others. Develop your own taste and improve your skills so your work will merit attention. We're often blind to flaws in our own work; criticism can help reveal them. Take criticism objectively and it can help you grow.

Photography is a difficult medium for personal expression because the hand of the artist is well-concealed. Selection, organization, and postmanipulation are our major creative tools. Technically, photography is easy; artistically, it's a formidable challenge.

There's a considerable difference between what the eye and brain perceive and what the camera will record. We "see" what we want to see in our own photographs; viewers see only what the camera has recorded. Photographs can communicate effectively if the subject is presented clearly and simply. Composition is important, too, but there are no firm rules to follow. Symbolism can be effective, but it's made difficult by photography's inherent realism.

Any honest, thoughtful approach to making photographs is valid. One photographer chose to produce palladium prints of the natural landscape and present them in book form.

Photography is more important than photographs are.

Introduction to the Photographic Process

Untitled

Photograph by Michael Regnier. Commercial photographers rarely have complete freedom in the selection and arrangement of their subject matter, and are frequently challenged to make exciting images of mundane objects. In this illustration, made for a paper company, Regnier displays his professional ingenuity and skill by creating a dramatic pattern of light and form using the simplest of subjects.

Light is a form of energy

A negative image reverses the light effect

A latent image must be developed to become visible

Most modern materials employ the halides of silver

Silver images are not stable until they have been fixed

Light-Sensitive Materials

Light is a form of energy. It affects many materials in various ways. Sunlight bleaches dyes, darkens freshly sawn pine, turns plants green, makes some plastic materials disintegrate, and reddens or tans human skin.

Photography takes advantage of this property of light. By shielding part of a sensitive surface and allowing light to act on the uncovered portion, a simple *photogram* can be produced. If the material is bleached by the action of light, as dyes are, the shaded portion of the surface will remain relatively dark and the illuminated area will be lighter in tone. This results in a *directpositive* image, one in which the illuminated area produces a light image tone and the shaded area results in a dark image tone. A *negative* image results when the light effect is reversed, that is, when the illuminated area turns dark in tone and the shaded area remains light-toned. This is the photographic process that sunbathers unwittingly use to print photograms of bikinis on their bare skins.

In these examples the images are formed gradually, but directly, by the action of light alone. An image formed in this way is said to have been *printedout*. Some modern photographic materials can be used to produce printedout images; however, it's more satisfactory to *develop-out* the image by treating the exposed material with a chemical developer solution.

It takes a relatively short exposure to form a developable image, and the image is *latent* (invisible) until the developer makes it appear (fig. 3.1). A developed image is also stronger than a printed-out image; that is, its dark tones are darker and the contrast of the image is higher. Generally, a developed image is also more neutral in color. Printed-out images are usually brownish, pinkish, lavender, or slaty blue, depending on the material with which they have been sensitized.

Virtually all photographic films and papers currently used are coated with emulsions of silver compounds suspended in hardened gelatin. Gelatin has a number of unique properties that make it suitable for this purpose. It is easy to apply to the base material during manufacture. It absorbs the developing solutions quickly and evenly, but is not dissolved. It protects the sensitive silver compounds, improves their image-forming efficiency, and when dry forms a tough, durable, uniform surface.

A great many silver compounds are sensitive to light, but most modern photographic emulsions employ the halogen salts or *halides* of silver. (The halogens are the chemical elements fluorine, chlorine, bromine, and iodine.) Silver chloride, bromide, and iodide are most commonly used, and they are blended in various proportions to produce emulsions of widely diverse characteristics. In general, the *slower* (less sensitive) materials, such as *contact printing papers*, are sensitized with emulsion mixtures rich in silver chloride. *Faster* papers, such as those designed for *projection printing*, are likely to be coated with *chlorobromide* emulsions. Film emulsions contain higher proportions of silver bromide and iodide, as a general rule.

It's a curious fact that chloride emulsions, which are the least sensitive of the developing-out papers, are most satisfactory for printing-out experiments. They form a relatively rich and contrasty printed-out image quickly in strong light. Film emulsions, on the other hand, do not form satisfactory printedout images under any conditions of exposure, although they are thousands of times more sensitive to light than papers are when used in the conventional developing-out process.

Regardless of how they are formed, silver images are not stable until they have been *fixed* by a chemical treatment that dissolves the unused halides from the emulsion. If not removed, these still-sensitive compounds will gradually discolor and darken, degrading the highlights of the image and eventually ruining it. There are a number of chemicals that can dissolve the unused

Figure 3.1 Half-image appearing in developer.

halides without harming the silver image. They are all referred to commonly as *hypo*, in honor of Herschel's discovery of the chemical he mistakenly called 'sodium *hypo*sulphite.'' Actually, it should have been named sodium thiosulfate; perhaps, if Herschel had named it correctly, we'd call the fixing bath ''thio'' now, instead of ''hypo.''

Image Formation

Photogram images are the shadow records of objects placed on or close to the paper surface. Camera images result from light patterns projected onto the sensitive film surface by the lens. Actually, it's possible to form a useful image in a camera without any lens at all; a simple pinhole will do the job (fig. 3.2).

Using a Pinhole

A pinhole forms images by allowing only a single, thin ray of light from each object point to reach the film surface. This is an easy concept to visualize if you consider, for example, photographing the stars in the Big Dipper constellation (fig. 3.3). Stars can be considered to be *point sources* of light because they are so far away that they have no measurable dimension. They are, however, radiating countless rays of light in all directions, so that each star illuminates the entire earth's hemisphere that faces it. If you point a pinhole camera at the Big Dipper, only those light rays that happen to be aimed straight toward the pinhole can pass through to the film. Each star in the constellation can contribute only a single ray of light to the image, and since light travels in straight lines, the star images on the film surface form a miniature duplicate of the constellation.

Because the entering rays must cross each other at the pinhole, the image they form is upside down and backwards. This is easily remedied, however. After the film has been developed, it can be turned right-side up and viewed from the back to display an unreversed image. A simple pinhole can form a useful image

The image is formed upside-down and backwards

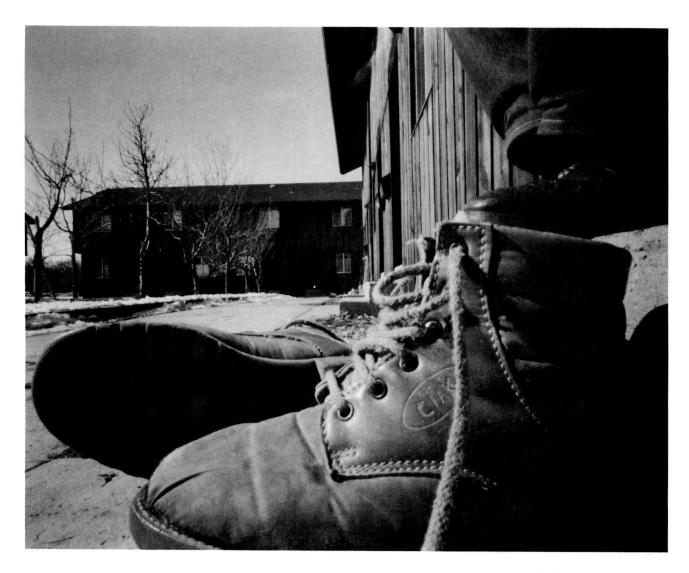

Untitled, 1984. Phil Moody. Moody has made many remarkable pinhole photographs, in both black-and-white and color, using a large camera of his own design. In this typical photograph, he has exploited the unlimited depth of field that the pinhole provides to present an intriguing study of shoes in grossly distorted scale.

(Courtesy of the photographer)

It is impossible to produce a truly sharp pinhole image

As a device for forming images, a pinhole has two major drawbacks: its images are not really very sharp and it works very slowly. Unless the pinhole camera is carefully designed and used under optimum conditions, the image points can never be smaller than the pinhole itself, so the pinhole must be very small if the image is to be usefully clear and adequately defined. In practice, however, the pinhole cannot be extremely small or image sharpness will be reduced by *diffraction*—a kind of turbulence in the light rays, induced by the edges of the aperture, that is somewhat similar to the water spray that results from a faulty hose nozzle. It is impossible, therefore, to produce a truly sharp pinhole image because image quality is degraded if the hole is either too large or too small.

Even the largest useful pinhole is tiny and the amount of light it transmits to the film is correspondingly small. That's why a pinhole camera is not suitable for photographing the Big Dipper. The light from the constellation is extremely dim. After being attenuated by the tiny pinhole, virtually nothing would be left to affect the film.

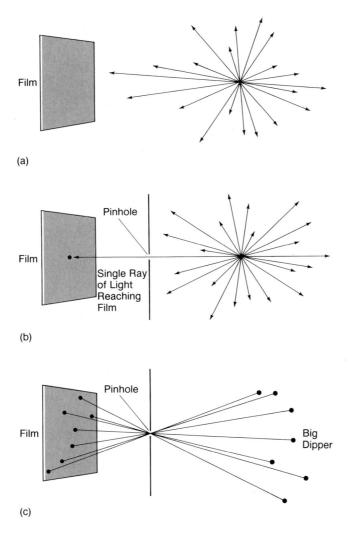

a. If film is exposed directly to light from a single point source, such as a star, the uncontrolled rays affect the entire surface equally and the film is simply fogged without forming a useful image.

b. If the film is shielded from most of the starlight and only a single ray is allowed to strike the film surface, only a tiny area of the film is exposed and an image of the star is formed.

c. Each of the seven stars of the Big Dipper constellation projects a single light ray through the pinhole to the film surface to form an image of the constellation.

Using a Lens

Camera lenses were invented to solve these problems. A good lens can focus light rays to much finer points than can be formed by any pinhole, and because of its much larger aperture, a lens admits a great deal more light, possibly several thousand times more (fig. 3.4).

Consider the Big Dipper again and imagine that you have pointed a regular camera at it. If the effective diameter of the lens opening is one inch, for example, the lens will admit a cylindrical beam of light that is one inch in diameter from each star within its field of view. These cylinders of light do not reach the film directly. The lens converges each one into a cone, and if the camera is properly adjusted, just the tip of each light cone touches the film surface to form the star image. If the camera is not focused properly, the light cones fail to converge precisely on the film surface and the resulting star images are visible as *circles of confusion*, rather than points.

When photographing stars or any other objects that are very far away, the lens is focused on *infinity* and the image light cones all converge neatly on the surface of the film. When the objects are closer than infinity, but at different distances from the camera, the image points are formed at different Lenses form sharper, brighter images than pinholes do

a. A very large pinhole will admit a bundle of rays and form a blurred image area (rather than an image point) on the film. A lens can concentrate these light rays to focus at a point. If the film is positioned accurately at the focus point, it can record a precise image of the star—much brighter than the image formed by a pinhole. b. If the film is not placed precisely at the focal plane, the converging rays will form blurred circles of confusion rather than sharply defined points, and we say the image is out-of-focus.

c. Light rays from very distant objects will focus on a single plane and will all be recorded sharply when the camera is focused at infinity. Objects closer than infinity, however, form images at different points behind the lens. No single adjustment of the camera focus will render them all equally sharp. (a) (a) Film Film

distances from the lens. If the camera is focused on a nearby object, its image will be sharp but distant objects will be imaged as blurred shapes. In this situation a pinhole may be better than a lens. Although no portion of a pinhole image is critically sharp, it does not have to be focused and is, at least, uniformly sharp for objects at all distances. A lens can produce more precisely defined image details for objects at some specific distance, but may not, at the same time, be able to include closer or more distant objects within its *depth of field* (range of acceptable sharpness) (fig. 3.5).

Film and Paper

Some cameras can be hand-loaded with sensitized paper, if you have any reason to do so; however, they all normally use film. In either case, the image formed after exposure and development is negative. For camera use, film is preferable to paper for two reasons: we seldom have use for a negative print on paper, and most films are much faster than papers; therefore, they require much less exposure to form a useful image.

The term *negative*, when used alone, almost invariably refers to a film negative image. Film negatives are generally not useful as finished images, but are intended to be printed on sensitized paper either by contact, which

Most films are faster than most papers

(a)

means that the negative is placed in contact with the paper emulsion and exposed to light, or by projection. A machine called an *enlarger* is used for projection printing, and as the name implies, the projected image is usually, but not always, larger than the negative itself. Most enlargers can also be

this is rarely necessary or desirable. The term *print* usually means a positive image on paper. Strictly speaking, a print is a negative of the negative, which means that the subject tones that were reversed in the film negative are reversed again in the print. A positive image, therefore, resembles the original subject.

adjusted to project images of the same size or smaller than the negative, but

If, for some reason, we need a negative image on paper, we would normally refer to it as a *negative print*. Similarly, if we wanted to produce a positive image on film, we might describe it as a *positive*, a *film positive*, or a *positive transparency* (fig. 3.6). The term *direct positive*, which was mentioned previously, also has a specific meaning. It refers to a positive image that has been produced without having gone through a separate or identifiable negative stage. Xerox prints are good examples of direct positive images. In conventional photography, direct positive materials are rare and specialized.

Figure 3.5

a. The camera lens was focused on the glass frame in the foreground. At maximum aperture the lens renders the foreground sharply but depth of field is shallow and the background greenhouses are badly blurred. b. Although contrast in the shadows is reduced and fine details are blurred, this pinhole image is uniformly sharp from front to rear.

The term print usually refers to a positive image on paper

A positive image resembles the original subject

A negative and the positive transparency that was made from it. The negative is seen here from the back, so the image is correctly oriented. The positive is seen from the emulsion side. If this film positive were mounted in a standard $2'' \times 2''$ slide mount, it would be suitable for projection and we would refer to it as a black-and-white slide.

Summary

In photography, light rays reflected from an object enter the camera through the lens and are focused onto the film surface. This surface is coated with a light-sensitive emulsion of silver halides, which absorb the light to produce a latent or invisible image. The film is then developed into a visible silver image and fixed to remove the unused halides. The developed film, called a negative, is then washed and dried.

The negative is printed either by placing it in direct contact with the paper or by projecting it onto the paper through an enlarger. This forms another latent image, which is also developed and fixed. The result is a positive image that resembles the original object in tonality.

Camera Types and Accessories

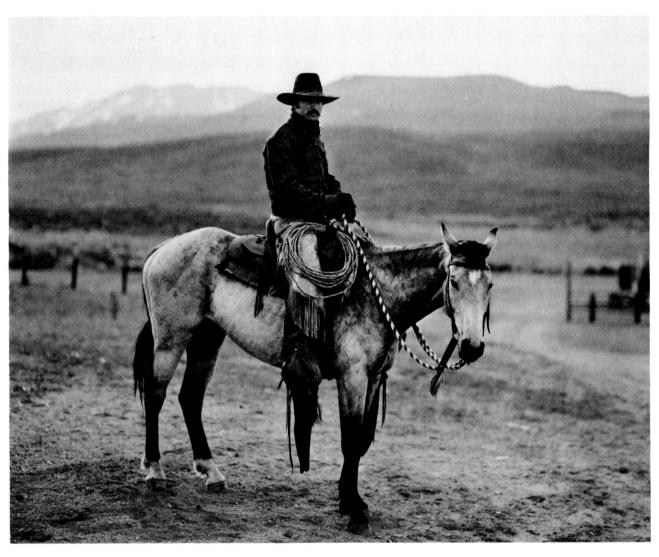

Martin Black, Stampede Ranch, Nevada, 1982

Photograph by Jay Dusard. Large-format cameras are rarely used now for pictures of this sort because of the expense and difficulty involved. The effort is clearly worth making, however, if meticulous rendering of detail and texture and superbly subtle gradation are important to you—as this beautiful image demonstrates.

Regardless of its other features, every useful camera must be a lighttight box equipped with a lens on one side and a film-holding device on the other. A viewfinder, often including some sort of focusing aid, facilitates finding and composing the subject. A shutter mechanism regulates the exposure time and an iris diaphragm controls the intensity of the exposing light.

The most primitive cameras may not include provisions for adjusting focus, lens opening, or shutter speed. At the other extreme some modern cameras provide such a bewildering array of computer-controlled functions that it's difficult to imagine a use for some of them. Before you buy a camera, consider what you'll use it for. Then choose the one that has the features you want, feels best in your hands, is most convenient for you to operate, and provides the best viewfinder image.

Simple Cameras

Just a few years ago "simple cameras" were inexpensive, uncomplicated devices of limited capability. Some still are; but the currently popular "point-andshoot" models—while easy to operate—are highly sophisticated (fig. 4.1). Their distinguishing features are small size, fully automatic control of both focus and exposure, built-in electronic flash, motorized film advance and rewind, and moderate price. A few models feature lenses that can be switched from normal to moderately long focal length at the touch of a button. Although these remarkable little cameras are extremely convenient to carry and use, and are capable of producing photographs of very good quality, they are most suitable for "snapshot" photography under normal conditions. By eliminating the need for manual control these cameras prevent the photographer from modifying the basic camera settings—focus, aperture and shutter speed for creative or expressive purposes. For this reason they're not particularly appropriate for general student use.

Rangefinder Cameras

Although the manufacture of professional-quality rangefinder cameras is limited, many desirable models are available on the used market (fig. 4.2). Because cameras of this sort typically combine a brilliant viewfinder image with accurate rangefinder focusing (fig. 4.3), they are particularly suitable for use in dim light and in situations that require accurate framing of rapidly moving objects. Although these cameras rarely provide any automatic features, they are fast and quiet in operation and accept a variety of interchangeable lenses.

Reflex Cameras

Reflex cameras reflect the viewfinder image onto a ground-glass screen as a two-dimensional image to be looked *at* rather than *through*. This makes framing and composition of the image relatively easy and provides some indication of the *depth of field* (the region of the subject area that is in satisfactorily sharp focus). Although the ground-glass image is sometimes difficult to focus precisely, most reflex cameras combine a *Fresnel* (pronounced fray-nell) lens with the ground-glass screen and provide some sort of *focusing aid*, such as a *microprism grid* or *rangefinder prism*, to make the job easier.

Choose the camera that works best for you

"Point-and-shoot" cameras are ideal for snapshot photography

Rangefinder cameras are easy to focus

Reflex cameras make framing and composition of the image relatively easy

Figure 4.1

Figure 4.2

This "point-and-shoot" camera provides both normal and telephoto lens functions. (Photograph courtesy of Nikon, Inc.)

The microprism grid is typically a small circular array of tiny plastic pyramids set in the center of the viewing screen. The pyramids fracture an outof-focus image causing it to shimmer when the camera is moved slightly. A focused image appears rather coarse-grained but whole, and no shimmer is visible. The rangefinder prism is a similar device, consisting of a pair of shallow plastic wedges laid side by side, pointing in opposite directions. They split the out-of-focus image, displacing its halves along the intersection of the prisms. Focusing brings the image halves into alignment (fig. 4.4). Although these focusing aids work well enough under normal conditions, neither is as accurate as a real rangefinder nor as effective when used with a lens of inappropriate focal length or with any lens at small aperture. wide-angle finder.

Leica M-3 with 21mm lens and accessory

Figure 4.3

When a rangefinder camera is not focused properly, the image will appear something like this. When the double image blends into one—as you can make it do by turning the focusing control—the image is in focus.

Figure 4.4

a. This SLR viewing screen contains a diagonally divided rangefinder prism, surrounded by a circular microprism grid, and a ring of fine-textured ground glass for visual focusing. The rest of the screen area is a Fresnel lens whose concentric line pattern shows in the corners of this detail. The camera is focused on the crest of the snow-covered hill in the middle distance; the building corner is slightly out-of-focus.
b. When the camera is focused for close-up, both the building corner and the hill are out-of-focus.

c. Stopping the lens down renders both focusing aids useless and the ground-glass grain shows strongly.

(a)

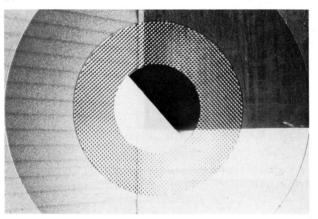

(C)

The TLR has separate viewing and taking lenses

The *twin-lens reflex* (TLR) design features matched "viewing" and "taking" lenses placed close together to minimize framing errors (*parallax*) (fig. 4.5). The upper lens provides a full-size, laterally reversed image on the ground glass. Although they are no longer popular, used TLRs in good condition are still occasionally available. They're typically "medium-format" cameras that make square pictures on size 120 rollfilm. Despite their limitations— reversed finder image, difficult dim light focusing, and (on most models) lack of interchangeable lenses—they are capable of producing fine image quality.

Figure 4.5 Twin-lens reflex.

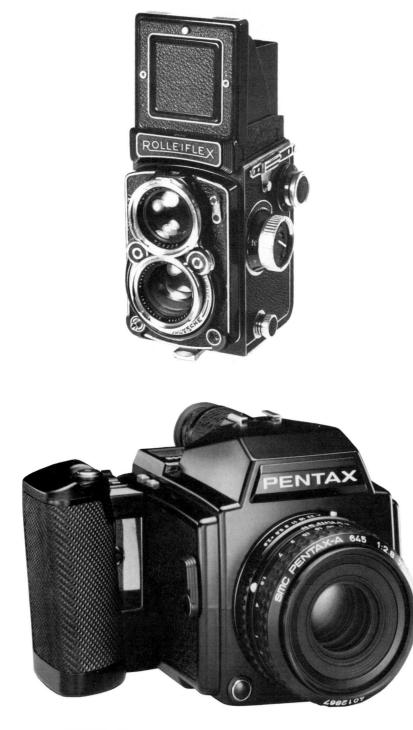

The popular *single-lens reflex* (SLR) design combines the viewing and taking functions in one lens, so there is no parallax error at all and the view-finder image is virtually identical with the image the film will record (fig. 4.6). The angled mirror that reflects the finder image upward to the viewing screen flips up out of the light path when the shutter release is pressed, allowing image light to reach the film plane (fig. 4.7). During the actual interval of film exposure, the viewfinder goes black but the mirror drops back into position to restore the finder image when the shutter closes. This brief image blackout is usually only a minor annoyance but in some cases it can be troublesome.

Figure 4.6 Medium-format single-lens reflex. (Courtesy of the Pentax Corporation)

The SLR combines viewing and taking functions in one lens

Figure 4.7

Cutaway view of the Olympus OM-1, a typical prism reflex 35mm camera. (Courtesy of the Olympus Camera Corporation)

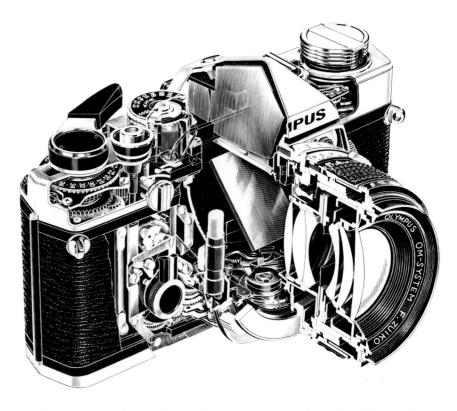

If you wear glasses with certain cameras, you may not be able to get your eye close enough to the viewfinder eyepiece to see the entire image area. Cameras differ in the *eye-relief* characteristic. Try several other models; you may be able to find one that lets you photograph comfortably with your glasses on. If you need glasses but prefer not to wear them when photographing, you may be able to equip your camera's viewfinder with an accessory lens to correct for nearsightedness or farsightedness. Some manufacturers can also supply corrective eyepiece lenses ground to your own prescription.

Virtually all small cameras are equipped with built-in exposure meters that may offer any of four basic modes of exposure control. In *manual mode* the camera meter indicates correct exposure when the lens and shutter settings have been set properly, but leaves the actual adjustment of the controls to you. In other words, the meter tells you what to do but doesn't help you do it.

In *semiautomatic mode* you select either the lens or shutter setting, then the camera adjusts the other for you. In semiautomatic *aperature priority mode*, you set the aperature control and the camera adjusts the shutter speed to maintain correct exposure in any light condition within its range. In semiautomatic *shutter priority mode*, you set the shutter speed and the camera adjusts the aperture as required to maintain correct exposure.

If your camera offers fully automatic *programmed operation*, it determines the proper exposure and sets both the aperture and the shutter speed, choosing the setting from a list of "most appropriate" values stored in its memory (fig. 4.8). Some cameras even consider the lens focal length in making this choice, favoring higher shutter speeds and appropriately larger aperture settings (to minimize image blur from camera movement) when a telephoto lens is mounted on the camera.

Cameras differ in eye-relief characteristics

Cameras with built-in exposure meters may offer any of four basic modes of exposure control

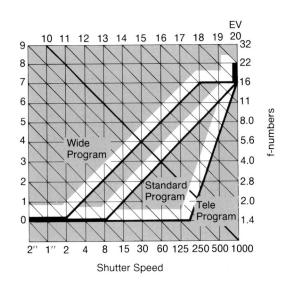

Figure 4.8

Because the danger of camera movement blur increases as the focal length of the lens increases, modern programmed cameras provide different programs for wide-angle, normal, and telephoto lenses. This chart illustrates a program that, for example, provides three settings for EV 10 exposure: 1/30 @ 5.6 for wide-angle lenses: 1/60 @ f/4 for normal lenses: and 1/250 @ f/2 for telephoto lenses.

(Reprinted by permission of Canon U.S.A., Inc.)

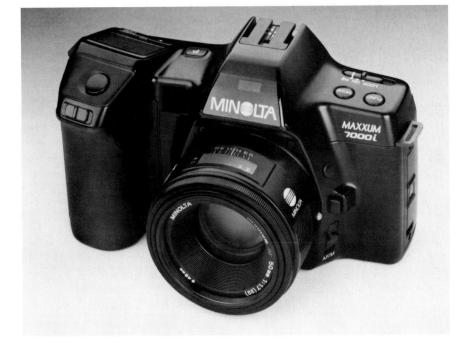

Most 35mm SLRs allow you to choose either manual or semiautomatic operation at the flip of a switch, and quite a few offer the programmed option as well (fig. 4.9). A few cameras allow only programmed operation; and very few—mostly larger format cameras—permit only manual operation.

Shutter Types

Almost all 35mm cameras use one of two types of *focal plane* (FP) shutters. Both types, as the name implies, operate in the camera body just in front of the film plane. *Curtain* FP shutters are made of either thin metal foil or cloth. Two curtains are actually involved (fig. 4.10). In the closed position their edges overlap slightly to cover the film completely. During exposure the curtains separate and travel across the film gate in tandem, allowing light to reach the film. Figure 4.9

One of the popular fully automatic SLRS. This model features a built-in motor drive. (Courtesy of the Minolta Corporation)

Almost all SLRs use curtain or blade shutters

Leaf or blade FP shutters typically consist of several thin overlapping metal leaves that retract behind the margins of the film gate during film exposure, then snap out again to seal the film gate when the exposure is terminated (fig. 4.11).

Focal plane shutters can be synchronized successfully with electronic flash at exposure times of about 1/125th second or longer, because at these relatively low speeds the shutter curtains or blades open fully to expose the entire film area at once. Electronic flash synchronization is impractical at higher speeds that are obtained by narrowing the gap between the shutter curtains or blades so that only a portion of the film is actually uncovered at any given instant. Despite this minor disadvantage, focal plane shutters are popular with camera designers because they permit virtually unlimited interchangeability of lenses and other accessories, and simplify exposure automation.

Figure 4.11 Focal plane blade shutter.

FP shutters are popular with camera designers

Figure 4.12 BTL shutter with blades partly open.

Between-the-lens (BTL) shutters are part of the lens assembly and, as the name implies, operate in a space between the lens elements. The thin metal leaves of the shutter are arranged coaxially with the lens axis and are pivoted so they can swing open to admit light, or snap close to restrict it (fig. 4.12). Small BTL shutters usually provide speeds of up to 1/500th second; larger models may be limited to a maximum speed of about 1/500th second. Because BTL shutters illuminate the film plane completely during the entire exposure interval, they can be synchronized with electronic flash at all speeds. Although a few small cameras are equipped with them, BTL shutters are primarily used with *view* and *field cameras*.

BTL shutters are easiest to synchronize with flash

View and Field Cameras

View and Field cameras are both basically *bellows* enclosures with removable *lensboards* and *spring backs* that accept *sheet film holders*. Both types are designed for mounting on a *tripod* for use, and both must be focused by inspection of the image that's formed, upside down and backwards, on the built-in ground glass. These cameras are large and slow to operate but they can make images of incomparable technical quality. The most popular models use $4'' \times 5''$ sheet film but $5'' \times 7''$ and $8'' \times 10''$ sizes are also common. Larger and smaller formats are available, but relatively rare.

View cameras are generally constructed with rugged metal frames and are designed primarily for studio use (fig. 4.13). They permit a great range of adjustment, accept a wide variety of lenses and accessories, and many are "modular"; that is, their various components are interchangeable. Field cameras are typically more lightly constructed of wood and are designed to be folded compactly for carrying (fig. 4.14). They also accept interchangeable lenses and their adjustment range—although somewhat limited—is more than adequate for any normal purpose.

View and field cameras need tripod support

Figure 4.13 View camera.

Figure 4.14

A deluxe field camera and tripod outfit that is ideally suited for pictorial photography but is versatile enough to cope with almost any photographic problem requiring large-format image quality.

(Field camera courtesy of the Wisner Classic Camera Company; field tripod courtesy of the Ries Camera Company)

The tripod is a useful accessory

Some cables have a locking feature

Most lenses accept a variety of threaded accessories

Some lenses may require series adapters

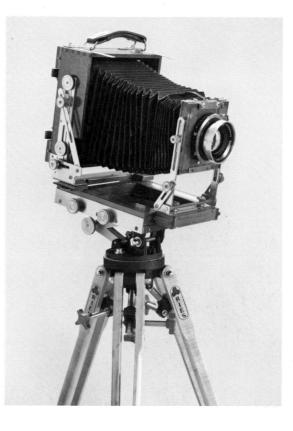

Accessories

There are a few accessories that can sometimes improve the quality of your photographs and make your work easier. A good tripod is one such item. Look for one that will hold your camera steady at least head height, even in a moderate breeze. Some models include an extensible center column, sometimes crank operated, for convenient minor height adjustments—a desirable feature. The leg locking mechanism should operate smoothly and hold the leg sections firmly at any extension, without binding.

A *cable release* is another important accessory. Buy a good quality flexible *cable* that is at least 10 inches long. Some cables can be adjusted to lock the depressed plunger so that timed exposures of any length can be made using the shutter's (B) *Bulb* setting—a feature that's useful for SLRs, which rarely provide a (T) *Time* setting.

Most modern lenses can be fitted with a variety of threaded accessories such as caps, filter, sunshades, and closeup lenses that are designed to be screwed into the front of the lens mount. If you have lenses of several different diameters, you may be able to use one set of accessories. Buy accessories that fit the largest lens you have, then equip your smaller lenses with threaded *step-up-rings*. Most lens accessories are double-threaded so they can be used two or more at a time, or "stacked" for storage. This is a convenient feature but remember that using multiple accessories may cause *vignetting* (pronounced vin-yetting)—shading of the image corners or edges—and may also reduce image sharpness and contrast.

Lenses of nonstandard size can sometimes be fitted with standard accessories by equipping them with *series adapters* that slip over the lens barrel rather than screw into it. Some view camera lenses, especially the larger sizes, are difficult to fit with either screw-in or slip-on rings. It's possible to fit these

lenses with *filter holders* that accept *gelatin filter* squares instead of the circular glass filters that are normally used on small cameras. Actually, many view camera users simply tape the flexible gelatin filters in place over the lens; but this must be done with care to avoid marring the relatively delicate gelatin surface.

When a lens is not actually in use, its surfaces should always be *capped* for protection. You should also use a *lens shade* or *lens hood* when photographing to reduce the effects of *flare* light (fig. 4.15a). Buy a shade that's deep enough to exclude side light but not so deep that it causes vignetting. If you have an SLR or view camera it's easy to check for vignetting: focus the camera at *infinity* and inspect the image corners as you *stop down* to the smallest aperture your lens provides. If the corners darken with the shade in place and lighten when it's removed, the shade is too deep for that lens (fig. 4.15b). Try a shallower one.

Flash Units

If you frequently work in poor light conditions or are interested in some control over light effects you may find an *electronic flash* unit useful. Some flash units are designed to be mounted on the camera's *hot shoe*, which supports the unit and connects it to the camera's electrical circuitry (fig. 4.16). Larger, more powerful units may be attached to a bracket that fastens to the camera's tripod socket. A coiled cord then makes the electrical connection (fig. 4.17).

Most electronic flash units contain photocell sensors and *thyristor* circuitry that automatically control exposure by varying flash duration as the subject distance varies. When used with the camera for which they are designed, *dedicated flash units* automatically adjust the camera shutter speed. Some units also include one or more LED *ready lights* in the viewfinder to indicate when the flash unit is fully charged or to verify proper exposure.

Figure 4.15

a. Lens shade on camera.
b. Vignetted corners will result if you use a too-deep lens shade. In this case a 24mm lens was used with a shade intended for a 35mm lens.

You should certainly have lens caps and a lens shade

You may find an electronic flash unit useful

Dedicated flash units interact with the camera controls

Figure 4.16 Flash unit mounted on the camera hot shoe.

Figure 4.17 Flash unit mounted on bar with cord connector.

Figure 4.18 Winder on a Pentax camera

If you work with flash only occasionally or need more light than a cameramounted electronic flash unit can provide, consider using ordinary *flashbulbs*. Although flashbulbs are relatively expensive, they don't deteriorate in storage, they're compact and easy to transport, they're relatively powerful, and equipment cost is relatively very low. Electronic flash units are expensive to buy but relatively inexpensive to operate, especially when powered by house current. Battery operation can be more costly, particularly if the unit uses *ni-cad* (nickel-cadmium) rechargeable batteries, which lose their ability to hold a charge, and must be replaced, if they are not used frequently.

Electronic flash is certainly convenient to operate, simplifies exposure determination, produces little heat, provides very short exposure times, and is well-suited for use with color films; but flashbulbs are preferable if you need more than a few sources of light or want to illuminate a large area. Consider both options; then, if you decide to buy an electronic flash unit, be sure it's powerful and versatile enough to serve your purposes. The smallest ones are little more than toys.

Motor drives attach to the base of the camera and, by automatically advancing the film and winding and releasing the shutter, permit sequence photography at the rate of about five or more pictures a second. Simpler, less expensive versions, called *winders*, are also capable of automatic operation at the rate of about two frames per second but are primarly useful in situations where advancing the film manually would be inconvenient or impossible (fig. 4.18). Both can be operated remotely by wire—or in some cases by radio—for nature, sports, or scientific photography. The popular "point-and-shoot" cameras now include built-in winders that not only advance the film between exposures, but load it and rewind it automatically. Several SLR models also include built-in motor drives that provide all the features of the accessory units without their bulk and weight.

Before You Buy

Before you buy any camera try to determine the sort of pictures you want to make and your standards of image quality. Small cameras are easy to carry and convenient to use, but enlargements from their small negatives are grainier and less sharp than similar-size prints from larger negatives. Very large cameras, on the other hand, produce superb image quality but are comparatively heavy and bulky to carry, and slow and awkward to use. Electronic flash is well-suited for use with color films

Motor drives permit sequence photography at the rate of about five or more pictures a second

Before you buy, consider your needs

A 35mm SLR is probably the best choice for a beginner

Shop carefully

You can save money by buying good used equipment . . .

. . . but insist on a trial period and a guarantee

One of the popular 35mm SLRs is probably the best choice for a beginner. There are many models to choose from and they are generally less expensive to buy and more convenient to operate than larger rollfilm cameras of similar capability. In addition, there are more types of film and a wider variety of accessories available for them. Despite the fact that larger film sizes of any given type are generally capable of producing sharper, finer-grained images than small films can, the differences, in practice, are not always significant. If you work carefully, you can produce technically fine images with a 35mm SLR.

Prices for new cameras vary widely, but if you shop carefully you may be able to get a satisfactory outfit at a substantial discount from the list price. If you buy from a mail-order house, ask the salesperson for assurance that you'll receive a new (not a store sample), properly imported camera in its original factory carton, and be sure that you can return the camera for a full refund if it is not satisfactory. "Gray market" cameras (which have been imported by unauthorized distributors) sometimes sell at unusually low prices, but they may not be guaranteed and their instructions may not be printed in English. Avoid them if the manufacturer's guarantee is important to you.

If you prefer to buy a used camera, choose a well-known brand and buy from a reputable dealer. Inspect the camera thoroughly, inside and out, for signs of damage or excessive wear. Examine the lens surfaces for scratches, chips, or abrasion marks. Check the shutter at all speeds and the lens diaphragm at all apertures to be sure both work smoothly. Check the meter by comparing several readings with those of another meter, and try focusing the lens at several distances to see whether the viewfinder and focusing aid are comfortable for your eye.

Insist on a trial period and be sure you can return the camera for a full refund if it fails to operate satisfactorily. Then shoot at least two rolls of film under a variety of light and subject conditions, being careful to focus and expose accurately. If the resulting photographs are not completely satisfactory, take the camera and the pictures back to the dealer to discuss the problem and arrive at a settlement. Don't try to make any repairs yourself or have them done by anyone else as long as the equipment is under warranty.

Summary

Even the simplest camera must be a lighttight box equipped with a lens, film holder, and some means of viewing and composing the image. The popular "point-and-shoot" cameras are totally automated and very simple to use. Rangefinder cameras are quiet, convenient to operate, and the finder image is easy to see in dim light. Twin-lens reflex cameras are now fairly rare. Although they are somewhat inflexible in use, they can produce images of fine quality.

Single-lens reflex cameras provide a parallax-free viewfinder image. Focusing aids make manual focusing easy even in quite dim light and some models provide automatic focusing. Most SLRs are equipped with focal plane shutters and accept a wide variety of interchangeable lenses and accessories. They include built-in exposure meters, some of which include sophisticated computerized systems for totally automatic exposure control.

View and field cameras are functionally similar but field cameras are typically smaller and lighter, with fewer, more limited adjustments. Both must be used on a tripod. They are slow to operate but can produce images of incomparable technical quality.

There are many accessories available. You should probably have a tripod, cable release, lens shades, and lens caps. Other desirable items include electronic flash units, motor drives and winders.

The Camera's Controls and Features

Pacific Lumber Co. Mill Pond, Scotia, CA

Photograph by Ellen Land-Weber. The ominous dark of sky and water is emphasized by the glaring white of the logs in this image which is part of Land-Weber's extended photographic portrait of the town of Scotia, California.

(Courtesy of the photographer)

In this chapter you'll find a description of the controls of typical 35mm SLRs and a discussion of their functions and use. There is no information here about the very popular, fully automated "point-and-shoot" cameras. These little cameras are very convenient for casual snapshooting, but because they permit almost no manual adjustment of either exposure or focus, they are not particularly suitable for school use.

If your camera has features that are not mentioned here or if its controls appear to work differently from those described, consult your owner's manual for information about them.

Checking the Batteries

Figure 5.1

Almost all small cameras available today rely on battery power at least to some extent. If the batteries in your camera are more than a year old or if you have any other reason to suspect that they might need attention, this is a good time to check them.

On most older cameras, and many new ones, the battery compartment is located on the *baseplate*. If your camera needs larger batteries to run a built-in motor drive or some auto-focus feature, the battery case may be hidden in the hand grip.

Figure 5.2

Open the case, being careful not to let the battery (or batteries) fall out, and check the installation diagram that may be printed on the inside of the cover to be sure the batteries are correctly oriented. The positive terminal is usually marked with a plus sign (+). When you're sure you know how to replace the batteries correctly, tip them out of the compartment onto a clean cloth or tissue. Don't touch the battery terminals with your bare fingers; moisture or oil from your skin can cause corrosion that will interfere with the flow of electric current.

Figure 5.3

Inspect each battery for signs of leakage. If the joint seals appear to be exuding a white powdery substance, replace the battery. Inspect the contact points in the battery compartment to be sure they're bright and clean. Wipe the battery terminals thoroughly with a clean cloth or tissues; then without touching the contact surfaces, reinstall the batteries, being careful to observe correct polarity. Replace the compartment cover and your camera circuitry should function normally.

The Camera Controls: Focus

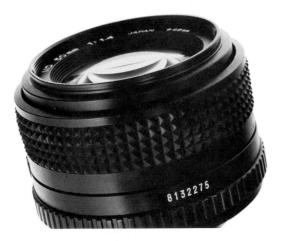

Figure 5.4

On almost all SLRs, *focusing* is accomplished by turning a wide knurled or ribbed ring on the lens barrel. As you turn the ring you'll probably notice that the lens moves in or out of its mount a little way. If you watch the image in the viewfinder as you focus, you'll see that when the lens moves forward—away from the camera body—objects close to the camera become sharply defined. To focus on more distant objects turn the ring so that the lens moves back closer to the camera. Some lenses are focused by adjustment of their internal elements and do not appear to move as the focusing ring is turned.

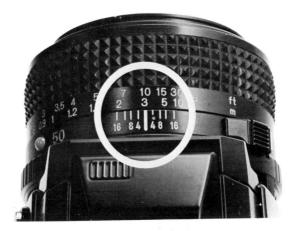

Figure 5.5

There is usually a *footage scale* printed on the top of the lens mount close to the camera body. If you focus on some object 10 feet from the camera, for example, you should see the number 10 on the focusing ring aligned with a fixed index mark on the lens barrel. There may also be a set of numbers printed in a different color, indicating the distance in meters (a meter is about 40 inches). These scales are generally identified at one end by the engraved symbols *ft* and *m*.

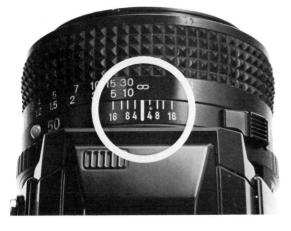

Figure 5.6

Now turn the focusing ring until the lens is fully retracted and you'll see an *infinity symbol* (∞) aligned with the index mark. When the lens is focused at infinity, it's set to take sharp pictures of very distant objects. At this setting the distance from an optical measuring point within the lens to the surface of the film in the camera is called the *focal length*.

Figure 5.7

The focal length of a lens is one of its identifying features and is generally given in millimeters or centimeters (a millimeter is about 1/25 of an inch; a centimeter equals 10 millimeters). You'll find the focal length marked on the outside of the lens barrel near the front or engraved on the retaining ring that holds the front glass element of the lens in place. In this illustration MD is a manufacturer's code, 50mm is the focal length, 1:1.4 identifies the maximum aperture, Japan is the country of manufacture, and 49mm is the diameter of the threaded opening of the lens barrel. Special 49mm *filters*, lens shades, and other accessories can be screwed directly into these threads in the front of the lens.

The relative aperture relates lens diameter to focal length

Apertures are customarily referred to as f-stops or stops

Aperture Calibration

The aperture ratio 1:1.4 tells us that the focal length of the lens (50mm) is 1.4 times greater than the aperture diameter. In other words, the diameter equals the focal length (f) divided by 1.4. This relationship is commonly written as f/1.4. Together the focal length and the maximum aperture of a lens supply a partial description of its capabilities, and we'd refer to the lens in this example as a "fifty-millimeter, f-one-four" lens.

Apertures described this way are called *f-numbers*, and because the aperture size effectively limits light transmission through the lens (stops some of the light from passing), it's also customary to refer to apertures as *stops* or *f-stops*. The term *stop* is also used in other contexts in photography and we'll refer to it frequently in subsequent chapters.

Figure 5.8

The maximum aperture of a lens is usually a very large opening that allows a great deal of light to enter the camera—often more than is necessary. To reduce the intensity of the light that reaches the film, we can *stop down*—that is, reduce the size of the lens opening—by adjusting the *iris diaphragm* with the aperture control ring. Typically this is another knurled or textured ring that is similar to, but generally narrower than, the focusing ring. It is also associated with an index mark on the lens barrel and is calibrated in f-numbers from this standard series:

.... 1, 1.4, 2, 2.8, 4, 5.6, 8, 11, 16, 22

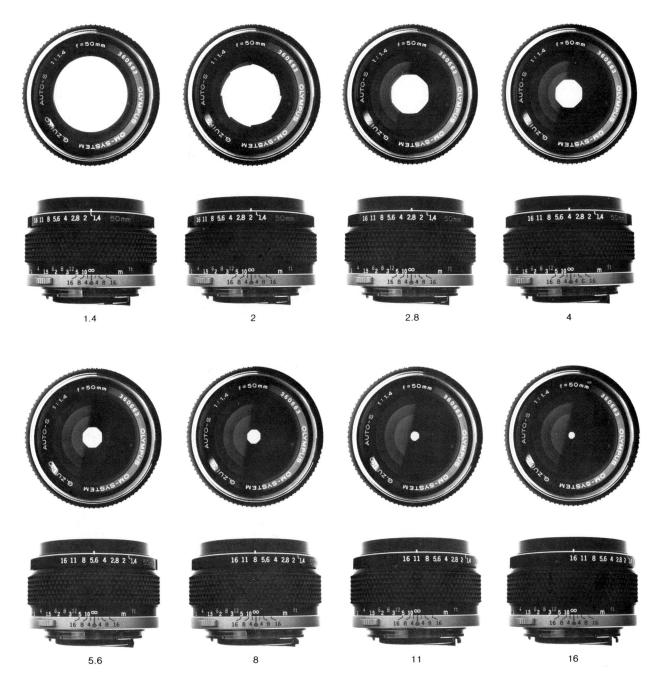

Figure 5.9

Each of these f-numbers, or f-stops, identifies a particular lens opening. Each number, therefore, stands for a specific amount of light transmission through the lens. The series is calculated so that inchanging the aperture setting from one f-stop to the next higher one (from f/2 to f/2.8, for example) will halve the light intensity that reaches the film.

The lens aperture's capacity for light transmission is commonly referred to as its *speed*, so in the example above, we'd say that f/2 is *faster* than f/2.8 (actually twice as fast). Notice that as the f-numbers increase, their speed decreases; thus, for example, f/16 represents a very small opening and is very much *slower* than f/1.4.

Set the aperture control on its fastest speed (largest opening, smallest number), then look into your lens and notice that the diaphragm is fully open. Watch the opening as you turn the aperture control ring to its smallest stop. If your camera is not an SLR, you'll see the diaphragm close as the ring is turned. If the camera is an SLR, the lens will probably remain wide open, regardless of the aperture setting. This is normal; SLR lenses are designed to stay open to maintain the brightest possible viewfinder image until the instant of exposure. Then, as you press the shutter release, the diaphragm automatically stops down to the aperture you've preselected and the shutter opens to make the exposure. As soon as the shutter has closed, the diaphragm snaps open again.

Depth of Field

Figure 5.10

Most SLRs have a *depth-of-field preview* lever or button that will allow you to stop the lens down manually to its preset aperture. If your camera has this feature, set the aperture at f/16 and watch the diaphragm close as you actuate the preview control.

(b)

Figure 5.11

With the aperture still set at f/16, point the camera at some nearby object and examine some out-of-focus area of the viewfinder image as you stop the lens down with the preview control. Notice that the image becomes very dark and hard to see at the smaller aperture but that the out-of-focus area appears sharper.

Experiment a little by focusing on objects at several distances and observing the image at both maximum and smaller apertures. Although the object you've focused on may appear very sharp at all apertures, things in front of the object and beyond it may appear quite *soft* (unsharp) when the lens is wide open. As you preview the image at smaller apertures, notice that both foreground and background details become sharper and that the range of acceptable sharpness increases. We call this range of acceptable sharpness the *depth of field*. We'll have more to say about it later, but at this point all you need to remember is that more of the subject area, from near to far, will be pictured sharply at small apertures than at larger ones. In other words, stopping the lens down increases the depth of field.

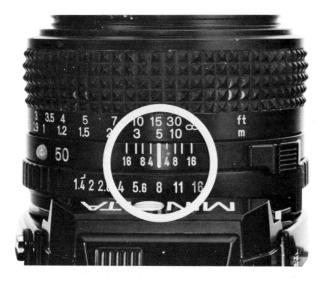

Figure 5.12

Although the viewfinder image shows that depth of field changes as you change the lens opening, it's difficult to determine the actual depth limits, especially when the image darkens at the smaller apertures. You can estimate the effective depth of field more accurately by consulting the depth-offield scale that's associated with the focusing scale index mark on the lens barrel. The numbers that surround the index mark are f-numbers; notice that each number appears twice-once on each side of the index mark. The little (usually red) dot over the number 4, (right center of white circle) is the focusing index mark for infrared film (see Chapter 8).

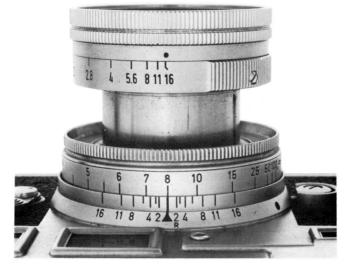

Figure 5.13

The focusing and depth-of-field scales on this old Leica Summicron 50mm f/2 lens are especially legible and well-calibrated. The index mark is aligned with 8 on the footage scale, indicating that the lens is focused at 8 feet. The numbers 2, 4, 8, 11, and 16, flanking the index mark, are actually fnumbers; the missing stops, 2.8, and 5.6 (see the standard series, mentioned earlier) are indicated by short lines.

The scales now reveal that if the lens is stopped down to f/16 the effective depth-offield limits (found on the footage scale opposite the two 16s) are located at approximately 5½ and 15 feet. This means that although the lens is actually focused at 8 feet, everything between 5½ feet and 15 feet will be acceptably sharp in the picture. Similarly you can see that at f/8, for example, the depth of field will extend from only about 6½ feet to about 10½ feet; and that at f/2, the maximum aperture of this lens, only the subject area between about 7½ feet and 8½ feet will be in focus.

The IR focusing index mark on this lens is the small R below the number 2 on the depth-of-field scale.

Shutter Calibration

Exposure results from the combined effects of light intensity and time

Because the aperture affects both depth of field and light transmission through the lens, its choice must sometimes be a compromise. You must provide the film with sufficient exposure to form a good image, and film exposure results from the combined effects of light intensity and time. In practice this means that, for example, if f/8 illuminates the film brightly enough to expose it well in 1/60 second, then f/5.6 (which supplies twice as much light) will require only 1/125 second (half as much time) for proper exposure. Similarly, f/2 will do the job in only 1/1000 second, but f/16 will need 1/15 second. These very brief exposure intervals must obviously be measured quite accurately, and that's what the camera's shutter mechanism is designed to do.

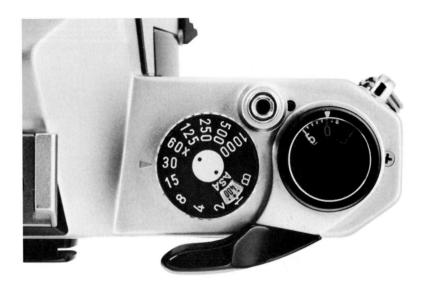

Figure 5.14

On virtually all SLRs and many other small cameras, the shutter speeds (exposure intervals) are set by turning a dial or knob on the top of the camera, usually close beside the film advance lever as shown here. The speed numbers represent fractions of a second, but to save space on the crowded dial they're written as whole numbers. For example, 15 stands for 1/15 second, 2 stands for 1/2 second and 500 stands for 1/500 second. Some shutters can also provide timed speeds of more than one second. On their dials the fractional values may be marked with a small superscript slash (/15 for 1/15, for example) or printed in a different color from the whole-second speeds. These calibrations can be confusing; if your camera offers speeds in this range, be sure you know which ones are which!

The Built-in Meter: Film Speeds

Figure 5.15

If your camera contains a built-in exposure meter—as most now do—it can help you decide (or decide for you) which f-number to match with which shutter speed. First, though, you'll have to "tell" the meter how much exposure the film requires. You can do that by setting the *film speed* number on a dial that is typically located on, or concentric with, the shutter speed knob. The film speed dial is set for a film speed of 125.

Figure 5.16

You don't need to set the film speed manually on some of the more automated cameras; they can "read" the film speed and other pertinent information, such as roll size, directly from this "DX code" pattern printed on the film cartridge.

Figure 5.17

You'll find the film speed that's appropriate for your film listed as an ASA or ISO number printed on the outside of the film box (also sometimes on the inside) or on the instruction sheet that some manufacturers include with the film. See Chapter 8 and Appendix 1 for more information about film speeds.

Figure 5.18

SLR meter designs vary greatly but in most cases you'll have to switch the meter on manually before it will operate. The meter switch—if there is one—is usually on the top of the camera and may be combined with the battery test switch as shown here. Some meters are designed to turn on automatically when you swing the film advance lever away from the camera body, or when you exert slight pressure on the shutter release.

Figure 5.19

If your meter provides more than one operating mode, there'll also be a mode selector switch, possibly incorporated into the meter switch or the shutter speed dial. If you select the programmed mode (probably marked P on multi-mode cameras, but possibly A for automatic on simpler cameras) the camera will select both lens and shutter settings without any help from you. In this illustration the A stands for aperture priority, which means that when you set the aperture manually the camera will choose the appropriate shutter speed to accompany it. In shutter priority mode (sometimes marked S) you choose the shutter speed manually and the camera then selects the appropriate f-number and sets the aperture for you.

Figure 5.20

You'll see some indication of the camera settings in the margins of the viewfinder image. In this simple example the meter pointer is indicating potential underexposure. Manually opening the lens or reducing the shutter speed will move the needle into the central region of correct exposure on the dial, or (if the correction is overdone) into the region of potential overexposure that's marked by the plus (+)sign. More sophisticated cameras usually display the state of the exposure settings with arrays of light-emitting diodes (LEDs) that may illuminate a scale of values, or even print out actual exposure data and other pertinent information.

Preparing to Photograph

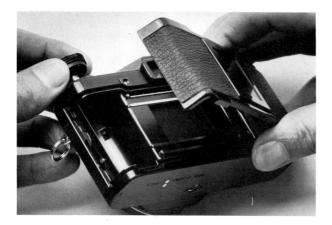

Figure 5.21

a. If you're a beginner I suggest using a medium speed black-and-white film such as KODAK PLUS-X or T-MAX 100 (TMX) or Ilford FP-4, and plan to work in good daylight. If you prefer to work in color, try a *color slide* film such as KODAK EKTACHROME 100. Avoid bright light while loading or unloading your camera. On this typical camera the back latch is released by pulling up on the rewind knob.

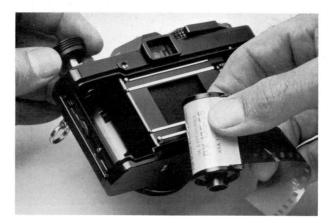

b. Be sure the inside of the camera is clean and dust-free. Insert the film cartridge, then push the rewind knob down to engage the cartridge spool.

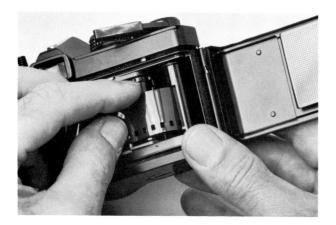

c. Insert the film tongue into the slotted take-up spool and be sure it's fully engaged and straight. Some photographers prefer to do this before inserting the cartridge into the camera.

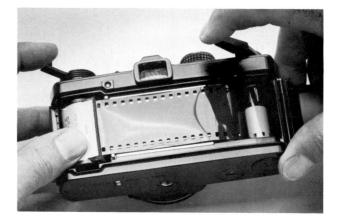

d. Wind the film by working the advance lever and releasing the shutter until both rows of perforations are mated with the teeth of the sprocket wheels. Then take up the slack film in the cartridge gently by turning the rewind knob until the film is under slight tension. Don't overdo this or you may cause *cinch marks*—short horizontal scratches—on the film. Close the camera back and wind off two exposures to get rid of the exposed film *leader*.

e. If your camera cannot read the DX film speed code from the film cartridge, or if you're using a film that is not DX coded, set the film speed manually now before you forget it.

f. If your camera is equipped with a reminder frame of this sort, insert the end flap from the film box in it so you won't forget what kind of film you have in the camera.

g. After exposing all the pictures on a roll of 35mm film, you must rewind the film into its original metal cartridge before it's safe to open the camera in the light. To do this you'll have to release the film sprocket wheel by flipping a lever, turning a knob, or pressing a button on the base plate. Then turn the rewind crank or knob until you feel the film leader (or *tongue*) pull loose from the take-up spool and reenter the cartridge. It's then safe to open the camera and remove the film cartridge.

Your camera is a precision instrument; protect it

Exercise a stored camera every few weeks; better yet, use it

Caring for Your Camera

Your camera is a precision instrument. Protect it from dust, moisture, excessive heat, and physical shock. Carry your camera on a short neckstrap while photographing, and protect it in a padded case while traveling. If you have extra lenses, keep them capped on both ends and carry them in padded cases. Cap your camera lens, too, when it's not in use. To protect the lens from blowing dust or rain while in use, use a *skylight filter* or a clear glass cap. After photographing in wet weather, dry your camera carefully before storing it.

If you aren't going to use your camera for a few weeks or months, remove its batteries, release tension on the shutter, wrap the camera loosely in clean cloth or put it in its case to protect it from dust. Then tuck it away in some clean, reasonably cool, dry place. Don't wrap it in plastic or moisture may condense inside.

It's a good idea to exercise a stored camera every few weeks. Wind and release the shutter at several different speeds, especially the slower ones. Then work the other controls to keep them free and ready for action. If the camera has a built-in flash feature, charge and fire the flash several times to keep its capacitor in good shape. If you've had to install batteries to make the shutter or flash function, remove them before you put the camera away again. Better yet, don't return the camera to storage; take it out and make some photographs!

Figure 5.22

a. Clean the inside of your camera frequently. Blow dust out of the film chamber and off of the mirror with a rubber syringe. *Don't* touch the mirror surface; it is very fragile and easily damaged.

b. Don't clean the lens surfaces unless they are obviously dusty or soiled; then begin by dusting the glass very gently with a soft brush to remove loose particles that might scratch the glass during cleaning.

c. Alternatively, blow off the surface dust with a rubber syringe. *Don't* use "canned air!" Although the manufacturers like to call it "air," it's really Freon, a confirmed environmental hazard.

d. Moisten a clean, crumpled piece of lens tissue or a clean ball of surgical cotton with a drop of lens cleaning fluid . . .

e. . . . and rub the lens gently with a circular motion until the soil is loosened. Then polish the surface dry with a fresh piece of lens tissue, crumpled into a soft wad, or a clean ball of surgical cotton. Be gentle!

Figure 5.23 Untitled.

Summary

It's a good idea to check your camera's batteries occasionally. In simplest terms, all you need to do to work your camera effectively is adjust the controls for proper focus and exposure. You can focus visually or consult the footage scale. Lenses are usually marked with their name, serial number, maximum relative aperture, and focal length. The lens diaphragm controls light transmission through the lens; its aperture scale is calibrated in f-numbers. The aperture setting also affects depth of field. The shutter controls exposure time.

A built-in meter may offer more than one operating mode: manual, aperture priority, shutter priority, or programmed. You must set the film speed number into the meter before it can provide proper exposure settings. Be careful to load your camera properly. Exposed 35mm film must be rewound into its cartridge before it's safe to open the camera in the light.

Protect your camera from dirt, moisture, and physical shock. Keep the lens capped when not in use, and clean the lens only when necessary. Remove the batteries when you store a camera and exercise a stored camera periodically to keep it in operating condition.

Using Your Camera Effectively

M. Miranda—Le Penché

Photograph by Calvin O'Neal/Gold Magi Studios. O'Neal is a professional photographer who specializes in glamour and dance photographs. This beautiful image expresses the elegance and grace of a famous ballerina.

(Courtesy of the photographer)

What equipment you use is less important than how you use it

Don't stifle your intuition; ask yourself, "Why?"

You probably aren't aware that you've learned how not to see

Your camera will record appearances

You'll have to learn to perceive visual relationships

You don't have to own an expensive camera equipped with all the available accessories to make good pictures. In fact, many very fine pictures are made with relatively simple cameras, without any accessories at all. The secret of good photography is not *what* equipment you use, but *how* you use it.

Of course, that oversimplifies the situation a little, because no matter how skillful you are, you'll find that some subjects can't be photographed easily and effectively—if at all—without a particular kind of camera or some specialized equipment. We'll consider some of these special situations in later chapters, but for now, you should become acquainted with some general principles of successful camera use that apply to any subject.

Know Your Purpose

The first principle is so obvious that it hardly seems worth mentioning: you should have some *reason* for making a photograph. Experienced art photographers may dispute this and argue that you should photograph whatever interests you, letting intuition be your only guide. I'll accept that as valid for their purposes, but I can't recommend it as a reliable model for beginners. Although there may be some danger in being too analytical, I think you'll find it helpful—at least at first—to try to identify your motives quite specifically. Don't stifle your intuition—let it lead you as far as it can; but before you press the shutter release, ask yourself ''Why was I attracted to this subject and what do I want this picture to express?'' When you've answered these questions, you've taken the first step toward making a meaningful photograph.

Visualization and Perception

As soon as you've decided *what* you want to do, decide *how* you're going to do it. This will certainly require that you study the subject itself, while trying to visualize the scene as you'd like it to appear in the final picture. If you're a typical beginner in photography, you'll probably find effective visualization much more difficult than it sounds. You probably aren't aware that much of what you think you see isn't really there at all—and much of what is visible you don't notice. The fact is, you've spent most of your life unwittingly learning how *not* to see things.

If you think this is an exaggeration, test yourself. Look at a telephone, for example, to see what color it is. If you think it's black (or red, white, or whatever), you haven't really seen it. Your perception of the phone is a blend of information that's only partly visual; your eyes have merely identified the object and sent the message "telephone" to your brain. Your brain checks your memory file under "telephone" and finds "black," and that ends it. Actually, of course, the telephone is probably many shades of gray, subtly tinted with various colors reflected from its environment; but unless something about the telephone stimulates your interest or arouses your curiosity, you'll probably remain unaware of its appearance even though you continue to "look" at it.

Although the ability to ignore visual stimuli is often a blessing (imagine having to really *see* magazine ads and TV commercials), it's bad preparation for photography. Your camera won't ignore anything you point it at because it's designed to record appearance. Until you learn to see things as the camera does—subduing what you *know* about the subject in favor of what it *appears* to be—your pictures are likely to contain a lot of unpleasant surprises!

"Camera vision" is more than just the ability to see individual objects; you'll have to learn to perceive visual relationships that exist throughout the entire subject area. For example, if you are photographing a building wall from a distance of 20 feet, your normal lens will include all the building details within an area of about 14 feet wide by about 9 feet high. While you may think you

Figure 6.1

Untitled, Berkeley, CA 1983. Gordon Hammer. By supplying a great deal of descriptive information about this bather's environment, Hammer challenges the viewer to create a personal interpretive "portrait" of an otherwise anonymous person.

(Courtesy of the photographer)

can see a much larger area than that, your sharp central vision (the portion you use to examine things closely) covers a spot only a few inches in diameter on the wall surface. If you hope to observe the building as accurately as the camera will, you'll obviously have to spend some time deliberately scanning the subject area, and paying close attention to what you see!

Figure 6.2

Old/New Houses. Henry Gilpin. Gilpin has emphasized a contrast of architectural styles to produce an interesting composition that can also be interpreted as a wry social statement.

(Courtesy of the photographer)

Figure 6.3

lce Shanty (revised) #2. Carlos Diaz. Fascinated by the structural variety of the numerous ice fishing shanties on Michigan's frozen lakes and their quaint identifying patterns, Diaz presents this formal grouping, which invites comparison.

(Courtesy of the photographer)

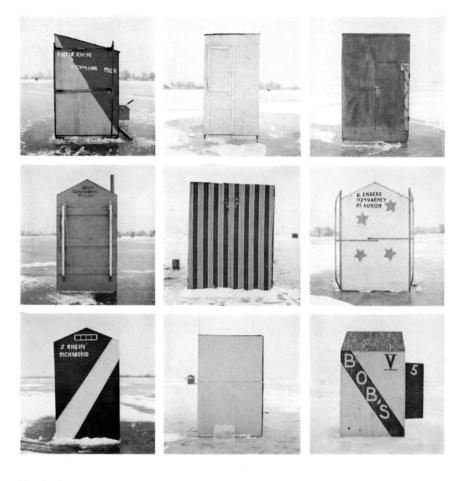

Technique

We've identified *purpose* and *perception* as important prerequisites for successful photography, but there's at least one more: *technical competence*. If you aren't familiar enough with the photographic process to handle it capably, your pictures won't be very effective no matter how purposeful and perceptive you are. Fortunately, technique is easy to learn. If you're willing to study and practice, you can master the mechanics of this medium.

This is a good time to start. Since the process begins with camera handling, let's review the camera controls to see what effects they have on the image and how those effects can be used for creative or expressive purpose.

Controlling the Camera Image: Framing

Your most important concern—after selecting the subject to photograph will be deciding where to position the camera. Several factors must be considered. First, it's important to appraise the light condition that exists in the subject position and select a camera angle that will provide the most desirable effects of highlight and shadow on the subject forms. To keep image contrast from being degraded by *flare*, always use a lens shade—especially when direct light might otherwise strike the lens (see fig. 4.15a).

Technique is important; fortunately it's easy to learn

Appraise the subject light condition . . .

. . . and the foreground/background relationships

(a)

(b)

Examine the viewfinder image carefully as you check the subject from various angles, paying particular attention to the *value* (light/dark) relationships of the subject outlines against their backgrounds. Try to place light subject areas against dark backgrounds and vice versa, so that the most important forms and details are well defined (fig. 6.4b). At the same time, be sure that the subject is displayed from an appropriate and attractive angle. Don't overlook the possibility of high or low viewpoints; subjects that appear cluttered and confusing from eye level sometimes "open up" nicely when viewed from above or below (fig. 6.5).

Most SLR finders display somewhat less of the subject area than will be recorded on film, so you can assume that everything you see in the finder will be included in the final image. Try to compose the subject tightly within the boundaries of the viewfinder's image area. Fill the entire frame!

It's obvious, of course, that moving close to the subject will enlarge the image details but reduce the subject area that's included. It may be less obvious that moving the camera toward or away from the subject will also affect perspective, and alter the relationship between subject and background. The final camera position, then, must be a compromise between good light effect, attractive arrangement of subject forms, harmonious relationship between subject and background, and tightly organized composition in the image frame.

Figure 6.4

a. If you want to reduce the visual impact of some object in your photograph, place it against a matching background—a camouflage technique that is both effective and useful. Here "Granny-doll's" light dress and dark apron blend into their backgrounds, making her relatively inconspicuous.

b. When the background tones are reversed, Granny's light-toned face and dress show clearly against the dark fabric, and the dark shape of her apron is obvious against its light background. Notice that the visual textures of subject and background are still quite similar. Granny would be even more conspicuous if either her clothes or the background fabrics were plain.

Fill the frame!

Figure 6.5

a. Although this low viewpoint describes the situation well enough, separation between some of the figures and the pictures on the wall is poor, and the image appears cluttered. These visual relationships change constantly as the subjects move. Wait and watch for the right moment and you may be able to make a fine photograph.

Preview

If you're using an SLR, don't forget that the lens is working at maximum aperture to form the viewfinder image. This means that the depth of field you can see in the finder may be extended significantly when the lens stops down to make the exposure. Make it a point to preview the image at the preselected aperture (if your camera permits it) to be sure that the depth of field will include the subject satisfactorily and to see whether background details, which will be rendered more sharply by the reduced aperture, are still sufficiently subdued (fig. 6.6a,b).

(a)

(b)

As you experiment you'll discover that when you're close to the subject, the depth of field at any given aperture is relatively shallow and the background details are relatively soft. Moving farther back from the subject (and refocusing to keep the subject sharp, of course) increases the depth of field and makes background details relatively sharper at any given aperture (fig. 6.7).

If you check your camera's depth-of-field scale, you'll discover that you can adjust the camera for maximum depth of field without consulting the viewfinder image at all. For example, if you preset the aperture at f/16 and turn the focusing ring until the infinity mark is aligned with the number 16 on the depth-of-field scale, the camera is set to record everything from about 8½ feet to infinity (on a typical normal lens). At this setting, the lens is actually focused most sharply at about 17 feet—as indicated by the central index mark on the scale (fig. 6.8). That distance is called the *hyperfocal distance*, and setting the camera this way is known as *hyperfocal focusing*.

Hyperfocal focusing provides the most efficient use of the available depth of field because the far limit of acceptable image sharpness always reaches infinity. At the same time, the distance from the camera to the near limit is— by definition—just half of the hyperfocal distance.

In figure 6.8, the lens was set on its smallest aperture to achieve the greatest possible depth of field, but you can use this focusing technique at any aperture. Just be sure to align the f-number you're using (on the depth-of-field scale) with the infinity mark. For example, in figure 6.9 the lens is adjusted for hyperfocal focus at f/5.6. In this case, the near plane of the depth of field is about 23 feet from the camera and the hyperfocal distance is about 46 feet. As you can see, the hyperfocal distance is different for each f-number.

Figure 6.6

a. SLRs are normally focused with the lens wide open so that the image is as bright and the depth of field as shallow as they can be. In this case the subject appeared to be sharply defined against her out-of-focus background, so the picture was made at maximum aperture to record the image as it was seen in the finder. Unfortunately, the depth of field is too shallow to record the cup, the model's arm, and the earring as sharply as desired.

b. Here the preview control was used to allow inspection of the image at various apertures. The chosen aperture—two stops down from maximum—sharpens the foreground perceptibly while leaving the background soft enough to remain relatively unobtrusive.

For maximum depth of field, use hyperfocal focusing

(a)

Figure 6.7

a. At this close range, with the lens set at a medium aperture, the depth of field is barely sufficient to cover the flower centerpiece. Both foreground and background details are obviously out-of-focus.

b. Here the same lens was used at the same aperture but the subject distance was doubled. The apparent depth of field is much greater, but image details are only half as large and the photograph includes a much larger area of the subject.

c. Here the center area of the second negative is enlarged to match the scale of the first. Notice that the greater subject distance provides greater depth of field, even when lens focal length and relative aperture are identical and the images are printed at similar size. Also notice the difference in image perspective.

(b)

Chapter 6

Figure 6.8

This lens is set for hyperfocal focus at f/16. The hyperfocal distance, 16 feet, is indicated opposite the focusing index mark, and the depth of field extends from 8 feet (half the hyperfocal distance) to infinity.

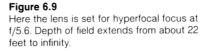

There's a related technique called *zone focusing* that's very useful when you expect some object to appear, or some action to occur, within a predictable distance range. For example, if you want to be prepared for action between 10 and 25 feet from the camera, you can turn the focusing ring until 10 and 25 are equally spaced on either side of the scale index mark (fig. 6.10). Then use the aperture that's indicated closest to the numbers—in this case, f/8.

The appearance of the image may be affected by your choice of shutter speed, too (fig. 6.11). If you choose a very slow shutter speed, either subject or camera movement may blur the image. You can do this deliberately for visual effect, of course. If you swing the camera to follow a moving object during the exposure (a technique called *panning*), you can often isolate the subject against a totally blurred background for very interesting visual effects. Be sure to keep the camera pointed at the subject as long as the shutter is open. This is difficult with an SLR because the finder image disappears during the exposure; but if you start panning before pressing the shutter release and continue to swing the camera during the blackout, you can frequently track the subject accurately enough to get good results. If you have a rangefinder camera, your view of the subject won't be interrupted and you'll find panning quite easy.

In ordinary work, subject movement is most likely to cause blur if the subject is (a) close to the camera, (b) moving rapidly, and (c) moving *across* the camera's line of sight (blurring is less likely if the subject is moving toward or away from the camera). For average picture-taking at normal distances, shutter speeds of 1/125, or higher, should stop ordinary subject movement satisfactorily.

Problems of both subject and camera movement are especially serious when you're using long-focus lenses because the movement is magnified just as the image is. As a general rule, if you want sharp pictures, don't try to handhold the camera at shutter speeds that are less than the reciprocal of the lens focal length in millimeters, even if the subject is stationary. For example, if you're using a 200mm telephoto lens, it's probably prudent to set the shutter speed dial on 250 (1/250 second) or higher. If you're using a 28mm Zone focusing is a useful technique

Motion blur can be visually effective

Long lenses emphasize motion blur

Figure 6.10

You can preset your camera to provide some specific depth of field. This lens is zone-focused to cover the range from 10 to 25 feet at f/8.

Figure 6.11

"Panning"—swinging the camera to follow a moving object at a slow shutter setting—is an effective way to suggest speed and reduce background clutter. A 1-second exposure time produced this photograph.

wide-angle lens, you can probably use 1/30 second safely. You should be able to handhold your normal lens (50mm focal length, typically, for a 35mm camera) at speeds as slow as 1/60 second, if you're reasonably careful to hold the camera still, and squeeze—not poke—the shutter release.

Calculating Exposure

As you can see, choosing the appropriate aperture and shutter speed settings requires some thought. Depth of field and subject motion will certainly have to be considered, although in many cases they may not influence your choice significantly. Film exposure, on the other hand, is *always* important. If the film is seriously under- or overexposed, your negative won't be printable—so it won't make any difference whether or not depth of field and motion have been taken care of satisfactorily!

Film exposure is always an important consideration

Four things influence film exposure directly: (1) the sensitivity or speed of the film, (2) the intensity of the light available in the subject area, (3) the amount of light permitted to enter the lens, and (4) the duration of the exposure interval.

In a simple analogy, exposing film is like filling a cup with water. The size of the cup relates to film speed—a small cup requires only a little water and can be compared with fast film that requires only a small quantity of light to form a satisfactory image. This concept—light quantity—is an important one to remember.

The water supply pressure is related to the intensity of the subject light. Assuming that the water pressure is adequate, you can fill a cup by opening the faucet wide for a brief interval or by allowing the water to drip slowly into the cup for a long while. Similarly, you can provide the film with the quantity of light it needs (if there's enough available) either by opening the aperture wide for a brief time or by stopping the lens down for a relatively long time.

In practice, film speed is indicated by the film's ASA or ISO number (see Chapter 7). If your camera is capable of "reading" the ISO speed code that is printed on most 35mm film cartridges, it will adjust itself for the proper speed setting as soon as you load the film. If you're using a film cartridge that isn't coded or if your camera can't "read" the code, you'll have to set the film speed into the meter dial (see fig. 5.15). Then you can use the meter to measure the average value of subject light intensity; and it will signal proper exposure when the aperture and shutter speed controls have been adjusted correctly.

Semiautomatic Exposure Control

In the previous example, we've assumed that you'll set both the f-stop and the shutter speed manually, using your meter simply to indicate when the exposure is correct. In many instances, however, you'll find it convenient to select the most important setting—either aperture or speed—and let the camera maintain correct exposure in one of its semiautomatic modes. This form of operation is especially desirable when the light condition of the subject is varying unpredictably, because it leaves you free to concentrate on the viewfinder image, ready to react instantly to subject action without worrying about over- or underexposing the film as the light changes.

As mentioned previously, there are two modes of semiautomatic operation: aperture priority and shutter priority. Aperture priority is ideal when you feel that controlling the depth of field is of utmost importance and conditions are such that the shutter speed settings are likely to remain within a safe

Figure 6.12

Cave Run Lake, Morehead, KY. David Bartlett. By portraying a placid seascape in misty soft focus and featuring the suspended spider's crisp silhouette, Bartlett has created a startling and disturbing image.

(Courtesy of the photographer)

Semiautomatic operation is often desirable

When depth of field is critical, use aperture priority

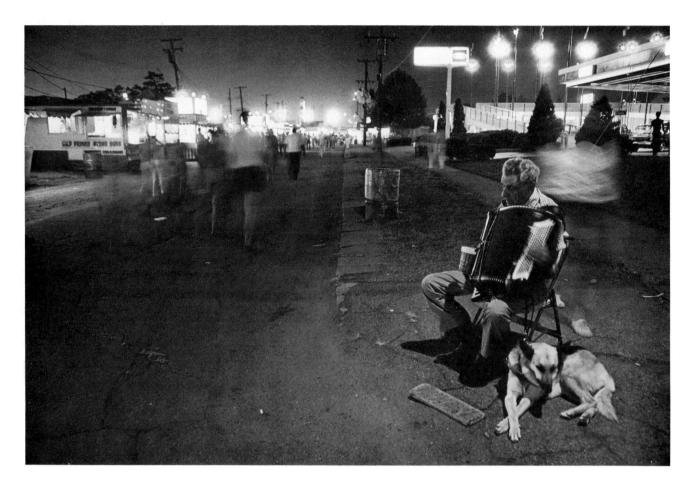

Figure 6.13

Untitled, 1984. Robert Kangas. Kangas views his environment with ironic interest, which occasionally approaches amazement. Many of his photographs contrast sharply focused details with blurred or diffused elements. In this instance he has employed motion blur to comment on public attitudes toward the handicapped.

(Courtesy of the photographer)

Programmed operation sets both aperture and speed

range. Use this mode also when you are planning some out-of-focus effect for visual or expressive purpose; it will insure that you'll get on film the same degree of image softness that you've previewed in the finder.

Use the shutter priority mode when control of subject or camera motion is your primary concern. There are two obvious applications: you can choose a high shutter speed to stop some rapidly moving object (plate 18) or select a relatively slow speed for a deliberate effect of blurred subject motion (fig. 6.13).

Programmed Exposure Control

Fully automatic (programmed) operation is convenient when you aren't particularly concerned with specific control of depth or motion, and prefer not to be bothered with technical details. In programmed operation, the camera selects both aperture and shutter settings as required to provide correct exposure over a very wide range of light conditions. Not all programmed systems are alike, but typically they will choose small apertures and high shutter speeds in bright light, modifying both as the light dims until the shutter speed approaches a dangerously slow speed for handheld operation—perhaps 1/30 second or so. Then the shutter setting is held constant and only the aperture setting is changed as the light level decreases. When the lens has reached its maximum aperture, the camera displays some signal to warn that tripod support is advisable and proceeds to lengthen the shutter speeds until the program reaches the end of its range.

For most work, I believe semiautomatic operation is most practical. It combines a desirable degree of control over image characteristics with the advantages of operating speed and convenience. Programmed operation is

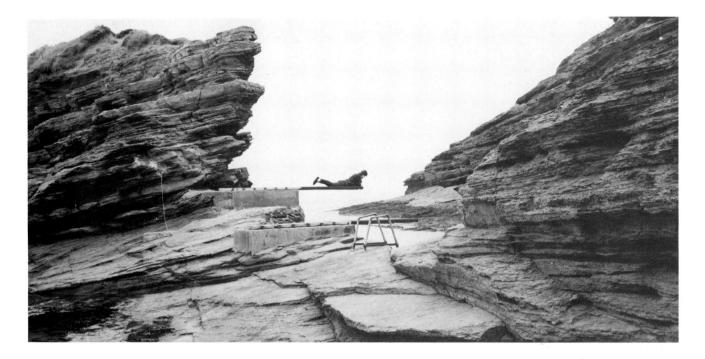

fine for shooting casual snapshots and is extremely valuable for remote operation, such as wildlife photography or scientific documentation in hazardous or physically inaccessible environments.

Every camera should also provide manual operation (although not all do) for situations that require adjustments beyond the camera's automatic range and for that dreaded moment when batteries expire. Learn to use all the operating modes that your camera provides. They're there to make your work easier.

Unusual Subject Conditions

When you've set the appropriate ISO number into your camera's film speed dial, its built-in meter can measure the subject light and indicate (or actually set) lens and shutter settings that will expose the film properly. In most cases, you can depend on the meter to do its job well, but you'll have to modify its recommendations occasionally to compensate for some unusual light condition or to produce some unusual effect of image tonality. It will be easier for you to understand why this is necessary when you know how the meter works.

Built-in meter designs vary widely, but they all measure subject *lumi-nance*—that is, the light that's directed toward the lens from the various subject surfaces. If the subject were simply a flat panel of uniform tone, the luminance value of all areas of its surface would be the same and exposure determination would be easy. Unfortunately, real subjects usually contain a great many areas of different size and shape, often ranging in value from black to white with a great variety of intermediate grays. If the meter could read very small areas of the subject surface (as handheld *spotmeters* can), it would suggest a variety of exposure settings for that subject and you might have some difficulty deciding which one to use.

To avoid that problem, meters are designed to *average* the various subject luminance values to arrive at a single exposure recommendation, which is presumably correct for the average value yet close enough to be usable for the extremes. Because the average of all subject luminance values is typically a middle value (sometimes referred to as "middle gray"), that's the value that meters are designed to expose accurately. In other words, the meter's

Figure 6.14

Boy on Diving Board, 1986. G. Michelle Van Parys. $9'' \times 18''$ silver print. This handsome, graphically appealing treatment of a simple situation is curiously provocative.

(Courtesy of the photographer)

Learn to use all the operating modes your camera offers

You'll have to modify your meter's recommendations occasionally

Built-in meters measure subject luminance values . . .

(a)

Figure 6.15

a. If you don't override your meter to increase the exposure when photographing a white subject, such as this computer drawing, the meter will assume that it's reading a gray subject in very bright light and underexpose, with this result.
b. Here the override control was set at +2. The two-stop "overexposure" was sufficient to record the white drawing paper in a more appropriate value.

In some cases the meter may mislead you

(b)

recommended lens and shutter settings will provide sufficient exposure to reproduce middle gray areas of the subject as recognizable middle gray areas in the print image. At the same time lighter values in the subject will overexpose the film locally and produce light areas in the print; while dark subject areas will underexpose the film to form dark image areas—which is exactly what should happen.

Of course, the meter doesn't know anything about the subject or what you want to accomplish. It is programmed to translate the luminance value that it is reading into middle gray, and it will try to do that regardless of subject or light conditions.

This can lead to rather serious exposure errors in some instances. For example, if you're trying to photograph a delicate pen drawing on white paper, the average luminance value will be essentially the same as the luminance of the white paper itself. But the meter will assume that you've pointed it at a gray subject in very bright light, and will underexpose sufficiently to make the paper gray in the print (fig. 6.15a,b). Similarly, if you follow the meter's recommendations while photographing something like the proverbial black cat in the coal pile, it will interpret the black subject as a gray subject in poor light and provide sufficient exposure to "correct" it. In cases such as these, the print image will be a poor representation of the subject and will probably be unsatisfactory (fig. 6.16a,b).

SLR meters don't read the subject areas directly; instead, they scan the image formed by the lens inside the camera. In many designs, the meter cells read light from the viewfinder screen. In others, the sensitive cell may read a portion of the image light that's directed to it by a tiny mirror. In some cases, the cell(s) may read image light reflected from a printed pattern on the shutter curtain or actually from the surface of the film itself during the exposure interval.

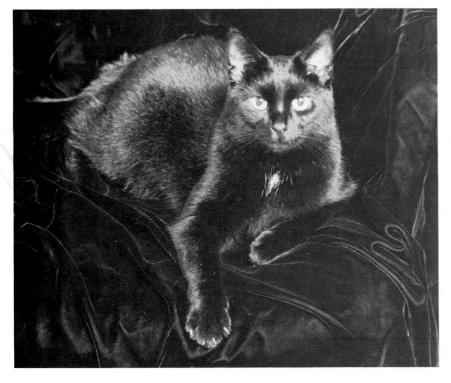

Figure 6.16 a. The meter "saw" this black cat on black a. The meter saw this black call of black velvet as a gray subject in very poor light, and "overexposed" to compensate.
b. Setting the override control on -2 adjusts the camera to photograph the cat more realistically.

(b)

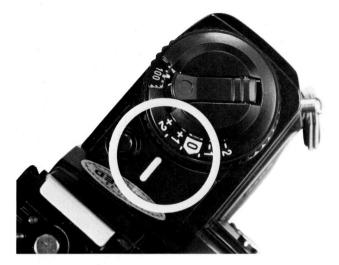

In early designs, SLR meters attempted to average light from the entire image area. Before long it became apparent that these full-field averaging meters were paying too much attention to the corners and edges of the image format. Most of us tend to center important image details and we naturally expect the meter to concentrate on them. This led to center-weighted metering systems, then to bottom weighted, semi-spot, and other designs. All were attempts to improve the accuracy and usefulness of the meter's readings.

Most meters are now more or less center-weighted, which means that they are affected most strongly by the luminance values near the lower center of the image area. Sensitivity typically diminishes quite rapidly toward the margins of the image field. For example, a single candle in a darkened room will have very little effect on the film exposure if it's placed in a corner of the image format, but will be a significant influence if it's centered within the frame.

Check your camera owner's manual to see what sensitivity pattern your meter has and keep it in mind as you view your subjects. If the subject values within the weighted area are obviously lighter or darker than middle gray, it's likely that the meter will give you faulty exposure information. You don't have to accept that; you can always *override* the meter.

If your camera has an override control (check your manual to see), exposure correction is relatively simple—when you decide what you want to do (fig. 6.17). Remember that the meter will always attempt to make things middle gray. Therefore, if you're photographing a light-toned object *that fills the weighted area of the finder* and if you want it to be pictured realistically in the print, you must deliberately *increase* the meter's recommended exposure. To preserve the appearance of a very light gray subject, turn the override control to +1 (to increase the exposure by one stop, which doubles it); turn the control to +2 (a two-stop or four-times increase) if the subject is brilliant white. Conversely, to prevent a dark-toned subject that occupies most of the image area from being unnaturally lightened in the print, turn the override control to -1 (a one-stop reduction halves the exposure); if the subject is black, turn the override control to -2 (to reduce it two stops—for one-fourth the recommended exposure). If your override control isn't marked (it may just be a button to push), consult your manual for instructions.

Remember, the meter is not likely to be fooled—and won't have to be overridden—unless most of its weighted area is occupied by abnormally light or dark subject material. Experience will tell you when to override the meter and how much correction to apply.

Most SLR meters are more or less "centerweighted"

You can always override your meter . . .

. . . but it's not usually necessary

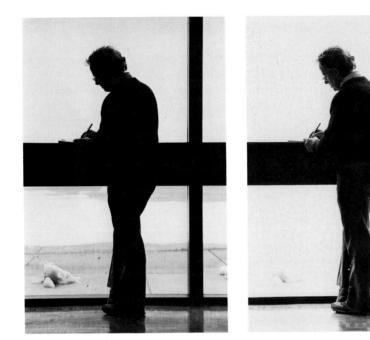

Figure 6.18

a. The average brightness of this subject area is very high. The meter is fooled by the intense backlight and underexposes, picturing the figure in silhouette.
b. A +2 setting of the override control burns out the background details, but provides some shadow detail on the figure.

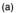

(b)

If your camera doesn't have an override control, you can still make the desired compensation in manual mode. To increase the exposure by one stop (double it), turn the aperture control from one f-number to the next *lower* one—from f/11 to f/8, for example. Similarly, turn the aperture control from f/11 to f/5.6 for a two-stop or four-times ($4 \times$) increase. Turn the control the other way (stop-down) to reduce the exposure.

If you prefer, you can adjust the exposure by changing the shutter speed instead of the aperture setting. In this case the exposure ratios are a little more obvious—if you remember that the shutter speed numbers are really fractions! Thus, going from 15 (1/15) to 60 (1/60) is equivalent to a two-stop or $4 \times$ *decrease*, while changing from 8 (1/8) to 4 (1/4) increases the exposure one stop, which doubles it.

There's one more way to override the meter's recommendation: you can trick it into believing the film is actually faster or slower than it really is, by changing the ISO setting. For example, if you're using ISO 125 film, you can double the exposure (increase it by one stop) by resetting the ISO dial to 64. Similarly, changing the setting from 125 to 500 will reduce the effective exposure by two stops, or $4 \times$.

You'll see how important the override control can be if you try to photograph a *back-lighted* subject. In extreme cases, for example, when the subject is small and dark, and the light is shining directly into the camera lens, the meter will be completely fooled by the light intensity and underexpose drastically. This will almost certainly display the subject in silhouette, devoid of detail (fig. 6.18a,b). Compensate as described above by deliberately overexposing as much as necessary (you'll have to judge this by experience) to achieve the visual effect you want.

Finally, for ordinary handheld shooting, find a way to grip your camera that's comfortable and that allows you to work the essential controls conveniently (fig. 6.19). When you must shoot at speeds too slow to be handheld safely, avoid camera movement by bracing the camera firmly or supporting it on a tripod; then (if your camera permits it) lock the mirror up to avoid vibration from "mirror slap," and use a cable release to make the exposure. Note: Very long exposure times (1 second or more) will require some compensation for *reciprocity failure*. See Chapter 18 and Appendix 7 for more information.

Figure 6.19

This is good form for shooting with a small camera. The right hand holds the camera body, releases the shutter, and winds the film. The left hand supports the camera and operates the focusing and aperture controls.

Backlighted subjects may fool the meter completely

Experience will tell you when and how much to compensate

Figure 6.20

Julie and the Judge, from the Seagram Bicentennial Courthouse Project, 1976. Ellen Land-Weber. One of several photographers chosen to document American courthouses. Land-Weber has transformed what could have been a very plain and ordinary "design" photograph into a whimsical and charming double portrait.

(Courtesy of the photographer)

Summary

You can make good photographs with almost any camera if you have some reason to make them, are perceptive in appraising the subject and visualizing the image, and are technically competent. Choose your viewpoint carefully and preview the image at your selected aperture. Use hyperfocal focusing for maximum depth of field that extends to infinity. For predetermined depth of field at closer range, use zone focusing.

Subject or camera movement is not likely to be a problem when you're shooting in bright light, but sometimes you can use movement blur for visual or expressive effect.

Semiautomatic exposure control is convenient and effective for most work. Use aperture priority mode for control of depth of field; use shutter priority mode for control of motion effects. Programmed operation is useful for casual shooting, and for some scientific work.

Built-in meters read averaged values of subject luminance and are typically more or less center-weighted. Meters tend to expose accurately for middle gray. If the subject is predominantly lighter or darker than middle gray, you may have to override the meter manually. Experience will tell you when and how much to override the meter.

Light and Lens Characteristics

Swimmers, 1967 You'll find a long lens useful when you can't approach the subject closely. This photograph was made with a 200mm lens, on Kodak type 2475 recording film, from a distance of about 110 feet.

(Courtesy of the University of Michigan Press)

a. Candle emitting photons.

b. Candle emitting light waves

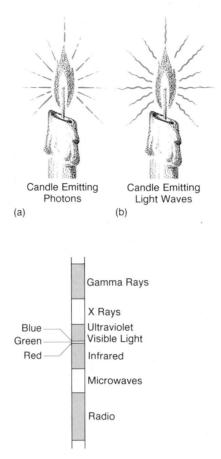

In photography, light is our basic raw material and lenses are our principal tools. Although it's possible to take photographs without knowing anything at all about either light or lenses, a working knowledge of their characteristics will make you a more efficient, more versatile photographer.

There's no single, simple way to explain light. Its photochemical effects (dye bleaching, image formation on film, and so on) are best explained by the theory that a luminous body emits packets of energy called *photons* that are capable of doing work on sensitive surfaces. Optical effects (color, lens action, and so on) are easier to explain if light is considered to travel through space in somewhat the same way that ripples travel across a pond—in waves (fig. 7.1). However, instead of vibrating only up and down as ripples do, light and other electromagnetic waves are thought to vibrate in all directions perpendicular to their direction of travel.

Water waves can vary in size from the mammoth Pacific ground swells a hundred feet or more from crest to crest—to tiny ripples less than an inch long. By comparison, the electromagnetic spectrum contains radio waves that can be measured in miles and, on the other extreme, high-energy waves so incomprehensibly tiny that they must be measured in millionths and billionths of a millimeter.

The visible portion of the electromagnetic spectrum—which we call light is a relatively minute band of colors, ranging from deep red with a wavelength of about 700 *nanometers* (one nanometer equals one millionth of a millimeter), to deep violet, whose wavelength is about 400 nm (fig. 7.2). Above this 400 nm boundary lies the region of *ultraviolet* (UV) radiation; below 700 nm is an

There's no simple way to explain light

The portion of the spectrum that we call "light" is minute

Plate 18

Snowmobile. John Welzenbach. A high shutter speed is required to stop rapidly moving objects at close range. This dramatic photograph expresses the thrill and excitement of a popular winter sport.

(Courtesy of the photographer)

Plate 19

Rainbow colors are caused by the refraction and dispersion of light by raindrops.

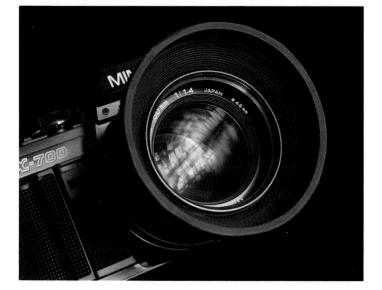

Plate 20 Lens coatings appear colored because they "cancel out" certain spectrum colors from the light they reflect.

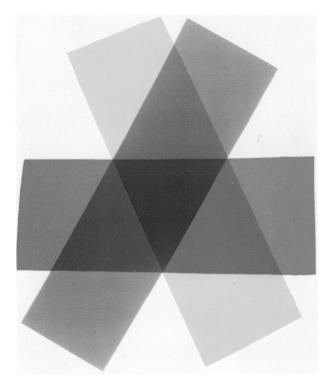

Plate 22 Light primary colors blend additively, producing secondaries that are brighter and more pastel than the primaries themselves. Mixtures of the three primaries, in proper proportion, yield white.

Plate 23 Pigment or dye primary colors are pure and bright. Their mixtures become less bright and more neutral, approaching black.

Plate 25 a. This photograph was taken without filtration.

b. A Polaroid filter was used to darken the sky in this photograph.

Plate 26

Photographs by Janice Levy. a. Daylight color film, exposed in normal daylight, produces colors that are natural and believable.

b. If you expose daylight color film in tungsten light, you can expect it to produce orange-brown pictures.

c. If you expose tungsten film in daylight, the image will be stained blue, like this. (Courtesy of the photographer)

Plate 27

Provincetown, 1976, from the series, *Cape Light.* Joel Meyerowitz. Meyerowitz is one of several photographers currently working in large-format color, but his work is notable for the sensuous and dramatic chromatic blends he achieves by working at dawn and dusk, and mixing natural and artificial light sources. In this typical photograph, he captures the gorgeous hues that exist—but are rarely perceived or appreciated visually—in a familiar and mundane subject.

(Courtesy of the photographer)

Plate 28

Untitled, 1984. Michael VanderKallen. This strange light effect resulted from a double exposure. The relatively long exposure required to record the sunset left the model in silhouette. She moved slightly before the flash was fired, revealing the black edge of the silhouette image.

(Courtesy of the photographer)

Plate 29

33 W. Monroe Bldg., Chicago, IL, 1981. Skidmore Owings and Merrill, Architects. Nick Merrick/Hedrich Blessing. It's easy to make a photograph that simply identifies a building. It's *not* easy to isolate a building from its city environment, emphasize its best features, and translate it into a photographic image that is both descriptive and beautiful. Merrick, one of the best young architectural photographers in the country, manages to do that routinely. Here he has chosen a viewpoint and a condition of daylight that transforms the face of this building into a plane of blazing gold.

(Courtesy of the photographer)

extensive band of *infrared* (IR). Both are invisible, but UV affects photographic films and papers strongly. Only a few special materials are sensitive to IR, but some meters are influenced by it to a troublesome degree.

Light Behavior

A light ray will zip along in a straight line until it encounters something, then any of several things may happen to it. An opaque material will absorb all the ray's energy and block its passage; translucent materials dissipate part of its energy and *diffuse* or scatter it. If the ray grazes a sharp edge, a special kind of scattering, called *diffraction*, occurs. If it enters a denser medium (as in traveling from air to water or glass, for example) it will slow down, part of it will be *reflected* or bounced from the surface, and if it strikes the surface of this new medium at an angle other than 90 degrees, the entering ray will also be *refracted* or bent (fig. 7.3).

White light is really a blend of all the visible wavelengths (colors) of the spectrum. When white light is refracted, it is also *dispersed* or separated into its component colors because the various wavelengths are bent to different degrees. In nature, the colors of the rainbow result when rays of sunlight are refracted and dispersed as they pass through falling raindrops (plate 19).

Light can also be split into its component colors by *interference*. Lens coatings, oil films on water, and soap bubbles operate on this principle (plate 20). By trapping light rays between their closely spaced reflecting surfaces, they fold certain wavelengths back on themselves and cancel them. As the film thickness varies, different wavelengths are subtracted from the spectrum, leaving the colors that we see.

When light passes through a common glass prism, its rays are deviated from their course. If parallel light rays are made to pass through a pair of triangular prisms placed base to base, their emerging rays will converge along a line. A simple *positive* lens, with its *convex* (bulging) spherical faces, is more versatile; it refracts parallel rays so that they converge (focus)—more or less accurately—at a point. *Negative* lenses *diverge* or spread light rays and are not capable of focusing *real* image points, but a *virtual* image can be seen by looking at the lens itself. The familiar magnifying glass is a common example of a positive lens and the artist's reducing glass is an example of a negative lens (fig. 7.4).

A light ray will zip along until it encounters something

White light can be separated into its component colors

Lenses focus light to form images

a. Light transmitted through transparent material.

b. Light diffused by translucent material.

c. Light absorbed by opaque material.d. Light partially absorbed, partially

transmitted.

e. Light refracted in passing through a glass sheet.

Basic lens types: left—the negative lens reduces the image; right—the positive lens magnifies the image.

Figure 7.5

Lens aberrations affect the margins of the image field most seriously. This enlarged corner of a color transparency shows the combined effect of several aberrations, probably including chromatic and spherical aberrations, astigmatism, and coma.

Lenses suffer from several aberrations

Lens Aberrations

Simple lenses form less-than-perfect images because they suffer from a number of *aberrations*, or defects, that prevent them from focusing precisely (fig. 7.5). *Curvature of field* describes the tendency of a simple lens to form its image points on a saucer-shaped plane rather than on a flat plane. *Spherical aberration* makes *marginal* rays (light rays that pass through the lens near its perimeter) bend more sharply than they normally would to focus with the *axial* rays that pass through the center of the lens. *Coma* prevents rays that pass through the lens diagonally from focusing properly; and *astigmatism* discriminates between lines that radiate from the center of the field (*radial* lines) and lines that lie at right angles to them (*tangential* lines), focusing them on different planes.

Barrel distortion causes lines that lie parallel and adjacent to the edges of the subject area to bulge outward in the image (fig. 7.6); *pincushion distortion* bows them inward. The various forms of *chromatic aberration* result from dispersion and produce color fringes around image forms, especially near the margins of the image field.

Correcting these aberrations to a useful degree generally requires combining two or more simple lenses of different characteristics. Typical modern lenses for 35mm cameras contain at least four *glasses*, or simple lenses. In most cases, two or more glasses are cemented together and the various lens *elements*—either cemented or single—are arranged in *groups*. Some of the more complex lens designs, such as *zoom* and *fish-eye* lenses, may contain a dozen or more glasses combined as cemented or *air-spaced* elements into several groups (fig. 7.7).

Figure 7.7 Diagram of a typical zoom lens.

The task of designing and constructing a fine lens is obviously a formidable one. In fact, modern lenses would not be affordable—or perhaps even possible—without constant refinement of materials and manufacturing techniques, and computers to do the necessary calculations. For example, *aspheric* lens elements, that can simplify the correction of certain aberrations and reduce the number of components necessary for satisfactory performance, have been difficult and expensive to grind and polish from glass. Now the nonspherical curvature of their faces is being produced successfully by molding optical plastics. Research in variable-density glass promises to result in similar improvement in the characteristics of conventional spherical elements.

The lavender or brownish color of your camera lens results from the interference effect of the lens *coating*—a thin film of transparent material that's applied to the lens surfaces during manufacture. As previously mentioned, the coating traps some of the light waves between its surfaces. The remaining portion of the spectrum escapes to form the color that you see (plate 20). Lens design and construction are constantly improving

Figure 7.6

Designers try to eliminate barrel distortion from ordinary lenses so that straight lines in the subject will remain straight in the image. Fisheye lenses emphasize barrel distortion and bend subject lines into sweeping arcs.

The flare spots that extend upward from the sun image are actually multiple images of the diaphragm opening, formed by multiple reflections between the various lens surfaces. Flare would have obscured this image if the lens had not been coated.

(Photograph by Janice Levy)

Lens coatings reduce internal reflection

Normal lens coverage approximates human vision

Field coverage is related to focal length

To alter field coverage, change lenses or subject distance

By varying the thickness of the coating, lens designers can eliminate any portion of the spectrum; thus, the amount of *internal reflection*, or light that bounces back and forth between the surfaces of the various lens elements, can be greatly reduced (fig. 7.8). This, in turn, reduces *flare*—nonimage light that reaches the film—and improves both image contrast and color purity. In some cases, where the lens design requires it, the glass surfaces are *multicoated* to affect several selected portions of the spectrum.

Lens Characteristics

The "normal" lens on your camera is called that because its *coverage* (inclusive view) of the subject approximates that of the human eye. Lenses actually form a circular image. Because image quality always deteriorates near the edge of the image circle, the circle's diameter must be somewhat greater than the diagonal measurement of the film format. Thus your normal lens probably forms an image circle that's at least 45mm or 50mm in diameter because the diagonal measurement of the 35mm film format is approximately 40mm (fig. 7.9).

Lens *field coverage* is given in degrees, and usually refers to the angular relationship between the lens focal length and the format diagonal. Using that corner-to-corner measurement, your normal lens covers about 44 degrees. Actually, there's almost no reason to concern yourself with either image circle or format diagonal coverage; you'll usually want to know how much of the subject's width or height a lens will cover from some viewpoint. If we use the 35mm format width in the calculation, the normal 50mm lens is found to cover only about 39 degrees. The format height includes a field angle of about 27 degrees.

If you have *wide-angle* or *telephoto* lenses for your camera, you'll quickly become aware that coverage is approximately related (inversely) to focal length. In other words, if you double the focal length, you'll cut the field width in half. For example, if—from some viewpoint—your normal lens includes 30 feet of subject width and you're interested in only half (15 feet) of it, you can fill the frame with the 15-foot area if you simply replace your normal 50mm (focal length) lens with one having a focal length twice as great—a 100mm lens (fig. 7.10).

Of course, you might also reduce the subject field and produce the larger image by walking halfway to the subject with your normal lens, but there are at least two reasons why changing lenses may be preferable. One reason is that it might be inconvenient or impossible to approach the subject. The second reason is that the perspective of the image will be different, and perhaps less desirable, from the closer viewpoint.

This is the full field circle of a 50mm lens. The white rectangle represents the actual image area that is recorded on 35mm film.

(a)

(c)

Figure 7.10

a. This photograph of farm store signs was taken with a normal (50mm) lens. It includes too much unrelated material and appears cluttered.

b. A 100mm lens, used from the same distance, doubles the size of the image details and cuts the coverage angle approximately in half.

c. When the 50mm lens is used at half the original subject distance, the sign images are increased to twice their original size. Although the signs now match those in *b*, the closer viewpoint has altered the image perspective. The foreground railroad ties are enlarged, the background details are reduced, and the visual effect is again confusing. Always try to find a viewpoint that provides the best foreground/ background relationships (perspective). Then, for maximum image quality, choose the lens focal length that will frame the subject area tightly.

a. From any given distance, a telephoto lens can expand a relatively small area of the subject to fill the image frame.

c. If both lenses are used at the same subject distance, the image perspective is identical. Although there is an obvious loss of sharpness and a noticeable increase in image grain, this enlarged section of the wide-angle shot matches the perspective of the telephoto image exactly.

(Photographs by Janice Levy)

Image Perspective

Contrary to a fairly common belief, lenses don't affect perspective; the camerato-subject distance does. From any given viewpoint, you'll get identical perspective with any lens your camera can accept (fig. 7.11). The advantage of a *long* (focal length) lens is its ability to fill the image frame with a relatively small subject area at a relatively great subject distance (fig. 7.12). The advantage of a *short* lens is its ability to include a wide expanse of subject area at relatively close range.

Whether image perspective is "correct" or not is determined by the print viewing distance. As a rule of thumb, if you want pictures you've made with a long lens to appear in "normal" perspective, they should be presented as relatively small prints and viewed from a relatively great distance. On the other hand, wide-angle shots should be enlarged rather considerably and viewed at quite close range to be seen realistically.

Specifically, the angle of view should be the same as the coverage angle of the lens that made the picture. For example, a 35mm negative (about 1½ inches wide), made with a 2-inch lens, might be enlarged 10 diameters (to about a 15-inch width) and viewed from 20 inches for the appearance of normal perspective. Similarly, an 8'' \times 10'' negative shot with a 14-inch lens might be *contact printed* and viewed from 14 inches, or enlarged 2 diameters (to 16'' \times 20'') and viewed from about 28 inches.

Figure 7.12

The very long lens used to make this photograph apparently foreshortens the ship and raises the horizon line unnaturally when the image is viewed at normal reading distance. The perspective will probably appear more normal if you view this photograph from a distance of about 8 to 10 feet.

Lenses don't affect perspective; distance does

Correct image perspective depends on print viewing distance

Distortion appears when a print is viewed from an ''impossible'' position

Use distortion deliberately for impact and interest

Depth of field is affected by several factors

Halving the focal length approximately doubles the depth of field

The so-called wide-angle distortion or telephoto distortion effects result from viewing the print image from an "impossible" spatial position. When seen from greater-than-average viewing distance, a small print of a wide-angle photograph will appear to have very deep image space with sharply emphasized perspective, and foreground objects will seem unnaturally large and distorted. A telephoto (long lens) print, enlarged considerably and viewed from close range, will present the opposite effects: the image space will seem to be unnaturally shallow, background objects will loom large, and perspective "vanishing lines" won't converge as you'd expect them to.

In both cases, the perspective "distortion" is an illusion created by the mismatched viewing distance. When seen from its "correct" distance, each image will again appear normal. There's no rule that says you must view your prints normally, of course. You can sometimes enhance the impact and interest of an image considerably by deliberate use of perspective distortion.

Depth of Field

You've already learned that depth of field can be varied by changing the aperture of the lens—increasing as the aperture size decreases—and you may remember that depth of field is also affected by subject distance—increasing as the subject distance increases. We now add a third important control: the lens focal length. Depth of field decreases as focal length increases.

Although we usually think of varying the aperture as the most convenient method of altering depth of field, it is not the most effective one. Halving the aperture diameter (equivalent to doubling the f-number) approximately doubles the depth of field. The same relationship holds for focal length changes: halving the focal length approximately doubles the depth of field. By comparison, changing the subject distance is about twice as effective: doubling the subject distance quadruples (at least) the depth of field.

All of these relationships are fairly consistent when the subject distance is moderate—say, no more than about 60 to 90 focal lengths (10 to 15 feet for the 50mm lens on your SLR)—and the old "rule of thumb" applies: approximately one-third of the available depth lies in front of the plane of sharpest focus and two-thirds lies beyond it. At very close range, however, the near and far depths are very nearly equal, and at long range, the far depth increases much faster than the near depth.

In comparing depths of field you must also consider the effect of image magnification. Although it appears that short lenses produce much greater depth than longer ones (when the other factors are similar), remember that the smaller images must be enlarged for valid comparison. Enlargement has the same effect as changing the focal length; for example, doubling the image size will halve the effective depth of field.

When all of these factors are considered, it's apparent that the greatest depth is obtainable when the subject distance is great, even though a long lens must be used to preserve the image size. But this advantage may be tempered by the fact that great subject distances will reduce the image perspective effect unnaturally, and perhaps undesirably. At the other extreme, if you use a short lens at closer range to correct the perspective, remember that if enlargement is required it will certainly degrade sharpness and increase image grain (figs. 7.13 and 7.14).

This series of photographs demonstrates the effects of lens focal length, aperture, subject distance, and image magnification on the effective depth of field. In every case the lens was focused carefully on the star in the center of the central print. Notice in these pictures that the perspective is determined by the subject distance, regardless of the lens focal length or image magnification.

a. This photograph was made with a 50mm lens at f/2.8 at a distance of 5 feet 6 inches. The calculated depth of field is about 7.1 inches. See figure 7.14 to compare the depth-of-field limits and total extent for the various conditions.

b. Here the 50mm lens was stopped down to f/5.6. The subject distance remains at 5 feet 6 inches. Calculated depth is now approximately 14.4 inches.

c. For this photograph the 50mm lens was again used at f/2.8 but the subject distance was increased to 11 feet. Calculated depth of field is about 28.7 inches.

d. This photograph is identical with c, except that the image has been enlarged $2\times$ in printing. This shrinks the calculated depth of field to about 14.2 inches.

e. Here a 100mm lens was used at f/2.8. The subject distance is 11 feet and the calculated depth of field is also approximately 14.2 inches.

f. Here the 100mm lens was stopped down to f/5.6. The subject distance remained at 11 feet, and the calculated depth is again about 28.7 inches.

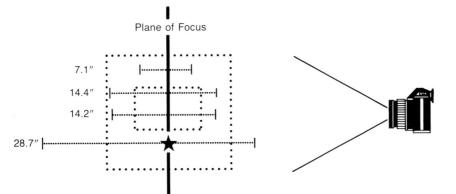

This diagram illustrates the relationships of the depths of field in the photographs shown in figure 7.13. Notice that at this short range the depth beyond the plane of focus is only a little greater than the depth in front of it. As the subject distance increases, this relationship changes and the far depth increases dramatically—eventually extending to infinity.

Controlling depth of field involves compromises, and for moderate subject distances at least, there may not be any compelling reason for choosing one focal length/aperture combination in preference to another. If you'd prefer not to have to worry too much about the details of depth of field control, just remember these two general facts: (1) any feature or condition that makes the image small (short focal length, great subject distance, contact printing, or minimal print enlargement) or difficult to see clearly (great viewing distance, dim light) will tend to increase the effective depth of field, and vice versa; and (2) in any given situation, a small aperture will always produce greater depth of field than a larger aperture can.

Figure 7.15

Poppenrock, Morehead, KY. David Bartlett. A gray, misty atmosphere pervades many of Bartlett's photographs. This starkly simple composition is typically luminous and beautiful.

(Courtesy of the photographer)

Controlling depth of field involves compromises

Summary

Light is a tiny portion of the electromagnetic spectrum, ranging from red to violet and bordered by the invisible radiations infrared and ultraviolet. A light ray can be absorbed, diffused, diffracted, reflected, or refracted by encounters with various substances. White light can be separated into its component colors by dispersion or interference.

Prisms can bend light rays; positive lenses can focus them to form real images. Negative lenses form only virtual images. Simple lenses suffer from aberrations—such as field curvature, spherical and chromatic aberration, coma, astigmatism, and distortion—that impair image quality. Correction of the aberrations requires combining simple lenses of different characteristics. Practical camera lenses typically contain several elements. Lenses are coated to reduce flare and to improve image contrast and color purity.

Normal lens coverage approximates that of the eye. Field coverage usually expresses the angular relationship between focal length and the image format diagonal. Coverage based on image width or height is more useful. Lens coverage is approximately inversely proportional to focal length.

Lenses don't affect image perspective; subject distance does. Perspective appears normal when the print viewing angle is similar to the effective coverage angle of the taking lens. Prints viewed from inappropriate distances will appear spatially distorted—an effect that can sometimes be used for dramatic effect.

Depth of field is affected by lens aperture, subject distance, and lens focal length. Its perception is also affected by print viewing conditions. In general, any condition that makes the image small or hard to see increases the apparent depth of field; and under any given conditions, small lens apertures produce greatest depth of field.

Films and Filters

Cobblestone House, Avon, New York, 1958

Photograph by Minor White. Infrared film and heavy red filtration to exclude most visible light from the camera combine to produce the dramatic tonality of this dreamlike photograph.

(Courtesy of the Minor White Archive, Princeton University © Trustees of Princeton University, 1982) Photographic films are available in a variety of sizes and types from several manufacturers. Although there are obvious differences in size and packaging, popular films (with the exception of Kodak and Polaroid "instant" films) share two general characteristics: they all consist of silver-halide-sensitized gelatin emulsions, coated on sheets or strips of acetate or polyester plastic.

Image Characteristics

Exposure to light renders the silver halide crystals in the emulsion developable. During development, the exposed crystals are reduced to particles of metallic silver that form the visible *negative* image in black-and-white film. In most color films (and in the relatively rare "chromogenic" black-and-white films supplied by Agfa and Ilford), a developing process produces both silver particles and dyes; after which the silver is removed, leaving either a negative or positive dye image in color.

Although the individual silver particles in a typical black-and-white negative are too tiny to be seen with the unaided eye, they overlap randomly to create a grainy image structure that is not generally noticeable in the negative itself, but is often quite visible in an enlarged print. As a general rule, *fast* (very sensitive) films form images of relatively coarse grain, and *slow* films tend to form fine-grain images.

Many modern films—both color and black-and-white—benefit from "tabular grain" emulsion technology, which forms the sensitive silver halide particles into flat wafers instead of the irregular lumps that appear in conventional emulsions. These flattened tablets present a relatively large surface to the exposing light to provide a relatively high effective film speed; but because of their small mass, they're reduced to relatively small particles of image silver during development.

In general, grain *size* is determined mostly by the characteristics of the film emulsion itself, but development conditions can affect the *appearance* of image graininess significantly.

Speed (sensitivity) and grain are important considerations in choosing a film, but they're not the only ones: image sharpness, contrast, and latitude are equally significant. As a rule, slow films—especially the *thin emulsion* types—have *high acutance*, which suggests that they are capable of forming very sharp images. Typically they also produce relatively high contrast and have limited *latitude*, which means that they're not very tolerant of exposure errors and are not especially suitable for use with extremely contrasty subjects. Faster films are less sharp, tend to have greater exposure latitude, and are less contrasty, as a general rule (fig. 8.1). Medium speed films (ISO 100 to 400) combine good latitude, moderate grain structure, good acutance, and satisfactory contrast, and are a good choice for general photography.

The sharpness of any film image is likely to be reduced by overexposure because the image edges "spread" or "thicken" as light is diffused laterally through the translucent emulsion layer. In addition, light that penetrates the emulsion can be reflected back from the surfaces of the plastic base material, or "piped" through the base material itself—to fog a relatively wide area of the emulsion. The diffused spreading or thickening of overexposed image lines is called *irradiation. Halation* is the term given to light fringes or haloes that occasionally form around overexposed image areas (fig. 8.2).

To reduce halation effects, all conventional films include an *antihalation* backing layer of dyed gelatin that's clearly visible through the back of the undeveloped film. On most commonly available 35mm films, the antihalo backing is dark green or brown, but on some other types it may be dark blue or red. This color, whatever it is, is removed more or less completely during film processing. Light piping is reduced (and halation further attenuated) in

The silver particles overlap randomly to form visible "grain"

There are several things to consider in choosing a film

Overexposure tends to reduce image sharpness

Most films have features that minimize halation and irradiation

(b)

most 35mm films by a gray dye incorporated into the film base material itself. This color remains unchanged after development, but since it is fairly light, its presence is of no consequence.

Film Speed

Film sensitivity, or speed, is indicated by its *ASA* or *ISO* number, as mentioned briefly in Chapter 4. Speed numbers are determined by carefully regulated testing procedures originally formulated by the American Standards Association (ASA)—later renamed the American National Standards Institute (ANSI). These procedures are now endorsed by the International Organization for Standardization (known, for some reason, as the ISO instead of IOS) and the ASA initials are gradually being phased out.

Here is a portion of the familiar ASA film speed number sequence that has now been adopted by the ISO:

. . . 20, 25, 32, 40, 50, 64, 80, 100, 125, 160, 200, 250, 320, 400, 500, 640, 800, and so on.

These speed numbers are directly related to film sensitivity; that is, a film rated at ISO 100 is twice as fast as one rated at ISO 50. Notice, too, that every *third* number in the ascending sequence is doubled, which means that the sequence progresses in third-stop intervals. Thus, Plus-X film (ISO 125) is 1 1/3 stops faster than Ilford Pan F (ISO 50), but 1 2/3 stops slower than Tri-X, which is rated at ISO 400.

When the ISO standard was formulated in 1974, it adopted both the American ASA system and the German DIN (Deutsche Industrie Norm) system and combined them for international use. Although they are equally valid and useful, the numbers are in different series: the ASA numbers are related arithmetically and the German system is logarithmic. Thus, the official ISO rating for Plus-X film, for example, is now ISO 125/22°—the degree symbol (°) being used to indicate the logarithmic number. Film speeds are generally printed on the outside of rollfilm boxes and on the instruction sheets that are packed with some films (see fig. 5.17 and Appendix 1).

(C)

Figure 8.1

a. These old baggage tags were photographed on a slow (ISO 50), fine-grain film. The image is very sharp and practically grainless.

b. Even in this 20x enlargement the image details and textures are well-defined and the grain structure is hardly noticeable.
c. This photograph was made on a popular fast film (ISO 400). Although the quality of this 20x enlargement is remarkably good, the image is less sharp and grainier than b. Notice also that the fast film's greater sensitivity to red has lightened some of the lettering (which is red) and portions of the tags that are brownish-orange.

Film speed is indicated by an ASA or ISO number

The ISO system combines ASA and DIN speed numbers

Figure 8.2 Christmas Tree. Robert Kangas (Courtesy of the photographer)

Reciprocity affects both film speed and image contrast

Black-and-white films record colors in various shades of gray

Reciprocity Effects

As mentioned above, film speed numbers are determined by the manufacturer under very specific conditions of exposure and development. As long as the film is used normally, its speed number can be trusted; but when conditions are such that the exposure interval is greater than about 1/10 second or less than about 1/1000 second—the film's sensitivity diminishes and its assigned speed number is no longer accurate. To compensate for this *reciprocity effect*, the film exposure must be increased (and development decreased) for long exposures; for very short exposure times the film requires both increased exposure and increased development. See Appendix 7 for further explanation of reciprocity effects and suggested compensation.

Color Sensitivity

Although black-and-white films don't produce color images, they do respond to color in the subject by recording the different hues in various shades of gray. The natural color sensitivity of the simple silver emulsion is restricted to blue, violet, and ultraviolet; it's essentially blind to red, orange, yellow, and green (fig. 8.3 and plate 21). *Ordinary* or noncolor-sensitized emulsions of this sort produce images that, in final print form, render blues and violet shades as almost white. Red, orange, and yellow objects show up in the print as black or dark gray tones. This effect is apparent in daguerreotypes and

(a)

(c)

(d)

in nineteenth-century prints made from collodion "wet-plate" negatives. Pale eyes in portraits of blue-eyed individuals, and blank white skies in landscape photographs demonstrate the predominately blue sensitivity of these early materials (fig. 8.4).

Orthochromatic ("ortho" for short) films have extended sensitivity into the green region of the spectrum. Their reproduction of the "cool" colors appears more natural, but red objects are photographed as if they were black. Further extension of sensitivity into the red region has given us *panchromatic* (often referred to as "pan") emulsions that reproduce all the spectrum colors in more or less believable shades of gray. A few films with *extended red sensitivity* render red and orange subject tones much lighter than the eye perceives them. Two popular examples are Kodak's Technical Pan, an extremely fine-grain, high-contrast film of moderate speed, and Type 2475 Recording Film, a very fast film of coarse-grained structure and average contrast.

Figure 8.3

a. This series illustrates the way black-andwhite films reproduce subject colors. In this first photograph, made on an ordinary bluesensitive emulsion, reds and yellows are darker than you'd expect them to be, and blues are lightened in value.

b. This picture demonstrates orthochromatic color sensitivity; reds are very dark but greens and yellows are rendered more appropriately.

c. This shows how common panchromatic films react to subject colors; reds and greens are quite similar in value and all colors are shown as grays of various shades.

d. Extended red sensitivity produces the rendering shown here; reds are unnaturally light in value and all the colors have a rather bland look. Compare these photographs with the color photograph of the still life on plate 21.

Figure 8.4

This baby's blue eyes were bleached white by the blue-sensitive plate that the photographer used to make this portrait in about 1880.

Almost all popular films are now panchromatic

Filters can influence a film's response to color

Blending the three additive primary colors produces white

Blending the three subtractive primaries produces black

Complementary colors neutralize each other

A filter will lighten its own color and darken its complement

Filters

Almost all 35mm films and rollfilms are now panchromatic. This means that they respond to all subject colors, which is a good thing; but it also means that they often translate strongly contrasting colors into shades of gray that are virtually indistinguishable. That's often disappointing; we generally expect color contrast in the subject to be represented as value contrast in a blackand-white print. Fortunately, we can influence the way colors are translated into print grays—we can use filters (fig. 8.5).

Filters are available in a variety of colors, only a few of which are useful for black-and-white work. Before you buy any of them, you should understand how they work and what they can do for you. That means you'll have to be familiar with the rudiments of color theory.

How Filters Work: Color Fundamentals

In photography we're mostly concerned with the visible spectrum. Taken as a whole, we see it as white light. If portions of the spectrum are missing, we see the remaining mixture of wavelengths as color. We perceive narrow sections of the spectrum, seen alone, as relatively pure color. If the spectrum is divided roughly into thirds, the colors are seen individually as red, green, and blue. We call these the *light primary* colors, and sometimes *additive primaries*, because they are basic colors (not mixtures of more fundamental hues) and because blending them together (adding them) makes white.

If pairs of light primaries are mixed together, they form the *secondary* colors. Thus, red and green light (not pigment) blended together make yellow; green and blue make cyan (greenish-blue); and red and blue make magenta. In every case, mixing light colors together increases the brightness of the light (plate 22).

Pigments and dyes don't have any color of their own. They appear colored because they absorb portions of the light spectrum and reflect the rest. Thus a dye that absorbs blue light reflects red and green and will be seen as yellow. A dye or pigment that absorbs green will be seen as magenta, and a material that absorbs equal amounts of red, green, and blue will simply reduce the brightness of the light and appear gray. Because pigments absorb light color they are called *subtractive* colors, and the pigment or dye primaries are sometimes referred to as *subtractive primaries*. Mixtures of the subtractive primaries, if properly balanced, absorb virtually all the incident light and appear black (plate 23).

If a dye or pigment color completely absorbs or *neutralizes* some other color, the colors are called *complementary* or *complements* of each other (fig. 8.6). Thus, magenta dye, which totally absorbs green light, is the complement of green; blue is the complement of yellow; and red is the complement of cyan.

These are the principles that make filters useful in black-and-white photography (fig. 8.7 and plate 24). A red filter placed over the camera lens will transmit red light to the film, absorbing both blue and green light. Therefore, blue or green objects in the subject will be pictured in the print as black, because none of their light reaches the film. Red objects, on the other hand, will appear nearly white in the print because red light passes through the filter as easily as white light does.

Filters lighten their own colors and darken their complementary colors in the print. If the filter color is intense and saturated, the effect on a similarly intense color in the subject will be dramatic. If the filter is a pale tint or an

Figure 8.5 Filters are available in a wide variety of types and sizes.

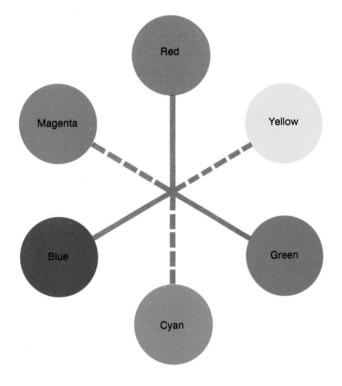

Figure 8.6

The standard color wheel. Colors that lie diametrically opposite each other (magenta and green, for example) are called *complements* of each other. Red, blue, and green are the *additive primaries;* magenta, yellow, and cyan are the *subtractive primaries.*

impure color, the filter effect will be less pronounced. The effect is also minimized, regardless of the strength of the filter color, if the subject color is pale or muted. Color filters have no selective effect at all on black, white, or neutral grays in the subject. Finally, filter effect depends to some extent on film exposure: underexposure tends to emphasize the effect; overexposure tends to minimize it.

(a)

Figure 8.7

a. These photographs illustrate the effects of filtering panchromatic film in daylight. For comparison, this first example shows the normal, unfiltered response of medium speed film.

b. A light yellow filter darkens the blue sky, the trousers, and the shadows—all slightly.
c. A red filter darkens the sky and trousers dramatically, darkens the grass somewhat, increases contrast, and lightens the red shirts to a pale gray.

d. A strong green filter darkens the shirts and trousers, lightens the grass slightly, and leaves other areas practically unaffected. e. A blue filter turns the sky almost white, lightens the blue trousers to gray, and darkens both the red shirts and the yellow caps. Compare these photographs with plate 24.

IR film can produce exciting images when properly filtered . . .

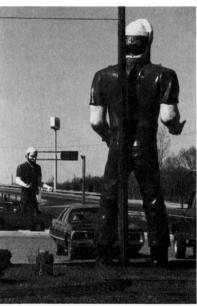

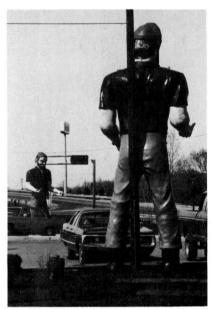

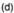

Filtering and Focusing for Infrared

Although most photographic materials are sensitized to respond to the visible spectrum, Kodak also supplies a specially sensitized infrared film in 35mm cartridges (and in sheet film). When used with a very dark red filter, which absorbs visible light and transmits infrared (IR), this film often produces dramatic, exciting images. Without the filter, infrared film responds strongly to visible light and produces rather unremarkable, grainy, not very sharp images.

(e)

Actually, we use the red filter with IR film mainly because it's a fairly common one that works quite well; but the red color is neither necessary nor particularly desirable (except to provide a viewfinder image). For maximum dramatic effect it's possible to use a special IR filter that absorbs *all* visible light. Although filters of this kind are apparently opaque, IR passes through them easily. You're not likely to find one in your local camera shop, but they're

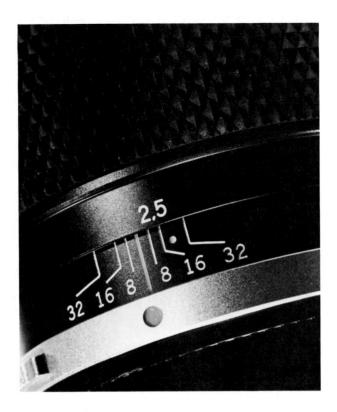

occasionally available from army surplus stores (or on special order from Kodak; the Wratten #87 is one example). They're obviously not suitable for use with hand-held SLRs (because there's no viewfinder image), but they work well with rangefinder cameras or other types used on a tripod.

Because infrared radiations are invisible and can't be measured reliably with an ordinary exposure meter, IR film has no ISO speed rating. The instruction sheet that comes with the film suggests exposure settings for average conditions; you'll probably have to experiment a little to refine those recommendations.

Since infrared radiations are outside the visible spectrum, ordinary camera lenses don't focus them normally. In practical terms, this means that IR images of objects that seemed sharp in the viewfinder will probably be out of focus unless you "correct" the camera focus manually. To make this correction easy, most 35mm SLR lenses (and many others) provide a special IR focusing index mark—often a small red dot or the letter "R"—close to the regular index mark on the focusing scale (fig. 8.8, also figs. 5.12 and 5.13). To use it with IR film, focus the camera normally by inspecting the image in the viewfinder; then note the distance indicated opposite the normal index mark on the focusing scale and turn the focusing ring to place that distance opposite the IR index mark. When you've done this, the viewfinder image may appear unsharp but don't worry about it; the lens is properly adjusted for the IR wavelengths and the negative image should be sharply focused. Caution: this adjustment is necessary only when using IR film that will be exposed with a deep red (or other suitable) filter over the lens.

Filter Factors

When film exposures are based on meter readings of white light, the exposure must be increased to make up for the light lost by absorption when a filter is used. This necessary exposure increase is called the *filter factor* and is usually expressed as a number by which the exposure must be multiplied (see

Figure 8.8

The focusing index mark for infrared light is the small dot between the f/16 and f/32 lines.

. . . and it has no ISO speed rating

IR doesn't focus normally; adjust the focus manually

Figure 8.9

"Riotous color effects of this sort can be obtained by mixing natural and artificial light sources or by 'painting' areas of the subject with filtered light during a time exposure."

(© Erik Lauritzen "Palm, 1986" Type C print)

Appendixes 5 and 6). For example, the Kodak Wratten #8 is a yellow filter having a factor of 2x in daylight. When it is used, the normal (white light) exposure must be doubled, either by doubling the exposure time or by opening the lens up one stop.

Similarly, the Wratten #25, a saturated red filter (suitable for IR filtering, as mentioned above), has a daylight factor of 8x, and a *tungsten* (artificial light from tungsten-filament bulbs) factor of 4x. When this filter is used in daylight with general-purpose panchromatic film, the white light exposure must be increased by 8x or three stops. In tungsten light, the exposure must be increased by 4x or two stops. The difference in the factors is due to the color of the exposing light; daylight is relatively blue, while tungsten light is relatively orange. The red filter restricts a large proportion of the bluish daylight, but transmits the orange tungsten light with relatively little attenuation.

Most modern SLR meters will respond to colored light in about the same way that panchromatic film will, although meter cells tend to be unduly sensitive to red and IR. Despite this red bias, it's generally feasible to fix your selected filter over the camera lens and take the exposure reading through it, allowing the meter to compensate for the filter factor automatically. The exposure error is not likely to be significant in most cases, but using strong

Multiply exposure by the filter factor

Light conditions may affect filter factors

Meters may not read filtered light correctly

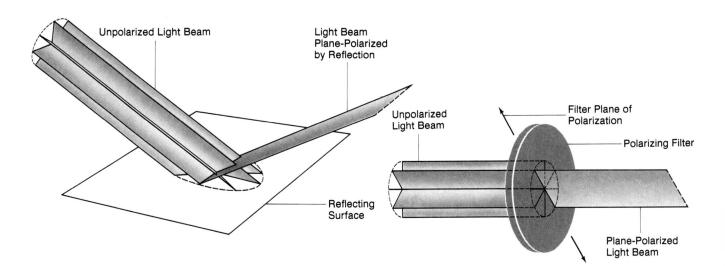

red or orange filters this way may cause your meter to underexpose. *Polarizing* filters confuse some meters, too; test your own meter to see how reliably it handles red and polarized light. Figure 8.10 Polarized light diagram: reflection, transmission.

Reflected light is often polarized

Polarizing Filters

When a light ray is reflected from a smooth surface (except polished metal) its normal multidirectional wave vibration is more or less restricted to a single plane and the light is said to have been *polarized* (fig. 8.10). This is an invisible effect. Polarized light looks just like unpolarized light to the camera, the film, and to most people—although some individuals are supposed to be able to detect it under certain conditions. Polarization is a useful phenomenon because it provides us with a unique method of filtering one sort of light from another without distorting colors.

Polarizing filters (sometimes called Polaroid filters or Pola-screens) are capable of polarizing transmitted light; that is, they are transparent to light waves vibrating in one plane, but more or less opaque to waves vibrating in other planes. This characteristic permits the filter to reduce or, sometimes, eliminate reflected "glare" light. You can watch this happen. If you view a glaring surface through a polarizing filter and slowly rotate the filter until its transmission axis is perpendicular to the vibration plane of the reflected light, the glare will be magically diminished without affecting the rest of the light at all (fig. 8.11).

Because they have no selective effect on color, polarizing filters can be used with both black-and-white and color films. Their ability to reduce surface glare often seems to increase subject contrast and color purity, and they have a unique ability to darken and intensify the blue of the sky under certain conditions (plate 25 A and B). This is because skylight is strongly polarized in a broad arc approximately 90 degrees from the sun's position. Point your forefinger at the sun and your extended thumb will point to the sky belt of most complete polarization.

Under some conditions, white light can be dissected into its component colors by selective polarization. This effect is easily demonstrated with a pair of polarizing filters and some scraps of cellophane (some other plastic wrap materials may not work well). Place the cellophane scraps on one of the filters and cover them with the other one. When viewed against the light, the cellophane scraps will appear in brilliant colors that can be varied dramatically if one of the filters is rotated. The effect results from cellophane's ability to rotate the plane of polarized light and is related to wavelength. Some structural plastics have this same ability; when strained or bent, they form color

Polarizing filters can often reduce surface glare . . .

. . . increase color purity, and darken the blue sky

Figure 8.11

a. Surface reflections from surrounding displays almost obscure the fossil in this museum case.

b. Eliminating the reflections with a polarizing filter over the camera lens reveals this ferocious-looking fish skull and its descriptive caption.

(a)

(b)

patterns that indicate the distribution of internal stresses. If you wear polarizing sunglasses while driving, you may have noticed the similar blotchy stress patterns in the tempered glass windows of the cars you've passed.

Polarizing filters don't have a single, constant filter factor because their absorption depends upon the amount of polarized light coming from the subject and the orientation of the filter axis relative to the polarity of the light. If no polarized light exists in the subject area, the filter factor for a typical polarizer amounts to about 3x, due entirely to its gray neutral density. That same

Polarizers don't have a constant filter factor

factor is approximately correct if the light is polarized in a plane parallel to the filter's polarization axis. However, if much of the subject light is polarized in a plane *not* parallel to the filter's axis, transmission will be greatly reduced and the factor may amount to 6x or 8x or even more. Since the amount of polarized light in the subject can't be determined visually, it's a good idea to *bracket* your exposures. If the picture is an important one; start with a 3x factor, then take one picture ''a stop over'' (one stop more exposure), and perhaps one ''two stops over,'' just to be sure.

Neutral Density Filters

Although you'll probably not have much use for them, you should also be aware of *neutral density* (ND) filters. Actually ND filters are not really filters because they have no selective action at all. They're simply intended to reduce light intensity without affecting the image in any other way. Kodak's Wratten ND filters are available as square sheets of dyed gelatin (*gelatin squares*) in thirteen accurately calibrated densities ranging from 0.1 (requiring a 1/3 stop exposure increase) to 4.0 (with a factor of 10,000x or 13 1/3 stops). Other manufacturers may calibrate their ND filters differently; don't confuse Kodak's *density* (logarithmic) values with simple factors. ND filters are useful when you want to use a slow shutter speed or a large lens opening—or both—when the light is too bright to permit it normally.

Although filter effects can sometimes be very exciting, I don't recommend using any filter unless you have some interpretive purpose in mind or unless you want to protect your lens from blowing dust or other hostile influences. After all, a filter adds two more surfaces to your lens system, thereby increasing the possibility of flare or fog that can degrade image contrast. A scratched or dirty filter can also reduce image sharpness. As a rule, don't use a filter unless you need it; then, be sure its surfaces are clean and scratchfree. Finally, be especially careful to protect the lens from side light (use a lens shade) to minimize the possibility of flare.

Summary

Speed, grain, acutance, contrast, and latitude are important considerations in choosing a film. Slow films are generally less grainy, sharper, and more contrasty than fast films. Medium speed films are a good compromise for general use. Film sensitivity is indicated by ISO speed numbers that combine the older ASA and DIN values. Reciprocity effects may require exposure compensation.

Simple silver halide emulsions are essentially insensitive to red and green light; orthochromatic films are sensitive to blue and green, but not red; and panchromatic films respond to all the visible colors. IR sensitivity extends beyond visible red into the infrared. Unless filtered to exclude most visible light, IR films produce unremarkable, grainy images. Unless camera focus is adjusted manually, filtered IR images are likely to be out of focus.

White light consists of three basic bands of color that are called "additive primary" or "light primary" colors: red, green, and blue. Their complements are the "subtractive primaries" or "pigment primaries": cyan, magenta, and yellow. Color filters transmit their own color freely and absorb their complements; thus, filters lighten their own colors and darken their complements in the print. The exposure increase that's necessary to compensate for a filter's light absorption is called the "filter factor." It's usually given as a number by It's a good idea to bracket

ND filters are used to reduce light intensity

Don't use any filter unless you really need it

which the film exposure must be multiplied. With some possible exceptions, it's feasible to take a meter reading through a filter to arrive at correct exposure directly without further compensation.

Polarizing filters can often be adjusted to attenuate surface glare, and are uniquely able to darken portions of the blue sky. They can be used with both black-and-white and color films. Their factor is variable, depending on the amount of polarized light that's present in the subject area. It's wise to bracket exposures.

Neutral density filters are used to reduce light intensity without affecting color or value relationships.

As a general rule, don't use a filter unless you need it; then be sure it's clean, and be careful to shield the lens from side light to minimize flare.

Working with Light

Scrimshaw Carver—Studio Set

Photograph by David Cornwell. Cornwell owns an enormous collection of antique artifacts and tools and uses them frequently as props in his meticulously detailed sets. This handsome "period piece" demonstrates his mastery of studio lighting.

We perceive depth and space in the real world by using our binocular vision; by observing the effects of light and shade; by noticing the overlapping of forms; and by analyzing the significance of relative size, position, and motion of observed objects. Pictures-being two-dimensional-leave us with few spatial clues; if familiar perspective effects are not obvious, we must base our interpretation largely on effects of light and shade—and we are frequently deceived. When viewing unrecognizable subject matter, we generally assume that the light is coming from the top of the image format. In this highly abstract picture, the forms are modeled strongly and the effect of depth is dramatic-but which forms are elevated and which sunken? Now turn the picture upside down and watch the valleys miraculously become jagged mountains. The picture is really a synthetic-aperture radar image of Greenland glaciers (the gray riverlike forms) flowing between mountains to the sea, then breaking up to form icebergs and floating ice chunks (the white particles in the dark ocean area).

(Courtesy of the Environmental Research Institute of Michigan [ERIM])

Light quality is profoundly significant

Direction is one important characteristic of light

Degree of diffusion is also important

As you gain experience in photography, you'll discover that light exists in a variety of forms, and that the *quality* of light can have a profound influence on the effectiveness of your photographs. Light reveals the subject's form and texture, describes the depth and space of the subject area, and often suggests a mood or atmosphere. If you use light effectively, your pictures will attract attention and admiration; if you ignore light, be prepared to have your photographs ignored, too.

One of the most important characteristics of light is its *direction*. Because we're accustomed to having light come from above or one side in the natural environment, we tend to assume top or side light in a photograph, especially when the subject is unrecognizable or ambiguous (fig. 9.1). When the subject is recognizable, we may associate bottom light with stage footlights or firelight, and interpret it as theatrical, unreal, or occasionally threatening (fig. 9.2).

Although we may not attach any distinct emotion to side, back, or top light, we do tend to associate these light conditions with circumstances that might produce them naturally. Side light may suggest the atmosphere of early morning or late afternoon; back light implies the glare, and perhaps discomfort, of squinting into the sun or seeing things in silhouette against the bright sky; and top light may remind us of hot, noon summer sunshine or the softer glow of an attic skylight.

In general, *cross light*—that is, light that rakes across the subject's surface—contributes to the illusion of roundness, depth, and space, and emphasizes texture (fig. 9.3); front light or back light tends to compress space, makes the subject seem more two-dimensional, and minimizes surface details and texture (fig. 9.4). Even though you may not be able to modify the light itself, you can often position your subject or your camera, or both, in any existing light condition to take advantage of these effects.

The *degree of diffusion* or—more specifically—the *area* of the light source is another very important characteristic of light. A small source, such as the unobstructed sun or a bare light bulb, produces a *hard* light that forms brilliant highlights; casts sharp, distinct shadows; and appears harsh and glaring

Figure 9.2 "Bottom" light has an unreal, theatrical quality.

(fig. 9.5a). A large-area source, such as an overcast sky or artificial light that's *bounced* from a wall or ceiling, produces a *soft* light that forms relatively dull highlights, casts soft-edged, indistinct shadows, and gives the impression of moderate or low contrast (fig. 9.5b).

Only you can decide whether hard or soft light is best for your interpretation of your subject, but be aware that they are not the same. Hard light frequently emphasizes the graphic structure of your composition by producing distinct patterns of light and dark. Soft light often places more emphasis on subject identity, fine detail, and subtle gradation (fig. 9.6).

Figure 9.3

Low cross light from the setting sun gives depth and roundness to the boys' figures and dramatizes the texture of the sand. (Photograph by Janice Levy)

Strong backlight outlines this fiddler and turns his bow into a luminous streak. (Photograph by Janice Levy)

Figure 9.5 a. Hard light casts sharp shadows, emphasizes form and contour, and creates high contrast. b. Soft light is almost shadowless. It displays subject forms and textures subtly, and minimizes contrast and minimizes contrast.

(Photographs by Janice Levy)

(a)

Light *intensity* is not, in itself, particularly important because it's almost always possible to compensate for it by adjusting the camera exposure settings. On the other hand, *relative* intensity, or lighting *contrast*, is very important, both in its visual effect on the rendering of form and texture, and in its influence on the mood or atmosphere of the photograph. You can sometimes reduce excessive lighting contrast without altering the basic appearance of the light condition. For example, if you want to retain the highlight and shadow patterns typical of direct sunlight without their characteristic harshness, try using a *reflector* or *flash* to *fill* the shadow tones and lighten them.

Light *color* is another characteristic that you should be aware of. We normally think of common light sources as being "white," but if we could see them side by side for comparison, it would be obvious that each has a distinct color. This doesn't affect our visual perception of subject colors very seriously because our eyes adapt readily to almost any light that has a *continuous spectrum*—that is, some proportion of all of the spectrum colors. However, the camera and film will see things objectively. For example, color film that's designed for use in daylight will record tungsten illumination (from ordinary light bulbs) as brownish orange and ordinary fluorescent light as some shade of yellow-green. We'll return to this subject in more detail in Chapter 14.

Figure 9.6

This soft top light is characteristic of skylight in the woods. It emphasizes the texture of this young great horned owl's plumage.

Intensity is relatively unimportant . . .

. . . but light color may be significant

Calf, India. Photograph by Jim Judkis. Bathed in soft available light, this calf seems to glow as if illuminated from within.

(Courtesy of the photographer)

Figure 9.8 M Bank, Dallas Texas; 3 DI Interior *Architects.* Nick Merrick. As one of the nation's top photographers of architecture, Merrick gets assignments of this kind frequently. This typically fine interior photograph is an object lesson in organization, composition, and lighting. (Courtesy of Hedrich-Blessing)

Plate 30

Untitled product illustration. Volker Liesfeld. This elegantly simple studio photograph, made for a major client by a German photographer, shows that European carbuyers are tempted by the same beautiful illustrations that we're accustomed to.

Plate 31

Untitled. Fred Conrad. Professional photojournalists are supposed to be competent, but competence alone won't guarantee great photographs. Here Conrad demonstrates that technical skill combined with artistic sensibility—and perhaps a bit of luck—can produce a stunningly beautiful image.

ENVIRER For

Plate 32 Untitled. John Welzenbach. Welzenbach, a very successful young Chicago-based professional whose advertising photographs appear regularly in the major national magazines, makes photographs like this to attract new clients and promote his business business.

Plate 35 McCormick Place Annex, Chicago; Skidmore Owings and Merrill, Architects. Nick Merrick. By dramatizing the linear patterns formed by the overlapping cables Merrick has not only documented the structural details he was assigned to shoot, but has also managed to create an eye-pleasing design.

(Courtesy of Hedrich-Blessing)

Available Light

The term *available light* refers to light conditions (other than normal daylight) that are not arranged specifically for photography. Usually this implies indoor daylight, or artificial light—indoors or out—that you can't adjust or control and must therefore cope with as you find it (fig. 9.7).

Available light is frequently difficult to work with. The intensity may be very low, requiring fast film, slow shutter speeds, and large apertures. The color will probably not be a problem in black and white, but may require filtration for color photography. The illumination will often be very uneven and may come from several directions. In some cases it may also be intermittent or flickering; theater marquees, flashing signs, and television images are a few examples.

Conditions such as these will test your ingenuity, but you can sometimes conquer them to make dramatic or exciting photographs. Pick a camera position (and lens focal length) that displays the subject clearly, provides the most dramatic viewpoint and most effective lighting, and expresses the mood or atmosphere. Focus carefully, and if dim light requires a large aperture, make use of the shallow depth-of-field and out-of-focus background shapes for best compositional effect (fig. 9.9). Brace the camera or use a tripod for sharpest results; but consider panning or subject motion if the resulting blurs will add interest or drama. If subject contrast is abnormally high, expose fully and develop for a little *less* than normal time, unless you want to eliminate shadow details for graphic strength (see Chapter 18 for discussion of contrast control). Finally, *bracket* your exposures (overexpose and underexpose a frame or two) and take a lot of pictures, to be sure you'll have a few good ones to choose from.

Figure 9.9

It takes a trained eye to recognize exciting relationships of form and light. Making dramatic photographs of this sort also requires technical skill and quick reflexes. (Photograph by Janice Levy)

Available light is frequently difficult to work with . . .

. . . make the best of it—and bracket

A piece of wild cherry bark was positioned carefully in natural window light to make this low-key, richly textured "selected light" photograph.

Selected Light

"Selected light" is not a commonly used term, but I'll coin it to refer to some available light condition that you've *chosen* to work in, and that allows you flexibility in positioning your camera and arranging your subject. For example, if you attempt to photograph a child at home, without making any attempt to interfere with his or her activities, you'll probably be working in "ordinary" available light most of the time. If you persuade the child to play in front of your camera on a window seat or under a skylight, you're working in selected light. That may not sound like much of a distinction, but it can improve your picture quality a great deal!

I highly recommend selected light, especially for beginners, for two reasons: first, the process of looking for good light conditions will increase your visual sensitivity considerably; and second, identifying "good" light is a lot easier than "creating" it. Before you try your hand at "arranged" artificial lighting, I urge you to make a lot of "studio-type" photographs in selected "found" light conditions (fig. 9.10). Practice doing informal portraits (fig. 9.11)

Select a light condition to work in . . .

. . . and analyze the pictures critically

and still-life arrangements, and examine the results critically. Don't be afraid to adjust the existing light by setting up reflectors or diffusers, but temporarily, I'd advise against adding actual light sources, such as flash, for example. I believe you'll learn more about light and become more appreciative of image quality by working for a while *with* the light you find, rather than *against* it.

Using Flash

By selecting your light condition with care and using a little ingenuity in improving it with reflectors, diffusers, backgrounds, and so on, you'll be able to make fine quality photographs of most subjects that you can arrange or control. Occasionally, though, you may want to photograph some subject that can't be moved or arranged, and that exists in an impossibly bad light condition. In some of these situations, at least, you may be able to get satisfactory results by using *flashbulbs* or *electronic flash*.

Flashbulbs

Flashbulbs are clear glass bulbs filled with fine metal wire in an oxygen atmosphere. When electrical current is applied to them they simply burn out immediately, providing a brilliant flash of light. They're declining in popularity now, but are still available in several sizes and styles from the relatively tiny multiple-unit *flashcubes* and *flashbars* to the enormously powerful "banquet" bulbs about the size and shape of an ordinary 150-watt light bulb.

Figure 9.11

Poppy at 91 Years, 1988. Janice Levy. Levy is a versatile and prolific photographer/ teacher whose extensive professional experience is evident in the quality of her work. This photograph is from a documentary series.

(Courtesy of the photographer)

In impossibly bad light, use flash

Flashbulbs are available in several sizes and styles . . .

. . . but synchronization is somewhat restricted

Be sure the synchronizer switch is set correctly

Electronic flash units have no firing delay . . .

. . . and flash duration is very brief

Ambient illumination may supplement the flash

Although it's possible to use any flashbulb in *open flash* technique—that is, opening the camera shutter on "Time" or "Bulb" and firing the flash manually to make the exposure—they're almost invariably *synchronized* (by a mechanism built into the camera or shutter) to flash while the shutter is open at some higher speed. Flashbulbs can be synchronized at any speed with between-the-lens shutters because the whole film area is exposed during the entire exposure interval. Synchronization is more restricted with focal plane shutters because, at their higher speeds, FP shutters are never fully open.

Most SLRs will "synch" ordinary flashbulbs safely at 1/60 second or longer—and some allow speeds as high as 1/250 second—as long as the "synch selector" switch (if your camera has one) is set on the M (for *mediumpeak* flashbulbs) position. This setting delays the shutter opening for a few milliseconds after firing current is applied to give the bulb time to fire up to full brilliance. The X position on the switch (intended for use with *electronic flash*) is not recommended for flashbulbs, but can be used at slow shutter speeds. It will open the shutter at the same time the firing contact is made, and at speeds higher than about 1/15 second, the shutter will probably have opened and closed before the bulb has had time to produce much usable light. Some older cameras may provide an FP switch position for special Focal Plane type bulbs. These bulbs—now relatively rare—have extended flash duration that makes them usable at all focal plane shutter speeds.

Electronic Flash

Electronic flash units (sometimes incorrectly called *strobes*) produce their light by passing a very brief pulse of electricity through a glass or quartz tube filled with a mixture of gases such as argon, krypton, and xenon. There is no firing delay of any consequence, so electronic flash units will synch properly only on the X setting of the switch; if you inadvertently leave your synch switch set on M while using electronic flash, the flash will go off long before the shutter opens, and your film will be blank.

The flash duration is very brief—typically 1/500 second or less—and many units contain *thyristor* circuits and light sensors that measure the flash light reflected from the subject surfaces and *quench* (turn off) the flash when sufficient light has accumulated to expose the film properly. By using only as much power as is needed to make the exposure, these circuits can extend battery life appreciably. In addition, because they work by limiting the flash duration, they may provide effective flash speeds of 1/50,000 second or less, in some units.

Electronic flash synchronizes easily at all speeds with BTL (between-thelens) shutters, and with all FP (focal plane) shutter speeds that provide a full shutter opening. In almost every case, the flash duration determines the actual exposure interval, and if the *ambient* illumination (the light existing at the subject position) is fairly dim, the shutter setting isn't particularly critical as long as it's a safe synch speed.

If there is a significant amount of ambient illumination, it will supplement the flash, and if the subject is moving, a double image may be formed—one sharply defined by the brief flash and the other, probably less sharp, resulting from the longer exposure provided by the ambient light and the slower shutter speed (plate 28). You can induce this ghost image effect deliberately if you want to. It's possible to control the relative strengths of the images and the amount of blur by varying the shutter and aperture settings and adjusting the ambient light intensity. In general, changing the aperture setting will affect both images; changing the shutter setting will affect only the ambient light "ghost." If the exposure interval is long enough, you may be able to fire the flash several times for multiple image effects. You won't be able to use your camera meter (or an ordinary hand-held meter) to determine exposure when using flashbulbs, but many electronic flash units can be set to provide automatic exposure control—under some conditions. As described above, a built-in light sensor measures the light reflected back from the subject and quenches the flash when enough light has accumulated to expose the film properly. This system works well as long as the sensor is pointed at the subject; but if the flash is tilted to bounce light from the ceiling, for example, and if the sensor moves with the flash head, you'll get proper exposure for the ceiling—not the subject. Some units overcome this problem in the obvious way by separating the flash head and sensor so they can be moved independently.

Dedicated flash units are designed to work with specific cameras and to share some functions with them. Dedicated units can provide almost foolproof exposure control by using the camera's own off-the-film (OTF) metering system. Because OTF meters read light reflected from the film surface itself, it doesn't matter where the flash is pointed or how it's used; when enough light has accumulated, the meter signals the flash unit, and the flash is quenched. This system is extremely easy to use and potentially very versatile, but it is still somewhat limited; it can work only with flash units that are connected directly to the camera electrically (they can be separated physically). For the time being, at least, automatic control of multiple flash setups is limited.

If you want to measure flash output manually to calculate camera exposure settings, you can buy a hand-held *flashmeter* or one of the combination models that can read either ambient light or flash light, or both. This might be a good investment if you plan to do a lot of work with electronic flash, especially if you anticipate using *slaves*—self-powered remote units that are triggered by the flash of a "master" unit that's connected to the camera. We'll discuss the use of hand-held meters in Chapter 18.

Flashmeters aren't practical for use with flashbulbs, for the obvious reason that flashing the bulbs to measure their output destroys them. Generally, therefore, we rely on tables of flash *guide numbers* for exposure information. A guide number is simply the product of the distance from flash-to-subject and the lens f-number. If you know one of these, divide it into the guide number to find the other. For example, if the guide number for a certain flashbulb used with a certain film is 110 and you want to set the aperture at f/11, you'll have to position the flashbulb 10 feet from the subject, because $110 \div 11 = 10$. If you decide to place the light 5 feet from the subject, the appropriate aperture is f/22: $110 \div 5 = 22$.

Guide numbers are quite reliable as long as the flash is pointed directly at the subject along the camera's line of sight, but if the flash is moved to strike the subject from an appreciable angle, the exposure will probably have to be increased somewhat. You'll probably also need to increase it if you work outdoors at night or in some other dark, nonreflective environment. Obviously, bouncing the flash or using multiple flash units will introduce problems that the guide numbers can't solve, although they're useful as a basis for educated guessing.

Simple Uses of Flash

The small, camera-mounted electronic flash units that are popular with amateurs are fine for making record photographs of nearby objects and for "filling" the shadows to reduce the contrast of backlit subjects in daylight, but they are neither powerful enough nor flexible enough to be truly versatile. When used as the sole source of light and directed at the subject from the camera position, they produce a harsh front light that diminishes rapidly in intensity Some flash units provide semiautomatic exposure control

Dedicated flash units interact with the camera controls

Special flashmeters can determine flash exposure

. . . but they're not practical for use with flashbulbs

Guide numbers are fairly reliable

Small flash units are fine for "filling" shadows . . .

. . . but used alone they provide a harsh, glaring light

This New Year celebrant was stopped in mid-laugh by the instantaneous burst of light from a camera-mounted electronic flash unit. (Photograph by Janice Levy)

(Filotograph by Janice Le

(fig. 9.12). Photographs made this way typically display glaringly overexposed foreground objects silhouetted against murky black backgrounds. This isn't a necessary characteristic of electronic flash; an ordinary light bulb, candle, or flashlight mounted in the same position will produce the same effect. Direct front light from *any* small source provides unsubtle, harsh, and frequently ugly illumination.

Photojournalists, who must often work with camera-mounted flash units, frequently bounce the flash from a wall or ceiling—if one is available—to soften the light and improve its modeling effect on the subject forms. When that's not possible, they sometimes bounce the light from a small white card mounted on the flash unit itself. Although this doesn't eliminate the flattening effect of front lighting, it does soften the light a little by enlarging the source. A third technique that's effective in small, reflective spaces, is to use a *bare bulb*— a flashtube without any reflector—either alone, or in combination with a conventional flash unit. By illuminating the surrounding room surfaces, the bare bulb provides fill light that reduces contrast and improves gradation.

Although any of these techniques is better, for most purposes, than simple, direct, on-camera flash, they are all really emergency measures designed to guarantee acceptable results under difficult conditions. In fact, they often produce very satisfactory—and occasionally very pleasing—photographs (fig. 9.13). I recommend any of them for use when time is short and conditions are uncontrollable.

Artificial Lighting

Recognizing good light is easier than creating it. No matter how skillful you are in exploiting daylight and available light situations, your first attempts at artificial lighting are likely to result in less-than-beautiful pictures that leave you baffled and a little frustrated.

Beginners typically make three serious mistakes when they attempt artificial lighting. They tend to use lights raw (small sources, direct without diffusion) and they place them too close to the subject (for maximum intensity). This inevitably produces a harsh, glaring effect with burnt-out highlights and

Bouncing light to enlarge the source improves quality

The results are often very satisfactory

Beginners typically make three mistakes in lighting

a. This informal group portrait is totally unsuccessful in the existing room illumination. From this camera position, the window glare is overwhelming.
b. Direct flash fill from the camera position reveals details of the subject satisfactorily, but creates characteristic edge shadows and minimizes surface form and texture.
c. Bouncing the flash from the ceiling produces a much more flattering quality of light. The illumination is more uniform, the edge shadows are eliminated, and forms and surfaces are described with greater subtlety.

(a)

(b)

(c)

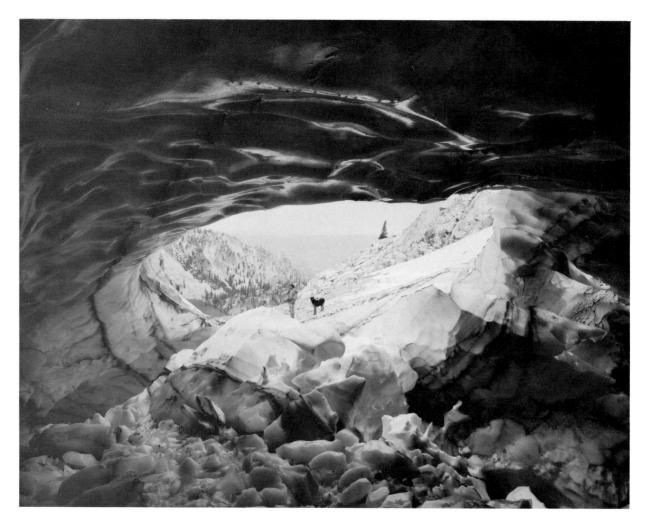

Looking Through the Snow Tunnel Above Goat Lake, Sawtooth Range, Idaho, 1981. Mark Klett. Klett has handled this difficult subject with great skill. The subtle gradations and delicate textures of the icy surfaces are rendered with remarkable clarity.

(Courtesy of the photographer)

Direction and source area are most important

Ordinary daylight consists of a small main source . . .

black shadow areas, which leads to the third mistake—adding more lights to "kill" the shadows. This almost never works, and simply makes the picture visually confusing. You'll probably make these mistakes, too, but don't despair; it takes a little while to develop "an eye" for good lighting. You'll improve with practice.

The Attributes of Light

The basic attributes of light, described previously, are *direction*, *area of source*, *intensity*, and *color*. The most important of these are direction and source area. Intensity, per se, is significant only when it begins to cause exposure problems, and light color—unless extreme—is rarely a serious concern in black-and-white photography, although it's critically important in color work.

Although it's not easy to simulate daylight in the studio (nor is it always desirable to try), daylight is a familiar and believable light condition that's worth referring to from time to time. Ordinary sunny daylight is characterized by a single, relatively small, intensely bright *main* light source (the sun) that typically shines downward on the subject, forming distinct shadow and highlight patterns. In the absence of any *fill* light to illuminate the shadows (as is the case in outer space, for example) sunlight is a very contrasty light and the *lighting ratio* (illuminance difference) between highlight and shadow areas can be extreme.

Fortunately, the sky serves as a very large source of diffused fill light that effectively reduces the lighting ratio and makes shadow details visible. In most outdoor situations, a substantial amount of light is reflected into the shadows from the ground and from nearby objects, so contrast is reduced still further. In practice, the measurable difference between sunlight and shadow illuminance may range from less than one stop (on a heavily overcast day) to several stops, when the atmosphere is clear and the sky is cloudless.

One of the most significant characteristics of daylight is its uniformity. Because both the sun and the sky are so far away, there's no measurable variation in illuminance (barring cloud shadows, of course) anywhere within camera range. That's definitely not the case in the studio where, if you're not careful to prevent it, illumination intensity can vary considerably within just a few feet—from one side of the subject space to the other. This is especially true when only a single light source is used.

This light *falloff* (loss of intensity with distance) is explained by the *inverse* square law, which tells us that ''illumination varies inversely with the square of the distance from the light source to the illuminated surface.'' This implies that, for example, if the distance from a light to some surface is tripled, the light intensity on the surface is reduced to one-ninth its original value.

That, in itself, isn't particularly serious because you can usually make up the difference by simply increasing the exposure—in this case by three stops. It becomes much more significant when two or more objects at different distances from the light source must be photographed together (fig. 9.15).

Fortunately, the inverse square law is completely accurate only for "point" light sources in totally unreflective environments. In real life, it's not quite as serious as it sounds because practical light sources are larger than "points" and there is almost always some reflected light present to reduce contrast. There's no doubt, though, that objects close to a light source will normally be more brightly illuminated than distant objects are, and if both are included in your photograph and nothing is done to correct the situation, the difference will be obvious.

Basic Lighting

An excellent way to combat illumination falloff is to enlarge the light source. Just as an overcast sky provides practically shadowless illumination, light can be bounced from the studio walls and ceiling to flood the set with soft, indirect light that can be essentially uniform in intensity throughout the entire subject area. Although this kind of light alone is appropriate for *high key* effects that translate the subject tones into pale grays or light pastel colors without black accents, it's really too bland for general purposes. It's a good way to start a lighting setup, though, because it will guarantee at least adequate shadow illumination (fig. 9.16).

Adding a main light to this general illumination can transform it into a very workable light condition. Position the main light (normally above and a little to one side of the camera) so that it provides a pleasing relationship of high-light and shadow on the subject, and adjust its angle until the illumination is as even as possible across the subject area. Then adjust the lighting ratio (by increasing the intensity of the main light or decreasing the general illumination level) until the subject's form and texture are well expressed and the visual contrast is satisfactory. In general, as the lighting ratio increases (that is, as the main light becomes relatively brighter and more dominant), contrast and color saturation will increase and the subject's form and depth will be emphasized (fig. 9.17).

. . . plus diffused fill light

Daylight is uniform, studio light rarely is

The inverse square law . . .

. . . is completely accurate only for point sources

To combat light falloff, enlarge the source

A main light plus general illumination is often workable

(a)

Figure 9.15

a. This photograph demonstrates the harsh, uneven quality of illumination that is typical of a single, small-area light source used close to the subject. The floodlamp was placed about 8 feet from the group and the illumination intensity diminishes by about a stop-and-a-half across the width of the group.

b. Moving the floodlamp about 30 feet from the subject illuminates the group more evenly although the light quality is still harsh and unpleasant.

c. Increasing the source area by bouncing the light from large reflectors placed above and in front of the group produces a much softer, more attractive quality of light. Despite the fact that the larger source was only about 8 feet from the subject, the light falloff is negligible.

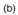

(C)

When light reaches the subject quite evenly from all sides, the effect is bland and lifeless. Color and value contrast are reduced and the subject forms are modeled very subtly. Although this sort of light is not very useful by itself, it's a good way to begin a lighting setup.

Figure 9.17

By increasing the intensity of the illumination in selected areas of the reflecting surfaces that surround the subject, it's possible to improve the modeling of form without sacrificing shadow details or creating harsh contrasts. This photograph was made with the same basic setup used in figure 9.16, but with an extra light bounced from the large reflecting "flat" (movable wall) above and at the right of the camera. Although this is a simple lighting arrangement, it's very useful.

Marat/Sade. Max Waldman. Waldman's artistry in the control of light and image tonality is demonstrated in this sensitive image.

(Courtesy of the photographer)

. . . but refinements may be needed

Contemporary portraiture suggests a trend toward informality

This basic lighting arrangement—general, directionless, low-intensity illumination, plus a directed main light of higher intensity to emphasize form and add visual contrast—can be used very satisfactorily without modification for some sorts of subjects. In many cases, though, you'll need to enhance local details or textures, modify the light distribution in some way to affect the mood or atmosphere of the picture, or alter the contrast between some subject area and its background (fig. 9.18). These refinements may require additional lights or reflectors, or both, and are sometimes difficult to accomplish, but they can often improve the appearance of the photograph immensely.

Professional portrait photographers, for example, have traditionally used at least three—and usually four—light sources for their ''standard'' studio poses. The main or ''key'' light establishes the dominant pattern of light and shade; a fill light (substituting for the general studio illumination mentioned above) reveals shadow details and controls the lighting ratio; a back light or background light separates the subject from the background tone; and a ''hair'' light—usually placed high, behind the subject—is used to create a bright halo effect around the subject's head (fig. 9.19). There have been many individual variations of this standard setup, of course, and contemporary styles

(c)

(d)

(b)

in portraiture are increasingly diverse, suggesting a trend toward a less formal approach to both pose and lighting.

Still-life photography is an excellent way to gain experience in lighting because it doesn't require very much space or a lot of expensive lighting equipment. Also, you can work at your own pace and reshoot as many times as necessary to get the results you want. Finally, if you run out of ideas and need inspiration or guidance, you can compare your own efforts with the many excellent examples of still-life arrangement and lighting in the advertising pages of any major national magazine.

Figure 9.19

Portrait photographers have traditionally used three or four lights for studio "headand-shoulders" portraits. A key light (*a*) establishes the basic pattern of light and shade; (*b*) the addition of a fill light, or reflector lightens the shadows and reduces contrast; (*c*) adding a background light separates the subject's shoulders from the background bone; and (*d*) a hair light completes the setup by providing highlight emphasis and outlining the head against the dark background. In some situations, the background light may not be necessary. Photographs of model Jennifer Sater by Roxanne Frith.

(a)

Figure 9.20

a. In the direct light of a single photoflood lamp, this brass camel appears excessively contrasty and the ground shadow is confusing.

b. In a white tent environment with totally directionless light, contrast is reduced and the polished brass surface appears dull and gray.

c. Here the white background paper has been replaced with light gray and selected areas of the white tent surface have been more strongly illuminated to accent the form and emphasize the camel's high polish.

Ad illustrations can teach you a lot about lighting

Tent lighting permits almost total control . . .

. . . try it

(b)

(C)

Whether you are interested in commercial photography or not, you can learn a lot about lighting by studying advertising illustrations. I suggest that you select a few that appeal to you and analyze them. Try to figure out how many light sources were used and whether they were small sources that formed hard bright highlights and sharp-edged shadows or large sources that produced soft, milky highlights and grayish shadows. See if you can tell where the lights and reflectors were placed and how close they were to the subject. Notice how the photographer controlled the light to emphasize the important features of the product. Study the formal arrangement. Notice especially how clearly the important forms have been separated from their backgrounds and how that separation has been accomplished. Finally, has the photographer used light in a way that suggests a mood or atmosphere? Can you identify the techniques or manipulations that contribute to the mood?

Tent Lighting

Product photographers frequently use some form of *tent lighting* because it effectively isolates the subject in a visually "clean" environment and permits almost total control of the light. You'll find evidence of this in their photographs if you look at them carefully. Hard shadow edges, conflicting shadow patterns, and confusing surface reflections are rare in professional work.

I suggest that you experiment with tent lighting. Find some interesting object that's not too large to be handled easily and photograph it first in direct light on a simple *limbo* background (fig. 9.20a), then enclose it in a tent of

translucent paper and photograph it again (fig. 9.20b). Examine the images critically to see how the form, texture, and volume of the object have been affected by each light condition.

Good *descriptive* lighting usually illuminates the three major surfaces (top, front, side) of a three-dimensional object differently. Typically we expect the top to be most brightly illuminated, and the front and side planes to be assigned two lower levels of illumination. Frequently the three-dimensional effect can be enhanced even more by using a background of medium tone (fig. 9.20c). Although many subject forms are more complex than simple cubes, this "three-plane" lighting principle is valid in most situations where forms must be described clearly. Like all other "principles," however, it isn't mandatory; I suggest it merely as something to consider when things aren't working out well and you suspect your lighting arrangement may be the problem.

When you're constructing a tent, don't enclose the subject any more completely than is necessary to isolate it from outside interference. It's much easier to provide a directional main light if you can leave all or part of one side of the tent open; and of course, you'll have to leave an opening in the front wall to shoot through. If you don't need the contrast and crisp shadow edges of a direct main light, try concentrating intense illumination in a small area of a tent wall (with a spotlight, for example) to provide a condition similar to hazy sunlight. Alternatively, you may be able to get good results by simply covering one or more of the tent walls with black paper to increase the lighting ratio. This will reduce shadow illumination considerably, often modeling the subject forms nicely and increasing image contrast without harshness.

As you make these adjustments of light direction and relative intensity, watch the subject surfaces carefully to check for awkward shadow and reflection patterns. If they seem unavoidable, consider moving either the camera or the subject. In some cases, you may be able to subdue or eliminate unwanted reflections by using a polarizing filter over the camera lens. Be careful, though; the polarizer may affect other areas of the subject undesirably.

You can see how the controlled environment of a tent works to improve surface rendering in figure 9.21. Simply shining a raw light on an object is rarely a good way to handle it. Ordinary indirect room light may be satisfactory for some types of subjects, but polished surfaces reflect details of the room interior that can interfere with perception of the subject's own form and texture. Shielding the object from the confusion of the room environment will "clean up" the surfaces, but "tenting" the subject completely may neutralize the surfaces and leave them sterile and lifeless. You can restore the subject's form and luster with planned reflections, by fastening strips of gray, black, or colored paper to the tent walls.

In some cases you may see the entire interior structure of the tent defined clearly in the mirrorlike surfaces of bright metal or glass objects. The camera reflection may appear there too, and if you've tried to avoid it by poking only the lens through a hole in the tent wall, the lens will probably show as a black spot. There is almost no way to eliminate these reflections without altering the character of the surface itself, so accept the fact that they're going to be there and make them work for you!

You'll have to use your imagination and creativity here, but you may be able to cover the troublesome reflections—or at least divert attention from them—by using the paper strips to ''draw'' your own reflection patterns. ''If you can't hide it, paint it red!'' is good advice. Attack reflection problems boldly; if there are going to be reflections, make them a feature of the photograph, not an obvious blemish.

The subject's own shadow is sometimes reflected in its surfaces, causing unsightly patterns and visually "tying" the subject to the ground. You may be able to solve this problem by shooting the object on a *light table* (a transilluminated translucent surface) or by raising the subject off the table surface "Three-plane" lighting is often desirable

Check for awkward shadow and reflection patterns

Shiny objects may create troublesome reflections

"If you can't hide it, paint it red!"

The subject's own shadow may "tie it down"

(a)

Figure 9.21

a. Although dull-surfaced objects seem to be easier to light than shiny ones, all objects are affected by their environments. When you learn to light shiny surfaces well, you'll find matte surfaces easier to deal with, too, and the results will be better. Here a polished silver spoon, illuminated by diffused window light, reflects the room interior in confusing patterns.

b. Simply standing a white card beside the spoon "cleans it up" by blocking off part of the room reflections.

c. Here the spoon is completely "clean." Covering it with a translucent tent of tracing paper has eliminated the reflections but left the surface featureless and formless. The polished surface appears matte and gray. d. To restore some of the form and surface quality necessary to express the character of silver, controlled reflections are produced by applying black paper strips to appropriate areas of the tent, both inside and out. The cast shadow from the cardboard strip at upper right produces a soft gray reflection; the small black strip inside the tent adds a sharp black accent. e. Here is one possible effect. The variations are endless.

f. Here is the spoon as it would appear with the tent removed. Simply directing a light at a shiny object (or any object) is rarely a good way to handle it.

(b)

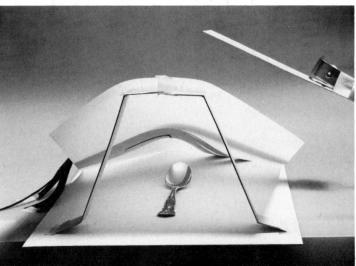

(d)

(f)

Figure 9.22

a. Although this router bit is well described by the single light and the natural reflections from the white table surface, the shadow is an awkward and confusing visual element. b. Here the router bit has been elevated about 4 inches above the table surface on a concealed wire support. A small piece of black paper placed on the table out of the picture area removes the white reflection from the left "wing" of the bit, and a piece of aluminum foil supplies the bright reflection on the cutting edge, at right.

(a)

(b)

so that it can be lighted more evenly. If the subject is small and light, you may be able to support it on a wire or a dowel projecting through the background wall. Larger, heavier objects can sometimes be supported by sturdier structures or, in extreme cases, rested on a stand, facing upward, and shot from above. Be sure the support dowel or stand is completely concealed behind the object and that there are no obvious shadows from the support (fig. 9.22).

These few suggestions should introduce you to artificial light control, but you'll have to learn lighting techniques by experience. Start small; even a medium-size set consumes a lot of space and takes a lot of light-much more of both than is available in the average home. It's a mistake, for example, to try to do serious figure studies in your living room with a couple of 500-watt floodlights and a bed-sheet background; that's simply asking for blown fuses and frustration.

Remember, for descriptive clarity in your work, create only one set of shadows (one main light source) and keep the lighting ratio low enough to preserve both shadow and highlight detail. Use direct "raw" (small area source) light sparingly; "bounced" light (large area source) is softer, gentler, and generally preferable. Remember, too, that there are no "rules" of lighting; if you're not interested in simply describing the subject accurately and elegantly, use any sort of illumination that pleases you (fig. 9.23). Just be sure to look at the light effect as you create it so that you'll realize what you're doing-and know when you've done it right.

Start small; give yourself room to work

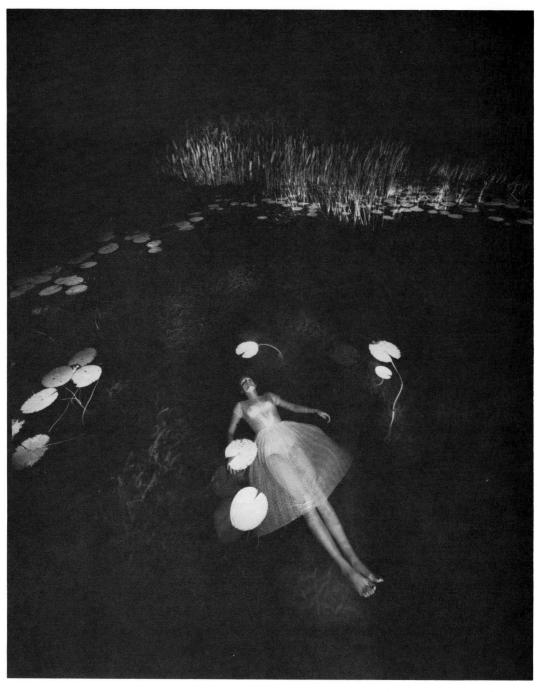

Figure 9.23

Untitled, 1976. Lorran Meares. Meares assembles fascinating photographs, such as this one, by patiently painting selected areas of the subject with light and multipleexposing with a stereo camera. Although these images are intended to be viewed in stereo, they're graphically strong and haunting in ordinary reproduction.

(Courtesy of the photographer)

Summary

Light has several characteristics that affect the appearance of the photographic image as well as our interpretation of it. The direction from which light strikes the subject and the degree of diffusion (as determined in part by the area of the source) are very important. Intensity is sometimes an important factor; light color is mainly important in color photography.

Available light is frequently difficult to work with, but if you take advantage of existing conditions, they can sometimes help you make exciting photographs. Bracket your exposures and take lots of pictures to be sure you have some good ones. If you can move your subject into some selected light condition, it will be easier to get good results. Add reflectors or diffusers if necessary to modify the subject light.

Use flash in situations where available light is unworkable. Flashbulbs produce a lot of light, but are somewhat inconvenient to use. Electronic flash is more popular and most units can be set for automatic exposure control. Unless used as open flash, both types must be synchronized. Bulbs require M or FP synch; electronic flash synchronizes on the X setting of the synch switch. Dedicated flash units may use the camera meter to control exposure.

You can measure flash output with a special flashmeter—almost a necessity if you plan to work with multiple slave lights. You can estimate exposure settings for simple flashbulb setups by consulting a table of guide numbers.

Bouncing flash will improve image quality in many cases; so will the use of bare bulb flash.

Beginners typically make three mistakes in lighting: they use lights raw, they place them too close to the subject, and then they use more lights to try to cover up the problems they've caused.

The important characteristics of light are direction, area, intensity, and color. Direction and area are most important in black-and-white photography. When you recognize these characteristics, you can produce almost any kind of light effect with almost any sort of light—within reason. Daylight is a useful model to study.

The inverse square law identifies the cause of light falloff. Counteract it by keeping lights at a distance, by feathering them, and by increasing the source area. Reflected light usually helps fill the shadows and reduces lighting contrast.

Bounce light is fine for high key work; add a main light for increased subject contrast and improved modeling. Improve edge separation and local contrast with additional lights or reflectors. Standard portrait lighting takes four lights, but individual practices vary.

Still-life photography is an excellent way to study lighting. Study advertising illustrations to see how the professionals solve lighting problems. Tent lighting provides a clean environment and allows considerable control of light effects. Descriptive lighting usually separates the three major subject planes: top, front, and side.

Shiny objects will reflect their environment; tent them and control the reflection patterns by modifying the surfaces of the tent walls. Float the subject on a hidden support to eliminate a ground shadow.

Good lighting requires room to work and serviceable equipment; don't expect to do excellent work in a crowded environment without adequate facilities.

Processing Rollfilm

Casa del Oro, Monterey, California

Photograph by Roger Fremier. Fremier's technical skill in preserving an amazing range of subtle tones in both ends of the print scale has raised this rather banal subject out of the ordinary to produce a beautiful print/object.

(Courtesy of the photographer)

You can use a tank to process film in normal room light

After rollfilm has been exposed in the camera, it's customary to load it (in total darkness) into a lighttight developing *tank* so that the necessary chemical processing steps can be carried out safely in normal room light. The film is treated first in the *developer* solution, where the *latent* (invisible, hidden) image is gradually converted to a visible one that grows darker and more contrasty as development progresses. When the image is sufficiently formed, development is halted by the *stop bath;* then the *fixing bath* dissolves the unused silver halides so that the film is no longer light-sensitive. Washing and drying complete the process.

Rollfilm Processing Equipment and Facilities

Rollfilm can be processed successfully in any clean environment where temperature can be controlled within reasonable limits, where there's a convenient supply of clean water, and where a totally dark space is available for tank loading. Only a few items of equipment are required.

The Developing Tank

You will need a developing tank and there are several types to choose from. I recommend a good quality stainless steel model that is large enough to hold two rolls of 35mm film (or one roll of 120-size film). It should have a cover and one or more *reels* to accommodate your film size. Plastic tanks, although less expensive and perfectly usable, are less desirable in my opinion. Admittedly, stainless tanks are more difficult to load until you learn to handle them, but they're generally more durable, more economical with solutions, easier to clean, and less likely to cause problems of uneven development. Not everyone agrees with this, though, so make up your own mind.

Thermometer

Developer temperature control is very important, so you'll need a good thermometer that covers a temperature range of approximately 50° F to 120° F. I recommend the thin-stemmed metal dial type, but the less expensive glass thermometers designed for photographic use are satisfactory.

Timer

A timer of some sort is essential. A watch or clock with a second hand will suffice, but you'll find a regular darkroom timer more convenient to use. Get one with large, luminous hands and numerals so you'll be able to read it easily in the dark. If you buy a digital timer, be sure the display can be dimmed or turned off so that it can be used later for *tray processing* of special film materials. If money is no object, you may want to consider a programmable timer that can be set to give audible signals at the end of each of several process intervals.

Utensils and Containers

You'll need some utensils for mixing, measuring, and storing the various processing solutions. Plastic graduates, funnels, and stirring rods are relatively inexpensive and serviceable. Store developers in clean brown bottles (to protect them from light); ordinary white bottles are fine for storing the other solutions. Glass bottles are excellent for storage of all the solutions, but are relatively heavy and breakable. Plastic bottles are probably preferable, especially in a community darkroom environment.

There are several tank types to choose from

You'll need a good thermometer . . .

. . . and a timer

Plastic utensils are serviceable

Film Washing and Drying Equipment

Rollfilm can be washed satisfactorily in the developing tank, but special film washers will do the job faster and more efficiently. If you want to improvise, you can make an effective film washing tank out of an old plastic jug by cutting off the top and punching a few holes around the bottom edge. Stack the loaded film reels in it and set it under the faucet. Water flowing in the top will leak out the bottom, carrying the processing chemicals with it.

You can use wooden or plastic clothespins to hang the film for drying, but special *film clips* are better. I recommend stainless steel clips. Use one to hang the film and another to weight its lower end to prevent curling.

Although films treated with a *wetting agent* solution usually dry evenly, you may occasionally find it necessary to wipe them. Special photographic sponges and rubber squeegees are available for this purpose, but I don't recommend either. If you find that you must wipe film, I suggest using a fine, clean chamois skin that has been well soaked and squeezed—not wrung—dry (fig. 10.8). Wringing a chamois skin is liable to tear off tiny fibers that can remain on your film.

Cleanup

A large sponge is useful for cleaning work surfaces and soaking up spilled liquids. Reserve a few old towels for darkroom use, too, and launder them frequently. Don't use good towels because the chemicals will stain them badly. It's impossible to keep a darkroom too clean. When in doubt, wash everything. Then wash your hands.

Process Introduction

Water for Photographic Use

In most locations, tap water is generally satisfactorily clean and pure for photographic use, but in some cases it may contain dirt particles, algae, or chemical residues that can be troublesome. As a rule, mildly contaminated water is usable as long as it remains more or less consistent, but if the quality varies unpredictably, it can have disastrous effects on image quality. Dissolved air, which is common in tap water, is potentially harmful to some photographic solutions—especially developers—that are to be stored for more than a few days or weeks. However, if the water is otherwise satisfactory, boiling and cooling it or simply letting it stand for a day or two to allow the air to escape will make it usable. If you suspect that your water is not entirely safe, you can use distilled or deionized water for mixing developers, *toners*, and other sensitive solutions. Any water that's palatable and safe to drink should be suitable for most other photographic applications, including mixing or diluting developers for immediate use.

Preparing and Storing Developers

There are a great many different film developers. Some are sold as ready-touse solutions and some are packaged in powder form, to be mixed with water for use. Schools frequently supply their students with liquid developer concentrates—or *stock solutions*—that must be diluted to make the *working solutions*. At least one of these developers (Kodak's HC-110) requires an extra step: it suggests a preliminary dilution of the syrupy concentrate to prepare an intermediate stock solution, then specifies further dilution to any of several listed strengths, for use. Liquid concentrates are not all alike and their mixing instructions can be confusing; read and follow their directions carefully. You can improvise a film washer

If you must wipe film, use a damp chamois

Keep your darkroom—and your hands clean

Tap water is usually suitable for photographic use

Dilute concentrated stock solutions to make working solutions

Most working solutions don't keep well

One-shot developers are consistent and convenient

D-76 is a good general-purpose developer

Photographic chemicals can cause contact dermatitis

You can avoid Metol if necessary

Working solutions of most developers deteriorate within a relatively short time (a few hours or days) if exposed to air, especially if they've been used. For maximum life, it's a good idea to store developers in concentrated stock solutions whenever possible, and keep them in tightly capped bottles of brown glass or plastic, filled to the top to exclude as much air as possible. If you choose one of the highly advertised (and expensive) name-brand developers that are designed to be used and *replenished* repeatedly, it's particularly important to store it safely. Because replenished developers are routinely poured into and out of various containers during their working lifetime, they're particularly susceptible to contamination. Keep your graduates and funnels clean!

One-shot developers are designed to be stored in stock solution, diluted for one-time use, and then discarded. This procedure has two major advantages: the highly concentrated stock solutions are very long-lived, and because every film is developed in freshly diluted working solution, development is predictable and repeatable (as long as water quality remains constant) from the first roll to the last. By comparison, replenished developers are generally less stable and less controllable.

Some prepared developers can be used either by replenishment or, with some dilution, as one-shots. When this option exists, I strongly recommend one-shot use. Kodak's old faithful, D–76, is a good example. Although a replenisher is available, I advise against using it. D–76 is a popular developer that's efficient, convenient to use, and relatively inexpensive, but it doesn't keep very well. Its solutions gradually gain strength with age and can become dangerously active in just a few weeks—long before there's any significant color change to warn of deterioration. For this reason I consider replenished solutions of D–76 to be unreliable and recommend mixing the developer in small quantities, using it as a one-shot, and discarding any unused stock solution that's more than a month old. When used this way, D–76 is a fine, versatile, clean-working developer that's well-suited for use with all generalpurpose films.

Although working solutions diluted from liquid concentrates can be used immediately, powdered chemicals may not dissolve completely for several hours, even though the solution may appear to be quite clear. For this reason, when mixing developers (especially) from dry ingredients, it's a good idea to prepare the solutions a day or so before you plan to use them.

Metol Poisoning

A few unfortunate photographers are sensitive to some processing chemicals and suffer from skin rashes, itching, and open sores when working with them. When this contact dermatitis occurs, it's so often caused by a common developing agent called Metol (Kodak's product name is Elon) that the condition is commonly known as Metol poisoning, whether or not Metol is actually at fault.

Metol is a very useful chemical and has been a major ingredient in most film and print developers for many years. Now an increasing number of developers have replaced Metol with a relatively harmless agent, introduced by llford as "Phenidone." Although most developers carry chemical warning labels and usually list Metol (as something like "monomethyl para-aminophenol sulfate") when it's included in the formula, it may not be clearly identified. Metol is rarely included in very highly concentrated liquid stock solutions and is much more likely to be present in developers that are sold as powders, but this is not a totally reliable guide.

(g)

(c)

Figure 10.1

a. Open the film cartridge with Kodak's special gadget or a hook-type can opener b. Cut off the film tongue. Some films will tear; some won't. Scissors are recommended.

c. Palm the spool and squeeze the film edges together lightly to keep the extended end from rolling up.

d. Locate the end of the spiral film guides with your forefinger. They should be at the top of the reel, pointing toward the hand that holds the film.

e. The reel hub may be equipped with a clip to hold the film end or it may simply have a wide slot, as shown. Insert the film into the slot and center it between the reel flanges with thumb and finger of the left hand. This is important.

f. The start is critical; keeping the film slightly curled with the right hand and centered between the reel flanges with the left hand, pull on the film lightly and turn the reel counterclockwise so the film is bent sharply around the hub. It should slip smoothly into the spiral track. Let your left forefinger ride lightly on the back of the film to check for bulges and continue rotating the reel, feeding the film with the right hand. g. If you detect any irregularity as you wind the film, go back at least a full turn and find the trouble; don't just try to force it. Correctly loaded film will feel loose in the reel grooves. When the reel is loaded, cut off the film spool and tuck the film end into the tank. Be sure the cover is on snugly before turning on the lights.

(f)

(d)

Figure 10.2

If you don't load the tank properly or if you handle the film roughly, your negatives and prints may suffer, as shown here. On the negative strip (seen from the emulsion side) the irregular black blob resulted from improper loading; adjacent layers of film touched, preventing the processing liquids from doing their work. The raw emulsion material, neither developed nor fixed in this case, appears on the negative as a milkygray area that is virtually opaque to transmitted light. It prints as a totally white shape. The little black crescent shapes I call "findernail marks" because they resemble nail trimmings. They result from kinking the film; they print white or light gray.

Figure 10.3

a. Check each solution's temperature and set the bottles in a water bath if they need adjustment. If much change is necessary pour the solution into a stainless steel film tank and set the tank in the water bath. Stir the solution with the thermometer stem gently until the temperature is satisfactory. b. You can pour the developer into the loaded tank, like this, or you can fill the tank with developer before you load the film and place the loaded reel into the tank in the dark. Be sure to cover the tank before turning on the lights. In either case, start the timer as soon as the film is covered with developer.

c. Agitate continuously and vigorously for the first 15 seconds or so, then start a routine agitation procedure as described in the text.

d. When the developing time is almost up, discard the developer if it's a one-shot (recommended). If you're using a replenished developer, pour the solution back into its storage bottle. Time either operation so that you can complete it and begin to pour in the stop bath before the timer rings. Ideally the tank should just be filled with stop as the timer goes off to signal the end of the developing step. e. Agitate for about 30 seconds then discard the stop solution. Some photographers save and reuse the stop bath but I prefer to mix it fresh for each use. f. Pour in the fixing bath and note the time so you can determine the film clearing time.

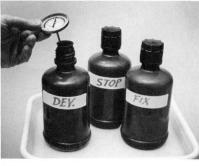

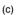

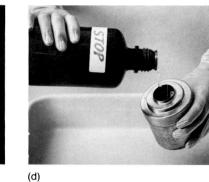

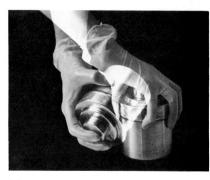

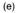

(f)

(i)

(k)

(m)

(j)

(I)

(n)

g. Agitate for 15 seconds or so, then remove the tank cover and inspect the film to see if it's clear. If not, return it to the fixer and agitate it occasionally by lifting the reel out of the solution and replacing it. When the film appears to be clear, determine how long clearing has required and continue the fixation for another similar time interval (see text).

h. Pour the fixer back into its storage jug. You can reuse it until it fails the hypo test (see text).

i. Rinse the film briefly to remove the surface fixer, then pour in the hypo-clearing bath. Follow the manufacturer's recommendations for clearing time. Agitate periodically by picking the reel out of the tank and replacing it. Discard the used clearing bath unless the manufacturer's instructions recommend reusing it.

j. Wash the film in running water. If you use the film tank for this operation, as shown, empty it completely several times during the washing process to insure complete water changes. Follow the washing instructions given for the clearing bath you use.

k. Treat the film in a wetting solution such as Photoflo, suitably diluted with distilled water. Let it soak for a few seconds, then . . .

I. . . . attach film clips to both ends of the film strip and seesaw it through the wetting solution a few times to rinse off any particles of dirt or lint that may be present in the solution.

m. After several brisk passes through the wetting solution stretch the film strip out to its full length, almost horizontally, and let the liquid flow to one edge as it drains off the lower corner. This will help to shift possible dirt and scum marks to the edge of the film, out of the image area.

n. Hang the film strip to dry in a drying cabinet, or other well-ventilated, dust-free environment.

It's very important to control time, temperature, and agitation

Development Controls

The ideal negative is neither too *dense* nor too *thin*, neither too *contrasty* nor too *flat*. Since negative quality is largely dependent on development, it's very important to control the factors that can influence it. There are several of them. The most important ones are *time*, *temperature*, and *agitation*.

Time

The time of development is easy to control. Most developers need several minutes to form a good image and an error of a few seconds is not very serious. It's conventional to begin timing development as soon as the film is completely immersed in the developer and to consider development finished as soon as the stop bath covers the film.

Temperature

Temperature control is important because developers—and virtually all other chemical solutions—work faster when their temperature is raised. The standard temperature for film development is 68° F (20° C). For consistent negative quality, this temperature should be maintained within one or two degrees Fahrenheit (plus or minus one degree Celsius).

Agitation

During development the developer chemicals at the image site are being exhausted. If the solution is allowed to remain stagnant, fresh active developer is prevented from reaching the emulsion. In addition, the development process produces soluble bromide salts that effectively *restrain* developer action, significantly slowing development. To counteract these effects, you'll have to *agitate* the developer throughout the development period.

There is considerable disagreement on the subject of tank agitation but one fact is indisputable: if you don't do it right your negatives will develop unevenly. Although it seems obvious that constantly shaking or twirling the tank to keep the developer in motion will solve the problem, it's not quite that simple.

As a general rule, too little agitation during 35mm film development results in streaks of varying density running crosswise on the film strip, clearly related to the film's edge perforations (fig. 10.4a). These streaks are apparently caused by *bromide drag* as the heavy soluble bromide tends to drain down across the film. Obviously some agitation is necessary to disrupt this gravity-induced flow.

I used to share the common belief that too much agitation causes overdevelopment of the film edges, due to excessive developer turbulence near the reel flanges. It now seems more probable that this edge effect (fig. 10.4b) results from continuous (or too-frequent intermittent), but *too-gentle* agitation. When *all* the developer in the tank is set in motion by vigorous agitation, development is most likely to be uniform.

For routine tank development of general-purpose films, I now recommend inverting the tank abruptly, then twirling it around its vertical axis vigorously, repeating this performance at least twice in 5 seconds. Then let the tank rest quietly for 25 seconds. Repeat this agitation sequence for the entire time of development.

No matter how vigorously you agitate, it's difficult to obtain uniform development if the tank is completely full of developer. If possible, include an empty film reel in the tank as a spacer, and use only enough developer to

If you don't agitate properly your negatives will develop unevenly

It's difficult to agitate a full tank effectively

(a)

cover the loaded reel or reels. This will leave enough air space so that the developer has room to flow freely through the film layers during tank inversion, effectively flushing out the accumulated bromide. Not all photographers will agree with this recommendation, but it works for me and I think it will work for you, too.

There are certain exceptions, however. Kodak's Technical Pan films seem to prefer much less vigorous agitation (at least when developed in their special Technodol developer), and if you prefer to use a replenished developer with general-purpose films, you should probably fill the tank to minimize foaming and splashing that hastens the oxidation of the developing agents. You may also have to use a greater-than-minimum volume of developer when using certain highly-diluted one-shot developers, simply because the minimum quantity required to cover the film reel may not have enough reserve strength to develop the film satisfactorily. The instructions will generally tell you what minimum volume is required, and you should follow them.

The Stop Bath

The usual *stop bath* is a 1 percent to 2 percent solution of acetic acid. It's generally prepared for use by diluting a standard stock solution (28 percent acetic acid) with from 15 to 30 parts of water. Some stock solutions contain an *indicator* dye that colors the working solution yellow as long as the acid is active, then turns purple to warn of exhaustion. The 28 percent acid has a strong odor and can irritate the skin, but it's not really dangerous if handled carefully.

The more potent (99 percent) *glacial* acetic acid—while not as violently corrosive as hydrochloric or sulfuric acids—will attack some metals, can burn the skin painfully on brief contact, freezes (and may break a glass container) at about 62° F, and is a good solvent for certain plastics. It also has an extremely sharp, penetrating odor that you're not likely to forget, and its vapors are said to be flammable. Despite this dangerous potential, glacial acetic is a relatively "friendly" sort of acid that deserves respect, not fear. If you must use it, handle it carefully (wear hand and eye protection when handling any concentrated acid) in a well-ventilated area and you'll have no trouble with it.

Figure 10.4

a. If you agitate rollfilm too little or not at all during tank development, you can expect to see your pictures streaked from "bromide drag," like this.

b. Too gentle, too frequent agitation can result in relative overdevelopment of the film edges. The negatives then print with light margins and darker centers, like this. Alternate brief (5-second) periods of vigorous agitation with longer (25-second) periods of rest. A stop bath of diluted acetic acid is recommended

There are two types of fixing bath

The fixing bath dissolves unused halides and hardens the emulsion

Fix film for twice as long as it takes to clear . . .

. . . repeat: TWICE as long as it takes to clear

Although some photographers prefer to use a plain water rinse after development, I recommend a mild acid stop bath for several reasons. First, the acid rinse stops development almost immediately (an important consideration in tank development of rollfilm) so that development time can be controlled with some precision. Second, by neutralizing the developer, it prevents alkaline "carry over" into the fixing bath; thus preserving the life of the fixer, which must remain acid to harden the film effectively. Third, the acid stop bath is believed to be effective in preventing the formation of scums and *dichroic fog* (a rare but potentially troublesome iridescent stain) that can sometimes form on the film surfaces. Since there appear to be no compelling reasons for *avoiding* the acid stop bath, it seems sensible to use it routinely.

The Fixing Bath

There are two varieties of fixing bath, or hypo as it's sometimes called. Regular "fixer" is largely sodium thiosulfate and is sold in powder form to be dissolved in water for use. The so-called rapid fixing baths, based on the much more energetic ammonium thiosulfate, are typically supplied as liquid concentrates.

Follow the mixing instructions for each very carefully. If the mixing water is too warm, regular hypo may form a milky solution. If the rapid fixer concentrate is not sufficiently diluted before its accompanying liquid "hardener" is added, its solution, too, may be milky and unusable. Although these solutions may clear after standing a day or two, it's safer to mix them properly in the first place.

The stock solution of ordinary fixing bath is used without dilution for either films or prints, although separate volumes of fixer should be reserved for each. "Film strength" rapid fix is usually stronger than the solution recommended for papers. Both types of fixing bath can be used repeatedly; a simple chemical test will tell you when they should be replaced (see Appendix 3).

The fixing bath performs two major functions: it dissolves all the undeveloped silver halides from the film emulsion and it hardens the emulsion gelatin. If you were to examine the film after development and before placing it in the fixing bath, you'd see the image as a dark pattern against a light gray background of still-sensitive emulsion. As the fixer dissolves this emulsion material, the film gradually loses its milky translucency and the margins of the image area become transparent. When this has occurred, we say the film has *cleared*.

Although cleared film appears to be completely "fixed" and safe to expose to bright light, it's a good idea to leave it in the fixing bath a little longer, just to be sure all the soluble halides have been removed. As a rule, I recommend leaving the film in the fixing bath for at least twice as long as it takes to clear.

Here's how to do it. After the stop bath has been poured out of the tank and the fixer poured in, note the time and agitate the tank for at least 30 seconds. Then, in dim room light, remove the cover and inspect the film on the reel (fig. 10.5). (Contrary to popular opinion, there is no danger of fogging the film with this brief exposure if you have used an acid stop bath to neutralize the developer.) If the film appears milky, replace it in the fixer for another 30 seconds or so. Repeat this procedure until the film appears uniformly dark. Check the time. If 2 minutes has elapsed since fixing began, give the film another 2 minutes in the fixing bath, with occasional agitation. If it has taken 5 minutes for the film to clear, give it a total of 10 minutes in the fixer. If you pour the fixer into the tank and wait for, say, one minute, and find the film completely clear when you inspect it, you should assume that it has just cleared at that moment and give it another minute.

Because this concept seems to be a difficult one for some students to understand, let me repeat: keep track of the clearing time and let the film

remain in the fixer for a total of twice that time, whatever it is. In other words, total fixing time is *twice as long as it takes to clear*.

It may seem that this is an unnecessarily complicated way to determine fixing time, but it is really sensible for at least two reasons. First, not all films fix at the same rate, so a fixing time that is adequate for one may not be safe for some other. Second, as the fixing bath ages, it works more slowly, so that a time that's adequate for a fresh bath cannot be considered safe for a wellused one. The clearing time provides a good indication of fixing action and, when doubled, assures adequate treatment.

Reticulation

Although the effect of temperature on the activity of the stop and fixing baths is not, in itself, particularly important, temperature *differences* between baths—especially between the developer and stop bath—should be kept to a degree or two to minimize danger of film *reticulation*. Reticulation is the name given to a fine, netlike pattern or texture of cracks or folds in the gelatin of the film emulsion layer (fig. 10.6). It can result from ''temperature shock,'' as when film is moved from warm developer to a cold stop bath, for example. Temperature difference between the stop and fixing baths is also hazardous, but somewhat less so. After the film has been thoroughly treated in the fixing bath (which contains a hardening ingredient), the gelatin is usually tough enough to withstand shocks of several degrees without harm.

The Hypo-Clearing and Wetting Baths

Although it's not absolutely necessary to use a *hypo-clearing* bath or *washing aid*, it can reduce film washing time and improve washing efficiency. Several brands are available, some as powders and some as liquid concentrates. I recommend using a hypo-clearing bath (except for RC prints) and suggest a liquid concentrate for convenience. Follow the manufacturer's instructions for dilution and use. If you choose not to use a hypo-clearing bath, wash your film in running water for at least a half hour, emptying and refilling the washing container completely several times during the washing period.

Following the wash, films are usually treated briefly in a diluted *wetting* bath. This is an important step that is intended to reduce the surface tension of the final rinse water so that it drains off the film surfaces in a smooth sheet. If you simply rinse the film in plain water before you hang it up, water droplets that dry on the emulsion side of the film may leave indelible marks on the image; drops that dry on the back of the film may deposit mineral scums.

(c)

Figure 10.5

a. After 30 seconds in fixer, Plus-X film (left) and infrared (right) are both still milky and opaque. Infrared appears lighter because it is on clear base material without antihalation dye.

b. After 1 minute the Plus-X is almost clear. The infrared image areas are clearing but the leader is still milky and opaque.
c. After 3 minutes, Plus-X is clear and fully fixed. Infrared film is still showing traces of milkiness on the leader, particularly around the sprocket holes, but the image areas are clear. It cleared completely after another minute and was given 4 more minutes to insure complete fixing.

Maintain processing temperatures within one or two degrees

. . . to avoid reticuation

The hypo clearing bath improves washing efficiency

A wetting bath can help to prevent drying marks and scums

Figure 10.6

Untitled, 1979. Michael J. Teres. Teres creates these fanciful images by controlled melting of portions of the negative emulsion. The delicate textures of the flowing gelatin, combined with the unmodified fragments of photographic reality, give this work a weird beauty.

(Courtesy of the photographer)

Figure 10.7

Many photographers resort to some form of manipulation of the image to achieve dramatic or expressive effects. The partial reversal of the image tones in this photograph is an example of the "Sabattier Effect," which is commonly—and wrongly called "solarization." The effect is achieved by reexposing the partially-developed film to dim light, then continuing development until the original shadow areas of the image reach the desired density. Print images can also be solarized quite successfully.

(b)

(d)

Although it's possible to avoid these problems by squeegeeing the film or (preferably) wiping its surface dry with a damp chamois pad (fig. 10.8), wiping wet film with anything can scratch the emulsion. I recommend using a wetting bath, and suggest wiping only as a last resort.

Again, several brands of wetting bath are available, any one of which should be satisfactory. I recommend using distilled water and mixing the solution at about one-quarter to one-half the strength recommended by the manufacturers. It's best to use the wetting bath as a one-shot but if you want to save it, filter it carefully after each use and replace it fairly frequently. Old solutions tend to develop strange algaelike growths that may leave unpleasant scums on your negatives.

Film Drying and Negative Storage

No matter how clean your films may be when you remove them from the final rinse, you'll have to dry them carefully if you want clean negatives. Dust particles that settle on the damp film emulsion will probably embed themselves in the gelatin and become a permanent part of the image. Commercial film dryers generally circulate warmed, filtered air around the film strips so that they dry clean and guickly. If you don't have a film drying cabinet, at least hang the films in a dust-free environment and protect them from excessive heat. I don't recommend turning a fan on them; there's too much danger of stirring up dust.

When the films are dry, cut them into convenient strips and file them in acetate, polyethylene, or polyester plastic sleeves, or in sleeves or envelopes of acid-free paper (fig. 10.9). For long-term (archival) storage, avoid glassine, kraft paper, and polyvinyl chloride materials.

(c) Figure 10.8

If you find it necessary to wipe your films, it's probably best to use a photo-grade chamois skin. First soak the chamois thoroughly in clean water. Then squeeze it dry, stretch out the wrinkles, fold it into a flat pad, and wipe the film gently.

Dry your films in a dust free place . . .

. . . and store the negatives in sleeves

Figure 10.9

Store your finished negatives in protective sleeves or envelopes. Plastic sheet sleeves will fit a standard three-ring notebook for convenient storage.

Summary

Rollfilm can be processed in any clean environment that can be darkened for film loading and has water available. You'll need a developing tank, a thermometer, a timer, measuring and mixing utensils, chemical storage bottles, some minor items for washing and drying the processed negatives, and materials for cleaning up the work space.

Processing chemicals are sold in powder form to be mixed with water for use, or in concentrated liquid stock solutions that require dilution. Ordinary tap water is usually suitable for mixing the solutions, although distilled or deionized water should be used if the quality of the tap water is questionable.

Developer working solutions deteriorate fairly rapidly. Developers should be stored as concentrated stocks and kept in brown bottles, filled to the top, for maximum life. One-shot developers are convenient and reliable. D–76, used as a one-shot, is recommended.

Some photographers contract contact dermatitis from handling the processing chemicals. Metol, an ingredient in many developers, is frequently the cause. The rate and extent of film development is controlled by monitoring the developing time, and the temperature and agitation of the developer. If the film is not agitated properly, it will not develop evenly. When development has proceeded far enough, it's halted in the stop bath.

The stop bath is a weak solution of acetic acid. Sometimes it's sold containing a yellow dye that turns purple when the acid is exhausted. Stop bath stock solution is usually 28 percent strength and is safe to handle. Glacial acetic acid is much stronger and should be handled with care.

Regular fixing bath is mostly sodium thiosulfate and is sold in powder form. Rapid fixing bath is based on ammonium thiosulfate and is usually sold as a liquid concentrate. Both types must be mixed carefully to avoid forming a milky precipitate. A simple chemical test will identify an exhausted fixing bath. The fixing bath removes the undeveloped halides from the emulsion so that it is no longer light sensitive. Film should remain in the fixing bath twice as long as it takes to clear.

Hypo-clearing baths increase film washing efficiency and are generally recommended. Treat the well-washed film in a wetting bath to prevent water spots and minimize scum marks on the dry film. Dry the film in a dust-free place. Store the finished negatives in sleeves or envelopes made of inert plastic or acid-free paper.

Printing Equipment and Materials

Untitled Photograph by Gail Fisher. (Courtesy of the photographer) Divide your darkroom into wet and dry areas

Provide plenty of electrical outlets and good ventilation

Equip your darkroom with at least two safelight fixtures

Yellow and black are good darkroom colors

You'll need a special enlarger timer

Condenser enlargers are efficient

Standard diffusion enlargers are not suitable for color printing

The Darkroom

Printing, like film processing, is easiest in a darkroom space with hot and cold running water. It's convenient to have a large sink to work in but a table surface will do if it can be waterproofed to contain spilled solutions safely.

Divide your darkroom into separate "wet" and "dry" areas, preferably on opposite sides of the room. The sink and the chemical mixing and storage areas constitute the wet side. Designate the printing area, film loading area, and film and paper storage cabinets as the dry side. If space permits, do your film and print drying and print finishing in an adjoining room.

Install plenty of properly grounded electrical outlets and provide adequate ventilation. For added comfort and convenience, cover the floor with padded outdoor carpet, pipe in some stereo music, and have an extension phone installed.

Safelights

Because most films are extremely sensitive to light of all colors, they must be processed in total darkness, but because most printing papers are insensitive to the "warm" end of the spectrum (yellow, orange, and red), they can be handled for reasonable periods of time in yellowish *safelight*. You should have at least two safelight fixtures—one near the enlarger and one over the sink. For a large darkroom I suggest adding another one or two safelights to make the space as bright and pleasant as possible. If you install bulbs of the recommended wattage and place the safelights at the recommended distance from your working areas, there's little danger of *fogging* your printing paper in normal use.

I recommend painting most of the wall and ceiling area with a washable, nongloss, yellow enamel. In the yellow safelight illumination, the yellow paint will appear as bright as white paint, but white light that strikes a yellow wall will be reflected as safe yellow light. For maximum safety, paint the walls and ceiling close to the enlarger with flat black paint to absorb light of all colors and reduce the possibility of fogging films or other especially sensitive materials that you may occasionally want to expose under the enlarger.

Much of your film processing equipment, such as graduates, funnels, stirring rods, bottles, and so on, will also serve for printing, but you should have a special timer for your enlarger. I recommend one of the many electronic models that are now available. Even the least expensive ones provide accurately controlled times of from a fraction of a second to a minute or more. The more expensive models offer a variety of convenience features, including audible time signals and programmable intervals.

The Enlarger

For many years enlargers have been categorized as either *condenser* or *diffusion* types (fig. 11.1). These terms refer to the design of the light source. In the condenser system, light from the bulb is concentrated by one or more large condenser lenses and converged through the negative toward the enlarger lens. This system is highly efficient in the sense that very little light is lost, but it tends to illuminate the center of the image area a bit more than the edges. A condenser enlarger, especially when equipped with a *point light source*, produces images of relatively high contrast and maximum sharpness—a characteristic that also tends to emphasize image graininess and record dust and scratches on the negative with great clarity.

Standard diffusion enlargers use *cold light* systems that employ coils or grids of gas-filled glass tubing. They are cool and efficient but the light color is not suitable for color printing.

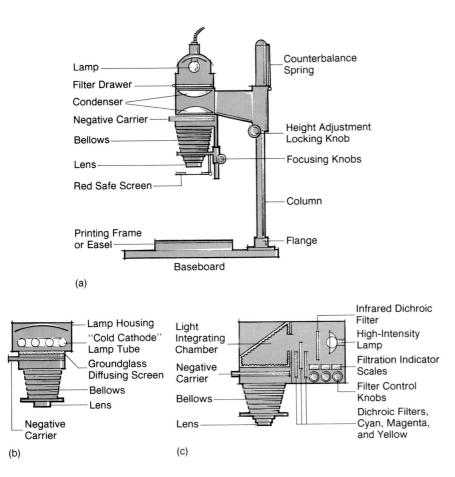

In a currently popular system, a *tungsten-halogen* bulb shines through UV and IR filters into a white "diffusion chamber" directly above the negative stage, combining cool, relatively efficient operation with even illumination of the image area. When adjustable heat-resistant *dichroic* filters (of cyan, magenta, and yellow) are included in this design, the enlarger becomes a *color enlarger* and the lamp housing is called a *color head* (fig. 11.2). Although designed to facilitate color printing, color enlargers are also excellent for black-and-white. They are particularly suitable for use with the popular *variable contrast* printing papers, such as Polycontrast and Multigrade and, although they're relatively expensive, I recommend them.

Enlarging Lenses

If you plan to use more than one film format size, buy an enlarger that will accommodate the largest one and adapt it for use with the smaller sizes by changing *negative carriers* and lenses. Condenser enlargers require some adjustment of the condenser system when the enlarger lens is changed, but this is guickly and easily done.

Although it's possible (and sometimes recommended) to use your camera lens in your enlarger, a regular enlarging lens is likely to provide sharper images. This is because camera lenses are *optimized* to work at relatively great subject distances and their aberrations are less well-corrected at the shorter distances encountered in enlarging. For this same reason, enlarging lenses (which are corrected for close work) are not as well-suited for ordinary camera work, although they're actually superior to ordinary camera lenses for extreme close-up photography.

Figure 11.1

a. In a condenser enlarger, the condensers concentrate the light from a tungsten lamp and direct it through the negative into the projection lens. This design provides intense illumination that allows short printing times, and image contrast is typically high.

b. Diffusion systems illuminate the negative with a broad, unfocused light that is less intense, but quite efficient. Image contrast is relatively low.

c. Color heads combine the advantages of a brilliant tungsten light source with the uniform illumination characteristics of the diffusion systems. A well-designed color head is efficient and convenient for both black-and-white and color printing.

Color enlargers are fine for both color and black-and-white

Camera lenses are not ideal for use with an enlarger

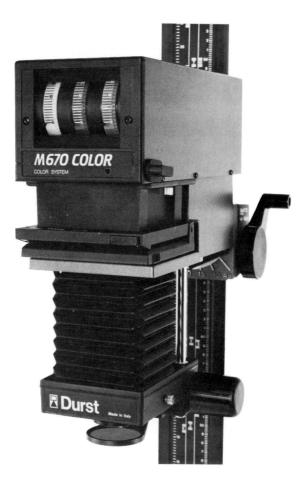

Enlarging (or *projection*) lenses suffer from the same aberrations that afflict camera lenses, so it's important to buy the best ones you can afford. As a general rule, the focal length of an enlarging lens should be approximately equal to the diagonal of the negative format, which means that an appropriate focal length for 35mm negatives is about 45mm (typically they're 50mm); for the popular 2 1/4" square (120 film) format, about 75mm or 80mm; and for $4'' \times 5''$ sheet film negatives, about 135mm to 150mm.

Since image magnification is roughly proportional to the ratio between lens focal length and projection distance (from lens to image), it's obvious that from any given enlarger height short focal length lenses produce greater magnification than long ones. Despite this seeming advantage, it's wise not to use lenses that are too short because, unless they're specially designed for wide-angle work, they may not "cover" the negative satisfactorily. This means that the image edges may be both unsharp and underexposed compared with the image center. In fact, when either of two lenses can be used in a given situation and they are of equal quality, it's probably wise to use the longer one because you'll be using only the center of its useful field where both sharpness and illumination are optimal.

Enlarging lenses are supplied with iris diaphragms, but no shutters. Although the diaphragm mechanism is strictly manual (without the automatic linkage that's built into SLR lenses), it typically features *click stops*—detents that mark the stop and (sometimes) half-stop settings with an audible and tactile click. This is usually a convenience when the aperture scales can't be seen easily in the dim safelight; by counting clicks you can stop the lens down to a desired f-number without looking at it. Some enlarging lenses are supplied without the click stop detents—an advantage when it's desirable to control light intensity without regard for the marked settings.

Buy a good-quality enlarging lens of appropriate focal length

Click stops are convenient for general use

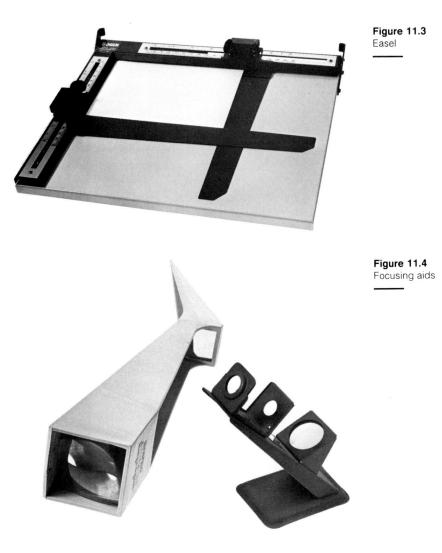

Accessory Equipment

Easel

You should have a good enlarging *easel* to hold the paper flat while it's being exposed. I recommend an all-metal model with adjustable blades that can be set to provide white borders of any desired width on all four sides of the print (fig. 11.3). One desirable type permits adjustable margin widths on prints $11'' \times 14''$ or smaller, but will also hold $14'' \times 17''$ paper for full-area prints when the adjustable mask assembly is removed.

Grain Focuser

When the projected image contains no sharply defined details to focus on, you may find a *grain focuser* helpful (fig. 11.4). One type lets you see a magnified detail of the image that's formed on a fine ground-glass screen; the other popular type has a clear glass screen (marked with a cross or circle that serves as a reference "target") and produces an *aerial image* that seems to hang in space. An aerial image takes some getting used to because instead of going in and out of focus, as you'd expect it to when you manipulate the enlarger's focusing knob, it simply moves up and down through the target. The trick is to make it lie in the target plane, which is easy enough when you learn to focus your eye on the target and wait for the image to arrive.

You'll need an easel

A grain focuser is a useful item

You can make your own dodging and burning tools

Heavy-duty smooth-bottom plastic trays are recommended

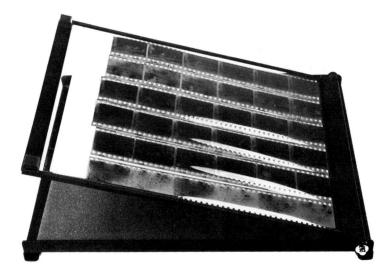

The ground-glass type focuser may seem easier to use but the aerial image focuser generally provides a brighter image and, when well-adjusted and used properly, is probably a bit more accurate. Both types magnify enough to make focusing on ordinary film grain quite easy.

Printing Frame

You'll need a *printing frame* for proofing negatives and making contact prints. Unfortunately, it seems the only printing frames available these days are poorly designed and cheaply made, but expensive to buy. If you can find an old one that is well-constructed of hardwood and still in good shape, buy it. A metal *proofing frame* is a reasonable alternative (fig. 11.5).

Dodging and Burning Tools

Dodging refers to the practice of shading part of the image area from the exposing light to prevent it from printing too dark. *Burning-in* is just the opposite; a portion of the image is given more light to make it darker than the surrounding area. You can make dodging tools by using thin, stiff wire for handles and bits of black paper, cut to any desired shape, to produce the necessary shadow. A sheet of cardboard with a small hole cut in it near the center makes a useful "burning" tool (fig. 11.6). You can improvise tools for special purposes as you need them.

Processing Trays

Prints are processed in special plastic trays that are available in several sizes to accept standard-size printing papers. I suggest that you buy a set of six in the size you'll use most (probably $8'' \times 10''$), and sets of three or four in each of the sizes you'll need less often (such as $5'' \times 7''$, $11'' \times 14''$, $14'' \times 17''$, or $16'' \times 20''$). I recommend the heavy-duty white or yellow trays with smooth bottoms, rolled edges and well-formed pouring lips. I advise against the more angular, hard plastic types with ridged bottoms; they are prone to crack, and although the ridged bottom contour prevents prints from ''sticking down'' (a common annoyance when RC [*resin-coated*] papers are processed in flat-bottom trays), it may cause uneven development in some situations.

Figure 11.7 Print siphon

You can wash prints satisfactorily in a tray that's one or two sizes larger than the prints if you equip it with an automatic *tray siphon* and use it properly (fig. 11.7). For more efficient washing action, especially for archival processing of *fiber-base* printing papers, consider buying a print washer. Good print washers are expensive, so I don't recommend buying one unless you'll do a lot of printing on a continuing basis.

Good print washers are expensive

Miscellaneous Items

Many photographers like to keep their hands out of the various processing solutions by handling prints with *print tongs* or *print paddles* (fig. 11.8). These tools are convenient for small prints, but I prefer to handle prints larger than $8'' \times 10''$ with my fingers, rinsing my hands in clean water between chemical steps to avoid contamination (latex surgeon's gloves will protect your hands from the chemical solutions). If you want to use tongs, I recommend the ones that have soft plastic or rubber tips and are color coded so you can assign them to specific trays without confusion. You should have at least two—one for the developer tray and one for stop bath and fixer. Some photographers insist that you should have three—one for each tray—and that's certainly a harmless practice.

After they've been washed, *resin-coated* (RC) prints can be sponged or squeegeed surface-dry and hung up by one or two corners to air-dry. Alternatively, they can be laid out faceup, on blotters, plastic screens (aluminum-framed window screens are fine) or clean cloth. *Fiber-base* papers can be

Print tongs or protective gloves will keep your hands dry

dried in blotter books or rolls, laid facedown—to minimize curling—on screens or clean, lintless cloth (or photo-grade blotters), or heat-dried in an electric print dryer. Unless you're interested in *ferrotyping* fiber-base papers to produce a high-gloss surface or unless you do a lot of printing every day, a commercial heat dryer is an unnecessary expense. I recommend screens; they're cheap, convenient, easy to store, and easy to keep clean (fig. 11.9).

Mounting and Matting Equipment

Finished prints are often mounted or matted for presentation. *Dry-mounting* has been a preferred method for general use because it's fast, neat, and permanent, but many photographers now prefer to mount exhibition prints with paper *corners* or *hinges*. If you opt for dry-mounting, you should have a *dry-mounting press* and its associated *tacking iron*.

Matting involves measuring and cutting the mount and mat boards, and requires miscellaneous tools. A *print trimmer* or *paper cutter* is convenient for cutting prints and *dry-mounting tissue*, but mat and mount board should be cut with a *mat knife* and a heavy metal *straightedge*. You'll need a special *mat cutter* if you want neatly beveled edges on your mats, and you'll find a T-square, a ruler, a soft pencil, and a large draftsman triangle (30°-60°) useful for measuring and marking the boards. You'll also need an eraser and some plastic or (preferably) linen tape.

Figure 11.9 Drying cabinet with screens

Drying screens are cheap, convenient, and effective

Dry-mounting is fast, neat, and permanent

Introduction to Printing Materials

Developer

Print processing follows the same sequence of steps that you're now familiar with in film processing but prints don't have to be processed in total darkness. Because papers are less sensitive than films and because they respond mainly to blue light, you can use them in yellow safelight. There are a few other differences, too. Films are treated with relatively mild developers that work slowly and development is stopped while the image is gradually darkening. Paper developers are much stronger and more vigorous than film developers as a rule, and prints are usually developed *to completion*. This means that virtually all of the exposed silver compounds in the emulsion have been converted and development has practically ceased before the prints are put into the stop bath.

Prints *can* be developed in film developer, but it takes a long time and the image is typically weak and brownish gray. Films processed in print developer, on the other hand, develop very rapidly and the negative image is likely to be too dense and too contrasty to print satisfactorily.

Print developers are stored in relatively concentrated stock solutions, diluted for use, and discarded after the printing session. The working solutions have considerable reserve capacity and will typically process from ten to twenty or more 8'' \times 10'' prints per quart, without serious loss of image quality. It's not wise to try to economize on print developer, though; a single sheet of paper may be worth more than your entire trayful of developer. If you're interested in consistently fine print quality, don't push your developer to the limit of its capacity. See Appendix 3 for developer formulas and mixing instructions.

The Stop Bath

The printing stop bath is similar to the one used for films—usually about 1 percent or 2 percent acetic acid. I recommend using an indicator stop for printing because paper developers are much more alkaline than film developers are, and they "wear out" the acid much more rapidly. Consequently, the stop bath is likely to need replacement at least as often as the developer does. Although obviously yellow in ordinary room light, a healthy indicator bath appears water-clear in the yellow safelight. As its acid is gradually neutralized, the bath slowly turns purple, which makes it appear gray and dirty under the safelight. That gives you plenty of warning to replace it before it stops working completely. See Appendix 3 for stop bath formulas and mixing instructions.

The Print Fixing Bath

Papers are sensitized with relatively soluble halides, and the print image is comparatively delicate. For these reasons, prints are usually (but not always) treated in a less-concentrated fixing bath than is used for films. Prints are likely to be bleached perceptibly if fixed for too long or fixed in a bath that is too strong.

Fixing baths have great capacity for dissolving halides from photographic emulsions. Their *useful* capacity is limited, however, because as a fixer ages, it tends to form complex silver compounds that are difficult to remove from the emulsion by practical washing techniques. If these compounds remain in the emulsion, they're likely to fade or discolor the image, eventually ruining it. Because prints are more susceptible to this sort of chemical attack than You can handle most papers in yellow safelight

Paper developers are vigorous . . .

.... and have considerable reserve capacity

An indicator stop bath turns purple when it's exhausted

The print image may be bleached if the fixer is too strong

Replace the print fixer before it approaches exhaustion

Fiber-base and resin-coated papers have different characteristics

Use fiber-base papers for fine art prints; RC papers are fine for general use

Contact printing papers are not suitable for enlarging

Chlorobromide papers typically produce warm brown images

negatives are, and because fiber-base prints are much more difficult to wash clean than films are, it's particularly important to monitor the condition of the print fixer so it can be replaced before it approaches exhaustion.

As a very general rule, you should expect to fix about 100 8'' \times 10'' prints in a gallon of fixing bath. In practice, of course, the useful life of the bath may vary. A gallon of fixer might treat 200 very dark prints quite safely (because they'd have very little halide content for the fixer to dissolve), while more than 75 or 80 *high-key* (very light, pale) prints might be too many. The hypo-test solution described in Appendix 3 will indicate when your fixer should be replaced, and to help your print images live as long as possible, I recommend using it rather frequently as your fixer ages.

Printing Papers

Fiber-base papers really are high-quality paper. The term *fiber-base* distinguishes them from the popular resin-coated or RC papers, which, as the name implies, are paper that has been laminated between thin sheets of plastic. The two types have quite different characteristics. In general, fiber-base papers are preferred for fine-art photographs because they have a more attractive appearance and "feel," and when properly processed, they produce prints that are relatively permanent. RC papers are very convenient to use because they can be processed and dried very quickly, and the finished prints have almost no tendency to curl. Although prints made on the earliest RC papers had a rather unpleasant, hazy appearance and a tendency to crack and peel after only a few months, those problems seem to have been solved. Contemporary RC papers provide fine image quality and are said to be suitable for fairly long-term storage.

Paper Characteristics

If you plan to make "fine prints" for display or for sale as works of art, you'll probably want to work with a premium fiber-base paper. If you're doing routine school assignments or making prints for publication, scientific record, or some commercial purpose, RC papers will probably be perfectly satisfactory. But that's only the first decision you have to make. There are several other paper characteristics—type, sheet size, weight, surface texture, base tint, contrast, brand, and quantity—that you must also consider.

The type of paper you should buy depends on whether you'll use it for *contact* or *projection* printing. Contact printing papers are intended to be placed in contact with the negative in a printing frame or printer. They're very slow and require relatively long exposure to bright light. Projection (or enlarging) papers are much more sensitive. They *can* be used for contact printing (in subdued light), but they're intended to be used with an enlarger. Contact papers are relatively rare now, but if you're considering a paper that you've never used before, check to be sure it's suitable for enlarging if that's what you want to do with it.

Contact papers are sometimes referred to as *chloride papers* because they're sensitized primarily with silver chloride—the least sensitive of the useful halides. The addition of silver bromide to the emulsion mixture produces *chlorobromide* papers—suitable for projection printing and by far the most popular paper type available today. Chlorobromide papers typically provide good tonal separation in both highlights and shadows, and they produce images that range in color from warm brown to nearly neutral black. I recommend them for general use.

Figure 11.10 *Roadside Vegetable Stand.* Phil Davis.

Years ago many pictorialists favored *bromide papers* for their cold black tones and their tendency to "mass" shadow tones together, subduing texture in favor of simple light/dark pattern. It's doubtful that the few modern "bromide" emulsions are pure silver bromide, but they do include "bromide," "brom," or "bro" in their titles, suggesting their ancestry. Agfa's "Brovira" produces the cold black image tones of traditional bromide prints; Kodak's "Kodabromide" tones are quite neutral and Ilford's "Ilfobrom" behaves much like a cool chlorobromide paper.

Papers come in a variety of standard sizes, the most popular of which are probably $5^{\prime\prime} \times 7^{\prime\prime}$, $8^{\prime\prime} \times 10^{\prime\prime}$, $11^{\prime\prime} \times 14^{\prime\prime}$, and $16^{\prime\prime} \times 20^{\prime\prime}$. Fiber-base papers are available in several thicknesses or weights, variously referred to as light weight, single weight, medium weight, double weight, heavy weight,

Bromide papers generally produce cold black image tones

Printing papers come in a variety of sheet sizes, weights . . .

. . . package sizes . . .

. . surface textures . . .

. . base tints . . .

. . . and contrast grades

ISO Range numbers indicate paper contrast

The image contrast of variable-contrast papers can be altered . . .

... by adjusting the color of the printing light

and probably others. Most photographers seem to prefer double weight papers—at least in $8'' \times 10''$ size and larger—because they're less likely to be damaged during processing and they feel more substantial when finished.

You can buy papers in several package sizes. Small and medium sizes are sold in 25-sheet packages, each consisting of a lighttight paper or plastic envelope contained in an outer envelope of heavy, opaque paper or cardboard. The larger sheet sizes are sold in similar packages of 10 sheets. Larger quantities of all sizes are sold in boxes of from 50 to 500 sheets. The 100-sheet box of 8" \times 10" sheets is a popular and economical unit for school use.

You'll usually have a choice of several paper surface textures, such as glossy, fine-grain lustre, smooth matte, and others. Examine the dealer's paper sample book to find the surface that appeals to you, but remember that very dull surfaces reduce the depth and richness of the image shadow tones and tend to mute image contrast. Highly lustrous papers, on the other hand, reveal the greatest possible range of image tones, but surface reflections may make the image difficult to see in some environments. For commercial reproduction, a smooth, glossy surface is almost ideal. I think you'll find a slightly textured, lustrous surface preferable for fine-art photographs.

Some papers are offered in more than one base tint or color, such as white, natural, cream, warm white, and so on. Generally, papers that produce warm image tones are available in both white and one or more off-white base tints. Cold-tone papers are generally available only in white, which is often emphasized by the addition of fluorescent *brighteners* incorporated into the paper stock.

Probably a paper's most important characteristic is its contrast *grade*. Unlike films, whose image contrast is largely determined by development conditions, a paper's contrast is an inherent characteristic of its particular emulsion mixture, and can't be altered very usefully by changing development time. For this reason, many papers are available in "graded" contrasts, identified by numbers from 0 to 5 (fig. 11.11), or words such as *soft, medium, extra hard,* and so on. In general, a very contrasty negative will print most satisfactorily on a very soft (#0) paper, a normal negative will print on a medium (#2) paper, and a very low contrast negative will require an extra hard (#5) paper for best results. Soft (#1) and hard (#3) papers match negatives of high and low contrast respectively.

Some manufacturers now label their paper packages with *ISO Range* numbers that describe the paper's contrast characteristic more precisely than the conventional grade numbers do. The approximate relationship between these ISO Range numbers and the familiar grade numbers is shown in figure 11.12.

Variable- or *selective-contrast* papers that can be adjusted to any contrast grade from soft to very hard are popular and convenient to use (fig. 11.13). They're coated with two different emulsions—one that's sensitized to blue light only and one that responds to both blue and green.

In use, the desired degree of contrast is produced by appropriately filtering the enlarger light. A magenta filter, which transmits blue but absorbs green, produces maximum contrast. Lowest contrast is provided by a yellow filter, which transmits green but absorbs blue. Intermediate contrast grades can be produced by dividing the exposure between magenta and yellow filters, or by a single exposure through a special *printing filter* of intermediate color. Printing filters are available in eleven contrast grades, numbered from 0 to 5 in half-steps. The number 2 filter is considered to be the normal one. It provides about the same degree of image contrast that results from exposing the paper to plain, unfiltered tungsten light.

2

4

Published Paper Grade Number

Published

ISO Range Number
 5
 4
 3
 2
 1
 0

 0g
 0g
 0g
 0g
 0g
 0g
 0g

Figure 11.11

Printing paper contrast is indicated by number. Low numbers indicate low contrast; high numbers indicate high contrast. These prints, all made from the same negative, show the range of a typical variable-contrast resin-coated paper when used with the manufacturer's filter set. The filter numbers are printed in the upper left corner of each image. The filter set also includes the intermediate grades 1/2, 11/2, 21/2, 31/2, and 41/2. The print exposures were adjusted to provide approximately equal image density in the middle values. Graded fiber-base papers are usually supplied in only three or four contrast grades, typically 1, 2, 3, and sometimes 4.

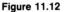

There is no official relationship between the conventional paper grade numbers and the ISO Range numbers but this shows their practical equivalence.

Because *cold light* diffusion enlargers produce light that's deficient in some colors, they are not particularly suitable for use with variable-contrast papers. Color enlargers, on the other hand, are ideal. Because they permit magenta and yellow image light to be combined easily in any proportion, color heads eliminate the need for separate printing filters and provide stepless control of contrast. Also, because their dichroic filters are exceptionally efficient, they extend the paper's contrast range slightly and reduce exposure times.

Color enlargers are ideal for use with variable-contrast papers

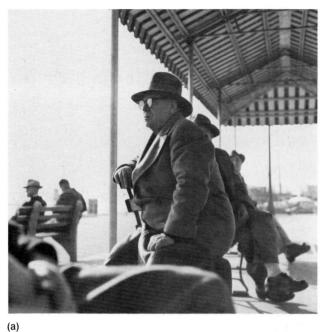

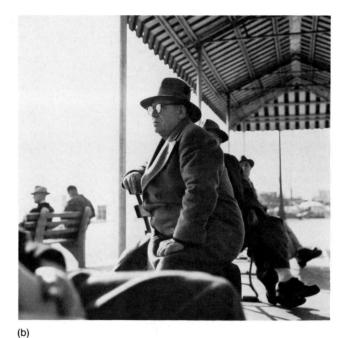

(c)

Figure 11.13

- a. Polycontrast filter #1
- b. Polycontrast filter #2
- c. Polycontrast filter #3 d. Polycontrast filter #4

Stabilized prints are not permanent

(d)

Stabilization Processing

Several papers on the market can be processed either in conventional open trays or in special processing machines. The familiar stabilization processors use only two chemical solutions—an activator and a stabilizer. Exposed paper is inserted into a slot in the front of the machine, transported by various pairs of rubber rollers through the two solutions and, after about ten seconds, ejected in damp-dry condition through a slot in the rear.

Stabilized prints are not fixed, so although they'll usually last for a few weeks or months, they're not really permanent. They're also heavily contaminated with chemicals and should not be stored with regularly processed prints

or allowed to come in contact with undeveloped papers. Despite these drawbacks, stabilization is a convenient procedure for producing quick proof prints, and if the images are worth keeping, stabilized prints can be fixed and washed conventionally to make them permanent.

The activator solution is highly alkaline, but it is not a real developer and will not produce an image on ordinary printing papers. Papers used for machine processing must contain the necessary developing agents in their emulsion mixture. Several such *developer-incorporated* papers are on the market—the most popular ones being Kodak's Polycontrast Rapid RC II, and Ilford's Multigrade II. Both are resin-coated, variable-contrast papers that are suitable for either stabilization or conventional tray processing, and both are capable of fine image quality. I recommend them highly for general use. Kodak's Ektamatic SC paper is similar, but its variable-contrast, developer-incorporated emulsion is coated on single-weight fiber-base (real paper) stock.

Summary

A good darkroom should have running water, a large sink, plenty of electrical outlets, and good ventilation. Separate the wet and dry activities; do your negative drying and print finishing in another room if possible. Paint the dark-room walls yellow and use several safelights to make the room seem bright without risking fogging your paper.

You can use much of your film processing equipment. You should have a special timer for your enlarger. Condenser enlargers are efficient but tend to emphasize negative flaws; cold light enlargers aren't very suitable for color printing. Color enlargers are excellent for both black-and-white and color printing. Buy an enlarger that will accommodate your largest negatives and adapt it for smaller negatives by changing lenses.

Buy the best enlarging lens you can afford; ordinary camera lenses are not very suitable for use with an enlarger. It's best, where possible, to avoid very short lenses for enlarging. Click stops are convenient.

You should have an enlarging easel. You may also need a grain focuser, a printing or proofing frame, dodging and burning tools, trays, and other miscellaneous darkroom items. If you plan to dry-mount your prints, you'll need a mounting press and tacking iron. A special mat-cutter will bevel the edges of your mats neatly.

Print processing follows the same steps used for film, but prints are developed to completion in strong developers. Avoid contact with developers containing Metol if you're susceptible to Metol poisoning. Use an indicator stop bath. Don't overwork your fixing bath; check it periodically with a test solution.

Fiber-base papers are desirable for fine-art prints. RC papers are fine for general work and are very convenient to use. Papers come in a variety of sizes, weights, textures, tints, and contrasts. Contact papers are slow and not suitable for enlarging. Chlorobromide papers are fine for almost all purposes. The paper grade number indicates its inherent contrast: a low number means low contrast; a high number, high contrast. The contrast of variable-contrast papers can be adjusted by controlling the color of the printing light. Color enlargers are excellent for use with variable-contrast papers.

Stabilization processors use only two chemical solutions. Stabilized prints are heavily contaminated with chemicals and will not last long; but they can be fixed and washed for permanence. Only developer-incorporated papers can be stabilized. They can also be tray processed very successfully and are excellent for general use. Developer-incorporated papers are suitable for stabilization processing

Black-and-White Printing

Finlayson, MN Photograph by David Bartlett. By emphasizing the glaring white antlers against the dark textured background, Bartlett arrests the viewer's attention with striking image that verges on the surreal.

(Courtesy of the photographer)

Figure 12.1

a. Set up your print processing trays in the darkroom sink. Arrange them from left to right: developer, stop bath, and fixer. Use chemicals of your choice. If you have no preference | suggest: developer-Kodak Dektol, diluted 1 + 2; stop bath-28 percent indicator stop bath stock solution, diluted 1 + 25; fixer-rapid fixer concentrate, diluted for paper as specified by the manufacturer (typically, about 1 + 7). If sink space permits, add a water rinse tray, a hypo-clearing bath, and a larger wash tray or print washer. Adjust the solution temperatures to between 18° C and 24° C (65° F to 75° F) for best results; much warmer solutions may induce stains and soften the print emulsion, much colder developer works more slowly and may not produce normal image contrast.

Proofing Your Negatives

b. Be sure your hands are clean and dry before proceeding. Clean the printing frame glass.

d. Remember this general rule in printing: for correct orientation of the image, the negative and printing paper must face each other—emulsion to emulsion. The negative emulsion is usually (but not always) on the inside of the natural curl and it is usually dull or matte compared with the more glossy back of the film. Also, the frame numbers and the image itself are reversed when viewed from the emulsion side. Here the left strip shows the emulsion side; the right strip is facedown and the back is showing.

c. Dust the negatives. Handle them carefully by the edges to avoid fingerprints.

e. Arrange the negatives on the glass, emulsion up, that is, with the backs touching the glass surface. Turn out the lights and work from here on in safelight.

f. Remove a sheet of paper from its package, reclose the package, and identify the emulsion side of the sheet. The emulsion is usually (but not always) on the inside of the natural curl and more lustrous than the back of the sheet. Resin-coated papers may be confusing; when in doubt expose a little strip and develop it.

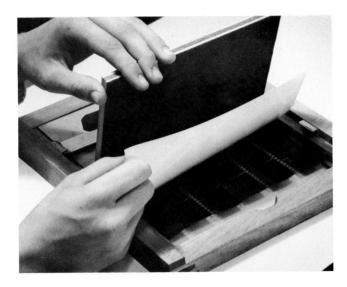

g. Lay a sheet of paper over the negatives, facedown (emulsion to emulsion), and close the printing frame.

h. Lay the printing frame faceup on the enlarger baseboard and make the exposure. As a rough guide, if the enlarger height is set to make an $8'' \times 10''$ print from a 35mm negative, and if the 50mm (2-inch) enlarging lens is set at about f/8, try exposing for about 15 seconds. This exposure will almost certainly have to be adjusted for optimum results. If the print is too light, increase the next exposure; if the print is too dark, reduce the next exposure. The ideal proofing exposure will print the film edges almost black, leaving the perforation pattern barely visible against the total black of the unprotected, fully exposed paper.

i. Place the exposed paper sheet facedown in the developer, being sure to avoid trapping an air bubble under it. Agitate vigorously for about 15 seconds then turn the print faceup and continue moderate agitation for your standard developing time. I recommend developing conventional enlarging papers for 2 minutes, resin-coated developer-incorporated papers (such as Polycontrast RC III SC and Multigrade RC III) for 1 minute. Other times may be satisfactory, but remember, papers are developed to completion; they must remain in the developer long enough to produce their maximum black but not so long that there's danger of producing fog or stains. Establish a time that works for you, then stick to it. Control print image density (darkness) by varying exposure time; control image contrast by changing paper grades or printing filters (with variable-contrast papers.) Don't try to manipulate print contrast by changing development time; it is not an effective control.

k. Agitate the print continuously in the fixer for 30 seconds or so. Fixing is generally complete in a minute or two in fresh rapid fix, but just to be safe, leave the print in the fixer, with frequent agitation for 3 or 4 more minutes. Too little time or inadequate agitation in the fixer may cause prints to darken and discolor eventually; extended fixing time may bleach the image somewhat. Overfixed prints are also likely to be so saturated with chemicals that they can't be washed satisfactorily.

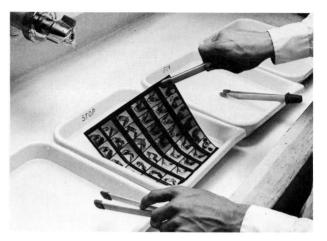

j. When the development time is up, use the developer tongs to deposit the print in the stop bath, then handle it there with the stop bath tongs. Fiber-base prints may sometimes make a sizzling or whining noise caused by tiny streams of gas bubbles generated by the neutralization of the developer alkali. This is normal; agitate the print in the stop bath for about 30 seconds or until the noise stops, then transfer it to the fixer.

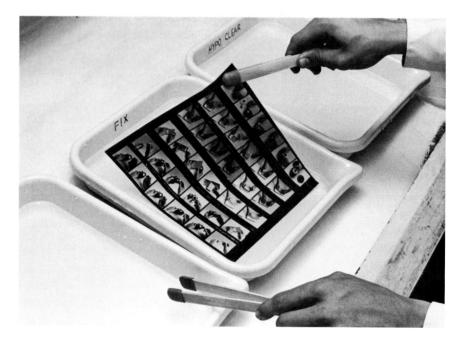

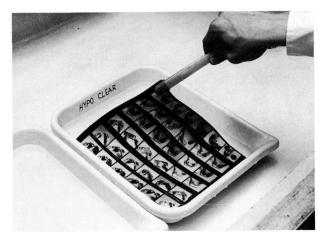

I. RC prints should be transferred directly from the fixer to the wash tray, but it's a good idea to treat fiber-base prints in the hypo-clearing bath before they're washed. You can put them directly into the clearing bath if you want to, but rinsing them first in plain water will extend the life of the clearing bath appreciably and increase its efficiency.

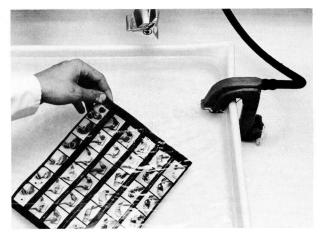

m. Treat the prints in the clearing bath, then wash them in running water, following the manufacturer's recommendations. Wash RC prints in running water for 5 minutes.

n. Squeegee the prints lightly or wipe them with a dampened viscose sponge to remove surface droplets. If you are using a fixing bath without hardener or if the print emulsion has been softened by warm water or prolonged soaking, be very careful not to scratch or abrade the print surface.

o. Hang RC prints or lay them faceup on a clean surface to air-dry. Drying screens are excellent for both print types but fiber-base prints should be dried facedown to reduce their tendency to curl. p. Alternatively, fiber-base prints can be dried between blotters or in blotter books or rolls. Don't dry RC prints this way. Electrically heated print dryers of various sorts are available and convenient for school or commercial use but they may contaminate your prints with residual chemicals if they're not kept clean.

Making Prints by Projection

Figure 12.2 a. Adjust the enlarger for your negative size (if it's a condenser enlarger be sure the condensers are positioned or adjusted appropriately for the focal length of the enlarging lens). Inspect the lens and clean it if necessary.

b. Position the negative in the negative carrier so that its emulsion side will be down (facing the print paper emulsion) and so the projected image will be right-side up. Dust both surfaces of the negative carefully. If your enlarger permits it, raise the condensers and dust the negative in place, using a small brush to pick the dust particles off the surface, one by one. Wiping the brush across your forehead or nose to pick up a little "nose oil" will help to dispel static electricity and hold the dust particles better but don't overdo it; too much nose oil will show up in the print image. Don't use "canned air" to blow the dust off; despite at least one manufacturer's cynical claims of "safety," it's really Freon, a material that's been identified as destructive to the earth's protective ozone layer.

c. Open the lens aperture fully to provide maximum light focusing and composing the image. Turn out the white lights and work in safelight from here on.

d. Adjust image size and composition. To make the image larger, raise the enlarger on its column. If it can't go high enough to produce the desired image size, change to a shorter focal length lens. To reduce image size, lower the enlarger. If that doesn't make the image small enough, use a longer lens. If you change lenses, be sure to readjust the condensers to keep the image illumination uniform over its entire area...

e. Focus carefully.

f. Stop the lens down to your printing aperture; f/11 may be a suitable starting point.

g. Turn the enlarger light off. Cut a sheet of paper into test strips and return all but one to the paper package; then close the package to protect the paper from light.

h. Expose a test strip as described in the text. Then process the strip as previously described.

i. Appraise the density and contrast of the test strip image. Remember, you can control image density by adjusting print exposure; if the image contrast is not satisfactory, adjust it by changing paper grades or—if you're using a variable contrast paper—by changing filters. If you must change paper grades (or filters) the exposure will be affected; make another test strip with the new paper (or filter). See the text for a detailed description.

j. When you've determined the proper exposure and paper grade, make a full print, process it, and inspect it critically in good light.

k. If the print image needs local adjustment, you can make another and dodge . . .

I. . . . or burn, as indicated.

Making Test Strips

Print exposure is controlled by adjusting light intensity (by varying the aperture) and exposure time (by setting the timer), but it is also affected by several other factors. Obviously, the negative density is one. A dense negative will require more exposure than a thin one. Image size is another. Illumination diminishes as the image area increases, so you'll need to adjust the exposure when changing from one enlargement size to another. Papers of different brands or types may vary in speed. Slow papers will require more exposure than fast ones to produce the same image density. Changing contrast by changing from one paper grade to another, or by changing filtration on a variable-contrast paper, will require exposure adjustment. For these reasons and because there's no other convenient (and inexpensive) way to determine print exposure, we usually make *test strips*.

A test strip is simply a sample print that has been given a series of progressively increasing exposure steps. After development, it's usually easy to identify the best image step and the exposure that produced it.

There are two ways to make test strips and I urge you to learn both. The common method produces an *arithmetic* step sequence by simply repeating some chosen (*fixed increment*) exposure time and allowing it to accumulate on successive steps (fig. 12.3a). For example, a strip of sensitized paper is exposed for 2 seconds. A portion of it (about 1/5) is then covered with an opaque card and the exposure is repeated for a total of 4 seconds. Then another 1/5 is covered and the exposure is repeated, then another, and another. After development, the strip should display 5 steps of increasing density, corresponding to exposure totals of 2, 4, 6, 8, and 10 seconds.

Fixed increment tests are easy and they're often satisfactory, especially when you know the approximate exposure and only need to pin it down precisely; but this procedure has two limitations. It often can't include a very great range of exposure times, so it's possible to make a test that tells you

Make a test strip

Fixed-increment tests are often satisfactory . .

(a)

Figure 12.3

a. Geometric test strip.b. Fixed increment test strip. The steps are practically invisible.

nothing; and as the exposures accumulate, the *proportionate* difference between them decreases. This often makes it difficult to distinguish one step from another.

(b)

The reason for this is that exposure effect is *geometric;* that is, to maintain more or less uniform visible separation of steps, you have to *multiply* the times by some factor, not merely add them together. For example, the difference between exposures of 2 and 4 seconds is 2 seconds and represents a 100 percent increase that's clearly visible. The difference between 10 and 12 seconds is also 2 seconds, but it now represents an increase of only 20 percent and the visible difference is insignificant.

Geometric test strips eliminate these problems, and once you understand the principle involved, they're just as easy to make as the fixed increment type (fig. 12.3b). All you need to remember is the rule that "the next exposure must equal the *accumulated total* under the cover sheet." For example, start with a time that you're sure will be too short, such as 2 seconds, and expose the entire strip. Then cover a little section. The accumulated total . . . but geometric tests have some advantages

under the cover is 2 seconds, so the next exposure must be 2 seconds. After that exposure, cover another little section of the strip. Because the total under the cover sheet is 2 + 2, or 4 seconds, the next exposure must be 4. After the 4-second exposure, the next one must be (2 + 2 + 4) 8 seconds, then 16, then 32, and so on.

When the geometric strip is developed, you'll find that you've sampled a very great range of possible exposures and the steps (that can be seen at all) are clearly separated. You can count from either end to check the exposure times for individual steps, but remember that the last exposure *total* will always be twice the last exposure *given*. For example, if you've given the strip individual exposure times of 2, 2, 4, 8, 16, and 32 seconds, they will have accumulated to form total exposures of 2, 4, 8, 16, 32, and 64 seconds.

After you've done it a few times, you'll find the geometric method just as easy as adding a fixed increment repeatedly, and it's a more useful technique for sampling unknown or unusual exposure situations. The fixed increment method is best for subtle adjustments of exposure once you know the general range. Learn to use both methods.

The Test Print

Using one of the methods just described, position a strip of normal (#2 contrast grade) paper on the enlarging easel where it will sample an important area of the image, preferably including both extremes of tone, and make a test strip. If you choose to use a variable-contrast paper, expose the strip without filtration or use the #2 printing filter.

Examine the test steps critically; then using the exposure time represented by the most satisfactory step (or some estimated time between steps), expose a full sheet of paper and develop it normally. Rinse it in water for a minute or so after the fixer, then (after checking to be sure your paper package is safely closed) turn on the white lights and inspect the print carefully (fig. 12.4).

Learn to use them both

Select the best exposure and make a test print

(a)

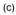

If the image highlights are too light or too dark, refer to your test strip to estimate the required exposure adjustment and try again. When the highlight values are satisfactory, inspect the shadows for detail and black emphasis. If the shadows are gray, the image contrast is too low; change to a paper (or filter) of higher contrast, perhaps #3 or #4. If the shadows are black without detail, the image contrast is too high; change to a lower paper (or filter) grade, such as #1 or #0. Some photographers prefer to follow this procedure in reverse; that is, they establish the shadow exposure first, then monitor the highlights to determine the proper contrast adjustment. Either method will work but in both cases changing paper grades or filters will also require some exposure adjustment.

Alternatively, some photographers prefer to establish image contrast first, then adjust print exposure to control image density. Using this approach, if the test print image contrast is excessive (fig. 12.5a)—that is, if the print tones range from pure white to pure black with loss of detail and texture in highlights or shadows, or both—you'll need to make a new test strip using a paper

Figure 12.5

a. This print is too contrasty; use a paper or filter of lower contrast (lower number).
b. This print is too flat (not contrasty enough); use a paper or filter of higher contrast (higher number).
c. This print is too light. It has been underexposed; use a larger lens opening or increase the exposure time.
d. This print is too dark. It has been overexposed; use a smaller lens opening or decrease the exposure time.

Appraise image contrast and density

(d)

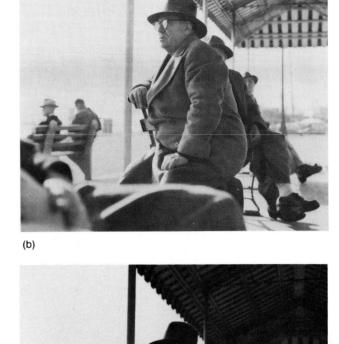

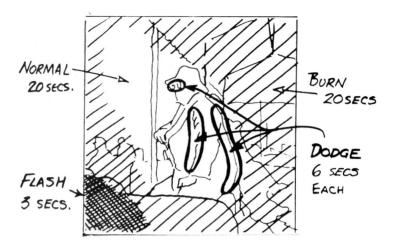

grade (or filter) of lower contrast. On the other hand, if the contrast is too low (fig. 12.5b)—if highlights or shadows, or both, are gray with neither white nor black accents, and the print looks muddy and lifeless—change to a paper (or filter) of higher contrast. In either case, be sure that the new test strip samples both extremes of image tone; you will not be able to judge contrast effectively from mid-tone values alone.

Dodging and Burning-in

When you've produced a print image (by any test procedure) that has satisfactory density and contrast, inspect the image for signs of tonal imbalance. Is the sky too light? Should a face shadow be lightened? Is there detail in the negative that's not being recorded satisfactorily in either highlight or shadow? In almost every print, there are areas of tone that should be adjusted to improve the visual structure of the photograph or to shift the visual emphasis for greater impact. You can make these improvements by dodging or burningin the image during the print exposure.

If the changes are extensive, it's wise to make separate test strips of the individual areas and make a little sketch of the image forms, labeling the areas you plan to modify with the exposure times each should receive (fig. 12.6). The basic exposure time will be the time required for the largest area of the image. Areas that require less time will be *held back* or dodged (fig. 12.2k). Areas that require more time will be burned-in by allowing beams of image light to fall on them through appropriately shaped holes cut in opaque cards (fig. 12.2l). This will take practice, but it's not particularly difficult if you do it systematically.

Through experience you'll probably discover that there's more than one way to print any negative. That's normal because printing is a personal matter and what may have been a satisfactory interpretation of the subject at one time won't necessarily please you months or years later. The most important thing is to remain sensitive to the image and refine it as well as you can every time you print it (fig. 12.7).

There's more than one way to print any negative

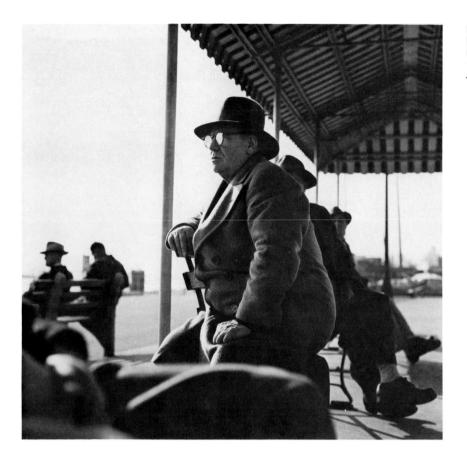

Figure 12.7

Final print, 20 seconds, with dodging, burning, and flashing as indicated in figure 12.6.

Post-Development Controls

Reducing

Dodging and burning can adjust the general tonal balance of the print, but they aren't effective for very small image areas. Although there is no easy way to darken (*intensify*) image details selectively, they can be lightened (*reduced*) fairly easily after the print has been fixed. It's best not to reduce a print that you plan to tone because toning often affects reduced areas strangely and they may not match the color of the surrounding image.

There are several chemical solutions that will reduce the silver image usefully, but the most common one is called "Farmer's Reducer" (after Howard Farmer, who invented it in 1883). It's composed of potassium ferricyanide and sodium thiosulfate (hypo), and it works in a two-stage process. The ferricyanide converts the image silver into a compound that's both light-sensitive and soluble in hypo, and the hypo dissolves it away in the normal fixing action. The solutions can be used separately, if desired, but the action is easier to appraise if they're mixed together. The combined solution must be fresh. It deteriorates within a few minutes after mixing, whether it's used or not. The separate solutions will keep for a long time if protected from air and strong light. See Appendix 3 for formulas. Remember, it's a good idea to wear protective gloves when mixing and using these chemical solutions.

Farmer's Reducer . . .

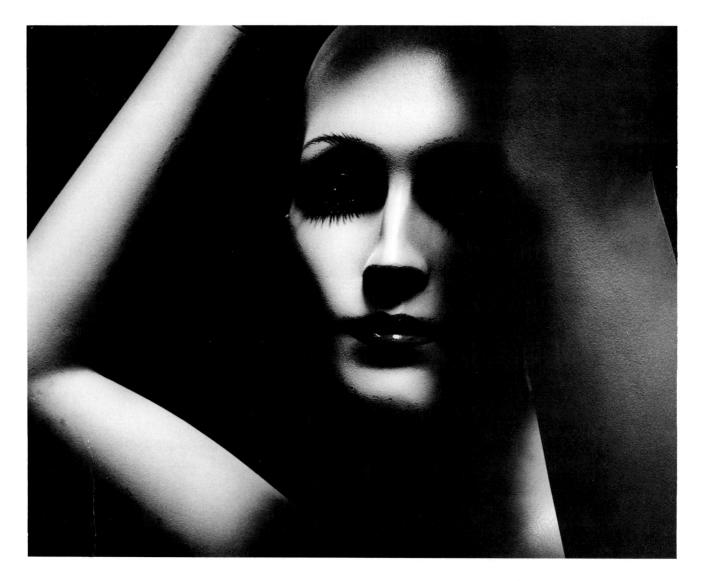

Figure 12.8

Judy, from Mannequin Series One. Neil Chapman. One of the handsome and expressive photographs from a fine series that Chapman made in a mannequin warehouse.

(Courtesy of the photographer)

. . . . can be used to lighten all or part of the image

Wash the treated prints thoroughly

Farmer's Reducer can be used to lighten the entire print image or only selected portions of it. If you want to lighten a print overall, presoak it in plain water to soften the emulsion, then slip it into a tray of diluted reducer and agitate continuously until the image begins to show signs of change. Remove the print to a tray of running water just before it's as light as you want it, because the action will continue in the water for a few seconds. Work cautiously; you can always return the print to the reducer to lighten it further, but there's no way to recover the image if it goes too far. I suggest practicing with a spoiled print or two before you reduce a good one.

To reduce the image locally, follow the step-by-step instructions in figure 12.9. If the reducer is the right strength and your technique is good, it will take three or four cycles of wiping, reducing, and flooding to complete the job. Be careful of light-toned areas and highlights because the reducer will etch through light grays very quickly.

Reduced prints are contaminated with hypo and should be treated in a hypo-clearing bath and washed as if they had just been removed from a normal fixing bath.

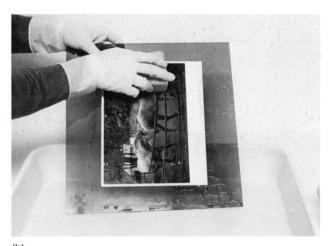

(a)

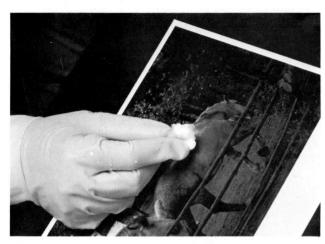

(b)

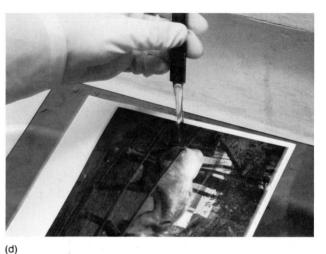

(c)

(e)

Figure 12.9

a. The light on these farm horses is quite beautiful, but not quite emphatic enough to compete with the background details. Reducing can improve it.

b. Prepare the print for treatment by soaking it briefly to wet the emulsion thoroughly. Then sponge it surface-dry and go to work.

c. Using a wad of cotton soaked in diluted Farmer's Reducer, then squeezed dry to avoid dripping, treat the highlight areas carefully. It's a good idea to wear protective gloves when handling any photographic chemical solutions.

d. After a few seconds, before the reducer has had any obvious effect, flood the treated area with water and inspect it. If the print needs more reducing, sponge it surface-dry again, and reapply the reducer. Repeat this cycle until the image tones are satisfactory. e. Treat the finished print in the usual hypoclearing bath (unless it's on RC paper) and wash as usual. If you've done your work well, the image will be improved without showing obvious signs of having been worked on.

(a)

(b)

(c)

Figure 12.10

a. Working on the dry print, paint over the image areas you wish to preserve with Maskoid. Thin the Maskoid with its special solvent if necessary, and be sure to cover the image completely without pinholes.

b. The Maskoid will dry almost immediately. Put on your protective gloves and immerse the print in the bleach bath. Agitate it until the unprotected image has lost all trace of gray. The bleach bath will stain the paper pink and brown; don't be alarmed.

c. Rinse the print in running water until the water runs clear, without any noticeable pink tint, then agitate the print in a nonhardening fixing bath until the stain is gone and the bleached area is pure white. If this takes more than about 5 minutes, treat the print in a 1 percent solution of sodium bisulfite to clear the stain.

d. Rinse the print briefly, then blot it partially dry so you can remove the Maskoid film. Touch the film with a piece of masking tape to get it started, then strip it off. If little bits of it stick to the surface, pick them off with masking tape. Treat the print in hypoclearing bath, and wash as usual.

Bleaching

(d)

Farmer's Reducer can be used to remove the silver image, but a light tan stain almost always remains. For stain-free removal of the image, I recommend permanganate or iodine bleaches (formulas are given in Appendix 3).

The permanganate bleach must be fresh because it spoils fairly quickly after mixing, even if not used. It's best for treating large areas of the print and it can be applied with an old brush (it may ruin a good one) or a cotton swab. If you want to work up to a sharp image edge, protect the image area you wish to retain by coating it with Maskoid, liquid frisket, or thinned rubber cement, following the procedure illustrated in figure 12.9.

Small image areas and black spots that occasionally appear can be bleached conveniently with ordinary tincture of iodine, available at any drugstore. For precise control, apply the iodine to the dry print and clear the resulting stain with a hypo solution, as illustrated in figure 12.10. If a trace of the spot remains after the hypo treatment, wash the area with several changes of water and blot it as dry as possible before reapplying the iodine. Iodine won't work on a hypo-contaminated area. Finally, treat the print in hypo-clearing bath and wash it as usual.

Use a bleach bath to remove the image entirely

lodine is convenient for removing small black spots

Figure 12.11

a. Black spots, such as the one shown here in this greatly enlarged section of a blackand-white print, can be removed with tincture of iodine.

b. Deposit a small drop of iodine solution on the spot using a sharpened toothpick or something similar. Don't use a good brush; iodine makes brush hair brittle. The iodine will stain the paper as it converts the spot from black to brown. If the spot remains gravish after the first treatment, pick the iodine off carefully with the corner of a moistened blotter and apply a fresh drop. c. When the iodine has done its work, pick it off again with a blotter corner and remove the brown stain with a brushful of nonhardening fixer. Treat the print in hypoclearing bath and wash as usual. When the print is dry, use spotting dyes to take care of the white spot, as demonstrated in figure 13.1.

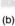

(c)

Renew the chemicals frequently

Use two fixing baths in tandem . . .

. . . or follow llford's suggested procedure

Archival Processing of Prints

Prints that are processed conventionally will probably last for many years without fading or discoloring, but they aren't totally free of harmful chemical traces, and the silver image is not well-protected from attack by atmospheric contaminants. *Archival processing* attempts to correct these problems. The procedure is not basically different from the normal one, but there is greater emphasis on the use of fresh chemicals, control of processing times and temperatures, and more thorough washing. Additionally, the print is frequently *toned* to make the image more inert chemically.

Although RC papers have been improved considerably in recent years and are now said to be suitable for archival storage, I recommend that you use premium-quality double-weight fiber-base paper and adjust your enlarging easel to provide white margins, at least an inch wide on all four sides of the image. Since image deterioration frequently begins along the print edges, the wide borders will delay its spread into the image area.

Renew your print developer more frequently than usual and develop the image fully. Use a mild stop bath of only about 1 percent strength; an acid bath that is too strong may contribute to *water soak*—a mottled, semitrans-lucent pattern that's most visible on the back of the print. Watersoak is not very likely to afflict double-weight prints and it will probably disappear when the print dries, but it's best to avoid it if you can.

Use two fixing baths, mixed with only half the normal amount of hardener. This should be enough to protect the emulsion from damage in normal handling, and it will improve washing efficiency. Treat the print in the first bath, with agitation, for 2 minutes; then rinse it briefly in running water and transfer it to the second bath for 2 more minutes. After about one hundred $8'' \times 10''$ prints (or the equivalent) have been treated this way, discard the first bath and replace it with the second, mixing a new second bath. After 100 more prints, repeat and fix another 100 prints. Then discard both baths and start over with fresh ones.

If you want to wash prints in groups, you can let them accumulate in a "holding" tray of clean water after the first fixer. Change this water frequently because if the prints soak in contaminated water for a long time, they may develop yellowish stains.

llford recommends this alternative fixing procedure for prints made on llfobrom or Galerie papers, processed in llford chemicals. Use a single, fresh, film-strength bath (1 + 4 dilution) of llfobrom nonhardening fixer, and treat prints individually with constant agitation for only 30 seconds. Then wash for 5 minutes, treat in llfobrom Archival Wash Aid (1 + 4) for 10 minutes, and wash again for 5 minutes.

This abbreviated fixing is said to minimize the amount of harmful chemicals that can soak into the paper, thus reducing washing time. *Don't* treat prints in a fixing bath that has been used previously to fix films. (It's generally safe to fix films in a bath that has been used for prints, though.)

No doubt this procedure is satisfactory, but I can't confirm it from experience. I suspect it might be risky to apply this technique to other manufacturer's materials without careful testing.

For maximum longevity, black-and-white silver prints should be *protectively toned*—that is, treated with a chemical solution that either "plates" the silver particles with some inert substance (such as gold or platinum) or combines with the silver to form some compound that's more stable than the silver itself. All toners change the color of the image, and some lighten or darken it noticeably. Not all toners are protective. Some may actually shorten the life of the image.

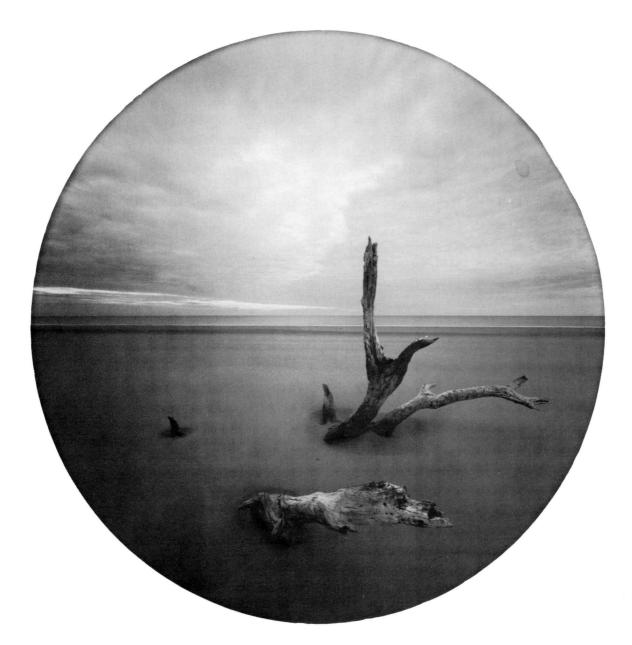

Selenium is the most popular protective toner, but gold is favored by some photographers. Platinum and palladium toning formulas that appear in the old literature should be equally effective, but are almost never mentioned by contemporary authors. See Appendix 3 for toning formulas and instructions for their use.

Kodak supplies Rapid Selenium Toner as a liquid concentrate that can be added to a working solution of Kodak's own Hypo-Clearing Agent (for simultaneous clearing and toning) at the rate of 2 fluid ounces of toner per gallon. Prints can be placed into this bath immediately after being removed from the fixing bath. Treat them in this solution for 3 minutes, then wash them in running water for 30 minutes (or more), and they can be considered to be adequately prepared for long-term storage.

Some photographers object to the combined toning and clearing bath because it doesn't permit control of the image color. If you prefer, you can use the toner as a separate solution, controlling the toning time to produce

Figure 12.12

Driftwood and Seascape, Hunting Island #3, Sam Wang. Elegant economy of design, a unique format, and beautiful print quality combine to make this a memorable image. (Courtesy of the photographer)

Protective toning with selenium is recommended

You can add selenium toner to the clearing bath . . .

. . . or use it as a separate solution

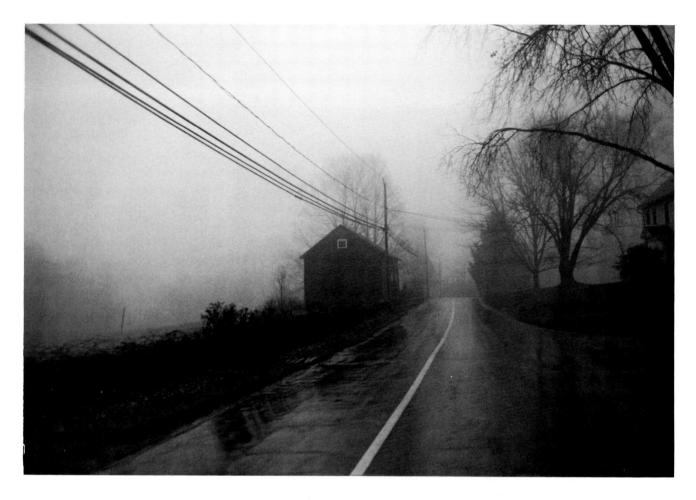

Figure 12.13

Flanders Road, October 1985 David Vestal. Vestal photographs everyday things that matter to him. His work is typically quiet, unpretentious, and understated; and his prints are luminous and elegant.

(Courtesy of the photographer)

Treat the print in hypo-clearing bath and wash thoroughly

the visual effect you want. I recommend diluting the toner concentrate with about 30 parts of water and treating the print in this solution until the image shadows are noticeably darkened. At this first stage, the image color may appear to be cooled slightly, but further toning will shift the color toward purplebrown.

The color will continue to change for a short time after the print is removed from the toner so take it out a little before it reaches the desired shade, treat it in a hypo-clearing bath with agitation, and wash as described above. Prolonging the toning treatment, especially in a strong toner solution, may produce a "split tone" effect in which the image shadows are distinctly brown while the light tones appear bluish gray.

For many years, it has been thought that all traces of hypo should be removed from silver prints, and it has been customary to treat prints in a *hypoeliminator* bath to prepare them for archival storage. This treatment removed the hypo effectively, but also softened the print emulsion rather dangerously and frequently stained the whites slightly yellow. It has been suggested recently that trace amounts of hypo may actually help to protect the image, but Kodak scientists continue to advocate complete hypo removal. As a practical matter, I no longer recommend the use of the hypo-eliminator bath. Instead, I suggest that you concentrate on improving washing efficiency by (1) using a fresh fixing bath with a minimum quantity of hardener (or none at all) for the minimum safe fixing time, (2) using a hypo-clearing bath, (3) being sure the water flow through the wash tray (or washer) is sufficient to change the water completely in 3 or 4 minutes, (4) washing only a few prints at a time and keeping them well-separated, and (5) periodically dumping the wash tray and draining the prints thoroughly before continuing the wash in fresh running water.

Fixing and washing are the critical steps in archival processing. Take them seriously and your prints will last for a long time.

Fixing and washing are the critical steps

Summary

Set up processing trays in the sink, using solutions of your choice at room temperature. Handle your negatives carefully to avoid fingerprints and place them against the printing paper, emulsion to emulsion, in the printing frame. Expose contact printing paper to strong direct light; use the enlarger as a light source for proofing on projection papers.

Develop the print for an appropriate time with constant agitation, but don't vary developing time in an attempt to adjust image density or contrast. RC papers are treated differently than fiber-base papers in the fixing, washing, and drying steps. If you want to produce a mirrorlike finish on glossy fiber-base papers, you can ferrotype them.

Negatives go into the enlarger with emulsion down. Dust them carefully. Raise the enlarger to make the image larger, lower it to produce a smaller image. Check image focus with a grain focuser.

Test strips are useful for determining proper print exposure. Fixed increment strips are best for minor exposure adjustments; use the geometric method for sampling a great range of exposure times.

If the test print is too dark or too light, the print exposure was wrong. If the print contrast is not satisfactory, you'll have to change paper grades or printing filters. Local adjustment of tonal balance can be accomplished by dodging or burning-in the image during exposure.

You can lighten all or part of a finished print image by treating it with a chemical reducer solution. Use a bleach bath to eliminate the silver image entirely. Protect the portions of the image that you want to save by coating them with a resist. Don't reduce or bleach an image that you plan to tone later.

Archival processing is intended to prepare your prints for indefinite storage without deterioration. Use fresh chemicals, time them carefully, and pay particular attention to the fixing and washing steps. Toning the prints will help to protect them from atmospheric contamination.

Print Finishing

Ruttinger's Gift Shop From the "Dexter Portfolio." 1972. The extreme luminance range of this subject demanded careful metering and purposeful control of both film exposure and development.

(Photograph by Phil Davis)

Pigments lie on the print surface

Dye is completely absorbed—if applied correctly

Assemble your spotting materials

Saturate the brush, then stroke it dry on tissues

If you discover any flaws in the print image, they should be corrected before the print is exhibited. Dust or lint on the negative will show in the print as white spots or lines, and scratches or cuts in the negative emulsion will probably show as black marks. Bleaching the black marks will make them white marks, and white marks will have to be *spotted*.

Print Spotting

There are spotting colors (that are really finely ground pigments) and spotting dyes. Pigments are easy to use, but because they're visible on the print surface, they're really suitable only for prints that will be reproduced. I recommend dyes for spotting exhibition prints.

Beginners (and some experienced photographers) have a lot of trouble with dye spotting because they think of it as painting and assume that the dye is supposed to be deposited on the print surface, like pigment. Wrong! If liquid dye is spread heavily enough to wet the emulsion visibly, it will be hard to control and may leave a scum on the surface. If it's used too dry, it will look coarse and ragged on the surface, and can be easily wiped off. When dye is the right consistency—and applied properly—it's completely *absorbed* by the gelatin, without leaving a visible trace on the surface, and simply becomes part of the image tone. It won't do this for you at first, but it will eventually if you understand how it's supposed to work and use the right tools and technique.

Spotting dyes are available in several shades, ranging from rich brown to dark blue. The most nearly neutral dye color offered by Spotone (one of the popular varieties) is labeled #3, and is a good one to start with. Provide yourself with a bottle of neutral dye, a small container of water, a white saucer or plastic palette for mixing the dye shades, some facial tissues or paper towels, and a good red sable watercolor brush, about size #4.

This recommendation will strike many photographers as ridiculous because the brushes that are usually recommended for spotting are much smaller—typically #00 or even #0000. I can't understand why these tiny brushes continue to be popular because they can hold so little liquid that the dye dries out rapidly as you work, changing in consistency and tone with almost every stroke.

By comparison, a good #4 sable will form as fine a point as any smaller brush will (try it in the store before you buy it) and will hold enough dye mixture so that you can work for 2 or 3 minutes, at least, without any serious change in dye consistency or tone. Once you've worked with the larger brush for a while, I think you'll see its advantages.

Place a practice print in good light, avoiding surface glare if you can. Protect the emulsion surface under your hand with a cover sheet. Dip the brush into the dye and deposit a brushful on the saucer, dividing it into three or four separate puddles. Then dip the brush into the water and, without rinsing it, deposit several blobs of "dirty" water on the saucer. Now stroke the brush on the tissues, holding the handle low and pulling it across the tissue surface so the brush hairs are straightened. Rotating the handle in your fingers as you stroke will help to form the fine point you need. Continue stroking the tissue until the brush leaves only a faint line of moisture and appears to be surface-dry (fig. 13.1). It now contains a light-toned dye mixture, suitable for use on a light gray image area.

Holding the brush almost vertically, bring the tip hairs into contact with the white margin of the practice print and draw a thin line. Notice that the dye color is pale when the brush moves rapidly and becomes darker when the brush moves slowly. Also notice that going over the line more than once darkens the dye tone. Practice brush control by making short, thin lines in

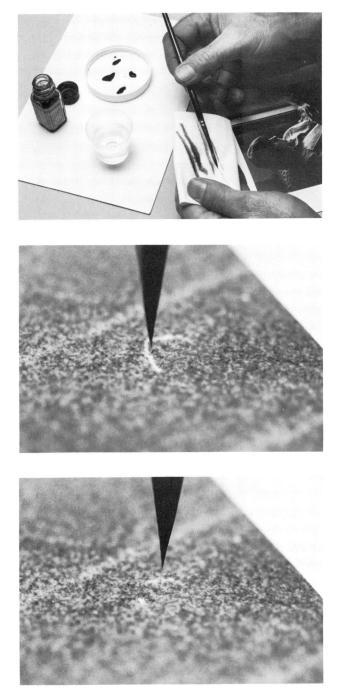

a. Saturate the brush in the appropriate dye mixture and stroke it almost dry on tissue. Rotate it as you stroke to keep the point well formed.

b. Greatly magnified view of a lint mark on a medium gray area of a moderately grainy image. Notice the fine brush point. A smaller brush will form no better point and will dry out much sooner, shifting the dye color and laying dry dye on the print surface. Some prints, especially those on RC paper, may refuse to absorb the dye properly causing it to remain on the surface as a granular film. When this happens, press the corner of a dampened blotter against the print surface in the area of the spot. In a few seconds the emulsion will probably accept the dye normally.

c. Here the lint mark is partly spotted. Use a stipple stroke to match the grain texture and break the line into sections first to avoid the possibility of simply reinforcing the linear appearance if your technique is not perfect.

various directions and try stippling an area of the practice image with tiny dots. You'll probably find stroking motions that make little apostrophe-shaped marks are easier to control than poking motions that deform or split the brush tip. Practice a blended-dot technique to build up tone gradually. Long linear strokes are much more difficult to control and are likely to be very visible in the print image.

After 2 or 3 minutes you'll notice that the dye marks are getting darker and more granular and the brush tip is losing its spring. These are signs that the brush is too dry. *Don't* simply dip the tip in dye to recharge it! Blend a puddle of dye and water on the palette to produce the tone you want, then saturate the brush in it and again stroke it surface-dry on the tissue. Failure to do this will result in uncertain dye tone and improper consistency, and you'll soon regret it. When the brush shows signs of drying, resaturate it

Practice until you feel confident

Break lines into short segments

Use just the tip of the brush; don't bear down

If the print surface repels the dye, dampen it

You may be able to remove a little of the dye if necessary

RC papers require patience, but they can be spotted

Protect your spotting brush; moths love sable hair

Experiment for a while. You'll soon discover that the easiest spots to deal with are dust spots on a grainy image, in an area of medium-light tone. The most difficult ones to eliminate are fine white hairlines on black image areas. After you've labored over a few of those, you'll learn to clean your negatives before you print them! Practice until you feel confident, then charge the brush with a very light tint (barely dirty water) and tackle a good print, starting with the lightest areas.

There are a few tips that may help you get started. Never try to follow a white line with a single stroke; break the line into short segments first, then stipple them in, one by one. Always try to make your brush marks simulate the natural texture of the image.

Be especially cautious when working on very dark areas of the image; you won't see immediate results because the dye density builds up slowly and you may be tempted to bear down on the brush to speed things up. Don't do it. Pressing down will spread the brush hairs out and you'll simply paint a dark ring around the spot. Work with just the brush tip and be patient. It may take a while to build up the tone you need, but you can't rush it.

Work on the dry print if the image is sharp; if the image grain is soft or blurry you may find it easier to match if you dampen the emulsion. Dampen the surface also if the emulsion appears to be "waterproof" and repels the dye. If the neutral dye doesn't match the color of your print image, you can adjust it by blending in a little of one of the other available colors, but try it on a scrap print before you use it on a good one. The dye color that you see on the palette may not indicate the color it will assume on the print. In the lighter areas of the image, start with a weaker dye mixture than you think you'll need; you can always darken it, but it's very difficult to lighten dye and almost impossible to remove it entirely once it's been absorbed by the emulsion.

If you *do* make a mistake and get the dye too dark, you may be able to lighten it a little by soaking the print for a while in a weak alkaline bath. Try about a tablespoonful of ammonium hydroxide or sodium carbonate in a quart of water. Be careful of the concentrated ammonia. It's a strong alkaline liquid with a suffocating odor; don't use it without hand protection and good ventilation. The diluted solution will have a strong odor, but is perfectly safe to handle. This alkaline treatment will soften the image gelatin and make the print feel slippery. Rinsing it briefly in a weak stop bath solution (preferably without the indicator dye) will cure the soapy feel. Then wash the print for a few minutes and dry it normally.

RC papers have a reputation for being difficult to spot, with some justification. It's true that they seem to take the dye more slowly than fiber-base prints do and the dyes seem more likely to show on the emulsion surface. If you have this trouble, add a drop of wetting agent to two or three ounces of water and use it to mix the dyes; then work slowly. When it's apparent that the emulsion has stopped accepting dye, let it rest while you work on another area. When you come back a few minutes later, I think you'll find the area receptive again.

Use your spotting brush only for spotting, and preferably only for dyes; pigments will eventually grind off the fine tip hairs that form the delicate point you need. When you're through spotting, rinse the brush thoroughly in clear water and shake it dry. Form the hairs into a point and don't let anything deform the point as the brush dries. For long-term storage, wrap the brush in a cylinder of paper and seal it; moths love red sable hair.

Mounting and Matting Prints

Prints to be exhibited should be mounted in some way to hold them flat for comfortable viewing. There are several ways to do this. Prints that will be handled a great deal (as in a professional portfolio, for example) will survive longer if they're bonded to a substantial support, such as "illustration board." You can use spray adhesives, liquid adhesives, pressure-sensitive adhesive sheets, or thermoplastic adhesive sheets. Pressure-sensitive sheets are fine for RC prints, but I prefer thermoplastic sheets, called *dry-mount tissue* for both RC and fiber-base prints.

There are two types of dry-mount tissue available. The higher temperature type is typically light tan or brown, translucent, glossy, and crisp to the touch. Use it only for fiber-base prints, and set the mounting press thermostat to about 250° F (121° C). *Don't* use this tissue or this press temperature for RC or color prints or they'll melt. There's a special low-temperature tissue for them. It typically looks pure white, waxy, only slightly translucent, and feels leathery. Actually it's a wax-impregnated tissue that should be used with the press set at about 190° F (88° C). This low-temperature tissue is perfectly satisfactory for fiber-base papers, too, of course, and I recommend that you use it for everything that you dry-mount.

Dry-mounting is a fairly foolproof procedure, but a few problems can arise. If the press is too hot or the print is heated too long, fiber-base papers may not adhere well (the wax may liquify and soak into the board) and RC and color prints, as mentioned above, will be ruined. There is no cure for this. If the press is too cool or the time too short, the prints (both kinds) won't stick to the mount, or they may stick for a little while before popping or peeling off. Put them back in the press at a higher temperature or for a longer time.

If the *platen* (the hot aluminum press plate) is dirty, it may emboss the print emulsion with little dimples, even through the cover sheet (*always* use a cover sheet). Dirt particles trapped between the print and the mount board will show up as pimples on the print surface. There's no real cure for either problem; clean the platen and mount a new print without the dirt.

If either the mount board or the press pad is damp, steam bubbles may form under the print, preventing adhesion and appearing as flat blisters. You may be able to cure this problem by drying out the press pad, reheating the print, and cooling it under pressure. This is less common with the low-temperature wax tissue than with the high-temperature material, but it can happen if someone has been using the mounting press to dry damp or wet prints a thoroughly antisocial thing to do!

If you want to trim prints "flush," without borders so that the image "bleeds" on all four sides, follow the procedures in figure 13.2. To mount the print in position on a larger board without an *overmat*, see figure 13.3. If you prefer to mount your print with a "square cut" mat opening, see figure 13.4. For a step-by-step demonstration on how to cut "bevelled" mats with the popular Dexter mat-cutter, see figure 13.5.

Although dry-mounting (with thermoplastic tissues) is considered to be archivally safe, most collectors and museum directors prefer that photographs be unmounted or held in position on their mounts by acid-free paper *corners* (fig. 13.6) or tissue *hinges* so that the prints can be removed for storage or remounted if desired.

Prints should be mounted for comfortable viewing

There are two types of dry-mount tissue

Don't use high-temperature tissue for RC prints

Always use a cover sheet

Mounting styles, with or without an overmat

Acid-free corners or hinges are preferred for fine prints

a. Lay the print facedown on a clean surface and attach a sheet of dry-mount tissue to it with a light touch of the hot tacking iron. Tack it in only one spot, preferably near center.

b. Trim off any tissue that extends beyond the edges of the print. It's easiest to do this if you take a narrow strip of the print margin with the tissue, but be careful not to cut into the image area. The mat-knife and straightedge technique shown here is generally more satisfactory than using a print trimming board or paper cutter. When using a mat-knife, *always* keep a sheet of heavy cardboard under the work to serve as a cutting surface. *Never* cut on an unprotected tabletop or desktop.

c. Lift a corner of the print and tack the tissue to the mount board. Again, tack the tissue in only one spot to avoid creating folds or wrinkles in the tissue when it's pressed. The tissue that overhangs the mount board (right corner in the illustration) will have to be trimmed off before the board can be put into the press; otherwise it will stick to the press pad and make a mess. d. Cover the face of the print with a clean cover sheet and slip it into the press. Time and temperature will depend on the type of paper in use and the mat board weight. See the text for details.

e. Trim the mounted print to finished size with mat-knife and straightedge. You can use a plastic triangle to keep the corners square and protect the print surface, as is shown here, but don't use it as a cutting guide; the plastic nicks easily.

f. Smooth the edges of the trimmed print on both faces with fine sandpaper and a block. Stroke away from the print face to avoid chipping the edge of the image gelatin. Then wax the smoothed edges and polish them with tissue. You can use wax crayons if you want toned borders; paraffin will finish the edges without leaving any visible trace.

a. If you want your print mounted with borders, but not matted, you'll have to trim it to finished size and place it carefully on the mount board. The actual procedure will depend on the mounting technique used, but in any case you'll have to determine the image dimensions and mark the print position carefully and lightly on the face of the mount board. Use soft pencil and light pressure so the marks can be erased.

b. If you plan to dry-mount the print, attach the tissue and trim both print and tissue to finished size. An alternative dry-mounting method, using Scotch brand adhesive sheets #567, is shown here. Lay the adhesive sheet dull-side down on a clean surface and carefully peel back the adhesive tissue from the release paper. Lay the print facedown on the release paper.

c. Lay the tissue back down to cover the print and squeegee firmly to attach the tissue to the back of the print.

d. Lift a corner of the adhesive backing paper and slowly peel it away from the print. The adhesive film adheres to the print back as it leaves the backing paper. It is selftrimming.

e. The print will stick to your fingers now but it can be moved around on the board without adhering. Position it carefully on the guide marks and press it down lightly with your fingers.

f. Now cover the print with a clean paper, preferably a silicone-release paper, and squeegee firmly. This pressure bonds the print securely to the board.

g. If traces of the adhesive show around the print edges, they can be removed easily with a rubber cement lifter or a kneaded eraser. This mounting adhesive is claimed to be safe for photographs, long lasting, and nonstaining. If necessary, prints can be removed from the mounts, with rubber cement thinner.

a. Tack a piece of dry-mount tissue to the back of the print, then trim off any tissue that extends beyond the edges of the print. A print to be matted should not be trimmed to exact size before mounting but final image dimensions must be known. Determine the composition with L-shaped cardboard strips (cropping Ls) laid over the print. Then measure the image dimensions and jot them down.

b. Determine the mat and mount board size by adding the desired margin widths to the print dimensions. Cut the mount board slightly smaller than the mat so the mat will cover it completely. Mark the image corner positions on the front of the mat board. Some mat boards will not tolerate erasure so make the marks as light and inconspicuous as possible.

c. Using a metal straightedge as a guide, cut the mat opening with a sharp mat-knife or utility knife. Always cut on the "waste" side of the straightedge so, if the knife wanders off line, it won't damage the mat itself. Cut just past the corner marks so the mat corners will be clean and free from tufts of uncut fibers.

d. Place the print on the mount board; place the mat board over it; and align the mat and mount boards carefully. Then slide the print into satisfactory position in the mat opening. Check to be sure the boards are still in exact alignment.

e. Hold the print in position on the mount and lift the mat carefully. Then lifting a corner of the print, tack a corner of the drymount tissue to the mount board.

f. Protecting the print face with a cover sheet, insert the mount board into the press and heat the print to bond it to the board.

g. Align the top edges of the mount and mat boards; the mount board should be faceup and the mat board facedown. Tape the intersection together to form a hinge. Use fabric library tape for archival quality prints, and plastic or paper tape for temporary use. Ordinary masking tape is not desirable; it will dry out and discolor with age and may damage the print if it comes into contact with it. You can, of course, drymount or glue the mount and mat together permanently if you want to

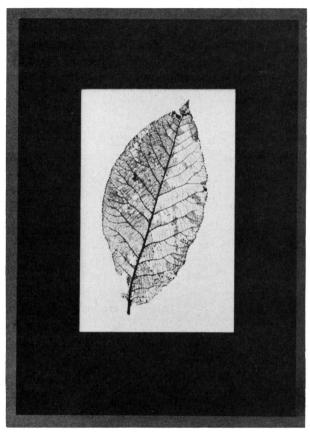

h. The finished print is neatly presented. Select mat boards in any color or texture that pleases you.

a. Cutting beveled mats is not much different from cutting ordinary ones but a special mat-cutter makes the job easier. Here's one method using the familiar and relatively inexpensive Dexter mat-cutter. Determine the mat opening dimensions and mark them on the *back* of the mat board. You can be bold with these lines and draw them well past the corners.

b. Place the mat board facedown on a sheet of expendable cardboard to serve as a cutting surface, and align both boards with the edge of your work table or drawing board. This allows you to use a metal Tsquare to keep the lines straight and to use as a cutting guide. The T-square is much easier to hold steady than an ordinary straightedge. Align the edge of the matcutter with the drawn border line and insert the knife point just behind the cross line, as shown. Press it down firmly.

c. Slide the T-square over to the cutter and allow it to square the cutter if it's slightly out of line. Check the board alignment again to be sure it is snug against the T of the Tsquare.

d. The Dexter mat-cutter is a strictly righthanded instrument. Place your hand on it naturally, and holding the T-square down firmly, push the cutter along the metal guide. If the knife blade is in good shape, it should cut cleanly and easily without any tendency to wander away from the guide. Cut about ½-inch past the cross line to insure a clean corner. One authority suggests pinning the mat board down to help hold it in place—a good idea. Use a couple of pushpins in the waste center area of the board.

e. A finished mat corner.

f. Align mat and mount boards, as previously described, and center the print in the mat opening.

a. There are several ways to make paper corners for archival print mounting. This is the one I prefer. Simply fold narrow strips of acid-free paper as shown and fasten them in place with strips of linen tape. I recommend *museum barrier* paper if you can find it (some art supply stores carry it). It's safe and substantial enough to make corners that will support prints of any size.

b. Some people like to use gummed art corners for mounting. If you want to try this method, it's helpful to hinge the mat and mount boards before positioning the print. Then hold the print in position and open the mat. Moisten the gummed backs of the art corners, one at a time. Slip them over the print corners and press them down firmly. They stick almost immediately. I suggest using a dampened sponge instead of licking them (the glue tastes terrible).

c. Some photographers prefer to attach strips of acid-free tissue to the backs of their prints, then attach the strips to the mount board so that the print simply hangs in place behind the overmat. Fold the tissue strips into hinges to mount small prints that will not be overmatted.

Summary

Prints should be spotted for presentation. You can use spotting colors, but dyes are preferable for exhibition prints. Dyes come in several shades from dark brown to dark blue. Neutral dye is best to start with.

A medium-size brush is preferable to the tiny brushes usually recommended. Don't just wet the tip of the brush with dye, saturate it; then stroke it surface-dry to form the point and achieve the right dye consistency. Practice spotting on spoiled prints until you're confident of your technique.

Break lines into segments and stipple them. Work slowly and don't bear down on the brush. Work on the dry print if the grain is sharp; dampen it if the grain is soft. You may be able to lighten the dye by soaking the print, but it's not easy to remove it entirely. RC emulsions absorb dye slowly; don't rush them. Use your spotting brush only for dye spotting and store it carefully.

Prints can be mounted in several ways. Dry-mounting is probably best for prints that will be handled a great deal. Use high-temperature tissue only for fiber-base prints—never for RC prints in black-and-white or color. Lowtemperature tissue is recommended for all prints that you wish to dry-mount. Consider mounting your exhibition prints with acid-free corners or tissue hinges, and overmats.

Introduction to Color Photography

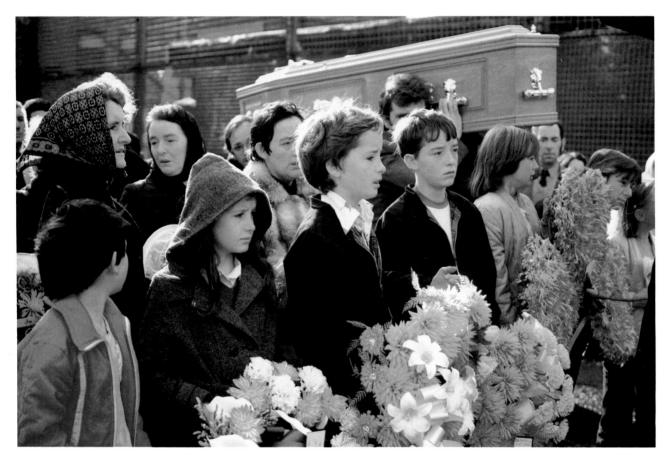

Catholic Funeral, Belfast Photograph by Bill Pierce. Photojournalists witness extremes of human emotion by definition of their jobs, yet documents that are both as descriptive and as sympathetic as this one are rare. Pierce has portrayed this somber moment in gentle light and gorgeous color.

(Courtesy of the photographer)

Your first color slides may surprise you

We can't identify colors very accurately without some reference . . .

. . . and that may be a good thing

Color transparency films are balanced for some specific "white"...

. . . that's identified as a color temperature

There are three standard "whites"

Color Balance

When you first begin to work in color, especially with positive *transparency* materials such as color slide films, you'll probably be surprised by some of the results you get. Light conditions that seemed quite ordinary while you were photographing may appear in your slides as distinctly off-color, as if the pictures had been tinted or toned. Actually, the pictures may be fairly accurate records of the real light color that you simply failed to recognize.

This problem arises because the human eye and brain are remarkably accommodating and the film is not. We see color *comparatively* to a large extent and can identify rather subtle distinctions between hues, seen sideby-side, even when the color and intensity of the illumination vary widely. We can't identify colors very accurately without some reference, though, and in this respect our color perception is similar to our ability to judge the pitch of musical tones.

Most of us can distinguish a high note from a lower one, or sing simple melodies without straying off-key, but very few individuals can tell that an automobile horn is playing an A-flat major chord, for example. The few who are blessed with this ability are said to have "perfect pitch." It's doubtful that anyone has perfect color pitch (as color films do), and that's probably a good thing. If familiar objects apparently changed color every time the light color shifted, it would be unsettling, to say the least.

In almost any condition of illumination, we can identify white objects, even though the entire scene may be strongly tinted with color. This perception of white provides us with a reference for judging both the color and value of other areas of the subject. Interestingly enough, if a brighter "white" of more neutral color is introduced into the scene, we immediately perceive the first reference "white" area as tinted and grayed—but we still may be able to think of it as white. In fact, our perception of the color of familiar objects is almost independent of illumination color, as long as the light contains a reasonable proportion of all three of the primary colors—red, green, and blue. Color transparency films aren't this adaptable; they're *balanced* during manufacture to recognize a "white" of very specific color.

Light that's emitted by a hot body, such as the sun or the tungsten filament of a common light bulb, is said to have a *continuous spectrum* because it contains an unbroken series of wavelengths. At temperatures below the point of incandescence, a hot body radiates only a wide band of infrared wavelengths, some of which we can perceive as heat. The radiation band is expanded toward the shorter wavelengths as the temperature is increased, and when the temperature reaches about 1000° *Kelvin* (degrees Celsius above absolute zero), some visible wavelengths are included and a dull red glow appears. Rising temperatures reach progressively further into the visible spectrum and the emitted light color shifts gradually through red, orange, and yellow toward blue, becoming progressively ''whiter'' and more intense.

Because light color is related directly to the temperature of the radiating source, it's customary to identify standard whites by their *color temperatures*. For example, the light emitted by an ordinary 100-watt electric light bulb is said to have a color temperature of about 2900° K because its color approximately matches the color of a black body at that temperature.

Transparency films recognize one of three standard white lights: *daylight* films are balanced to regard 5500° K as white; *Type A* films are balanced for the 3400° K light produced by some *photoflood* bulbs; and *Type B* films are balanced for the standard 3200° K photofloods and other studio tungsten lights used by professionals. At present there is only one Type A film—Ko-dachrome 40—and it is available in only one size—35mm cartridges. All other tungsten films are Type B emulsions.

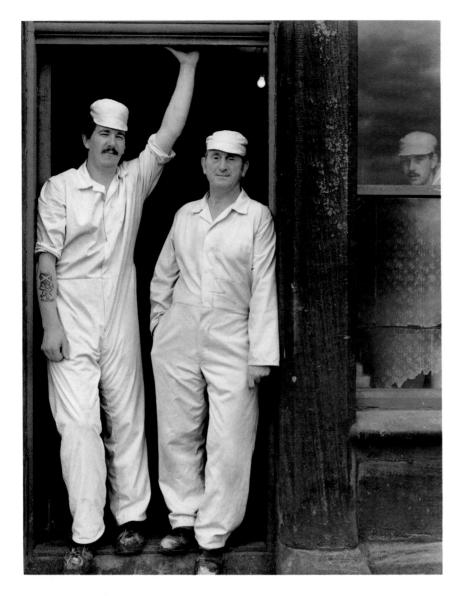

Color films see only the light color they're balanced for as white. If you use either of the *tungsten* (Type A or B) films in daylight without corrective filtration, your pictures will be heavily stained with blue; using daylight film in tungsten light will produce orange-brown pictures (plate 26).

High voltage *gas-discharge* lights (such as neon signs and mercury-vapor lamps) that ionize some gas into incandescence emit a *discontinuous spectrum*. That means that their light consists entirely of a few narrow bands of color, between which whole sections of the normal spectrum may be missing. Because their unusual spectral characteristics can't be matched by light emitted by a "hot" source, such as the sun or a tungsten filament, these "cold" lights have no Kelvin degree equivalents and can't be assigned meaningful color temperatures.

Ordinary fluorescent lights also fall into this category, and although the light they produce appears to be white, there are actually gaps in the red and blue regions of its spectrum. Fluorescents generally are fine for black-and-white work, but color films typically interpret their light as some shade of yellow-green. Only one or two special types of fluorescent tubes (Verilux is one brand) are acceptable for color photography.

Figure 14.1

Short's Mill, Berwick; part of East of Scotland series. Phil Moody. In this handsome informal portrait—from a series done in Scotland—Moody has placed the brilliant white-clad figures against a rich, dark background of muted color to create a bold and effective composition. The face of a third worker appears in the window as an added element of interest.

(Courtesy of the photographer)

Some light appears white, but isn't

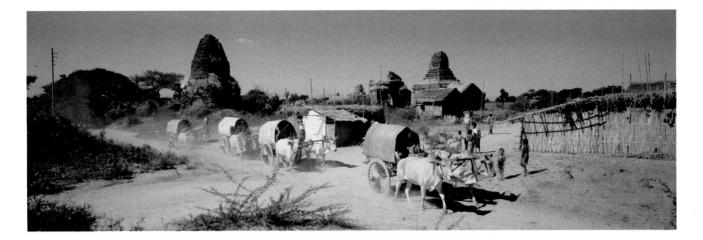

Figure 14.2

Untitled. Fred Conrad. As a staff photographer for the New York Times, Conrad's assignments frequently place him in strange environments. This beautifully composed rural scene in Burma proves that his eye remains fresh and receptive despite the pressures of his professional work.

(Courtesy of the photographer)

Color temperature defines the orange-blue balance

Conversion filters shift color temperature

Light-balancing and color-compensating filters are useful, too

Color Filtration

Color temperature defines the "orange-blue" balance of a light. A relatively high color temperature indicates that the light contains a preponderance of blue light; a low temperature indicates that more red and orange are present. This suggests the possibility of raising the color temperature by adding more blue, or lowering the temperature by adding more red. Of course, you can also raise the color temperature by *subtracting* red, or lower it by *subtracting* blue. The only difference is that by adding color, you'll increase the *intensity* of the light, while subtracting color will *decrease* intensity.

Filtration alters color temperature by subtraction. For example, placing an orange filter (of the proper hue and saturation) over the camera lens will absorb enough blue light from normal daylight to convert it into the equivalent of tungsten light. This special *conversion filter* will therefore permit you to use tungsten film satisfactorily in daylight. Similarly, you can use daylight film in tungsten light if you use the appropriate blue conversion filter over the lens. Of course, because these filters absorb some of the light, they will necessitate an increase in exposure, as was explained in the discussion of filter factors in Chapter 8.

You can use filters for less dramatic shifts of color, too. Eastman Kodak manufactures an extensive line of *light-balancing* and *color-compensating* filters, as well as the conversion filters just mentioned. There isn't any firm distinction between conversion and balancing filters (Kodak actually refers to them both as light-balancing filters), but when the term *conversion* is used, it ordinarily applies to filters in the 80 (blue) and 85 (orange) series; and the term *light-balancing* generally refers to the less-saturated colors in the 81 (tan) and 82 (bluish) series. See Appendix 5 for a list of these filters and their characteristics.

In selecting a conversion or light-balancing filter for use, you must know the color temperature of the light you're working with and the kind of film you're using. The correct filter is one that will shift the light color to match the film balance. For example, if you're working in normal daylight (5500° K) and using Kodachrome 40 film (Type A, 3400° K), you need a filter that will *lower* the Kelvin temperature (shift the color toward red) by 2100° (5500 - 3400 = 2100). The appendix chart indicates that an 80B filter is the correct one and that it will require an exposure increase of 1²/₃ stops.

Of course, ''daylight'' is not always 5500° K. Late evening light may reach a low that approximates tungsten light (in which case it might be appropriate to use tungsten film without filtering). Blue sky light, such as you'll find in an area of open shade on a clear day, can be as high as 20,000° K. These are extreme conditions, of course, but ''normal'' daylight is fairly rare. If your work requires highly accurate reproduction of subject color in natural light, you probably should acquire a *color temperature meter* so that you can determine the color of the light with some precision.

Fortunately, it's rarely necessary to record subject colors exactly—in fact, color films are inherently incapable of precise color duplication. For most purposes, it's sufficient to match light and film to within 100° K or so, and an error of as much as 200° is rarely serious, although it will probably be noticeable. Of course, for creative or expressive purposes, you may be content to accept whatever color balance your film produces or you may elect to manipulate image colors deliberately. "False" color effects can sometimes help to translate a rather ordinary subject into an outstanding photograph (plate 27).

Color Compensating Filters

Conversion and light-balancing filters are intended for color temperature shifts in the orange–blue range. Color compensating (CC) filters are available for any other color adjustments you'd like to make. They're supplied in six colors representing the light primaries: red, green, blue, and their complements (the pigment primaries), cyan, magenta, and yellow. Each color is available in at least six degrees of saturation from a very pale tint to a moderately strong hue, and all are fully identified for easy selection. For example, CC 20R identifies a red color-compensating filter whose *density* for cyan light (its complementary color) is 0.2; CC 05M describes a magenta filter having an effective density of 0.05 for green light.

Special-Purpose Filters

Ultraviolet light affects all films strongly, but it's not usually a serious problem in black-and-white work because the UV simply contributes mostly to the total exposure. UV is less tolerable in color photography. Color films can't distinguish between ultraviolet and visible blue light so when UV is present in morethan-ordinary amounts, it adds a generally undesirable blue stain to the image. The faintly pinkish *skylight* filter (Wratten #1A) and the yellow-tinted *haze* filters (Wratten 2-series) are designed to correct this problem. These filters appear to be almost colorless and have practically no effect on visible light, but they absorb UV very effectively. They have a negligible effect on film exposure and no compensation is necessary.

Unlike the filters discussed above, polarizing filters have no selective effect on color. They can often increase the apparent purity and saturation of image colors, however, by removing glare light from the subject surfaces. They can also be used in some situations to intensify the blue color of the clear sky, as has been previously explained. Polarizers have a variable factor because their actual absorption depends upon the amount of polarized light in the scene and the orientation of the filter. It's safest to bracket your exposures when using a polarizer. See Chapter 8 for more information about polarizers and their uses. Exact color rendering is rarely necessary

Color films can't distinguish between blue and UV

A polarizing filter can often enhance color purity

Figure 14.3

This picture, a delightful visual bonus of the space program, was made by a Landsat satellite 575 miles above the earth. These satellites observe the terrain in four spectral bands—green, red, and two bands of invisible infrared—and record a 115 × 115 mile square area in 25 seconds. In this digitized false-color image of the area around Las Vegas, Nevada, vegetation appears in shades of red; bare soils range from light to dark gray; clear water is dark blue or black; turbid water is light blue; asphalt roads and dense urban areas are blue to black; clouds, snow, and sand are white; and cloud shadows are black.

(Courtesy of the Environmental Research Institute of Michigan)

How Color Films Work

It's a practical fact that light of any tint or shade of any color can be produced quite satisfactorily by blending together various proportions of the light (additive) primaries—red, green, and blue. Similarly, if dyes or pigments of sufficient purity can be obtained, any color can be produced by mixing together proper amounts of the pigment (subtractive) primaries—cyan, magenta, and yellow (plates 22 and 23).

In color photography the appearance of full, natural color is achieved by filtering the complex shades and tints of the subject to *separate* them into their component primary colors and form an intermediate negative image. Then the complements of these *separations* are recombined to form the final, positive color image.

Color Negative Films

Color negative film consists essentially of three separate black-and-white emulsions, coated one over the other on a common base. Each emulsion layer contains a *color coupler* that, by a process called *chromogenesis*, is capable of forming a dye while the silver image is being developed. During exposure, each of the emulsion layers responds to a single primary color: the top layer contains a yellow dye coupler and records blue light, the middle layer contains a magenta coupler and records green light, and the bottom layer contains a cyan coupler and records red light. After exposure, the film is developed in a special *color developer* that, in a single operation, produces negative images in both silver and dye in all three layers. Then a bleach bath removes all the silver, leaving the dye images—yellow, magenta, and cyan—superposed. In practice, the process allows controlled amounts of the color-forming emulsion ingredients to remain along with the image to provide a color-correcting *mask*. This mask layer gives color negatives their characteristic orangetan tint (plate 36).

Printing a color negative simply repeats this process (without forming the mask layer) on a paper base. The positive image is formed in both silver and dye in each of the emulsion layers; then the silver is removed, leaving the dye layers superposed to form the print image. See Appendix 1 for a list of some currently available color negative films.

Color Positive (Reversal) Films

Color slides and other color film transparencies are positive images formed on the original film base rather than being printed on paper. Again, three emulsion layers containing the necessary color couplers are involved, each responsive to a single light primary color. In this case, though, the *first developer* produces only a conventional negative silver image in each layer. This leaves, in each layer, a residue of unexposed and undeveloped emulsion that is, in fact, a potential positive image.

When this remaining emulsion material has been thoroughly fogged by *reversal* exposure or chemical treatment, a color developer forms both a silver image and a dye image in each of the three layers simultaneously. This leaves the film completely opaque, with both negative and positive silver images combined with a positive dye image in each layer. After a bleach bath has removed all the silver, the three dye layers remain to form the final color image that, when viewed against the light, reproduces the subject colors with commendable accuracy (plate 37). See Appendix 1 for a list of some currently available color transparency films.

One slide film type—Kodachrome—is unique. Unlike the films described above, the Kodachrome emulsion layers contain no couplers, so the three image dyes can't be created all at once in a single development step. Instead, after the initial black-and-white negative development, the film layers are reexposed individually and developed in separate developers, each containing the appropriate coupler. The procedure is too complicated to be carried out in the average home darkroom and Kodachrome must be sent to a Kodak laboratory or one of the licensed independent labs for processing.

Special Film Types

A few unconventional color materials are worth mentioning. The Polaroid Corporation manufactures special film packs that combine the functions of film, processing chemistry, and print material. After exposure in a specially designed camera, the individual films are ejected and process themselves in Color negatives contain a color-correcting mask

Color positive films must be developed twice

Kodachrome film is unique

Figure 14.4

Untitled Still Life. Volker Liesfeld. Liesfeld is a well-known German photo-designer whose still-life arrangements are notable for their bold design, bright color, and frequent use of illusion, as exemplified here.

(Courtesy of the photographer)

seconds to produce "instant" color prints. The system relies on *dye diffusion*—a process in which the image dyes actually migrate from their original sites in the film emulsion to the "print" surface.

Polaroid also produces instant color films in large-format sizes. These films produce remarkable color print quality and have been used very effectively by art photographers and other professionals.

Polaroid manufactures an instant color slide film, too, complete with a processing pack that must be loaded, with the exposed film in its cartridge, into a special processor. "Development" is simply a matter of turning a crank and waiting a few seconds; then the finished transparencies are cut from the film strip and inserted into special slide mounts in an ingenious "trimmer/mounter" device.

Because this is an "additive" color film (similar in principle to the Lumière brothers' Autochrome, mentioned in Chapter 1), the film is imprinted overall during manufacture with a fine "filter screen" of red, green, and blue dye lines that's visible—but not usually objectionable—in the magnified image. The image silver that remains after processing selectively controls light transmission through this filter screen to reproduce the subject colors with unusual luminosity. This residual silver also contributes to a distinctive midtone graininess and gives the transparencies a mirrorlike luster. The film is balanced for daylight and is fairly slow, but when properly exposed, the image color is remarkably good.

Conventional color films—both negative and positive—are available from several manufacturers in all the popular roll and sheet sizes and a wide range of speeds (Appendix 1). In general, as is the case with black-and-white materials, the slower films exhibit finer grain and produce somewhat sharper images than fast films, although emulsions have improved so much in recent years that even the fastest films provide fine image quality.

The popular "amateur" color negative films are balanced for use in daylight, but they'll tolerate other ordinary light conditions reasonably well, even without corrective filtration. Of course, it's best to filter these films to compensate for abnormal light conditions, especially when you want the best,

Polaroid's color slide film is an "additive" material

Amateur color negative films are balanced for daylight

most accurate color quality; but filtration is not as critical a problem as it is with reversal films. This is because it's possible to adjust image color rather considerably when the negatives are printed.

"Professional" color negative films are available in two versions, labeled S (for short exposure) and L (for long exposure). Type S films are balanced for daylight and are intended for use when the exposure time is 1/10 second or less. Type L films are balanced for tungsten light (3200° K) and are designed to be used with shutter speeds between 1/50 second and 60 seconds. Both films should be filtered to correct for abnormal light conditions, but some mismatch is tolerable because the image color balance can be restored in printing. Exposure times are more critical; if type S films are exposed for longer than about 1/10 second or type L films for less than about 1/50 second, uncorrectable color shifts (abnormal color changes) may occur.

Reciprocity Effects

These color shifts are due to an effect that's commonly called *Reciprocity Failure* or *Failure of the Reciprocity Law.* The law states that the exposure effect (on a photographic emulsion) will remain constant as long as the product of the exposing light *intensity* (I) and exposure *time* (T) remain constant. In other words, the law says that the values of I and T are individually unimportant as long as their product remains unchanged.

In practice this is not true. Every emulsion has a "preferred range" of light intensities, within which it functions normally and obeys the Reciprocity Law. If exposed to light intensities outside this range, however, the emulsion appears to lose sensitivity and must be given more than "normal" exposure to produce normal image density.

Reciprocity Failure is an important problem because it results in both a loss of effective speed and a change in image contrast. In black-and-white photography these effects can be counteracted to some extent by increased exposure and adjusted development time (Appendix 7); but color materials are less flexible. This is because color films (and papers) have not just one, but three separate emulsion layers—each with its own reciprocity characteristic. Good color reproduction is possible only as long as all three emulsions are responding similarly to the exposing light. When the "preferred exposure

Figure 14.5

Lake Powell, Arizona and Utah. William Garnett. Garnett's gorgeous aerial photographs are well-known. The quality of light in this fine example is reminiscent of nineteenth century American landscape paintings.

(Courtesy of the photographer)

Professional negative films come in two versions

Reciprocity Failure is an important problem

Figure 14.6

Untitled, from the Boy Scout series. Janice Levy. This perceptive portrait combines an air of easy informality with eye-pleasing color.

(Courtesy of the photographer)

range" of one of the emulsion layers is exceeded, its dye image will not be fully formed and its contrast will change, disrupting the color balance of the entire image (plate 43).

This would not be particularly serious if only the density of the dye image were affected; a simple deficiency of one color can be corrected quite easily in printing. But a change in *contrast* results in disproportionate distribution of that dye throughout the image density range. In other words, if the cyan dye layer (for example) is reduced in contrast, the image shadows may appear normal in color but the highlights will be deficient in cyan and appear reddish.

Of course, the actual colors that stain the highlights or shadows (or both) depend on which emulsion layer(s) fail, but the stains will always be complementary: that is, if the highlights are greenish, the shadows will be pink; if the highlights are blue, the shadows will have a yellowish cast; and so on. We refer to this effect as *color crossover* and it cannot be corrected by simple filtration.

Film Latitude

Most common black-and-white films have considerable *latitude*—that is, they will respond to a fairly wide range of exposures and handle subjects of either high or low contrast quite satisfactorily. Color films have relatively restricted latitude. In normal subject conditions, color negative films can usually tolerate underexposure of no more than one stop and overexposure of somewhat more than that—perhaps a stop or two—without serious loss of quality. Transparency films are intolerant of overexposure, but they respond quite satisfactorily to underexposure of a stop or two if the subject is not too contrasty. All color materials should be exposed as accurately as possible, of course, but if you must make exposure errors, it's best to *overexpose* color negative films and *underexpose* reversal films—a little!

After an initial "ripening" period during which their characteristics are stabilized, all sensitized materials deteriorate slowly as they age, typically losing speed and contrast, and suffering a gradual increase in background fog. For that reason, manufacturers label most sensitized materials with an "expiration date," which indicates the nominal end of their useful life under "normal" storage conditions. It's obviously safest to use them while they're still fresh, but *outdated* materials are generally usable and frequently very

It can cause uncorrectable color crossover

Color films have relatively limited latitude

Sensitized materials deteriorate slowly with age

satisfactory if they've been protected from excessive heat and humidity. Cold, dry storage extends the useful life of all sensitized materials considerably and freezing can prolong it almost indefinitely.

Black-and-white printing papers are relatively stable and are not generally dated. Black-and-white films also age slowly and normally remain "fresh" for two years or more after purchase, but color materials have more limited life. Kodak's "amateur" color films are designed to remain stable and reliable for a year or so (and are generally usable much longer than that), but the "professional" films are at their best as soon as they reach the dealers' shelves, and should either be used immediately after purchase or refrigerated until they're needed. Color printing papers are also sensitive to storage conditions and should be used before their expiration date for best results.

Processing Color Films

The contrast of black-and-white films can be controlled rather significantly by changing development time (as is explained in Chapter 18). Color film development is somewhat less flexible. Image contrast does vary if the development of color negative film is varied, but because the film's three emulsion layers are affected differently by abnormal development, color crossover and a general shift of color balance are very likely.

Transparency films are affected strangely by development variations. If the first development is *pushed* (extended beyond normal), the effect is similar to an increase in exposure—that is, the image is lightened overall. There may also be an initial gain in contrast but that is soon nullified, if development is extended further, by an overall loss of density that weakens the shadows. Image grain is increased, and if development is increased significantly, color shifts and crossover occur.

Despite these problems, most transparency films can be pushed to compensate quite satisfactorily for an underexposure of one stop, and some will tolerate a two-stop push before image quality suffers severely. Altering the second (color) development step is much less effective. Since it normally goes "to completion," there's no particular advantage in extending it greatly, and reducing it is likely to result in weakened and degraded color.

Developing color films is not much more difficult than processing blackand-white materials, but there may be more chemical steps, control of temperature is more critical, and you should be especially careful to avoid chemical contamination. Color chemicals are somewhat more hazardous than the usual black-and-white solutions, too—the color developer is typically a strong sensitizer and the bleach bath is fairly corrosive. You should always wear protective gloves when mixing and using them.

Color chemicals have fairly limited life after they've been prepared in working strength, even if storage conditions are ideal. Protect the developers from air and light, and store all the solutions in a moderately cool place; cold storage may cause them to crystallize. Although this may not harm the solutions, they'll at least have to be warmed and stirred to redissolve the crystalls before they can be used.

Color film processing is a straightforward procedure that you'll probably find rather tedious after the novelty wears off. There's very little advantage in doing it yourself—unless you want to vary the procedures for some unusual purpose—because chemical cost is high, the capacity of the solutions is limited, and their life is short. Unless you can process enough film to use up the chemicals completely within a week or so, it's not very economical. If you have a good commercial color lab in your area, I recommend that you let the professionals do your film processing for you. Cold, dry storage can extend their useful life

Color film development is relatively inflexible . . .

. . . although some variations are tolerable

Color chemicals are relatively hazardous . . .

. . . and expensive

Figure 14.7

Sheltered Fire and Petroglyphs in Eastern Utah, May 23, 1983. Steve Fitch. Fitch had to solve the formidable challenge of successfully combining fading daylight with firelight to produce this dramatic and mysterious photograph.

(Courtesy of the photographer)

Summary

We are capable of recognizing colors in almost any kind of illumination as long as the light itself contains the primary colors, red, green, and blue. Color films are not adaptable; for accurate color response they must be used in white light of very specific composition or color balance.

The color of light emitted by continuous-spectrum sources can be identified by its color temperature rating in Kelvin degrees. Fluorescent lights, and other discontinuous-spectrum sources, don't have meaningful Kelvin temperature equivalents.

Transparency films are available in daylight balance and in two tungsten types—A and B.

Filters alter light color temperature by subtraction. Conversion and lightbalancing filters work in the orange-blue range. Color compensating filters are available in six colors and at least six densities. Skylight and haze filters eliminate ultraviolet light; polarizing filters control surface glare and improve color purity.

Color films (and papers) have three emulsion layers, each of which records a single primary color. Color negatives include a color-correcting mask. Color reversal films produce positive transparencies. Polaroid "instant" color print films employ a dye-diffusion process. Polaroid's instant slide film process is unique and ingenious.

Amateur color negative films are balanced for daylight; the professional films are available in either daylight or Type B balance, and are designated S and L respectively. If S films are used for long exposures, or L films for short exposures, color shifts and color crossover may result because of reciprocity effects.

Color films have limited latitude and should be exposed accurately for best results. It's best to use all sensitized materials—especially color materials—before their expiration date. Cold, dry storage conditions will extend their useful life considerably.

Color processing is rather inflexible. Variations in development may cause unacceptable color shifts although transparency films can be "pushed" successfully. Color chemicals are expensive, relatively hazardous to handle, and have a short working life. Unless you use up the chemicals completely before they spoil, home processing of color film is not economical.

you have any doubt about the quality of your water supply, I suggest using distilled or deionized water for mixing developers and the color stabilizer bath, if one is used.

Because color print materials are obviously sensitive to light of all colors, there is really no "safe" safelight for them. Practically, though, it's possible to use a very dim amber safelight (Kodak #13 or equivalent) for brief periods when handling negative papers, such as Ektacolor. Reversal and direct positive papers should be handled in total darkness.

Tone and Color Fidelity

Every time a photographic image is formed, you can assume that some distortion of gradation has occurred. There will almost certainly be a change (usually a loss) in shadow and highlight contrast, and a relative increase in midtone contrast. This is true whether the image-forming process results in the usual *reversal* of tones (as from negative to positive or from positive to negative) or functions as a direct positive (positive-to-positive) process; for convenience we'll call them both ''reversals.'' Obviously, for best fidelity of tone (and color), the final image should have gone through as few tone reversals as possible.

Figure 15.1

Untitled. Jay Hyma. Unusual effects of light and color make this typical photograph an exciting visual treat.

(Courtesy of the photographer)

Work in the dark; use safelight sparingly

Every reversal affects contrast and gradation

Prints from negatives benefit from fewer reversals . . .

. . . but some printers prefer to work from transparencies

Contrast control is limited

The normal black-and-white process and the color negative process each have two: (1) positive-to-negative (subject) and (2) negative-to-positive (print). One or two reversals are usually required to produce a positive color print image from a positive original, but some processes require more. For example, it requires four reversals to produce a print in the chromogenic positive processes: it takes two to convert the subject to a positive transparency image, and two more to produce the positive print image.

This helps to explain why you'll probably notice a difference in image quality between prints made from negatives and prints made on reversal paper from transparency originals. The negative process is generally more subtle, producing better color fidelity and more richly detailed highlight and shadow tones. This is due partly to the fewer reversals in the process and partly to the negative's built-in color-correcting orange-brown mask.

By comparison, reversal prints from transparencies tend to produce harsh midtone contrast and strident, unsubtle color rendition. Bleached highlights, murky shadow tones, and evidence of color crossover are also typical—al-though not inevitable. Despite these shortcomings, reversal prints are usually quite satisfactory and, in some instances, remarkably good.

Considering that the negative color process not only produces generally better print quality but is also faster, simpler, and less expensive than the conventional reversal process, you may wonder why the reversal process has been around as long as it has. The reason is simple enough: many people take color slides for projection or record purposes, but often want prints as well. Also, beginning color printers often prefer to work from transparency originals because they're easier to judge than color negatives and because they provide a reference for color-balancing the print.

Negative Color Processes

Color prints can be made from either color negatives or color positive transparencies (slides), but there are several quite different principles involved in the various color printing methods. Printing from negatives on chromogenic paper is probably the most popular method. Although calculating the proper filtration and exposure can be a little confusing, and processing times and temperature must be closely controlled, the process is quite similar to the familiar black-and-white process and can be carried out very satisfactorily in any reasonably well-equipped darkroom.

Kodak Ektacolor Paper

If you're used to the idea of having five or six contrast grades of black-andwhite printing paper to work with, color printing will seem restrictive. Kodak manufactures only two grades of Ektacolor paper for use with color negatives (most other manufacturers supply only one). Ektacolor Professional is "normal" in contrast and is used as you would use grade 2 papers in black-and-white. Ektacolor Plus is about one grade more contrasty—functionally similar to blackand-white grade 3. There's no provision for further contrast control in the normal process. Attempting to adjust image contrast by altering development of either color negatives or prints is not usually recommended and may result in color crossover and generally degraded image quality.

Because of their built-in masks, color negatives can reproduce colors very faithfully and with considerable subtlety. When Ektacolor papers are properly processed, the dyes are quite stable and the prints are considered to be relatively long-lived.

Figure 15.2

Surface Survey no. 5 from Artificial Survey Series, 1987. Michael McGillis. McGillis made this Cibachrome image by photographing a low-relief collage using fragments of Landsat photographs, bones, and other common objects on a textured ground.

(Courtesy of the photographer)

Positive Color Processes

Kodak Ektachrome Papers

Ektachrome papers are reversal materials. The present versions are faster than the papers they've replaced; processing involves several chemical steps, but is uncomplicated and color quality is considerably improved.

Ektachrome paper can be processed in a conventional drum, using the appropriate Kodak chemicals, or their equivalents in other brands.

Ilford Cibachrome All

The shortcomings of the color reversal print process have led researchers to invent some interesting alternatives. One of them is Cibachrome, which, unlike ordinary color printing papers, is a direct positive material that comes from the factory with all three of its emulsion layers saturated with their appropriate dye colors. The color image is formed during processing not by *making* dye as is the case in chromogenic development, but by *destroying* the unwanted dye.

This approach has at least three advantages: (1) it reduces the number of "image-forming" steps from four to three (two reversals represented by the transparency, plus the final positive-to-positive step), thus decreasing their degrading effect on the image; (2) it produces unusually sharp image quality because the dye density limits diffusion of the exposing light in the emulsion layers; and (3) because the dyes don't have to be suitable for chromogenic formation, they can be selected from relatively stable colors. Reversal processing is lengthy, but uncomplicated

Cibachrome is a dye-destruction process

Figure 15.3

Soccer Player, Portugal, 1967. Phil Davis. The harsh contrasts and the hot, brilliant colors of this subject are rendered emphatically in the Cibachrome print from which this illustration was made. Cibachrome is now commonly supplied in two forms: (1) as a slightly textured, lustrous, resin-coated paper (described as "Pearl" surface) and (2) as a smooth, highly reflective white polyester-base material ("deluxe glossy") that has remarkably brilliant color quality. A film-base material for making display transparencies is also available. Processing is a simple three-chemicalstep process, and minor temperature variations are relatively unimportant. The current material, Cibachrome All, is said to incorporate a "self-masking" feature that increases color saturation and purity, and presumably contributes to lower contrast.

Despite these improvements, Cibachrome is a fairly expensive process (very expensive if you use the deluxe glossy paper) that still suffers from noticeable color crossover, and is still too contrasty to work well with many transparencies. When used with suitable originals, however, Cibachrome reproduces both saturated hues and pastels with good fidelity and exceptional

brilliance. It is probably the sharpest color print material available, and (the deluxe version, at least) is considered to be one of the most permanent. See the process instruction sequence later in this chapter for more information.

The Kodak Dye Transfer Process

Dye transfer is one of the oldest and best of color printing processes. It is also, by far, the most expensive and the most difficult to do well. "Dye" prints can be made from either negatives or positive transparencies, but most workers seem to prefer to work from transparencies. The gradation distortions and color shifts normally associated with prints from transparencies are minimized in the dye process by elaborate masking procedures.

In "standard" form, the process usually begins with one or more high contrast black-and-white *highlight masks* that are printed by contact from the transparency. The highlight mask(s) are registered with the transparency and two *principal masks* are made—one in red light and one in green. When registered with the transparency (replacing the highlight mask), the red principal mask is used to make two *separation negatives*—one in red light and one in

Figure 15.4

Ribbon with Blue Spring. J. Seeley. Much of Seeley's early work featured bold black-andwhite pattern images that were still recognizable as purely photographic. This more recent silk screen print shows his increasing concern with the visual fundamentals of line, color, shape, and the problems of spatial organization.

(Courtesy of the photographer)

Dye transfer is one of the oldest and best processes

. . . but it is complicated . . .

Figure 15.5

Julia with Devastation. Joanne Leonard. Many of Leonard's photographs are extensively modified or manipulated and they frequently feature her daughter, Julia, in surreal surroundings.

(Courtesy of the photographer)

green light. Then the green principal mask is registered with the transparency and used to make the third separation negative in blue light. All of these steps must be carefully monitored to keep the image colors in balance and maintain proper contrast.

Each separation negative is then projected onto special *matrix film* that, after suitable processing in a *tanning developer*, and subsequent treatment in a series of hot water baths, produces a gelatin image in low relief. These matrices are then soaked in appropriate dyes and rolled out, one after the other in register, on specially prepared gelatin-coated paper. As the dyes transfer from the matrix films to the paper, the image is built up, color by color, to its final form.

The dye process requires a substantial investment in both specialized equipment and materials. For this reason and because of its formidable technical complexity, it's used primarily by professional print labs for commercial work. The process is not as popular as it deserves to be, although a few art photographers have worked freely with the materials to produce expressive, distorted-color images.

Well-made dye-transfer prints are notable for their clean whites and their ability to record both brilliantly saturated and subtle pastel colors with remarkable fidelity. While not as sharp as Cibachromes, they can record fine detail very well. Because of the unusual stability of its dyes and the fact that the print material is fiber-based rather than resin-coated, dye transfer is considered one of the most permanent, as well as the most elegant, of color print processes.

. . and expensive

Color Negative Printing

There are two general methods of color printing: white light and tricolor. White color printing is not greatly different from printing black-and-white negatives, except that you'll have to get used to working in very dim amber safelight— or total darkness. You'll find that negative papers, such as Ektacolor, respond to exposure just as black-and-white papers do—that is, underexposure leaves them light in tone, and overexposure produces dark prints. Negative papers respond ''negatively'' to filtration, too (which may surprise you); if exposed to yellow light, for example, the print color will shift toward blue—the complement of yellow (plates 22 and 23, and fig. 15.10).

Positive papers, such as Cibachrome, are just the opposite: underexposed prints are too dark; overexposed prints appear bleached and pale. Positive papers' response to filtration is more understandable; they simply take on the color of the exposing light. If the exposing light is filtered yellow, for example, the print turns yellow.

If you're a beginning color printer, I recommend starting with the negative process because it's relatively inexpensive, the materials are readily available, and the image quality is potentially excellent. You'll need a good color negative, of course; a package of printing paper, such as Ektacolor Professional; and a kit of processing chemicals, such as Ektaprint 2, or their equivalents in other brands. Observe the chemical mixing instructions (as provided in the kit), being particularly careful to avoid contaminating the developer with any other chemical.

Figure 15.6

Alberta Landscape, 1983. Although value contrast is reduced when the sky is heavily overcast, colors may seem unusually intense. The remarkably rich green of this Canadian farmland is well expressed in this photograph, which was made on a drizzly day in early summer.

(Courtesy of the photographer)

White light *printing* is similar to printing in black and white

The negative process is a good first choice

The manufacturer suggests a starting filter pack

. . . but you'll probably have to modify it

The negative process reverses both value and color

Remember, "Less is More!"

Analyzers are really comparators . . .

. . . that must be calibrated on some standard image tone

Color Negative Filtration

Before you begin printing a color negative you'll have to filter the printing light—partly to compensate for color shifts that may have occurred in producing the negative image, and partly because color papers themselves are rarely balanced correctly for the light color produced by a typical enlarger bulb.

To get you started, the paper manufacturer's literature will probably suggest a basic *filter pack*. For negative printing the packs generally specify a combination of rather strong magenta and yellow filters. This recommendation used to be related to the kind of film you used to produce your negative, but this is no longer true. Kodak now suggests starting with a filter pack value of 40M + 50Y (for Ektacolor Professional paper), with no mention of the negative material.

This basic filter pack may produce a satisfactory color print but it probably won't; the print is likely to show a distinct overall tint of some color magenta, for example—that will have to be eliminated. You may think that you can correct this problem by removing some magenta from the filter pack, but think again! When printing from negatives, the process *reverses* both value and color; that is, exposure to light turns the paper dark, and vice versa. Also, too much of a color in the filter pack produces an excess of its *complementary* color in the print image. To decrease the magenta print stain, therefore, you should adjust the filter pack by either *subtracting green* or *adding more magenta*!

Remember, "Less is More!" when printing from color *negatives*. To *produce less* of a color in the print, *add more* of that color to the filter pack! Stated another way: *less* of a color in the filter pack produces *more* of that color in the print (refer again to plates 22 and 23).

Color Analyzer

If you're seriously committed to color printing, you may want to consider buying a *color analyzer.* These machines should probably be described as "comparators" because when measuring the color of some image area, they tell you how much it differs from a previously calibrated "standard" color.

You can use any standard you want, but most photographers calibrate their instruments on some relatively neutral color such as the negative image of a gray card or a "typical" skin tone. First, by trial and error, you must find a filter pack that reproduces the standard test color satisfactorily on a particular paper. Then, using that pack, project the test image onto the instrument's light-sensitive *probe* and adjust each of the three *color channels* by turning the appropriate dials until the indicator light or needle indicates "neutral" or "null" (fig. 15.7).

When you've accomplished this, the dial settings indicate the amount of each primary color that's present in the test area. To determine proper filtration for another negative, simply locate an area of your standard color in the image, measure it with the probe, and adjust the *filter pack* (NOT the analyzer controls) until the analyzer indicates "null." It's not even necessary to know what the actual filter values are; as long as they satisfy the analyzer, the print color should match your standard.

You've probably noticed the flaw in this system; if the new negative image doesn't contain a suitable reference area, it can't be compared directly with your calibrated standard. One solution to this problem is to make an extra negative of every subject you plan to print and include a gray card in the subject area when you shoot it. Then you can measure the gray card image, but print the "real" negative. If you're using rollfilm, it's usually sufficient to expose one frame of the roll to a gray card alone and use that frame to determine the filter pack for the rest of the negatives. Obviously this won't work very well unless all the pictures are made in similar light conditions, avoiding reciprocity effects.

In general I don't recommend buying an analyzer. Unless you print frequently, you're likely to find that you spend as much time calibrating your machine and your materials as you do making pictures. In any case, it's not difficult to arrive at satisfactory filtration by making simple test exposures and you can make a lot of tests before they add up to the price of a good analyzer. On the other hand, an analyzer can simplify and speed up your operation under some conditions. Use your own judgment; they are fun to play with and occasionally very useful, but you can get along very well without one—at least for a while.

Color Matrix

There are less expensive devices that can help you select filter pack values. You may find one of the *color matrix* sets useful; there are several brands on the market, all basically similar.

Matrix color guides are simply arrays of many small filters, arranged according to color in graded densities. It's assumed that when the matrix is contact printed in correctly balanced light, the colors will be reproduced without any serious shift. If the light color balance is not correct, some of the color patch images will be shifted toward neutral gray. When the "most neutral" patch is identified, usually by comparing it with a standard gray, the filtration required to correct the color shift can be found on an accompanying chart (plate 40).

It's obviously necessary to expose the matrix to "neutral" light if the test is to be valid. There are at least two ways to do this: it's probably best to use the projected color negative image of a standard gray card as the printing light, but you obviously can't work this way unless you've had the wit to make a very large image of a gray card on the same kind of film and in the same conditions that you used to record the subject.

Another approach that usually works pretty well involves printing the matrix by *integrated* image light. Project your "real" negative onto the matrix, but diffuse the image light (by projecting it through the translucent screen supplied with the matrix set) so that it becomes a "neutral" average of all the scene colors (fig. 15.8i). Whether that integrated light actually is neutral will depend on what colors were present in the subject and how they were distributed. This method is rarely precise, but it's often helpful in arriving at a reasonably well-balanced filter pack. When you're ready to begin printing, follow the process instruction sequence (fig. 15.8).

Figure 15.7

Adjust the three color channels to "null" on the image of some standard neutral tone such as the gray of a "gray card."

You can't analyze a nonstandard tone

Analyzers are fun to play with, but you can get along without one

A color matrix may be useful

Make the test exposure in "neutral" light

Figure 15.8

a. This cardboard mask can speed up exposure and filtration testing and save materials. Fasten it to your easel blades as shown. Focus and compose the image in the mask opening. Then clip off the upper righthand corner of a sheet of printing paper (to identify the "top" of the image area); insert the paper into the easel and make the first exposure. If the mask is positioned as shown here, the first image will fall in the upper left corner of the (horizontal) sheet. Next, rotate the paper sheet so that the clipped corner is in the lower left and expose a second test. Then flip the mask left-to-right (or top-to-bottom) and make the third exposure. Finally, rotate the paper sheet back to its original position (clipped corner in upper right) and make the final exposure. If you've done this properly you will need to process only one sheet of paper to obtain four test images.

b. If you're using Unicolor R-2 chemicals, the temperature of the solutions is not very critical. The drum will be hot when the processing chemicals are poured in and the small volumes involved will be warmed almost immediately. Nevertheless, it's wise to standardize on a starting temperature of about 75°F to 80°F (24°C to 26°C). Be sure the drum is clean. You can leave it in the sink if you plan to load it wet. (Unicolor representatives recommend this procedure.)

c. If you plan to load the drum dry, be sure it's dry inside and out. Place it in a convenient location so you can find it in the dark.

d. Clean the negative carefully. Place it in the enlarger and focus and compose the image.

e. If you plan to use a *color matrix*, such as Unicolor's Duocube (see text), center the cardboard mask opening under the lens. Enlarge the image as desired (don't try to make it fit into the mask opening unless you want the final print to be that size.) Focus the image, but don't worry about composing it.

f. Make up the recommended filter pack, or dial in the filtration if you have a color head.

g. Stop the lens down at least one full stop from maximum aperture. Turn out the lights and work the next four steps in total darkness.

h. Put a sheet of paper in the easel. Don't forget to clip one corner so you can determine the position of the sheet in the dark.

i. The Duocube will fit neatly into the cardboard mask opening. Expose through the plastic diffuser that comes with the Duocube kit. After the first exposure, rotate the paper sheet and make another exposure, varying either time or filtration but not both at the same time. Keep a written record of the tests; don't trust your memory. After the second exposure, remove the paper to a lightlight container and turn on the lights.

j. Turn the cardboard mask over and retape it to the easel so you can expose the other two quadrants of the paper. Turn out the lights. Replace the paper and the Duocube and make the final two exposures. The clipped corner will help you identify the location of each exposure.

k. If you're loading the dry drum, load it now in total darkness. If you prefer to load wet, tuck the paper away in a lightfight container and turn on the lights. Fill the drum with hot water (about 105°F, or 41°C). Turn out the lights and load the drum. With either method, be sure the end cap is securely seated before turning on the lights.

I. If you loaded the drum dry, now is the time to fill it with 105°F (41°C) water.

m. Put on protective gloves. Measure out 2 ounces of each of the chemical solutions— developer, stop, and Blix—(at about 75° to 80°F, or 24°C to 26°C) in separate, clean containers. Set the containers in a tray of warm water (80°F, or 26°C) to maintain the temperature of the solutions. Let the paper presoak for 1 minute, then dump the hot water.

n. Set the drum on the motor base (agitator). If you don't have an agitator, set the drum on its feet. In either case, be sure the drum is level. Set the timer for 4 minutes. Pour in the developer.

o. Start the agitator and the timer. If you don't have an agitator, simply knock the drum off its feet and roll it back and forth on a level surface until the time is up.

p. At 3:45, dump out the developer, and drain until the timer rings.

q. Pour in the stop.

r. Agitate the stop for a full 30 seconds. Measure out 2 ounces of Blix.

s. Dump the stop, and drain the tank thoroughly.

t. Pour in the Blix.

u. Agitate the Blix for 2 full minutes.

v. Dump the Blix. Pour several ounces of water into the drum and agitate it for a few seconds; then remove the print and slip it into a tray of running water.

w. Wash the print in running water for 2 minutes.

x. Soak the print in a tray of stabilizer for about a minute.

After you've gained some experience you'll learn to estimate the necessary filter correction by simply inspecting the finished print in good light. Looking at the print through various CC filters (or the equivalent special "viewing filters") may suggest an improvement (fig. 15.9). Don't stare through any filter for more than a few seconds at a time though, or your eye will adapt to the filtered light and cloud your judgment. Incidentally, the color of the viewing light is important; don't expect a print that you've corrected in fluorescent light to appear the same in tungsten light, for example. Also, don't try to judge a wet print; the colors will change significantly when the print is dry.

In general, if the image appears to be corrected satisfactorily as you view it through a filter that's held at the eye, you should *subtract* a filter of that *same color* and *half that value* from the filter pack. If laying the filter directly on the print surface provides the desired color correction, subtract the *equivalent* value of that filter from the pack. NOTE: This applies only to prints made on negative papers such as Ektacolor; positive papers are generally less responsive to filtration changes and require more drastic correction.

Calculating Filter Pack Adjustments

Analyzers and color matrix arrays can take most of the uncertainty out of print color correction, but it's up to you to decide when the print *looks* right, and what to do if it doesn't. Appraising the color errors will take a little practice, but calculating the necessary filtration is fairly easy once you understand how the filters work with each other and what their numbers mean.

To review briefly, each of these filters is identified by a prefix (CC or CP), followed by a number representing its density (actually its density multiplied by 100) for light of its complementary color and, finally, a letter indicating the color of the filter itself. For example, CP 30B designates a blue Color Printing filter whose density in yellow light is 0.3.

Density has specific significance in photography, but it needn't trouble us at this point; we'll discuss it further in Chapter 18. All you really need to know now is that as the filter numbers get larger, the color gets stronger; and putting two filters of the same color together adds their values. For example, 10Y + 30Y = 40Y.

y. Squeegee the print lightly to remove surface moisture, and hang it (or lay it out, faceup) to dry. Wait until the print is dry before attempting to judge the color balance.

You must understand what the filter numbers mean

You'll eventually learn to estimate filtration . . .

Filter values add up . . .

Figure 15.9 Judging print color balance with the aid of special viewing filters.

Figure 15.10 The standard color wheel. Colors that are diametrically opposite each other are called complementaries.

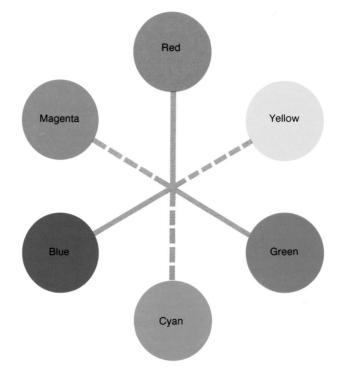

Plate 36

During exposure, color negative film separates the subject colors into the three light primaries and forms a latent image of each color on one of its three emulsion layers. Development produces both blackand-white and color negative images in each layer. A bleach-fix step removes the silver negative images, allowing the superimposed negative dye images to form the final color negative. Controlled amounts of unused couplers are allowed to remain in two of the film layers to form a color-correcting "mask," which gives color negatives their typical yellow-brown appearance.

Red

Green

Blue

Plate 37

During exposure, color positive film separates the subject colors into the light primaries and records each of them on one of the three emulsion layers. First development produces black-and-white negative images in each layer. After suitable "fogging" by light or chemical action, the remaining emulsion in each layer is developed by the color developer to form both silver and dye positive images. Bleaching and fixing baths remove the silver, leaving only the positive dye images, superimposed, to form the final transparency.

Red

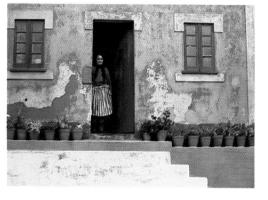

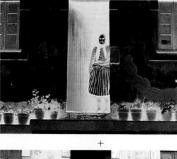

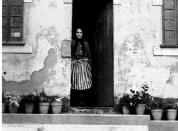

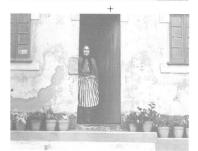

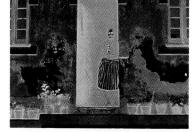

Green

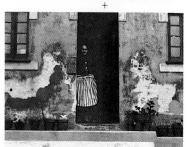

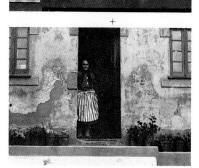

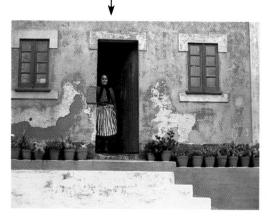

1/2 Stop Over

Magenta

Yellow

Normal

Blue

Green

Plate 38

"Color-negative" prints seem to be much more affected by exposure and filtration changes than "positive" prints are. These Unicolor prints represent exposure variations of one-half stop from normal, and filtration variations of 10CC in each of the six colors. Notice that filter color is subtracted from these prints and that increased exposure makes the prints darker. Compare this test group with the Cibachrome array in Plate 29b.

1/2 Stop Under

Cyan

Plate 39

a. The simplest way to judge exposure and filtration is to make a test strip, using the manufacturer's recommended filter pack as a starting point. This test, using 30Y + 10C filters and exposures of 3, 6, 12, and 24 seconds, indicated a need for more yellow. Final print was made with 50Y + 10C at 7 seconds.

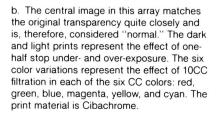

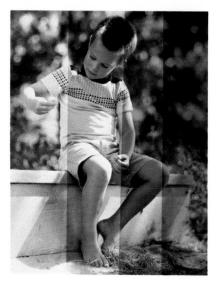

Blue

Cyan

Green

Normal

1/2 Stop Under

Magenta

Plate 40

a. Locate the most neutral section of the Duocube image by using the gray comparator card.

Plate 41

If you live in an area where there are frequent and severe variations in the power line voltage, you should probably get a voltage regulator. Under normal conditions, however, the line voltage rarely varies more than a few volts from the nominal value of

117 vac, and the problem is not usually very serious. This example shows the very slight exposure difference and negligible color shift resulting from 5-volt variations from normal: print *a* was exposed at 122 vac; print *b* at 117 vac; and print *c* at 112 vac. No compensation was made in exposure

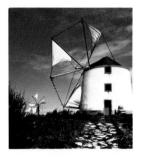

time, aperture, or filtration. These prints are on Cibachrome, which is relatively tolerant; negative print papers are affected more obviously, but except for critical work, voltage variations of this magnitude are no great cause for alarm.

Plate 42 a. "Normal" exposure of 4 seconds @ f/5.6 produced this print.

 b. Supposedly equivalent exposure of 32 seconds @ f/16 causes slight underexposure and very slight shift toward blue.

c. An exposure of 4 minutes and 15 seconds @ f/45 should also be equivalent to "normal," but the reduced illumination causes serious reciprocity failure. The resulting print is distinctly dark (underexposed) and bluish.

Plate 43 Early morning and late evening light often transform familiar scenes by revealing color relationships that are rare and beautiful. In this desert landscape, taken just after

sunset, the several-second time exposure has introduced reciprocity effects that add to the exotic color quality.

Furthermore, when unequal parts of two primaries are combined, *equal* amounts are used to produce the secondary color and the excess primary remains unchanged. So, for example, 30M + 20Y = 20R + 10M; and 50C + 05Y = 05G + 45C. Finally, if all three primaries are present in the mixture, equal parts will combine to form *neutral density* (gray) and the remaining colors will combine as indicated above. For example, 20Y + 30M + 20C = 20ND + 10M; and 05Y + 20C + 30M = 05ND + 15B + 10M.

Just for practice in calculating these relationships, what happens if we combine 25M + 50C + 10Y? Work it out this way:

 $\begin{array}{r} 25M + 50C + 10Y \\ - 10M - 10C - 10Y (``10ND'' uses up all the yellow) \\ 15M + 40C + 10ND \\ - 15M - 15C (produces ``15B'') \\ 25C + 10ND + 15B \end{array}$

We get a greenish-gray blue: 25C + 15B + 10ND

Now for a practical problem: suppose you have made an Ektacolor print that has a very obvious overall cyan cast. By peering critically at the print through various viewing filters, you decide that a 30R filter, held at the eye, provides good correction. Because this is a negative color process, the print filter value should be half that, or 15. The filter pack you used to make the print consists of 50M + 40M + 50Y + 05Y plus the UV filter, which we can ignore. What do you do?

First, remember that this is a negative process, and "Less is More"; so, to remove cyan from the print you must either ADD cyan to the filter pack, or SUBTRACT (the complement of cyan) red. It's best to subtract filters whenever you can. First, write out the actual values of the pack: 50M + 40M = 90M, and 50Y + 05Y = 55Y. Then (to correct the print color) subtract 15R to find the new pack values; there are two ways to do it:

90M + 55Y	_	35M + 55R
<u>- 15M - 15Y</u>		— 15R
75M + 40Y	=	35M + 40R

Simply dial 75M and 40Y into your color head, or if you're using filters, assemble 50M + 20M + 05M + 40Y; or if you have all six filter colors to use, a better pack is 30M + 05M + 40R.

Practice calculating filter pack values

Remember, this is a negative process

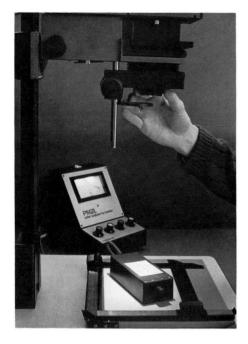

Figure 15.11

Your color analyzer can suggest exposure corrections. After you've experimentally determined the correct exposure for one negative, null the instrument on some standard density in that projected negative image using the white light channel control. To arrive at the approximate exposure for a different negative, find an area of similar image density, and without altering the channel control setting, null the instrument by adjusting the lens *aperture*. Some instruments also provide direct readings for exposure time adjustment if you prefer to leave the aperture setting unchanged.

You can estimate exposure changes by comparing filter packs

Each "10" (except yellow) is worth 1/5 stop

. . . and each filter sheet requires a 10 percent increase

Neutral densities complicate the calculation somewhat

Exposure Calculation

Your color analyzer (if you have one) is probably capable of determining exposure for the new pack semiautomatically. Simply set it to its "exposure" mode and adjust the lens aperture to vary the intensity of the projected image light until the instrument indicates "null" (fig. 15.11). If you established the original exposure without an analyzer—as by test strip or color matrix test—you can estimate the new exposure by comparing filter packs.

For purposes of illustration, let's assume that your print exposure, using the 50M + 40M + 50Y + 05Y pack in the example above, was 20 seconds at f/11 and that your new pack consists of 50M + 20M + 05M + 40Y.

For this "quick and dirty" method of exposure estimation, ignore the yellow filters entirely in calculating color densities (unless all three primary colors are included: see below), and consider each value of 10 in any of the other colors to reduce light intensity by 1/5 stop—in other words, a 30M filter (for example) is worth 3/5 stop, 25C is worth 2.5/5 or 1/2 stop, and 100R is worth 10/5, or 2 stops.

The "stop" values in the first pack (not counting the yellow filters) add up to 90, or 9/5 (1.8) stop. The second pack is worth 75, or 7.5/5 (1.5) stop. The second pack, therefore, is 3/10 (0.3) stop *less* dense than the first and, on the basis of color densities alone, will require 3/10 stop *less* exposure.

But that's not all. As a very general rule, each filter *sheet*, regardless of color, reduces the light intensity by about 10 percent. In this case there are 4 filters in each pack (not counting the UV filter, which will always be there), so there's no change. The total correction, therefore, is 3/10 stop, which works out to be about 4 seconds. Use 16 seconds for your next exposure and see what happens.

These calculations assume that there's no neutral density in the pack. If there is (that is, if all three primary colors are present in the pack), the correction factors become more drastic because each 10 value of ND is worth 1/3 stop (30 equals a stop). Let's assume that you arrived at the corrected pack in our example above by adding cyan, rather than subtracting red, remember? That makes this pack:

$$50M + 40M + 50Y + 05Y + 10C + 05C$$

or

90M + 55Y + 15C<u>- 15M - 15Y - 15C</u> (take out cyan, making 15ND) 75M + 40Y + 15ND

Now, ignoring the *remaining* yellow density, we have magenta that's worth one-and-one-half (7.5/5) stops, plus neutral density that's worth one-half (1.5/3) stop, for a total of 2 stops. The exposure was based on the original pack (90M), which was worth 1.8 (9/5) stops, so we subtract 1.8 from 2 to get 0.2, or 1/5 stop.

The new exposure, then, must be 1/5 stop MORE than the original 20 seconds at f/11. Make this correction first. It's too small to make by adjusting the aperture, so we'll have to extend the time; the new exposure—based solely on dye density differences—should be about 23 seconds at f/11.

Now we must apply the "sheet" correction. By reshuffling the pack to use the fewest possible sheets, we arrive at

50M + 20M + 05M + 40Y + 10C + 05C

That's two more sheets than the original pack contained, so the increase is about 20 percent (this is an approximate method, so it's safe to simply multiply the number of sheets by 10 percent). The final exposure, then, is about 28 seconds at f/11; or, if you prefer, about 14 seconds at f/8.

The calculations in the examples above assume the use of filter packs composed of actual filter sheets—not settings of the filter controls on a dichroic color head. Although print exposure is definitely affected by changes in dichroic filtration, the required correction may not be as great as is suggested above. Furthermore, there is never any "sheet correction" factor to apply to color head settings. I highly recommend the use of a dichroic color head if you have one, but unless you have some way of measuring the intensity of the filtered image light (such as a color analyzer, for example), you'll have to arrive at exposure corrections by making test strips and keeping careful records.

CAUTION: print colors—especially negative print colors—change as the print dries. It's best to judge color balance and select correction filters by inspecting the dry print in bright "white" light. A blue-bulb tungsten lamp supplies light that approximates the "standard" viewing illumination, but ordinary tungsten light is usually satisfactory. Avoid fluorescent light if possible; some types may affect your perception of color.

Color Positive Printing

Because the various color positive processes are quite different from each other, no single set of process instructions is adequate to describe them all. None of them is difficult, however; if you follow the manufacturer's processing instructions carefully, you should have no trouble. If you want to begin with the Cibachrome process (fairly expensive, but a good choice), you'll need a good color positive transparency, a pack of Cibachrome paper (I recommend the RC Pearl surface material for your first efforts) and kit of processing chemicals. The process sequence for Cibachrome is illustrated in detail in figure 15.12.

White light positive printing is similar to the negative procedure, just described, with one very important difference. That is, positive papers—as has been mentioned before—respond *positively* to both exposure and filtration. Increasing exposure lightens a positive print and filtered light imparts its own color to the image (plate 37b).

In general, you'll find that positive papers are fairly tolerant of filtration changes. For example, a color shift that might be corrected by *subtracting* a 10 filter in negative printing will probably require *adding* 20 or more on a positive paper. That leads to the general rule "if the print color appears correct when viewed through a filter held at the eye, *add* THAT filter to the pack; if laying the filter on the print surface produces the desired correction, add a filter of that SAME COLOR and TWICE that value to the pack."

All of the other principles of filter pack adjustment and exposure calculation explained above apply equally here.

If you use a color enlarger there's no "sheet correction"

Judge the dry print in good light

Positive materials react positively to exposure and filtration . . .

. . . but they are fairly tolerant of filtration changes

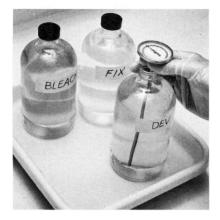

Figure 15.12

a. Cibachrome P–30 is relatively tolerant of temperature variations, but for best results, adjust the temperature of the solutions to about 75°F (24°C). Wear protective gloves while mixing and using the chemical solutions. *NOTE: The solution volumes given here are appropriate for 8''* \times 10'' prints. Larger prints require greater liquid volume. See the manufacturer's instruction sheet.

b. Be sure the drum is clean and dry. Set it out in a convenient location so you can locate it in the dark. The drum in this illustration is an old style. It's not as easy to clean as the newer ones, but I prefer it because it has a single, center drain hole.

c. Clean the transparency carefully, using the enlarger light to reveal the dust and lint.

d. Adjust the image size and focus.

e. Stop the lens down to a medium aperture—f/8 or f/11.

f. Make up the recommended filter pack and insert it into the filter drawer, or dial in the filtration if you have a color enlarger. Now turn out the lights and work in total darkness (no safelight).

g. Remove a sheet of Cibachrome paper from its package and place it in the enlarging easel, emulsion up. Identifying the emulsion side may be difficult; it is smoother than the back of the paper and will make almost no sound when stroked lightly with a dry finger. Stroking the back lightly will produce a faint "whispering" sound, but you'll have to listen closely to notice the difference. If you can't tell any other way, clip a corner from a sheet and examine it in the light. The emulsion side is dark brown; the back is white.

h. Make a geometric test strip, as explained in Chapter 12. You can use a color matrix, such as the Duocube, if you prefer. Follow the manufacturer's instructions for use with positive transparency films.

i. Load the drum. The paper emulsion must be inside the curl.

j. In separate clean cups measure out 2.5 ounces (about 75 ml) of each solution, and place the cups in a tray of warm water (about 78°F, or 25°C) to maintain the temperature of the solutions. *NOTE: The P-30 process allows partial reuse of the chemicals. For subsequent prints (during a single printing session), add 1.25 ounces (about 37 ml) of fresh solution to an equal volume of the used solution and adjust the temperature as necessary. Be careful to avoid contaminating the various solutions.*

k. Stand the drum on end and pour the developer into the funnel opening. The solution flows into a cup in the end cap and will not contact the paper until the drum is laid down on its side.

I. Set the timer for 3 minutes and start it running. Immediately lay the drum down on its side, on a level surface, and roll it back and forth continuously during the developing period. Be sure to roll it more than one complete revolution each way. Use an automatic agitator if you have one.

m. At the end of the developing time, stand the drum on end and allow the developer to drain into a clean container for partial reuse. The center drain hole of the old-style drum is an advantage here. While the developer is draining, pour about 3 ounces (about 90 ml) of 75°F (24°C) water into the funnel top. Drain for 15 seconds, then lay the drum down again (or put it on the agitator) and

n. . . . agitate the water rinse for 30 seconds.

o. Let the rinse water drain away while you pour the bleach into the funnel top. Set the timer for 3 minutes. Drain for 30 seconds, then . . .

p. . . . start the timer and agitate.

q. When the timer rings, drain the bleach into a clean container for partial reuse, and pour in about 3 ounces (about 90 ml) of water (about 75°F, or 24°C). Drain for 15 seconds, then . .

r. . . . agitate for about 15 seconds

s. Let the rinse water drain away while you pour in the fix. Set the timer for 3 minutes. Drain for 30 seconds, then . . .

t. . . . start the timer and agitate.

u. When the timer rings, drain the fix into a clean container for partial reuse. The water rinse that is illustrated here is optional.

v. Remove the print from the drum and wash it for 3 minutes in running water. Disassemble the drum, wash it thoroughly, and dry it inside and out.

w. Squeegee the washed print lightly to remove surface water and hang it, or lay it out faceup, to dry.

NOTE: If you plan to reuse the chemical solutions, save 1.25 ounces (about 37 ml) of each and pour the excess into a large plastic or glass (not metall) waste container. This is important; the chemicals must be mixed before they're discarded so that they can neutralize each other. When you're through printing, add all of the used chemicals to this container, then pour the mixture down the drain. DON'T discard the solutions individually!

Tricolor Printing

Tricolor printing can be done with almost any enlarger as long as it's free from significant light leaks and has a good lens. It's considered good practice to install a heat-absorbing glass in the enlarger lamp housing if it doesn't already have an IR filter built in.

The process requires only three filters. The usual "separation" set, Wratten #29 (red), #61 (green), and #47B (blue) can be used, but the set Kodak recommends specifically for tricolor printing consists of the Wratten #25 (red), #99 (green), and #98 (blue). These filters are available as gelatin squares and can be used under the lens in the image path. It's important to mount them so that they can be exchanged without moving the enlarger between exposures. Notice that the usual UV filter is not needed because the tricolor filters absorb UV effectively.

The setup is conventional in other respects. Working in total darkness, expose your test print (from a color negative) in the following ratios:

Filter	Exposure Ratio
Red #25	2x
Green #99	12x
Blue #98	5x

Because the actual exposure times will be affected by the efficiency of your enlarger, the lens opening, the negative density, the print magnification ratio, and the printing speed of your paper, it's impossible to be more specific. Make a series of test exposures and adjust the times as required.

Try to keep the exposure times from exceeding about 60 seconds, if possible, to minimize reciprocity effects. It's risky to change the aperture setting to control individual color exposures; moving the lens even slightly will probably result in a doubled image. There's also a possibility that changing the aperture may change image sharpness and contrast, although if your lens is a good one, the difference will probably be negligible.

Color corrections can be made by varying the individual filter exposures. For example, to decrease the amount of cyan in a (negative) print, decrease the red filter exposure time. This will probably require some increase in green and blue times to keep the total exposure constant. You'll need to be totally familiar with filter relationships to handle tricolor printing efficiently. I recommend that you keep very complete records of your tests.

Tricolor printing is adaptable to either positive or negative materials and, when properly controlled, gives excellent results. If you become seriously interested in pursuing it, investigate the special tricolor enlargers that are available. Although they're fairly expensive, they can simplify this printing method considerably.

Color Print Permanence

Color photographs are dye images, and dyes in general are notoriously fugitive, especially when exposed to bright light, high temperatures, or high humidity. Although photographic dyes are relatively stable, manufacturers are careful to avoid suggesting that they're permanent. In fact, the selection of a dye for photographic use is a compromise; it must (at least) be the right color and relatively "fast" or stable, and it must be compatible with the other emulsion ingredients and the processing chemicals. The choice is narrowed still further if the dye must be formed by chromogenic development—that is, by reaction between the development products and the film's dye coupler chemicals. The process requires only three filters, but is demanding

A special enlarger can simplify the process

Image dyes will fade in time . . .

Don't let fears of fading images stop you

Considering these and other requirements, it's remarkable that color photography is as workable as it is. Color quality and dye stability have been improving steadily and our present print materials are significantly better than those of just a few years ago. No doubt improvements will continue to be made; but in the meantime, we use color materials with the understanding that they are not truly permanent and that, sooner or later, our color photographs will fade and discolor.

Whether that's a serious problem or not depends on how you feel about "permanence." Even the most fugitive of contemporary color prints will probably last for a few years without self-destructing totally, and the most stable ones should remain in good condition for a lifetime, if properly cared for. If you're interested in working in color, don't let fears of fading images stop you.

Summary

Color printing is worthwhile and fun. You'll need a color enlarger or a set of printing filters, a processing drum, and the usual darkroom utensils. A voltage regulator will keep your enlarger light at constant intensity, but you may not need one. Color safelights are not really safe and should be used cautiously.

Every image-forming step in the photographic process introduces some tone or color distortion. To avoid this, image ''reversals'' should be kept to a minimum. Prints from color negatives provide high image quality because the process involves only two reversals and because of the negative's corrective mask. Printing from transparencies has its advantages, however, and modern reversal positive prints are usually satisfactory.

Ektacolor paper is supplied in two contrast grades; no other contrast control is available in the normal process. Ektacolor image quality is excellent and the prints are relatively stable.

Ektachrome papers are reversal materials for use with positive transparencies.

Cibachrome is available in resin-coated and polyester-base forms. It is a dye-destruction process that produces extraordinarily sharp, richly colored images that are said to be very stable.

The dye transfer process is the most flexible, most versatile, and most expensive of current color printing processes. Image quality is excellent and stability is considered to be unusually good. Only cost and process complexity keep this process from being more widely used.

There are two general methods of color printing: "white light" and "tricolor." White light color printing procedure is quite similar to black-and-white printing, although it requires some specialized equipment. You can print from either color negatives or positives (slides or transparencies); negative printing is relatively inexpensive and produces excellent quality.

You must establish a filter pack to balance the printing light and adjust the process for good color reproduction. Use CP or CC filters, or set the dichroic filters in your enlarger color head. Negative papers react negatively to both exposure and color filtration. You can determine proper filtration by using a color analyzer, a color matrix, or simply by trial and error. Filters influence exposure and their effect must be calculated. Color positive printing paper responds positively to both exposure and filter color, although it is typically less responsive to filtration changes than negative paper is. Tricolor printing requires a special filter set and carefully regulated exposure times. When properly done, it can produce exceptionally rich color prints on either negative or positive materials. Special tricolor enlargers are available. Although expensive, they simplify the process significantly.

Because dyes are fugitive, color photographs will eventually fade and discolor. Most modern color print materials are relatively stable, however, so don't let fear of print impermanence keep you from enjoying color photography.

Close-up Photography and Copying

The Photographer's Hand Photograph by Kate Keller. (Courtesy of the photographer) Most cameras' focusing range is restricted . . .

. . . for at least three reasons

Most TTL meters provide accurate close-up exposure automatically

. . . but hand-held meters don't

Fortunately, exposure compensation is easy to calculate

The necessary exposure increase is called ''bellows factor''

Close-up photography generally refers to pictures taken at subject distances such that the film image ranges from about 1/8 life-size to perhaps twice size. The procedure for making images of greater magnification—up to about 50 times life-size—is technically *photomacrography*. Photographing at greater magnifications with the aid of an optical or electron microscope is called *photomicrography*. Most photographers ignore these distinctions and simply refer to any work at unusually close range as "macro-" photography.

Most small cameras—your 35mm SLR included—can't make "close-up" photographs without special equipment because their closest focusing distance is rarely less than about 8 or 10 focal lengths; that is, your 50mm (2-inch) normal SLR lens probably won't focus on objects closer than about 16 to 20 inches. For larger cameras this distance is proportionately greater. Typically, a 75mm or 80mm normal lens (for Hasselblad, Bronica, or Rolleiflex, for example) can focus down to between 2 and 3 feet (about 600mm to 900mm).

There are at least three reasons why the focus adjustment of a normal lens is restricted: first, the increase in focal distance that's required to shift focus from infinity to its 2- or 3-foot minimum is fairly slight and can be provided by a relatively simple and inexpensive "helical" (spiral-threaded) focusing mount; the much longer threaded mount required for closer focusing would add to the complexity and cost of the lens. Second, ordinary lenses are designed for use at medium to long subject distances; at very short range, they are affected more severely by the various aberrations and image quality is somewhat reduced.

Third, moving the lens away from the film plane—as is required for focusing—reduces light intensity on the film. This light loss is negligible throughout the normal focusing range, but it begins to be significant when the lens has been "extended" to focus at about the 8-focal-length subject distance. At closer subject distances, the extension must be increased considerably and film illumination diminishes dramatically.

Most 35mm SLRs and some larger cameras equipped with TTL (throughthe-lens) meters calculate the exposure on image light intensity measured at or near the plane of focus, so they respond to the same light the film will see and provide accurate exposure information regardless of the lens extension. That's not the case with view (and other) cameras that rely on hand-held meters for their exposure information. Hand-held meters measure light outside the camera—not film illumination—so if their exposure recommendations aren't modified to compensate for the lost light, serious underexposure of close-up subjects is possible.

Fortunately, the light loss—and the necessary exposure compensation are fairly easy to calculate because they conform to the inverse square law, with which you are already familiar. For example, if focusing on your subject requires you to extend your normal 50mm (focal length) lens to a total focal distance (lens-to-film distance) of 100mm—twice its focal length—the film illumination will be reduced by a factor of $4 \times$, or two stops. Similarly, extending a 6-inch view camera lens to 18 inches (three times its "normal" distance from the film plane) will decrease the film illumination by a factor of $9 \times$ and require 3+ stops more exposure than is recommended by a hand-held light meter.

The reason for this light loss is obvious enough (fig. 16.1). Only so much light can enter the camera at any given aperture and it's distributed more or less evenly over the film area. If the distance from lens to film is doubled, for example, the light is spread over an area four times greater than the original film area and is therefore diminished to one-fourth its original intensity.

The necessary exposure compensation (often referred to as the *bellows extension factor*, or simply the *bellows factor*, is *directly* related to the square of the focal distance divided by the square of the focal length. That is, if the

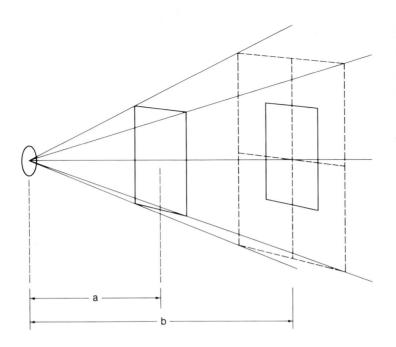

Figure 16.1

The light that covers the film area at infinity focus (normal focal length) is spread over a much larger area, and consequently reduced in intensity, as the focal distance is increased. Here the focal distance (*b*) is twice the focal length (*a*) and the film illumination has been reduced by a factor of 4.

focal length of the lens is 4 inches, and (after focusing the camera on the close-up subject) the focal distance (lens-to-film distance) is found to be 10 inches, the bellows factor is:

$$10^2/4^2 = 100/16 = 6.25$$

Alternatively, of course, you can divide 10 by 4 and square the result to arrive at the same answer:

10/4 = 2.5 $2.5^2 = 6.25$

Notice the distinction between *focal distance* and *focal length. Focal distance* refers to the distance from the lens to the plane of the focused image, regardless of subject distance; *focal length* is the distance from lens to focal plane when the camera is focused at infinity—a special case of focal distance.

You can make the desired exposure correction either by multiplying the exposure *time* by the bellows factor or by converting the factor to stops (by counting on your fingers . . . see Chapter 18) and adjusting (opening up) the aperture. Do one or the other, but not both! For example, if the meter suggests an exposure of 1/60 second @ f/32, you can provide the necessary exposure compensation (for the example above) by either multiplying 1/60 by 6.25 to arrive at about 1/10 second @ f/32; or you can convert 6.25 to stops (a little less than 2 2/3) and open up the lens to about f/12.7 (about two-thirds of the way from f/16 toward f/11), leaving the time at 1/60 second.

In practice, it's risky to set ordinary view camera shutters between their marked speeds because you'll probably not get a predictable intermediate value. In this instance, therefore, you'll have to choose between 1/8 and 1/15 second. It's usually wise to favor overexposure (with negative film), so the appropriate choice here is the longer time, 1/8 second @ f/32.

Adjust the shutter speed or aperture—but not both!

As a rule, don't set BTL shutters between their marked speeds . . .

Figure 16.2

A view camera set up to make a life-size copy. The focal distance is now twice the focal length and the total distance from subject plane to film plane is equal to four focal lengths.

. . . but intermediate aperture settings are okay

At unit magnification, subject and image are the same size

You can calculate bellows factor from magnification

Intermediate aperture settings, on the other hand, are usually reliable and you can probably estimate the f/12.7 setting satisfactorily. However, if the aperture has click stop detents that make intermediate settings difficult, it's best to use the larger opening, in this case f/11 at 1/60 second.

As the subject approaches the camera from infinity, the lens must be moved away from the film plane to keep the image in focus, and the image gradually gets larger until it attains *unit magnification*. At this point the subject and image are identical in size, and each is separated from the lens by two focal lengths (fig. 16.2). If the camera is moved still closer to the subject, the image continues to grow and image distance increases rapidly. Finally, when the subject is situated just one focal length in front of the lens, the image is formed at infinity and is infinitely large. As you can see, for all subject distances between infinity and two focal lengths, the image is less than life size. For all subject distances between one and two focal lengths, the image is larger than life size. The lens can't form a focused image if the subject distance is less than one focal length.

Image size is an important consideration in close-up photography and we frequently identify it by a number that indicates its *magnification*—that is, its size relative to the size of the subject.

There's some confusion about magnification numbers; you may hear reference to (for example) a "two-times reduction" or "50 percent reduction," meaning that the image is half the subject size, but " $0.5 \times$ magnification" is a better way to express it. Numbers less than $1 \times$ indicate that the image is smaller than the subject; numbers greater than $1 \times$ indicate that the image is larger than the subject. It's also important to remember that magnification numbers refer to *linear*, not *area*, measurements; if the subject is 1 inch square, for example, and its image is 3 inches square, the magnification is $3 \times$ (sometimes called "three diameters"), not $9 \times$.

Magnification ratios give us another way to calculate the "bellows factor": the formula is $(M + 1)^2$. For example, if some dimension of the subject measures 2 inches and a similar dimension of the image (on the ground glass) measures 1 inch, the magnification (M) equals 1/2, or $0.5 \times$, and the necessary exposure increase is:

 $(0.5 + 1)^2 = 2.25 \times$

In some cases calculating the bellows factor this way is easier than working with the focal distance/focal length ratio.

Close-up Photography with a Small Camera

There are several ways to outfit your camera for close-up work. You can get fairly good quality pictures within a somewhat restricted range by simply adding a "close-up" lens to your regular camera lens. Close-up lenses are simple *positive* lenses, generally supplied in screw-in mounts to fit most standard camera lenses. They're available in several "strengths" that are indicated in *diopters*—an optometrist's way of measuring focal length.

A diopter number is the reciprocal of the focal length in meters; for example, a + 1 lens is a positive lens whose focal length is 1 meter (39.37 inches). A +2 lens is a positive lens of 1/2 meter focal length, and a +10 lens is a positive lens of 1/10 meter—about 4 inches—focal length.

Using Supplementary Close-up Lenses

If you focus your camera lens at infinity, then add a +2 close-up lens to it, you'll find that the camera is actually focused at about 20 inches—the focal length of the close-up lens. Set the lens at its closest marked distance (probably about 16 to 20 inches) and you'll find that it's really focused at a little less than 12 inches. Replace the +2 close-up lens with a +4, for example, and the infinity setting will again focus the lens at a distance equivalent to

Figure 16.3

F. K., Boston 1984. Nicholas Nixon. Nixon's patience and skill are beautifully demonstrated in this intimate photograph. In the original 8" \times 10" contact print the old man's hands and wrinkled forehead have the translucency of alabaster.

(Courtesy of the photographer)

Supplementary close-up lenses are calibrated in diopters

Infinity focus distance is determined by the close-up lens

Close-up lenses don't require exposure compensation

If you use extension tubes or a bellows unit . . .

. . . you should probably reverse the lens in its mount

You'll have to stop down manually

the focal length of the close-up lens—in this case, about 10 inches—while the closest setting will allow you to move in to about 6 or 7 inches from the subject.

Close-up lenses effectively shorten the focal length of the camera lens (permitting it to function as a shorter lens, extended), so you can focus on close-up subjects without an apparent increase in focal distance, and there's no "bellows extension" or exposure compensation to worry about. These supplementary lenses are also relatively inexpensive; and at moderate image magnification and fairly small aperture, they provide reasonably good image quality. Although they can be "stacked" (used in combination for greater magnification), I don't recommend it except in an emergency. Even a single, relatively weak (+1 or less) close-up lens increases the aberrations of the lens system to some extent, and image sharpness deteriorates progressively as the strength of the close-up lens is increased, or as extra lenses are added to the system.

Extension Tubes and Bellows Units

If you want greater magnification than close-up lenses can provide satisfactorily, consider *extension tubes* or a *bellows unit*. Both of these devices are designed to fit between the camera body and the lens, to permit close focusing just as a view camera does—by increasing the focal distance.

If you use your normal lens with extension tubes or bellows, you should stop it down to a fairly small aperture for best results—partly because depth of field is very shallow at this close range and partly because ordinary lenses aren't designed to work at short subject distances. They're optimized for a relatively great "subject" distance and a relatively short "image" distance, although, in fact, the lens doesn't care whether it faces the subject or the image. The important thing is that if one distance is greater than the other, the front element of the lens should face the greater distance.

For this reason, most authorities recommend that a normal lens be "reversed" in its mount for extreme close-up work—that is, whenever the image is greater than life size. Under these conditions, the image distance is greater than the subject distance and the lens may function a bit better if it's turned around to face the film. In some cases this orientation may also increase image size a little, but that's usually of secondary importance. Several manufacturers offer *reverse adapter* rings that screw into the front threads of the lens mount and attach it to the extension tubes.

Notice that when using an SLR lens this way, you'll have to stop it down manually and your camera will no longer operate in "shutter priority" or "programmed" modes. However, cameras (such as Olympus) whose meters read light from the film surface will continue to permit "aperture priority" operation.

Macro-Zoom Lenses

Zoom lenses contain relatively complex assemblies of lens elements—some fixed and some arranged in movable groups that are designed to alter the magnification of the system as they are shifted from one position to another. In addition, some zooms are designed with a special adjustment that permits them to work in the close-up range. These *macro-zooms* simplify framing and composition because you can make fairly substantial changes in image size without having to move the camera. Also, because they typically have relatively long focal lengths, macro-zooms can make close-up photographs without actually having to be excessively close to the subject.

Macro-zoom lenses are very convenient to use and they are capable of producing reasonably satisfactory close-up results of most subjects; but they are not a good choice for serious work where image quality is of primary importance. Typically their close-up range is limited and they suffer noticeably from both field curvature and distortion.

Special Macro Lenses

Most lens manufacturers now offer specially designed *macro* lenses for highquality close-up work. The most popular 35mm *SLR* macros are normal (about 50mm focal length) lenses of moderate aperture (typically about f/2.8 to f/3.5) that are supplied in extra-long focusing mounts. Most cover a subject range from infinity to about 9 inches without accessory equipment and, at their shortest distance, provide $0.5 \times$ magnification (half-size). Some models come equipped with an accessory extension tube, which allows them to focus down to about 4 inches for 1:1 (full-size) reproduction. Although these lenses are optimized for close work, they are also very satisfactory for general use and some photographers use them routinely as normal lenses.

If you need to produce greater-than-life-size images on film, consider buying a bellows unit and one of the *barrel mounted* macros designed to work in specific magnification ranges. These lenses are expensive but unsurpassed for sharpness and freedom from distortion when used within their relatively limited design range.

Close-up Photography with the View Camera

The view camera is well-suited for close-up work. It's the obvious choice when you need a larger film image than the 35mm SLR can provide, but you'll probably find it awkward to use at first. For one thing, it's big: an SLR normal 50mm lens extended to form a life-size image is only about 4 or 5 inches long, but the normal 152mm lens for a 4" \times 5" view camera requires a little more than 12 inches of bellows for life-size reproduction. Longer lenses require even more extension to produce any given degree of magnification. For example, to produce 2× magnification using a 16 inch lens (moderately long for an 8" \times 10" view camera), you'll have to *rack out* the bellows close to 4 feet!

You can see from these examples that the maximum magnification that's possible with any camera is limited by both the length of its bellows (or extension tubes) and by the focal length of the lens. Although it sounds implausible, you can produce larger images (greater magnification) with a short lens than with a long one when you're working in this close-up range. That's because magnification is determined by the relationship between focal length and focal distance—and the maximum focal distance attainable is determined by the bellows length.

For example, if you are using a 4'' \times 5'' view camera at its full extension of 16 inches, you'll be able to produce a full-size (1 \times) image with an 8 inch lens. Change to a 6 inch lens and you'll get 1.67 \times magnification; a 4 inch lens will give you about 3 \times magnification; and a 3 inch lens will enlarge the subject some 4.3 \times . This concept seems to confuse beginners, but try to remember it: if you need more magnification at any given bellows extension, change to a shorter focal length lens. Obviously, that will change the subject distance and you'll have to refocus the image. Macro-zoom lenses are convenient, but limited

For best results use a special macro lens

The view camera is well-suited for close-up work

Short lenses provide greatest magnification

Focusing may occasionally seem to be impossible

The front focusing controls are almost useless

Depth of field is critical; focus carefully

Some lenses exhibit a focus shift at small apertures

You'll discover that focusing is often difficult—and sometimes seemingly impossible—at close range. It can be particularly frustrating near the unit magnification range, where (as you should recall) the object and image distances are equal, and each distance is equivalent to two focal lengths. This is a critical "crossover point" where a little increase in the object distance results in an almost equal decrease in image distance, and vice versa.

It's important to realize that at unit magnification the object and image are as close together as they can ever be—just four focal lengths apart. If the distance between them is less than four focal lengths, you will never be able to focus the image by moving the *lens* back and forth, no matter how wildly you twirl the focusing knobs. You'll sometimes have a similar problem even when the distance is a little greater than four focal lengths; focusing with the front controls (moving the lens) may do nothing more than change the image size without affecting the sharpness very noticeably. It's even possible to get yourself into a situation where the image is sharp and can't be thrown *out* of focus by minor adjustments of the front knob!

Let me emphasize, focusing with the *front* controls is not very effective at close range, and may not work at all. Focusing with the *back* controls is more effective, but even that technique may not seem to work as well as it should in some cases. The most reliable and efficient method of rough focusing is to move either the subject or the entire camera. Then, when the image is fairly sharp, you can fine-tune it with the back controls. Leave the lens alone; moving it will probably not help, and may get you into trouble.

If you need to change image size, lengthen or shorten the bellows first; then refocus approximately by moving the camera, and fine-focus with the back. This principle applies to small cameras as well as large ones; in fact, most 35mm bellows units have some provision—frequently a separate focusing knob—for moving the entire camera/bellows assembly forward and backward on a geared track.

Because depth of field is so critical at close range, you should be extra careful in focusing. I suggest that you focus first with the lens wide open for maximum image brightness. If the subject is flat and facing the lens squarely, focus directly on its surface. If it's three-dimensional, focus not quite halfway back between the front and rear extremes, then stop the lens down until the depth of field increases sufficiently to include both extremes sharply—or until you reach the limit of the aperture scale.

Finally, inspect the stopped-down image with a hand lens or loupe, and adjust the focus as necessary. You'll probably find this difficult, because the image will be very dim and the ground-glass grain imposes an overall texture on the image that you'll have to ignore. Adjust the focusing cloth to exclude as much outside light as possible, and if necessary, direct a strong light on the subject while you check it. Be careful not to press on the ground glass as you use the loupe or you may shift the plane of focus. Also, try not to breathe on the ground glass; in cold or humid weather, it can steam up and make accurate focusing impossible.

This final focus adjustment with the lens stopped down to the selected "taking" aperture is a fairly important step because some lenses exhibit a "focus shift"—that is, the plane of sharpest focus moves—when they're stopped down. This isn't a very serious problem at normal subject distances because the depth of field is generally great enough to cover it; but at close range a focus shift can ruin your picture. Watch out for this effect when using very old or inexpensive lenses; it probably won't be significant if you're using a good quality lens of fairly recent vintage.

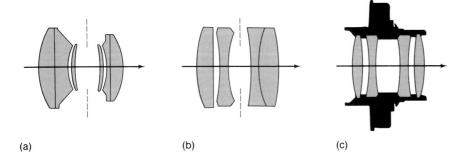

Figure 16.4

a. Several manufacturers supply highquality lenses of this popular 6-element, 4group design, for general use.
b. Tessar-type lenses of this 4-element, 3group construction are also popular.
c. Process lenses are often constructed with four symmetrically positioned, fully airspaced elements.

View Camera Lenses for Close-up Work

The most popular normal lenses for view camera use are now six-element, four-group, fairly symmetrical designs that maintain their correction quite well at all subject distances. Lenses of this type are very satisfactory for most ordinary macro work. General purpose lenses of four-element Tessar-type construction are less suitable, but certainly usable if that's all you have.

View camera lenses that have been designed specifically for copy work at close range are sometimes known as *process lenses*. They are usually of four-element, air-spaced construction (although some are Tessar-types) and are often labeled as *apochromats*, indicating that they have been unusually well-corrected for the color aberrations (fig. 16.4).

Process lenses are typically slow—maximum apertures of f/9 to f/11 are not uncommon—and their coverage is relatively limited. They're also quite expensive. If you're planning to buy a view camera lens for general use, I think you'll find that the six-element types, mentioned above, are more versatile. It's worth noting, though, that not all apochromats are process lenses; some currently available apochromats are designed for use at normal subject distances and are excellent for general use.

Lighting for Close-up Photography

In general, the principles that govern ordinary studio lighting apply equally to close-up photography; but, because close-up subjects are generally quite small and the subject distance is very short, it's difficult to light the subject area conventionally without scorching the camera or casting its shadow on the subject.

If the subject distance is great enough, it's possible to construct a simple tent of translucent paper or plastic sheet material and illuminate it from outside. You can make a fine tent for small objects from an empty plastic gallon jug by cutting off the bottom and shooting through the open top (fig. 16.5). Use the tent on a light table for backlight effects, or to subdue a ground shadow.

You can achieve an *axial light* effect (as if the light were shining from the camera along the lens axis) by angling a white card between the lens and the subject, and illuminating the card surface from one side. Shoot through a hole in the card and modify the reflection patterns in the subject's surfaces by applying bits of colored paper or aluminum foil to the card surface (fig. 16.6). If the lens hole reflection in the subject's surface is objectionable, you may be able to eliminate it by replacing the white card with a sheet of plate glass. When properly placed and illuminated, the glass surface will serve as a semitransparent mirror and reflect a uniform flood of light on the subject. Be sure the glass is clean and dust-free, and protect the lens from the direct light of the lamp to minimize the possibility of flare.

Symmetrical lenses maintain correction quite well

Process lenses are optimized for close-up work

Some apochromats are excellent for general use

Close-up lighting is often difficult, but tents are useful

Axial lighting provides front light . . .

Figure 16.6

a. Axial lighting is convenient and effective for close-ups of small objects, such as this dime. The strong, diffused front light illuminates the subject evenly; the shadows and highlights can be emphasized by careful placement of the light source.
b. Here is the setup used to photograph the dime, as seen from above. The dime conceals the dowel on which it is supported. The bits of black paper and aluminum foil taped to the white board control the surface reflections to increase the three-dimensional quality of the subject surfaces.

Figure 16.7 Ring light electronic flash unit

If you're interested in using electronic flash for close-up work, consider buying a *ring light*—a special flash tube that's formed into a circle to fit around the lens (fig. 16.7). Ring lights are wonderfully handy devices for hand-held close-up work with your SLR—for example, when you want to stalk butterflies or shoot wildflowers that are swaying in the breeze. They're also very useful for some medical and dental photography, especially in color. The flattening effect of the axial light is likely to be less attractive in black-and-white.

For most immobile subjects, ordinary tungsten light is probably preferable to flash because you can't preview the visual effect of ring light flash very easily. But tungsten light can be difficult to deal with, too, because it produces a great deal of heat. If you've used masking tape, wax, modeling clay, or other similar materials to hold your set together, it can literally melt before your eyes if you get the lights too close. To minimize heat problems, don't use any more light intensity than you need to make the picture, and turn the lights off when you're not actually arranging the lighting, focusing, or shooting.

Metering for Close-ups

The built-in meter in your SLR, used normally, will generally give you quite reliable close-up exposure information, and there's generally no need to modify it for bellows factor compensation.

If you're using a camera without a through-the-lens metering system, you'll have to resort to hand-held metering. In general, I recommend incident readings for close-up photography because it's frequently impossible to use a luminance meter effectively in the limited space between the lens and the subject. Of course, you're also likely to have difficulty getting an incident meter into the subject space, but it's usually possible. Also, the incident meter is less likely to interfere with the subject light condition, and its placement and alignment in the subject area is less critical.

If you're photographing a single object, it may be practical to remove it temporarily and replace it with the incident meter while you take the reading. In some cases it may be feasible to move the camera out of the way so that you can take a luminance reading—of the subject or of a gray card placed in the subject position.

However you manage to take the light reading, you'll have to modify it for use by applying the appropriate bellows factor, as explained above. If you're using a filter, that factor will also have to be included in the calculation. Finally, if the exposure *time* exceeds about one second, you should make a further exposure adjustment to compensate for *reciprocity failure* (Appendix 7). . . . so does a ring light

Tungsten light may melt your set

Incident metering is frequently best for close-up work

Apply the bellows factor . . .

. . . . and bracket your exposure if reciprocity is involved

It's usually important to avoid distortion in copying

A copy stand is convenient for copying small subjects

Shoot larger subjects on a wall

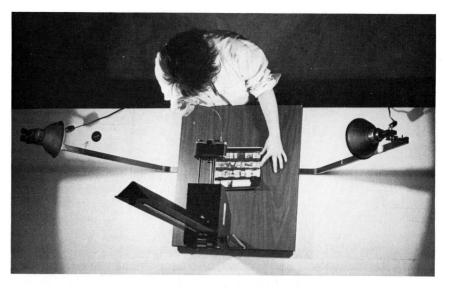

There's always the possibility of error in these calculations, especially when reciprocity compensation is involved. For this reason, I strongly recommend that you bracket your exposure, and if you have plenty of film available, shoot a duplicate of the "normal" exposure. Process this extra film first; then, if you need to adjust image contrast, you can modify the development of the other films.

Copying

Copying usually refers to the practice of photographing printed material or other flat subject matter, such as paintings, stamps, and so on. It's usually important to reproduce these things as exactly as possible, without obvious distortion. This means that the camera must be adjusted to face the plane of the copy subject squarely.

Books, small drawings, and similar copy subjects can be handled most conveniently on a vertical *copy stand* (fig. 16.8) that positions the camera directly over the center of the copy area, while allowing it to be moved up and down freely on its support column for precise adjustment of image size and framing. Lights mounted on opposite sides of the copy area illuminate the subject evenly from an angle of about 45 degrees to minimize the possibility of surface glare. These vertical stands typically can be used with either 35mm or medium-format rollfilm cameras.

If you need to copy something without using a stand, you may find it easier to mount the subject on a wall and shoot horizontally. This is particularly true if the subject is very large (a painting, for example) or if you want to use a view camera to obtain a large negative or transparency.

It's relatively easy to align the camera at right angles to the vertical surface of the wall, so be sure the subject is fastened flat against the wall. If it isn't parallel to the wall, you'll have to relate the camera position to the subject angle—a much more difficult problem.

Figure 16.9

Subjects too large to fit on a copy stand can be photographed on a wall, like this.

First, move the camera right up to the subject and adjust the tripod height to position the lens directly opposite the center of the subject area. Then draw a line (or lay a strip of tape) on the floor, perpendicular to the wall, from directly below the center of the subject to the camera position. Next, keeping the camera directly over the line, move it forward or back as required to frame the subject satisfactorily (fig. 16.9). If you've made these adjustments properly, the image should appear free from distortion when it's centered in the finder. If you're using a view camera that has vertical and horizontal lines scribed on its ground glass, it will be easy to see whether the subject is square. If it isn't, recheck the camera position. If the image is square but not centered, use the camera's shift adjustment to correct it.

Light the subject area symmetrically from opposite sides, at an angle of about 45 degrees, and don't get the lights too close—remember the inverse square law! It will be easiest to balance the illumination if the lights are identical and the bulbs are the same "age." This is especially important if you're shooting in color because old bulbs will probably produce a weaker, browner light than new ones.

If there is any sign of surface glare, reduce the lighting angle until it disappears. If that doesn't work, view the subject through a polarizing filter (from the camera position) and rotate the filter slowly to see if it can be positioned to eliminate the glare. If the polarizing filter over the lens isn't completely effective, try covering the lights with the special polarizing screens that are sold for this purpose. By orienting the screens and the camera filter together, it's usually possible to conquer fairly stubborn glare problems.

Adjust the lights individually, feathering them across the subject area to get the illumination as uniform as possible. Then turn them both on and check the illumination level at all four corners of the subject, and its center, with your incident meter. Balance the illumination as required by moving or turning the lights until the five meter readings are no more than a half-stop apart.

Light the subject area symmetrically

Check the illumination level with your incident meter

Figure 16.10

Here is a simple, but effective method for making photocopies from books or magazines. The book pages are held flat by a large clip, and the book is held open by fastening the vertical half to a brick with a large rubber band. Adjust the camera position over the copy area by viewing the reflection of the lens in a mirror that is placed flat on the book page. When the viewfinder image shows the lens reflection in the center of the mirror, and the rangefinder prism (in the center of the ground glass) is centered in the lens reflection, the camera is facing the copy squarely. For best accuracy of exposure, set the camera meter on "manual" mode and take the reading from a standard gray card placed on the book page. The single light is sufficient here because the vertical book page acts as an efficient reflector. This is the setup used to make the copy in figure 1.12.

Depth of field is rarely a problem; shoot at medium aperture

Slip a black sheet under printed copy to minimize "print through"

Use your SLR's MANUAL mode to read the gray card

Depth of field is rarely a problem in copy situations, so there's no need to stop down for that reason. In fact, it's generally best to shoot flat copy at a medium aperture, about two or three stops down from maximum, because diffraction reduces image sharpness at very small apertures. Your SLR's normal lens will probably produce its sharpest images at between f/4 and f/8; use your 4'' \times 5'' view camera lens at about f/11 to f/22 for best results.

When copying from books or magazines that can't be opened flat for conventional lighting, you can get good results with a single light, as shown in figure 16.10. Hold the pages flat with stationer's clamps and use the vertical page as a reflector to balance the illumination. If printing on the other side of the book page shows through, a sheet of black paper slipped under the page will usually eliminate it. If the page is curled or wrinkled, press it flat with a sheet of plate glass. If the camera's reflection is visible in the glass surface, shade the camera from the light and shoot through a hole in a sheet of black cardboard. To be sure this has been effective, inspect the finder image carefully with the lens stopped down. A reflection that's invisibly out-of-focus at maximum aperture may show up at a smaller stop.

Your SLR's built-in meter may mislead you when you're copying because the subjects may not represent average grays. For that reason, it's wise to take the reading from a gray card placed temporarily on the subject surface (or use an incident meter) and adjust the camera manually (fig. 16.11). Don't leave the camera set on its automatic or semiautomatic modes, or it will ignore the gray card reading and react to the subject when the exposure is made. Bellows compensation won't be necessary if you use the built-in meter, but don't forget to apply it if you use incident readings. Remember reciprocity compensation, too, if the exposure time exceeds about one second.

(a)

(C)

Summary

Close-up photography produces images of from about 1/8 size to perhaps twice size. Most small cameras can't make close-up photographs without special equipment because their focusing range is deliberately restricted.

Focusing on close-up subjects reduces light intensity on the film and requires exposure compensation. TTL meters make the compensation automatically; the bellows factor must be calculated if a hand-held meter is used. BTL shutters can't be set reliably between their marked speeds; use the speed that favors overexposure. Intermediate aperture settings are generally reliable.

Figure 16.11

a. Flat material must be evenly lighted for best copy results; place a light on each side of the copy board and position them so there's no apparent surface glare on the copy as seen from the camera position. You can check the relative intensity of the lights by inspecting the shadows of a pencil (or finger) touching the copy board near center. Move one of the lights toward or away from the copy board until the shadows appear to be of equal intensity. In this picture the light at the left is too strong; move it farther away.

b. If you're using a camera without a built-in meter, use a hand-held meter in its reflectance mode to read a gray card in the center of the copy area. It's safe to use the reading it gives you without other compensation (except for bellows factor, filter factor, or reciprocity compensation if any of them apply.)

c. An incident meter is even more convenient than the gray card. Be sure the meter cell is exposed to the same light intensity that exists on the copy surface, as shown here. At unit magnification the object and image are identical in size and spaced four focal lengths apart—as close together as they can ever be. If magnification is greater than $1\times$, the image is larger than the subject; if less than $1\times$, the image is smaller than the subject. Magnification refers to linear measurement, not area. It can be used to calculate the bellows factor.

Close-up lenses are calibrated in diopters—a measure of focal length. Use them to effectively shorten the focal length of your camera lens so it can focus on close-up subjects without an apparent increase in focal distance. No exposure increase is required. Stop the lens down to a fairly small aperture for best results with close-up lenses.

Extension tubes and bellows units permit close-up focusing by extending the focal distance. Normal lenses may work better if they're reversed for very close work. Reversed lenses lose their automatic features. Macro-zoom lenses are convenient to use, but their range is limited and image quality is generally only fair to good. Special macro-lenses are preferable for quality close-up work. Some are also suitable for general use.

View cameras can make fine close-up photographs, but they're clumsy to handle. Image magnification depends on lens focal length and bellows extension; for maximum magnification, use a short focal length lens at full extension.

Focusing is often difficult at or near the unit magnification range. For quick, approximate focus adjustment, move the whole camera; fine-focus with the back controls. Don't focus with the lens controls at close range; they're relatively ineffective.

Do your rough focusing at maximum aperture. Then stop down and check for possible focus shift by inspecting the ground-glass image with a loupe; readjust the focus if necessary. Modern symmetrical lenses hold their correction relatively well at close range. Process lenses are specially designed to be used near unit magnification.

Tent lighting is useful for some close-up work. Axial lighting can be provided by reflection from angled cards or glass. Ring lights surround the lens for axial lighting; they're convenient for hand-held close-up work. Tungsten lighting is generally preferable for immobile subjects, but heat can be a problem.

Built-in SLR meters are easy to use for close-up work. Hand-held metering of close-up subjects is usually difficult. Incident metering is probably most reliable. Don't forget to apply the bellows factor, filter factor (if appropriate), and reciprocity compensation if it's needed. Exposure errors are possible; it's a good idea to bracket.

Use a copy stand with your SLR to photograph flat subject matter. Photograph paintings or other large, flat subject matter on the wall. Center the camera on the subject and balance the lighting carefully. A polarizing filter may help to reduce surface glare. In severe cases you may need polarizing screens for the lights as well. Stop down to a medium aperture for sharpest results.

Hold wrinkled pages flat with plate glass but watch out for reflections. Eliminate type "print through" with black paper. Be sure your SLR is in manual mode if you want to use incident or gray card readings.

Using the View Camera

Harry Mattison, Photographer

Photographed by Bill Pierce. In an abrupt shift of technique, Pierce used an $8'' \times 10''$ view camera to make this studio portrait of a fellow photojournalist in dramatic black and white.

(Courtesy of the photographer)

a. Opened film boxb. Notches in the corner of each film sheet identify the film type and indicate the emulsion side.

(b)

(a)

View cameras are relatively primitive in principle, but frequently sophisticated in design and construction. They are essentially lighttight, flexible boxes, capable of accepting a lens at one end and a sheet of film at the other. Their sophistication results from the fact that (in at least some designs) virtually every part of the camera is either interchangeable or adjustable so that it's relatively easy to adapt the camera design to suit your needs. Almost all modern view cameras are made of metal and most are of *monorail* construction (fig. 4.13). These cameras are exceptionally capable and adaptable, but because they're relatively heavy and awkward to transport, they're best suited for work in the studio.

Modern field cameras are essentially pared-down versions of what view cameras used to be—that is, *flat bed* designs constructed of wood with relatively few (or no) interchangeable parts and somewhat limited adjustments. They are generally designed to fold compactly for carrying and are remarkably light in weight for their size (fig. 4.14). Wooden field cameras are more fragile and less versatile than the metal monorails, but they're capable of doing almost anything that you'll normally need to do with a large-format camera, either in the studio or on location.

Sheet Films

Although some models can accept rollfilms (in specially designed *rollfilm backs*), view and field cameras are usually used with *sheet film* (sometimes referred to as *cut film*). This film is popularly packaged in units of 25 sheets, although several other package sizes are available. The film sheets are stacked between thin sheets of cardboard, then wrapped and sealed in a vinyl-foil envelope and enclosed in a lighttight box composed of three interlocking "halves" (fig. 17.1a). Some brands of sheet films are packed with interleaving sheets of thin paper; Kodak films are packed without the interleaves.

For use in the camera, sheet films are loaded into *film holders*. Panchromatic films must be loaded in total darkness, and it's prudent to load even slow orthochromatic and blue-sensitive films in the dark to avoid any possibility of fog. If you feel you must use a safelight, be sure it's suitable for use with the film you're loading, and use it as sparingly as possible.

Obviously, it's important that the films be loaded so the emulsion side will face the camera lens when the exposure is made. That means that you'll have to identify the emulsion side of each film sheet as you load it. Fortunately, that's easy to do; the manufacturers cut one or more notches into one edge of each sheet, close to the corner on the short dimension. When you hold the film with its long dimension vertical, the notches will be found along the top

Almost every part of a view camera can be adjusted

Field cameras are light, compact, and capable

View and field cameras generally use sheet film

. . . that must be loaded into holders in the dark

The film sheets are notched to indicate the emulsion side . . .

Chapter 17

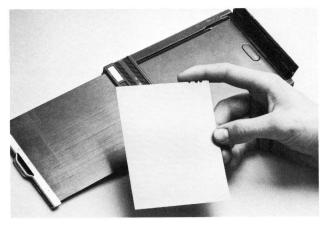

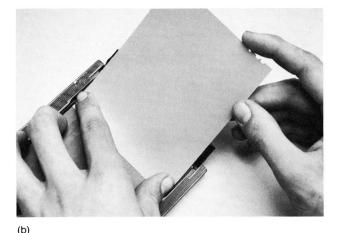

(a)

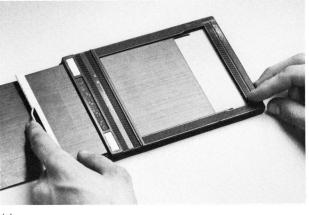

(C)

edge in the upper right corner of the sheet when the emulsion side is facing you (figs. 17.1b, 17.2a). Of course the emulsion will still be up if the notches are found in the lower left corner of the bottom edge, but don't complicate things! Remember "top edge, upper right corner, emulsion up" and you'll avoid trouble.

The number and shape of the notches also identify the film type. For example, Tri-X Pan films have three closely spaced V-shaped notches. Plus-X sheets have one V-shaped notch, a space, then two closely spaced, nearly square notches (reading from the center of the edge toward the corner) (fig. 17.1b). These notch patterns are also printed on the bottom of the film boxes and on the information sheets included in the boxes. You must know who made the film before you can identify it reliably, but the position of the notches identifies the emulsion side of the film sheet, regardless of who manufactured it.

There are a few special-purpose films (Kodalith is one you're likely to encounter) that are not corner-notched. In every case these are relatively slow, blue-sensitive or orthochromatic materials. Since it's safe to handle these films in suitable safelight conditions, you can identify the emulsion side visually it's usually much lighter in color than the back—so the notches aren't needed.

You'll find that some sheet films have familiar names (Tri-X, T-Max 400, HP-5, for example). Others will be strange to you; there are no rollfilm equivalents for such films as, for example, Ektapan, Commercial, or Contrast Process Ortho. In general, roll and sheet films of the same type can be expected to have similar characteristics, but they are not necessarily identical. For example, Plus-X 35mm film behaves very much like Plus-X Pan Professional roll-film (120 size), but Plus-X Pan Professional *sheet* film has different gradation characteristics and responds somewhat differently to development.

Figure 17.2

a. Clean the holder and position its slides, silver side out, like this. Hold the film lightly by the edges to avoid fingerprints. The film notches in the upper right-hand corner of the sheet indicate that the emulsion is facing you.

b. Place your thumb and fingertips over the ends of the film guides. When you feel the film slip under your fingers, you can be sure it is entering the guides properly.

c. Push the film sheet all the way into the holder. If it is not all the way in, the end flap will close only with difficulty if at all, and the slide may not close completely. If the film is loaded properly, the end flap and the slide will interlock easily to seal the holder against light.

. . . and the film type

A few types are not notched

There are no rollfilm equivalents for some sheet films

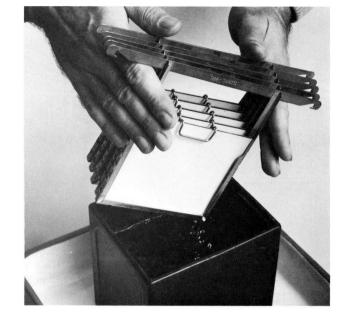

The roll and sheet versions of Tri-X are even less alike. Tri-X 35mm and rollfilm are rated at an ISO speed of 400 and are deservedly popular as versatile general-purpose films with considerable tolerance for exposure and development variations. Tri-X Professional films, available in both 120 rollfilm and sheet film sizes, are rated at ISO 320 and are designed primarily for studio use. Although many photographers use them routinely as general-purpose films, they differ obviously from regular Tri-X in image gradation, are less for-giving of exposure errors, and require quite different development. The characteristics of the T-Max films seem to be similar in all sizes.

Sheet films differ from 35mm films in some other obvious ways, also. Sheet films are noticeably thicker and stiffer than rollfilms because they're coated on heavier plastic stock. Both acetate and polyester are used for film base material and at least one film type—Commercial—is available on both. You'll notice a difference in base color, too. Virtually all 35mm films are coated on a gray base that's designed to limit "light-piping" and irradiation effects. This gray tone is not removed during development—as the dyes of the anti-halation backing are—and remains in the negative as neutral density. Sheet films (and rollfilms), by comparison, are coated on clear base material. Their negatives have a relatively low base density, although they are frequently tinted light pink or blue by residual dyes.

If this is your first experience with sheet film, I suggest that you practice loading your film holders in the light (using old negatives or spoiled film, of course) before attempting to load good film in the dark. Consult figure 17.2 for explanation and step-by-step illustration of the procedure.

Processing Sheet Film

Sheet film can be processed in tanks of various sorts (and in professional automated processors) just as rollfilm can. Although many photographers use "daylight" sheet film tanks with satisfactory results, I don't recommend them. I find it very difficult to provide adequate agitation in tanks of this sort, and I know of no way to avoid uneven development when using them. The old tank-and-hanger development procedure is safer (fig. 17.3), but "hanger marks"

Sheet films are thicker and stiffer than rollfilms

You can process sheet films in tanks or drums . . .

Practice loading holders in the light

and evidences of "bromide drag" are not uncommon. Drum processing is a feasible alternative for small batches of film. It's possible to process four 4" \times 5" film sheets or two 5" \times 7" sheets or one 8" \times 10" at a time in a Unicolor drum, and at least with motorized agitation, the results are generally good.

You can also process a few sheets at a time (by hand, in total darkness) in open trays. Like any other skill, tray processing requires practice. At first you'll undoubtedly ruin a few negatives by allowing the film sheets to stick together in the developer, by improper agitation or by gouging the soft emulsion with your fingernails or the sharp corners of other film sheets.

Despite these problems—which are a normal part of learning the technique—don't give up on tray processing. It's fast, economical of chemicals, convenient (after you learn how), and capable of producing negatives of excellent quality. This is the method I recommend as standard procedure for from two to about six sheets at a time. Start out modestly, though; until you've attained real skill, you probably shouldn't try to handle more than two or three sheets at once.

Tray development, like loading film holders, is a process you should practice with spoiled film in the light before you work with "real" films in the darkroom.

Processing Chemicals

Sheet films go through the same sequence of chemical treatment that's used for rollfilm. For ordinary work with general-purpose films, the same developer (D-76) that I recommended for rollfilm works well, although you may prefer to use it "straight" rather than diluted 1+1 for some film types. Notice that tray processing involves *constant agitation* rather than the intermittent agitation procedure that's employed routinely in rollfilm processing. Constant agitation increases the rate of development rather dramatically and therefore shortens development time. Tables of sheet film development times usually provide data for both constant and intermittent agitation. The times will be quite different; be sure you choose the right one.

Some films—such as Super-XX, Agfa 400, and (to a lesser extent) Royal Pan and the T-Max films—require more than ordinary development to produce acceptable image contrast. Although straight D-76 will usually develop these films satisfactorily, more active developers such as HC-110A, T-Max, or DK-50 will permit shorter development times.

Subsequent chemical solutions can be identical with those used for rollfilms, and immersion times are similar. As is the case with rollfilm, sheet films should be fixed for "twice the time it takes to clear" them. The T-Max films, especially, require extended fixing time to remove their characteristic magenta dye stain. Follow the step-by-step instruction sequence (fig. 17.4) for description of the processing procedure.

Using View and Field Cameras

When all its controls and adjustments are locked in their neutral positions, the view (or field) camera is easy to operate. You'll probably be able to photograph most of the subjects that interest you by following the instructions and illustrations in figure 17.5. Occasionally, though, you may want to take advantage of some of the camera's *shifts* and *swings*—the adjustments that permit some unusual manipulation of image depth of field and perspective.

. . . . but tray processing has certain advantages

The processing chemical steps are familiar . . .

. . . but some films need unusually vigorous development

Figure 17.4 a. Holding the films lightly like a hand of cards, count the corners to be sure you have them all and that they are separate.

b. Keep one hand dry. Insert the first film into the developer solution and pat it down to be sure it is completely immersed.

c. Place the other sheets, one at a time, on the surface of the developer and pat each one down to wet it thoroughly before adding the next.

d. Herd the sheets gently into one corner of the tray, then . . .

. commence the agitation by sliding е. . the bottom sheet out from under the stack and carefully laying it flat on the surface of the solution.

f. Pat it down and extract the next sheet from the bottom of the stack. Continue this sequence throughout the development time.

a. Mount the camera on its tripod, adjust its height, and point it in the general direction of the subject. Open the lens fully so that the image will be as bright as possible for easy focusing and composing. Setting the shutter dial on "time" is one way to do this.

b. Some shutters provide a convenient "press focus" button or lever that you can use to open the shutter blades fully regardless of the speed setting.

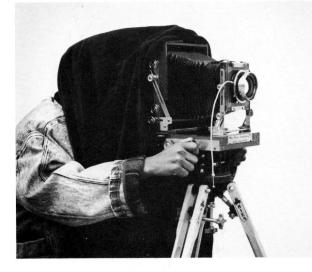

c. Cover your head and the camera back with the focusing cloth to exclude light and make the ground glass image appear brighter. Focus the camera and compose the image on the ground glass.

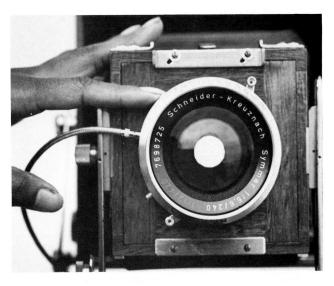

d. Stop the lens down to the aperture you intend to use and check the focus and depth of field with a small magnifying glass. The aperture control on the shutter is a flat lever that's not visible from this angle.

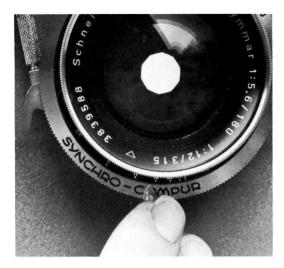

e. The aperture control on this shutter is much easier to find and use. Some shutters provide two aperture scales so that the numbers can be read from above or below—a real convenience.

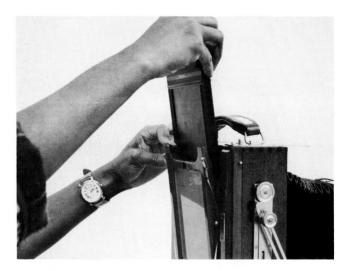

f. When you're satisfied that the camera controls are set properly, insert the film holder, being very careful not to displace the camera. Here the model places her left thumb on the carriera body and prys the back open with her left forefinger. This equalizes the forces and leaves the camera stationary.

g. Set the shutter on the speed you want to use and cock it. It's a good idea to cock and release the shutter once or twice to be sure it's operating smoothly. Check the holder before you do this to be sure the film is still protected by the dark slide.

h. When everything is ready, pull out the front dark slide, that is, the one facing the lens. If you pull the rear slide, you'll ruin that film. Notice here that the shiny side of the slide border is facing forward, indicating that fresh film is ready to be exposed.

j. Replace the dark slide, this time with the black side of the margin facing forward to indicate that this film has been exposed. Remove the holder and store it in your camera case to protect it from light. In hot weather try to keep the case in the shade to keep the film as cool as possible.

i. If the camera is not equipped with a lens shade or hood, it's usually a good idea to shield it from light as well as you can with whatever is handy. Here the model uses the dark slide to exclude top light. Be careful not to let the slide sag into the lens field or it will mask out some of your image. Leave some slack in the cable release so that your finger pressure won't jiggle the camera. Press the release plunger to make the exposure.

The Shifts and Swings

Shifts are simple lateral or vertical movements (of either the lensboard assembly or the camera back) that decenter the lens with respect to the film while allowing the lensboard and film plane to remain parallel to each other. The vertical shift of the lensboard is referred to specifically as the *rising front* (fig. 17.6). Old wooden view cameras and a few contemporary field cameras provide shifts of the front standard (the lensboard's supporting structure) only; the back can't be moved either laterally or vertically. This is sometimes inconvenient but rarely a serious problem.

Swings permit the lensboard and back to rotate around their vertical and lateral axes. The lateral-axis swings are sometimes called *tilts*. A design that allows the lensboard (or back) to be tilted around its lateral axis, independent of its standard, is referred to as a *center swing* or *center tilt* (fig. 17.7). If the entire standard tilts with respect to the camera base or *bed*, it's described as a *base tilt* design. Some photographers prefer the center tilt, others prefer the base tilt; both are workable and the choice is largely a personal one.

View and field cameras provide shifts . . .

. . . and swings

a. When all its shift and swing adjustments are in their neutral positions, a view camera looks like this. The planes of lensboard and back are parallel and the lens is centered in front of the film.

b. The shifts decenter the lens with respect to the film, but the back and lensboard remain parallel. Here the back is shifted to the left and the lensboard is shifted to the right.

c. The vertical shift of the lensboard is usually referred to as the "rising (and falling) front." Many medium-size view cameras also permit vertical shifts of the back, but this adjustment is rare on field cameras.

(a)

(C)

Figure 17.7

a. The swings throw the lensboard and back out of their normal parallel relationship. Here both the lensboard and the back have been swung around their vertical axes. b. Swings around a horizontal axis are called "tilts." This camera design permits "center tilts."

c. This camera is designed with "base tilts."

(c)

This circular image, made on $8'' \times 10''$ film, demonstrates the coverage of a 135mm Symmar lens. The large circle (solid outline) represents the extreme limit of image tones, but the area outside the dashed-line circle is not sharp enough to be useful. The dashedline rectangles illustrate the permissible limits of lateral and vertical shift. The film normally occupies the area outlined by the inner dashed-line rectangle. The solid-line rectangle shows the film position used to make the photograph in figure 17.9c.

What the Shifts Do

Shift adjustments are useful and possible because the image circle formed by the lens is usually substantially larger than the film itself, and the film can be positioned to record any portion of it (fig. 17.8). Obviously, a lens that forms a very large image circle will permit extensive use of the shift adjustments, but they should always be used with discretion. Image quality deteriorates rapidly toward the perimeter of the image circle, and although edge details may appear acceptably sharp in the ground-glass image, they may turn out to be distressingly fuzzy when the negative is developed. When in doubt it's a good idea to check the sharpness of the ground-glass image with a hand magnifier or loupe.

The shifts can sometimes be used to eliminate or reduce the effect of converging perspective lines in the image. Although this is often described as the major function of these controls, only architectural photographers are likely to use the shifts for this purpose very frequently (fig. 17.9). I think you'll use them much more often for refining the framing and composition of the ground-glass image, thereby avoiding the inconvenience of having to move the entire camera when only a slight adjustment is required.

Shifts reposition the film within the image circle

Use them to control perspective and adjust composition

a. Tilting the camera upward to frame this country church comfortably has caused the vertical lines of the building to converge. Many photographers consider this evidence of perspective to be undesirable.

b. Leveling the camera eliminates the perspective convergence but amputates the steeple.

c. Leaving the camera level and raising the front frames the church satisfactorily and avoids the perspective convergence of vertical lines. Notice that you can achieve this same effect by tilting the camera up, then swinging both the back and the lensboard to a vertical position. Perspective convergence is eliminated when the planes of the lensboard, the camera back, and the subject are all parallel, no matter how that is accomplished.

Swings alter the normal parallel relationship between film and image plane

Because the camera image is threedimensional

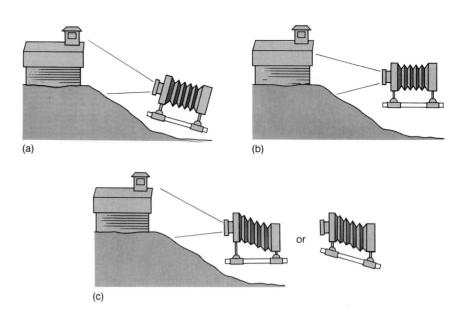

You'll find this technique particularly valuable in copying or close-up work. It's often important to preserve the proportions of copy subjects, which means that the camera must be positioned to face the subject squarely so that the planes of subject, lensboard, and film are parallel. This is a painstaking, timeconsuming task and when you've finally managed it, it's not unusual to find that the image isn't properly centered on the ground-glass.

Moving the tripod is likely to throw the image out of square again. In some cases you can shift the subject slightly, but that may change the image proportions and necessitate refocusing. It's much easier to shift either the lensboard or the camera back in the desired direction until the image is positioned satisfactorily.

What the Swings Do

The shift adjustments effectively reposition the film within the image circle, leaving the lensboard parallel to the film plane. The swing adjustments may or may not affect the actual *placement* of the film in the image circle, but they will usually alter the normal parallel relationship between the film surface and the image plane.

Actually, the terms *image plane* and *image circle* are somewhat misleading because they suggest that the image is infinitely thin and flat, and that it hangs in space behind the lens like an invisible sheet of paper. If that were the case, focusing the camera would be a simple matter. Merely bringing the film plane and image plane into coincidence would be sufficient to guarantee a totally sharp image with infinite depth of field (figs. 17.10, 17.11, 17.12, and 17.13)!

In fact, the image (of any three-dimensional object, at least) is not a plane at all; it's actually a miniature three-dimensional, upside-down and backward replica of the subject. When you focus the camera, you are simply moving the ground-glass viewing screen back and forth through the image space, sampling one thin section of the image after another. As you do this, some

Depth of Field at f/5.6

(b)

Figure 17.10

a. This photograph illustrates the very limited depth of field that's provided by a typical view camera lens at maximum aperture. In this case the lens focal length is 240mm (slightly less than 10 inches) and the lens was used wide open at f/5.6. The camera was focused sharply on the ball that's touching the table stripe at left. The calculated depth of field is about 2½ inches—only slightly greater than necessary to render the ball totally sharp. b. This illustration diagrams the situation in compressed scale and shows the shallow depth of field barely including the ball.

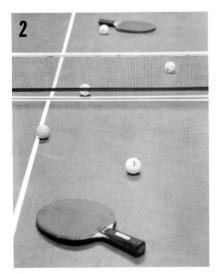

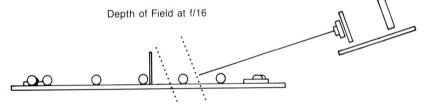

(b)

Figure 17.11

a. This photograph was taken with the lens stopped down to f/16. Although the smaller aperture has increased the depth of the field to some extent (its calculated value is a little more than 8 inches), it is far from adequate. b. This illustration shows that the depth of field has been expanded but still includes only the one ball.

(a)

details come into sharp focus, others go out; the film can never be positioned to capture all of the image points (of a typical subject, at least) with equal sharpness. This is why depth of field is such a perennial problem.

If you've learned photography with a 35mm camera, you probably haven't had much occasion to worry about depth of field. That will change when you begin to work with the view camera. Despite the fact that view camera lenses can be stopped down to at least f/32 or f/45—or even smaller apertures—you'll find that you can't always get sufficient depth by simply stopping down. This is where the swings can sometimes help; not by actually *increasing* the depth of field, but by making more efficient use of it.

depth of field is a perennial problem

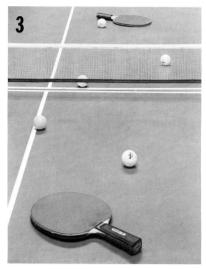

(a)

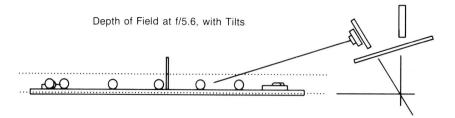

(b)

Figure 17.12

a. With the lens at its maximum aperture again, the camera's back standard was tilted backward and the front standard tilted a little forward to make the plane of focus lie parallel to the tabletop. You can see that the table is now sharp from foreground to background, but the top of the net "protrudes" through the shallow depth of field and is obviously blurred b. This illustration shows the effect of the tilts, and indicates that the extended planes of lensboard, back, and table surface meet to satisfy the Scheimpflug condition. Although the depth of field is still shallow, it now coincides with the plane of the table surface and most of the subject is satisfactorily sharp. Only the top of the net is still out of focus.

In making these tilt adjustments, I recommend that you tilt the back first; then optimize the adjustment, if necessary, by tilting the lensboard slightly. Although making the major correction with the back tilt will tend to emphasize the perspective effect, this is usually tolerable. The lensboard tilt adjustment, on the other hand. displaces the image toward the margin of the lens' image circle where the aberrations are more troublesome and sharpness generally decreases. For this reason it's usually a good idea to swing or tilt the lens as little as possible: you can correct the perspective in printing if necessary (by tilting the enlarging easel and the negative carrier), but there's no practical way to make a sharp print from a fuzzy negative.

(a)

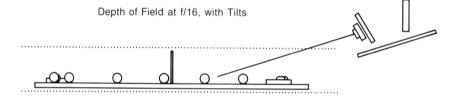

(b)

Figure 17.13

a. Stopping the lens down to f/16 expands the depth of field vertically to include the top of the net. Everything is sharp and the only "penalty" is a very slight increase in the image foreshortening, which makes the foreground paddle appear slightly larger. b. With the camera adjustments unchanged, the depth of field still parallels the table surface, but now the smaller aperture has increased the depth to include the entire height of the net.

a. Tessar-type lens construction.
b. Diagram of a Rodenstock Sironar, a typical premium-quality lens of 6-element design.

View Camera Lenses

To be satisfactory for use with the shifts and swings, a view camera lens must be well-corrected for the various aberrations, and capable of forming a large image circle that's usably sharp right out to the edges. Good quality lenses of traditional four-element, three-group Tessar construction (fig. 17.14a) are often very satisfactory in normal or longer-than-normal focal lengths, but the useful coverage angle of this design is generally too limited for extensive use of the shifts and swings, or for wide-angle work.

The major manufacturers now seem to have agreed that medium-aperture lenses of six-element, four-group design (fig. 17.14b) are most versatile and appropriate for general use because of their excellent correction and wide coverage angle. Some older lenses of other designs—such as the famous Goerz Dagor, for example—are also much admired by experienced view camera users.

If you're planning to buy a view camera lens, consider what you'll use it for and be sure the focal length, aperture range, and field coverage are appropriate for your purposes. Then, if you have a choice, buy a top-quality lens of reputable manufacture. A fine lens will be expensive, but consider it an investment; with proper care it will serve you well for a very long time.

Shutters

View camera lenses are almost always sold complete with factory-mounted between-the-lens shutters. By comparison with the impressive range of shutter speeds provided by a typical 35mm SLR, view camera shutters seem very limited indeed. The small or medium-size shutters supplied with most lenses of less than about 8 inch focal length may offer top speeds of up to 1/400 second, although a maximum of 1/200 or less is not uncommon. Larger lenses, of course, require larger shutters that may, in some cases, provide maximum speeds of only 1/50 second or so (fig. 17.15).

This is less of a handicap than it may appear to be because any subject that you can capture satisfactorily with a tripod-mounted view camera must necessarily be holding fairly still. Virtually all view camera shutters offer both T (Time) and B (Bulb) speeds for exposures of a second or more, and you'll be surprised how frequently you'll need them.

Large-format photography is admittedly a specialized activity that will restrict your choice of subject matter somewhat, and force you to pay close attention to the basics of composition, focus, and exposure. It's demanding and often frustrating, but if you delight in the visual elegance of a truly fine print, I think you'll agree that the effort is well worthwhile. Fine lenses are expensive

Large-format photography is demanding, but worthwhile

Summary

For maximum photographic image quality, use a large-format camera equipped with a fine lens and make contact prints.

View cameras are very versatile but are most useful in the studio. Field cameras are almost equally capable and are much lighter and easier to transport into the field.

Most view and field cameras can be equipped to use rollfilms but are used mostly with sheet film. Film sheets must be loaded into film holders for use in the camera. Notches cut into one edge of each film sheet identify the emulsion side of the sheet and the film type. The emulsion side of unnotched films can be identified visually in appropriate safelight.

Sheet and rollfilms may have the same name, but their characteristics are not necessarily identical. There is a great variety of sheet-film types from which to choose.

Sheet films can be processed in tanks, drums, or open trays. Tray processing is a skill that will take practice, but it's an excellent way to process a few sheets of film at a time. Sheet-film chemicals are similar to those recommended for rollfilm and the processing sequence is the same.

View and field cameras have special adjustments called shifts and swings that can be used to alter image characteristics. The shifts are especially useful for adjusting image framing and combatting perspective convergence; the swings affect image perspective, proportion, and depth of field. The shifts and swings should be used with discretion.

View camera lenses should be well-corrected and provide wide coverage. Before you buy a lens, consider what you'll use it for. A fine lens will serve you well for a long time.

View camera shutters have a limited range of speeds, but this is not usually a serious handicap. Large format photography is demanding and often frustrating, but if you appreciate fine print quality, the effort is worthwhile.

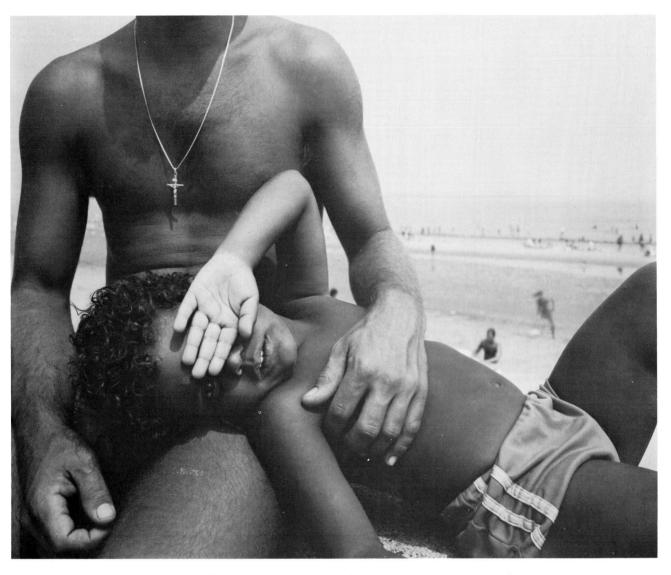

Figure 17.16 *Revere Beach, Massachusetts, 1980.* Nicholas Nixon. Nixon's legendary ability to photograph strangers at point blank range— apparently without disturbing them—is all the more remarkable because he works with an $8'' \times 10''$ view camera. This characteristic image combines the spontaneity of a snapshot with the luminous gradation of the large-format contact print.

(Courtesy of the photographer)

Exposure/Development Systems

Provincetown 1977 (Window) Photograph by Joel Meyerowitz. (Courtesy of the photographer) Expose for the shadows; develop for the highlights

Test the effects of exposure and development yourself

Use sheet film . . .

. . . or rollfilm

The Exposure/Development Relationship

Generations of student photographers have been advised to "expose for the shadows and develop for the highlights." This is an abbreviated way of saying that film exposure should be sufficient to record the shadow tones of the subject without loss of detail, and that development should be stopped just as the image highlights reach optimum printing density. This relationship between film exposure and development, and negative density and image contrast, is an important one. You must understand it thoroughly if you hope to produce consistently excellent black-and-white negatives and prints, especially with a large-format camera.

Testing Film

You can demonstrate the effects of exposure and development variations with a series of nine test negatives. I recommend that you make this test using your own camera and materials, and keeping careful records of your procedures. Find a stationary subject of average contrast in a light condition that will remain constant while you work on it. Position the camera on a tripod so the viewpoint will be identical in all nine photographs. Meter the subject in your accustomed way.

If you are using sheet film, set the camera controls for normal exposure. Use a fairly small aperture for good depth of field, but keep the shutter speed shorter (higher) than about 1/8 second to avoid reciprocity effects. Using this normal exposure setting, expose three films identically.

Identify these exposed films by marking the appropriate sides of the holders with an "N" (for "normal" exposure). Next, adjust the camera to overexpose by two stops (don't let the shutter speed drop below 1/8 second), and expose three more sheets of film identically. Mark these films +2 to indicate the two-stop overexposure. Similarly, readjust the shutter to provide an exposure of two stops less than normal, and expose three more films. Mark these films -2 to indicate the two-stop underexposure.

For example, let's assume that you've chosen a normal exposure of 1/30 second at f/32, based on your meter reading. Expose the three "N" films at that setting. Then change it to 1/8 second at f/32 to provide a two-stop over-exposure and shoot three films, marking them +2. Then reset the controls to 1/125 second at f/32 and shoot the three underexposed films, marking them -2.

If you're using rollfilm, the procedure must be done differently. Either use three separate rolls of film and expose one-third of the frames on each roll normally, then overexpose the next third of the frames by two stops, then underexpose the remainder of each roll by two stops; or vary the exposures on a *single* roll in a repetitive sequence (under, normal, over; under, normal, over; and so on) until the roll has been used up.

In the darkroom, set up a process line of fresh chemicals for film developing and adjust them to the proper temperature. If you are using sheet film, take one normally exposed sheet, one overexposed sheet, and one underexposed sheet, and develop them together for *half* your *normal* developing time. Next, in fresh developer, develop a similar set of over-, under-, and normally exposed films for your *normal* time. Finally, in fresh developer, develop the remaining set of three films for *twice* your normal time. Be careful to process all three sets at the same temperature, and keep the agitation as uniform as possible. Fix, wash, and dry the films as usual.

If you have used three rolls of film for the test, each roll will contain some underexposures, some normal exposures, and some overexposures. Develop one roll for half the normal time, one for normal time, and one for twice the normal time, using fresh or properly replenished developer for each roll.

If you have made all the exposures on a single roll, develop the roll in an open tank in the dark, lifting the film reel out of the tank and replacing it quickly—twice every 30 seconds—to simulate normal tank agitation as closely as possible. At half the normal developing time, remove the reel from the tank, unroll about one-third of the film, and with a pair of scissors, snip it off into a tray of stop bath. Snip the next third of the film until you have doubled the normal time. Add this last film to the stop bath, then transfer all three lengths to the fixer. Agitate them briefly before you turn on the lights (wash the fixer off your hands before touching the light switch). Wash and dry the films as usual.

Figure 18.1

Navaho Lands, New Mexico, 1983. Nick Merrick. Merrick's personal photographs reflect his interest in the ways in which people of various cultures relate to—and visibly affect—their natural environment. His large-format images are exquisitely detailed and beautifully printed.

(Courtesy of the photographer)

If you follow the exposure/development test procedures that are described in the text, your negatives should look something like these when they're viewed on a light box. The top row represents overexposure; the middle row is normally exposed; the bottom row is underexposed. The left column represents underdevelopment; the center column is normally developed; and the right column is overdeveloped. The "normal" negative (normally exposed and normally developed) is in the center of the array.

The test will yield nine different negatives

Print them . . .

Analyzing the Test Results

If you've done the test properly, you will now have nine different negatives. Arrange them on a light box in a three-by-three array with the normal negative in the center, as shown in figure 18.2. Study the contrast and the shadow density carefully to see how the various images differ.

Although exposure and development aren't separate influences by any means, it's generally true that image contrast is most closely related to development, and image density—especially shadow density—is most closely related to film exposure. A good normal negative will have moderately thin, well-detailed shadows and moderately dark, but still translucent, highlights. With a little experience you'll be able to identify abnormal negatives at a glance, and tell whether film exposure or development was at fault.

Now try printing these negatives. If you contact print the entire set on a single sheet of paper (or print the negatives separately with identical exposures) basing the print exposure on the normal negative, you'll have a dramatic demonstration of the effect of film exposure (and, to a lesser extent, development) on image density. The overexposed negatives will make relatively light prints; the underexposed negatives will produce dark prints; and prints from the normal negatives will fall somewhere in between (fig. 18.3).

Because development also affects image density to some extent, the underdeveloped negatives in each category will produce relatively dark prints, and the overdeveloped negatives will produce relatively light prints; but image *contrast* differences should be even more apparent. Typically, the underdeveloped negatives will produce relatively "flat," low-contrast prints, while the prints from the overdeveloped negatives are harshly contrasty. You can demonstrate the contrast differences even more effectively by making the best possible print from each negative (on the same paper grade), varying the printing times as necessary to match print densities (fig. 18.4). Study these images until you have learned to recognize their characteristics at a glance and understand what caused them. This is valuable, fundamental information.

Interpreting the Film Characteristic Curves

In the technical literature, these exposure/development relationships are frequently displayed graphically as *characteristic curve* diagrams. The horizontal axis of these graphs is always calibrated in values of exposure, increasing from left to right; and the vertical axis is calibrated in values of image *density*, increasing from bottom to top. The curve itself expresses the relationship between the various exposure values and the values of density that result from them after development. Each curve represents a single developing time.

Figure 18.3

This contact print of the test negatives was exposed to produce a good print of the normal negative in the center. The effects of exposure (especially) and development variations on image density and contrast are clearly demonstrated.

. . . and study the images to recognize their characteristics

Characteristic curves demonstrate the exposure/development relationship

In this print series each of the test negatives has been printed as well as possible on normal (grade 2) paper. The individual exposures were adjusted as necessary to produce a fairly uniform shade of gray on the side of the barn. Although the effects of film exposure variations are still visible especially in the image shadows—this printing procedure dramatizes the differences in image contrast that result from variations in film development.

Proper exposure generally involves both toe and straight-line portion

An extended curve is shown in figure 18.5. In the region labeled *Base plus Fog*, exposure has been insufficient to affect the emulsion, so there is no image density. The minimal density that does exist results entirely from the faint cloudiness of the emulsion gelatin and the tint of the film-base material. As exposure increases (moving to the right along the x-axis) the emulsion eventually responds and an image density begins to appear at point A, sometimes referred to as the *threshold of sensitivity*.

Further exposure increases result in rapidly accelerating image formation and the curve slope or *gradient* (G) increases disproportionately. This upwardcurving region of the curve is called the *toe* portion. As exposure continues to increase, the emulsion begins to respond more uniformly to form the *straightline* portion of the curve. Eventually the exposure increases begin to saturate the emulsion and the curve gradient gradually decreases to form the *shoulder* region. Further increases in exposure may actually decrease the image density as the emulsion is effectively desensitized by the extreme intensity of the exposing light. This is the curve region of *solarization*.

Proper film exposure will distribute the image tones along a section of the curve that includes the upper portion of the toe and some of the straight-line portion. An underexposed image uses too much of the toe region so that shadow detail is obscured; severe overexposure may push the image tones up into the shoulder region so that highlight contrast is diminished.

Now you should be able to relate the curve segments in figure 18.6 to the characteristics of the test negatives in figure 18.2. The length of the curve segments expresses the range of subject tones; that is, the extreme left end

Curve features: gradient; toe; straight-line portion; shoulder

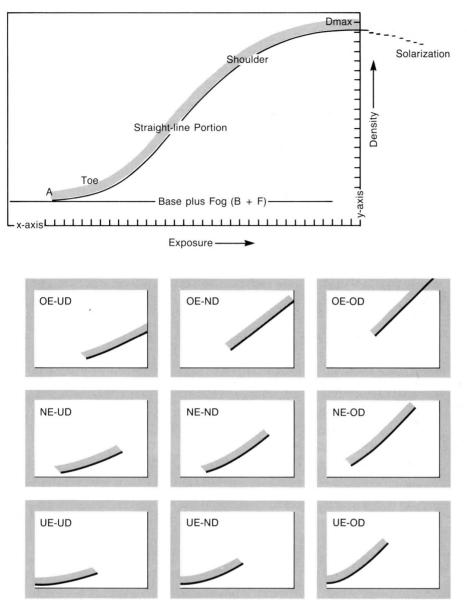

Figure 18.5 A typical film characteristic curve diagram.

Figure 18.6

These curve segments symbolize the characteristics of the test negatives in figure 18.2. Underexposure shifts the curve segments toward the left edge of the graph; overexposure moves them to the right. Low slope indicates underdevelopment; steep slope results from overdevelopment.

of the curve corresponds to the deepest shadow values and the extreme right end represents the brightest highlights, with the middle tones distributed along the curve between the extremes. The horizontal placement of the curve segments in the graph space is related to film exposure; that is, increasing the test exposure shifts all the subject tones from left to right along the film curve.

The vertical placement of a curve (or any point along its length) indicates image density. Ordinary film curves slope upward from left to right, indicating increasing image density as exposure increases. The gradient of the curve is an indication of image contrast; a steep slope indicates an image of high contrast (great density difference between shadow and highlight tones), and a gentle slope indicates low contrast. Curve gradient—and therefore image contrast—increases as film development is increased. Horizontal position in the graph space relates to exposure, vertical position to density

Curve gradient is an indication of image contrast

The sensitometric curves and data in the publication from which these curves were taken (Kodak publication no. F–5) represent current product under normal conditions of exposure and processing. They are averages of a number of production coatings and, therefore, do not apply directly to a particular box or roll of film. They do not represent standards or specifications that must be met by Eastman Kodak Company. Kodak reserves the right to change and improve product characteristics at any time.

(Reprinted courtesy of Eastman Kodak Co.)

A stop equals a ratio of 1:2, or a log value of 0.3

Negative logs indicate fractional values

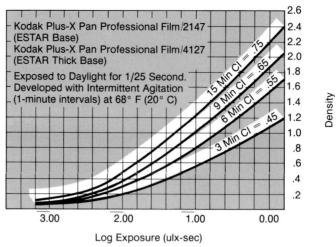

Characteristic Curves for Kodak HC-110 Developer (Dilution B)

Film manufacturers publish characteristic curves of their materials and the information these graphs contain can be very helpful. In this technical literature the calibration values of exposure and density are almost invariably expressed in log numbers; in fact, *density* values are logs (of *opacity*) by definition.

You don't need to know much about logs to interpret this information. If you can remember that an exposure change of one stop (which doubles or halves the exposure) is approximately equivalent to 0.3 in log terms, you can read these graphs. In other words, an exposure ratio of 1:2, an exposure change of one stop, and the log number 0.3 all express the same thing some value of exposure has been doubled or halved.

You can see this relationship demonstrated in the calibrations of most hand-held exposure meters. There are typically three subdivisions of the meter scale within each stop division, and each subdivision is equivalent to 1/3 stop or the log interval 0.1.

In figure 18.7 the x-axis calibration unit is the "meter-candle-second" (mcs)—that is, the total exposure effect that will be produced by a "standard candle" held at a distance of one meter from the film surface for 1 second. You'll often see graphs of this sort calibrated in "lux-seconds" instead of mcs, which means essentially the same thing. This exposure unit is obviously very large for film testing (a 1-second exposure to candlelight will certainly fog ordinary films severely), so the actual values used are fractional. This is indicated by the negative (minus) log values: "3.00 equals 1/1000 mcs; "2.00 equals 1/100 mcs; "1.00 equals 1/10 mcs; and 0.00 equals 1 mcs."

When larger values of exposure are required, as is the case with printing papers, the log numbers are positive, indicating multiples of the exposure unit. For example, the log number 1.00 means 10 units (mcs or whatever) and 2.00 stands for 100 units.

The scale of the graph axes is the same; that is, if 10 units of exposure span a length of 1 inch on the x-axis, 10 units of density will span an inch on the y-axis. This convention is important because it standardizes the relationship between exposure and density values which, in turn, standardizes the slope or gradient of the curves themselves. This consistency helps to make the graphs easy to read.

Curve Gradient

Because curve gradient increases (the curve slope gets steeper) as development proceeds, it's convenient to define gradient numerically so that degrees of development can be calibrated accurately. If you visualize the

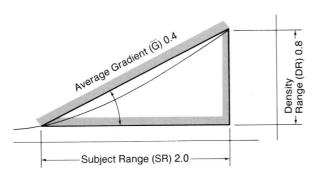

Figure 18.8 Film curve, simplified into a triangle.

horizontal and vertical graph axes as the base and altitude of a right triangle, it's easy to see that the curve can represent the hypotenuse. Curve gradient can therefore be expressed by dividing the density range (altitude of the triangle) by the exposure range (base of the triangle) (fig. 18.8).

Now it's apparent that the gradient value will be less than 1 when the slope is less than 45 degrees and greater than 1 when the slope exceeds 45 degrees. You can also see that varying any one of the sides of the triangle must necessarily affect at least one other dimension. For example, if the exposure range (base dimension) increases and the density range remains unchanged, the curve gradient must decrease. Similarly, if the exposure range remains unchanged but gradient increases, the density range must increase.

Of course typical film (or paper) curves aren't straight lines, so the hypotenuse analogy is not quite accurate. The concept is so valuable, though, that we often ignore the curvature and assume that the portion of the curve that interests us is, in fact, straight. Years ago when film curves really were more nearly straight than they are now, gradient values were calculated exclusively from the straight-line portion of the curve and defined as *gamma* (γ) (fig. 18.9a). Now we generally prefer to include part of the curve toe in the slope calculation, so it's customary to select two significant points on the curve and calculate the slope of a straight line that connects them. When these points are chosen arbitrarily, the calculated values represent the *average gradient* (G) of the selected curve segment (fig. 18.9b). Kodak's *Contrast Index* (CI) values are an elegant form of average gradient, calculated from a specifically defined section of the film curve (fig. 18.9c).

The relationship between SR, G, and DR has real practical significance. Superficially, it can tell you some things you already know; for example, if you increase developing time, image contrast increases. Also, if you photograph both contrasty subjects and flat subjects on the same roll of film (so they get identical development), some negatives will be more contrasty than others.

What may not be quite so obvious is that you can relate developing time to subject range to produce negatives of uniform contrast for any reasonable subject condition. In theory, at least, this makes it possible to photograph any sort of subject in any kind of light condition and print all your negatives on a single grade of paper! In practice, you can actually make this work most of the time if you control the processes carefully.

All useful exposure "systems" (such as the Zone System) are based on this concept. Before you can work with one of these systems, you must have test data that tell you how your film will respond to a variety of development conditions. Then all you have to do is meter the subject carefully to determine its range (and appropriate camera settings), relate the SR value to your chosen negative DR value, and consult your test data to find the appropriate development time. Then, if all your decisions have been good ones, you should be rewarded with a "perfect" negative—that is, one that prints easily and well, and interprets the subject tones as you expected it to. Curve gradient equals density range divided by exposure range

Gamma measures the gradient of the straight-line portion of the curve

Average gradient (G) and Contrast Index (CI) measurements include some of the toe

You can produce negatives of uniform contrast from any subjects

All useful exposure/development systems are based on this concept

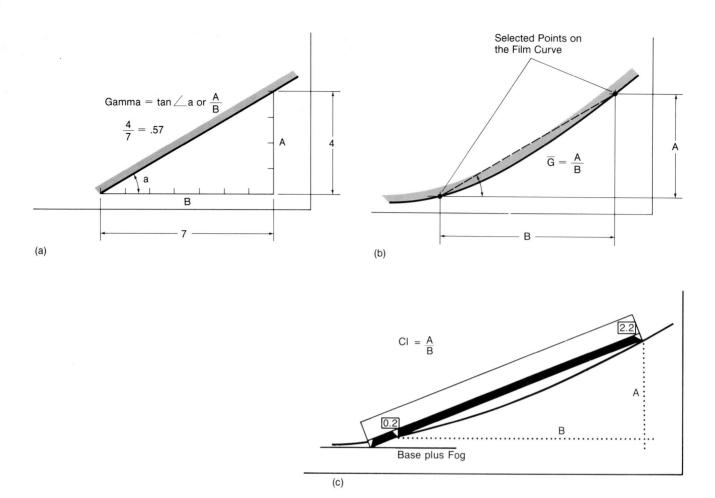

a. Gamma.

b. Average Gradient.

c. Contrast Index—Kodak's Average Gradient method—can be determined by applying this special "ruler" to the film curve. The ruler length is 2.2 log units (in the scale of the graph), with a reference mark at the 0.2 point. When the lower tip of the ruler touches the B + F line and both the 0.2 mark and the 2.2 mark touch the curve, the angle of the ruler represents the average gradient. The calculated value (A/B) is the Contrast Index.

Test your own materials

The paper's ES value is an indication of its inherent contrast

The ISO Range is calculated from the ES value

You can test your own materials and produce curve families for analysis if you have a photographic step tablet and a densitometer. Suitable step tablets are available from Kodak dealers or from most graphic arts supply companies. The procedure is quite simple: print the step tablet on your chosen paper using your normal printing method, then process the paper strip normally. When it's dry, read the step densities and plot them against their respective step tablet steps (fig. 18.10).

The Paper Exposure Scale (ES)

Establish the print image limits (we'll refer to them as IDmin and IDmax), as shown in the figure 18.10, and determine the paper's exposure scale (ES) value. The ES value indicates the range of exposing light intensities that is required to produce the full range of useful image tones and is directly related to the paper's contrast grade number. For example, a large value of ES indicates that the paper needs a great range of exposing light intensities, which is another way of saying that it requires a very contrasty negative to make a satisfactory print. Its grade number would typically be 1 or 0 and we'd call it a "soft" paper.

Some manufacturers are now identifying the contrast of their papers with "ISO Range" numbers in addition to the more familiar grade numbers. The ISO Range numbers are derived by rounding off the ES number to the nearest tenth, then multiplying it by 100. For example, if a paper's ES value is found to be 1.07, it rounds off to 1.1, and when multiplied by 100, it becomes 110. From the chart (fig. 18.11) you can see that the ISO Range numbers are more specific indications of paper contrast than the ordinary grade numbers are.

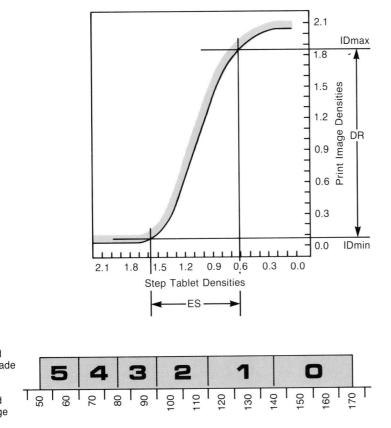

A typical printing paper curve with its analysis lines. The exposure scale (ES) identifies the range of exposing light intensities (or exposure times) required to produce the full density range (DR). Think of the ES as representing the negative and the DR as representing the print image.

Published Paper Grade Number		5	4	•	3	2	2		1		(כ	
Published ISO Range Number	20 1	60	02	80	06	100	110	120	130	140	150	160	170

Figure 18.11

There is no official relationship between the conventional paper grade numbers and the ISO Range numbers, but this shows their practical equivalence

When you've determined your paper's ES, you can proceed to test your film. Make five identical contact prints of the step tablet on your chosen film and develop the films for times ranging from about half the "normal" developing time (for that film/developer combination) to about twice the normal time. When the negatives have been processed, read the individual step densities and plot them against their respective step tablet densities to complete the curve family.

Printing is generally easiest and most successful when the negative DR matches (is approximately the same as) the paper's ES. Because the ES of a graded paper is a relatively inflexible characteristic, we generally accept it as a limit and adjust the negative contrast (DR) to match it (by varying the film development time). In other words, the printing paper's ES effectively determines how you should expose and develop your film.

Locating the Film's Speed Point

"Proper" film exposure will place the darkest useful image tone (IDmin) high enough on the toe of the curve to provide good shadow separation and detail, but not so high that the negative density is increased unnecessarily. Because the location of the IDmin point has such a direct influence on the proper rendering of the critical shadow areas, and because shifting it to the left or right affects film exposure, it is a convenient reference point for determining effective film speed. For this reason we sometimes refer to each curve's IDmin point on the exposure axis as the speed point for that curve.

Several procedures have been proposed for establishing the speed point location but they are included in two general methods. The simplest procedure places the IDmin point on each curve at some fixed density level over the B+F density level of that curve. Other methods, including Kodak's popular Contrast Index (CI) procedure (fig. 18.9c), relate the IDmin density to curve

The negative's DR should approximately match the paper's ES

The film curve's IDmin is sometimes called its speed point

The IDmin and IDmax points, as you establish them, define the working limits of the film curve.

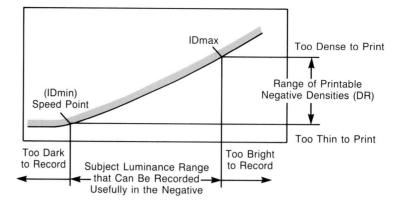

gradient in some way. The fixed density method is easy to use but produces negatives of somewhat inconsistent quality. The gradient-related procedures provide for maximum useful film speed and consistent negative quality but they're a little awkward to implement. Despite that minor difficulty, we'll use the Contrast Index method to locate the speed points for the curve analysis demonstrations that follow.

Referring to figure 18.12 you can see that when the lower limit of the negative density range is positioned on a curve at speed point level the upper limit of the negative range, projected horizontally to the curve, defines the useful upper limit of the curve. In other words, any curve density value that falls above or below the density range limits will not be included usefully in the negative image. Similarly, only those subject tones (luminance values) that lie between the IDmin and IDmax limits on the exposure axis will be included in the image. Subject luminance values that fall to the left of the IDmin point will be lost in black in the print; values that fall to the right of the IDmax point will be rendered in the final print image as pure white.

Charting the Working Data

When these maximum and minimum negative density limits (IDmax and IDmin) have been established separately for each curve in the family it's quite easy to extract working information from the curve family and compile it into more useful form, as illustrated in figure 18.13. Here a family of film curves, plotted from controlled tests of T-Max 400 sheet film and tray-developed in D-76, diluted 1+1, is shown with the desired IDmin and IDmax limits of each curve established, and the subject ranges labeled in stops.

Notice that because the speed point density values increase as curve gradient increases, the line connecting the IDmin points slants downward from left to right. Also, because the IDmax point on each curve is located by adding the DR to its corresponding IDmin value, the IDmax line also slants, but somewhat less obviously. Now it's possible to construct a working chart that relates subject range (SBR) in stops to development time in minutes (fig. 18.14).

Because development times are directly related to curve slope, it's similarly possible to produce a chart that plots average gradient values against development times. First, you have to determine the \overline{G} values by dividing the DR value (which is common to all the curves in the family) by the respective subject ranges. Of course you must convert the subject ranges (stops) to logs or the DR values to stops before the calculation, but if you can remember that each stop is equivalent to 0.3 in log terms, the conversion is simple enough. It's probably easiest to convert stops to logs, so multiply each SBR by 0.3. Then proceed with the division to find the \overline{G} values. For example:

Curve #3 7.2 stops \times 0.3 = 2.16

 $\overline{G} = 0.9/2.16 \text{ or } 0.42$

The Contrast Index procedure can locate a useful speed point

IDmin and IDmax define the useful limits of the film curve

Relate developing time to subject range

. . . or average gradient

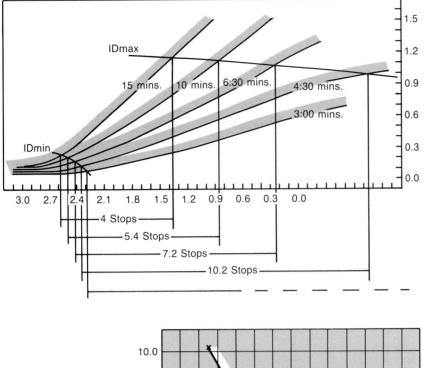

A typical family of film curves and the construction lines that we can use to analyze the film's working characteristics. The vertical distance between the IDmin and IDmax points represents the desired negative density range; the horizontal distance between each pair of IDmin and IDmax points indicates the range of subject luminance values that can be included in that negative.

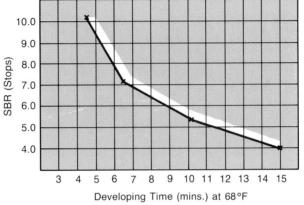

Figure 18.14

Here is a chart that displays useful working information that was derived from analysis of the film curves. Although the points should be connected with a smoothly curving line for best accuracy, a chart of this kind can help you estimate the appropriate development time for any reasonable subject range.

The various manufacturers publish many charts (for their own materials) that plot \overline{G} (or CI) against development. Although these \overline{G} /Development data are not quite as convenient to use as the SBR/Development charts are, they do have one major advantage: because they're based on curve *slope* their information is not limited to any particular SBR or any specific value of ES or DR. In other words, the development data are useful for any subject, any paper grade, and any printing method.

For example, if you have found that your printing procedure produces an ES value of 0.9 on your favorite paper and if you determine that your subject's luminance range is 8 1/3 stops, or 2.5 in log terms, you can find the appropriate value of \overline{G} (or Cl) by dividing 0.9 by 2.5 to arrive at 0.36. Find a \overline{G} / Development chart that's suitable for your film and developer combination, locate the development time for a \overline{G} of 0.36, and process your film accordingly (fig. 18.15).

Because exposure and development are somewhat interactive, it's also advisable to relate exposure to subject range. It's convenient to do this by substituting an "effective film speed" (often called an *exposure index*) for the official ISO film speed that's normally set into the meter.

In general you'll find that effective film speed varies directly with development; that is, increasing development results in an effective increase in film speed, and vice versa. The actual amount of speed variation, and its relationship to both subject range and developing time, can be found from further You can also relate exposure to subject range

Figure 18.16

If you know what contrast index (CI) or average gradient (G) value you need, you can find the appropriate development time from a chart of this sort. Here a desired G value of 0.36 is found to require a development time of about 5 minutes and 40 seconds.

Because the IDmin point generally moves laterally as film development is varied, it can be used as a reference point for determining

effective film speed for any development

condition. In this example you can see that

the nominal film speed rating of 400 is not

precisely appropriate for any of the tested development times. Although ignoring this

speed variation is not likely to be disastrous, it's best to compensate for it if possible.

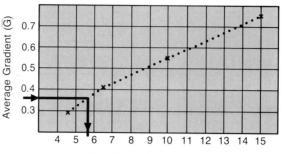

Developing Time (mins.) at 68°F

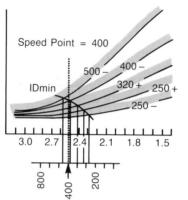

The film exposure index should be changed when the subject range changes. Although not all films require identical exposure adjustment, differences are relatively minor for popular films used under typical conditions. You can calibrate this chart to find exposure index values for use with the film of your choice, for subjects of any luminance range. Simply label the vertical index line with the rated film speed as given by the manufacturer, then calibrate the rest of the scale with successive numbers from the standard film speed series. Speed numbers increase from left to right along the chart's horizontal axis.

There are two types of light meters

analysis of the film characteristic curve family (fig. 18.16). Figure 18.17 presents this information in usable form. When you've calibrated it as suggested in the caption, I think you'll find it quite satisfactory when using ordinary metering procedures with most popular general-purpose films and developers.

Light Meter Types and Characteristics

There are two general types of light meters: (1) those that measure *illuminance*—that is, the light that exists at the subject position, irrespective of the subject, and (2) those that measure *luminance*—that is, light that has been reflected from, emitted by, or transmitted through the subject surfaces. Simply stated, "illuminance" refers to light that's available but hasn't yet reached the subject; "luminance" is light that is directed toward the camera after encountering the subject.

(a)

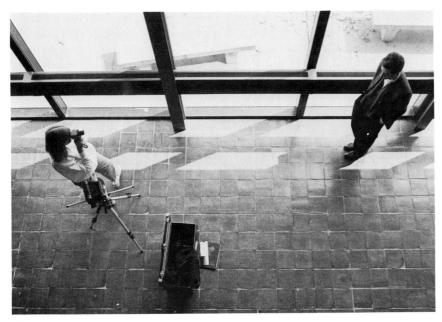

(b)

Illuminance is commonly referred to as *incident light*, meaning that it's "falling onto" or "impinging on" the subject surfaces. Photographers almost always refer to luminance as *reflected light*. *Incident meters* are obviously used to measure illuminance or incident lights; *luminance meters* are usually called "reflected light meters" or sometimes *reflectance* meters—although reflectance is more properly a property of surface than of light.

Both types of meters can provide reliable exposure information if they're used properly, but there is an important difference in the way they are used: incident meters are intended to be pointed *at the camera* from the subject position (fig. 18.18a); luminance meters are normally pointed *at the subject* from the camera position—ideally along the camera's line of sight (fig. 18.18b). Remember this distinction.

Figure 18.18

a. An incident meter should generally be pointed toward the camera from the subject position.

b. A reflectance meter should generally be pointed toward the subject, along the camera's line of sight.

Both are useful, but they are used differently

Luminance meters integrate subject light and provide an average reading

. . . which may be misleading

Spotmeters are best for area-by-area analysis

Wide-Field Averaging Luminance Meters

A typical hand-held luminance meter has an "acceptance angle" of about 30 degrees, which means that from a distance of 20 feet, for example, the meter will read a circular area of the subject about 10 feet in diameter. Furthermore, it will integrate all the variations of light intensity within its field and give you a single *average* reading.

Whether this average reading is correct, or even useful, depends not only on the values of luminance represented, but also on their proportionate areas; that is, the meter will be influenced much more strongly by large areas of tone than by small ones. If the meter's field includes mostly dark objects with only a few small areas of light tone, it will indicate a low value of average luminance. If the field covers mostly light areas with only a few dark accents, the meter reading will be relatively high.

Although this sounds sensible enough, it can create problems for you because that's not the way the *camera* sees things. The camera doesn't average the subject luminance values because it forms a *focused* image, reproducing the subject areas individually, more or less tone for tone.

The film needs enough exposure to record details in the dark shadow areas regardless of their size; that is, the exposure should be essentially the same whether the shadows cover most of the subject area or only a few square inches of it. As far as the camera is concerned, only the individual values of luminance are significant; neither their relative areas nor their overall average is of any practical importance.

To illustrate, suppose you want to photograph some blackbirds feeding in the snow. The film requires an exposure sufficient to render detail and tone in the dark feathers. Once you've arrived at that exposure, you can photograph one bird or a thousand without changing it, despite the fact that an average luminance reading of a single bird in a field of snow will be considerably higher than a reading of the assembled flock.

Spotmeters

When you need to measure the luminance of a very small area of a relatively distant subject, you'll find a spotmeter a useful tool. A typical spotmeter can read a 1 degree field—equivalent to a circular area about 4 inches in diameter at a distance of 20 feet—and the field is accurately defined in the meter view-finder (fig. 18.19). A spotmeter integrates all the luminance values that are included within its field, just as a wide-field meter does, but its limited coverage makes it unsuitable for average readings. We generally try to confine spot readings to subject areas of flat, unbroken tone and use several of them in an area-by-area analysis of the *subject luminance range*.

Luminance and brightness are often used interchangeably, but they have different meanings. Luminance is objective and measurable; brightness is subjective and is our perception of luminance. Despite this distinction, the abbreviation SBR is sometimes used (instead of the obvious SLR) to stand for subject luminance range, because SLR is universally understood to mean single-lens reflex. So remember, when you encounter SBR, that it really means subject *luminance* range.

You might think it would be a simple matter to measure the entire subject luminance range directly with a spotmeter, by taking readings of the subject highlight and shadow areas to find the difference in stops. That's a fine idea, but it doesn't work very well in practice because the extremes of subject tone are usually too small or too inaccessible to be read accurately. Even the relatively small field of the spotmeter is much too large to probe the creases and crevices that provide the "accent blacks," or the tiny, glittering reflections that enliven the highlights of the typical subject. In addition, no spotmeter is optically perfect, so there is always some danger that flare light will inflate the dark tone readings. Some meters are worse than others in this respect, but no spotmeter is entirely trustworthy when measuring "backlit" subjects or when reading small, dark subject areas that contrast strongly with their immediate backgrounds.

Since luminance meters of both types are so easily misled by abnormal distribution of the subject tones, it's sometimes desirable to ignore the subject entirely and take the necessary reading from a standard *gray card* placed in the subject space. These cards, available from your camera dealer, are designed to reflect about 18 percent of the incident light and are popularly believed to represent the average reflectance of an ideal subject. This is a misconception. The average reflectance of a normal subject is actually closer to 9 percent. Despite that fact, the gray card is a valuable standard that can yield useful information if it is used intelligently. (A gray card can be found inside the back cover of this book.)

Because the gray card provides a neutral surface of unvarying tone, meter readings taken from it are influenced only by changes in illumination. Gray card readings, in other words, are really "incident readings," even though they're made with a luminance meter.

Figure 18.19

The large light circle indicates the area (field) that a typical reflectance meter reads when pointed at the subject from a distance of 20 feet. The area inside the smaller white circle defines the approximate field of a typical spotmeter.

No spotmeter is entirely trustworthy

You can ignore the subject entirely with a gray card reading . . .

(a) Figure 18.20

a. Slide the translucent dome over the meter cell to prepare for incident light measurement.

b. Slide the cell cover aside to expose the cell for reflectance readings.

. . . but incident meter readings are more reliable

Most photographers approve of incident readings for color

. . . but consider them less suitable for black-and-white

(b)

Gray card measurement is a workable procedure for determining exposure, but it isn't entirely satisfactory. The card is small, which means that an ordinary meter must be held close to it to get an accurate reading, and it's sometimes difficult to avoid casting the meter's shadow on the card surface. In addition, the card is flat so it doesn't really simulate the three-dimensional surface of the typical subject; and it must be positioned with care to avoid highlight or shadow emphasis. Finally, the card must be handled carefully; if it gets bent or soiled in use, it may not give reliable readings. These problems were solved when someone invented the incident meter.

Incident Meters

An incident meter is really just a luminance meter with a built-in "gray card," in the form of a translucent plastic dome, that covers the meter cell (fig. 18.20). The plastic dome transmits about 18 percent of the incident light to the meter cell, and because of its hemispherical shape, it accepts light from the same directions and in the same relative intensities as the subject does. When the meter is held in the subject light condition and pointed at the camera, its reading(s) can be used to calculate proper camera settings. Remember that the incident meter is *pointed at the camera* from the subject position; this is because the meter dome must be exposed to the same light direction and intensity that affects the subject.

Most photographers will probably agree that an incident metering is appropriate for color work. That's because simple incident metering tends to maintain uniform highlight exposure, which is critically important for transparency films. If the highlights are properly formed, the shadows will usually take care of themselves in a color transparency.

These same photographers will most likely not recommend using an incident meter for "serious" large-format work in black and white because it's well known that negative films (both black-and-white and color) must have adequate *shadow* exposure. When that's provided, the highlight density of color negatives is usually tolerable, and controlled film development will take care of the highlight density in black-and-white.

Large-format photographers have generally overlooked the incident meter's potential utility for black-and-white work. They've apparently assumed that because it ignores the subject entirely and measures only the general illuminance, an incident meter can't possibly provide any useful information about the subject's luminance range. The spotmeter has become their favorite tool because of its unique ability to measure the individual subject areas, tone by tone. That's generally considered to be a much more logical approach to range determination than measuring the incident illumination.

In fact, no meter or metering system can measure the subject luminance range *directly* and infallibly. Although luminance and incident meters must be used in very different ways to find exposure and range information, both are capable of providing consistently valid working data. Contrary to popular opinion, the incident meter *can* be used in a way that permits a great deal of creative control of image quality. It's also relatively foolproof, because when used this way, incident metering errors usually result in overexposure rather than underexposure, so unprintable negatives are rare.

An Incident Metering System

The Incident System procedure makes two assumptions that may sound arbitrary, but are usually valid: (1) the luminance range of a "normal" subject is seven stops—that is, the highlights are about 128 times brighter than the shadows (see Chapter 17); and (2) five of those seven stops are due to the subject's *reflectance* range—that is, they result from local variations of subject color or value. The remaining two stops are due to local variations in illumination. This concept, you see, depends on separating the subject *luminance* into its component parts—*reflectance* and *illuminance*—and treating them individually.

Presumably, then, a normal subject (having a five-stop reflectance range) in a totally uniform light condition, without either surface glare or areas of shade or shadow, will have a maximum luminance range not exceeding five stops (fig. 18.21a). If a portion of that "five-stop subject" is then shaded, and a portion left in full light, its *total* range is now the basic five stops, *plus* the illumination contrast—whatever that is (fig. 18.21b). Because the incident meter is ideally suited for measuring values of illumination, it's easy to find the new SR value: take one reading in the unshaded area and one in the shaded area and find the difference between them in stops. Add this number to the basic five stops to arrive at a good approximation of the total subject luminance range.

For example, suppose you measure the shaded area of the subject with your Luna-Pro (in incident mode) and get a reading of 10. Then, measuring the unshaded area gives you 14. The illuminance range is four stops. Add that to the basic 5 that represents the subject's own reflectance range and you get 9—the total subject luminance range.

You'll probably get reasonably good results when using this method if you consult the "effective film speed" chart (fig. 18.22a) and use the value it suggests for a nine-stop range. But that EFS value—while appropriate for most metering methods—is not ideal for use with the Incident System. Because of the way incident meters are calibrated, basing exposure on *shadow* luminance—as the system dictates—will overexpose the film by *one full stop*. To adjust the EFS chart for Incident System use, simply *double* the film speed values. For example, if you're calibrating the T-Max 400 chart for use with the Incident System, assign 800 to the normal ISO position on the chart and adjust the other values accordingly (fig. 18.22b). That's a misconception; incident metering is appropriate

The Incident System treats illuminance and reflectance separately

Measure the illuminance range and add it to 5

Recalibrate the EFS chart for this system

a. In uniform, shadowless illumination, subject range is typically no greater than about 5 stops.

b. When part of the subject is in shade, the total subject range is approximately equal to the illumination difference plus the typical value range of 5 stops. In this illustration the shadow reduces illumination by 2 stops. The total subject range, therefore, is 2 + 5, or 7 stops.

(a)

Figure 18.22

a. This chart is appropriate for use with any T-Max 400 film and ordinary metering procedures.

b. Use this chart with its doubled film speeds for Incident System metering only.

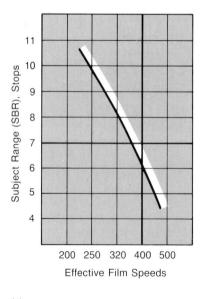

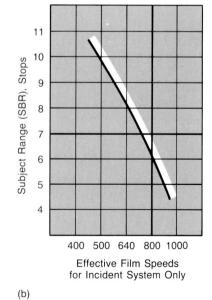

(a)

Chapter 18

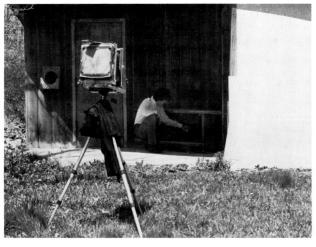

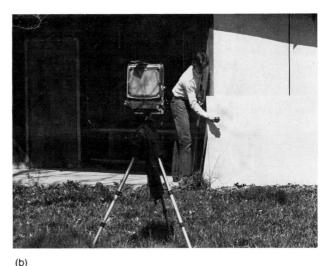

(a)

Using the chart information adds only one short step to the usual metering process. Here is the procedure you should follow in the field:

- 1. Take an incident reading in the deepest shadow area of the subject in which you would like a black object to be faintly toned—that is, distinguishable from absolute black—whether there is actually a black object in that shadow area or not (fig. 18.23a).
- 2. Similarly, take a reading in the most brightly illuminated area of the subject in which you'd like a white object to appear delicately textured—that is, visually separated from pure white—whether there is actually a white object in that area or not (fig. 18.23b).
- Subtract the shadow reading from the highlight reading; convert the difference to stops, if necessary, and add it to 5. This is the Subject Luminance Range.
- 4. Consult figure 18.22b to find the appropriate value for this subject range, and set that value into your meter dial in place of the normal ISO rating of the film. This adjustment provides the exposure compensation reguired by the development time.
- 5. Set the meter dial to the shadow reading (step 1), thus "exposing for the shadows." Then select an appropriate lens opening and shutter speed pair from the meter dial, and make the exposure. Mark the film holder with the Subject Luminance Range number, in stops.
- 6. Back in the darkroom, consult an appropriate SR/Developing Time chart and develop the film for the indicated time, following the specified processing conditions.

The Zone System

The Zone System is the best-known and most widely practiced exposure/ development control system in existence. Originated by Ansel Adams and Fred Archer many years ago, it has been extensively publicized and is generally considered to be a technical milestone in the history of photography.

The details of the usually recommended testing and calibration procedures that are required to adapt the system for individual use are too well known and too extensive to warrant repeating. Ansel Adams' book *The Negative*, and *The New Zone System Manual* by White, Zakia and Lorenz cover these procedures thoroughly and are the usually recommended references (see the bibliography).

Figure 18.23

a. The Incident System requires two meter readings: one in the deepest shadow area where detail must be held, and one in the area of brightest illumination. Determine the exposure from the shadow reading.
b. Take a reading in the area of brightest illumination and compare it with the shadow reading to find the illuminance range. Add that to 5 to find the total subject range, which determines film developing time.

The Zone System is the best-known system in existence

Zones identify specific print grays

The Zone System's guiding principle is *previsualization*—that is, the process of analyzing the subject's appearance before the exposure is made, and comparing it with a mental picture of the finished print image to decide how the camera should be handled and how the image tonality should be adjusted for best graphic and expressive effect. Exposure and film development time are determined from interpretation of the shadow and highlight readings of subject luminance. Film processing is more or less routine.

The Concept of Zones

The System gets its name from the fact that certain tones of gray in the print have been identified as "zones" and numbered for easy identification. Zone V (roman numerals are always used) is identified as middle gray. Higher numbers refer to lighter gray tones; lower numbers signify darker grays. The range of zone numbers varies somewhat, depending on whose version of the system you're dealing with. Minor White's interpretation of the system is probably the most widely accepted one. It defines the zones as follows:

Zone I	Maximum photographic paper black
Zone II	Last distinguishable dark tone
Zone III	Very dark gray
Zone IV	Dark gray
Zone V	Middle gray
Zone VI	Light gray
Zone VII	Very light gray
Zone VIII	Last distinguishable light tone
Zone IX	Maximum photographic paper white

Presumably, if nine films are given a series of individual exposures, ranging—in one-stop increments—from four stops underexposure (equivalent to Zone I) through normal exposure (Zone V) to four stops overexposure (Zone IX), then developed normally and printed, the resulting print values should approximate the descriptions above. Although these print tones *represent* the subject zones, they can't *duplicate* the nine-stop range; print densities (measured by reflection) can rarely reach a range of 2.1 (equivalent to seven stops) even under ideal conditions.

In an attempt to make his Zone System as comprehensible and accessible as possible, Adams purposely avoided direct involvement with curve analysis and chose, instead, to determine materials' characteristics by subjective test procedures. This has made it possible for competent photographers to test their own materials and formulate their personal working procedures without having to struggle with the characteristic curves. This approach has been a mixed blessing; it has undoubtedly stimulated interest in technical control of the medium for expressive purpose and has contributed greatly to photographers' understanding of their craft. On the other hand, the system has a reputation for theoretical accuracy that it (at least as ordinarily implemented) doesn't entirely deserve. Most photographers aren't concerned about this; the Zone System works well enough for any individual who takes the trouble to personalize it.

Application of the Zone System principles, as they are usually explained, must follow extensive testing to determine (1) the minimum film exposure required to produce the first useful printing density (used to determine the working film speed), (2) the normal developing time, and (3) variations in developing time that will effectively *expand* and *contract* the density range of the negative to compensate for unusual subject luminance ranges. Expansion refers to increasing image contrast by greater-than-normal development; contraction refers to decreasing image contrast by less-than-normal development.

The system requires extensive subjective testing

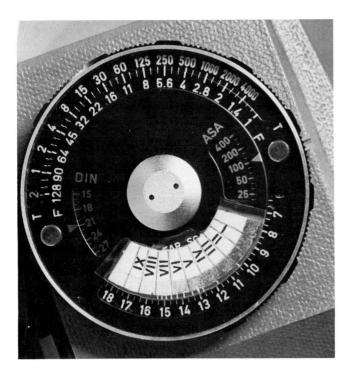

When luminance value 10 is placed in Zone II and luminance value 15 falls in Zone VII (one stop above your chosen Zone, VI), the N-number is N - 1.

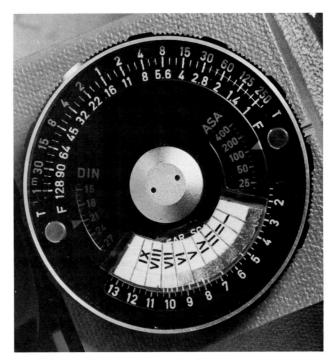

Figure 18.25 When 6 is placed in Zone III and 9 falls in Zone VI instead of your target Zone, VIII, the N-number is N + 2.

This testing procedure results, ultimately, in establishing a "working film speed" that is generally considered appropriate for all situations, regardless of the subject luminance range. In addition, a normal developing time is found and identified as N. A final field test is recommended to verify these experimental findings.

The fact that subjects may vary in contrast (luminance range) is recognized and the system uses a distinctive and ingenious approach to range measurement. It's based on the assumption that a normal subject (for which N development is appropriate) has a total luminance range of nine stops, as identified by the nine zones. This includes both extremes of tone (pure black and white), which serve as image accents, so the ''working'' range is actually seven stops. This seven-stop definition of ''normal''—excluding the accent extremes—is generally accepted as a standard in the technical literature.

The system also assumes that any subject tone can be *placed* in any zone by proper exposure; for example, if some subject area appears to be a very dark gray (Zone III) and you'd like it to be reproduced in the print as a middle gray (Zone V), you can accomplish this change by simply overexposing the subject by two stops. Similarly, you can place a light gray (Zone VI) subject area in Zone V, for example, by a one-stop underexposure.

You can calculate zone placement easily if you have equipped your meter dial with a "zone scale," as shown in figures 18.24 and 18.25. This makes it easy to see the "one zone = one stop" relationship that is fundamental to the system in its traditional form. In practice, zone placement is semiautomatic: choose the zone in which you'd like to place some subject area, read its luminance value—preferably with a spotmeter, then adjust the meter dial to align that luminance value with the selected zone number on the zone scale.

For example, if your selected subject area has a luminance value of 10, and you'd like it to be reproduced in the final print as the last distinguishable dark tone before absolute black (Zone II), be sure your working film speed is

. . . to establish the working procedures

The system uses a unique approach to range measurement

Subject tones are placed by controlling exposure

A zone scale on your meter dial will help

Development is determined from calculation of subject range

. . . which is expressed as an N-number

Zones and stops are equal only when the subject range is normal

Long-term users have learned to make adjustments

If you vary the metering zones, the N-number may vary set in the meter's ASA/ISO window, then turn the meter dial as necessary to align 10 with II (fig. 18.24). This adjusts the meter for proper exposure, as it has been defined by your previous tests.

Development is determined from calculation of the subject range, as it must be in any system, but the Zone System procedure is unique. Continuing the example above, suppose you've chosen an area that you'd like to see as a light gray (Zone VI) in the print, and its luminance value is found to be 15. Without moving the meter dial from its previous setting (10 in Zone II), check to see where 15 *falls* on the zone scale. In this case it's opposite Zone VII— one zone too high. To keep your dark tone in Zone II and get this light tone to fall properly into Zone VI, the measured luminance range must be "compressed" by one stop. By Zone System definition, that means that the proper development is "normal, minus one stop," or N-1.

As another example, suppose you've placed luminance value 6 in Zone III and you'd like luminance value 9 to show in the print as Zone VIII. Unfortunately, with 6 in Zone III, 9 falls in Zone VI. To move it from VI to VIII, you'll have to expand the range by two stops (fig. 18.25). According to Zone System practice, that will require development of N+2. In this case, if you were content to have luminance value 9 appear in the print as a light gray (Zone VI), there'd be no need for either expansion or contraction development because 9 has fallen naturally into the chosen zone; simply give the film the normal N development.

There are two problems with this conventional version of the Zone System. In the first place, it fails to adjust exposure for changes in subject luminance range, and under extreme circumstances, this can result in significant—though usually tolerable—exposure error. In the second place, the entire concept of zone placement is based on the premise that zones and stops are equal an assumption that's valid only for normal seven-stop subjects.

Although this misconception will not lead to significant error for subjects of near-normal range, the system data can be misleading for subjects of extreme range. Whether aware of the potential problem or not, most long-time Zone System users have learned to make intuitive adjustments to correct it. Fortunately, the photographic process has sufficient latitude to forgive moderate errors, so these problems have gone more or less unnoticed.

Weighing the obvious benefits of the Zone System's enormous popularity against the relatively minor practical effect of its theoretical flaws, it's apparent that Adams made a wise decision in advocating empirical test procedures. If he had based the Zone System on sensitometric analysis of materials and processes, it would probably be unknown today. A slightly imperfect but workable system that has brought pleasure and satisfaction to thousands of photographers is clearly preferable to a more rigorously accurate one of limited appeal.

Zone System Calibration

We have already prepared working charts that plot values of effective film speed and developing time against both CI and SBRs. For Zone System use we'll have to translate those charts to plot EFS and developing time against N-numbers.

First, though, we'll have to specify the metering zones. That's because metering for Zones II and VIII, for example, will give you a different N-number than you'll get by metering for Zones III and VII—even though the subject range is the same. The critical variable here is the difference, or "spread," between the measured zones. There are six zones (and normally six stops) between II and VIII, but only four zones (and normally four stops) between III and VII.

Since the total range of a normal subject is seven stops (not including the accent extremes) you're measuring 6/7 of the total range when you meter on Zones II and VIII, but only 4/7 of the range when you meter on III and VII. That difference is immaterial as long as the subject is normal (and zones and stops are equal), but it becomes significant when the subject range is greater or less than normal (and zones and stops are *not* equal).

For example, suppose you are confronted by a subject of ten stops range. If you elect to meter on Zones II and VIII and place luminance value 5 in Zone II, luminance value 13²/₃ should fall in Zone VIII—but it actually falls a little beyond Zone XI for an N-number of about N-3.2. By comparison, if you meter for Zones II and VI, leaving luminance value 5 in Zone II, luminance value 10²/₃ should fall in Zone VI. Actually, it falls just above the borderline between Zones VII and VIII for an effective N-number of about N-1.7.

Although both N-3.2 and N-1.7 describe the same subject range in this example—and therefore require the same exposure and development—they obviously can't use the same chart data. You can plot separate chart lines for several spreads, of course, but you'll avoid confusion and possible errors if you standardize on a single zone "spread" when you compile your working data, and while you're actually metering your subjects.

For this reason, I suggest standardizing on Zones III and VII because their "four-zone spread" is great enough to provide a good indication of total subject range, without being too extreme to meter easily. Of course, this chart information will also permit you to meter on other four-zone spreads, such as II and VI, or IV and VIII, if you want to.

Translating CI to N-Numbers

To translate CI (or \overline{G}) values into N-numbers, you'll first have to find the subject ranges. You need to specify a value of negative DR, of course, and we'll continue to use 0.9 as normal. The equation is:

SR = DR/CI

so, for example, if the CI value is 0.36 and the DR is 0.9:

 $SR = 0.9/0.36 = 2.5 \text{ or } 8\frac{1}{3} \text{ stops.}$

When you have found the range in stops, use the desired zone spread (we'll use 4) to find the N-numbers, like this:

- 1. Divide 8.33 (the SR in stops) by 7 (the normal zone range) to find 1.19 (the "length" of each subject zone in stops).
- 2. Multiply 1.19 by 4 (the desired spread) to find the spread in stops, 4.8.
- 3. Subtract 4.8 (the stops spread) from 4 (the zone spread) to find the N-number, N-0.8.

When you've converted the chart values of SBR to N-numbers using this procedure, it's easy to draw charts that display the relationships of EFS and developing time to N-numbers. As an example, figure 18.26 includes charts based on the use of T-Max 400 sheet film, tray-developed in D-76, diluted 1+1, at 68° F, for a negative DR value of 0.9. Notice that although the effective film speeds were doubled for use with the Incident System, they are *not* doubled for the Zone System; the normal value is the actual ISO speed of the film. I suggest that you keep a copy of the EFS chart in your camera case so that it will always be available when you need it. Keep the developing time chart in your darkroom.

To avoid confusion, standardize on a single zone spread

You can calculate N-numbers from CI or \overline{G} values

DON'T double the film speeds for Zone System use

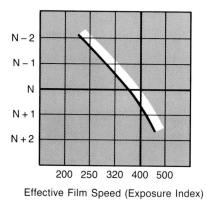

а

Figure 18.26

a. The EFS chart for T-Max 400 converted for use with Zone System N-numbers.
b. Zone System developing chart for T-Max 400 sheet film, tray-developed in D-76 diluted 1 + 1 at 68° F.

Follow this working procedure

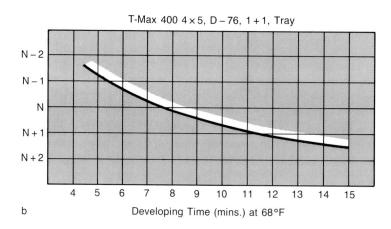

Now here's a brief summary of this modified Zone System procedure:

- 1. Read your selected subject areas (Zones III and VII) to find the low and high luminance values and compare their difference in stops with the standard four-stop spread to find the N-number.
- 2. Consult the N/Film Speed chart to find the appropriate exposure index number; set it into the meter.
- 3. Place the low luminance value in Zone III; select camera settings from the meter dial, and make the exposure. Mark the holder with the N-number.
- 4. Back in the darkroom, consult the N/Developing Time chart and develop for the indicated time.

Summary

Although film exposure and development are interactive, exposure primarily affects image density, and development primarily affects image contrast. You can demonstrate these effects by making a nine-negative test series.

The film's response to variations in exposure and development is expressed concisely in the technical literature in the form of characteristic curves. In these graphs values of exposure are displayed along the x-axis; values of density are displayed along the y-axis; and each curve represents a specific time or condition of development. Curve graphs are usually calibrated in logE and Density values. The scale of the graph axes is identical.

The position and angle of a curve segment in the graph space is significant. The angle is called its slope or gradient. Slope is often expressed as gamma, average gradient, or Contrast Index. These values indicate the relationship between subject range and negative density range, and when plotted against film developing time, they provide us with practical working information.

You can prepare your own working charts by trial-and-error testing, but curve analysis is easier and more accurate.

There are two general types of light meters: luminance meters are pointed at the subject and measure reflected light; incident meters are pointed at the camera and measure illuminance. Wide-field luminance meters typically cover a field of about 30 degrees; spotmeters typically cover a field of about 1 degree. Exposure must be sufficient to record shadow details regardless of their relative area. Luminance meters are easily fooled by abnormal subject conditions. Gray card readings measure incident light and are sometimes helpful, but not infallible.

An incident meter is simply a luminance meter with a built-in gray card. Incident metering is acknowledged as useful for color photography, but many photographers mistakenly consider it unsuitable for serious black-and-white work.

The Incident System assumes a normal SR of seven stops, of which a maximum of five stops can result from subject reflectance, and two stops from illuminance variations. SR values can be found from the difference between highlight and shadow readings, added to 5. Exposure is based on the shadow reading. Accuracy is improved if the film's exposure index is adjusted to compensate for development changes.

The Zone System relies on luminance readings and defines certain print values as Zones that are considered to represent a nine-stop SR. A subject value can be "placed" in a chosen zone by manipulating exposure.

You can find Zone System data by empirical testing, by curve analysis, or by extracting information from manufacturers' specification sheets. Spec sheet analysis can provide only approximate data, but you can fine-tune the system by field testing. Some calculation is necessary.

Appendixes

- 1. Some Available Film Types and Their Characteristics
- 2. Some Available Paper Types and Their Characteristics
- 3. Chemical Formulas
- 4. Close-up Exposure Correction
- 5. Filtration for Color Photography
- 6. Filtration for Black-and-White Photography
- 7. Compensation for Reciprocity Effects
- 8. Equivalent Lens Focal Lengths for Various Camera Sizes and Lens Angular Coverage Chart
- 9. Film Development Charts

1 Some Available Film Types and Their Characteristics

Some Available Film Types: Black and White

Film Name	ISO/ASA Speed	Available Sizes	Characteristics, Uses
Agfa-Gevaert, Inc.			
Agfapan Professional	25	135/36, 120, 4×5/25	Slow, extra-fine grain, high definition; for fine detail
Agfapan Professional	100	135/36, 120, 4×5/25	Medium speed, fine grain, high definition; universal use
Agfapan Professional	400	135/36, 120, 4×5/25	Fast; available light photography, sports
Eastman Kodak Company			
Verichrome Pan	125	rolls (no 135), Cirkut	Medium speed, very fine grain, excellent gradation; universa
Panatomic-X	32	135/20/36, bulk 35	Slow, extremely fine grain, excellent definition; fine detail
Panatomic-X Professional	32	120	Same as above
Plus-X	125	135/20/36, bulk 35	Medium speed, extremely fine grain, excellent sharpness; especially recommended for daylight use
Plus-X Pan Professional	125	120, 220, 4×5 filmpacks	Same as above
Plus-X Pan Prof. 2147	125	35, 46, and 70mm bulk	Very sharp, fine grain, enhanced highlight contrast; studio
Plus-X Pan Prof. 4147	125	Sheets and 31/2" bulk	Same as type 2147 except on Estar thick base
Tri-X Pan Tri X Pan Drafaasianal	400	135/20/36; bulk 35; rolls	Fast, wide latitude, excellent gradation; all purpose film
Tri-X Pan Professional	320	120, 220, filmpacks	Fast, brilliant highlight gradation; studio and general use
Tri-X Pan Prof. 4164	320	Sheets, 31/2" bulk	Similar to Tri-X Pan Professional except on Estar thick base
Tri-X Ortho, 4163	320	Sheets only	Fast orthochromatic, medium grain and sharpness; general use where red sensitivity is not important
Recording Film 2475	1000-4000	135/36, bulk 35	Extremely fast, coarse grain, extended red sensitivity; special
High Speed Infrared	none	135/36, bulk 35, sheets	Infrared sensitivity, coarse grain; scientific and special
Royal Pan, 4141	400	Sheets, 31/2" bulk	Fast, fine grain, highlight separation; studio and commercial
Ektapan, 4162	100	Sheets, 31/2" & 70mm	Long-toe, fine grain; portraiture, flash; general use
Commercial Film 6127	50D/8T	Sheets	Medium speed, blue-sensitive; copying, positive transparencies
Contrast Process Ortho 4154	50T	Sheets	High-contrast, orthochromatic; copying, special effects
Kodalith Ortho, Type 3	8–25	Sheets, 35 bulk, others	Extremely high contrast, orthochromatic; graphic arts, special
Kodalith Pan 2568	32T	Sheets	Similar to Kodalith Ortho, except panchromatic
Technical Pan	25-160	135/36, 120, sheets	Extended-red panchromatic sensitivity, high acutance, fine grain; speed and contrast depend on processing conditions;
T.M., 100 D. (1050	100		scientific, industrial, pictorial, special techniques
T-Max 100 Prof. 4052	100	Sheets, long rolls	T-Grain emulsion: very sharp, extremely fine grain; for
5052	100	35mm, 24 and 36 exp.	general studio and outdoor photography
6052 T-Max 400 Prof. 4053	100 400	120 rolls Sheets, long rolls	T Orain and later share from the first
5053	400	35mm, 24 and 36 exp.	T-Grain emulsion: sharp, fine grain, fast; for general use,
6053	400	120 rolls	photojournalism, and difficult lighting conditions
Super-XX Pan Film 4142	200	Sheets only	Medium speed; general purpose; separation negs
llford, Inc.			
lford Pan F	50	135/20/36, bulk 35, 120	Low appendicultra fina area manine at finition for the
lford FP4	125	135/20/36, bulk 35, 120, 220, sheet sizes	Low speed, extra-fine grain, maximum definition; fine detail Medium speed, fine grain, excellent definition; universal use
lford HP5	400	135/20/36, bulk 35, sheet sizes	Fast, wide latitude, excellent gradation; all purpose film
lford XP1 400	400	135/20/36, bulk 35, 120	Chromogenic (C-41 compatible); variable speed from 100 to 1600
lford Commercial Ortho	80D/40T	Sheet sizes	Medium speed, fine grain, orthochromatic, wide dev. latitude

Some Available Film Types: Color Positive

Film Name	SO/ASA Speed	Available Sizes	Characteristics, Uses
Polaroid			
Type 57 High Speed Print Film	3000	4×5 sheet	15 sec. development; general purpose
Type 107 High Speed Print Film	3000	$3\frac{1}{4} \times 4\frac{1}{4}$ pack	Same as above
Types 667 and 107C HS Print Films	3000	$3\frac{1}{4} \times 4\frac{1}{4}$ pack	30 sec. development; no coating required
Type 87 High Speed Print Film	3000	$3\frac{1}{4} imes 3\frac{3}{8}$ pack	Same as above
Type 55 Positive and Negative	50	4×5 sheet	20 sec. development; needs clearing bath of sodium sulfite
Type 665 Positive and Negative	50	$3\frac{1}{4} \times 4\frac{1}{4}$ pack	30 sec. development; needs sulfite clearing bath
Polapan Type 52 Fine Grain Print Fi	lm 400	4×5 sheet	15 sec. development; wide tonal range, superb detail
Polapan Type 552 Fine Grain Print F		4 $ imes$ 5 pack	Same as above
Type 53 Fine Grain Print Film	800	4×5 sheet	30 sec. development; medium contrast; no coating required
Type 553 Fine Grain Print Film	800	4 $ imes$ 5 pack	Same as above
PolaPan CT	125	35mm; 12, 36-exp	Continuous tone slide film. This and the following films require a special processor
PolaGraph HC	400	35mm; 12-exp	High-contrast slide film; graphic effects
PolaBlue BN	8	35mm; 12-exp	White on blue slides from high-contrast originals
Agfa-Gevaert, Inc.			
Agfachrome 50 RS	50	135/120, sheets	Slow, daylight slide film, proc. not included, E-6 compatible
Agfachrome 100 RS	100	135/120, sheets	Medium speed, otherwise similar to 50 RS
Agfachrome 200 RS	200	135/120	Fast, otherwise similar to 100 RS
Agfachrome 1000	1000	135/120	Extremely fast, otherwise similar to 200 RS; available light
Eastman Kodak Company			
Kodachrome 25*	25	135	Slow, high resolution, fine grain; daylight, general use
Kodachrome 64*	64	135/120*	Moderate speed, fine grain; daylight, general use
Kodachrome 200*	200	135	Fast, fine grain; daylight, general use
Kodachrome 40A	40	135	Moderate speed, fine grain, 3400° tungsten balance
Ektachrome Prof. 50	50	135/120	Moderate speed, 3200° tungsten balance
Ektachrome 64 Prof.	64	135, rolls, sheets	Moderate speed; daylight, general purpose
Ektachrome 100*	100	135, rolls, sheets*	Fast, brilliant color; daylight, studio, general use
Ektachrome 100+*	100	135, rolls, sheets*	Fast, enhanced contrast; daylight, studio, general use
	160	ready load packs* 135/120*	Fast, 3200° tungsten balance; studio, general use
Ektachrome 160*	160		Fast, well-balanced color; daylight, general use
Ektachrome 200*	200 400	135, rolls*, sheets 135	Fast, brilliant color, versatile; daylight, general use
Ektachrome 400 Ektachrome P800/1600 Prof.	800/1600	135	Very fast, pushable; dim light, action, general use
	800/1000	100	
Fuji Photo Film U.S.A., Inc.			
Fujichrome 50D	50	135, rolls, sheets	Moderate speed and contrast, fine grain; daylight
Fujichrome 64T	64	120, sheets	Similar to 50D but 3100° tungsten balance
Fujichrome 100D	100	135, rolls, sheets	Faster, slightly higher contrast than 50D; daylight
Fujichrome 400D	400	135	Very fast, moderately contrasty; daylight, general use
Fujichrome P1600	1600	135	Extremely fast, moderate grain, pushable; sports, action
Photo Color Systems Division/3M			
Scotch Brand HR 100 Color Print F	ilm 100	135/24/36	Very sharp, fine grain; for bright to average daylight All Scotch Color Print Films C-41 compatible
Scotch Brand HR 200 Color Print F	ilm 200	135/24/36	Sharp, versatile; general outdoor light, action, flash
Scotch Brand HR 400 Color Print F		135/24/36	Fast, pure color; for daylight action, sports, wildlife

*When both amateur and professional versions are available, the special features of the professional film are starred.

Some Available Film Types: Color Negative

Film Name	ISO/ASA Speed	Available Sizes	Characteristics, Uses
Polaroid			
The following films are self-processi	ng and each	n camera exposure produces	s a single color print.
Type 779 Integral Color Print	640	$3^{1/_{B}} imes 3^{1/_{B}}$ pack	Self-timing development; daylight and electronic flash
Type 708 Integral Color Print	150	$3\frac{1}{8} \times 3\frac{1}{8}$ pack	No battery, otherwise same as above
Time Zero Supercolor SX-70	150	$3\frac{1}{8} \times 3\frac{1}{8}$ pack	Daylight balance
Polacolor ER Type 59	80	4×5 sheet	60 sec. development; day and electronic flash, medium contra
Polacolor ER Type 559	80	4 imes 5 pack	Same as above
Polacolor ER Type 669	80	$3\frac{1}{4} \times 4\frac{1}{4}$ pack	Same as above
PolaChrome CS Color Slide Film	40	35mm, 12, 36-exp.	General use, daylight color transparency film: requires special processor
Agfa-Gevaert, Inc.			
Agfacolor XRS 100	100	135/120	Sharp, fine grain, daylight balance; general use
Agfacolor XRS 200	200	135/120	Medium speed, similar to XRS 100
Agfacolor XRS 400	400	135/120	Fast, medium grain, similar to XRS 200
Agfacolor XRS 1000	1000	135/120	Very high speed, medium grain, similar to XRS 400
Eastman Kodak Company			
Ektar 25	25	135	Exceptionally sharp, fine grain, daylight balance
Ektar 1000	1000	135	Very fast, pushable, moderate grain; daylight
Kodacolor Gold 100	100	135/120	Moderate speed, versatile, brilliant color contrast
Kodacolor Gold 200	200	135	Fast, brilliant contrast; daylight, general use
kodacolor Gold 400	400	135/120	Very fast, improved grain and sharpness; general use
Kodacolor VR 1000	1000	135	Very fast, moderate grain; sports, action, general use
Ektapress 100 Prof.	100	135	Moderate speed, very sharp, fine grain; daylight
Ektapress 400 Prof.	400	135	Fast, sharp, fine grain, daylight, professional use
Ektapress 1600 Prof.	1600	135	Pushable, moderate grain and contrast; professional use
Vericolor 400 Prof.	400	135/120, sheets	Versatile, daylight balance, good color, fine grain
Vericolor HC	100	120, sheets	Enhanced contrast, sharp, fine grain; daylight
Vericolor III S Prof.	160	135, rolls, sheets	Moderate speed and grain, versatile; daylight
Vericolor II L Prof.	100	120, sheets	Moderate speed, balanced for long exposure times
Fuji Photo Film U.S.A., Inc.			
Fujicolor Super HR 100	100	135/120	Moderate speed, very fine grain, medium contrast; daylight
Fujicolor Super HR 200	200	135	Medium speed, fine grain, medium contrast; daylight
Eujicolor Super HR 400	400	135/120	High speed, versatile, good grain, contrast; daylight
ujicolor Super HR 1600	1600	135	Very fast, moderate grain and sharpness; daylight
Fujicolor 160 Prof. Type S	160	135, rolls, sheets	Professional daylight film for short exposure times
Fujicolor 160 Prof. Type L	160	120, sheets	Professional tungsten balance for long exposure times
Photo Color Systems Division/3M			
Scotch Brand HR 100 Color Print Fil		135	Very fine grain, very sharp, pure color; daylight
Scotch Brand HR 200 Color Print File		135/110, disc	Fine grain, sharp, pure color, versatile; daylight
Scotch Brand HR 400 Color Print File	m 400	135	Moderate grain and sharpness, good color; sports, action

Some Available Paper Types: Black and White, Fiber Base

Paper Name	Contrast Grades	Weight	Surface	Characteristics; Uses
Agfa-Gevaert, Inc.				
Brovira 1	1,2,3,4	S	Glossy	Neutral white fiber base, cool image tone; projection
Brovira 111	1,2,3,4,5	D	Glossy	Similar to above, except weight
Brovira 112	1,2,3,4	D	Smooth semi-matte	Similar to above, except surface
Brovira 119	1,2,3,4	D	F.G. lustre	Similar to above, except surface
Portriga-Rapid 111	1,2,3	D	Glossy	Slightly warm tone, off-white base, rich blacks
Portriga-Rapid 118	1,2,3	D	F.G. semi-matte	Similar to above, except surface
Insignia 111	1,2,3,4	D	Glossy	More neutral tones than Portriga; white fiber base
Eastman Kodak Company				
Polyfiber	Variable	S, D	F, G, N, A	Rich, neutral tones, white base; filters control contrast
Elite	1,2,3	Н	S (high lustre)	Premium quality, neutral tone, white base; standard sizes
Kodabromide	1,2,3,4,5	S, D	F	Neutral tone, high speed; commercial and general use
	2,3,4	S, D	E (fine grained)	Same, except lustre surface
Ektalure	Single (3)	D	G, R, X, K	Brown-black tones, medium speed for contact or
				projection
Ektamatic SC	Variable	S	F, N	Developer-incorporated for stabilization or tray processing
		D	F	Warm black tones when stabilized; neutral when tray-
				processed
		L	A	Contrast controlled by filtration, 1-4
AZO	1,2,3,4,5	S	F	For contact printing only; neutral tone, white base
	2	D	F	
	2,3	S	E	
	2	D	E	
Polycontrast Rapid RC III	Variable	M	F, N, G	Fast, developer-incorporated, white RC base; general use
Kodabrome RC II	1,2,3,4,5	M	F, N, G	Similar to above, except not variable contrast
Polyprint RC	Variable	M	F, N, G	Similar to Polyfiber, except for base material
llford Inc.				
llfobrom	1,2,3,4,5	S, D	Glossy	Uniform contrast grade spacing; uniform printing speed
		- 1	Matte	for grades 1-4. Neutral black image tones, white fiber
			Semi-matte	base with optical brighteners
Ilfobrom Galerie	1,2,3,4	D	Glossy	Exhibition quality, exceptionally rich blacks, neutral image
	1,2,0,1	2	Matte	tone, white fiber base
Multigrade FB	Variable	S, D	Glossy	Filters control contrast, neutral black image tones, fast
Mangrade i B	Vanabio	D	Matte	printing time, white fiber base contains optical
		D	Velvet stipple	brighteners, developer-incorporated emulsion
Multigrade III RC Rapid	Variable	Mid-weight	Glossy	Similar to above, except for resin-coated base and
Multigrade in no hapid	Variable	wid weight	Pearl	surfaces; cool image tones
			Matte	Sanaess, eeer inage tenes
llfospeed RC	0,1,2,3,4,5	Mid-weight	Glossy	Similar to above, except graded instead of variable-
lilospeed RC	0,1,2,3,4,5	wid-weight	Pearl	contrast; specially-treated back surface accepts pencil
			Matte	and some ball-points inks
Oriental Photo Ind. Co., Ltd.				
New Seagull G	1,2,3,4	S, D	Glossy	Exhibition quality, cool black tones, white fiber base
			Lustre	
New Seagull Select VC	Variable	D	Glossy Lustre	Similar to above, except variable-contrast
Center	2,3	D	Glossy	Warmer image tones than Seagull, white base
New Seagull RP	2,3,4	Med.	Glossy	Cold image tones, white resin-coated base
non obagai ni	L, O, T	inica.	S.000,	g_ terret,

Some Available Paper Types: Black and White, Resin Coated

Paper Name	Contrast Grades	Weight	Surface	Image Tone, Characteristics, Uses
Agfa-Gevaert Inc.				
Brovira-Speed 310PE	1,2,3,4,5	М	Glossy	Neutral, bromide emulsion; 8×10 , 11×14 , 16×20
Brovira-Speed 312 PE	1,2,3,4	Μ	Semi-matte	Same as 310 PE
Brovira-Speed 319 PE	2,3,4	Μ	Fine-grain lustre	Same as 312 PE
Portriga-Speed 310 PE	2,3	Μ	Glossy	Chlorobromide emulsion, warm tone, white base
Portriga-Speed 318 PE	2,3	N	F.G. Semi-matte	Similar to above; both types, 8 \times 10, 11 \times 14, 16 \times 20.
Eastman Kodak Company				
Polycontrast Rapid II RC	Variable	Μ	F, N	Fast, developer-incorporated, neutral tones, white base;
			E (Lustre-Luxe)	contrast controlled by filters, 1-4
Polyprint	Variable	Μ	F, N, E	Non-developer-incorporated; otherwise similar to Poly II RC
Panalure II RC	Single (4)	Μ	F	Panchromatic, dev-inc; for B/W prints from color negatives
Kodabrome II RC	1,2,3,4,5	Μ	F, N, E	Warm-black tone, white base, dev-inc; general commercial
		2		use
llford Inc.				
Ilfospeed Multigrade II	Variable	М	Glossy 1M Pearl 44M Matte 5M	RC, developer-incorporated; filters 0 to 5 control contrast; all Multigrade II papers can be used in stabilization processor or processed conventionally in trays; standard
llfospeed RC	0,1,2,3,4,5	Μ	Glossy Semi-matte Pearl	paper sizes Ilfospeed RC paper and matching chemicals designed for rapid processing; neutral image tone, white base Pearl paper has special back surface for pencil, etc.; standard paper sizes
Oriental Photo Distributing C	ompany			
Seagull RP	2,3,4 2,3,4	S S	Glossy (RP-F) Semi-matte (RP-R)	Both types: fast, white base, jet-black image tone
PSI Photo Systems Inc.				
Unicolor RC	1,2,3,6 2,3	M M	Glossy Matte (N), Lustre (E)	5 \times 7 and 16 \times 20 in contrast grades 2 and 3 only
			and Pearl	8 imes 10 and 11 $ imes$ 14 only, neutral tone, white base
Unicolor Thrifty Paper	2,3	M	Glossy	5×7 and 8×10 50-sheet packages only, budget priced.
Unicolor Multi Contrast	Variable	М	Glossy	Filters control contrast, 1–4; 5 $ imes$ 7, 8 $ imes$ 10, 11 $ imes$ 14

*Kodak Paper Surface Codes F—Smooth, glossy J—Smooth, high-lustre, white A—Smooth lustre, white, light-weight base N—Smooth, semi-matte, white K—Fine-grained, high lustre, warm-white base R—Rough, twed texture X—Lustrous, tapestry surface, cream-white base G—fine-grain lustre, cream-white base E—(fiber-base) Fine-grain lustre, warm-white base E—(resin-coated) Lustre-Luxe; fine-grained, white S—Ultra-smooth, high lustre

Some Available Paper Types: Color

Paper Name	Weight	Surface	Characteristics, Uses
Agfa-Gevaert, Inc.			
Agfacolor	MCN 310 312 319	Glossy Semi-matte Lustre	Process in Agfa 92 or Ektaprint 2, or equivalent
Agfachrome Type 63	Medium	Glossy	Medium contrast; for prints from transparencies
Agfachrome ATM 1002	Medium	Glossy Matte	Higher contrast than type 63 Similar to above, except surface
Agfacolor Type 8	Medium	Glossy	For making prints from color negatives
Agracolor Type o	Wealdin	Semi-matte	Same, except surface
		Pearl	Same, except surface
Eastman Kodak Company			
Ektachrome 22 Ektacolor Professional	Medium Medium	F, N E, F, N, Y	Process R-3000 or equivalent; available 8 \times 10 to 30 \times 40 and rolls Normal contrast; Ektaprint EP-2 (or equivalent) process
Ektacolor Plus	Medium	E, F, N	Higher contrast; for flat negatives or more saturated color; EP-2
Fuji Photo Film U.S.A., Inc.			
Fujicolor Paper Type 01	Medium		Normal contrast; Ektaprint 2 compatible
llford, Inc.			
Cibachrome-All	М	Deluxe glossy	Polyester base, sharp, brilliant color; 4-step P-30 dye-bleac
CPSA. 1K CRCA. 44M	Medium	Pearl	process
			Resin-coated, relatively inexpensive. Process P-30
PSI Photo Systems, Inc.			
Suprachrome Reversal Color Print Paper	М	Glossy	For making prints from transparencies
		Lustre	Same except surface
Exhibition Resin-Coated Paper	M	Glossy	For making prints from negatives; premium quality
		Lustre	Same except surface
Unicolor RB Resin-Coated Paper	M	Glossy	For making prints from negatives; general purpose
		Lustre	Same except surface
		Matte	Same except surface

3 Chemical Formulas

Although there is certainly no shortage of proprietary ready-to-mix (or ready-touse) photographic chemicals on the market, it's occasionally necessary or desirable to mix some special solution from bulk chemicals.

Ordinary tap water is satisfactory for most solutions but fine-grain developers and toners should be mixed with distilled water if it's available. Be sure the chemicals are fresh and the mixing utensils are clean. Wear hand protection and avoid contact with the dry chemicals and their concentrated solutions; especially avoid breathing chemical dust or vapors.

It's generally a good idea to add the individual chemical ingredients to the solution in the order they're given in the formula, dissolving each completely before adding the next. Store the mixed solutions in clean, clearly labeled glass or plastic bottles and cap them tightly, as soon as the solutions have cooled, to exclude air. Wash your hands and all utensils thoroughly after chemical mixing.

Special note: When mixing developer solutions containing Elon, or Metol (same chemical, different name), add just a pinch of the sodium sulfite to the water before adding the Metol. Although Metol dissolves very slowly in a moderately strong sulfite solution, a trace of sulfite in the water won't hinder the process, and will help to prevent oxidation as the Metol dissolves.

Print Developers

For General Use

Kodak's Dektol is a well-known, widelyused standard print developer that is available only in packaged form. The published formula, D–72, produces very similar results and can be mixed from bulk chemicals. It produces neutral image tones and normal contrast. Here it is:

Water (52° C or 125° F)	750 ml
Elon or Metol	3 gm
Sodium sulfite	
(dessicated)	45 gm
Hydroquinone	12 gm
Sodium carbonate	
(monohydrated)	80 gm
Potassium bromide	2 gm
Cold water, to make	1 liter

Dilute this stock solution 1+1 or 1+2with water and develop developerincorporated papers for 1 minute; ordinary papers from $1\frac{1}{2}$ to 3 minutes.

For Low Contrast

Print contrast is not affected greatly by changes in development time, but some developer formulas produce more or less contrast than others. Here is a print developer that produces neutral image tones and fairly low contrast without sacrificing maximum image density. This slightly modified version of the old Ansco (now GAF) 120 formula is valuable when you need a little less contrast than ordinary developers give.

Water (52° C or 125° F)	750 ml
Metol	14 gm
Sodium sulfite (dessicated)	40 gm
Sodium carbonate (monohydrated)	40 gm
Potassium bromide	2 gm
Cold water, to make	1 liter

Dilute 1+2 with water and develop prints from $1\frac{1}{2}$ to 3 minutes.

For Warm Image Tones

Print image color is somewhat affected by development conditions. For warmerthan-usual image tones on naturally warm-tone papers, you may find this developer formula satisfactory:

Water, 52° C or 125° F	750 ml
Hydroquinone	15 gm
Sodium sulfite	
(dessicated)	40 gm
Sodium carbonate	
(monohydrated)	55 gm
Potassium bromide	2 gm
Cold water, to make	1 liter

Dilute this stock solution 1+3 or 1+4 with water and develop for from 3 to 5 minutes. Prints developed in this solution will require substantially more exposure than usual.

Stop Bath

The common stop bath in most photographic processes is simply a weak solution of acetic acid. You can prepare a useful stop bath (of about 1.5% strength) by adding 15 ml of glacial acetic acid to 1 liter of water, but I don't recommend it because the glacial acid is a hazardous material that shouldn't be handled any mix a stock solution of intermediate strength—generally about 28%. To make this stock solution, wear hand and eye protection, and in a *well-ventilated* area, pour 3 parts of glacial acetic acid into 8 parts of cool water. In other words, to make a little more than a liter of 28% stock solution, add:

more often than necessary. It's safer to

	Glacial acetic acid (99%)	300 ml
to	Water (room temperature)	800 ml

and mix thoroughly. Handle the concentrated acid with care: it's corrosive, it can burn skin severely, and its fumes are overpoweringly sharp and penetrating. The 28% stock solution has a strong odor, and may be irritating but is not dangerous.

To make a stop bath working solution add:

Acetic acid, 28% stoc	k
sol.,	55 ml
to	
Water	1 liter

This solution strength (about 1.4%) is generally satisfactory for both films and papers, although a stronger bath (3% to 4%) has been recommended for litho films, and many photographers prefer to use a weaker bath (35 ml per liter—about 1%) for 35mm and rollfilms.

Fixing Bath

There isn't much point in mixing fixing baths from bulk chemicals because, for ordinary work, the commercially available packaged powders or liquid concentrates are convenient and economical to use. Occasionally, though, you may need a simple, nonhardening fixing bath—perhaps to use with paper before toning or as a clearing and fixing bath for bleached images on either film or paper. Here is a useful formula:

Water (52° C or 125° F)	500 ml
Sodium thiosulfate	
(hypo)	250 gm
Sodium sulfite	
(dessicated)	10 gm
Sodium bisulfite	25 gm
Cool water, to make	1 liter

Use this solution (and subsequent solutions) at 20° C (68° F) or less, to avoid excessive softening of the image emulsion.

Farmer's Reducer

This is a useful solution for reducing the density of overexposed negatives, and for lightening the print image—either locally or overall.

Stock Solution A Potassium ferricyanide	4 gm	Wate Pota
Water	100 ml	
Stock Solution B Sodium thiosulfate		Stock S Wate
(hypo) Water, warm	60 gm 300 ml	Hydi

Store these solutions in separate bottles. For use, add one part of A to 16 parts of water, then add 3 parts of B and stir thoroughly. Use less water for faster action (on film, for example) or more water for milder action on prints.

Presoak films or papers to be treated, then immerse them in the mixed solution and agitate continuously until the image is sufficiently lightened. Rinse the image thoroughly in running water to stop the action, then treat with hypo-clearing bath and wash as usual. Mixed solutions of the reducer will not keep; mix fresh solution for each use. The stock solutions will keep indefinitely if protected from air and light.

Bleach Baths

Farmer's Reducer, if used in sufficient strength, will bleach the silver image very effectively, but it tends to leave a yellowish stain that is difficult to remove. Dichromate bleaches have a similar characteristic. For complete removal of the image without residual stains, use either of these bleach formulas. I recommend the iodine bleach for removing small black spots from the print image; use the permanganate bleach in a tray for removing large image areas.

Iodine Bleach

For print spotting, use ordinary tincture of iodine (available from drugstores) or mix this solution:

25 ml
0.5 gm
2.5 gm

The iodine is virtually insoluble in plain water but dissolves slowly in an iodide solution. Store in a small bottle; it will keep indefinitely. Apply this solution with a toothpick, a cotton swab, or an inexpensive brush. Don't use a good brush; the iodine will eventually ruin brush hair.

Permanganate Bleach

Stock Solution A Water, warm	200 ml
Potassium permanganate	1 gm
Stock Solution B Water, cold	200 ml
Hydrochloric acid (concentrated)	20 ml

Caution: hydrochloric acid is a highly corrosive, dangerous substance that must be handled with great care. Wear hand and eye protection, and don't breathe the fumes. When mixing solutions of strong acids, such as this one, always pour the acid into the water never the reverse. In case of skin contact, flood with water for several minutes, then apply baking soda and get medical attention.

For rapid bleaching action, combine equal parts of *A* and *B* and use without further dilution. For milder action, combine equal parts of *A* and *B* and dilute with 2 or more parts of water. Solution *B*, although diluted, is still a corrosive mixture and should not be stored or used in metal containers. Store the stock solutions in individual plastic or glass bottles, tightly capped; they'll keep indefinitely. The mixed solutions will deteriorate quickly, whether used or not. Mix fresh solutions for each use.

When the image has been bleached in a permanganate solution, the print paper and the tray will have been stained a dirty brown. Wash the print in the tray in running water until the drain water is clear or only faintly pinkish, then treat the print in the nonhardening fixing bath (described earlier) until the image traces and the brown stains have disappeared. Then treat the print in a hypo-clearing bath and wash as usual. Handle the wet print carefully; the bleach may soften the image gelatin noticeably.

Hypo Eliminator

Unlike hypo-clearing baths, which merely improve the efficiency of the washing process, this formula destroys hypo chemically. Unfortunately, it also softens the image gelatin dangerously and leaves the print highlights faintly yellowed in some cases. Because complete elimination of hypo may not be essential for archival stability of the silver image, I've stopped recommending this treatment; but here's the formula for those who still consider it desirable.

500 ml
125 ml
100 ml
1 liter

Prepare the ammonia solution by adding 10 ml of ammonium hydroxide (28%) to 90 ml of water. *Caution:* Ammonium hydroxide is a strongly alkaline solution with an overwhelmingly suffocating odor; use it only in a very well-ventilated area, and wear hand and eye protection. In case of skin contact, flood the area with stop bath solution (weak acetic acid), then wash in running water.

Treat well-washed prints in the freshlyprepared solution for about 6 minutes at no more than 20° C (68° F). Don't store the mixed solution in a closed container because the evolved gas may break a stoppered bottle. Discard the bath after treating ten or twelve 8" \times 10" prints per liter, or after an hour or two of use. Wash the treated prints for about 10 minutes and dry them faceup to avoid damage to the softened emulsion.

Toners

Toners alter the color of the silver print image by reacting with—or in some cases replacing—the silver. A few toners increase image permanence, and this "protective toning" is considered desirable for archival processing of silver prints.

Selenium is the most popular protective toner but it's such a poisonous substance that it's no longer generally available as a bulk chemical for home use. Fortunately, Kodak supplies a liquid selenium concentrate that's relatively safe and very convenient to use—either mixed with the hypo-clearing bath or used as a separate bath. Wear hand protection while mixing and using selenium toner.

To produce distinctly purple-brown tones on most papers, dilute the toner concentrate with from 3 to 9 parts of water. For protective toning with less obvious color change, dilute the concentrate 1+15 or more. Prints must be fully fixed (preferably with minimum hardening) and should be hypo-cleared before (or during) toning. Agitate the prints in the toning bath frequently; when the image color is satisfactory (a barely perceptible color change is sufficient for protective toning), wash the prints thoroughly and dry as usual. Don't overdo the toning: selenium darkens the image and increases contrast somewhat; also, remember, prints darken as they dry. Wash your hands and all utensils thoroughly after using selenium toner.

Gold Toner

Solution A Gold chloride Water, distilled	1 gm 100 ml
Solution B Sodium, potassium or	
ammonium	
thiocyanate	10 gm
Water, preferably distilled	1 liter

4 Close-up Exposure Correction

A fairly simple method of exposure compensation, based on the increase in lens focal distance required for close focusing, is explained on pages 290–91. You can also calculate the correction factor by working from image magnification. Find the image magnification by dividing some image dimension by the corresponding subject dimension.

$$M = \frac{\text{Image dimension}}{\text{Subject dimension}}$$

then apply the formula

Exposure factor = $(M + 1)^2$

For protective toning, add (with vigorous stirring) 1 ml of Solution *A* (for each 8'' \times 10'' print to be toned) to 500 ml of Solution *B*. Treat thoroughly washed prints in this bath—one at a time, with frequent agitation—until the image color darkens and cools slightly. Use more gold for a more obvious blue tone. Don't replenish a used bath with gold; the bath spoils fairly soon and should be used only when fresh. Prints will dry darker and cooler than they appear while wet. Wash the toned prints in running water for at least 10 mintues.

There are numerous other toners. Brown tones are most common, and generally most stable, but almost any image color can be produced if archival permanence is not a serious concern. For more formulas, consult a reference such as the *Photo-Lab-Index* published by Morgan & Morgan.

For example, some image dimension is found to be .8 inches and the corresponding subject dimension is .5 inches. The magnification (M) is:

$$M = \frac{.8}{.5} = 1.6$$

The exposure factor (EF) is

 $EF = (1.6 + 1)^2 \text{ or } 2.6^2 \text{ or } 6.76$

The factor found this way is useful for lenses of normal construction but for lenses of telephoto or reversed telephoto (retro-focus) construction, the *pupillary magnification* of the lens must be considered. To find the approximate value of pupillary magnification, divide the apparent aperture diameter, as the lens is held at arm's length and viewed from the rear (the *exit pupil* diameter), by its apparent diameter as seen, similarly, from the front (the *entrance pupil*).

Pupillary magnification (P) = Diameter of exit pupil Diameter of entrance pupil

then use the formula,

$$EF = \left(\frac{M}{P} + 1\right)^2$$

Hypo-Test Solution

Store this test solution in a dropper bottle. It keeps indefinitely.

Water	100 ml
Potassium iodide	2 gm

Add one or two drops to the used fixing bath. If a yellowish cloud forms in the solution within a second or two, film fixer is nearing exhaustion and should be replaced. Discard print fixer if any sign of cloudiness appears within about 10 seconds.

For example, if the exit pupil measures 12 mm and the entrance pupil measures 18 mm, the pupillary magnification is

$$P = \frac{12}{18} = .67$$

If the image magnification is 1.6, the formula is

$$\mathsf{EF} = \left(\frac{1.6}{.67} + 1\right)^2$$

or $(2.39 + 1)^2$ or 3.39^2 or 11.5

5 Filtration for Color Photography

Eastman Kodak manufactures the Wratten filters in an extensive line that includes conversion, light-balancing, and color-compensating filters for color photography. In practice, both conversion and light-balancing filters are used to adjust light color temperature. Although there isn't any firm distinction between them, the term conversion is usually applied to filters in the 80 (blue) and 85 (orange) series; and the term lightbalancing is used to describe filters in the 81 (yellow-tan) and 82 (bluish) series. The terms are often used interchangeably, but light-balancing is probably the most common.

As shown in table A5.1, the 80A filter (for example) can adjust 3200° K tungsten light to 5500° K for use with daylight color film; but this is a deceptive method of calibration because the extent of color shift in Kelvin degrees depends upon the color of the existing light. The 80A filter can produce a color temperature shift of 2300° K when used with a light source of 3200° K, but it will shift 5500° K daylight to almost 20000° K a correction of 14500° K! On the other extreme, it can shift candlelight only about 630° K, from about 1900° K to about 2350° K.

There is a way, however, to calibrate filters so that their shift value is a constant for all light colors. If the color temperature in degrees is divided by 1,000,000 and then inverted (the same as dividing 1,000,000 by the color temperature—a more direct procedure), the number obtained will express the light color in *mi*cro-*re*ciprocal *d*egrees, or *mireds* (pronounced my-reds).

Mireds simplify filter calculation considerably because they can be applied to any light color. For example, suppose you're using daylight color film (5500° K) with an old model electronic flash gun that produces light of 6200° K. Obviously you must warm the light by about 700° K to match the film's balance, which means that you need a yellowish lightbalancing filter-but which one? You might be tempted to select an 81EF, which (according to the table) can convert 3850° K to 3200° K-a shift of close to 700° K, but that's not the correct choice for this light condition. Working with mireds will give you the proper information. First convert 5500° and 6200° to mired values:

Mireds = 1,000,000/Kelvin° so 1,000,000/5500° = 181.8 and 1,000,000/6200° = 161.3

Subtracting 161.3 from 181.8 gives 20.5, the desired color temperature shift in mireds. The table shows that the 81A mired value is 18 and the 81B mired value is 27. Take your choice: the 81A will "undercorrect" the light a bit, leaving the image color faintly cool (bluish); the 81B will "overcorrect" a little, producing a slightly warm-toned (yellowish) image. The 81EF, with its mired rating of 52, is much too strong and would stain the image an obvious yellow-brown.

Working with mireds or *decamireds* (ten-mired units) is a great convenience, but it has one confusing aspect: the *direction* of shift (toward yellow or blue) is indicated by the *sign* of the mired number. That is, a *positive* number indicates a yellow or orange filter that will warm the light, and a *negative* number indicates a blue filter that will cool the light. Thus, the 85B filter, with a rating of 131 mireds, is orange in color; the 80A, rated at -131 mireds, is blue.

If you can remember the rule "subtract what you *have* from what you *want*," you should have no difficulty in choosing the appropriate filter colors. For example, if you're using tungsten color film, type B (3200°) with photoflood lamps rated at 3400°, "you have" 3400 and "you want" 3200. Subtract the mired value of 3400° (294) from the mired value of 3200° (312):

$$312 - 294 = 18$$

The number 18 is positive, so the appropriate filter is the 18A. If you use Kodachrome type A film (3400°) with professional photofloods (3200°), you *have* a mired value of 312 (3200) and you *want* 294 (3400), so you'll have to subtract:

$$294 - 312 = -18$$

This is a negative number, indicating a "cooling" (bluish) filter. There is no -18 mired filter listed, but the 82A (at -21) is close enough to be useful.

Incidentally, if you combine filters, you can add their mired values to find the approximate value of the combination. For example, if you need a mired value of, say 70, you can approximate it by using two 81Cs or an 81A and an 81EF. Notice that although you *add* the mired values, you must *multiply* the filter factors to find the combined factor. Thus the 81A (factor $1.3 \times$) and the 81EF (factor $1.7 \times$) require a total exposure increase of:

 $1.3 \times 1.7 = 2.2$, or about one stop.

Combining filters should be considered an emergency procedure, but one that may save a picture for you someday.

Table A5.1

Light-Balancing Filters for Color Photography

-	-	• • •		
Filter Color	Wratten Filter Number	Color Temperature Shift in Kelvin Degrees	Mired Shift Value	Filter Factor
Bluish	82	3100° to 3200°	- 10	1.3×
	82A	3000° to 3200°	-21	$1.4 \times$
	82B	2900° to 3200°	-32	1.6×
	82C	2800° to 3200°	-45	1.7×
Yellowish	81	3300° to 3200°	9	1.3×
	81A	3400° to 3200°	18	1.3×
	81B	3500° to 3200°	27	$1.4 \times$
	81C	3600° to 3200°	35	1.5×
Brownish	81D	3700° to 3200°	42	1.6×
	81EF	3850° to 3200°	52	1.7×
Blue	80D	4200° to 5500°	-56	2×
	80C	3800° to 5500°	-81	2.5×
	80B	3400° to 5500°	-112	$4 \times$
	80A	3200° to 5500°	-131	5×
Orange	85C	5500° to 3800°	81	1.3×
	85	5500° to 3400°	112	1.6×
	85B	5500° to 3200°	131	1.8×

6 Filtration for Blackand-White Photography

Table A6.1

Filter Factors for Black-and-White Photography

	Dauliaht				
	Daylight	Tungsten	Daylight	Tungsten	
v (K2)	2	1.5	2.5	2	
v-green (X1)	4	3	4	3	
yellow (G)	3	2	5	3	
A)	8	6			
n (B)	8	8	8	5	
	8	16	6	8	
red (F)	25	12			
n (N)	12	12			
	()	red (F) 25	red (F) 25 12	red (F) 25 12 —	

7 Compensation for Reciprocity Effects

Under normal conditions, film (and paper) exposure obeys the reciprocity law, which states that the exposure effect remains constant as long as the product of exposure time and light intensity remains constant. In other words, if the exposing light intensity is doubled (for example) and the exposure time is halved, the film exposure normally remains the same.

Under extreme conditions of light intensity, however—when the exposing light is either exceptionally bright or dim—the emulsion acts as if its sensitivity has been reduced, and more-thannormal exposure is required to form a normal image. We refer to this effective change in emulsion speed as "failure of the reciprocity law" or "reciprocity failure."

It's possible to compensate for reciprocity failure by either increasing the exposure time or by using a larger lens aperture, but these methods are not equally effective. Because the image is formed by light of many different intensities-corresponding to the various areas of highlight, mid-tone, and shadow-the reciprocity effect is not uniform over the entire image area. In dim light failure, the image shadows-the dimmest areas of the image-are most seriously affected and are exposed less effectively than the highlights are. Consequently, image contrast increases, and development should be decreased correspondingly. In bright light failure, on the other hand, the highlights are most seriously affected and are less well-formed than the shadows are, so image contrast decreases, requiring an increase in development.

For these same reasons, it's more efficient to compensate for dim light failure by opening the aperture, because the increased film illumination reduces the severity of the reciprocity effects. Relatively more compensation is necessary if the film illumination is unchanged and only the exposure time is adjusted. The opposite is true in bright light failure: opening the aperture aggravates the problem by increasing the film illumination still further. It's best, in this case, to increase the exposure time, if possible.

Because we have no convenient way to monitor film illumination, we rely on indicated exposure time to alert us to the need for reciprocity compensation. As a rule of thumb, film exposure times of more than about 1 second, or less than about 1/2000 second, suggest that compensation is necessary. In practice, however, bright light compensation is almost never necessary, and except when working with specialized high-speed electronic flash equipment, we generally ignore it.

There's a very general compensation formula for dim light failure that's fairly easy to remember. Read the subject light with your meter and choose an aperture setting; then see table A7.1.

Table A7.1

If the indicated speed is	open aperture or	multiply time by	and reduce*† development by	
1 second	1 stop	2×	5% to 10%	
10 seconds	2 stops	$5 \times$	10% to 20%	
100 seconds	3 stops	12×	15% to 30%	

*I recommend the minimum development reduction percentages

†T-Max 400 Film does not require any reduction in development.

Equivalent Lens Focal Lengths for Various Camera Sizes and Lens Angular Coverage Chart

Table A8.1

Equivalent Lens Focal Lengths for Various Camera Sizes

	Angular Coverage of Horizontal Field*											
Image Size	100° mm	81°	65°	55°	45°	39 °	24 °	15°	10°	5°	3.4°	2 °
35mm	15	21	28	35	43	50	85	135	200	400	600	1030
1%" × 2¼" 4.5cm × 6cm 2¼" × 2¼" 6cm × 6cm	22	32	42	52	65	76	127	205	308	615	910	1545
$2\frac{1}{4}$ '' \times $2\frac{3}{4}$ '' 6cm \times 7cm	28	39	52	63	80	93	155	250	377	750	1110	1890
$2\frac{1}{4}^{\prime\prime} imes 3\frac{1}{4}^{\prime\prime}$ 6cm $ imes$ 9cm	34	48	64	78	100	115	192	311	469	940		
$3\frac{1}{4}$ " $ imes$ 4 $\frac{1}{4}$ " 9cm $ imes$ 12cm	45	63	85	103	128	150	250	402	605	1210		
$4'' \times 5''$	53	74	100	122	152	180	295	478	720			
5'' × 7''	75	104	140	171	210	251	418	676	1015			
8′′ × 10′′	107	149	200	244	300	359	597	965	1450			
			W	de			Lo	ong				
	Very w	ide			''N	lormal''		0	Ve	ery long		

*Lens coverage is usually given for the image diagonal (corner to corner) measurement—an unrealistic statistic. This table indicates the useful coverage along the long dimension of the image. Focal lengths are given in millimeters.

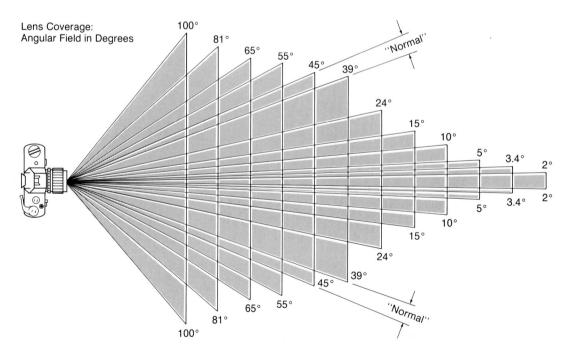

Figure A8.1

Lens Angular Coverage Chart.

9 Film Development Charts

The charts in figures A9.1–A9.5 can be used to determine appropriate developing times for five popular 35mm rollfilms. These data are based on the use of D–76, diluted 1 + 1, at 68° F, with intermittent agitation (about 5 seconds of every 30 seconds) in a small tank.

For any given film/developer combination, developing times are influenced mainly by printing conditions (the type of enlarger used), by the paper grade selected, and by subject luminance range. When the subject contrast is normal (SBR about 7 stops) and normal (grade 2) paper is used with a condenser enlarger, the film should be developed to an average gradient (or Contrast Index) of about 0.45. When a diffusion enlarger is used under the same conditions, the film should typically be developed to a \overline{G} (or CI) value of about 0.51. Low contrast subject will dictate longer developing times; flat subjects will need greater development to produce "normal" negative contrast.

Obviously, it's impossible to develop each frame of 35mm rollfilm separately; so, unless you've devoted an entire role to some specific subject condition, it's unlikely that the development time you choose will be optimum for all the pictures on the roll. Just be sure that all the images have been adequately exposed, then choose a development time that will be appropriate for the majority of the subjects. You can print the few negatives of abnormal contrast on appropriate graded papers or by using a variable-contrast paper with an appropriate filter.

Finally, you'll almost certainly have to adjust any development recommendations to fit your own lab conditions and working habits. If you find that these chart data produce too much or too little contrast to suit you, simply read the development times from a different subject contrast level. For example, if you have based your normal development on a G value of 0.43 and the resulting negatives are consistently a little too low-contrast, consider your personal "normal" \overline{G} to be higher—perhaps 0.47. After one or two adjustments of this sort, these data should prove to be useful and reliable.

Figures A9.1–A9.5 show five films tank-developed in D–76 1 + 1 with intermittent agitation for 5 seconds of every 30 seconds.

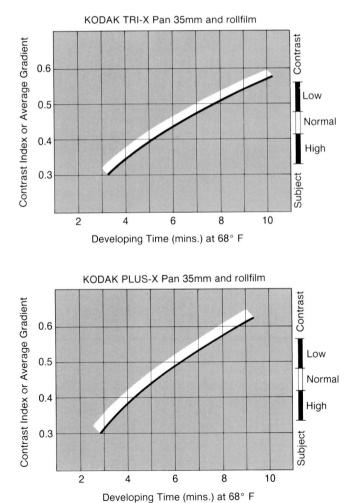

Figure A9.1 Kodak Tri-X Pan 35mm and rollfilm.

Kodak A9.2 Kodak Plus-X Pan 35mm and rollfilm.

Figure A9.3 Kodak Panatomic-X 35mm rollfilm.

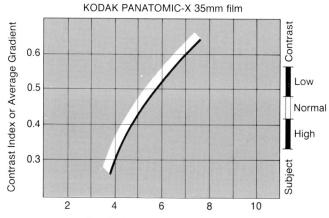

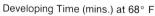

Figure A9.4 Kodak T-Max 100 35mm and rollfilm.

KODAK T-MAX 100 35mm and rollfilm

Developing Time (mins.) at 68°F

Figure A9.5 Kodak T-Max 400 35mm and rollfilm.

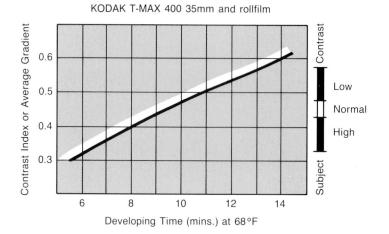

Glossary

- aberrations The several defects of a lens inherent in its design, material, and construction that, by deforming the image points in various ways, limit the sharpness of the focused image. accelerator See activator.
- acetic acid A relatively mild acid used, in
- highly diluted form, as the rinse bath (stop bath) that follows the developer in the normal film and paper developing processes. The acid in vinegar.
- achromat A lens that has been corrected for two colors, thus partially eliminating the effects of chromatic aberration.
- acid A hydrogen compound having a pH value less than 7. Most acids will combine readily with certain metals to form salts. Typically, an acid solution feels gritty when rubbed between the fingers and has a sharp sour taste. Acid solutions neutralize alkaline solutions and turn blue litmus paper red. The stronger acids cause severe burns and are dangerous to handle.
- activator The chemical ingredient of a developer solution that stimulates the reducing agent to begin its work and accelerates it. The activator in most developers is an alkaline salt, such as sodium carbonate or borax. Also called the accelerator.
- acutance In laboratory testing, describes the ability of a film, when exposed to a point light source, to form a sharply defined image of a knife edge.
- adapter rings Narrow metal rings, threaded on the outside to fit most popular lenses and threaded on the inside to accept accessories of other than nominal lens diameter. *Step-up* rings adapt a lens for use with largerthan-normal accessories; *step-down* rings permit the use of slightly smaller accessories than the lens will normally accept.
- additive system A name for the principles of color mixing using the light primaries. Mixtures of light colors are brighter and lighter in tone than the individual colors were, and the three light primary colors—red, green, and blue—produce white light when blended.
- aerial image An image formed in space. Normally invisible, aerial images can be inspected with a properly positioned magnifying glass or cast onto a screen or ground glass for conventional viewing.

- agitation The process of stirring, swirling, or otherwise causing a liquid to move freely over the surfaces of film or paper during processing.
- air-bells Tiny bubbles of air that are apt to cling to a dry surface when immersed gently. In developing films or papers, an initial vigorous agitation is usually recommended to dislodge air-bells so as to avoid pinholes.
- air-spaced elements In a compound lens, those elements that are not cemented together.
- albumin Commercially, simply dried egg white. Used in the preparation of printing paper emulsions from about 1850, it was replaced by gelatin in the 1880s. The old spelling is albumen.
- alkali A compound whose pH value is greater than 7. Alkaline solutions typically feel slippery or soapy when rubbed between the fingers and are difficult to wash off, especially in soft water. They neutralize acids and turn red litmus paper blue. The stronger alkalis can cause severe burns and are dangerous to handle.
- ambient illumination The light condition existing at the subject location.
- ambrotype A silver image on glass, popular in the 1860s and 1870s, made by coating a weak collodion negative with black lacquer. Viewed by reflected light, the image appears as a grayish positive. Ambrotypes were usually mounted in plastic or leather cases, like daguerreotypes, and were frequently hand-tinted.
- anastigmat A lens that has been well corrected for all the aberrations, specifically including astigmatism and curvature of field.
- angular coverage The field of view seen or covered by the lens, expressed in degrees.
- anhydrous Without water; dry. Used to distinguish the dehydrated form of a compound from its crystalline form, which might normally contain a substantial amount of water of crystallization while still appearing to be completely dry. When chemical measurements are made by weight, less of the anhydrous than the crystalline form will be required.
- ANSI American National Standards Institute. The present title of the organization that used to be called the American Standards Association (ASA).

- antihalation backing The colored layer that appears on the back of most films. See halation.
- aperture An opening, specifically, of the lens and expressed as a fraction of the focal length. The f/number. See relative aperture.
- aperture priority The camera operating mode that adjusts the shutter speed for correct exposure automatically when the user selects the aperture setting. See shutter priority.
- apochromat A lens that has been corrected for three colors, which thus reduces chromatic aberrations to negligible amounts. Apochromatic lenses sometimes include the prefix "Apo-" in their names, e.g., Apo-Tessar, Apo-Lanthar, etc.
- archival processing Procedures followed during film or print processing to produce a stable image, free from harmful residual chemical compounds and resistant to attack by environmental contaminants.
- ASA The American Standards Association, now the American National Standards Institute. A system of film speed rating used in the United States.
- aspheric Describes a lens surface of nonspherical curvature.
- astigmatism One of the common aberrations of photographic lenses and the human eye, characterized by the lens's inability to bring into common focus lines that are radial and lines that are tangential to the image circle.
- available light The light condition that the photographer finds existing at the subject position. The term usually implies an indoor or nighttime light condition of low intensity, requiring fast film, large lens aperture, and slow shutter speed.
- average gradient The slope of a line connecting two selected points on a characteristic curve; generally expressed numerically.
- B See bulb.
- back That portion of a camera containing the film; specifically, the complete assembly attached to the rear standard of a view camera (usually removable), which includes the focusing screen and accepts the film holders.
- back focus The distance from the rear surface of the lens to the focal plane when the lens is focused at infinity.

- backlight Illumination from a source beyond the subject, as seen from the camera position, which tends to silhouette the subject. See rim light.
- balance Refers to the relative sensitivity of the three emulsion layers of color film or paper, as evidenced by the emulsion's ability to reproduce subject tones and colors accurately, and without an apparent overall color cast, when illuminated by some standard "white" light source.
- bare bulb Refers to a flashbulb or electronic flash tube used without the customary reflector, so that much of the light reaches the subject by reflection from nearby walls, ceiling, or other surfaces. Useful in a reflective environment to improve shadow illumination and reduce the harsh, high contrast effects that are typically produced by ordinary camera-mounted flash units.
- barrel distortion An aberration that is characterized by a bowing-out of lines near the edges of the image. See pincushion distortion and rectilinear.
- barrel mount The metal structure of an assembled lens, exclusive of the glass elements, generally including an iris diaphragm assembly but specifically excluding a shutter mechanism.
- base The transparent sheet material, usually acetate or polyester, upon which film emulsion is coated.
- baseboard The large, flat board, usually plywood, to which the enlarger column is attached, and on which the enlarging easel is normally placed.
- base-plus-fog density The density of an unexposed area of a developed film or paper.
- **bas-relief** A picture printed from the slightly misregistered images of a negative and its positive mask. The print usually resembles the linear shadow pattern of the subject as it would be seen in low relief in strong slanting light.
- bed The base structure of a view camera on which the camera back and lensboard standards are mounted.
- bellows The center section of a view camera that connects the front and back standards. The bellows is usually made of leather, cloth, or plastic, is accordionpleated for flexibility, and is, of course, lighttight.
- bellows extension A term often used to refer either to the total bellows length or to the additional extension of the bellows (beyond that required for infinity focus) necessary for focusing at close subject distances.
- belt The endless canvas strip that carries prints through a motorized or manual drum dryer. Sometimes called an **apron** or **blanket**.
- **benzotriazole** A restrainer, used in conjunction with or in place of potassium bromide in developer solutions, especially those compounded with Phenidone.

- between-the-lens shutter A shutter designed to operate in a space between the elements of the lens. See leaf shutter and focal plane shutter.
- bichromate Also, and preferably, dichromate. Refers to the chromium salts of sodium, potassium, and ammonium, which are used in various bleach baths and in the numerous variations of the gum and pigment printing processes. They are poisonous and can be absorbed directly through the skin to cause painful dermatitis and ulcers.
- black body A hypothetical, unreflecting source of pure radiant energy.
- blade arrestor Old term for device similar to press-focus lever. See press-focus lever.
- blade shutter Generally describes a vertically running focal plane shutter whose active element consists of a fanlike array of several thin metal plates or leaves.
- bleach A chemical bath or treatment that either converts the silver image into a less visible form or removes it entirely. See reducer.
- bleed An image edge trimmed without a border; as, "the picture bleeds top and bottom."
- blend (1) A composite photographic image whose component parts are so skillfully combined that their boundaries are invisible. (2) The process of producing a blend.
- blind An emulsion not sensitive to certain colors; colorblind.
- block-up Refers to an area of the negative image so overexposed, and therefore dense, as to obscure textures and details.
- blotter book A number of sheets of pure white blotting paper, interleaved with nonabsorbent tissue sheets and bound at one edge to form a large book. Used for nonglossy drying of relatively small prints.
- blue-sensitive The sensitivity of an ordinary silver emulsion; red and green blind.
- bounce To reflect light; specifically, light directed away from the subject toward some nearby light-toned surface so as to reach the subject diffused by reflection.
- bracket To make a number of exposures (some greater and some less than the one considered to be ''normal'') in addition to the ''normal'' one, with the intent of getting one near-perfect exposure.
- brightener A compound added to photographic paper during manufacture (or applied during processing) that, by white fluorescence in ultraviolet light, enhances the brilliance of print image highlights.
- brightness Our subjective interpretation of luminance or illuminance. Brightness is perceived; luminance and illuminance are objective qualities that can only be measured.

- bromide Any salt of hydrobromic acid, but commonly used as a shortened form of potassium bromide. See restrainer.
- bromide drag Refers to the streaks of relatively low density generally running across the width of rollfilm negatives and frequently related to the edge perforations of 35mm film, resulting from inadequate agitation during development and caused by the inhibiting effect of soluble bromides released from the film emulsion by the action of the developer as they flow down the film surface.
- bromide paper A printing paper
- sensitized principally with silver bromide. BSI British Standards Institution. A system of film speed ratings used in Great Britain; essentially, they are similar to the
- ASA and ISO speeds.
- BTL See between-the-lens shutter.
- buffered paper Paper that has been impregnated with calcium carbonate, or other alkaline material for long-term protection against acid deterioration.
- bulb A marked setting (*B*) of most shutters that permits the shutter to be held open for an indefinite period by continued pressure on the shutter release. See time.
- burned out Describes an area of the print image in which highlight detail has not been recorded, usually because of severe overexposure of the negative. See block-up.
- burning-in The process of allowing some relatively small image area to receive more than the normal exposure by shielding most of the printing paper surface from the light. See **dodging** and **flashing**.
- cable Abbreviation of cable release. cable release A long flexible cloth or metal braid-covered plunger that scre
- metal braid-covered plunger that screws into a special threaded socket on the shutter or camera body. Compressing the plunger with thumb and finger pressure will release the shutter without much danger of camera movement or vibration.
- cadmium sulfide cell A light-sensitive (photoconductive), solid-state device, formerly used in exposure meters.
- calotype The ancestor of modern photographic processes, invented by William Henry Fox Talbot in about 1840. The camera exposure was made on sensitized paper and developed out. The prints were made by contact on salted paper, printed out, and fixed. The process came to be known as talbotype and was quite popular. It would probably have been much more widely used if Talbot's patents had not been so restrictive.
- camera Literally, *room* in Latin. The instrument with which photographs are taken, consisting of, at least, a lighttight box, a lens that admits focused light, and some device or provision for holding the film in position.

- camera obscura Latin for *dark room*. Ancestor of the photographic camera; probably originally an actual room in which observers could watch the images of outside subjects formed by light rays entering the room through a small aperture and passing directly to the opposite wall. The camera obscura eventually evolved into a portable box, equipped with a lens and viewing screen, which was used for viewing and sketching, and finally, after the invention of suitable sensitized materials, for actual photography.
- carbon process A method of making prints or transparencies using carbon (or some other pigment) suspended in gelatin as the image material. The process is extremely flexible and versatile, and is capable of excellent photographic quality. It was popular with the Pictorialists but is rarely practiced now because the materials are no longer widely available commercially and are difficult to manufacture at home.

carrier The negative holder in an enlarger. carte-de-visite A popular image form of

- carte-de-visite A popular image form of the 1860s and 1870s; they are albumin prints mounted on cards about 2 1/2" × 4 1/8", usually depicting individuals or small family groups. They were sometimes used as visiting cards, but portraits of famous men and women were also collected and exchanged as novelties and keepsakes.
- cartridge The disposable metal or plastic container in which lengths of film are sold and used. Sometimes called a cassette.
- cassette A metal container (usually designed to hold lengths of 35mm film) which can be used repeatedly. Of ingenious design and construction, cassettes are made specifically for a particular camera and will not normally work in any other brand. Sometimes referred to as a cartridge.
- catadioptric lens A lens system comprised of both reflecting and refracting elements.

cats Slang term for catadioptric lenses.

- CC filters Color-compensating filters, intended for use in color photography to modify the overall color balance of the image. They are available in six colors and several degrees of saturation. CdS Cadmium Sulfide.
- CdS meter An exposure meter that employs a cadmium sulfide cell as its light-sensitive element.
- cemented lens A lens composed of two or more individual glasses whose adjacent surfaces are ground to fit accurately and are bonded together with some transparent adhesive. Most photographic lenses contain some cemented components as well as some air spaces.
- characteristic curve Another name for the D log E Curve.
- chloride paper Printing paper sensitized principally with silver chloride. A term seldom used any more.

- chromatic aberration A general name for the inability of a lens to bring all the light colors of an object point to a common point of focus in the image plane. Chromatic aberration causes simple blurring of the image in black and white, and color fringing of the image in color photography. Two forms are described, lateral and axial, or longitudinal, and the effects are most severe near the edges of the image area.
- chromogenesis In certain color films and papers, the formation of dye colors (by the chemical alteration of certain "coupler" substances contained in the emulsion) that accompanies development of the silver image.
- CI See contrast index.
- cinch marks Short parallel scratches, usually running lengthwise on the back of rollfilm, caused by gritty particles between the film layers; especially when the roll has been overtightened during winding or rewinding.
- circle of confusion The tiny, but not necessarily the *most* tiny, blurred circle of light that a lens will form as an image of a point of light at the subject position. It has no significance as a measure of lens accuracy or precision, but is measured and discussed simply as a means of defining tolerable sharpness of the image, and therefore the acceptable limits of depth of field.
- clear The appearance of a negative after the fixing bath has removed all visible traces of undeveloped silver halides.
- clearing time The length of time required to clear a negative. It depends on the strength, temperature, and agitation of the fixing bath and the kind of emulsion being fixed.
- click stops Detents in the diaphragm or shutter scale of a lens that produce a tactile indication and an audible click to mark the significant scale settings.
- close-up lens A positive supplementary lens that, when placed over a camera lens, shortens its focal length and thereby permits closer-than-normal focusing.
- close-up photography The techniques and practice of using supplementary lenses, extension tubes, bellows units, etc., to take pictures at closer ranges than the normal focusing adjustment of an ordinary hand-camera will allow. Refers to image magnification ratios of up to, perhaps, 2X, and therefore overlaps photomacrography. See photomacrography.
- coating The thin film of magnesium fluoride, or other material, deposited on the surfaces of the lens glasses, which gives photographic lenses their characteristic magenta, amber, or greenish color by reflected light. Its purpose is to reduce the intensity of flare light within the lens, which in turn increases the brightness and contrast of the image.
- cocking the shutter Winding or tensioning the shutter mainspring prior to making the exposure.

- cold light General term for the light produced by the high-voltage, gas-filled tubes or grids that are used in some diffusion enlargers.
- cold tones Bluish or greenish tinge in the black-and-white image.
- collodion A thin, clear, slightly syrupy solution of pyroxyline in ether and alcohol. It was used in the preparation of wet-plate emulsions, a procedure described by Frederick Scott Archer in 1851.
- collotype process A printing process, similar to lithography, that uses a plate of selectively tanned gelatin, dampened and inked, to produce photographic images in ink on paper. Unlike other ink processes, collotype plates produce halftones without screening. Although capable of exquisite quality, the process has been superseded by faster, cheaper printing methods.
- color analyzer An electronic instrument designed to measure the relative amounts of the primary hues in color negative and positive film images as a guide for filter selection in printing.
- color-compensating filters A special family of filters—available in calibrated strengths in red, green, blue, magenta, yellow, and cyan—intended for use in color photography. Each is identified by the prefix CC, followed by a number that represents its density (multiplied by 100) for light of its complementary color, and a final letter that identifies the filter color. For example, CC 20Y designates a yellow filter whose density for its complement (blue) is .2.
- color coupler A chemical compound included in the emulsion of certain types of color films and papers that, during color development, contributes to the formation of image dye at the site of the developing silver image.
- color crossover In color images, an overall stain of some color in the highlights that shifts to a complementary color stain in the shadow areas, resulting from a difference in contrast among the three image layers.
- color fringes The rainbowlike outlines caused by lateral chromatic aberration of the lens that surround dark areas of the image and are particularly apparent in areas of high contrast near the edges of the image.
- color head An enlarger light source containing adjustable dichroic filters, which can be set to provide light of any color for color printing.
- color matrix A compact array of graded color filters, intended to be printed on color paper, to facilitate the selection of printing filters and the determination of print exposure.
- color temperature A standard for defining the color of light based upon its similarity to the light color emitted by a black body heated to a known temperature. Color temperature is expressed in degrees Kelvin, or "Kelvins," and is only appropriate for the description of continuous spectrum light such as is emitted by the sun, tungsten filament bulbs, etc.

coma An aberration of the lens that causes marginal light rays from a subject point off the lens axis to fail to converge at a common image point. The effect is most severe near the edges of the lens field and can usually be eliminated by stopping the lens down. It is a common defect of high-speed lenses.

compaction See contraction.

- compensating developer A developer whose activity tends to be inversely proportional to image density. It therefore is self-limiting, working relatively vigorously in areas of underexposure, and slowing down in the overexposed areas as density increases. No practical developer is outstanding in this respect, but those containing the reducing agent Pyrocatechol or two-solution Metol formulas are sometimes recommended. Almost any developer will tend to be more compensating in action when it is highly diluted and is used with only occasional and gentle agitation.
- complementary colors Any two colors in the subtractive system that produce black or dark neutral gray when mixed in the proper proportion. In the additive system, any two colors whose mixture results in white light.
- completion That state of development when essentially all of the exposed silver halides have been reduced to metallic silver; that is, when further development will produce no more image density.
- concave Hollowed out. The side of a spherical surface seen from the center of the sphere.
- condenser enlarger An enlarger employing condenser lenses to provide uniform illumination of the negative.
- condenser lens A positive lens used to concentrate light rays. Condensers are used in many enlargers to collect the light from the bulb and direct it through the negative into the enlarger lens.
- contact paper A printing paper, usually sensitized with silver chloride, intended for use in contact printing.
- contact printing A method of printing in which the negative is placed in contact with the printing paper, emulsion to emulsion, and held in that position in a printing frame. The exposure is made by exposing the frame to raw light so that the paper emulsion is exposed by light passing through the negative densities. Contact printers, machines containing a controllable printing light, are also used.
- contact screen Type of engraving screen in which the dots are not sharply defined but, rather, are surrounded by individual haloes of decreasing density. These screens will form excellent halftone negatives by simple contact printing methods. At least two types are used: gray screens for color work, and magenta screens to permit control of image contrast in black-and-white work. Also sometimes called halo-dot screens.

- continuous spectrum Light that contains an appreciable amount of all the visible wavelengths or colors. See discontinuous spectrum.
- continuous tone Describes an image containing a gradation of grays as well as black-and-white extremes. See dropout.
- contraction In the Zone System, reduced development that compensates for high subject contrast so as to produce normal contrast in the negative. Some photographers prefer the word compaction.
- contrast Density difference, usually of adjacent areas of the image.
- contrast grade A number or descriptive term assigned to a particular printing emulsion that identifies its contrast characteristic. In the range from 0 through 5, a normal contrast paper is usually considered to be 2, with the lower numbers indicating a tendency toward lower contrast and higher numbers indicating higher contrast. Printing filters for use with variablecontrast papers are numbered similarly. In some cases paper contrast is indicated by such terms as *soft, medium*, and *hard*, instead of by numbers.
- contrast index The numerical expression of the relationship between the negative density scale and the subject luminance range when, simply, the minimum useful image density is considered to be about 0.1 above base-plus-fog and the useful curve length is assumed to be 2.0. It is actually a specific form of average gradient.
- conversion filter A filter designed to shift the color temperature of subject illumination to match the color balance of the film in use. Generally refers to filters in the orange/blue range, such as the Wratten 85 (orange) and 80 (blue) series. See light-balancing filter.
- converter An optical unit that can be interposed between the camera body and lens to effectively double or triple the lens focal length; usually, but not always, with some loss of image quality, and always with a substantial loss of lens speed. Sometimes called an extender.
- convertible lens A lens whose two major components can be used either together or separately. They were once called "double anastigmats" because each half is separately corrected. When used together the two components yield the "normal" focal length and a relative aperture of about f/5.6 or f/6.3. When used separately the components work as long lenses—about 1.2 to 2.5 times the normal focal length—at reduced aperture. Performance and correction of the complete lens is excellent. The individual components are fair to moderately good.
- convex Bulging. The opposite of concave. The surface of a sphere seen from outside the sphere.

- copy stand A device consisting of a horizontal baseboard, vertical column with camera bracket, and symmetrically arranged light sources that facilitate photocopying of flatwork of moderate size, such as book pages, drawings, prints, and so on.
- correction The design and construction refinements of a lens that tend to minimize the aberrations. A practical photographic lens usually consists of several simple lenses (or glasses), since adequate correction normally requires a variety of types of glass and lens shapes, and meticulous spacing of the elements.
- **coverage** The area of the image (formed by a lens) that is of useful quality. Also, the area of the subject that the lens can record as an image of useful quality.
- crop To trim, or sometimes to cover, the borders of an image for any reason, but usually to improve the composition.
- cross light Light striking the subject from one side.
- curtain shutter A shutter variety in which a slit or opening in a strip of metal or cloth is made to travel past the film surface to effect the exposure. See leaf shutter.
- curvature of field The tendency of a simple lens to form its image on spherical, rather than a flat, plane.
- cut film Another name for sheet film. cyanotype process An iron-sensitive process that produces an image in
- bright blue dye. The blueprint process. **daguerreotype** Generally recognized as the first practical photographic process, it was invented by Louis Jacques Mandé Daguerre and announced publicly in 1839. The image was formed on a polished silver plate, sensitized by fuming with iodine, and developed, after camera exposure, in the vapors of warmed mercury.
- dark slide The black plastic or fiber sheet inserted into a film holder through a lighttight slot to seal the film chamber against light.
- daylight Sunlight or skylight or any mixture of the two. For the purposes of color photography, daylight is considered to have a color temperature of from about 5500°K to 6000°K; this condition is likely to exist when the sun is high and slightly overcast. Under other conditions the color of daylight is likely to be quite different from the "norm" and must be filtered if "normal" color rendition is desired.
- decamired Ten mireds. See mired. dedicated flash An electronic flash unit so designed that it senses and may actually control some camera functions. These units are usually designed for specific camera models and may, among other things, set the camera shutter at the appropriate synchronizing speed and provide "ready" and "proper exposure" lights in the camera viewfinder.
- deep tanks Commercial film processing equipment in which large volumes of processing solutions are agitated by nitrogen burst, and controlled replenishment maintains the solutions at optimum strength throughout their life.

- delay In synchronized flash photography, the interval between the application of the firing current to the bulb and the opening of the shutter. The delay interval is controlled by the shutter. See M, F, X.
- dense Descriptive of a negative that is dark overall, or of an area of a negative that has a heavy silver deposit and therefore transmits only a little light.
- densitometer An instrument designed to measure the amount of light transmitted by individual small areas of a negative or reflected by areas of a print image, thus appraising the density of the areas.
- density The common logarithm of the reciprocal of transmission. That characteristic of the image silver deposit that absorbs (or prevents it, for any reason, from transmitting) light. Transmission density refers to the absorption of transmitted light, as by areas of a negative. Print tones are described as reflection densities because they are seen and measured by reflected light.
- density range The range of densities represented by a photographic image. It is found by subtracting the lowest density value from the highest and is expressed numerically. Also called density scale.

density scale Same as density range. depth of field The region of acceptably

- sharp focus around the subject position, extending toward the camera and away from it, from the plane of sharpest focus. The boundaries of the depth of field are referred to as the near limit and the far limit.
- depth of field scale A calibrated scale, ring, or chart—often a part of the camera lens mount—on which the depth of field for any distance and aperture setting is indicated.
- depth of focus The little zone including the focal plane of the lens through which the film can be moved, toward and away from the lens, and still record an acceptably sharp image.
- desiccated Dried. Describes a substance from which at least some water has been removed. Not necessarily anhydrous. See anhydrous
- developer The solution that produces the silver image in the normal photographic process. It ordinarily contains a reducing agent, a preservative, an accelerator, and a restrainer in water solution. A practical developer must develop only the exposed silver halide grains in the emulsion, leaving the unexposed grains unaffected. Such a developer is called clean-working. A solution developing an appreciable quantity of unexposed halide is said to produce chemical fog.
- developer-incorporated Refers to certain black-and-white printing papers, such as Kodak Polycontrast Rapid RC III and Ilford Multigrade III, that include developing agents in their emulsion mixture.
- developing-out The photographic process in which relatively brief exposure produces a latent image that is made visible by subsequent development. See printing-out.

- diaphragm The assembly of thin metal leaves, usually incorporated into the lens barrel or shutter assembly, that can be adjusted to control the size of the lens aperture. Same as **iris diaphragm**.
- dichroic filter A filter, usually of glass coated with a thin film of some durable material, having the unique ability to transmit certain colors while reflecting the rest of the spectrum. Because the transmitted and reflected colors are complementary, the filter appears to change color in certain lights, hence the name "dichroic." Dichroic filters are highly resistant to heat and fading and are therefore especially suitable for use in color printing applications.
- dichroic fog A fairly rare discoloration of film caused by improper processing conditions. It's visible as a very thin surface layer (of colloidal silver) that typically appears reddish or purplish by transmitted light but greenish by reflected light.
- diffraction The tendency of light rays to be bent around the edge of an obstruction.
- diffusion Of light, the random scattering of rays as by transmission through a turbid medium or by reflection from a matte surface.
- diffusion enlarger An enlarger that employs diffused light to illuminate the negative.
- diffusion transfer Process in which, typically, an exposed film is treated in an activator solution, then rolled into contact with a special "receiving" film or paper. The image-forming substances not used in producing the negative image then diffuse into the emulsion of the receiving sheet to form the final positive image.
- **DIN** Deutsche Industrie Normen. The German system of film speed determination.
- diopter An optician's term that identifies the power of a lens. It expresses the reciprocal of the lens focal length in meters and is usually preceded by a plus or minus sign to indicate whether the lens is positive (converging) or negative (diverging). Thus, a close-up (positive) lens having a focal length of 50 cm (½ meter) would be labeled a +2 lens.
- direct positive A positive image formed from a positive original without an intervening negative step. Also, a process that produces a negative from a negative, or a positive from a positive, in a single step.
- discontinuous spectrum Light radiation from which certain wavelengths (colors) are missing or present in negligible amounts.
- dispersion The separation of a light ray into its component colors, as by a prism.
- distortion Sometimes referred to as linear distortion or curvilinear distortion, it is an aberration of the lens characterized by variable magnification of the image. The effect increases toward the edges of the image area and will cause straight lines near the edges of the subject field to be formed near the image margins as curved lines. Two forms are identified, pincushion and barrel distortion.

- D log E curve The graphic presentation of the relationship between exposure and density when development is a constant. When several conditions of development are expressed, the result is a "family of curves."
- Dmax Maximum density.
- Dmin Minimum density.
- dodging The practice of shading a relatively small area of the image in printing to prevent it from becoming too fully exposed, and thus to render it in the finished print as lighter in tone than it would otherwise have been. See burning-in.
- dodging tool Any device used in dodging. Usually, a thin wire handle on which is mounted a piece of cardboard trimmed to match the shape of the image area to be dodged.
- DR See density range.
- dropout A photograph from which certain tones—usually the grays—have been eliminated.
- drum dryer A machine (now obsolescent) for drying paper prints. It typically consists of a heated drum or cylinder of metal and an endless canvas belt that holds the prints in contact with the drum surface. The larger models are motorized for continuous operation.
- dry-mounting A method of mounting prints on cardboard or similar sheet materials. Dry-mounting tissue placed between the print and mount board is softened by the heat of a dry-mounting press to effect the bond.
- dry-mounting press A machine for drymounting prints. It has a large flat metal pressure plate that can apply uniform pressure and thermostatically controlled heat on the prints to be mounted.
- dry-mounting tissue A thin tissue paper impregnated with shellac or some similar material that, when heated sufficiently, softens to become an effective adhesive for paper.
- dry plate Term used in the 1880s to distinguish gelatin-coated glass plates (dry plates) from the previously very popular collodion-coated plates that had to be sensitized immediately before use and inserted into the camera while still damp.

DS Density Scale. See density range.

- dye-diffusion Diffusion transfer in which the image-forming process transfers dyes to the receiving layer. See diffusion transfer.
- dye transfer A method of making very high-quality color prints in which the final full-color image is produced by separate printings (transfers) of the three primary dye images—cyan, magenta, and yellow—from individual film matrices to a single sheet of prepared paper.
- easel The device, usually a frame of metal with adjustable metal masking strips, that holds printing paper flat for exposure under the enlarger and permits adjustments of the width of the picture borders.

- electronic flash A photographic light source that produces a brilliant flash of light by the discharge of electricity through a gas-filled glass or quartz flash tube. The flash duration is very short, usually less than 1/500 second, and there is no firing delay. Most flash tubes produce a light that approximates daylight in color; therefore, only minor filtration is required for use with daylight color films. Electronic flash is commonly referred to as **strobe**, an inaccurate nickname derived from stroboscope, a related but different device.
- element Of a lens, one of the unit structures. A term rather loosely used to refer to a single glass unit, a cemented unit of one or more glasses, or even a complete component of several airspaced and cemented glasses; as, "the front element (component) of a convertible lens."
- Elon Eastman Kodak's brand of pmethylaminophenol sulfate, most familiarly known as "Metol," which is itself a trade name (GAF, Agfa, Hauff, etc.). See Metol.
- emulsion The light-sensitive coating on photographic film or printing paper.
- enlarger A printing machine designed to project the image of an illuminated negative onto a sheet of sensitized paper. While all enlargers can be adjusted to make prints larger than the negative image, most can also be adapted to make prints reduced in scale as well, so the name is somewhat misleading.
- ER Exposure range.

ES See exposure scale.

- EVS A system intended to simplify the determination of exposure. It assigns the EV numbers, 0 through 12, to the shutter speeds, 1 second through 1/1000 second, and the EV numbers, 1 through 12, to the relative apertures, f/1.4 through f/64. Similarly, Additive Speed Values (ASV), 0 through 10, are assigned to ASA Indexes, 3 through 3200, and Light Value Scale (LVS) numbers, 0 through 10, are assigned to illumination levels of 6 footcandles through 6400 footcandles. In use, the sum of film speed (ASV) plus light intensity (LVS) yields a number that must be matched by the sum of a shutter speed EV number plus an aperture EV number. The system has not elicited much enthusiasm
- expansion In the Zone System, extended development that compensates for low subject contrast, so as to produce normal negative contrast.
- exposure (1) The act of subjecting a photosensitive material to the action of light. (2) The accumulated effect of the action of light on a sensitized material.
- exposure factor A number (multiplier) indicating the exposure increase required when, for example, a filter is used. The factor for a condition requiring, for example, four times the normal exposure would be written 4X.

- exposure index A number indicating the relative effective light sensitivity of a given film, as determined by any methods other than those proposed by the ANSI or similar organizations.
- exposure meter An instrument used to measure the luminance of the subject or the illumination level at the subject position, and to equate this information with the film speed to indicate appropriate camera aperture and shutter speed settings.
- exposure range The difference between the limits of exposure, expressed numerically as a simple ratio, or its equivalent value in stops or logs.
- exposure scale The range of exposures (usually the range of light intensities with exposure time a constant) required to produce, after suitable development, the useful range of densities that a given emulsion can produce. The term is relevant specifically to paper emulsions. extender See converter.
- extension tubes A set of three or more (usually) rings or tubes of varying lengths, intended to be interposed between the body and lens of a small camera, so as to permit focusing the lens on subjects very close to the camera
- eye relief The maximum distance that can separate the eye from the camera viewfinder ocular lens (eyepiece) while providing an unobstructed view of the entire finder image.
- F An index mark, found on some old camera shutters, that identifies the correct synchronizer setting for use with "fast peak" flashbulbs; now obsolete.
- factor A number by which the duration or effect of some action or process must, for some reason, be multiplied.
- failure of the reciprocity law Refers to the fact that sensitive emulsions, when subjected to extremely intense or extremely dim exposing lights, require more total exposure than would be predicted by the reciprocity law. See reciprocity law.
- fall Zone System term referring to the positioning of a measured high value of luminance on the meter scale, as the result of "placing" a related lower value on a selected "zone" on the scale. See zone.
- fall-off Progressive reduction in light intensity or exposure effect; as with distance from a light source, or as toward the dimmer margins of a centrally illuminated surface.
- Farmer's Reducer A water solution of potassium ferricyanide and sodium thiosulfate, proposed in 1883 by E. H. Farmer as an effective reducing solution for the silver image. It is still popular.
- fast A term used to describe lenses of large relative aperture or films of high sensitivity. Sometimes also applied to unusually sensitive papers.
- FB Fiber base. See fiber-based paper.

- feathering a light The technique of evening the illumination across a set by directing the bright central beam of a light toward the farthest objects, thus allowing the nearest objects to be illuminated by the less intense margins of the beam.
- ferrotype One name for the tintypes. They were also called melainotypes. They were made on small polished and varnished sheets of iron, hence the name ferro-type.
- ferrotype tins After gelatin-coated printing papers became popular, prints were sometimes dried by squeegeeing them, emulsion down, on a Japanned (varnished) iron sheet or ferrotype tin. Prints so treated dried with a high gloss and the technique of glossing a print came to be known as ferrotyping. Nowadays glossy fiber-based prints are sometimes dried on chromium-plated brass or plastic sheets or chromium or stainless steel drum dryers, but the term ferrotyping persists.
- fiber-based paper Printing paper whose base material is a high-quality paper, usually coated with a thin layer of barium sulfate (baryta). The term is clumsy but frequently used to distinguish plain paper-based materials from resin-coated papers. See resin-coated papers.
- field camera A simple view camera of special light-weight construction, intended for use outside the studio. Field cameras are usually built of wood and are designed to fold up compactly for carrying.
- field coverage The limits of the subject area that will be recorded on the film, expressed in degrees from the lens position. See angular coverage.
- field curvature See curvature of field. fill light Light directed into the shadow
- areas of the subject to reduce the lighting contrast.
- film Generally, the familiar light-sensitive material used in cameras in the practice of photography. It normally consists of a flexible, thin, transparent sheet or strip of acetate or polyester plastic coated on one side with a light-sensitive emulsion, and on the other with a dyed layer of gelatin to reduce curl and halation.
- film clip A spring clip of metal, plastic, or wood designed to hold the film securely as it hangs in the film dryer.
- film holder Thin container of plastic, metal, or wood—usually black designed to hold two sheets of film in separate compartments, back to back. Film is loaded into the holder in the darkroom and is protected from light by the dark slide. The film is positioned so accurately in the holder that, when it is inserted into the camera and the slide is withdrawn, the previously focused image falls precisely on the film surface, insuring that the photographer will actually get the picture he saw on the ground glass.

- film pack A metal container of several sheets of film, so designed that when the pack is loaded properly into the camera, an exposed sheet can be removed from the focal plane into a lighttight compartment and a fresh sheet can be positioned for the next exposure by simply pulling a paper tab protruding from the end of the pack. After all the films are exposed, the pack can be removed from the camera, but must be unloaded in the darkroom. Film packs are not normally reusable.
- film speed A number indicating the relative light sensitivity of a given film, as determined by some official body such as ANSI or the ISO.
- filter (1) To pass light through some material that absorbs selected wavelengths or colors or polarized portions of the light. (2) A sheet or disc of plastic, glass, or other material, usually colored, which can be used to absorb selected components of transmitted light.
- filter drawer A removable frame or holder, typically built into the lamp housing of an enlarger, designed to accept printing filters.
- filter factor The exposure increase required to compensate for light absorbed by a filter, generally expressed as a number by which the exposure time must be multiplied; as, for example, 4X.
- filter pack The assembled group of CC filters required to adjust the image color in color printing; also, the equivalent settings of the dichroic filter controls of a color enlarger.
- fingernail marks Slang term for little crescent-shaped gray, black, or occasionally translucent marks that appear on negatives, resulting from pressing or crimping the film before development, as, for example, when loading rollfilm (inexpertly) onto a tank reel. The emulsion may be either effectively exposed or desensitized by physical violence of this kind, and the marks are authentic parts of the developed silver image. They will almost always be seen to coincide with a visible crease in the film base. They cannot be removed.
- first developer In a reversal process, the developer that produces the first (usually negative) image, in preparation for a second development step that will produce the final image.
- first surface Describes a mirror whose reflecting layer lies on the exposed side of the supporting glass or plastic.
- fisheye lens A type of super wide-angle lens, or lens attachment, capable of covering a field of about 180°. Fisheye images are circular if the whole image appears on the film, and are notable for their barrel distortion.
- fix To make the film insensitive to further exposure to light, usually by bathing the emulsion with a solution containing hypo or some other effective silver halide solvent. Such a solution is called a fixing bath.

- fixing bath The chemical solution that, by dissolving the unused light-sensitive compounds, protects the film or paper image against further effect from exposure to light. See fix and hypo.
- flare Extraneous light, not part of the controlled image light, that passes through the lens to the film. Flare light resulting from diffusion of the normal image light by dirty lens surfaces, reflections from scratches or chips in the glass, or reflections from bright metal surfaces inside the camera usually causes a more or less general fogging of the film. Actual patterns, usually the outof-focus images of the lens aperture, are caused by multiple reflections of strong light between the various lens surfaces, and are called ghosts.
- flash General name for any photographic light source that produces a very brilliant, very brief pulse of light.
- flashbars An array of several small flashbulbs, each with its own reflector, mounted side-by-side on a common base and designed to permit sequential firing. Flipflash is a similar device.
- flashbulb A light source, similar in appearance to an ordinary electric light bulb, but containing a quantity of combustible wire and some priming material in an oxygen atmosphere. When a suitable electrical connection is made to the bulb terminals, the primer fires, igniting the wire which in turn burns very rapidly with a brilliant flash of light Typically, the flash reaches useful intensity about 15 milliseconds after the application of the firing current, with the peak intensity occurring at about 20 milliseconds. Total effective duration is in the order of 10 to 30 milliseconds. A flashbulb can only be used once, of course
- flashcube Small, cube-shaped assembly of four tiny flashbulbs, each with its own reflector, in a common housing. A special base design fits the flash socket of certain specialized cameras and permits the flash units to be fired in quick succession. Coupled with motorized film transport, flashcubes can be used to make four synchronized flash pictures in just a few seconds. Now obsolescent.
- flashing The technique of darkening an area of a print image by exposing the sensitized paper to raw white light. Flashing fogs the image unlike **dodging** and **burning-in**, both of which modify the effect of the image-forming light itself.
- flashmeter An exposure meter designed to measure the brief burst of light provided by electronic flash and to provide appropriate exposure information.
- flash synchronization The adjustment of the timing of the application of firing current to a flashbulb and the actuation of the shutter release so that the peak flash intensity occurs while the shutter is open.

- flat (1) A large, free-standing, movable wall or panel, usually painted white, and used as a reflector or background in studio photography. (2) A term used to describe a low-contrast image, usually in reference to a print; it implies that the contrast is *too* low.
- flat bed Describes a type of view camera whose basic support structure is a wide, flat frame, usually constructed of wood.
- floating elements A glass or group of glasses in a lens, designed to move independently during focusing so the lens spacing is optimized for all subject distances.
- flood A photographic light source designed to illuminate a wide area with light of relatively uniform intensity. Almost without exception, it implies an incandescent or fluorescent source, but flood reflectors are also available for use with flash sources.
- flop Slang term for "reverse"; as to turn a negative over purposely during printing, to reverse the image.
- f-number The numerical expression of the aperture diameter of a lens as a fraction of the focal length. See relative aperture.
- focal distance The distance from the lens to the plane of the focused image. In practice, it is usually measured from the plane of the lens diaphragm.
- focal length Loosely, the focal distance when the lens is focused on infinity; more accurately, the distance from the rear nodal point of the lens to the image plane when the lens is focused on infinity. See nodal point.
- focal plane shutter A curtain or blade shutter operating in the camera body just ahead of the film (or focal) plane.
- focus To adjust a camera, for example, so that an image is formed precisely on the film plane. Also a term applied to the adjustment of such instruments as binoculars and microscopes so as to provide a visual impression of sharpness in the image. Generally, the adjustment of any positive lens system so that light rays passing through it converge at a desired point. The convergence of light rays to a point.
- focusing aid A magnifying device that facilitates focusing the projected image during enlarging. Also sometimes called a "grain focuser" because it reveals the negative's granular texture.
- focusing cloth Sometimes also called dark cloth. A large square or rectangular piece of black material, usually cloth, used by photographers as an aid in focusing the image on the ground glass screen of a view camera. It is used to enclose the camera back and the photographer's head, thus excluding outside light to make the image appear bright and clear.
- fog Any tone or density (in the developed emulsion) caused by extraneous light or chemical action not related to the normal formation of image.

- footage scale The focusing scale on a lens or camera. It may be calibrated in either feet or meters.
- forced development Development deliberately prolonged considerably beyond the normal time. See push. FP shutter See focal plane shutter.
- frame (1) To adjust the position and angle of the camera with respect to the subject for the purpose of containing or composing the image within the boundaries of the viewfinder. (2) The useful area and shape of the film image; the picture.
- frame numbers Numbers printed on the paper backing strip and along the edges of rollfilm, and outside the perforations of 35mm filmstrips, which can be used to identify the individual pictures (or frames).
- freckling Slang term describing a common flaw in ferrotyped prints. Groups or areas of tiny dull spots in an otherwise highly glossy surface.
- fresnel lens A thin plastic sheet bearing concentric or spiral ridges that are actually sections of a convex lens. Fresnel (pronounced fray-nell) lenses are typically used in ground-glass viewing systems to brighten the image and make it appear more uniformly illuminated than it would otherwise be.
- frilling The detachment (and wrinkling) of areas of the emulsion layer along the edges of the film or paper base during processing. Likely to occur with, and for the same reasons as, reticulation. See reticulation.
- f-stop The common name for a lens aperture; also sometimes used to refer to the calibration numbers on the lens aperture scale, or to some specific setting of the aperture. See f-number.
 G See gradient.

GaAsP Chemical symbol for gallium

- arsenide phosphide, the compound from which gallium photo-diodes are made. Familiarly known by the initials GAP.
- gallium photo-diode A solid-state photoconductor, characterized by fast response time, freedom from memory effects, and relative insensitivity to infrared; used as a light sensor in some camera meters. Also known by the initials GPD.
- gamma A numerical expression of the gradient of the straight-line portion of the film characteristic curve. Loosely, an indication of the contrast of the image as influenced by development. See contrast index.
- gelatin A complex protein substance made from animal hides and hooves, which is used as a chemical-bearing medium and binder in the manufacture of photographic emulsions. Its many unique properties make it especially suitable for use in silver halide emulsions, but it is also an essential material in some nonsilver techniques such as the collotype and carbon processes.

- gelatin filter squares Thin sheets of dyed gelatin of high optical quality, available in various sizes and colors, and intended for use in the image light path for the selective absorption of color or for the control of light intensity.
- generated images General term for images that have been produced or extensively modified by some machine other than a camera—such as, for example, Xeroxed images, computer graphics, holograms, and so on.
- glacial acetic acid The concentrated (99%) form of acetic acid. It is a transparent, colorless, dense liquid with a sharp, powerfully penetrating odor. It freezes at about 16°C (60°F); it is an effective solvent for some plastics; and its vapors are flammable. It burns the skin painfully on brief contact and should be handled with caution. See acetic acid and short-stop.
- glasses The individual glass units that are assembled into groups to form a typical camera lens. See element and lens.
- glossing solution A bath in which prints are soaked briefly before being ferrotyped. It is intended to reduce freckling, prevent sticking, and generally improve the luster of the print surface.
- glossy Describes a printing paper with a smooth surface suitable for ferrotyping, or with a mirrorlike luster such as is produced by ferrotyping.
- GPD See gallium photo-diode.
- gradation Variation in tone. Tonal range or scale.
- grade A number that identifies the inherent contrast characteristic of blackand-white printing paper. The number 2 identifies a paper of "normal" contrast; higher numbers indicate higher contrast, lower numbers stand for lower contrast.
- gradient Slope, specifically the slope of a film characteristic curve or some section of one; therefore, an indication of image contrast.
- graduate A container—usually made of glass, enameled steel, stainless steel, or plastic—that is calibrated in fluid ounces or milliliters, or both, for use in measuring liquid volumes.
- grain The visible granular texture of the silver image, caused by apparent clumping of the individual silver particles, not usually apparent until the image is enlarged or viewed under magnification. grain focuser See focusing aid.
- gray (1) Any of the intermediate tones of a black-and-white image. (2) Describes a print image that is without extremes of tone and is unpleasantly low in contrast. See flat.
- gray card A card of known reflectance, usually 18 percent, intended to be placed in the subject area and used as a meter target in the determination of exposure. Also used in color photography to establish a neutral reference for the adjustment of print color.

- gray scale (1) The gradation of an image. (2) A strip of film or paper displaying individually uniform areas of density ranging from light to dark in a series of steps. Also sometimes called step tablets, they are used in testing the sensitivity and contrast characteristics of photographic materials.
- gross fog density See base-plus-fog density.
- ground glass A general name for the focusing screen in a reflex or view camera.
- group A single lens or, more typically, an assembly of two or more glasses, either air-spaced or cemented, that can be identified as one of the major units of a composite lens.
- guide number A number, used to estimate correct exposure in flash photography, that indicates the effective "power" of a flashbulb. Under the stated conditions, dividing the guide number by either an fnumber or a selected flash-to-subject distance will yield the other.
- gum process Also gum bichromate process. A method of printing in which the sensitized surface is a coating of gum arabic, a pigment, and a dichromate. The emulsion is rendered insoluble by exposure to bright light, and the image is ultimately composed of the areas of pigment that are not washed away during development in plain water.
- halation The fringe of halo sometimes occurring around very heavily exposed image points as excess light that penetrates the emulsion layer and is reflected back into the emulsion from the surfaces of the film base. It is reduced in modern films by dyeing the film base material or by applying a dyed gelatin layer, called the antihalation or antihalo backing, to the film back.
- halftone Printer's and engraver's term for an image that has been screened so as to produce the effect of continuous tone. This is accomplished by breaking up the image into halftone dots in a regular pattern too fine to be visually resolved under normal conditions. Tones of gray are identified by percentage numbers that indicate the total area of ink in a given area of the image. Thus a 10 percent gray would imply that the dots composing it were 1/10 as large in area as the area of the white paper separating them.
- halides Metallic compounds of the halogens, namely the elements fluorine, chlorine, bromine, and iodine. The chloride, bromide, and iodide of silver are the light-sensitive materials upon which most photographic processes are based.

halo-dot screen See contact screen.

- hand camera Little-used term to identify any camera that can be carried and used without a tripod. Also "hand-held" camera.
- H and D curves Film characteristic curves, specifically those plotted by F. Hurter and V. Driffield, who published their procedure in 1890.

- hangers The frames, usually of metal or plastic, in which sheet films are placed for processing in deep tanks.
- hard Term occasionally used to describe high contrast in images or lighting arrangements. See harsh.
- hardener A chemical solution for tanning or toughening the emulsion. Hardeners may be used as separate baths or they may be included in some other solution.
- harsh Implies an unpleasant lack of subtlety of gradation or light distribution. Contrasty, glaring.
- haze filter A nearly colorless, faintly yellowish filter with strong UV absorption, useful in reducing the photographic effect of atmospheric haze in some situations.
- high acutance A term used to describe a film that's capable of producing images with sharp edge definition.
- high key Describes a photograph consisting mostly of light gray tones.
- highlight mask A deliberately underexposed, high-contrast black-andwhite negative of a color transparency, which records only the highlight areas of the transparency and which is bound in register with the transparency while the principal color correcting masks are being made. Its purpose is to increase the highlight contrast of the final color print image in the dye transfer process. Highlight masks are also useful in blackand-white photography.
- highlights The brightest light accents in the subject. Also, the areas in the image corresponding to the subject highlights. In the negative, of course, the highlights are the most dense areas.
- hold back To retard image formation, specifically by dodging an area of an image during exposure.
- holder See film holder.
- hot shoe A mounting bracket designed to support an electronic flash unit and provide appropriate electrical connection with the camera, thus eliminating external wires. Often such units provide dedicated flash.
- hot-spot An undesirable concentration of light on the subject in studio photography. The brilliant area of illumination produced by the concentrated central beam of a floodlight or spotlight. An area of unusual brightness in the projected light from an enlarger or projector.
- hydroquinone Common name for pdihydroxybenzene, a reducing agent in many popular developers. Its fine, needlelike crystals are white, lustrous, and fairly soluble in plain water and in sulfite solutions. It keeps well in dry form, but only fairly well in solution. It is a highcontrast developer, especially so when accelerated with caustic alkalis, such as sodium hydroxide. It is normally nonstaining but must be heavily restrained to prevent fog. In general use, it is almost invariably teamed with Metol or Phenidone-combinations that not only exhibit the best features of each ingredient, but have some additional desirable characteristics of their own. See Metol and phenidone.

- hyperfocal distance The distance from the camera to the near plane of the depth of field when the lens is focused on infinity. Also the distance from the camera to the plane of sharpest focus when the far plane of the depth of field is at infinity.
- hyperfocal focusing Setting the focusing control so that the far limit of the depth of field (as located on the camera's depth of field scale) falls on infinity. The lens will then be focused most sharply on the hyperfocal distance and the depth of field will extend from half the hyperfocal distance to infinity.
- hypo The common nickname for the chemical sodium thiosulfate, which was originally called sodium hyposulfite by Sir John Frederick William Herschel, who discovered it in 1819 and recommended its use to Talbot in 1839. It is still considered one of the best of the few practical solvents for the silver halides and is the major ingredient in almost all of the general-purpose fixing baths. The term hypo is commonly used to refer not only to the chemical itself but also to fixing baths compounded with it, and even to those baths made with ammonium thiosulfate-the so-called rapid fixing baths.
- hypo-clearing bath A chemical solution, used after the fixing bath, in which blackand-white films and fiber-base papers can be treated to facilitate hypo removal during the following wash step. Also sometimes called a washing aid.
- hypo eliminator A bath for films and papers, recommended for use following the fixing bath and intended to convert the chemical products of fixation into compounds more readily soluble in water, thus facilitating washing and increasing the stability of the silver image. Most such baths are more properly called hypo-clearing baths because they do not really eliminate hypo but do aid in its removal.
- IDmax In this book, maximum image density.
- IDmin In this book, minimum image density.
- illuminance Light generated by, transmitted through, or reflected from the subject's surfaces.
- image The photographic representation of the subject photographed. The visible result of exposing and developing a photographic emulsion.
- incident light The light reaching the subject from any and all sources.
- incident meter An exposure meter designed or adapted for the measurement of incident light intensity or illuminance.
- indicator stop bath Stop bath to which an acid-sensitive yellow dye has been added. The dye signals approaching exhaustion of the stop bath by changing color from yellow to purple.

- infinity For photographic purposes, that distance from the camera beyond which no further focusing adjustment is required to maintain a satisfactory sharp image of a receding object. It varies with the focal length of the lens, the aperture, and the photographer's standard of sharpness, but for most purposes infinity can be considered to be beyond a quarter of a mile or so from the camera.
- infrared Name assigned to an extensive band of invisible, long wavelength electromagnetic radiations that continue the spectrum beyond visible red light. We can perceive a portion of the infrared spectrum as heat, and some special films are capable of making pictures by infrared.
- inspection A method of determining the extent of development by observing the image under dim safelight illumination.
- intensifier A solution used to increase the density or contrast of the silver image, usually to improve the printing characteristics of underdeveloped negatives.
- interchangeable lens A lens that can be removed from the camera body as a complete unit and replaced by another.
- interference The cancellation or reinforcement of light waves resulting from phase shifts such as may be caused by reflection between surfaces spaced apart by some appreciable fraction of the light wavelength. The effect is frequency-selective and often results in colors or patterns such as those visible in soap bubbles, oil films on water, and lens coatings.
- intermediate positive A positive image made from a negative original as a preliminary step in the production of a duplicate or enlarged negative.
- intermittent agitation In film processing, brief periods of agitation separated by longer periods of rest.
- internal reflection Light reflection between the various glass surfaces of a compound lens assembly.
- interval timer A device for indicating the end of a selected period of time, usually by ringing a bell or sounding a buzzer. It is used to time development and other procedures that must be carried out in darkness or where a conventional clock cannot be seen.
- inverse square law A statement to the effect that "illumination intensity on a surface will vary inversely with the square of the distance from the light source to the illuminated surface."
- iris diaphragm See diaphragm.
- irradiation The lateral spread of light, or "bleeding," beyond the normal borders of the photographic image, aggravated by overexposure. Generally in reference to film images.

- ISO Initials that stand for the International Organization for Standardization (International Standards Organization). In 1974 the ISO adopted a standard for determining film speeds that, in effect, combined our existing ASA (arithmetic) system with the German DIN (logarithmic) system. ISO film speeds, as presently used in this country, include both; so that, for example, Plus-X film is now rated ISO 125/22°—the degree sign indicating the DIN logarithmic value.
- Kelvin temperature Temperature on the absolute Celsius (or Centigrade) scale. In photography, another name for color temperature.
- Iantern slide A transparency mounted in a cardboard or metal frame or bound between glass plates for projection.
 Usually implies the 3¼'' × 4'' slide size used in large auditorium projectors. See slide.
- latent image The invisible impression on the sensitized emulsion produced by exposure to light in the developing-out processes. Development converts the latent image to a visible one.
- latitude Describes the maximum exposure range limits, within which a film or paper can record an image of satisfactory quality.

LCD See liquid crystal display.

- leader A strip of film or paper, attached to and preceding the useful film area of rollfilm, for threading the film into the camera and, in some cases, for protecting the unused film from light during storage and handling.
- leaf shutter A type of shutter, usually operating in the space between the major lens components or immediately behind the lens, consisting of a number of thin metal leaves or blades arranged concentrically around the lens axis, pivoted so they can either form an opening for the passage of light or overlap to block it. An associated mechanism controls the movement of the leaves and the duration of the exposure interval.

LED See light-emitting diode.

lens A disc of transparent glass, plastic, or other material whose opposite faces are ground into (usually) spherical, nonparallel surfaces (one face, but not both, may be plane) having a common central axis and capable of forming either a real or a virtual image. If the center of the lens is thicker than its edges, it will form a real image and is called a positive lens. If the center is thinner than the edges, only a virtual image can be formed and the lens is termed negative. A single lens is usually referred to as a simple lens and is used for picture-taking in only the cheapest cameras. In photography, the term lens usually refers to the complex composite structures of two or more glasses as used in a camera. See correction.

- lens barrel The metal tube in which a lens is mounted. It usually also contains a diaphragm assembly. A barrel-mounted lens does not have an integral shutter.
- **lensboard** The wooden or metal panel on which a view camera (or other) lens is mounted.
- lens hood A device for shielding the front element of a lens from direct light from outside the subject area so as to prevent or reduce flare.
- lens mount That portion of the camera body that holds the lens in position.lens shade Same as lens hood.
- lens system A group or series of lenses assembled for the purpose of controlling
- light. lens tissue A special soft, lintless tissue used for cleaning lens surfaces.
- light-balancing filter A color filter designed to adjust light color to match the color balance of the film in use. Generally describes filters in the Wratten 81 and 82 series, although often used interchangeably with conversion filter.
- light-emitting diode A solid state device that converts electric current directly into light. LEDs are used commonly as indicator and warning lights in camera viewfinders and electronic flash units.
- lighting ratio The measured difference between highlight and shadow illumination in the subject area, expressed either as a simple ratio (such as 4:1, for example) or in stops.
- light meter An instrument that measures light intensity. If supplied with a suitable computing scale, it becomes an exposure meter. The term is commonly used interchangeably with *exposure* meter.
- light primaries The three light colors red, green, and blue—which, when mixed together, produce a color we recognize as white. None of these colors can be produced by mixtures of any other colors, but appropriate mixtures of the primaries can make any color desired.
- light table A table with a trans-illuminated surface, used in viewing transparent film images and in some sorts of still-life photography.
- lighttight Describes a container, room, or space that light cannot enter or leave, or a door, baffle, or aperture that light cannot penetrate.
- light trap A device (such as, for example, a maze) that permits the passage of air or water or objects, but excludes light.
- limbo background A studio background of essentially uniform tone, generally achieved by placing the subject on a "sweep" of seamless paper that conceals the usual visible junction between the background wall and the floor plane.
- linear aperture The diameter of the lens opening.

- liquid crystal display A thin-film device whose surface can be selectively polarized by weak electric currents to display patterns such as letters and numerals. Although they are not as brilliant and easy to read as LED display devices, and are susceptible to damage from extreme heat, cold, or physical shock, LCDs are becoming increasingly popular as digital readouts in watches, exposure meters, and some cameras because of their very low power consumption.
- long lens A lens of longer-than-normal focal length. Most accurately applied to lenses of conventional construction, but also commonly used to refer to telephoto lenses as well.
- luminance Light reflected from, transmitted through or produced by, a surface.
- luminance meter A meter that measures luminance. Also sometimes called reflectance meter or reflected light meter.
- LVS Light value scale. See EVS.M The camera synchronizer setting that's appropriate for ordinary ("medium peak") flashbulbs.
- machine art Art generated, or extensively modified by machine. See generated images.
- mackie lines The light-toned lines typically formed around areas of heavy image density in the sabattier effect.
- macro-lens Also occasionally micro-lens. A term used to describe lenses especially corrected for use at short subject distances and generally applied only to those supplied for small cameras. The prefixes *macro* or *micro* often appear in the lens name.
- macrophotography The process of making very large photographic images; for example, photomurals. See microphotography.
- macro-zoom A zoom lens that provides unusually close focusing ability.
- magnification A factor that describes the relative sizes of subject and image; the number found by dividing some image dimension by its corresponding subject dimension.
- main light The light in a studio setup, usually the brightest one, that establishes the light and shadow pattern on the subject and thus describes the forms. Also sometimes called the modeling light.
- manual mode The setting on an automatic or semiautomatic camera that disengages the automatic functions and permits the photographer to select both aperture and shutter speed.
- mask A negative or positive transparency made for the purpose of masking the original image.
- masking The process of blocking out portions of the image area or its borders with opaque tape or paint. Also, the technique of modifying image gradation by registering negative and positive versions of the same image and printing them together to produce a new version.

- mat A wide-bordered frame, usually of cardboard, placed over a picture to define the composition, isolate the image area, and improve the appearance for presentation.
- mat-knife A short-bladed knife with a large handle and, usually, replaceable blades, intended for cutting cardboard. In use it is generally guided by a straightedge metal ruler.
- matrix In dye transfer printing, the final positive film image. The matrix image is in gelatin relief, and it is used to make the actual transfer of dye to the print paper surface. Three matrix images are required, one for each of the pigment primary colors. The plural is matrices, but professional printers call them "mats."
- matte Dull, unreflective, nonglossy; referring to surface texture.
- maximum aperture The largest useful opening of the lens. Wide open.
- medium peak Describes flashbulbs that are designed to reach maximum (peak) brilliance about 15 to 20 milliseconds after the firing current is applied to them. See M, F, X.
- meniscus In photography, describes a simple lens, one of whose faces is convex, the other concave.
- Metol Most common name for the reducing agent p-methylaminophenol sulfate. Also known as Elon, Pictol, Rhodol, Photol, etc. It has low staining tendencies, is easily accelerated by mild alkalis, and produces little fog. It is supplied as a white or slightly grayish powder that turns yellowish or brownish with age and oxidation. It keeps well in powder form, but oxidizes quite rapidly in solution. It works very rapidly, producing an image of neutral tone and very low contrast. It is considered to be a strong sensitizer and will produce an irritating and painful skin rash on those photographers who are unfortunately susceptible. It is generally used in combination with hydroquinone which complements its characteristics very satisfactorily.
- microphotography The photographic production of extremely small images, as in the preparation of masks for electronic microcircuits.
- microprism Descriptive of the structure of a type of focusing aid incorporated into the ground-glass viewing screen of some miniature cameras. Consisting of a multitude of minute three- or four-sided transparent refracting pyramids arranged in a regular pattern and placed in the center of the viewing screen, it functions as an area of rather coarse-textured ground glass for viewing, but provides a more sensitive indication of image sharpness than ordinary ground glass does.
- mired Pronounced "my-red," it is a contraction of *micro-reciprocal de*grees. It is a value found by multiplying the reciprocal of a color temperature by 1,000,000. The expression of color temperatures in mireds rather than the usual Kelvin degrees simplifies considerably the problem of filter selection for color photography in unusual conditions of light color.

- mirror lens Optical system employing a (usually) spherical mirror surface, rather than a positive glass lens, to form a real image. Most such lenses for photographic use incorporate one or more glass lenses in addition to the main mirror element to improve the system performance. These composite systems are called catadioptric systems.
- monobath Processing solution, usually for use with film emulsions, combining the functions of developer and fixing bath.
- monohydrate The stable form of sodium carbonate, and the one commonly specified in formulas calling for this chemical. If either the anhydrous or crystalline form is used in place of the monohydrated form, the amount, by weight, must be adjusted. See anhydrous.
- motor drive A battery-powered accessory which, when attached to a camera, permits automatic film advance for single-frame exposures as well as continuous, rapid sequence exposures at the rate of several frames per second.
- MQ Nickname for developers compounded with the reducing agents *M*etol and (Hydro-) *Q*uinone. Also sometimes called MH, for *M*etol-*H*ydroquinone.
- multicoating An improved method of lens coating, employing more than one coating layer on one or more of the lens surfaces.
- **nanometer** One millionth of a millimeter. A unit used in measuring the wavelength of light. See wavelength.
- ND Abbreviation for neutral density.
- negative Any photographic image in which the subject tones have been reversed. Specifically, the reversed-tone image resulting from the simple development of the film exposed in the camera in the conventional process of taking a picture.
- negative carrier The frame of glass or metal that holds the negative in printing position in the enlarger.
- negative lens A diverging lens, thinner at the center than at the edges, which can produce only a virtual image.
- neutral density filter A thin sheet or disc of glass, plastic, or gelatin, having plane and parallel faces, toned to some uniform and specific shade of gray, and intended for use over the camera lens during exposure for the purpose of reducing the intensity of the exposing light without changing its color. Sometimes called ND filters, they are available in accurately calibrated densities from 0.1 to 4.0.
- nicad battery A type of rechargeable battery whose active ingredients are nickel and cadmium.
- nodal point A point on the axis of a lens around which the lens can be rotated slightly without displacing the focused image of an object at infinity. Specifically, the point from which an accurate measurement of the lens focal length can be made.

- normal lens Any lens whose focal length is approximately equal to the diagonal measurement of the film frame. See frame, 2. The angular coverage of a normal lens is usually about 55° across the film frame diagonal. See angular coverage.
- notches Specifically, the notches that film manufacturers cut into one of the short edges of a sheet of film that identify the type of film by their number, shape, and position and that indicate the emulsion side of the film sheet by their placement.
- null The neutral reading (between positive and negative values) of any "zerocenter" meter; specifically, in photography, of certain exposure meters, such as the Gossen SBC Luna-Pro and some types of color analyzers.
- object The thing photographed. Often used interchangeably with subject, but usually applied to inanimate things. See subject.
- objective In optics generally, the lens or lens assembly that faces the object. The objective normally forms an aerial image, which (in a microscope, for example) is then viewed through the eyepiece or ocular lens. In photography, the term objective is sometimes used to refer to a camera lens.
- off-the-film Describes the type of exposure meter, built into certain cameras, that measures the intensity of image light on the film surface.
- one-shot developer A developing solution, usually compounded and stored in very concentrated form, intended to be highly diluted for one-time use, then discarded.
- opacity A measure of a material's ability to block or absorb light; the reciprocal of transmittance.
- opal bulb Electric light bulb having an unusually dense, translucent envelope of white opal glass, intended for use where uniform diffusion of light is important as, for example, in an enlarger.
- opaque (1) Incapable of transmitting light.
 (2) A special fine-ground tempera paint, usually brick-red or black, for use in blocking out (opaqueing) unwanted areas of the negative image prior to printing.
- open flash Method of taking pictures with flash in which the shutter is opened on *Time* or *Bulb* and the flash is fired manually.
- opening Refers to lens opening and is used, loosely, to mean either aperture or relative aperture.
- ordinary Refers to emulsions whose color sensitivity has not been extended beyond visible blue light. Ordinary films are not really ordinary any more. The vast majority of available film types are now panchromatic. See orthochromatic.
- ortho Abbreviation for orthochromatic. orthochromatic Type of emulsion that is sensitive to visible blue and green, but not to red. See panchromatic.
- OTF Abbreviation for off-the-film.
- outdated Photosensitive material (film or paper) that has not been used before its expiration date.

- overexposed Refers to a photographic image that has received too much light. override To manually change the exposure settings provided by the camera's built-in meter.
- oyster shelling A defect in glossy prints dried on flat ferrotype tins, which shows itself as a series of concentric rings or ridges of torn or strained emulsion, caused by uneven drying. Not common in prints dried on glossy drum dryers.
- pan (1) Abbreviation of panchromatic.
 (2) To swing a camera during the exposure to follow a moving object, and thus to render the object sharp against a blurred background.
- panchromatic Describes an emulsion sensitive to blue and green and some, or all, of the red region of the spectrum. See Type A, 2; Type B, 2; and Type C.
- paper The sensitized paper used in making photographic prints.
- paper negative A negative image on a paper base, prepared either by exposing the paper directly in a camera or by printing from a positive transparency. The term implies that the image is not in its final form and that another printing step will follow. If the image is finished for presentation as a negative, it would more likely be referred to as a negative print.
- parallax In photography, the differences in both the framing of the subject forms and their spatial relationships between the image seen by the camera viewfinder and that recorded on the film. Sometimes referred to as the parallax error.
- PC lens See perspective control lens.
- pentaprism The five-sided prism that corrects (erects and reverts) the groundglass image in the viewfinder of a singlelens reflex camera to provide a rightside-up, correct-from-left-to-right visual image for convenient viewing.
- perspective control lens Typically for SLR cameras, a moderately wide-angle lens in a special mount that allows the lens to be decentered with respect to the film, thus providing image controls similar to those obtainable with the rising front and lateral shifts of the view camera.
- pH A logarithmic scale of acidity in which 7 indicates neutrality, values less than 7 indicate acidity, and values greater than 7 indicate alkalinity.
- phenidone Ilford's trade name for 1-phenyl-3-pyrazolidone, a reducing agent becoming increasingly popular as a substitute for Metol, especially in combination with hydroguinone. PQ developers can be prepared and stored for long periods as highly concentrated liquid stock solutions, and their working solutions are highly active, cleanworking, and relatively stable. Phenidone is not significantly affected by bromide and must usually be restrained by benzotriazole. It is not considered to be as strong a sensitizer as Metol and is generally tolerated well by persons who are susceptible to "Metol poisoning.

- photoflood A type of incandescent light bulb of high efficiency but limited life, designed to burn at 3400°K. Formerly popular with amateur photographers because of their small size, modest cost, and low current requirements. They are now being superseded by quartzhalogen lights.
- photogram A shadow image made by simply placing objects on the sensitized surface of a sheet of photographic paper and exposing it to light. If the light is sufficiently intense and the exposure long enough, the exposed portions of the paper will turn dark, and the image is a light-toned record of the shadow pattern on a dark background. This is called printing-out the image. Relatively brief exposure to light will form a latent image that can be developed-out like a conventional print image. Developed-out images are more neutral in tone and more contrasty. Both types must be fixed to be preserved for any great length of time
- photogravure A process in which the image, etched into the polished surface of a grained copper or zinc plate, is filled with soft ink, scraped or wiped to clean the surface, and printed in a press.
- photomacrography The photography of objects under some magnification, usually employing accessory bellows units, extension tubes, supplementary lenses, or simple microscopes. Image magnification may range from about lifesize (1:1) to perhaps 50X.
- photomicrography Photography through a compound microscope.
- pigment primaries The primary colors in the subtractive color system—normally considered to be red, yellow, and blue, but in photography specifically magenta, yellow, and cyan.
- pincushion distortion One of the two forms of curvilinear distortion in which image magnification is disproportionately greater near the edges of the field than near the center. Thus, for example, the image of a large square, placed concentric with the image center, would assume the shape of a pincushion. Barrel distortion is the other, and opposite, form.
- pinhole (1) A very small aperture in the front panel or lensboard of a modified or contrived camera for the purpose of forming an unfocused but useful image on the film. (2) A small transparent spot, usually circular, in a negative image, marking the position of an air-bell that, by shielding the emulsion from the developer, prevented the formation of silver in that area.
- place In the Zone System, to align, on the exposure meter dial, a measured value of luminance with an index mark that represents a desired shade (or "zone") of image gray.

- plane of focus The position of the focused image in space; the image plane, as distinguished from the film plane which will usually, but not necessarily always, coincide with it. The term is actually misleading, because the image of any three-dimensional subject closer to the camera than infinity is not plane but three-dimensional; even the image of a flat subject is plane only under unusual conditions, usually being warped into one or more spherical curves.
- plate A sheet of glass or occasionally metal, coated with light-sensitive emulsion and usually intended for exposure in a camera.
- platinotype Another name for *platinum print*. An iron-sensitive process producing an image composed of platinum metal on paper.
- polarized light Light waves that have been caused to vibrate uniformly in, or parallel to, a particular plane.
- polarizer A transparent material, such as certain natural crystals and some plastics, capable of polarizing transmitted light.
- polarizing filter A lens accessory designed to transmit polarized image light.
- Pola-Screen Eastman Kodak's trade name for their line of polarizing filters.
- portrait attachment An old term (and a rather inappropriate one) for a close-up lens. See close-up lens.
- portrait lens A lens designed to produce soft-focus images, popular with portrait photographers. See spherical aberration.
- positive An image in which the tones or colors are similar to those of the subject.
- positive lens A converging lens; one having a relatively thick center and thin edges and can focus light to form a real image.
- posterization Popular name for a printing process in which the image gradation is arbitrarily limited to two or three tones of unmodulated gray (or color) resulting in a simplified posterlike pattern.
- PQ Refers to mixtures of *P*henidone and hydro*q*uinone, as used in developer formulas.
- preservative The ingredient in a developing or fixing solution that tends to prevent or retard spoiling, usually sodium sulfite.
- press-focus lever A device incorporated in many leaf shutters permitting the shutter blades to be opened, or held open, regardless of the speed setting. On some old shutters this was called a "blade arrestor."
- previsualization Zone System jargon for visualization of the print image before making the film exposure, as an aid in planning appropriate exposure and development.
- primary colors Those fundamental colors, in light or pigment, that cannot be created by mixing any others. See light primaries and pigment primaries.

- print In photography, the term is generally used to identify an image on paper produced by photographic means. It is usually understood to mean a positive image and implies a final image rather than an intermediate one in some longer process.
- print finishing The process of producing a permanent, presentable photographic print, sometimes including treatment in the fixing bath and the final wash, but certainly referring to drying, spotting, cropping, mounting, matting, and other related operations.
- printing filter Generally refers to one of the contrast-control filters used in printing on black-and-white variablecontrast papers.
- printing frame A shallow, rectangular frame of wood or metal equipped with a removable front glass and a separate folding back that can be fastened to the frame with leaf springs so as to hold a negative and a sheet of printing paper against the glass smoothly and tightly. In use, light is allowed to shine through the front glass and through the intervening negative to reach the printing emulsion. Also called a contact printing frame. See contact printing.
- printing-out A method of photographic printing in which a visible image is formed by the action of light directly, and without subsequent development.
- printing paper Photographic printing paper. Any paper coated with a lightsensitive substance, for making photographic images, but a term generally used in reference to commercially manufactured papers coated with gelatin emulsion containing silver halides as the sensitive materials.
- print quality This terms refers to the craftsmanship of the print and whatever evidences there are of the photographer's technical understanding and competence (or lack of them). But there are often intangibles involved that influence the viewer in ways difficult to explain, and these factors, whatever they are, must be included in the term. Print quality is unrelated to pictorial content.
- prism-reflex A type of camera, usually small, in which the viewfinder image is focused, right-side-up and correct from left to right, on a ground-glass screen and viewed through a magnifying eyepiece. The optical system accomplishing this includes both a mirror and a pentaprism, hence the name.
- probe The remote light-sensing element of a photometer or color analyzer, generally used to measure the intensity of projected image light on the easel surface, in printing.
- process (1) To subject photographic films or papers to chemical treatment—such as, for example, development. (2) The sequence of chemical steps required to produce the desired image or result.

- process lens A photographic lens especially designed and painstakingly constructed for the purpose of producing images of the highest quality at object distances of only a few focal lengths. Usually nearly symmetrical in construction and corrected apochromatically, these lenses are exceptionally free from distortion, of relatively long focal length, slow, and very expensive. They are used almost exclusively by professionals in industry and the graphic arts. The nearest equivalent for the small-camera user is the *macro*-lens.
- programmed mode An operating option, which can be selected on certain cameras, that provides for automatic setting of both aperture and shutter speed. See aperture priority and shutter priority.
- projection print Any print made by projection, rather than by contact. Usually interpreted to mean an enlargement.
- projector In photography, usually a machine used to project enlarged images onto a viewing screen, such as a slide projector or movie projector.
- proofing The process of making test exposures, frequently of an entire roll of negatives in a printing frame, to obtain a record of the images and aid in their selection.
- protective toning Controlled chemical treatment of the silver (print) image to decrease its susceptibility to fading and discoloration, without necessarily altering the image color appreciably.
- push To prolong the time of development of film in an effort to compensate for underexposure. Also, to underexpose a film deliberately with the intention of attempting compensation in development. To force, but only moderately. See forced development.
- pyro Common contraction of pyrogallic acid or 1, 2, 3-trihydroxybenzene. One of the first organic reducing agents to be used as a photographic developer, it is usually in the form of white prismatic crystals of irregular size and shape. It is a very active developer. It keeps well in dry form or in suitable stock solution, but oxidizes very rapidly in most working dilutions. It is usual to prepare the stock as three separate highly concentrated solutions: Sol. A containing the pyro, the restrainer, and a substantial quantity of an acid sulfite as a special preservative; Sol. B containing the normal preservative; and Sol. C containing the accelerator. Pyro developers of this kind typically produce a heavy yellowish stain image and also tan or harden the image gelatin as they work so that the final image combines silver, stain, and gelatin relief. Pyro stains the hands and utensils badly and the usual handling cautions should be observed

- **quartz light** Also quartz-iodine light or quartz-halogen light. An incandescent electric light of small size and high efficiency employing a tungsten filament burning in an atmosphere of iodine or bromine vapor and enclosed in a quartz envelope. Characterized by long life, exceptional resistance to blackening or dimming with age, and uniform color temperature.
- quench To limit flash duration; a function performed in most small electronic flash units by a light sensor that measures the accumulating light on the subject and a thyristor circuit that interrupts the flash current when a preset value of exposure has been reached.
- racked out Referring to the bellows of a view camera, the term means extended.
- rangefinder Primarily refers to an optical device consisting of a system of lenses and beam-splitting prisms, which when viewing the subject through two slightly separated objective lenses, presents the images together in the viewfinder. When the two images are made to coincide by turning a dial, the subject distance can be read from a calibrated scale. Now also used to refer to a simple arrangement of two small prisms incorporated into the viewing screen of some single-lens reflex cameras as a focusing aid.
- rangefinder camera A camera featuring a built-in, coupled, optical rangefinder, usually incorporated into the viewfinder and linked mechanically with the focusing mount of the lens so that bringing the rangefinder images into coincidence also focuses the lens.
- rangefinder prism A pair of plastic wedges so placed centrally on the ground glass of a viewfinder that they fracture out-of-focus image lines, thus facilitating focusing.
- raw light Unfocused light.
- RC papers See resin-coated papers. ready light A light, usually on the back of a small flash unit or in the viewfinder of a camera equipped with a dedicated flash unit to indicate when the unit is fully charged and ready to fire.
- real image An image that can be projected on a surface and seen with the unaided eye. See virtual image.
- reciprocity effects The effective decrease in sensitivity and change in image contrast that results when a sensitized material is exposed to either extremely intense or extremely dim illumination.
- reciprocity failure See failure of the reciprocity law.
- reciprocity law A law stating that exposure remains constant as long as the product of time and intensity remains constant.
- rectilinear Free from linear distortion. reducer A solution of chemicals capable of dissolving the developed silver image, thereby reducing its density.

- reducing agent In chemistry, a substance capable of reducing the positive charge of an ion by supplying electrons. Many reducing agents are capable of reducing silver halides to metallic silver, but only a few are appropriate for use as photographic developing agents. See developer.
- reel The metal or plastic spool featuring parallel spiral flanges (sometimes adjustable) on which rollfilms are wound for small tank processing.
- reflectance Describes the ability of a surface to reflect light.
- reflectance meter See luminance meter. reflection The rebounding of light from a surface, especially a plane polished surface. Also the image seen by reflection, such as the image "in" a mirror.
- reflector A surface used to reflect light. Photographic reflectors are usually sheets of cardboard, plywood, masonite, or stretched fabric, painted white or covered with metal foil.
- reflex camera A type of camera in which the viewfinder image is formed by a lens and reflected by an inclined mirror onto a ground-glass screen mounted in the top of the camera body. See single-lens reflex and twin-lens reflex.
- refraction The bending of light rays as they pass obliquely through the interfaces of transparent mediums of varying or different densities.
- register To superimpose one image on another of identical outline so that the forms and edges coincide.
- relative aperture The relationship between the diameter of the lens opening and the focal length of the lens. It is found by dividing the focal length by the diameter and is, strictly speaking, the number so found—as distinguished from the aperture, which includes the prefix *f*. This is a niggling distinction photographers use the terms interchangeably.
- replenisher A solution of chemicals, similar in composition to a developer but usually more concentrated, intended to be added in measured quantities to a developer after each use for the purpose of restoring the strength of the developer and extending its useful life.
- resin-coated papers Printing papers employing a special plastic-laminated base material that, by limiting water absorption, allows for very rapid processing and reduces drying time.
- restrainer An ingredient in a developer solution intended to inhibit the development of unexposed halides. In most solutions that contain one, the restrainer is potassium bromide or benzotriazole.

- reticulation The pattern of tiny wrinkles or tears in the emulsion of a negative that sometimes results when the film is subjected to temperature extremes or harsh chemical treatment during processing. In extreme cases, the emulsion may be detached from the film base in large patches. See frilling. Mild cases of reticulation are often overlooked or confused with the image grain. See grain.
- retro-focus lens A type of wide-angle lens, supplied for reflex cameras, which has a back focus greater than its focal length. This is made possible by special reversed telephoto design and provides clearance for the reflex mirror.
- reversal (1) The transformation of the original tonal scale from negative to positive or vice versa, which occurs whenever a conventional photographic emulsion is exposed and developed. (2) A special process by which exposed film is made to produce a positive image of the original subject. This is actually a double reversal of the subject tones; the film is first developed to form a conventional negative image that is then bleached out of the emulsion. The remaining unexposed silver halides are then fogged by exposure to raw light or chemical treatment and developed to form the final positive image.
- reverse adapter A threaded ring that permits attaching the front end of an SLR lens to the camera body so that the rear of the lens faces the subject—as is sometimes desirable in close-up work.
- rim light Backlight that illuminates the edges of the subject, producing a bright outline.
- ring light A circular electronic flash tube, designed to be mounted concentrically with the camera lens to provide axial lighting.
- rising front One of the shifts of a view camera, it refers to that adjustment of the camera lensboard that permits vertical displacement of the lens while allowing the lensboard to remain parallel with the film plane.
- rollfilm Film supplied in rolls rather than sheets, but especially those films protected from light by paper leaders rather than those supplied in protective cartridges of metal or plastic.
- rollfilm back A special film holder designed to permit a view camera to be used with rollfilm.
- sabattier effect The partial reversal of image tones caused by exposure of the emulsion to light during development, usually after the image has been partially formed. Named after Armand Sabattier who first described the effect in 1862. Commonly referred to as solarization, which is a misnomer. See solarization,

- safelight Illumination, used in various darkroom processes, having a color and intensity that will not appreciably affect the emulsions being handled. Bluesensitive emulsions can be handled in a yellow safelight and orthochromatic emulsions are generally unaffected by orange or red safelight. Image density resulting from excessive exposure to safelight or to an inappropriate safelight color is known as safelight fog.
- salted paper Photographic printing paper such as was described and used by Talbot in his calotype process. It can be prepared by soaking a sheet of goodquality paper in a weak solution of salt, then coating it with one or more layers of a silver nitrate solution. The halide formed is silver chloride. The paper is used for printing-out, and the image is an elegant purplish tone that, unfortunately, changes to brown during fixation.
- SBC See silicon blue cell.
- SBR See subject brightness range, for which this is an acronym. Subject luminance range is preferred.
- scale focusing A method of focusing a camera by measuring or estimating the subject distance and adjusting the focusing controls to align the appropriate mark on the footage scale with the fixed reference mark on the camera or lens body.
- scattering Loss of intensity of light in passing through a turbid medium. The shorter wavelengths are typically absorbed most readily, causing the transmitted light to appear yellowish or reddish. This is the atmospheric effect responsible for the warmth of color in late afternoon sunlight and in sunsets.
- scheimpflug principle In view camera use, the principle that, when the swings or tilts are employed, maximum image definition is obtained most efficiently when the extended planes of the subject, the camera lensboard, and the camera back all meet at a common line.
- screen (1) The surface upon which images are projected for viewing. Usually made of a special fabric painted white, covered with tiny glass or plastic beads, or metallized for maximum reflectance.
 (2) The sheet of glass or film containing a fine pattern of lines or dots, through which films are exposed in the production of halftone printing plates. See halftone and screened image.
 (3) Occasionally used to refer to the ground glass of a camera, as the viewing or focusing screen.
- screened image A photographic image composed of minute dots that vary individually in size in proportion to the intensity of the light that formed them. Photographs or other continuous-tone images must be screened for reproduction by letter-press or offset techniques in order to preserve the gradation of the original subject. See halftone.

- secondary colors Colors resulting when approximately equal parts of any pair of primary colors are mixed together.
- sensitivity In photography, the susceptibility of an emulsion to alteration by light energy.
- sensitometry The science of the measurement of the sensitivity, and related characteristics, of photographic materials.
- separation (1) The characteristics of any image area that make it visible against its background. (2) The process of recording on individual black-and-white films the extent and intensity of each of the primary color components of a photographic subject or image. (3) An image resulting from the process of color or tonal separation.
- separation negative In dye-transfer printing, a black-and-white negative whose image densities represent the relative amount and distribution of one of the three light primary colors in the subject.
- series adapter A type of lens accessory ring that permits one of the several old standard "series" sizes of filters, lens shades, and so on, to be used on a modern threaded lens.
- shadow area Any region of a photographic image that corresponds to an area of shade or shadow in the original subject. Loosely, any dark area of a positive or light area of a negative image.
- sharpness The subjective impression of clarity of definition and crispness of outline in the rendering of detail and texture of the photographic image.
- sheet film Film supplied in individual pieces; also called cut film.
- sheet film holder See film holder.
- shifts and swings The various adjustments of the front and rear standards of a view camera, provided for the purpose of facilitating framing, control of perspective, and the efficient use of the available depth of field. See rising front.
- short lens A lens of less-than-normal focal length; a wide-angle lens. See wideangle lens.
- short-stop Old term, still occasionally used, to describe an acid stop bath.
- shoulder The upper, diminishing-gradient portion of a film characteristic curve, which represents the region of overexposure.
- shutter The mechanism, sometimes electronically controlled, that opens and closes to admit light to the film chamber of a camera and control the length of the exposure interval. See leaf shutter, focal plane shutter, and between-the-lens shutter.
- shutter priority Camera operating mode in which the photographer selects a shutter speed and the camera automatically sets the lens aperture for correct exposure with the film in use. See programmed mode.

- shutter release The lever or plunger that, when pressed, allows the shutter mainspring to operate the shutter mechanism and make the exposure.
- shutter speed (1) The duration of the interval of exposure. (2) The marked settings on a shutter dial. The numbers represent the denominators of fractions of which 1 is the numerator.
- silicon blue cell A silicon photo-diode (SPD), specially blue-filtered to restrict its infrared sensitivity and popularly used in exposure meters and camera metering systems.
- silicon photo-diode A solid-state photoconductor device used in many modern cameras and meters as a light sensor. It is characterized by fast response time, freedom from memory effects, and sensitivity extending well into the infrared. Abbreviated as SPD.
- single-lens reflex A reflex camera in which the viewfinder image is formed by the camera lens and reflected to a topmounted viewing screen by a hinged mirror normally inclined behind the camera lens. During exposure of the film, the mirror flips up to seal the groundglass opening, allowing the image light to pass through to the film chamber. In most designs, a focal plane shutter is employed.
- skylight filter A faintly pinkish filter designed to absorb UV radiation and counteract the excessive blueness that might otherwise afflict color photographs taken on clear days, particularly at high altitudes.
- slave A remote electronic flash unit, designed to respond to, and fire in synchronization with, the flash from a wired unit triggered by the camera shutter.
- slide (1) A transparency mounted in cardboard, metal, plastic, or glass for projection onto a screen for viewing.
 (2) A shortened name for the dark slide of a film holder. See dark slide.
- slow A term used to describe the longer exposure intervals provided by the shutter, as "one-half second is a slow speed." Also applied to relatively insensitive emulsions, as a "slow film."
- SLR Abbreviation for single-lens reflex. sodium thiosulfate One of the few
- chemicals that, in solution, can dissolve the silver halides, and one of a still smaller group that is suitable for photographic use. It is the principal ingredient of ordinary fixing baths and is somewhat less active, but is also less prone to attack the developed silver image than is ammonium thiosulfate, which is used in the so-called rapid fixing baths. Available in both anhydrous and crystalline form, the crystals are generally used and are sometimes sold as hypo-rice. See hypo.

- soft (1) Describes an image that is not sharp; that is, one that is blurred, diffused, or not accurately focused.
 (2) Photographic emulsions, specifically printing papers, that tend to produce images of lower-than-normal contrast; for example, the paper grades 0 and 1, and some others of similar characteristics, are called soft papers.
- solarization Originally, the reversal of image tones occurring in the early printing-out processes resulting from extreme overexposure; now almost universally used to describe the sabattier effect. See sabattier effect.
- spectrum A complete and ordered series of electromagnetic wavelengths, usually construed to mean the band of visible wavelengths that we perceive as colors. The visible spectrum consists of wavelengths of from about 400 to 700 nanometers, a band representing a gradual color transition from deep violet through blue, green, yellow, orange, and red. The spectrum colors can be displayed by dispersing white light with a prism. A natural example, resulting from the dispersion of sunlight by raindrops, is the rainbow.
- speed A term used variously to refer to: (1) the relative sensitivity of a film or paper, (2) an ASA or ISO number, (3) the light-transmission ability of a lens opening, (4) an f-number, (5) a shutter setting, (6) the time interval provided by a shutter setting.
- spherical aberration The tendency, inherent in any simple positive lens whose surfaces are spherical, to focus light rays passing through the peripheral areas of the lens at points closer to the lens than the focal point of the central rays. This results in a zone, rather than a plane of focus, and produces a film image that is generally well defined, but overlayed and blended with a kind of ethereal diffusion. It is a common and troublesome defect in fast lenses, but can be greatly reduced by stopping down. It is deliberately left uncorrected in some lenses intended for portraiture so as to produce a pleasing softness of image
- spin dropout Slang term for Kodak's tone-line process.
- split-image rangefinder A variety of rangefinder in which the opposite halves of the image are displaced along a dividing line when the instrument is not properly focused. Correct distance is indicated when the image halves are adjusted to match. See rangefinder and superimposed rangefinder.
- spotmeter An exposure meter that measures reflected light, or luminance, over a field of only a degree or two. The portion of the subject being read is outlined on a viewing screen to facilitate accurate appraisal of the individual luminances of small areas of the subject.

- Spotone Trade name of a popular spotting dye available in several shades of warm, neutral, and cool colors to match almost any black-and-white print image tone.
- spot reading A measurement of the luminance of a small area of the subject—specifically, a reading made with a spotmeter.
- **spotting** The process of bleaching or painting out blemishes in the print image for the purpose of improving its appearance.
- spotting colors The dyes and especially the pigments used in spotting.
- spring back The entire assembly attached to and usually removable from the rear standard of a view or press camera, including the ground-glass viewing screen and the frame and springs that secure the film holder in position.

SR Subject range.

- stabilization The process of rendering the unexposed halides in the developed image resistant to further visible change by the action of light. Stabilized prints are not permanent and they are heavily contaminated with chemicals, but the process is a valuable one for many purposes because it is fast and convenient. It does, however, require a special machine called a stabilization processor and uses special papers and chemicals.
- stain Colored or toned area, generally of a print, caused by chemical oxidation or contamination and not usually stable, permanent, premeditated, or desirable. The exceptions are the stain images formed by such developing agents as pyrogallic acid, which have certain virtues.
- star filter A glass disc etched or scratched in a regular pattern, intended for use over the camera lens for the purpose of producing radiating streaks around the highlights of the image. A square of shiny window-screening or a stretched piece of nylon stocking will produce a similar result.
- step-down ring A threaded ring that adapts a lens to use accessories of smaller diameter than the lens can accept normally. A step-up ring similarly adapts the lens to use larger accessories.
- step tablet A gray scale composed of regular areas of density increasing in incremental progression. Film step tablets are intended for use with transmitted light; paper step tablets are used with reflected light.
- still development Development without agitation.
- stock (1) The base or support material, such as paper, on which sensitized photographic emulsions are coated.
 (2) The concentrated form of a photographic chemical solution that is commonly diluted into the working solution for use.

- stop (1) Originally a metal plate, centrally perforated, and intended for insertion into a slot in the barrel of a lens for the purpose of limiting the amount of light passing through the lens. Sometimes referred to as Waterhouse stops (after James Waterhouse, who devised the system in 1858), these stop plates were supplied in sets with apertures of different sizes. (2) The aperture or f/ number of a lens. (3) A change in exposure, from any cause, that doubles or halves the preceding one. For example, changing the shutter speed from 1/25 second to 1/100 second, other things being equal, is said to reduce the exposure by two stops. (4) Contraction of short-stop, the acid rinse bath that commonly follows the developer. (5) To immerse a print or negative in an acid bath to stop development.
- stop bath A mildly acid solution (typically about 1 percent acetic acid) in which films or prints are treated immediately after their removal from the developer. By neutralizing the developer alkali, the stop bath halts development and prolongs the life of the fixing bath.
- stop down To reduce the size of the aperture of a lens.
- straight line portion The central length of the D log E curve, between the toe and the shoulder, representing a progression of image densities that are uniformly proportional to their corresponding increments of exposure. The portion of the curve exhibiting uniform gradient.
- strobe Shortened form of the word stroboscope. A special form of electronic flash unit capable of firing repeatedly and automatically at rates that can be varied from a few flashes per second to hundreds. This term is applied inaccurately, but almost universally, to ordinary photographic electronic flash units that usually require several seconds to recharge after each flash and do not flash repetitively. See electronic flash.
- subject The thing or view photographed. There is some implication that the term *subject* refers to animate things, and that *object* refers to inanimate things, but the terms are generally used interchangeably.
- subject brightness range See subject luminance range, a preferable term.
- subject luminance range The numerical difference between the light intensities of the shadows and the highlights of a subject as expressed in arithmetic or logarithmic terms, or in terms of the number of stops represented. Sometimes called "subject brightness range."
- subject range See subject luminance range.

- subtractive system The system of color mixing involving pigments or dyes in which the primaries represent the most intense and brightest colors available and any mixture of them must necessarily be darker and less intense. Pigments and dyes are seen to be colored because they reflect that color of the incident white light, absorbing the remaining wavelengths. The absence of all pigment color is assumed to be white, as represented by the untouched ground or surface that reflects light without selective absorption. Since each of the three pigment primaries absorbs one of the three light primaries, a mixture of the three pigments will absorb virtually all of the incident light, theoretically providing the visual effect of black. See additive system and pigment primaries.
- superimposed rangefinder A type of rangefinder in which the two images appear to overlap. One is usually slightly tinted for easy identification, and the instrument will indicate the correct subject distance when the images are adjusted to coincide by superimposition. See split-image rangefinder.
- supplementary lens A simple lens or lens system to be used over a camera lens for the purpose of altering effective focal length.
- surface A term relating to printing paper, referring specifically to the texture of the emulsion coating.
- swings and tilts Another name for the adjustments of a view camera. See shifts and swings.
- synchronizer The device, usually included in the shutter mechanism, that fires a flash unit at the precise moment required to provide peak light intensity during the instant that the shutter is open.

T See time.

- tabular grain (T-Grain) Describes an emulsion type in which the individual silver halide particles are formed into thin, flat wafers instead of the conventional irregular granules. T-Grain film emulsions are said to combine high effective film speed with relatively fine image grain size.
- tacking iron A small, electrically heated, thermostatially controlled tool used to tack or attach dry-mounting tissue to the back of a print or to the mount board, so as to hold it in place while the print is being trimmed and heated in the drymount press.
- taking lens The lens that forms the film image in a twin-lens reflex camera, as distinguished from the viewing lens that forms the viewfinder image.
- tank A small, lighttight container, usually of plastic or metal, in which film is placed for processing. Also the larger rectangular containers of hard rubber, plastic, or stainless steel used in sheetfilm processing, sometimes called deep tanks.

- tanning developer A developer solution that hardens the gelatin of the emulsion in the same areas and at the same time that it develops the silver image.
- telephoto A type of lens constructed in such a way that its physical length is unusually short in relation to its focal length. Telephoto lenses are usually more compact and sometimes lighter in weight than conventional lenses of similar aperture and focal length. They are invariably used as long lenses because their angular coverage is inherently restricted, and they are more likely to suffer from distortion and chromatic aberrations than are conventional lenses.
- tent lighting Lighting technique that involves isolating the subject in a plain environment or "tent" so that surface reflections and lighting effects can be closely controlled.
- Tessar A modified and improved version of the Cooke triplet lens, in which the rear element of the triplet was replaced by a cemented pair. Designed by Paul Rudolph for Zeiss in 1902, it was enormously successful and is still considered an excellent design for lenses of normal coverage and moderately wide aperture. It has been widely copied, and virtually every lens manufacturer in the world now has a few Tessar-type lenses among his offerings.
- test strip A piece of paper or film subjected to a sequence of regular and cumulative exposures and controlled development, so as to sample the estimated range of useful exposures in an effort to determine the optimum one.
- thin Describes the appearance of a transparency image (usually the negative) of low overall density.
- thin-emulsion film One of a group of modern roll and 35mm films coated with an unusually thin layer of silver-rich emulsion and capable of producing images of high resolution, relatively fine grain, and brilliant gradation. They are typically of medium or low speed and tend to produce high contrast unless specially processed.
- time One of the marked speeds on most shutters. A shutter set on *Time* will open when the shutter release is pressed and will remain open until the release is pressed again. It is a convenient setting for exposure intervals of more than a few seconds. See bulb.
- time-and-temperature The method of controlling film development, when the film is processed in small tanks or in total darkness in large tanks or trays, by maintaining the process solutions at a known temperature and limiting the duration of development to a selected interval. See inspection.
- time exposure Specifically, a camera exposure made by setting the shutter dial on *T*, but generally used to refer to any exposure, timed manually, of longer than a second or so.

- timer A mechanical or electronic device used to terminate an exposure interval or ring a bell or otherwise indicate the end of some selected interval of time.
- tintype Common name for the ferrotype or melainotype. Tintypes are collodion images on japanned (black varnished) iron sheets. Exposed in the camera and treated to appear as positive images, each tintype is unique. They were relatively inexpensive and extremely popular in the 1860s and 1870s.
- TLR See twin-lens reflex.
- toe The lower segment of the D log E curve, characterized by its progressively increasing slope or gradient. Its lowest extreme represents the region of underexposure of the emulsion.
- tonal scale The range of grays or densities of a photographic image. Gradation.
- tone-line process A method of producing a photographic image that resembles a pen-and-ink drawing. It includes a step in which a high-contrast film material in contact with a fully masked negative is exposed to slanting light while being rotated on a phonograph turntable, and is, therefore, sometimes called the spin dropout process.
- toner Any solution of chemicals used to alter the color of the silver image, either during development or, usually, as a postdevelopment treatment.
- trailer The length of opaque film or attached paper following the useful image area of the film strip that, when wrapped in several layers around the exposed film roll, serves to protect the image exposures from raw light.
- translucent Describes a diffusing material that will transmit light, but not focused light.
- transmittance The measure of a material's ability to transmit light, expressed as a ratio or percentage.
- transparency An image viewed by transmitted light. Specifically a film image, usually positive and often in color, intended for projection.
- tray The shallow, rectangular, open containers in which prints, and sometimes films, are processed. In England they are called dishes.
- tricolor printing A method of color printing in which three separate exposures are given—each filtered through one of the three additive primary colors.
- triplet A lens of three elements, specifically the three-glass lens designed in 1893 by H. D. Taylor and known as the Cooke triplet. It was considered a breakthrough in lens design and is the ancestral prototype of a great many modern lenses.
- tripod A three-legged stand, usually adjustable in height and provided with a tilting and swivelling head, on which a camera can be fastened for support and stability during use.
- TTL Through-the-lens; describes a type of exposure meter, incorporated in the structure of a camera, that reads the intensity of the image light transmitted by a lens.

- tungsten film Color film that's balanced for use in tungsten light. Two types are presently available: type A film, balanced for 3400°K; and type B film, balanced for 3200°K.
- tungsten-halogen Describes a type of tungsten lamp featuring a quartz envelope containing iodine or bromine vapor that protects the tungsten filament from premature failure and provides unusually consistent light color and intensity throughout its life.
- tungsten light Generally, the light emitted by a heated tungsten filament such as is contained in conventional electric light bulbs. Sometimes used to refer specifically to the light of special photographic tungsten-filament bulbs, which are designed to burn at either 3200 °K or 3400 °K. Also often used loosely to apply to artificial light in general, as distinguished from daylight.
- twin-lens reflex A type of reflex camera using separate but similar lenses in separate compartments of the camera body for the individual functions of viewing and recording the image. See single-lens reflex.
- Type A (1) Refers to those color films that have been balanced or specially sensitized for use in tungsten light of 3400°K. (2) Now rarely used to refer to panchromatic emulsions whose sensitivity to red light is minimal.
- Type B (1) The group of color films intended for use in tungsten light of 3200°K. (2) Occasionally, the designation of panchromatic films whose redsensitivity approximates that of the human eye.
- Type C Rarely used designation for panchromatic films whose red-sensitivity exceeds that of the human eye.
- **ultraviolet** The common name for the band of short wavelength, high-frequency electromagnetic radiations bordering the visible spectrum beyond visible violet light.
- underexposed Refers to a photographic image that has received too little light.
- unit magnification The formation by a lens system of an image identical in size or scale with the subject.
- US Uniform system. The name of an obsolete system of lens aperture scale marking that expressed, inversely, the arithmetic relationship of the light transmission of the various apertures. In the system, the number 1 was assigned to the aperture f/4.0, 2 was equivalent to f/5.6, 4 equalled f/8.0, 8 equalled f/11.0, etc.

UV Ultraviolet

value Lightness or darkness of tone, irrespective of hue.

- variable-contrast paper A type of printing paper coated with a mixture of two emulsions that are separately sensitized to (usually) green and blue light, and of different speeds. The overall contrast rendition of the paper can be controlled by varying the proportions of green and blue in the exposing light. With most such papers, green light will produce an image of low contrast, while high contrast will result from exposure to blue light. Light color—and therefore image contrast—is controlled by filters, each numbered to indicate the paper grade to which it corresponds.
- view camera A type of camera in which the image is viewed and composed on a ground-glass screen placed precisely at the film plane. The viewed image is therefore identical to the one presented to the film during exposure. After the image has been focused and composed, the ground glass is replaced by the film in a suitable holder and the picture is made. Most view cameras provide for considerable adjustment of the relative positions of the lensboard and film plane. They are typically designed to accept sheet film in the larger sizes and must be used on a tripod or other firm support. See shifts and swings.
- viewfinder The aperture or optical device, usually an integral part of the camera, through which or in which the subject can be seen, appraised, and composed.
- viewing lens In a twin-lens reflex camera, the lens forming the viewfinder image. See taking lens.
- vignetted Describes an image whose edges or corners have lost density, definition, or contrast. Print images are sometimes vignetted purposely to eliminate or subdue unwanted detail. Vignetting can also occur in the camera if the lens used cannot cover the film area adequately or if lens accessories, such as filters or sunshades, restrict the lens's angular coverage.
- virtual image An image, such as is typically formed by a negative lens, that can be seen in the lens or as an aerial image, but cannot be formed on a screen.
- warm tones In photography, shades of red or orange (browns) in the black-andwhite silver image. Generally, similar shades in the color or tone of any material.
- washed out A term to describe a pale, lifeless, gray print image, usually implying loss of highlight detail, such as might typically result from underexposure of the print.
- washing aid Another term for the hypoclearing bath.

- watersoak A mottled translucency in certain fiber-base papers, especially single-weight papers, apparently due to saturation of the paper fibers during processing. It usually disappears as the print dries.
- wavelength The distance from crest to crest or from trough to trough of adjacent cyclic waveforms. The completion of a single waveform, including crest and trough, is called a cycle, and the number of cycles completed in a second of time is called the frequency (of vibration) of the waveform. The traditional units of wavelength measurement in light are the Angstrom Unit, abbreviated Å and equal to 1/10,000,000 of a millimeter, and the millimicron, equivalent to 1/1,000,000 of a millimeter. The preferred unit is now the nanometer, which is equivalent to the millimicron. The unit of frequency is the Hertz, cycles per second.
- weak Describes an image that is not fully formed or which is unpleasantly low in contrast or density. Pale, gray, lifeless.
- wedging The deviation of a light ray in passing, for example, from air through a glass plate with plane, but not parallel, faces. Also sometimes used loosely to describe the lateral displacement of an image being projected through a thick glass or plastic filter that is slightly tilted in the light beam.
- weight The thickness of printing paper stock.
- wet-mounting Methods of attaching prints to their mounts by means of liquid, especially water-based glues or adhesives.
- wet-plate process Another name for the collodion process, in which glass plates coated with a thin film of salted collodion were sensitized in a solution of silver nitrate and immediately loaded into the camera for exposure while still damp. The process was popular from about 1850 until about 1880 when it was largely superseded by gelatin-coated dry plates.
- wetting agent One of a number of chemical substances that destroy the surface tension of water, thus permitting it to "wet" surfaces that might otherwise be water-repellent. It's used in very diluted solution as a final rinse in film processing to minimize water spots on the dried negatives.
- white light Generally used (as distinct from safelight) to refer to any light that is capable of exposing an emulsion. Also, in color photography, it describes light of a Kelvin temperature suitable for use with a particular emulsion type. Thus, white light for daylight film is considered to be about 5600°K, while "Type A" film white light is 3400°K, etc.

- white light printing The common method of color printing in which a single exposure is given through a filter pack that's chosen to balance the printing light for correct color rendering in the print.
- wide-angle lens Describes a lens whose angular coverage is substantially greater than that of a "normal" lens. Also sometimes called "wide field."
- winder A battery-powered camera accessory similar to a motor drive but intended primarily for single-frame operation. Some winders are capable of automatic sequence photography at speeds of up to about two frames per second.
- working solution Any solution used in photographic processing, as distinguished from stock or storage solutions, which are usually more concentrated for better keeping qualities. Stock solutions are almost invariably diluted for use, to make the working solution.
- **X** The setting of the shutter synchronizer control that's appropriate for use with electronic flash.
- zone In the Zone System, a specific subject tone as it will be rendered in the print. Seven to nine Zones are usually described as covering the useful range of print tones and each is assigned a number; thus, Zone III is considered to represent very dark gray in the print. Zone V is middle gray, Zone IX is maximum paper white, etc. In the subject the Zones are defined as being luminances and the interval between adjacent Zones of a "normal" subject is one stop.
- zone focusing Adjustment of the camera controls to achieve depth of field between selected near and far limits in the subject space. Often done in anticipation of the sudden or brief appearance of some subject whose position or movements can be predicted only generally.
- **zone system** A method of exposure and development determination advanced by Ansel Adams, and later propounded by Minor White, which involves analysis of the luminances of the significant areas and the tonal extremes of the subject and the previsualization of their translation into print densities. It is a logical theory, but one that tends to become pseudo-scientific, if not actually intuitive, in practice.
- zoom lens A type of lens of very complex structure that can be adjusted in use to provide a continuous range of focal lengths within its design limits. They are very popular with cinematographers and are also widely used in still photography with small cameras.

Bibliography

History Books of General Interest

- Braive, Michel. The Photograph: A Social History. New York: McGraw-Hill Book Company, 1966.
- Camera Work: An Anthology. Millerton, NY: Aperture, 1973.
- Doty, Robert. *Photo Secession: Photography as a Fine Art.* Rochester, NY: The George Eastman House, 1960.
- Emerson, Peter Henry. Naturalistic Photography for Students of the Art. 3d ed., including The Death of Naturalistic Photography. London: 1891; New York: 1899. Facsimile edition. New York: Arno Press, 1973.
- Gardner, Alexander. Gardner's Photographic Sketchbook of the Civil War. New York: Dover Publications, 1959.
- Gernsheim, Helmut, and Gernsheim, Alison. *The History of Photography 1685–1914*. New York: McGraw-Hill Book Company, 1969.
- Green, Jonathan. American Photography: A Critical History 1945 to the Present. New York, NY: H. N. Abrams, 1984.
- Mees, C. E. Kenneth. From Dry Plates to Ektachrome Film. New York: Ziff-Davis, 1961
- Newhall, Beaumont. The History of Photography from 1839 to the Present. 5th ed. New York: The Museum of Modern Art, 1982.
- Newhall, Nancy, ed. The Daybooks of Edward Weston, Vol. I, Mexico. Millerton, NY: Aperture, 1973.
- ——. The Daybooks of Edward Weston, Vol. II, California. Millerton, NY: Aperture, 1973.
- Rudisill, Richard. Mirror Image: The Influence of the Daguerreotype on American Society. Albuquerque, NM: University of New Mexico Press, 1971.
- Taft, Robert. *Photography and the American Scene*. New York: Dover Publications, 1964.

Contemporary Text, Reference, and Instructional Books

- Adams, Ansel, with collaboration of Robert Baker. *The Negative.* Boston: New York Graphic Society, 1981.
- ———. The Print. Boston: New York Graphic Society, 1983.
- Curtin, Dennis, and Maio, J. C. *The Darkroom Handbook*. Marblehead, MA: Curtin and London, 1979. Distributed by Focal Press.
- Davis, Phil. *Beyond The Zone System*. Somerville, MA: Curtin and London, 1981. Distributed by Focal Press.
- Eaton, George T. *Photographic Chemistry.* Hastings On Hudson, NY: Morgan and Morgan, 1965
- The Focal Encyclopedia of Photography. New York McGraw-Hill Book Company, 1969.
- Gassan, Arnold. *The Color Print Book*. Rochester, NY: Light Impressions Corp., 1981. ———. Handbook for Contemporary Photography.
- 4th ed. Rochester, NY: Light Impressions, 1977. Henry, Richard J. *Controls in Black-and-White*
- *Photography*. Monterey, CA: ANGEL Press, 1983.

- Horenstein, Henry. *Beyond Basic Photography*. Boston: Little, Brown and Co., 1977.
- LIFE Library of Photography. New York: Time-Life books, 1970. Also, The Art of Photography. The Camera; Color; Frontiers of Photography; Great Photographers; Light and Film, Photojournalism; The Print; and The Studio.
- Pittaro, Ernest M., ed. *Photo-Lab Index*. Dobbs Ferry, NY: Morgan and Morgan, 1979.
- Stone, Jim, ed. Darkroom Dynamics: A Guide to Creative Darkroom Techniques. Somerville, MA: Curtin and London, 1979. Distributed by Focal Press.
- Stroebel, Leslie. *View Camera Technique*. New York: Hastings House, 1967.
- Swedlund, Charles. Photography: A Handbook of History, Materials and Processes. 2d ed. New York: Holt, Rinehart and Winston, 1981.
- Todd, Hollis N., and Zakia, Richard D. *Photographic Sensitometry*. Hastings On Hudson, NY: Morgan and Morgan, 1969.
- Upton, Barbara London, with Upton, John. Photography. 3d ed. Boston: Little, Brown and
- Co., 1984. Vestal, David. The Craft of Photography. New York:
- Harper and Row, 1975.

—____. The Art of Black and White Enlarging. New York: Harper and Row, 1984.

White, Minor; Zakia, Richard; and Lorenz, Peter. *The New Zone System Manual.* Hastings On Hudson, NY: Morgan and Morgan, 1976.

Historic Processes Reference Books

- Bunnell, Peter C., ed. Nonsilver Printing Processes Four Selections, 1886–1927. Facsimile edition. New York: Arno Press, 1973.
- Burbank, W. H. Photographic Printing Methods. 3d ed. New York: 1891. Facsimile edition. New York: Arno Press, 1973.
- Burton, W. K. Practical Guide to Photographic and Photo-Mechanical Printing. London: Marion and Co., 1887.
- Crawford, William. The Keepers of Light: A History and Working Guide to Early Photographic Processes. Dobbs Ferry, NY: Morgan and Morgan, 1979.
- Denison, Herbert. A Treatise on Photogravure. London: Iliffe and Son, 1895. Reprint edition by Nathan Lyons. Rochester, NY: Visual Studies Workshop and Light Impressions Corporation, 1974.
- Ferguson, W. B. *The Photographic Researches of Ferdinand Hurter and Vero C. Driffield.* Facsimile edition, with introduction by Walter Clark. Dobbs Ferry, NY: Morgan and Morgan, 1974.
- Friedman, Joseph S. History of Color Photography. Boston: The American Photographic Publishing Co., 1945.
- Henney, Keith, and Dudley, Beverly, eds. Handbook of Photography. New York: Whittlesey House, 1939.

- Jones, Bernard E., ed. Cassell's Cyclopaedia of Photography. London: 1911. Facsimile edition New York: Arno Press, 1973.
- Lietze, Ernst. Modern Heliographic Processes. New York: D. Van Nostrand Company, 1888. Reprint edition by Nathan Lyons. Rochester, NY: Visual Studies Workshop and Light Impressions Corporation, 1974.
- Root, Marcus Aurelius. The Camera and the Pencil, or Heliographic Art. Philadelphia: Lippincott and Co., 1864. Facsimile with introduction by Beaumont Newhall. Pawlet, Vermont: Helios, 1971.
- Scopick, David. The Gum Bichromate Book Rochester, NY: Light Impressions, 1978.
- Snelling, Henry H. Art of Photography. Facsimile edition Hastings On Hudson, NY: Morgan and Morgan, 1970.
- Sobieszek, Robert A., ed. The Collodion Process and the Ferrotype: Three Accounts, 1854–1872. Facsimile edition. New York: Arno Press, 1973.
- Towler, J. *The Silver Sunbeam*. A facsimile of the 1864 edition with introduction by Beaumont Newhall. Hastings On Hudson, NY: Morgan and Morgan, 1969.
- Vogel, Hermann. The Chemistry of Light and Photography. New York: 1875. Facsimile edition. New York: Arno Press, 1973.
- Wilson, Edward L. *The American Carbon Manual*. New York: 1881. Facsimile edition. New York: Arno Press, 1973.

Aesthetics and Criticism

- Adams, Robert. *Beauty in Photography*. Millerton, NY: Aperture, 1981.
- Brooks, James T. A Viewer's Guide to Looking at Photographs. Wilmette, IL: The Aurelian Press, 1977
- Coffin, Charles. *Photography as a Fine Art.* Introduction by Thomas Barrow. Hastings On Hudson, NY: Morgan and Morgan, 1971.
- Gilles, John Wallace. Principles of Pictorial Photography. New York: 1923. Facsimile edition. New York: Arno Press, 1973.
- Hartmann, Sadakichi. *Landscape and Figure Composition*. New York: 1910. Facsimile edition. New York: Arno Press, 1973.
- ——. The Valiant Knights of Daguerre. Ed. by Harry W. Lawton and George Knox. Berkeley and Los Angeles, CA: The University of California Press, 1978.
- Lyons, Nathan, ed. *Photographers on Photography*. Englewood Cliffs, NJ: Prentice-Hall, 1966.
- Robinson, Henry Peach. *Pictorial Effect in Photography.* Pawlet, NH: Helios, 1971 (a facsimile of the 1869 edition).
- Scharf, Aaron. Art and Photography. Baltimore, MD: The Penguin Press, 1969.
- Sontag, Susan. On Photography. New York: Farrar, Straus and Giroux, 1977.

Index

Page references to illustrations appear in italics.

Abbott, Berenice, 34 Accessories camera, 94-97 printing, 205-8 Acetate CP (color printing) filter, 264, 277 Adams, Ansel, 38-39, 343 Adam-Salomon, 31 Adamson, Robert, 30 Advertising photography, 24-25, 180 Agitation as a factor in rollfilm processing, 194–95 Alberta Landscape, 1983, 271 Albright Museum of Art Exhibition of 1910, 34 Ambient illumination, 170 Ambrotype, 10 Americans, The (Frank), 41 An American Place gallery, 38, 39 Annan, J. Craig, 32 Ansco Company, 17 Anthony, Edward and Henry, 17 Aperture, 102, 103, 291 Aperture priority mode, 90, 109, 125-26 Apochromats, 297 Arago, Françoise, 5, 6 Arboretum photography project (Wylie), 68–74 Archer, Frederick Scott, 9, 343 Archival processing of prints, 234–37 Arentz, Dick, *Plate 3* Aristotle, 2 Art and photography, 17, 28-50 Artificial lighting, 172-84 Artificial Survey Series (McGillis), 267 ASA number, 149. See also ISO number Astigmatism, 136 Atget, Eugène, 34, 35 Autochrome film, 18, 19, 258 Available light, 167 Avedon, Richard, 56 Average Gradient, 331, 332 Axial light effect, 136, 297, 298

Babbitt, Platt, 9, 10 Back-lighted subjects, 131, 164 Bacon, Roger, 2 Barbizon painters, 28, 30 Barrel distortion, 136, 137 Barrel-mounted macro lenses, 295 Bartlett, David, 125, 145, 217 Batteries, checking camera, 100 Bauhaus, 36 Bayard, Hippolyte, 6–7 Beard's photographs, 20, 21 Becquerel, Edmond, 16 Bellon-Fisher, Linda, Plate 9 Bellows, 93, 294 Bellows factor, 290-92, 299 Bernis, Jim, Plate 13 Between-the-lens (BTL) shutters, 93, 170, 291 Bies, Tim, Plate 16 Biferie, Dan, 61 Bisson, Auguste, 12, 13 Bisson, Louis, 12

Black-and-white film, 148 available types of, 352 polarizing filters with, 157 processing, 187-99 response to color, 150, 151 using filters to manage, 152–53 Black-and-white negatives, 199–200, 219–22 Black-and-white papers fiber-based paper(s), 207-8, 210, 211-12, 222, 234, 355 outdated, 261 resin-coated, 206, 207, 210, 221, 222, 234, 242 Black-and-white photography filters, 152-53, 362 incident meters used in, 340-41 Black-and-white prints, 217-33 archival processing, 234-37 bleaching, 232-33 contact, 219-22 making by projection, 222-24 making test strips, 224-28, Plate 39 reducing, 229-31 spotting, 240-42 toner for, 234–35 Blade/leaf focal plane shutter, *92* Blanquart-Evard, Louis-Désiré, 8, 9 Bleaching prints, 232-33, 359 Block, Gay, 46 Blueprint (cyanotype), 17 Bouillabaisse Recipe-Studio Set (Cornwell), 76 Bourke-White, Margaret, 24, 27 Boy on Diving Board, 1986 (Van Parys), 127 Boy Scout series (Levy), 260 Boys Flying (Rexroth), 43 Brady, Mathew, 9, 11, 12 Brassaï (Gyula Halâsz), 25, 26 Brewster, David, 11 Brightness, 338 Broken Doll Still Life (H. Talbot), 58 Bromide papers, 211 Bulb setting, 94 Burning-in images when printing, 228, 229

Cable and cable release, 94 Calf, India (Judkis), 166 Callahan, Harry, 41 Calotypes, 6-8, 30 Camera, 85-114 accessories for, 94-97 aperture calibration, 102-3 battery check, 100 care and cleaning, 112-13 depth of field (see Depth of field) exposure meter and film speed, 107-9 field, 93, 94 (see also View cameras) first, 2-3 focal lengths for various, 364 focusing, 101 good form for holding, 131 Leica, 26 lens (see Lens(es), camera) loading film, 110-11 one-shot, 19 rangefinder, 86, 87

reflex, 86-93 (see also Single-lens (SLR) reflex camera(s)) selecting a, 97-98 shutter calibration, 106 shutter types, 91-93 simple, point-and-shoot, 86, 87 SX-70 instant print process, 20 view (see View cameras) Zeiss Ikon Ermanox, 24 Camera, effective use of, 115-32 Camera Notes (Stieglitz), 32 Camera obscura, 2, 3 Camera vision, 116-17 vs. human vision, 57-60 Camera Work (Stieglitz), 33, 37 Cameron, Julia Margaret, 31, 32 Canoes (Payette), Plate 1 Capa, Robert, 27 Cape Light series, Plate 27 Carbutt, John, 17 Carte-de-visite, 10, 11 Cartier-Bresson, Henri, 25, 26, 27 Casa del Oro . . (Fremier), 187 Catholic Funeral, Belfast (Pierce), 251 Cave Run Lake, Morehead, KY (Bartlett), 125 Chapman, Neil, 63, 230 Chapter House, Valle Crucis, Wales (Arentz), Plate 3 Chemicals, photographic for archival print processing, 234-37 bleaching prints, 232-33 for developing prints, 209-10 early investigations on, 3-4 formulas, 358-60 for processing color film, 257, 261 for processing rollfilm, 189-90, 194-99 for processing sheet film, 309, 310 reducing prints with, 229-31 Chess Players (W. Talbot), 7 Children's Playground after Storm . . . (Diaz), 60 Chloride papers, 210 Chlorobromide papers, 210 Christmas Tree (Kangas), 150 Chromatic abberation, 136 Chromogenesis, 257 Chrysotype, 17 Cibachrome prints, 20, 267-69, 271 printing sequence, 281, 282-84 Circles of confusion, 81 Close-up photography, 289-304, 360 Cobblestone House, Avon, New York, 1958 (White), 147 Cobo Construction series (Diaz), 75 Coburn, Alvin Langdon, 33, 34-35 Coin de la Rue Reynie, Un (Atget), 35 Cold-light enlargers, 202, 213 Collodions, 8-9, 10 Collotype, 16 Color(s), 152-53, 165, Plate 22, Plate 23. See also White additive primary, 152 balancing, in color photography, 252–53 complementary, 152, *153, 278* extended red sensitivity film, 151 light primary, 152

neutral density (gray), 279 primary, 252, 278 secondary, 152, 279 separation of, on color film, 256 subtractive, 152, 279 subtractive primaries, 152 tone and fidelity in color prints, 265–66, 280–81 Color analyzer, 272–73, 280–81 Color channels, 272, 273 Color compensating (CC) filters, 255, 264, 277 Color coupler, 257 Color crossover, 260 Color developer, 257 Color film, 256–62 available types of, 353–54 balancing color on, 252–53 color negative, 257 color positive (reversal), 257 color separation on, 256 impact of daylight vs. artificial light on, 165, 254-55 latitude, 260-61 outdated, 260-61 polarizing filters and, 157 processing, 257, 261, 264 reciprocity effects, 259-60 reciprocity effects, 259–60 special types of, 257–59 Color matrix, 273, 274–77, 280 Color negatives, 20, *Plate 36* available film types, 354 daylight-balanced, 258 filtration of, 272–81 printing from, 265, 266, 271 processiong, 257, 264 professional, 258–59 Color photography, 251–62 Color photography, 251–62 color balance, 252–53 color film operation, 256–61 color film processing, 257, 261, 264 color film processing, 257, 261, 264 color filtration, 254–55, 361–62 early history, 18–20 Color positives (transparencies, slides), 257, *Plate 37* available film types, 353 printing from, 265, 267–70, 281–84 processing, 261 Color prints, 263–87, *Plate 38* equipment for making, 264–65 instant, 20, 257–58 negative filtration, 272–81 color film operation, 256-61 negative filtration, 272-81 negative printing, 271 negative processes, 266 paper for, 357 permanence of, 285-86 positive printing, 281-84 positive printing, 261-64 positive processes, 267-70 tone and color fidelity in, 265-66 tricolor printing, 285-86 Color temperature, 252-53 filtration and, 254 Color temperature meter, 255 Coma, 136 Commercial photography, early history of, 9–16 Composition, 60–68 Computers and photography, 49-50 Condenser enlargers, 202, 203 Conrad, Fred, Plate 31 Constructivism, 36 Contact dermatitis, 190 Contact-printing papers, 78, 210-11 Contact-printing papers, 78, 210–11 Contrast, 165 curve gradient and, 329 filters and, 212–13 manipulating when printing, 226, 227, 228 printing paper and, 212, 214 reciprocity effects and color, 260 Contrast Index (CI), 331, 332 development time and, 336 development time and, 336 speed point of film and, 333, 334 translating to zone system N-numbers, 347-48 Conversion filter, 156, 254 Copy photography, 300–303 copy stand, *300* exposure, 302, 303

set-up for books/magazines, *302* view camera, *292*, 297 Cornwell, David, *76*, *161*, *Plate 34 Crawlers, The* (Thomson), *21* Criticism, using constructively, 54–55 Cubists, 34 Cunningham, Imogen, 38 Curtain focal plane shutters, 91, *92* Curvature of field, 136 Cut film. *See* Sheet film Cutting, J. A., 10 Cyanotype (blueprint), 17

D-76 developer, 190 Dadaism, 35, 36, 42 Daguerre, Louis Jacques Mandé, 4, 29 Daguerreotypes, 4-6, 9, 29 Darkroom. See also Printing equipment and materials rollfilm processing equipment and facilities, 188-89 Davidson, Bruce, 53 Da Vinci, Leonardo, 2 Davis, Phil, *211, 239, 268* Davison, George, 32 Dawn and Sunset (Robinson), 31 Daybooks of Edward Weston, The (Weston), 38 Daylight, 174 color and, 252, 255 uniformity of, 175 using flash with, 165, 171 Deceptions #22 (Porett), Plate 15 Decisive Moment, The (Cartier-Bresson), 26, 27 Delacroix, 28 Delacroix, 20 Delaroche, 29 Della Porta, Giovanni Battista, 2 Density, 277, 327 IDmax and IDmin and, 332, 333, 334, *335, 336* logarithmic values, 159, 330 Depth of field, 82, *83*, 86, 104-5 aperture priority and, 125-26 close-up photography, 296 combined factors affecting, 143-44 lens focal length and, 142, 145 previewing, 120, 121, 122 scale, 105 view camera swing adjustments and, 316-18 Developers color film, 257, 261 formulas, 358 prints, 209, 215 rollfilm processing, 189-90 tanning, 270 Development, film. See Processing film Develop-out image, 78 Diaz, Carlos, *60, 75,* 118 Dichroic fog, 196 Diffraction of light, 80, 135 Diffusion enlargers, 202, 203 Diffusion of light, 135, 162–63, 164 Digitized Agave (Walker), Plate 7 DIN number, 149. *See also* ISO number Diopters, 293 Diorama, 5 Discontinous spectrum, 253 Disdéri, Adolphe-Eugène, 10, *11* Dispersion of light, 135 Distortion, 142 Dr. Goebbels Heilsenf (Heartfield), 36 Dodging images when printing, 228, 229 Draper, John W., 9 Driftwood and Seascape, Hunting Island #3 (Wang), *235* Dry-mounting prints, 208, 243, *244–45* Ducos du Hauron, Louis, 19, 35 Dusard, Jay, 85 DX code, 107 Dye diffusion process for instant color prints, 257–58 Dyes, spotting prints with, 240-42 Dye transfer process for color prints, 269-70

Eakins, Thomas, 15, 16, 34 Easel, 205 Eastman Kodak Company, 17-18 Edith, 1986 (Gowin), Plate 6 Editorial photography, 20 Effective film speed (EFS), 341, 342, 346-47 Eisenstadt, Alfred, 24 Ektachrome paper, 267 Ektacolor paper, 266, 271 Electromagnetic spectrum, 134–35 Electronic flash, 92, 95–97 *Elevator Girl* (Frank), *41* Emerson, Peter Henry, 30, *31*, 32 Enlarger, 83, 202-4 autotransformer, 264 color, 203, *204*, 213, 264 enlarging lenses for, 203-4 making prints with, 222-24 types of, 202, 203 voltage regulator, 264, Plate 41 Environmental Portrait #5 (Ransweiler), 49 Equivalents, Stieglitz's, 38, 42 Eugene, Frank, 33 Evans, Frederick, 32 Evans, Ralph, 19 Evans, Walker, 25 Exposure(s) bracketing, 167, 300 calculating, 124–25, 280–81 close-up photography, 290-92, 299-300, 302-3, 360 compensating for reciprocity effect, 150 copy work, 302, 303 examples, Plate 42 film latitude linked to, 260 over-, and image sharpness, 148 programmed, 126-27 semiautomatic, 125–26 Exposure/development systems, 323–49 film test, 324-25 film test, 324-25 film test results analysis, 326-36 Incident Metering System, 341-42 light meter types and characteristics, 336-41 relationship between exposure and development, 324 Zone System, 331, 343–48 Exposure index, 335, *336* Exposure meter, 90 close-up work, 290, 299–300, 302–3 compensating for, or overriding, in unusual subject conditions, 127–31 film speed and, 107-9 flashmeters, 171 hand-held, 290 off-the-film (OTF), 171 through the lens (TTL), 290 types and characteristics, 336–41 Exposure scale (ES) for paper, 332, *333* Extended red sensitivity film, 151 Extension tubes, 294 Eye-relief characteristic, 90 F. K., Boston, 1984 (Nixon), 293 Falloff, light, 175, 176 *Family of Man* exhibit (Steichen), 39–40, 43 Fangor, Voy, *48* Farmer's Reducer, 229-30, 231, 359 Farm Security Administration project, 25 Fenton, Roger, 10 Ferrotype, 10 Fiber-based paper(s), 207-8, 210-12, 222, 234-35 Field camera(s), 93, *94* Field coverage of lens and focal length, 138, 139, 140 Film, 82-83, 147-51 autochrome, 18, 19, 258 autochrome, 18, 19, 258 available types, 352–54 black-and-white (*see* Black-and-white film) color sensitivity, 150–51 development charts, 365–66 effect of filters (*see* Filter(s)) Ektachrome, 20, 267

Ektacolor, 20

exposure (see Exposure(s)) first flexible commercial, 17 grain size, 148 image characteristics on, 148-49 ISO number (see ISO number) Kodachrome, 20, 257 Kodacolor, 20 latitude, 148, 260-61 loading, 110–11 matrix, 270 negatives, 78, 82–83, *84*, 148, 199–200 orthochromatic, 151 outdated, 260–61 panchromatic, 151, *154* reciprocity effects, 150 rewinding, 111 rollfilm processing, 187-200 sheet (see Sheet film) speed, 107–9, 111, 125, 148, 149 effective, 341, *342*, 346–47 speed point, 333, *334* Film advance lever, *106* Film characteristic curves, 327–28, *329, 330*–33 Film emulsions, 78, 148 color negatives, 257 "orthochromatic/panchromatic, 151 reciprocity effects on, 259-60 Film holders, 306 Filter(s) for black-and-white photography, 152-59, 362 for color photography, 254-55, 361-62 for color printing, 264 negatives, 272-81 for contrast, 212-13 conversion, 156, 254 dichroic for color printing, 203, 204 haze, 255 for infrared, 154-55 light-balancing, 254 Ight-balancing, 254 neutral density, 159 polarizing, 156–59, 255 red, *147*, 156 skylight, 112, 255 tricolor printing, 285 viewing, 277, 278 Filter drawer, 264 Filter factor(s), 155-59 Filter holders, 95 Filter pack, 272, 277-79 Filter sheet, 280, 281 Finlayson, MN (Bartlett), 217 First Baptist Church, Richmond, Texas (Biferie), 61 Firth, Francis, 12 Fisher, Gail, 21 Fish-eye lens, 136 Fitzgibbon, J. H., 9 Fixing bath (hypo), 6, 8, 78-79, 196-97, 209-10, 358 removing from archival prints, 236-37, 359 Flanders Road, October 1985 (Vestal), 236 Flare light, 95, 118, 138 Flash, 169-72 close-up photography, 299 electronic, 92, 170–71, 299 flashbulbs, 97, 169–70 quide numbers, 171 ring-light, 299 simple uses of, 171–72 softening, 172, *173* synchronizing focal plane shutter with, 92, 170 units, 95-97 using in daylight, 165, 171 Fluorescent lights, 253 Focal distance vs. focal length, 291 Focal length of lens, 101 aperture calibration and, 102-3 field coverage and, 138, *139, 140* vs. focal distance, 291 image perspective and, 141-42 for various cameras, 364 Focal plane shutters, 91, *92*, 170 Focusing aid, 86, *88*

Focusing reflex cameras, 86–87, 88, 101 hyperfocal, 121, *123* for infrared, 154, *155* view cameras for close-up work, 295–97 zone, 123, *124 Fontenelle Fatality* (Meares), *55* Footage scale, *101 Formal Frolic, Fla* (Ross), *Plate 14 Fortune* magazine, 24 Framing, 118–19 *Francis Bacon, Artist* . . . (Avedon), *56* Frank, Robert, *41* Fraprie, Frank, 32, 34 Fremier, Roger, *187* Fresnel, 86, *88* Friedlander, Lee, 41 f-stops, 102, *103* Futurists, 34

Garnett, William, *46*, *59*, *64*, Gas-discharge lights, Gelatin filter squares, *95*, Gelatin processes in photography, *16–18* Genthe, Arnold, Gilpin, Henry, Glacial acetic acid, *Good Joke, A* (Stieglitz), *Goodland, Kansas* (Garnett), Goodwin, Hannibal, Gowin, Emmet, *Plate 6* Grain focuser, *205–6* Gray card, *273*, *302*, *303*, 339, 340 Great Depression, Grosz, George, *Group at Niagara Falls* (Babbitt), Group f-64,

Haitian Woman, The (Lyon), 44 Halation, 148, *150* Hammer, Gordon, *58, 117* Hammond, Arthur, 63-64 Harry Mattison, photography (Pierce), 305 Havasu Falls, Arizona, 1984 (C. Smith), 263 Hayden, F. V., 13 Haze filter, 255 Heartfield, John, 36 Held, Der (Wegler), 67 Heliography, 4 Herschel, John Frederick William, 6-8, 17 High key effects, 175, 210 Hill, David Octavius, 30 Hill, Levi, 18–19 Hine, Lewis, 20, *23* Hinton, Horsley, 32 Höch, Hannah, 36 Homage to the Whale, 1980 (Fangor, Patkowski), 48 Horse's Motion Scientifically Considered (Muybridge), 15 Hot shoe, 95, 96 How the Other Half Lives (Riis), 21, 22 Hunt, Robert, 18 Hyma, 265 Hyperfocal focusing, 121, 123 Hypo. See Fixing bath (hypo) Hypo eliminator formula, 359

Ibex Dunes #1 (Garnett), 46 lce Shanty (revised) #2 (Diaz), 118 Illuminance, 336, 341 Image formation by light, 2–3, 78–80, 81, 82, 83, 84, 315 Image magnification, 142, 143, 204 Image perspective, 141–42 view camera shift adjustments for converging, 315–16 Impressionism, 29, 32 Incident light, 337 Incident meter, 337, 340–41 Incident Metering System, 341–42 India Portfolio (Strawn), Plate 5 Infinity, focusing on, 81, 101 Infrared light (IR), 135, *147*, 154-55 *In Front of the Sky* (Kangas), *51* Ingres, 28, 29 Instantaneous photographs, 14 Polaroid, 20, 257-58 Intensity (I) of light, 165, 174, 259 Interference, light, 135 Inverse square law, light, 195, 290 Irradiation, 148 ISO number, *108*, 125, *131*, 149, 155, 212, *213*, 332, *333*

Jackson, William H., 9, 12–13, 14 Jay, David Alan, 28 Jenkins, William, 44 Judkis, Jim, 166 Judy (Chapman), 230 Julia Sleeping (Leonard), 45 Julia with Devastation (Leonard), 270 Julie and the Judge . . . (Land-Weber), 132

Kallitye, 17 Kangas, Rob, *51, 62, 126, 150* Keiley, Joseph, 33 Keller, Kate, *289* Kertész, André, 25, 26 Kljć, Karel, 17 Kodachrome film, 257

Lake Powell, Arizona and Utah (Garnett), 259 Landsat photograph, 256 Landscape for Edith (Streetman), Plate 4 Land-Weber, Ellen, 42, 99, 132 Lange, Dorothea, 25 Lartigue, Jacques Henri, 34 Latent image, 78 Lauritzen, Erik, 156 Lee, Russell, 25 LeGray, Gustave, 8 Lens(es), camera aberrations, 136-38 accessories, 94-95 angular coverage chart, 364 aperture calibration, 102–3 applied to camera obscura, 2 aspheric elements of, 137 characteristics of, 138-40 close-up (positive), 293-94 close-up view camera, 297 coating, 137-38, Plate 20 effect on light, 135 fish-eye, 136 focal length of, 101, 102 image formation using, 81, 82, 135-40 macro, 295 macro-zoom, 294-95 negative and positive, 135, *136* reversing, 294 Symmar, 315 telephoto (see Telephoto lens) view camera, 315, 319 wide-angle (see Wide-angle lens) zoom, 127, 136 Lens(es), enlarger, 203-4 Lensboard, 93 Lens cap/shade, 95 Leonard, Joanne, 45, 270 Lerebours, Noel, 9 Le Secq, Henri, 10 Levy, Janice, 167, 169, 260, Plate 26 Levy, Jance, *107*, *109*, 200 Lewis, William, 4 Liesfeld, Volker, *Plate 30 Life* magazine, 24, 27 Light, 78, 134-35, 161-85 artificial, 172-84 attributes of, 162-65, 174-75 available, 167 behavior of, 135 brightness, 338 for close-up photography, 297, 298, 299

color, 165, 174, 252-53 (see also Color(s)) color separation of white, 19, 135 continuous spectrum, 252 cross light, 162, 163 diffraction, 80, 135 diffusion, 135, 162–63, *164* direction, 162, *163*, *164*, 174 discovery of image formation by, 2–3 falloff of, 175 failoir of, 175 flash, 169–72 (*see also* Flash) hard and soft, 162–63, *164*, *165* illuminance, 336 incident, 337 infrared (see Infrared light (IR)) in lens (see Lens(es)) intensity, 165, 174, 259 luminance, 127, 336, 338 meters (see Exposure meter) point sources (see Point sources of light) reflected, 337 selected, 168-69 ultraviolet, 134 Light, Ken, *47* Light-balancing filters, 254 Lighting ratio, 174, 175 Light-sensitive materials, 78–79 Linked Ring Brotherhood, 32 London Labour and the London Poor (Mayhew, Beard), 20, 21 Longo, Bill, 63 Look magazine, 24, 27 Lumière, Auguste and Louis, 18, 19, 258 Luminance, 127, 336, 338, 341 Luminance meters, 337 wide-field averaging, 338 Luminance range, 338, 341, 345 Lyon, Danny, 41, *44* McCormick Place Annex, Chicago . . . (Merrick), Plate 35 McGillis, Michael, 267 Macro lenses, 295 Macro-zoom lenses, 294-95 Magnification factors in close-up photography, 292 Magnum Photos, 26 Making a Photograph (Adams), 39 Mannequin Series One (Chapman), 230 Manual mode, camera, 90 Marat/Sade (Waldman), 178 Marat/Sade (Waldman), 178 Marey, Etienne Jules, 16, 34 Marginal light rays, 136 Marin, John, 33, 38 Martin Black, Stampede Ranch, Nevada, 1982 (Dusard), 85 Mask(s) cardboard, 274-75 color-correcting, 257 highlight, 269 principal, 269 Matrix film, 270 Matting prints, 208, 246-49 M Bank, Dallas, Texas . . . (Merrick), 166 Meares, Lorran, 55, 65, 184, Plate 11, Plate 17 Meares, Lorran, *55*, *65*, *184*, *Plate 11*, *Plate* Melainotype, 10 Merrick, Nick, *166*, *325*, *Plate 29*, *Plate 35* Meter. *See* Exposure meter Metol poisoning, 190 *Mexican Portfolio* (Strand), 37 Meyerowitz, Joel, *323*, *Plate 27* Microprism grid, 86, 87, *88 M. Miranda-Le Penché* (O'Neal), *115* Mode selector switch, *109* Mode selector switch, 109 Moholy-Nagy, László, 36-37 Molder, 29 years, Industrial Accident, 1975 (Light), 47 Moody, Phil, 80 Morse, Samuel F. B., 9 Motion blur, 123, 124 Motor drives, 97 Moulins de Montmarte 1842 (Bayard), 8 Mounting prints, 208, 243, 244–45 Muybridge, Eadweard, 14, 15, 16, 34 Mydans, Carl, 27

Naturalist photographers, 17, 30–32 Navaho Lands, New Mexico, 1983 (Merrick), 325 Negative, The (Adams), 343 Negative image, 78, 82–83, 84. See also Black-andwhite negatives; Color negatives Nègre, Charles, 9 Neutral density (ND) filters, 159 New Topographics photographers, 44–45 New Zone System Manual, The (White, Zakia, Lorenz), 343 Niépce, Isidore, 4–5 Niépce, Joseph Nicéphore, 4 Nixon, Nicholas, 293, 321

Off-the-film (OTF) metering, 171 O'Keeffe, Georgia, 33, 38 Old House in Cherry Street (Riis), 22 Old/New Houses (Gilpin), 117 One-shot developers, 190 Orthochromatic film, 151 O'Sullivan, Timothy, 9, 12 Outdated photographic materials, 260–61

Pacific Lumber Co. Mill Pond, Scotia, CA (Land-Pacific Lumber Co. Mill Pond, Scotla, CA (La Weber), 99 Painting, relationship to photography, 29–32 Palladium prints, 69, 73 Palm, 1986 (Lauritzen), 156 Panchromatic film, 151, 306 filtering, 154 Panning, 123, 124 Paper(s), printing, 82-83, 203, 210-15, 260-70, 332, 333, 335, 355-56 Paradise Cove Panorama (Cornwell), Plate 34 Paris by Night (Brassaï), 26 Parks, Gordon, 27 Patkowski, Carolyn, 48 Payette, Peter, Plate 1 Pencil of Nature (Talbot), 9 Perception and visualization, 116–17 Personal expression in photography, 53, 56–57, 62, 68, 75 Perspective. *See* Image perspective Pfahl, John, *54*, *Plate 12* Photoglyphic drawing, 16 Photogram, 36, 78 Photograph(s), qualities of good, 51-76 composition, 60-68 consumer vs. producer perspective, 52-54 human vision vs. camera vision, 57-60 limits to personal expression, 56-57 using constructive criticism, 54-55 B. Wylie's Arboretum project, 68–74 Photographer's Eye, The (Szarkowski), 43 Photographer bland, The, 289 Photographic magazines, 24, 27 Photography black-and-white (see Black-and-white photography) color (*see* Color photography) history of, 2–50 art and, 28-50 discovery and evolution, 2-28 introduction to process of, 77-84 image formation, 79-83 light-sensitive materials, 78-79 Photogravure, 17 Photojournalism, 10, 12, 24–28 Photomacrography, 290 Photoms, *134* Photo-Secessionists, 32, 33 Pictorial Composition in Photography (Hammond), 63-64 Pictorial Effect in Photography (Robinson), 62-63 Pictorialist movement, 32, 38, 42 Pierce, Bill, 251, 305, Plate 8 Pincushion distortion, 136, 137 Pinhole image formation, 79-80, 81, 82 Plansker, Laura, 66 Platinotype, 17 Point sources of light, 79, 81, 162, 175, 202, 290

Poitevin, Alphonse Louis, 16 Polarizing filters, 157-59, 255 Polaroid Corporation, 19, 20, 39, 257 Ponton, Mungo, 16 Poppenrock, Morehead, KY (Bartlett), 145 Poppy at 91 Years, 1988 (Levy), 169 Porett, Thomas, Plate 15 Portrait, East 100th Street (Davidson), 53 Portrait of Lincoln (Brady), 11 Portraiture, 8, 11, 12, 30, 178, 179 Positive images, 78, 83, 84 Post-war era, photography in, 40-43 Print(s) black-and-white (see Black-and-white prints) color (see Color prints) defined, 83 drying, 207, *208* mounting and matting, 208, 243–49 spotting, 240–42 stabilization processing, 214-15 Printed-out image, 78 Printing equipment and materials, 201-15, 264-65 Printing frame, 206 Print tongs/paddles, 207, 208 Processing film black-and-white rollfilm, 187-200 color film, 257, 261, 264 development charts, 365–66 sheet film, 308–9, *310* Processing trays, 206–7 Process lens, 297 Professional Photographers of America (PP of A), 43 Programmed operation mode, 90, 91, 109, 126-27 Projection-printing paper, 78, 210 Proofing frame, 206 Provincetown, 1976 (Meyerowitz), Plate 27 Provincetown, 1977 (Window) (Meyerowitz), 323 Pueblo Alto, Chaco Canyon, NM (Meares), Plate 11 Queen's Drive Bridge . . . (Chapman), 63 Rainbow, 135, *Plate 19* Rancho Seco Nuclear Plant . . . (Pfahl), *Plate 12* Rangefinder prism, 86, 88 Ransweiler, James, 49 Ray, Man, 36 Rayograms, 36 Reciprocity effect, 150, 259-60, 363 Reciprocity failure, 131, 259-60, 299, 363 Redstone Missile/Indian Creek Petroglyphs (Pfahl), 54 Reducing prints, 229–30, *231*, 359 Reflectance meters, *337*, *339* Reflectance range, 341 Reflected light, 337, 341 Reflected light, 337, 341 Reflection of light, 135, 158 Reflective surfaces, tent lighting to photograph, 181, *182, 183* Reflex camera(s), 3, 86–93. *See also* Single-lens reflex (SLR) camera(s) close-up photos with small, 290, 293–95 Refraction of light, 135 Refugee Camp, Sidon, Lebanon (Pierce), Plate 8 Regnier, Michael, 77, Plate 33 Rejlander, Oscar A., 29, 30, 31 Resin-coated (RC) paper(s), 210 for archival prints, 234 available types, 356 contact prints from, 221 drying, 207, 222 processing trays and, 206 spotting, 242 Reticulation and rollfilm processing, 197, *198 Revere Beach, Massachusetts, 1980* (Nixon), *321* Reverse adapter rings, 294 Rexroth, Nancy, 43 *Ribbon with Blue Spring* (Seeley), *269* Riis, Jacob, 21, *22*, 23 Roadside Vegetable Stand (Davis), 211 Robinson, Henry Peach, 30, 31, 32, 62-63 Rocky Mountains . . . (Jackson), 14

Rollfilm, 187–200, 307–8, 324–25 Root, Marcus A., 18–19 *Roses and Sunshine* (Weston), 39 Ross, Andy, *Plate 14* Rothstein, Arthur, 25 *Ruttinger's Gift Shop* (Davis), 239

Sabattier effect, 198 Safelights, 202, 265 St. Victor, Claude Niépce, 9 Sala, Angelo, 3 Salomon, Erich, 24 Savoie 46-Mont Blanc, vu de Mont Joli 1861 (Bisson), *13* Schad, Christian, 36 Schadographs, 36 Scheele, Carl Wilhelm, 3 Schulze, Johann Heinrich, 3 Scotia Coffee Shop at 11:45 a.m. Any Weekday (Land-Weber), 42 Scrimshaw Carver-Studio Set (Cornwell), 161 Seeley, J., 269 Selected light, 168-69 Selenium toner, 235-36, 359 Self Portrait (Steichen), 40 Semiautomatic mode, camera, 90, 109, 125-26 Separation negatives, 269–70 Sequences, Minor White's, 42 Sequences, Minor White's, 42 Series adapters, 94 Setting the Bow Net (Emerson), 31 Shadow exposure, 340 Shadows (Strand), 37 Shahe, Bog. 25 Shahn, Ben, 25 Sharecropper Mother Teaching Children (Lee), 25 Sheet film, 93, 306-10 Sheltered Fire and Petroglyphs in Eastern Utah, May 23, 1983 (Fitch), 262 Shutter(s), 91–93, 106, 319, *320* Shutter priority mode, 90, 109, 126 Shutter speed, *106*, 123, *124* adjusting exposure with, 131, 291 Silver compounds, 3–4, 5, 78 Silver compounds, 3–4, 5, 78 Single-lens reflex (SLR) camera(s), 89–91 close-up photography with, 290, 293–95 controls and features, 99–114 cut-away view, *90* focusing, *88* Skylight filter, 112, 255 Slides, color, 257, 258 Smith, Adolphe, 20 Smith, Clinton, 263 Smith, Eugene, 27 Smith, Hamilton, 10 Smith, John Shaw, 10 Snow Geese with Reflection of the Sun Snow Geese with Reflection of the Sun (Garnett), 64 Snowmobile (Welzenbach), Plate 18 Soccer Player (Davis), 268 Social Landscape photography, 41 Society for Photographic Education (SPE), 43 Solarization, 198, 328 "Songs of the Sky" (Stieglitz), 38 South Miami Beach (Block), 46 Southworth, Albert, 9 Speed point, film's, 333, 334 Spherical aberration, 136 Spotmeters, 338-40 Spotting prints, 240-42 Spring backs, 93 Stabilized prints, 214 Stanford, Leland, 15 Steichen, Edward, 33, 39-40, 43 Step-up-rings, 94

Steroscopic views, 10–11 Stieglitz, Alfred, *1*, 32–34, 37, 38 Still-life photography, 179, *180* Stop bath, 195–96, 209, 358 Stop down, 95, *102*, *104* Strand, Paul, 33, *37*, 38 Strawn, Martha, *Plate 5 Street Life in London* (A. Smith, Thomson), 20, *21* Street Life in London (A. Smith, Thomson), 20, *21* Street Life, Roy, 25 Subject luminance range (SLR or SBR), 338 Subject range (SB), 334–36 *Sunday on the Banks of the Marne* (Cartier-Bresson), *27 Surface Survey no. 5* (McGillis), *267* Surrealism, 36, 47 Sutton, color separations by, 19 *Swimmers, 1967* (University of Michigan Press), *133*

Szarkowski, John, 43

Talbot, Henry, 58 Talbot, William Henry Fox, 5–6, 7, 8, 9, 14, 16, 36 Talbotype, 8 Tanning developer, 270 Telephoto lens, 3 distortion, 142 field coverage related to focal length with, 138, 139, 140 Television, 27-28 Temperature, as a factor in rollfilm processing, 194 reticulation and, 197, *198* Tent lighting, 180-83, 297, 298 Teres, Michael J., 198 Terminal, The (Stieglitz), 1 Test strips, printing, 224–28, *Plate 39* fixed increment (arithmetic sequence) method, 224. 225 geometric method, 225-26 geometric method, 225–26 process of, 226–28 Thanksgiving with the Findells (Meares), 65 33 W. Monroe Bldg, Chicago, IL. . . . (Merrick), Plate 29 Thomson, John, 20, 21, 23 Threshold of sensitivity, 328 Through-the-lens (TTL) meters, 290 Time as a factor in rollfilm processing, 194 Timer, 188 Time (T), exposure setting, 94, 159, 291, 299 Tintype, 10 Tone, color, 265-66 Toners, 189, 234, 359-60 Transparencies, color, 252, 257, 260 printing from, 265-66, 281-84 processing, 261 Tricolor printing, 271, 285 Tripod, 93, *94*, 94 Tuescher, Ted, *68* Tungsten film, 253 *Tunner Family, Woburn, Mass.* (Käsebier), *33* Twin-lens reflex (TLR) camera, 88, *89* 291 Gallery, 33 Two Teenagers with Record, Armagh, No. Ireland, 1987 (Jay), 28 Two Ways of Life (Rejlander), 29, 30

Uelsmann, Jerry, 48 Ultraviolet (UV) light, 134–35, 255 Unit magnification, 292 "Unretouched" Photograph . . . (Wang), 49 Untitled (Fisher), 201 Untitled. Berkeley, CA 1983 (Hammer), 117 Untitled. San Francisco, CA 1988 (Hammer), 58 Untitled Still Life (Regnier), Plate 33 Untitled Still Life (Wang), Plate 10 Urban Canyon, Omaha, NE. (Meares), Plate 17 Utensils and containers, darkroom, 188, 206-8

Vachon, John, 25 VanderKallen, Michael, Plate 28 Vanity Fair magazine, 24 Van Parys, G. Michelle, 127 Variable (selective) contrast papers, 203, 212–13, 214 Vestal, David, 236 Video Generated Photographic Paintings (Bies), Plate 16 View cameras, 93, *94*, 305–21 adjustments, 306 close-up work with, 295–97 lenses, 94–95, 319 life-size copy with, 292 sheet film for, 306–9 sheet lim for, 306-9 sheet film processing, 310 shifts, 311, 313, 314, 315-16 adjustments, 313, 314 functions, 315-16 shutters, 319, 320 swings, 311, 313, *314*, 316–18 using, 309, *311–13* Viewpoint, 120 Vignetting, 94, 95 Vision, human vs. camera, 57-60 Visualization and perception, 116-17 Vogel, Hermann, 19 Voltage regulator, 264, Plate 41 Vortographs, 34, 35 Waldman, Max, *178* Walker, Todd, *Plate 2, Plate 7* Wang, Sam, *49, 235, Plate 10* Water for photographic use, 189 Water soak on prints, 234 Watkins, Carleton, 9 Weber, Max, 33, 34 Wedgwood, Thomas, 4 Wealer, Monika, 67

Wegler, Monika, 67 Welzenbach, John, Plate 18, Plate 32 Weston, Edward, 38, 39, 61 Wet-plate process, 10, 12 Wheatstone, Charles, 10-11 White, 165 color separation of, 19, 135 color separation with polarizing filters, 157 handling exposure meter when photographing, 128 White, Clarence, 33 White, Minor, 41, 42, *147* zone system interpretation by, 344 Wide-angle lens, 138, *139, 140,* 142 Willis, William, 17 Winders, 97 Winogrand, Garry, 41, 44 Wolcott, Marion Post, 25 Woodbury, Walter B., 16 Woodburytype, 16, 21 World War II, 27 Wylie, Bill, Arboretum project, 68-74

Yellowstone region, 12–13 Young Millworker (Hine), 23

Zone System, 39, 331, 343–48 Zoom lens, 136, *137* Zoopraxiscope, 15